WRIGHT OF DERBY

JUDY EGERTON

Wright of Derby

TATE GALLERY

front cover/jacket
A Philosopher giving that Lecture on the Orrery,
in which a lamp is put in place of the Sun exh.1766
(detail, cat.no.18)

ISBN 1 85437 037 5 paper
ISBN 1 85437 038 3 cloth

Published by order of the Trustees 1990
on the occasion of the exhibition at the
Tate Gallery: 7 February – 22 April 1990
Grand Palais, Paris: 17 May – 23 July 1990
Metropolitan Museum of Art, New York: 6 September – 2 December 1990

Photo credit: John Webb FRPS
Designed by Caroline Johnston
Published by Tate Gallery Publications, Millbank, London SW1P 4RG
Copyright © 1990 The Tate Gallery All rights reserved

Printed on Parilux matt 150gsm and typeset in Baskerville
Printed by Westerham Press Ltd, Westerham, Kent

Exhibition sponsored by The British Land Company

CONTENTS

7 Foreword

8 Acknowledgments

9 Introduction *Judy Egerton*

15 Joseph Wright of Derby and the Lunar Society
David Fraser

25 The Engraving and Publication of Prints of
Joseph Wright's Paintings *Tim Clayton*

31 Catalogue

32 Abbreviations

231 Catalogue of Engraved Works

232 Abbreviations

259 Chronology

263 Wright of Derby's Techniques of Painting *Rica Jones*

273 Wright's Picture Frames *Paul Mitchell*

289 Lenders

290 Index of Works

FOREWORD

'Mr Wright is a very great and uncommon genius' declared a contemporary reviewer. Joseph Wright's individuality lay in his often unconventional subject-matter and his lifelong preoccupation with light. This exhibition presents every aspect of Wright's work, on the same scale as previous major exhibitions at the Tate Gallery devoted to the paintings of Constable, Gainsborough and Stubbs.

At his best, Wright is an original and deeply-thoughtful artist who rarely does the conventional or obvious thing. His lifelong preoccupation with the effects of light underlies the two great pictures by which he will probably always be best known, 'An Experiment with a Bird in the Air Pump' and 'A Philosopher giving that Lecture on the Orrery'. The same interest in the effects of light governs his pictures of smithies and forges, of Vesuvius and fireworks, of moonlight and dramatic cloud. Wright's range is wide: as well as the portraits which provided his chief livelihood, it includes landscape painting, in which he was a late developer but often remarkably forward-looking. Wright may not be at the very top of the hierarchy of British painters, but he is a consistently interesting and original artist who deserves a place not far from it.

The last time that a substantial group of works by Wright hung in the Tate Gallery was in 1958, in a comparatively small exhibition (thirty four paintings and twelve drawings) organised by the Arts Council and catalogued by Benedict Nicolson. In his introduction Nicolson was at pains not to claim Wright as a major figure.

Ten years later, in 1968, Benedict Nicolson's brilliant and more openly enthusiastic study *Joseph Wright of Derby: Painter of Light* appeared, opening many people's eyes to the force and originality of Wright's work. Wright's best works are now eagerly competed for, and it is significant that important paintings have recently entered the collections of the National Gallery, the Louvre and the Metropolitan Museum of Art, New York.

A project of this kind could not be realised without the generous support of collectors both public and private and to all we wish to extend our sincere thanks. We are particularly grateful to Derby Art Gallery for lending so extensively from its collection and to David Fraser, Derby Museums and Arts Officer, for his unfailing helpfulness at all times.

We are most fortunate in having persuaded Judy Egerton to select and catalogue the exhibition for us. She was the curator of the Tate's *Stubbs* exhibition in 1984-5, joint author of *The Age of Hogarth*, the recently published catalogue of eighteenth century paintings in the collection of the Tate Gallery and retired as Assistant Keeper of the Tate's Historic British Collection in 1988.

After the Tate, this exhibition which will be shown, in a slightly smaller version, first at the Grand Palais, Paris, under the auspices of the Réunion des musées nationaux, and then at the Metropolitan Museum of Art, New York. We are delighted to have had the opportunity of collaborating with colleagues in both places, with Pierre Rosenberg and Cécile Scailliérez in Paris and with Phillippe de Montebello and Mahrukh Tarapor in New York. The overseas tour has been organised by the British Council and we are grateful to Muriel Wilson and David Fuller in London and to Cathérine Ferbos and Chantal Pilandon in Paris for their painstaking assistance. We are also grateful to colleagues at the Réunion, to Irène Bizot and Claire Filhos-Petit, for their support.

The exhibition at the Tate Gallery has been made possible by generous sponsorship from The British Land Company. We have enjoyed working with their Chairman, John Ritblat, in planning the promotion of the exhibition. We thank them for their enthusiastic support. This sponsorship has been recognised by an award under the Government's Business Sponsorship Incentive Scheme, which is administered by the Association for Business Sponsorship of the Arts.

Nicholas Serota *Director*

ACKNOWLEDGMENTS

I whole-heartedly second the Director's thanks to all the lenders to this exhibition, and in particular the private lenders. In my excursions to see pictures in private houses, I invariably met with great kindness. That preference for anonymity which increasingly prevails among lenders makes it impossible for me to thank them individually here, but for their general unselfishness in making this exhibition possible, I am profoundly grateful.

My greatest single vote of thanks is to David Fraser of Derby Art Gallery. From the start, he gave this exhibition enthusiastic and effective support; he has also been outstandingly generous, patient and good-humoured in supplying information, much of it from his own research. I am also indebted for information to his colleague Maxwell Craven, and to the architect Edward Saunders in Derby.

David Fraser is one of four scholars who have enhanced this catalogue by contributing essays on different aspects of Wright's work. Fraser's essay 'Joseph Wright of Derby and the Lunar Society' focusses on science and industry in and around Derbyshire, providing an illuminating context for Wright's work. Tim Clayton, in 'The Engraving and Publication of Prints of Joseph Wright's Paintings', highlights the superb quality of mezzotints after Wright, and shows how these helped to spread his fame abroad as well as in England. Clayton also contributes the first catalogue of engravings after Wright. Paul Mitchell, in 'Wright's Picture Frames', shows that Wright himself took a keen interest in choosing appropriate frames for his pictures, especially his 'candlelights'. Rica Jones, in 'Wright of Derby's Technique of Painting', analyses the artist's methods of working throughout his career, and demonstrates ways in which Wright achieved some highly original effects. To these four, we are all most grateful.

Many people have kindly supplied information for particular catalogue entries, and I hope I have expressed my thanks to each of them in those entries. Several long-suffering friends helped with a variety of problems, particularly Brian Allen, Alex Kidson, Kim Sloan, Jacob Simon and Duncan Bull. Among many others who helped in various ways, I should like to thank Edward Adeane, Elizabeth Bell, Mungo Campbell, Lindsey Candy, Margie Christian, John Cornforth, Cara D. Denison, William Drummond, Elizabeth Einberg, Craig Felton, Sir Brinsley Ford, Donald Garstang, Richard Godfrey, John Hayes, Elspeth Hector, Robert Holden, James Holloway, William Hood, Sir Gilbert Inglefield, Evelyn Joll, Diane Klat, Paul Laxton, Charles Leggatt, Clare Lloyd-Jacob, Jonathan Mason, Alexander Meddowes, Christopher Mendez, Rodney Merrington, James Miller, David Moore-Gwyn, Jane Munro, Gabriel Naughton, Lieut.-Col. R. S. Nelthorpe, Evelyn Newby, Vanessa Nicolson, Patrick Noon, Jeremy Rex-Parkes, Dr H. Stephen Pasmore, David Posnett, Sir Joshua Rowley, Francis Russell, Sidney Sabin, Mr & Mrs L. B. Sanderson, Cécile Scailliérez, William Schupbach, David Scrase, Anthony Spink, Mary Anne Stevens, Peter Timms, Cornish Torbock, Simon Towneley, Joseph Trapp, Julian Treuherz, Robert Upstone, Valerie Vaughan, Andrew Wyld and Michael Wynne.

Finally, I should like to thank Iain Bain, Caroline Johnston and Jo Ennos of the Tate Gallery Publications Department and Ruth Rattenbury and the staff of the Tate Gallery Exhibitions Department for their parts in producing the catalogue and mounting the exhibition. Special thanks are due to John Webb, whose photography, sensitive as well as skilful, will ensure that Wright's images remain vividly true on the page long after the exhibition has run its course.

Judy Egerton

INTRODUCTION

Wright was born at No.28 Irongate, in the centre of Derby, on 3 September 1734, the third son of John Wright, attorney and Town Clerk of Derby 1756–65, and his wife Hannah Brookes. He went to Derby Grammar School, whose past pupils included the astronomer John Flamsteed, Sir John Eardley Wilmot, Lord Chief Justice, 1766, and Robert Bage, novelist and paper-manufacturer; later pupils included Daniel Parker Coke MP and John Raphael Smith, who engraved some of Wright's works.[1] The Wrights were a solidly-established middle-class professional family. Of Wright's two elder brothers, John became an attorney and Richard a doctor.

Three chalk drawings made by Wright at the age of sixteen, probably his earliest surviving work, show him teaching himself the art of drawing by the time-honoured method of copying prints, and responding to the very different influences of English portrait mezzotints on the one hand and engravings after Piazzetta on the other. The earliest drawing exhibited here (No.70) is a copy of Faber's mezzotint of Allan Ramsay's rather flamboyant portrait of a boy in Vandyke dress, inscribed '. . . Atatis sua 16'. The other two drawings are almost the earliest plates in Benedict Nicolson's *Joseph Wright of Derby: Painter of Light*, 1968, the most authoritative and substantial study of the artist so far undertaken, to which reference will constantly be made throughout this catalogue: one is the head of an old man, dated 1751 and inscribed rather oddly 'Old John Rotherham's Hand' (? a Piazzetta-like head with a Derby character's hand), and the other, probably also from 1751, is identified by Nicolson as 'Head of Judith, from Piazzetta's Judith and Holofernes.[2]

Wright's formal training began in 1751, probably around his seventeenth birthday, when he became a pupil in Thomas Hudson's studio in London. Hudson, by no means an unimaginative portraitist, was a sound master of technique; he knew many other artists, and had a large collection of prints and drawings which probably furnished his pupils as well as himself with ideas. Wright stayed with Hudson initially for two years. On his return to Derby, he painted 'Portraits of his Father & Mother, his two Sisters, his Brother & himself . . . likewise the Portraits of many Friends.[3] The portrait of Wright's brother Richard is reproduced here (fig.1); the exhibition includes Wright's early 'Self-Portrait' (No.1) and the portrait of 'Anne Bateman' (No.2). His niece's MS. Memoir relates that 'Not being satisfied with himself, he went again to Hudson in 1756, and remained with him fifteen months'. This time John Hamilton Mortimer was a fellow-student; the two became and remained friends.

Wright, always self-critical, would have been well aware that his first 'Self-Portrait', the portrait of his brother Richard and the portrait of 'Anne Bateman'; were immature works. The date of '1755' on 'Anne Bateman' (a work unknown to Nicolson) makes it Wright's earliest dated painting so far known, and suggests that many other portraits which Nicolson dated to '*c*.1760' may also have been painted several years earlier. Undated lists in Wright's Account Book[4] of sitters at Newark, Lincoln, Boston, Retford and Doncaster, as well as at Derby, probably begin soon after his return from his second period in Hudson's studio, *c*.1756–7, and indicate the fairly rapid establishment of a portrait-painting practice. His local reputation grew quickly, reaching a high point when his portraits of six members of the Markeaton Hunt were displayed in Derby Town Hall *c*.1762–3. Four of them are exhibited here (Nos.5–8).

Wright first exhibited in London at the Society of Artists in 1765, by which time he was in his thirty-first year.

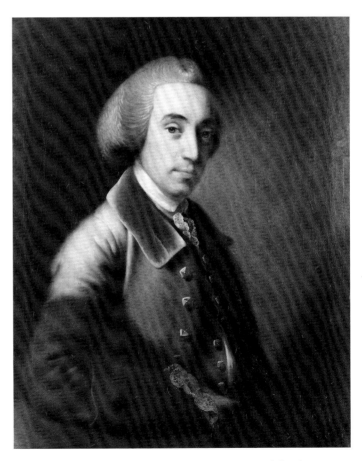

fig.1 Joseph Wright of Derby: 'Portrait of Richard Wright, the artist's brother' ? *c*.1755, oil on canvas $29\frac{1}{2} \times 24\frac{3}{4}$ (75 × 63)
The Wellcome Institute Library, London

He showed two works, 'Three Persons Viewing the Gladiator by Candle Light' (No.22) and 'A Conversation Piece' (probably No.10). 'Three Persons Viewing the Gladiator by Candle Light' was the first of a series of 'Candle Lights' by which Wright first established his name. The 'Gladiator' attracted attention: still more so did 'A Philosopher giving that Lecture on the Orrery, in which a lamp is put in place of the Sun', exhibited in 1766 (No.18) and 'An Experiment on a Bird in the Air Pump', exhibited in 1768 (No.21). At that point, only Wright's fourth year as an exhibitor, the *Gazetteer's* reviewer pronounced that 'Mr. Wright, of Derby, is a very great and uncommon genius, in a peculiar way'.[5]

In making large-scale 'Candle Light' paintings out of modern scientific subjects such as 'The Orrery' and 'The Air Pump', Wright displayed originality and, indeed, genius. Earlier Dutch painters such as Schalken and Honthorst (to whom Nicolson constantly refers in connection with Wright, though it is not clear how much of their work Wright could have seen) had made full use of candlelight and chiaroscuro effects, both in religious and genre scenes. But apart from the Irish-born Thomas Frye (see below), few British painters attempted to explore the effects of a single light source and the play of shadows which resulted. Reynolds is said to have painted (?c.1755) 'A candlelight study made at the Academy in St Martin's Lane'.[6] Romney, a friend of Wright's, experimented with a few candlelights (see fig. 5). Otherwise the only British painter to win renown for his 'candlelights' was Henry Robert Morland, whose 'fancy' subjects – a girl singing ballads by the light of a paper lantern, a servant girl with a candle, etc. – were mostly painted later (and exhibited later) than Wright's.

One of Nicolson's most important discoveries was that Wright was considerably influenced by the work of Thomas Frye (c.1710–1762), and in particular by Frye's large mezzotint 'Heads', published 1760–2. Frye's advertisement[7] for the publication in 1760 of the first twelve 'Heads' described them as 'drawn from Nature, and as large as the Life, from Designs in the manner of Piazzetta'; six more were published in 1761–2. The 'Heads', though drawn from life, are anonymous and thus free from the constraints of portraiture; some are drawn from unusual angles, others have some element of fantasy. Their powerful chiaroscuro effects, their echoes of Piazzetta and Frye's superb mezzotint technique, must have appealed powerfully to Wright. Nicolson (pp.42–4) illustrates some fairly direct borrowings by Wright for figures in 'The Orrery' and 'The Air Pump'. Frye's influence can also be seen in several drawings in this exhibition (Nos.54, 71 and 72). Frye's pupil William Pether became Wright's principal engraver from 1768.

Wright's four paintings of 'Blacksmiths' Shops' and 'Iron Forges', 1771–3 (Nos.47–50), his view of 'Arkwright's Cotton Mills by Night' (No.127) and his portraits of industrialists such as Sir Richard Arkwright, Francis Hurt and Samuel Oldknow (Nos.126,129,128) have prompted suggestions that Wright was keenly interested in the Industrial Revolution. In choosing to paint the 'Blacksmiths' Shops' and 'Iron Forges', Wright's chief preoccupation seems to have been, as always, with dramatic effects of light. As Rüdiger Joppien observes, Wright's 'interest in chiaroscuro and the contrasts of artificial and natural light led him directly to industrial workshops, where he could study labourers silhouetted against the white blaze of smelted iron'.[8] In the smithies and forges, as Robert Rosenblum notes,[9] Wright discovered 'a most extraordinary light source, the blinding white glare of a newly-forged iron bar'.

The 'Blacksmiths' Shops' and 'Iron Forges' are intensely dramatic representations of men at work, and show Wright's detailed interest in the implements and processes of that work. The traditional techniques portrayed in the two 'Blacksmiths' Shops' show that the Industrial Revolution has not reached them. The water-powered tilt-hammers at work in the two 'Iron Forges' are more advanced. But if Wright had really wished to portray the Industrial Revolution, he would probably have started off by painting Lombe's Silk Mill in Derby itself, a five-storeyed water-powered mill employing about three hundred people and preceding Arkwright's first Cotton Mill by over fifty years. Derbyshire was full of stocking mills, ironstone works, china works, coal and lead mines, all of which failed to catch Wright's eye; their only intrusion into his landscapes is when the chimney of a lead-mine makes a shadowy appearance on the horizon in Wright's 'View in Matlock Dale' (No.123) It is certainly true that Wright painted Arkwright's cotton mills in 1782–3, but he waited for many years before being moved to do so; the first mill was erected in 1771, the second in 1776.

Wright spent most of his life in Derby. He worked in Liverpool from the end of 1768 to the summer of 1771; he travelled to Italy, arriving in Rome in February 1774 and returning to Derby in September 1775; and he made an unsuccessful bid to follow in Gainsborough's footsteps as a fashionable portrait-painter in Bath, November 1775–June 1777. Not surprisingly, only his travels to Italy left any lasting mark on his work. What Wright called 'the amazing and stupendous remains of antiquity'[10] in Rome worked their spell on him as on countless others; but what he chiefly took away from Italy were two fiery subjects and two watery ones. The fiery subjects were 'Vesuvius' and 'Fireworks in Rome, or the Girandola'. Both might almost be described as 'open-air candlelights' on a vast scale. Vesuvius in particular became part of Wright's stock-in-trade after his return; he probably painted at least thirty variations on this theme. The watery subjects were two grottoes which he later elaborated into hauntingly mysterious pictures.

Wright began as a portraitist, and portrait commissions continued throughout his career to be his most reliable source of income (many of his subject pictures and landscapes remained unsold). Looking at the backgrounds of his portraits up to about 1770, with their unreal rocks, precarious walls and studio skies, one could hardly have predicted that Wright would become deeply interested in landscape

painting, and increasingly good at it. There may have been some stimulus from Alexander Cozens here, as suggested under No.75. Wright's earliest known pure landscape is the 'Rocks with Waterfall' of *c*.1772. With seeming suddenness, landscape backgrounds in pictures from about that date become convincing, and seemingly endlessly varied. Mr & Mrs Thomas Coltman (No.29) will set off for their morning ride against a background of leafy oaks and a windswept sky; the Old Man will endlessly regret his invocation of Death in an idyllic river landscape (No.38); the Earthstopper does his work against a background of rugged cliffs, the river Derwent tumbling and foaming at his side (No.51). And it is around 1769–70 that the moon makes her appearance in Wright's paintings: first glimpsed in subject pictures, then reigning over landscapes in their own right.

In Italy Wright's eye fell not just on such dramatic subjects as Vesuvius and the grottoes, but also on the serener subjects of Lake Albano and Lake Nemi, subjects often repeated on his return, with some indebtedness to Claude and to Wilson. He also made more landscape drawings than he had previously had time for. After his return from Italy, and to the end of his life, he seized every chance to paint landscapes; as he wrote to his friend John Leigh Philips on 31 December 1792 (DPL), 'I know not how it is, tho' I am ingaged in portraits . . . I find myself continually stealing off, and getting to Landscapes'.

The exhibition should show how varied Wright's landscapes are. In some, he seems to be concerned only with realities, recording a scene as accurately as he can, ignoring all picturesque conventions; 'View in Matlock Dale' (No.123) is a good example, though a 'picture-making' tree is introduced on the right. In others, Wright can be as capricious as any other landscape painter, juggling with his ingredients to get the most satisfying picture: in 'Landscape with Dale Abbey and Church Rocks' (No.117) Wright actually 'transports' the Abbey from some twenty miles away to place it in a setting of Church Rocks, near Matlock. 'Landscape with a Rainbow' (No.124) has now become a classic of British landscape painting. Less well known, but more original in their use of colour, are the 'Landscape with Figures and a Tilted Cart' (No.122) and the 'Italian Landscape' (No.119), two exciting pictures in advance of the work of most of Wright's British contemporary landscapists.

Any student of Wright must be deeply indebted to Benedict Nicolson's *Joseph Wright of Derby: Painter of Light*, 2 vols, 1968, and to his *Addenda* of 1968 and 1988 (fully cited under Abbreviations). Nicolson not only produced the first catalogue raisonné, incorporating evidence from Wright's Account Book, and fully illustrated; he also produced an illuminating study of the works, the patrons who bought them and the background to the times, the whole written in a vein of sustained brilliance, occasionally exuding a sense of astonishment that any British artist could produce work as good as the best of Wright's.

If Nicolson's book has a fault, it is (to me) an over-insistence on 'Netherlandish sources' for Wright's work. Nicolson describes Wright as 'brought up in the Dutch Caravaggesque tradition', for instance, and refers to 'Wright's old favourites, the Dutch Romanists' (pp.75, 91). It should perhaps be noted that when Wright went abroad, it was to Italy, not the Netherlands. While there must be some Dutch influence on Wright, we do need to know which paintings (or engravings after them) Wright could have seen. Where Nicolson suggested a drawing by Terbruggen as the source for Wright's Portrait of 'Mrs Gwillym' (No.36), J. Douglas Stewart later convincingly produced an engraving after Kneller, whom he showed to be the source for several Wright portraits.[11]

Much more work needs to be done on Wright's sources. The fact that he derived various poses and details from engravings by or after artists of very different schools suggests that he owned or had access to a large collection of prints (though probably not as large as that owned by the older artist Thomas Smith of Derby, which it took a four-night sale by Darres in 1768 to disperse). J. Douglas Stewart has illustrated several borrowings from Kneller, and some others are suggested in this catalogue. Nicolson in 1975 found a fairly obscure source for the pose of Miravan dismayed (in No.42, q.v.) in an engraving after René-Antoine Houasse. Richard W. Wallace observed Wright's use of several of Salvator Rosa's *Figurine*, not only in Wright's 'Grotto . . . with Banditti' (No.99), where they are not unexpected, but also in the 'Iron Forge from Without' (No.50), where Rosa figures were hardly to be expected. And Lance Bertelsen has shown that Wright adapted the lovers' tomb *mis-en-scène* from Benjamin Wilson's *Garrick and Mrs Bellamy as Romeo and Juliet* to his own variations on the theme of 'Virgil's Tomb' (Nos.61 and 62). Mr Bertelsen, making the connection between the Benjamin Wilson and the Wright on the evidence of the works alone, may be gratified to learn that Wright did indeed know of the Benjamin Wilson print: as he was beginning to turn his mind to his own (eventually very different) version of 'Romeo and Juliet', he wrote to William Hayley on 23 December 1786: 'When I think of the subject, a print after Ben: Wilson, w.ch you have seen I suppose, crosses my imagination – I sometimes fancy there is no way so good of telling the story – '(letter in a private collection).

Nicolson is curiously unsympathetic to Wright himself, whom he calls 'this cautious, humourless, dedicated man' (p.8).; and he is particularly impatient with Wright's references in letters to his health. In various letters, Wright speaks of months of 'torpor' in which he is quite unable to work. In a letter to William Hayley of 31 August 1783 (a period when he ought to have been actively working on 'Penelope'), he writes 'I have now dragged over four months, without feeling a wish to take up my pencil'; another letter speaks of being reduced 'to so torpid a state, I feel no inclination to pursue my art' (to John Leigh Philips, 4

September 1787, Bemrose p.88). Similar letters recur.[12]

It seems probable that Wright suffered not from hypochondria but from depression, that dreadful, recurring, disabling disease which also affected his contemporary, Samuel Johnson, and for which the eighteenth century had no remedy. Wright's letter to William Hayley of 31 August 1783 relates that his 'ill-health' has gone on for 'sixteen years past', which suggests that the bouts of depression must have started, seemingly unaccountably, about 1767, between the exhibition of 'The Orrery' and 'The Air Pump', a period which on the face of it should have been one of success and fame for Wright. For a creative artist, depression is a particularly cruel fate.

'What was he really like?', John Gage asked at the end of his review of Nicolson's book on Wright.[13] A well-informed answer is probably impossible, two hundred years after Wright's death; but we can review some of the evidence. Wright's works tell us that he was fairly prolific, and also that he was imaginative and inventive. His Account Book shows that he was methodical, and followed sound business practice (charging interest, for instance, on deferred payments). His letters, of which many survive, are invariably well-expressed. He had many friends; and to be the friend of men as different from each other as John Hamilton Mortimer, Peter Perez Burdett, Thomas Coltman and Rev. Thomas Gisborne suggests a high talent for friendship. His subject pictures show that he had a taste for literature, was evidently familiar with Sterne (the source for 'Maria' and 'The Captive') and read Dr Beattie's *The Minstrel* (the source for 'Edwin') when it was still fairly newly published. His books seem to have been dispersed; a small group of them found recently[14] includes William Hayley's *Ode to Mr Wright of Derby* and *Ode to John Howard Esq*, John Sargent's *The Mine*, Thomas Gisborne's *Walks in a Forest* and William Mason's *The English Garden*.

Wright particularly loved music. He played the flute, and according to Bemrose (p.9), was 'taught by Tacet': presumably Joseph Tacet, whom Grove describes[15] as one of the virtuoso players who came to England early in the eighteenth century in response to a growing English enthusiasm for the flute, particularly after the publication of Bach's sonatas and Handel's sonatas for flute and basso continuo. Wright took part in the weekly musical evenings held by Charles Denby, Organist of All Saints Church, some of whose music was published: Wright played the flute, Peter Perez Burdett the 'cello, and other friends the harpsichord and violins. Music evidently meant a lot to Wright. When he visited the Lake District with his friend Thomas Gisborne in 1794 and wanted to describe 'the most stupendous scenes I ever beheld', it was music which provided him with an analogy: 'they are to the eye what Handels Choruses are to the ear'.[16]

In the same letter, Wright, now aged sixty-one, shows himself to be spiritually at one with the new Romantic generation. Here he attempts to convey the 'grandeur and magnificence' of Lake District scenery: 'Mountains piled on mountains & toss'd together in wilder form, than imagination can paint or pen describe – To have done these tremendous Scenes any justice, I sh.d have visited them twenty years ago . . .'

Wright evidently found Derby a congenial place to live in, and a stimulating one. *A propos* 'The Air Pump', E.K. Waterhouse wrote of 'the passionate interest of the Midlands in science'. David Fraser's essay in this catalogue on 'Joseph Wright of Derby and the Lunar Society' explores Wright's connections with science and industry. While Wright was growing up, John Whitehurst FRS, whom he was later to paint (No.147), lived on the same side of the same street (Irongate). Erasmus Darwin settled in Derby in 1783, and became Wright's doctor as well as his friend. Josiah Wedgwood was probably also a friend as well as a patron, and on the marriage of Wright's elder daughter Romana in 1795, presented her with a dinner service of 150 pieces. Thomas Gisborne regularly called to practice the flute and to ask Wright's advice about his drawings.

Coleridge in 1796 found Derby 'full of curiosities, the cotton, the silk mills, Wright, the painter, and Dr Darwin, the everything, except the Christian'[17] Sylas Neville noted in his Diary[18] for 27 October 1781: 'Derby Town is a strange stragling place in a meadow'. The first sentence in James Pilkington's *View of the Present State of Derbyshire*, I, 1789, p.l. is 'Derbyshire lies nearly in the middle of England'. Derby was certainly no backwater. Glover in 1829[19] lists twenty-one coaches which passed through Derby daily, including *The Times*, which left Derby at a quarter to six in the morning and arrived in London at ten o'clock in the evening. Wright probably went to London for the annual exhibitions.

There are no indications in Wright's letters or elsewhere that he ever thought of leaving Derby to settle in London. He was happily placed where he was, with as many portrait commissions as he wanted, and with his brothers and sister nearby. He was particularly devoted to his brother Richard. Wright seems to have set up his 'painting-room' in Richard's house, which was bigger than his own, and to have held private views there.

Contentedness with Derby made him uneasy at Bath, where in 1775-7, hoping perhaps to recoup some of the expenses of the visit to Italy, he tried to set up a fashionable portrait-painting practice; but he reported that 'the great people are so fantastical and whimmy, they create a world of trouble'.[20] He was perhaps happier with middle-class Midlands sitters, though some of those were very much upper-middle class. Wright's best portraits – of Mrs Clayton (No.26), Mr and Mrs Coltman (No.29), Christopher Heath (No.137), the two men in the Coke group (No.142), John Whitehurst (No.147), Sir Richard Arkwright (No.126) and others – show great perception in discerning character, as well as keen observation of physical appearances. They also succeed in Dostoevsky's requirement that the portrait painter should light upon 'the moment when the model

looks most like himself. The portraitist's gift lies in the ability to spot this moment and seize it'.[21]

Wright married Hannah or Ann Swift in 1773; they had six children, three of whom died in infancy. Wright appears to have been an indulgent father to the three who survived. Hannah Wright's Memoir relates that 'there was not any part of the house in which they might not play, even in the room where the Pictures were arranged all round & upon the floor. M.r Wright allowed them to play whip tops in his Painting Room, when he was not employed', though when Wright was painting Arkwright's portrait, the model of the cotton-rollers was out of bounds.

Mrs Wright died in 1790. Wright continued to paint up to about 1796 or possibly 1797. 'Rydal Waterfall' (No.138), dated 1795, and 'Ullswater' (No.139), c.1795–6, are among his last finished pictures. He became asthmatic, and very nervous about the house he was living in: 'he could not sleep in a high wind, lest the chimnies should be blow down and fall upon them'.[22] It is sad to think of the painter of such wild night scenes as 'The Earthstopper' and 'Matlock Tor by Moonlight' falling prey to such fears. With his two daughters, he moved once more, to 26 Queen Street. Dr Darwin was treating him now for asthma and for 'a dropsical habit'. Wright died on 29 August 1797.

The label 'Wright of Derby' is likely to be permanent, though inevitably it has provincial connotations which now seem inappropriate. Wright seems never to have minded the label, which was pinned on him by reviewers of the Society of Artists' exhibitions in the mid-1760s, to distinguish him from the Liverpool artist Richard Wright, already exhibiting when Wright came on the scene (when Richard Wright's son began exhibiting, he was styled 'Mr Wright of Pimlico'). When the American artist Joseph Wright arrived in England in 1772, 'Wright of Derby' proved an even more useful distinction.

One set of people who have always rejoiced in the phrase 'Wright of Derby' are the people of Derbyshire, who have been consistently loyal to Wright. Exhibitions entirely devoted to his work were presented in Derby in 1883, 1934 (Bicentenary Exhibition) and 1947. Perhaps inevitably, with no scholarly eye yet trained upon Wright's work, a great many pictures not by Wright were included, particularly in the Bicentenary Exhibition. Nicolson's book purified the oeuvre. In 1958 the Arts Council presented a Wright exhi-bition at the Tate Gallery and the Walker Art Gallery, Liverpool; this was quite a small exhibition, of thirty-four paintings and thirteen drawings. The exhibition presented at Derby in 1979 was faultless.

I would claim for Wright a status as one of the most original, wide-ranging and consistently interesting eighteenth century British artists. Such a claim is a very long way from the strictures of Samuel and Richard Redgrave, who admired 'The Air Pump', but said of the rest of Wright's works that 'when placed beside the works of Reynolds or Gainsborough, they remind us of the labours of the house-painter'.[23] It is also a long way from Frederick Cummings' claim that compared with Wright's ability to execute an intellectually complex subject, 'Romney is amusing, but only occasionally moving, Gainsborough is ingratiating with his particularly refined visual sensibility, and Reynolds attractive while remaining old-fashioned and pretentious. In this context, Joseph Wright emerges as a Masaccio or Ghiberti of the new era'.[24]

Artists are, or should be, different from each other. Wright is not elevated by putting down Reynolds, nor are his gifts easily measured against Gainsborough's. Wright is his own man. It is his individuality of style, colouring and effects of light which distinguish his work from that of his contemporaries. The favourite eighteenth century adjective for this individuality is 'peculiar'; it is in this sense that Sylas Neville used the word when he recorded in his diary for 4 May 1785: 'Saw Wright of Derby's Exhibition . . . Here we have some pictures of great merit in the peculiar stile of his pencil – moon lights, storms of thunder & lightning, different effects of fire . . .'.[25]

In selecting this exhibition, I have tried to show Wright at his individual best (though some chosen pictures proved unavailable); and I have exercised the selector's privilege of not including pictures which in my opinion do not show him at his best, such as portraits of frumpish women and groups of simpering children. Wright is sometimes uneven in quality and sometimes rather strident in colour, but he is continually inventive. As the *Gazetteer's* reviewer wrote in 1768, 'Mr. Wright, of Derby, is a very great and uncommon genius, in a peculiar way'.

JUDY EGERTON

NOTES

Full references to works frequently cited are given under *Abbreviations*.

1 ed B.Tacchella, *Derby School Register 1570–1901*, Derby 1902.

2 Coll. Derby Art Gallery, repr. Nicolson pls.2–3.

3 Hannah Wright (daughter of Wright's brother Richard), MS Memoir of Joseph Wright, of which a fair copy is dated 1850; both in Derby Public Library.

4 National Portrait Gallery Archives: exhibited here as No.4.

5 23 May 1768, p.4.

6 Whitley 1928, 1, p.150.

7 Reprinted by Michael Wynne, 'A pastel by Thomas Frye', *British Museum Yearbook* 11, p.242; see also Michael Wynne, 'Thomas Frye (1710–1762)', *Burlington Magazine*, CXIV no.827, 1972, pp.79–84, figs.13–31.

8 *Philippe Jacques de Loutherbourg RA,* exh. cat. Kenwood 1973, introduction to 'Science and Industry' section.

9 Rosenblum 1960, p26.

10 Letter to his sister Nancy Wright 22 May 1774.

11 Stewart 1976; Stewart 1983.

12 The first quotation is from a letter to William Hayley, 31 August 1783, published by Bemrose p.61 see also letters of 12 December 1786 to Josiah Boydell and of 2 October 1795 to J.L. Philips (Derby Public Library). I am most grateful to Dr H. Stephen Pasmore for advice on matters relating to Wright's health.

13 *Burlington Magazine* CXI no.794, 1969, pp.304–5.

14 by Messrs Pickering & Chatto Ltd, 16 Pall Mall, London SW1, 1984.

15 ed Stanley Sadie, *The New Grove Dictionary of Music and Musicians*, 6, 1980, p.680.

16 Letter to Richard Wright, 23 August 1794, quoted by permission of J.M. Eardley-Simpson.

17 Samuel Taylor Coleridge, letter to Josiah Wade, 27 January 1796, E.L. Griggs, *Collected Letters of Samuel Taylor Coleridge*, 1, 1956, p.99.

18 ed Basil Cozens-Hardy, *Diary of Sylas Neville 1767–1788*, 1950, p.277.

19 Stephen Glover, *History of the County of Derby*, 11, 1829, p.418.

20 Letter to Richard Wright, 9 February 1776, quoted by permission of J.M. Eardley-Simpson. This letter, after giving various reasons for dissatisfaction with Bath, adds 'I wish I had tried London first, & if had not suited me, I wou'd then have retired to my native place, where tho' upon smaller gains I cou'd have lived free from the Strife and Envy of illiberal and mean spirited Artists'. But it seems unlikely that Wright contemplated a permanent move to London.

21 Quoted by David Piper in a review of Nicolson's book, *The Listener*, 6 February 1969, p.184.

22 Harriet Wright, MS Memoir (op.cit.)

23 Samuel and Richard Redgrave, *A Century of British Painters*, 1866, ed.1947, pp.105–6.

24 Cummings, 1970, p.271.

25 op.cit., p.326.

JOSEPH WRIGHT OF DERBY AND THE LUNAR SOCIETY

An essay on the artist's connections with science and industry

Joseph Wright's two major paintings of 18th century scientific activity, 'A Philosopher lecturing on the Orrery', 1766, and 'An Experiment on a Bird in the Air Pump', 1768, (Nos.18, 21), represent a complex synthesis of art, science and philosophy. They are works of outstanding aesthetic quality, sophisticated examples of that mastery of artificial light effects which became the basis of the artist's reputation. The highly unusual content of these two paintings owes much to the interests of Wright's circle of friends, acquaintances and patrons, who included members of an important provincial group of philosophers and scientists later known as the Lunar Society.[1] The group derived this title from its custom, established during the 1770s, of meeting monthly on the Monday nearest the full moon, to conduct experiments and discuss current developments in areas such as chemistry, electricity, medicine, gases, and other topical subjects for scientific and industrial investigation. Among the better-known members of the Lunar Society were ceramics manufacturer Josiah Wedgwood; Matthew Boulton and James Watt, industrialists and developers of steam technology; Dr Erasmus Darwin, grandfather of the evolutionist Charles Darwin; and Joseph Priestley, chemist and Dissenting minister. Various other doctors, inventors and philosophers made up the group, mainly working in the Midlands, and correspondence was maintained with other prominent practitioners and pioneers in similar fields of activity, both at home and abroad. The interests of the Lunar Society represent a microcosm of that European movement of the 17th and 18th centuries known as the Enlightenment, whose radical developments in scientific, religious, intellectual, philosophical and literary thought and practice transformed man's view of himself, of his role in the universal order, and of God. Despite his provincial location, Wright was able, through his contact with the Lunar Society, to draw from the mainstream of this transforming current of ideas. The figures in the artist's two major paintings of contemporary scientific activity convey, through their gestures and expressions, profound responses to this transformation in the perception of themselves and their place in the natural order: responses of curiosity, fascination, wonder, and awe.

The Lunar Society began to take shape initially around 1764–65, when Wright was about thirty years old, with an established portrait practice in his native town of Derby, and just beginning to paint subjects other than portraits.[2] Though the Lunar Society continued to evolve and increase in membership until c.1780, two of its earliest members in particular seem to have been close to Wright and influential upon his interest in scientific matters. The

first of these two men was John Whitehurst, FRS (1713–88), by trade a maker of clocks, watches, barometers and other instruments, whose house, no.22, Irongate, was only a few doors away from Wright's parental home, no.28, where the artist may also have maintained his studio.[3] Whitehurst was also a geologist of note, publishing in 1778 an 'Inquiry into the Original State and Formation of the Earth',[4] which covered both the overall issue of creation, and more specific topics such as volcanoes, and the geology of Derbyshire, interests which Wright commemorated in his portrait of Whitehurst, painted c.1782 (No.147). Wright, too, was interested in volcanoes, and during his trip to Italy (1773–75), witnessed an eruption of Vesuvius which led him to make the following comments to his surgeon brother, Richard, in a letter dated 11th November 1774:

> Remember me with respect to all my friends; when you see Whitehurst, tell him I wished for his company when on Mount Vesuvius, his thoughts would have center'd in the bowels of the mountain, mine skimmed over the surface only; there was a very considerable eruption at the time, of which I am going to make a picture. 'Tis the most wonderful sight in Nature.[5]

In fact, the artist produced thirty or more pictures of Vesuvius over the next twenty years, so much did the subject appeal to his sense of pictorial drama, but his letter reveals a degree of envy for Whitehurst's understanding of Nature from the scientific viewpoint. Whitehurst's treatise suggests the existence of a vast subterranean sea of fire beneath the Earth's surface, occasionally finding an outlet in the form of volcanic activity, hence Wright's comment that his friend's thoughts 'would have center'd in the bowels of the mountain'. Though Wright lamented that his knowledge was confined 'to the surface only' of Nature, some of his Vesuvius subjects capture the same sense of a potentially destructive unleashing of natural forces like those envisaged by Whitehurst (Nos.101–103, 105).

Wright's second principal contact in the Lunar Society was Dr Erasmus Darwin, FRS, (1731–1802), who studied medicine at Cambridge and Edinburgh before taking up practice in Lichfield in 1756, not far from Derby, and who later moved to Derby itself in 1781.[6] Darwin had an energetic, inventive mind and a voracious intellectual appetite, fully involving himself with Lunar Society interests such as electricity, atmospherics, geology, gases, canals and botany, as well as writing poetry and seeking to advance medicine. Though Wright first painted Darwin's portrait c.1770,

(No.144), the two men probably met earlier, in the mid-1760s, through Whitehurst, and became lifelong friends. Darwin treated the artist for the undefined sickness which plagued him, apparently from about 1767, until his death in 1797.[7] Wright's second portrait of Darwin, painted *c.*1793 (No.145) depicts the doctor in his literary role, holding a quill pen, for Darwin had just published his lengthy didactic poem 'The Botanic Garden' (1789–92), which encompassed a multiplicity of scientific and technological ideas, discoveries and inventions of his age, including descriptions of the planetary systems and of the workings of the air pump, which feature in Wright's paintings.

Though Wright painted commissions for other members of the Lunar Society, like his portrait of social philosopher Thomas Day (No.60) and classical subjects for Wedgwood (Nos.66, 68–9), it was the artist's scenes of contemporary experiments that most directly represent the scientific and philosophical interest of the Society.

The full title of Wright's first scientific painting is 'A Philosopher giving that lecture on the Orrery, in which a lamp is put in place of the Sun' (No.18). It was exhibited in London in 1766, only the second year that Wright exhibited his work in the capital. The painting depicts a darkened room in which a philosopher demonstrates an early type of planetarium known as an orrery, watched by a mixed audience of men, children, and a young woman. Illuminated by the light of a lamp which represents the sun, the faces of the philosopher and his audience emerge from the shadowy interior, and their expressions convey a deep concentration upon the subject of the lecture. The orrery was invented in the early years of the 18th century to show the movement of the planets round the sun during the course of the year, and it was named after the Earl of Orrery, who patronised its invention.[8] The instrument was operated by turning a handle on the side of the base, setting the planets in motion by clockwork: they rotated on overlapping concentric discs round the centre, where a brass ball on a stem usually represented the sun at the centre of the solar system. In Wright's painting, this sun-ball has been replaced by a lamp-wick burning in a jar of oil. Contemporary accounts describe lectures where the sphere is replaced by a lamp in this way, for the purpose of demonstrating an eclipse, and it is logical to assume that this is what Wright's lecturer is doing.[9] The Earth and moon can be seen on their stems immediately to the left of the sun-lamp, with Saturn and its rings beyond, slightly to the left. The audience in the painting is not a scholarly one, but a middle-class group of mixed age and sex. The philosopher is explaining some point or other to the man standing beside him making notes, while the expressions and postures of the other figures portray their responses of interest, curiosity, contemplation and wonder as they study this model of the universe in which they live.

The cosmological theme of Wright's 'Orrery', with its study of the operations of the universe, relates to the subject of Whitehurst's 'Inquiry into the Original State and Forma-tion of the Earth', in which the author attempted to 'inquire after those laws by which the Creator chose to form the world'.[10] Whitehurst deals with the creation of Earth from particles of matter in space according to Newton's theory of universal gravitation, while Wright's lecturer uses the orrery to describe how the planets move in space, their orbits governed by the same laws of gravitation. Though Whitehurst's treatise was not published until 1778, his correspondance reveals that he was researching the subject as early as 1763, for in that year his friend Benjamin Franklin, the American author, inventor and diplomat, wrote to him saying 'Your new Theory of the Earth is very sensible'. Wedgwood, too, mentioned Whitehurst working on his 'world' in 1767.[11] Thus Wright and Whitehurst were simultaneously concerned with the workings of the universe, with a common basis in Newtonian philosophy. Moreover, Whitehurst's practical experience as a clockmaker would have enabled him to advise his artist friend about the clockwork orrery and its operation; it seems somewhat surprising that there is no record of Whitehurst ever making an orrery of his own, for it was surely within his ability to do so.

It does appear highly likely that Wright had the opportunity to witness personally a lecture on the orrery, like that depicted in his painting, given in Derby in 1762 by Whitehurst's friend and correspondent the Scottish astronomer James Ferguson (1710–76).[12] Ferguson made scientific instruments, including the orrery, in his London workshop, published scientific treatises, and travelled the country giving scientific lectures, using an orrery, an armillary sphere, an astronomical clock, and other equipment. He was only one of a number of instrument-makers and philosophers to engage in such activities, and the scene depicted in Wright's painting was not a rare occurence by any means, but rather typical of the day. The content of Ferguson's Derby lectures is not recorded, but he advertised another course in Bath in 1767 as intended 'To explain the Laws by which the Deity Regulates and Governs all the Motions of the Planets and the Comets by Machinery: To show the Courses of the different Seasons, the Motions and Phases of the Moon, the Harvest Moon, the Tides, and all the Eclipses of the Sun and Moon, by means of an Orrery'.[13] Besides this specific link between the theme of Wright's painting and the content of Ferguson's lectures, the subject of Wright's second scientific painting, 'An Experiment on a Bird in the Air Pump', exhibited in 1768, also relates to Ferguson's activities, for it is known that the air pump too featured in his lectures from 1756 onward.[14] If Wright was present at Ferguson's Derby lectures of 1762, then we have, in them, a potential direct source of inspiration for the artist's two scientific paintings which he produced during the following six years.

One of Wright's contemporaries, the architect James Gandon, actually recorded in his memoirs (1846) that the lecturer in Wright's 'Orrery' was 'the celebrated Mr. Whitehurst, an eminent watchmaker of Derby, and well-known for his knowledge of mechanics, etc. The gentleman taking

notes was a Mr. Burdett: the remainder of the audience were either relatives or friends.'[15] While Gandon was probably correct about Wright using friends or family as models, he was surely mistaken about Whitehurst here, for the features of the heavy-jowled lecturer in the 'Orrery' are nothing like those of Whitehurst, as depicted in Wright's later single portrait of him (No.147). A description of Whitehurst accompanies an edition of his collected writings (1792): it speaks of a tallish, lean figure, with 'a countenance expressive at once of penetration and mildness'.[16] This description seems better suited to the philosopher in Wright's second scientific painting, the 'Air Pump' of 1768 (No.21), a thinner man who fixes the spectator with an unusually striking and penetrating gaze. Perhaps Gandon confused the two paintings when his memoir was compiled, in retrospect, eighty years after the painting has been exhibited in London.[17]

Gandon's other specific identification, of the man taking notes in the 'Orrery', as 'Mr Burdett', is verified by comparison with Wright's portrait of his friend Peter Perez Burdett and his wife, painted in 1765 (No.40). A surveyor, mapmaker, topographical artist and engraver, Burdett was residing in the early 1760s at Staunton Harold which, though in Leicestershire, is actually not far from Derby. By 1766, Burdett moved to a house in All Saints' Close, Derby, very close to Wright.[18] Staunton Harold was the seat of Washington Shirley, 5th Earl Ferrers, an amateur enthusiast of astronomy, who made his own orrery, had a paper on the transit of Venus accepted by the Royal Society in 1762, and who purchased Wright's painting of the 'Orrery'. It is tempting to speculate whether the painting was a commission from the Earl, especially as he and Burdett jointly signed a bond in 1763 undertaking to pay Wright £160, but there is no conclusive evidence on this issue. It seems more likely that the bond was intended to guarantee repayment to Wright of a loan to Burdett, which the artist's later correspondence indicates was never fully repaid. The Earl bought Wright's picture for £200. Commission or not, this scientific gentleman was an extremely appropriate purchaser for Wright's painting: a practising astronomer and wealthy, titled patron of art, sharing with Wright the mutual acquaintance of Burdett.[19]

As mentioned already, Newton's ideas on the operations of the universe, and in particular his theory of gravitation, formed the common basis of Wright's 'Orrery' and Whitehurst's 'Inquiry'. However, the 'Principia' of 1687, in which Newton first published these ideas, was a work completely inaccessible to the general public, written in Latin and comprehensible only to mathematicians. When the French philosopher Voltaire stayed in London from 1726 to 1728, he observed with his customary sharp-edged wit that every body was talking about Newton's works, but hardly any body could actually read or understand them.[20] The invention of the orrery itself was only one method of making Newton's theory of the universe accessible to the lay public, and it was used both for serious education and for instructive entertainment, as part of a wide movement to disseminate scientific knowledge to a popular audience like that represented in Wright's painting. Numerous publications were produced with the intention of communicating Newtonian and other scientific ideas to the lay public, such as John Harris's 'Astronomical Dialogues between a Gentleman and a Lady', first published 1719, and Algarotti's 'Neutonianismo per le Dame' (Newtonianism for ladies), first published in Naples in 1737. It would be difficult to over-estimate the impact of Newton's work on his own, and succeeding, generations: he was virtually deified on his death in 1727.[21] For example, in Venice in the late 1720s an Irish operatic impresario named Owen MacSwinny commissioned a remarkable painting, an 'Allegorical Monument to Sir Isaac Newton', from artists Giovanni Battista Pittoni and the two Valeriani brothers: this work, in the Italian Rococo manner, was one of a series commemorating 'illustrious Personages who flourish'd in England' in the late 17th-early 18th centuries, a series which encompassed British monarchs, nobles, and military heroes (fig.1).[22] In literature, Newton became:

> . . . pure intelligence, whom God
> To mortals lent to trace his boundless works
> From laws sublimely simple. . .
> (James Thomson, 'The Seasons', written 1725–30:
> Summer, l.1560–62)

Newton's theory of universal gravitation captured in a few mathematical equations the laws governing the movements of the planets, and presented a view of the universe as an ordered, harmonious system. Naturally, this affected man's view of himself, of his place in the natural order, and ultimately, of God, the architect of the universe. The expressions of the spectators in Wright's 'Orrery' signify their responses to the profound implications of this newly-perceived universal order. Watched by the man on the right with his back to us, the lecturer pauses to clarify a point to the note-taker, while the three children all gaze into the orrery with captivated expressions of curiosity and fascination. The young woman on the left, and the young man on the right supporting his head with his hand, both appear lost in deep, abstract thought before this microcosm of the vast, interplanetary system in which they themselves play such a tiny and fleeting role. Parallel responses of wonder, curiosity, fascination and awe, can be found in the works of 18th century writers and poets as they come to terms with the Newtonian view of Nature. For example, Addison described the impact of this new perception of the universe upon the imagination, in his essay of 1712, 'On the Pleasures of the Imagination':

> When we survey the whole earth at once, and the
> several planets that lie within its neighbourhood, we are
> filled with a pleasing astonishment, to see so many
> worlds, hanging one above another, and sliding round
> their axles in such an amazing pomp and solemnity. If,
> after this, we contemplate those wild fields of ether, that

In the author's mind, the stars and 'all the planets in their turn/ confirm the tidings as they roll For ever singing as they shine:/ the hand that made us is divine.' For those 18th century spectators who saw the universe in this way, Wright's painting would have assumed a religious significance, since they were contemplating, not just the workings of the solar system, but the operations of God himself. In the words of James Ferguson's advertisement for his lectures in Bath in 1767, Wright's painting could be seen to show a philosopher attempting 'To explain the Laws by which the Deity Regulates and Governs all the Motions of the Planets'.

Other poets besides Addison described the universe in Newtonian terms, and it would not be surprising if Wright, who painted literary subjects from classical and modern authors like Homer, Shakespeare, Milton and Sterne, was familiar also with the works of such poets as James Thomson, Mark Akenside, Robert Blair, and Edward Young.[23] For example, the immensely popular 'Seasons' of Scottish poet James Thomson (1700–48), written between 1725 and 1730, describes a mental excursion into space in order to discern the awesome workings of the universe, using imagery which could equally well describe the thoughts of Wright's spectators, were we to try and put words in their mouths:

> O Nature! all-sufficient! over all
> Enrich me with the knowledge of thy works:
> Snatch me to heaven: thy rolling wonders there
> World beyond world, in infinite extent,
> Profusely scattered o'er the blue universe
> Show me: their motions, periods and their laws
> Give me to scan: . . .

> (Autumn II, l. 1352–58)

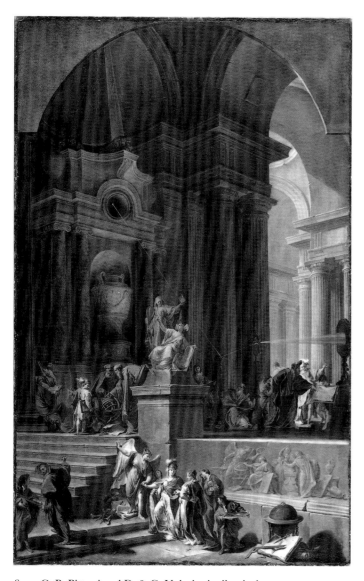

fig.1 G. B. Pittoni and D. & G. Valeriani, oil painting 1727–29: 'An Allegorical Monument to Sir Isaac Newton' *Syndics of the Fitzwilliam Museum, Cambridge*

The audience in Wright's painting are contemplating the same heavens and the same planetary systems as the poet, and are seeking to grasp the same Newtonian 'motions, periods and laws'. Their expressions signify a similar mental journey into the 'infinite extent' of space, discovering 'world beyond world', especially the expressions of those figures lost in abstract contemplation, whose minds literally seem to have been 'snatched to heaven' like the poet's. They are mere mortals, tiny, transient creatures confronted by a prospect of infinite time and space. In the words of Addison quoted earlier, their 'imagination finds its capacity filled with so immense a prospect, and puts itself upon the stretch to comprehend it'.

When Wright's friend Dr Darwin wrote his extended scientific poem, 'The Botanic Garden' (1789–92), he described the creation of the universe in dramatic imagery of suns, planets and light that not only recalls the imagery used by these poets of the earlier 18th century, but also now the striking pictorial effects of Wright's 'Orrery', painted thirty or more years earlier, near the beginning of their friendship:

> Let there be light!' proclaim'd the Almighty Lord.
> Astonish'd Chaos heard the potent word:

reach in height as far as from Saturn to the fixed stars, and run abroad almost to an infinitude, our imagination finds its capacity filled with so immense a prospect, and puts itself upon the stretch to comprehend it.

For Addison, Newton's discovery of a methodical, harmonious order in the universe confirmed the omnipotence and wisdom of God, the divine architect, and he expressed this sentiment in an ode, also of 1712, which is still found as a hymn in the Church of England's 'Hymns Ancient and Modern':

> The spacious firmament on high,
> With all the blue ethereal sky,
> And spangled Heavens, a shining frame,
> Their great Original proclaim.

Through all his realms the kindling ether runs,
And the mass starts into a million suns:
Earths round each sun with quick explosions burst,
And second planets issue from the first:
Bend, as they journey with projectile force,
In bright ellipses their reluctant course:
Orbs wheel in orbs, round centres centres roll,
And form, self-balanced, one revolving whole.
–Onward they move amid their bright abode,
Space without bound, the bosom of their God!

(The Botanic Garden, Canto I, l.107–118)

As a painting representative of Enlightenment philosophy, 'A Philosopher lecturing on the Orrery' makes dramatic use of one of the most common and obvious metaphors of the period for knowledge, reason and scientific discovery: light. In Mark Akenside's 'Hymn to Science', written in 1744, we find the poet acclaiming science as the 'light of truth' and 'sun of his soul', and writing:

Science! thou fair effusive ray
From the great source of mental day,
Free, generous and refined!
Descend with all thy treasures fraught
Illumine each bewilder'd thought
And bless my labouring mind.

In Wright's painting, the illuminated faces of the audience, emerging from the darkness of the room, similarly signify the illumination of their minds by the light of science, originating from the orrery itself. The figures are literally subject to a process of Enlightenment in the physical, as well as the intellectual, sense.

As already mentioned, Wright may have seen James Ferguson demonstrate the vacuum using an air pump in his Derby lectures of 1762, since Ferguson had purchased this instrument in 1756 in order to include pneumatics in his syllabus. It is doubtful, though, whether Ferguson's demonstration took the form shown in Wright's painting of 1768, 'An Experiment on a Bird in the Air Pump'. In his 'Lectures on Select Subjects', published as a treatise in 1760, Ferguson described the experiment thus:

If a fowl, a cat, rat, mouse or bird be put under the
receiver, and the air be exhausted, the animal is at first
oppressed as with a great weight, then grows convulsed,
and at last expires in all the agonies of a most bitter and
cruel death. But as this Experiment is too shocking to
every spectator who has the least degree of humanity, we
substitute a machine called the lungs-glass in place of
the animal; which, by a bladder within it, shews how
the lungs of animals are contracted into a small compass
when the air is taken out of them.[24]

It is significant that Wright chose to depict the 'shocking' version of the experiment using a live bird, instead of Ferguson's humane alternative using the lungs-glass, for then he could maximise the dramatic potential of the subject, expanding the range of human responses represented to include distress and horror, visibly manifested by the two girls. Wright's ability to dramatize modern life in this way makes him a true heir of Hogarth, and we must not forget that Wright's former master Hudson was a contemporary and acquaintance of this master of narrative painting.[25] In fact, both the 'Orrery' and 'Air Pump' paintings appear to make specific borrowings from Hogarth's gruesome disembowelling scene from 'The Stages of Cruelty', engraved 1751 (fig.2) – the nearest approximation to a 'scientific' scene in Hogarth's work. These borrowings include the compositional device of grouping figures in a room, round a circular piece of furniture or equipment, with a central dominating figure of a lecturer with outstretched hand. Wright's figure of the boy lowering or raising the cage, in the background of the 'Air Pump', appears to be directly lifted from the figure pointing upwards to the skeleton, on the left in Hogarth's engraving, in reverse. In addition, both Wright and Hogarth represent the more 'cruel' and shocking aspects of scientific demonstration.

fig.2 Engraving by William Hogarth, published 1751 'The Reward of Cruelty' *Trustees of the British Museum*

In his earlier painting of the 'Orrery', Wright's image of figures contemplating the vast timeless operations of the universe implied a sense of human mortality, of the transience of life. This theme is more explicit in the 'Air Pump', for the audience is confronted with a physical death, effected by natural laws upon the bird in the glass receiver. The fact that the audience encompasses figures of all ages from childhood, through youth and maturity to old age, recalls the traditional iconography of the 'Ages of Man', where the artist takes his spectators on a pictorial journey from infancy to senility in order to remind them of the transience of human existence. Wright developed this theme of mortality in subsequent paintings like 'A Philosopher by Lamp Light', 1769, (No.41), 'Miravan opening the Tomb of his Ancestors', 1772, (No.42), 'The Old Man and Death', 1773 (No.38) and 'The Indian Widow', 1785 (No.67).

Inasmuch as the 'Air Pump' presents a spectacle of death in the context of a demonstration of the laws of Nature, the painting shows Wright working within the conceptual framework of 'the Sublime', an 18th century term used to define man's various responses to Nature, particularly responses of awe, terror, or fear before the more threatening or dramatic aspects of the natural world. Some of the audience demonstrate similar Sublime responses as the contemplative, abstracted figures in the 'Orrery', witnessing awe and wonder at the laws of Nature, but the two distressed girls in the 'Air Pump' express an even more intense, emotional reaction on seeing the presence of death in Nature. Their reaction is directly aligned with a central theme in one of the most important treatises on the Sublime, Edmund Burke's 'Inquiry into the Origin of our Ideas of the Sublime and Beautiful' (1757), where the author states:

'No passion so effectually robs the mind of all its powers of acting and reasoning as fear. For fear, being an apprehension of pain or death, operates in a manner that resembles actual pain. Whatever therefore is terrible, with regard to sight, is sublime.'

Moreover, Wright is not content to register Sublime responses such as awe, wonder, fear and pain on the faces of the figures in his painting. The penetrating stare of his philosopher, and his arm outstretched toward us, directly engage us in the psychological circle of responses to this macabre experiment: we too are invited to experience a Sublime response.

The 'Air Pump' is the first of several paintings in which Wright incorporated imagery taken from the traditional repertoire of religious art. For example, in a recent study of this particular painting, German scholar Werner Busch finds a striking precedent for Wright's central group of the bird, the philosopher with outstretched hand, and the man pointing up at the bird, in an early Netherlandish type of Trinity subject where God the Father points up toward the dove of the Holy Spirit in the centre of the painting, while Christ the Son, on the other side of the dove, stretches out his hand toward us, the spectators.[26] In a subsequent scientific painting, 'The Alchymist Discovering Phosphorus', 1771 (No.39), Wright gave his alchymist the posture of a kneeling saint, arms outstretched and face uplifted in prayer, recalling images found in both Italian and Northern art of Saint Francis receiving the Stigmata, or Saint Jerome in prayer. Again, the nocturnal, ruined settings of Wright's two 'Blacksmith's Shop' scenes of 1771 (Nos.47, 48), with their figures grouped round a central light source, directly recall traditional nativity imagery.

What was the purpose of Wright's allusions to religious art in these scientific and industrial scenes? They certainly elevated the subject-matter by presenting it in the imagery of established pictorial tradition, but there was surely a more specific purpose, related to the way the natural world and its laws were perceived by Wright, his friends and his public. As the scientists and philosophers of the day demonstrated the hidden laws of Nature, they revealed the divine operations of God, or, in John Whitehurst's words, 'those laws by which the Creator chose to form the world'.[27] Addison's hymn of 1712 addressed the religious implications of Newton's view of the universe, but the principles of the vacuum, as demonstrated in the 'Air Pump', or the manufacture of phosphorus by Wright's alchymist, were just as much part of those laws governing the natural world, just as much part of divine creation. Therefore Wright's allusions to religious art make explicit the religious context in which these scientific demonstrations could be perceived in his day. Even Dr Darwin, Wright's friend who had a reputation for atheistic tendencies,[28] was not content to give straight factual explanations of scientific matters in his 'Botanic Garden', and couched his descriptions in mythological terms, where nymphs, naiads and gnomes preside over the operations of Nature and introduce her secrets to man. Thus Darwin, in this poem, introduced his own account of the air pump, its invention and operation, with mention of the 'charm'd indulgent sylphs' who 'crowned with fame your Torricelli and Boyle/ Taught with sweet smiles, responsive to their prayer/ The spring and pressure of the viewless air.'[29]

In the years 1771–73, preceding his trip to Italy, Wright began to paint subjects which signify that he, like most members of the Lunar Society, was interested in industry and technology. His scenes of iron forges and cotton mills are not as directly related as his earlier scientific subjects to Lunar Society activities, but they are connected with the developing Industrial Revolution to which the Lunar Society made its own major contribution. The industrialists whose portraits he painted towards the end of his career, like Arkwright and Strutt, were in touch with the Lunar Society, though not members of it.

There is a clear progression in the modernity of Wright's industrial scenes, from both the technological and the sociological aspects. In the two nativity-like scenes of the 'Blacksmith's Shop', painted in 1771, craftsmen forge a shoe for a lame horse at night, (Nos.47,48). This is a traditional craft rather than a modern industrial activity. The two 'Iron

fig.3 Aquatint engraving by John Bluck after Thomas Hofland, probably between 1806 and 1811: 'Matlock no.6.', showing Church Rocks, Matlock *Derbyshire County Library Service*

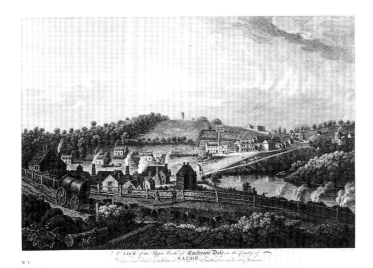

fig.4 Engraving by F. Vivares after Thomas Smith of Derby and George Perry, published 1758: 'A View of the Upper Works at Coalbrookdale in the County of Salop' *Derby Art Gallery*

Forge' subjects of 1772 and 1773 (Nos.49,50) show workmen performing a similar task of heating and shaping metal, but using modern, water-powered tilt hammers which, though not a recent invention at the time, were more up-to-date, and continued in use well into the 19th century. The artist could probably have seen such equipment operating in a foundry erected on the river Derwent in Derby in 1734, as well as further up the Derwent valley in rural Derbyshire.[30] His preparatory drawing for the first 'Iron Forge' (No.49) was undoubtedly made on the spot in such a forge. The second 'Iron Forge' scene, 'viewed from without' sets the building in a landscape whose river and cliffs distinctly resemble the setting of 'The Earthstopper on the Banks of the Derwent', painted the same year, 1773 (No.51). Though Wright obviously fabricated both scenes in the studio, using the same landscape background for two different subjects, this scenery, with its river and cliffs, sufficiently resembles Church Rocks by the river Derwent at Matlock as to indicate that the artist did base his landscape on an observed, genuine location. The scene is nowadays much more built-up, but Church Rocks appear in various topographical artists' work of the 18th and 19th centuries, much like Wright's scenery (fig.3). At this stage of Derbyshire's industrial development, iron forges like Wright's would still have operated as individual, isolated units, as shown in the painting, and the type of advanced industrial complex combining multiple operations on one site, like that in existence at Coalbrookdale in Shropshire, was not constructed in Derbyshire until the 1780s. The mention of Coalbrookdale is not purely coincidental, for an earlier Derby artist, Thomas Smith (died 1767), whose career overlapped in date with Wright's, produced two detailed topographical views of the Shropshire industrial site in 1758 (fig.4), which may have encouraged Wright to explore the potential of industrial subject-matter.[31]

The figures in the first 'Iron Forge' (No.49) dominate the scene, and are individually characterized. One workman rests from his task to gaze contentedly at a woman with her children: these are obviously his family. The presence of this woman and her children, and their psychological interplay with the workman, add an element of domesticity to the scene and establish an association between honest labour, and personal happiness and family fulfilment. The workmen themselves are muscular, fit and heroic in aspect, the artisan foundation of the industrial, economic and commercial wellbeing of a nation dedicated to progress and improvement.

The second 'Iron Forge' scene (No.50) expands upon this vision of the personal and social value of labour, and upon the artist's representation of the social organisation of industry, with the significant inclusion of an elegantly-dressed gentleman in addition to the workmen, the woman and child. This gentleman, leaning on his staff and watching the workmen at their labour, surely represents an ironmaster or similar entrepreneurial figure, overseeing the industrial operation in which he has invested. Thus we see a more

complete picture of the different people involved in the industry – differentiated in their work, dress, and class. These forge scenes, in their vision of industrial labour and organisation, eminently represented the values of rising middle classes who were investing in the Industrial Revolution. This vision was also acceptable to the aristocracy, for Wright sold one 'Blacksmith's Shop' to Lord Melbourne, the first 'Iron Forge' to Lord Palmerston, and the second 'Iron Forge' to the Empress of Russia.

Wright's view of 'Arkwright's Cotton Mills by Night', painted c.1782 (No.127), takes account of the significant change in industrial organisation that had occurred in the ten years or so since he painted his 'Iron Forge' scenes, even allowing for the switch in subject-matter from iron to textile industry. Now there are no workmen to dominate the scene: the mill itself, at the centre of the composition, has become the agent of production, and individual craftsmanship has given way to modern factory technology, with production lines operating twenty-four hours a day, powered by water. Wright's nocturnal view of the mill is almost surreal in its visual effects, for whereas buildings at night usually rise up as dark silhouettes, Arkwright's factory is strangely illuminated from without, with no visible light source. There may have been a simple, logical reason for this light, such as braziers burning to illuminate the paths between the buildings at night, but Wright chooses to keep us guessing. The yellow-red glow in each window directly indicates the candles standing on the windowsills to light the interior, but it also signifies the life and activity within the building. As in previous paintings like the 'Orrery', 'Iron Forge', and Vesuvius subjects, light here suggests life, energy, power and activity, and this association, together with the absence of human figures (save for a token shadowy presence in the foreground) leaves the factory itself to assume these attributes of a living entity. We are reminded of Lunar Society members Boulton and Watt, who gave their steam engines of the 1770s names like Belial and Behemoth, suggesting at the same time a sense of living, individual identity and an impression of dark, threatening forces unleashed.[32] Arkwright's factory represented a radical change in the technology, economics and organisation of the textile industry, and Wright's view of the illuminated mill, enclosed in the dark valley like a contained force, suggests its role as a dynamic agent of transformation, unleashing change upon the landscape and upon the social order.

In 1789–90, Wright painted his imposing, full-length portrait of Arkwright himself (No.126). The inclusion of a model of Arkwright's water-powered spinning frame initially seems wholly appropriate, and in keeping with the established convention of portrait-painting which includes symbols of the sitter's achievements. This matter may not, however, be so straightforward. Arkwright's claim to the invention was in fact spurious, and by the time Wright painted the portrait, had led to protracted and bitter legal disputes which resulted in Arkwright losing his patent in

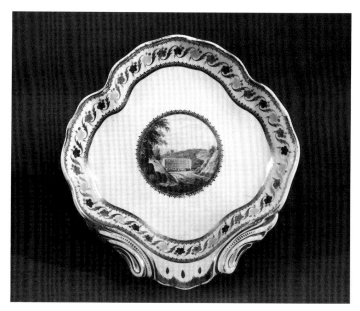

fig.5 Derby porcelain dish, decorated c.1790 with a view of Arkwright's mill at Cromford by Zachariah Boreman *The Arkwright Society (on loan to Derby Art Gallery)*

1785.[33] In the light of these disputes, and of Arkwright's own tenacious, aggressive approach to his business, Wright's portrait of him seated proudly with his model spinning frame can be seen as the final assertion of the industrialist's claim to originality, after the battle had been lost in the courts four or five years earlier. Members of the Lunar Society, aware of the potential threat to the patent laws which protected their own inventions, had generally supported Arkwright's case, despite their personal dislike of him: Erasmus Darwin and James Watt actually testified in court in Arkwright's favour.[34] Their dilemma in supporting the cause but not the individual, is summed up in a letter that James Watt wrote to his father-in-law in 1784:

> As to Mr. Arkwright, he is to say no worse one of the worst self-sufficient Ignorant men I have ever met with. Yet . . . whosoever invented the Spinning, Arkwright certainly had the merit of performing the most difficult part, which was the making it usefull . . .[35]

Of his philosophical friends and acquaintances, Wright was closer, in the later years of his life, to Erasmus Darwin. John Whitehurst had moved to London from Derby in 1775, becoming master of the Royal Mint, but Darwin moved from Lichfield to Derby in 1781, treating Wright as his spells of sickness and inactivity grew longer and more and more depressing. Lunar Society activities had come to focus more and more on Birmingham, and Darwin, feeling 'cut off from the milk of science' by his move to Derby,[36] founded an

offshoot in 1782/3, the Derby Philosophical Society. The membership of Darwin's new group included several patrons of Wright, such as Brooke Boothby of Ashbourne Hall, botanist and confidant of the French philosopher Rousseau, (No.59): Josiah Wedgwood of the Lunar Society: and Jedediah Strutt, former partner of Arkwright and an inventor and industrialist in his own right (No.131). Thus the movement to disseminate scientific knowledge and to promote invention, whose spirit is embodied in Wright's early 'Orrery' and 'Air Pump' paintings of the 1760s, was consolidated at a local level and continued into the 19th century, through local academies and philosophical groups like Darwin's Derby Philosophical Society.

One illustration has been selected as a final, comparative comment on the far-reaching transformation wrought on the landscape and the social order by the technological advances which Wright witnessed first-hand and painted. This illustration shows a porcelain dish, produced around 1790 at Derby's important china factory, founded c.1750 (fig.5). The centre of the dish is painted, not with a view of a picturesque rural landscape, or stately home, as was so often the case with porcelain tableware for the gentility, but with a view of Arkwright's cotton mill at Cromford. The consequences of the scientific and industrial revolution of the 18th century, simply represented on a piece of functional table china, off which one ate, had now reached the fashionable tables of the middle and upper classes, and as such, were becoming an established part of the nation's everyday life.

DAVID FRASER

NOTES

[1] The most comprehensive study of the Lunar Society to date is: Robert F. Schofield, *The Lunar Society of Birmingham*, Oxford, 1963.

[2] For a full account of Wright's life and art, the standard work is: Benedict Nicolson, *Joseph Wright of Derby: Painter of Light*, 2 vols, London, 1968.

[3] From 1764 until his departure for London in 1778 to take up the post of Stamper of the Money Weights, Whitehurst lived in a different house, No.27, Queen Street, but still within a few minutes' walk from Wright's parental home in Irongate. No.27 Queen Street was elegantly re-fronted for Whitehurst by Derby architect Joseph Pickford, (1736–82) whose two sons Wright painted (No.141).

[4] John Whitehurst, *Inquiry into the Original State and Formation of the Earth*, London, 1778. Other editions followed in 1786 and 1792, with a German edition in 1788.

[5] Quoted in William Bemrose, *The Life and Work of Joseph Wright*, ARA, London and Derby, 1885, pp.34–35.

[6] For an account of Darwin's life and work, see: Desmond King-Hele, *Doctor of Revolution: the Life and Genius of Erasmus Darwin*, London, 1977: also, Desmond King-Hele, (editor), *The Letters of Erasmus Darwin*, Cambridge, 1981, and Schofield (note 1 above).

[7] In a letter to his poet friend, William Hayley, dated 31st August 1783, Wright says, 'a series of ill-health for these sixteen years past (the core of my life) has subjected me to many idle days, and bowed down my attempts towards fame and fortune. I have laboured under an annual malady some years, four or five months at a time; . . .'. The letter is quoted in Bemrose, p.61.

[8] There is a full and fascinating account of the invention and use of orreries in: Henry C. King and John R. Millburn, *Geared to the Stars: the evolution of planetariums, orreries and astronomical clocks*, Toronto, 1978.

[9] Ibid., p.156.

[10] Whitehurst, 1st edn. (1778), preface, p.ii. Whitehurst subsequently begins chapter 1 with a characteristic (for him) attempt to reconcile scientific and Biblical accounts of creation: 'The number of ages elapsed since the DEITY created the constituent parts of the earth, and assembled them together by the laws of universal gravitation, . . .'.

[11] Franklin's and Wedgwood's comments are quoted in Schofield, p.176.

[12] King and Millburn devote a whole chapter to Ferguson, pp.178–194.

[13] Ibid., p.189.

[14] Nicolson, vol.I, p.113.

[15] *The life of James Gandon, Esq., . . . from material collected and arranged by his son, James Gandon, Esq.*, assisted by T. J. Mulvany, Dublin, 1846, p.211–212. Also quoted in Nicolson, vol.I, p.115.

[16] *The Works of John Whitehurst*, FRS, *with Memoirs of his Life and Writings*, London, 1792, p.18. Also quoted in Nicolson, vol.I, p.117.

[17] The identity of the model for the lecturer in 'The Orrery' (who actually bears some resemblance to Newton himself) remains a mystery. Bemrose, p.76, cites an annotated print 'once belonging to the artist' but now lost, identifying this figure as Mr Denby, organist at All Saints', Derby, at whose musical evenings Wright played the flute, and whose name appears in the list of subscribers in the first edition of Whitehurst's 'Inquiry'. The same man almost certainly appears on the left in Wright's 'Three Persons viewing the Gladiator by Candlelight', 1765 (No.22) and seated on the right in 'The Air Pump', 1768, (No.21). The unpublished manuscript memoir of Wright by his niece Hannah Wright, 1850 (Derby, Local Studies Library), identifies this elderly figure in 'Three Persons viewing the Gladiator by Candlelight' as 'old John Wilton in the Devonshire Almhouses', which stood in Full Street behind All Saints; however we know nothing more of this man.

[18] This address appears in the advertisement for Burdett's Map of Derbyshire, in the Derby Mercury, June 20th, 1766.

[19] The 'commission' problem is discussed in Bemrose, p.77, and Nicolson, vol.I, p.117, note 6.

[20] Voltaire, *Lettres Philosophiques ou lettres anglaises*, 1734. In the fourteenth letter, 'Sur Descartes et Newton', Voltaire says, 'Très peu de personnes à London lisent Descartes, dont effectivement les ouvrages sont devenus inutiles; très peu lisent aussi Newton, parce qu'il faut être fort savant pour le comprendre; cependant, tout le monde parle d'eux; on n'accorde rien au Francais et on donne tout à l'Anglais'.

[21] For a stimulating study of the influence of science on 18th century thought, and on literature in particular, see: Marjorie Hope Nicolson. *Newton demands the Muse*, Princeton, 1946, and *Mountain Gloom and Mountain Glory; the development of the aesthetics of the infinite*, New York, 1959. I am much indebted to Kathleen Monaghan, formerly of Santa Barbara Museum of Art, for introducing me to this line of inquiry several years ago.

[22] See the catalogue of the exhibition, *The European Fame of Isaac Newton*, Cambridge, Fitzwilliam Museum, November 22nd 1973 to January 6th 1974, which commemorated the Museum's acquisition of the painting by Pittoni and the Valerianis by bringing together a range of Newtonian material.

[23] Relevant quotations from Blair and Young are found in my earlier essay on this subject, 'Fields of Radiance: the scientific and industrial scenes of Joseph Wright', in: *The Iconography of Landscape*, a collection of essays edited by Denis Cosgrove and Stephen Daniels, Cambridge, 1988, pp.122–124.

[24] James Ferguson, *Lectures on select subjects in mechanics, hydrostatics, pneumatics and optics*, first published London, 1760, p.200. Also quoted in Nicolson, vol.I, p.114.

[25] Like Hogarth, Hudson was associated during the 1740s with the Foundling Hospital in London, and in 1748, Hudson, Hogarth, Hayman and others travelled together to France. See Ellen G. Miles catalogue for the exhibition, *Thomas Hudson, 1701–1779*, Iveagh Bequest, Kenwood, London, 1979.

[26] Werner Busch, *Joseph Wright of Derby: Das Experiment mit der Luftpumpe: Eine Heilige Allianz zwischen Wissenschaft und Religion*, Frankfurt, 1986. pp.29–49 deal with Wright's borrowings from religious art.

[27] See note 10 above.

[28] Evidence of Darwin's scepticism can be found in the accounts of his acquaintances, like the '*Life of Mary Anne Schimmelpenninck*', edited by Christiana Hankin, 1858.

[29] Erasmus Darwin, *The Botanic Garden*, Canto IV, l.126–130. There were numerous editions after the first edition of 1789–91.

[30] The Derby foundry is documented in: Stephen Glover, *History and Gazetteer of the County of Derby*, Derby, 1829, vol.II, p.424.

[31] Little is known of Smith's career. A few original oil paintings are known today, including several in Derby Art Gallery. Engravings of Smith's topographical views in Derbyshire and elsewhere, published from 1743 on, are more common.

[32] In a letter to Matthew Boulton written early in 1777, Darwin said: 'I hope Behemoth has strength in his loines Belial and Ashtororth are two other Devils of consequence, and good names for Engines of Fire.' (see *The Letters of Erasmus Darwin*, p.78).

[33] A full account of Arkwright's activities and his Cromford mill is found in: R.S Fitton, *The Arkwrights, Spinners of Fortune*, Manchester, 1989.

[34] Schofield pp.349–351 covers Lunar Society involvement with Arkwright's litigation over his patent.

[35] Letter from James Watt to his father-in-law James MacGregor, 30th October 1784, National Library of Scotland: quoted in Schofield, p.350.

[36] Letter from Darwin to Matthew Boulton, 26th December 1782: see *The Letters of Erasmus Darwin*, p.127.

THE ENGRAVING AND PUBLICATION OF PRINTS
OF JOSEPH WRIGHT'S PAINTINGS

A knowledge of the prints of Wright's paintings is fundamental to a proper appreciation of Wright's stature as a painter in his own day. Although his fame outside Derbyshire was established through the exhibitions of the Incorporated Society of Artists, it was sustained internationally by prints which, being relatively cheap and widely available, reached a much larger audience than the paintings. Almost without exception in Wright's case, the prints provided a lasting record of paintings that Wright had deliberately selected for exhibition. This was important since painters were usually discussed with reference to their engraved works before the invention of photography, and by defining the body of work which could be engraved the artist might determine the paintings by which he would be known.

The significance of prints in this respect was reflected by the casual assumption of Wright's obituarist, John Leigh Philips, that Wright's historical paintings of the 1760s 'are well known by Pether's mezzotintos'.[1] Prints were even more important abroad, where Michael Huber, a German scholar who compiled influential catalogues of English prints, pointed out in 1794 that it was 'par les estampes que la plupart des amateurs connoissent les talents des principaux peintres anglois' (Huber 1794, p.23) and listed Wright among the history painters entirely on the evidence of the prints. Although this is not the place to discuss Wright's proper position in the artistic hierarchy, it is significant to find that contemporaries who judged him from the prints of his work considered him a leading practitioner of this most prestigious kind of art.

Just as Wright's ambition to establish a reputation as a painter of serious themes through the exhibitions of the Society of Artists was sustained by the activity of engraver-publishers, they also gained by exploiting the aesthetic and commercial potential of Wright's work. At the exhibitions of the Society of Artists engravers showed their own work on an equal footing with the painters and the Society rapidly became an indispensable resource for engravers anxious to improve their reputations, and particularly for those who also published their own prints. Its quarterly meetings provided a point of contact with leading painters and its exhibitions provided both subjects to engrave and the opportunity to display prints that were about to be published. Professional publishers also made use of the Society, either by seeking permission to engrave pictures or by buying the plates of exhibited prints.

The first two prints after Wright were both exhibited with the Society of Artists. The first, *A Philosopher giving a Lecture on the Orrery*, was engraved and exhibited by William Pether in 1768, two years after Wright exhibited the painting, and was published during the period of the 1768 exhibition by Boydell. The second, *A Philosopher shewing an Experiment on the Air Pump*, was exhibited in 1769, a year after Wright's painting. It initially appeared with the name of the engraver Valentine Green as publisher but it was subsequently sold, possibly at the exhibition, to John Boydell. Following the successful reception of these two prints engravings appeared regularly. They were usually published either by Pether or Boydell some six months after the exhibition: the time required to obtain the painter's permission, copy the painting and engrave the plate. Indeed, of the twenty-five paintings Wright exhibited up to 1771, twelve were engraved and most of those that were not were portraits or small candlelights. All of the important 'history' paintings were reproduced.

The exact nature of Wright's involvement in engravings of his work is difficult to determine since painters were naturally shy of revealing a financial interest in self-promotion and in any case the particular circumstances of production varied from print to print. The six month gap between exhibition and publication suggests that there was not usually any plan to engrave the plate before the exhibition,[2] yet it is equally evident that the painter responded favourably to offers to reproduce his work. Wright's interest in two known instances is proved by the submission of proofs for the painter's comments and corrections and this was probably general practice. *An Hermit* was evidently approved by Wright since it was published while he was staying at the publisher's house while *William and Margaret*, unusually for Wright, was engraved before the painting was exhibited, a clear indication of collusion between painter and engraver in seeking maximum impact. In the 1790s, years covered by a greater number of surviving letters, Wright can be shown to have planned the reproduction of his prints in full awareness of the prestige good prints would bring, and it would have been characteristic, if perhaps unnecessary, for him to have done so throughout his career.[3] However, his reluctance to enter into partnership with Philips and Heath to publish 'Romeo and Juliet' and 'Antigonus' without knowledge of the financial risks involved suggests that he had not acted as publisher before.[4] Nevertheless, in his account book Wright noted debts owed to him by friends and patrons in the Midlands for impressions of *Edwin* and *The Dead Soldier* and this implies that he was allocated a share of impressions of these prints. It is not clear whether this was conventional practice or whether these entries indicate unusual circumstances. In 1778 Wright also acted as agent in providing

John Milnes with a collection of prints of his work supplied by the most prolific of his early engravers, William Pether.[5]

Born in Carlisle, William Pether (c.1738–1821) was probably a few years younger than Wright. He was a pupil and then a partner of Thomas Frye, the portrait painter, mezzotinter and manager of the Bow porcelain manufactory, whose series of mezzotint 'Heads' provided models for numerous figures in Wright's earlier paintings.[6]

Like his master, Pether worked in several media, painting occasional landscapes and frequent portraits in oil, crayon and miniature as well as engraving and publishing mezzotints. Indeed, it was as a painter, not an engraver, that Pether was elected a Fellow of the Society of Artists upon its Incorporation by Royal Charter in 1765. Like Wright, Pether had broad interests and entertained some advanced social and political ideas.[7] Although they were possibly introduced by Boydell when Pether engraved the *Orrery*, Pether had almost certainly already met Wright through the Society of Artists and they also shared a friend and patron in Dr Benjamin Bates of Aylesbury.[8] In 1769 Pether termed Wright his friend in the inscription on the *Gladiator*, and Wright mentioned his friend Pether in a letter written in Italy.[9] In 1770 Wright's address in the Society of Artists catalogue was 'at Mr Pether's, Great Russell Street, Bloomsbury' and during this stay *An Hermit* was published from Pether's house.[10]

After the *Orrery* which, as far as is known, was first published by Boydell in 1768,[11] all Wright's collaborations with Pether were published by the engraver in the expectation that profits would exceed any fee that Boydell might offer. All Pether's prints reproduced paintings that had been exhibited at the Society of Artists and three of his mezzotints were themselves exhibited there: the *Orrery*, immediately before its publication in May 1768, *An Hermit*, simultaneously with its publication in May 1770, and *An Alchymist* before its publication in 1775. The showing of *An Hermit* and its later companion provided publicity that had not been considered necessary for earlier publications, but even these risky historical subjects did not require advertisement in the press – a contrast with the practice of Pether's colleague Benjamin Green who had advertised his prints after Stubbs at a slightly earlier date. After 1778 John Raphael Smith succeeded Pether as Wright's chief engraver and Pether sold the copper plates of Wright's pictures in 1785.[12]

The 'Air Pump', perhaps the most imposing of all Wright's paintings, was engraved by Valentine Green (1739–1813) who came to London from Worcester in 1765 and exhibited two mezzotints after the fashionable Benjamin West before further enhancing his reputation with this plate (which he sold to Boydell) after the equally fashionable Wright. His print of the Bradshaw children was published by Boydell's rivals, Ryland & Bryer, also in 1769. A third print after Wright, *Miravan*, was apparently commissioned by Boydell in 1772, and a fourth, *Master and Miss Williams*, is recorded in Green's catalogue of 1780, ostensibly an

fig.1 William Pether: 'Self Portrait', mezzotint, c.1777

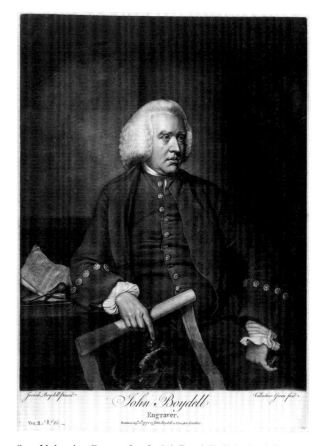

fig.2 Valentine Green after Josiah Boydell: *John Boydell*, mezzotint, 1772

authoritative source, but copies of the print have so far eluded detection.[13]

Apart from Pether, John Boydell (1719–1804) was the most active agent in the publication of Wright's early prints. The suspicion that he made a considerable amount of money from these undoubtedly contributed to Wright's sense of grievance when he clashed with Boydell over payment for his contributions to the Shakspeare Gallery in 1786. Boydell either commissioned or soon bought up the *Orrery*, the *Air Pump*, *A Blacksmith's Shop*, *Miravan* and *An Iron Forge*, and reserved a section in his 1773 catalogue for mezzotints after Wright, a distinction shared only with Rembrandt and Benjamin West.[14] It is likely that he paid Richard Earlom (1743–1822), the most talented young artist in his employ, to engrave the two forge plates. He later commissioned Thomas Ryder's engraving of *The Captive*, *A Winter's Tale* and *The Tempest*. After a brief and undistinguished career as a landscape engraver, Boydell had become the acknowledged market leader in copper plate publishing on the strength of his ventures in the early 1760s. He availed himself of a sophisticated distribution network in Europe and the colonies, using agents who sometimes worked upon a sale or return basis.[15] No doubt Boydell shrewdly appreciated both the financial potential of Wright's pictures and their suitability for interpretation in mezzotint and with Pether he was chiefly responsible for the spread of the artist's fame.

Conditions were different after Wright's return from Italy in 1775. The Society of Artists disintegrated following a bitter conflict with the Royal Academy, and since this institution debarred engravers from full membership its exhibitions were boycotted by the profession and the earlier pattern in the print publishing industry was disrupted.[16] Simultaneously, and to some extent as a consequence, the engraver-publishers who regarded themselves primarily as exhibiting artists were gradually displaced by a new breed of printseller-publishers whose output was more frequently designed for profit than for praise.

In 1778, however, Wright formed a lasting relationship with a publisher who was an exception to this rule. John Raphael Smith (1752–1812), the son of the landscape painter Thomas Smith of Derby, never acquired the reputation of Boydell as a publishing tycoon, but was nevertheless a major publisher of his own and other plates, besides being the most distinguished mezzotinter of his generation. A number of references to 'my friend Smith' in Wright's correspondence appear to refer to John Raphael[17] and Smith seems to have been an agreeable companion, ready and able 'to please all those who are fond of a song and a story' (Dayes p.350). His fashionable literary tastes for Sterne and Gothick ballads were concordant with Wright's and he favoured the kind of literary history painting that Wright was producing at this time.

Smith became Wright's most prolific interpreter with ten plates:[18] *Edwin*, *The Captive*, *Maria*, *John Harrison*, *The Children of Walter Synnot*, *William and Margaret*, *The Lady in Milton's Comus*, *The Widow of an Indian Chief*, *Erasmus Darwin* and *Sir Richard Arkwright*. Some of these were private commissions and the last was published after Wright's death, but the important plates reproduced exhibited paintings. They were available printed in colour as well as in black and white and the colouring imitates the originals so closely that Smith must have had a very good pattern for his printer and colourists.

About 1777 one of Wright's paintings, 'The Forge', was copied using a process for reproducing paintings developed in Birmingham by Jee & Eginton in partnership with Boulton & Fothergill.[19] Later, between 1790 and 1792, another four paintings by Wright were reproduced by the Polygraphic Society using what was almost certainly the same technique (bought from Boulton & Fothergill when they ceased trading). The Polygraphic Society was formed by Joseph Booth, a former portrait painter, to exploit the discovery in London and for several years it was both fashionable and successful. 'Mechanical paintings', or 'polygraphs', were very large transfer-printed aquatints, printed from several plates, applied to canvas, finished by hand and varnished to look deceptively like oil-paintings, for which they were intended to provide a cheap alternative. Very few now survive chiefly, no doubt, because they were sufficiently deceptive to have been mistaken later for poor copies of the original oils and consigned to oblivion. Many were destined for export and some may still survive abroad. Wright's surviving letters do not reveal any awareness of the existence of the Polygraphic Society and all the pictures that were reproduced had either been bought by the Society or lent by their owners.

In the 1790s Wright's patron John Leigh Philips, a Manchester merchant, became an important intermediary between Wright and the London art trade. Between 1789 and 1797 he was closely associated with the publication of *The Dead Soldier* by the line-engraver James Heath, a venture into which he may have put money. In 1790 he suggested a partnership with Wright and Heath to publish 'Romeo and Juliet' and 'Antigonus', but Heath could not be persuaded to engrave pictures that had been reviled in the press. In 1792 Philips borrowed a sketch book of drawings after Michelangelo from Wright, apparently in order to have them reproduced. Finally, soon after Wright's death Philips tried to organise the reproduction by Heath of Wright's two paintings of 'Hero and Leander' and 'The Dead Ass, Nampont'. However, none of these projects seem to have reached fruition.[20]

Contemporary collectors of fine prints held Wright's work in high esteem. In his *Catalogue Raisonné du Cabinet d'Estampes de feu Monsieur Brandes* (Leipzig, 1793–4), Michael Huber singled out Wright's engraved work for special praise:

Toute cette suite de Wright consiste en Estampes de la plus rare beauté. C'est ce que la manière noire anglaise a livré de plus brillant par le singulier effet d'un clair-obscur bien entendu. (p.642)

Wright's paintings were ideally suited for reproduction in mezzotint, the process upon which English claims to distinction in printmaking depended, whose beauty lay in its capacity for dramatic chiaroscuro, for rich velvet blacks and for delicate shades of grey. In Huber's opinion, which was widely respected, the mezzotints of Wright's paintings were the finest of all, excelling even the much praised interpretations of Reynolds's portraits and the fine prints after Rembrandt by McArdell and Pether.[21]

The collection on which Huber's comments were based, that of Georg Friedrich Brandes of Hanover (1719–91), contained all the mezzotints after Wright published before Brandes ceased collecting about 1785 except *The Captive*, *Maria* and *John Harrison* (further evidence that these prints were not widely distributed). Surviving collections formed before 1800 at Aschaffenburg, Karlsruhe and the Veste Coburg all contain examples of the chief prints, demonstrating that Huber's estimate of the excellence of the Wright mezzotints was widely shared.[22] The high percentage of early proofs contained in these collections bears out the observation, if not the cynicism, of the German travel writer Frederick Augustus Wendeborn who wrote in 1791 that 'Among the many countries, which lay out considerable sums in buying English prints, Germany is not the last . . . some of our rich *dilettants* will pay often times for an English print, three times the money that it costs in London, when they are told that it is scarce, or one of the first impressions; though, perhaps, the one is as improbable as the other'.[23] Indeed, the export market was of vital importance to the English print trade since it was true that, as a writer in 1786 commented, 'the export trade of our engravings to France far exceeds the trade at home'.[24]

Nevertheless, English print collectors were also keen buyers of Wright's prints as the surviving collection at the Fitzwilliam Museum demonstrates. Wright's friends and patrons in the Midlands also bought his prints and Philips and Milnes formed large collections. Prints were also bought simply as reproductions of paintings, or to supplement or substitute for paintings as decoration for the wall. The care with which Wright's plates were repeatedly reworked for Boydell and Smith over a long period indicates a large and enduring market among people indifferent to the quality of the impression and many of Wright's prints were still available in the mid-nineteenth century.

The demand for the relatively rare fine impressions accounts for the discrepancy between the published price of the prints and the high prices asked for proofs by printsellers, and obtained from the early 1770s at auction. Wright's

fig.3 Samuel de Wilde: 'John Raphael Smith', watercolour, *c*.1790

prints originally sold for between 5*s*. and 15*s*. depending on their size, but James Bretherton in 1775 had an impression of *An Academy* priced at 1 guinea and Hooper & Davis listed an impression of the *Air Pump* at £1 7*s*. in 1777. This level of interest was sustained until at least the early 1800s, when an impression of *A Farrier's Shop* made £1 17*s*. and *A Blacksmith's Shop* made £2 13*s*. in the sale of Lord Lansdowne's collection.[25] These prices confirm that the beautiful mezzotints engraved after Wright's paintings quickly attained the status accorded by Huber, and retained today, as some of the finest prints ever produced in England.

TIM CLAYTON

NOTES

1. The Monthly Magazine, IV (Oct. 1797) p.289.
2. In contrast to the contemporary practice of Stubbs who sometimes had his paintings engraved before they were exhibited so that the painting and the engraving could be shown simultaneously, a marketing ploy that demonstrates the painter's direct interest in the print's impact (see my discussion in Lennox-Boyd, Dixon and Clayton pp.21–4).
3. See letters from Wright to J. L. Philips of 11 June 1790 (Derby Public Library mss. ref. 8962, letter 15) and 14 April 1791 (8962, letter 21): 'Heath & Macklin will have an opportunity of seeing these pictures [at the Society of Artists' exhibition] . . . it would gratify my pride & resentment to the Alderman to have 'em engraved by Heath'.
4. The possibility of earlier ventures is not excluded with certainty since any earlier prints which Wright might have co-published, being mezzotints, would have entailed much lower financial risks than the line-engravings under consideration in this letter to Philips of 11 June 1790 (see note 3 above).
5. Pether's receipt was published by Bemrose p.125. Milnes bought the Orrery, the Air Pump, the Gladiator, An Hermit, Master Ashton, A Blacksmith's Shop, A Farrier's Shop, An Academy, Miravan and An Alchymist, a near complete set of Wright's early works, many of them fine proofs to judge by the high prices Pether charged. Pether either held in stock or obtained prints by other engravers after Wright as well as those he had engraved himself.
6. See Nicolson pp.31 and 42–4.
7. For this information I am indebted to David Alexander who intends to write an account of Pether's unusual and interesting career. Pether's cousin Abraham painted moonlights and also made musical and optical instruments, including telescopes, microscopes and air-pumps, and 'once read lectures on electricity with instruments of his own making' (Dayes p.343). The Pethers' preoccupations were uncannily similar to Wright's.
8. Pether referred to Bates as his friend in the inscription on Helena Forman wife of Rubens which he published in June 1769. The Gladiator, published a month later in July 1769, was also engraved from a painting in Bates's collection.
9. Quoted by Bemrose, p.31.
10. Further evidence that Pether's house was Wright's London base at this time is provided by a reference in Wright's account book to 'Two Girls wth. their Black Servant in the hands of Pether Sold to Mr Parker £40' (see Nicolson p.228). Presumably the painting was in Pether's care for the 1770 exhibition, not, as Nicolson supposed, for an engraving.
11. It is conceivable that Boydell did not commission the Orrery but bought it from Pether at the 1768 exhibition, since he appears to have acquired the Air Pump (exhibited 1769) from Valentine Green in this manner. Only two pre-Boydell impressions of the Air Pump are known to me and so the present lack of Pether-published Orrerys is insufficient evidence to disprove this speculation. However, Boydell published many of Pether's prints in the 1760s, notably the much lauded mezzotints after Rembrandt engraved just before those after Wright. See Alexander, pp.51–2 for discussion of Boydell and Pether.
12. Pether and Wright possibly remained in contact: Pether was the engraver of Alexander Cozens's New Method from which Wright painted copies in the 1780s. The low prices realised for Pether's plates suggest that the sale was a failure but this may partly have been because the plates were extremely worn and the accompanying impressions consequently poor.
13. Green no.148. Whitman accepted the print's existence but failed to find an impression.
14. Boydell 1773, pp.23–4.
15. According to Farington Boydell had £16,000 worth of property circulating abroad on commission in 1801. On Boydell see Bruntjen and on the Shakspeare Gallery also see Friedman.
16. In the opening remarks of his article 'An early exhibition and the politics of British printmaking, 1800–1812' (Print Quarterly, VI, 1989, pp.123–39) John Gage seems to me to underestimate the significance to engravers of the Incorporated Society and the extent of their hostility to the Royal Academy. By 1772 engravers accounted for 24 out of 120 Fellows and 4 of 24 Directors in the Society. Therefore, the prestige and influence of the profession was significantly eroded when engravers were excluded from full membership of the Academy and it was against this background that Sharp and Hall 'invariably spurned' the diploma of Associate Engraver 'considering, as did Woollett and Strange, that it was injurious to the profession, & degrading to the individual' (Raimbach p.19).
17. Two references are quoted by Morris, p. 105.
18. If Maria exists; see p.245.
19. The partnership was formed on 26 November 1776 and production started the following year. The scheme proved unprofitable and collapsed in 1780. See Aitken pp. 28–34 and Robinson and Thompson. The subject is being studied currently by Antony Griffiths.
20. The 'Antigonus' episode is discussed in the entry for that print (P36). The mysterious sketchbook is mentioned in three letters from Wright to Philips in Derby Public Library (mss. 8962, letters 24, 25 and 29). In the first of 24 September 1792 Wright reports the despatch of the book containing drawings after Michelangelo to Philips. In the second dated 29 November 1792 Wright expresses pleasure that the plates are ready for 'Mic:Angelo' and the fear that 'I shall never do my part, my hand is too unsteady now for lines'. This possibly implies that Wright was supposed to have etched the plates, but in the third letter of 26 February 1793 Wright asks 'How goes Mic:Angelo on? can you give me a proof of your abilities yet?'. The project is not mentioned again and the plates do not seem to have been published. In a letter to Philips of 1797 Heath wrote that he intended to get the Hero and Leander pictures as soon as Lord Lansdowne came to town and 'with respect to Sternes Old Man & Ass I think it would be a good thing to engrave. Mr Corbould would be the man to put the Background to it.' On 14 June 1798 Heath wrote 'I wish you would get the two Pictures of Hero & Leander for me. I should like to engrave them very much, I have mentioned them to Ld Lansdowne several times but he seems to hint that there is a family coolness that prevents him from asking for them'.
21. Pether turned to Wright immediately after engraving a series of highly successful plates after Rembrandt published either by himself or Boydell (see Alexander pp.51–2). Both Pether and Boydell must have recognised common features in Wright's and Rembrandt's paintings that rendered them suitable for treatment in mezzotint. For appreciation of the technical merits of the mezzotints after Wright see Morris and Buckley.
22. The formation of these collections, which must serve to illustrate a wider trend, is described in Lennox-Boyd, Dixon and Clayton pp.28–9. The collection at Coburg is particularly remarkable for its exceptional colour-prints.
23. A View of England towards the close of the Eighteenth Century, II, London 1791, p.214.
24. See Whitley I, p.72. C. F. Joullain in Réflexions sur la Peinture et la Gravure (Metz 1786) pp.32–3, also speaks of 'le commerce immense de gravures que l'Angleterre vend très-chèrement en France, dont elle tire des sommes considérables'.
25. Bretherton no.2492; Hooper & Davis no.504; Lansdowne, fifth day, nos 456–7.

References made here in abbreviated form are explained on pp.232–3.

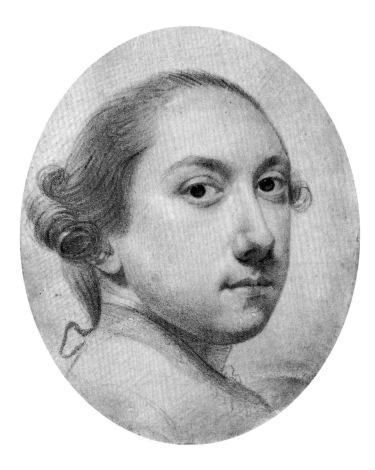

Joseph Wright of Derby: Study for the 'Self Portrait' of *c.*1753–4 (No.1, p.34)
Pencil, the eyes picked out in charcoal, on paper $4\frac{3}{8} \times 3\frac{3}{4}$ (11.2 × 9.5)
Syndics of the Fitzwilliam Museum, Cambridge

CATALOGUE

Exhibited New York only*

Dimensions are given in inches followed by centimetres in brackets; height precedes width.

ABBREVIATIONS

EXHIBITIONS

Derby 1839	Exhibition at the Mechanics' Institute, Derby
Derby 1843	*Museum Exhibition (for benefit of Town and Country Museum)*, Derby
Derby 1866	*Art and Industrial Exhibition*, Corn Exchange, Derby
Derby 1870	*Midland Counties Exhibition*, Derby
Derby 1883	*Paintings by Joseph Wright . . . with some Original Drawings and a complete Collection of Prints*, Corporation Art Gallery, Derby (184 works)
Derby 1934	*Wright of Derby . . . Bicentenary Exhibition*, Corporation Art Gallery, Derby (156 works)
Derby & Leicester 1947	*Paintings and Drawings by Joseph Wright ARA*, Derby Art Gallery and Leicester Art Gallery (67 works)
Derby 1979	*Joseph Wright of Derby*. An exhibition to commemorate the centenary of Derby Museums and Art Gallery, Derby Art Gallery (124 works)
Detroit & Philadelphia 1968	*Romantic Art in Britain. Paintings and Drawings 1760–1860*. Detroit Institute of Arts; Philadelphia Museum of Art
Durlacher NY 1960	A Loan Exhibition: Joseph Wright of Derby, Durlacher Bros., 11 East 57th Street, New York (26 works)
Graves 1910	*Loan Exhibition of Works by Joseph Wright ARA of Derby*. Henry Graves & Co. Ltd., 6 Pall Mall, London (97 works)
Lichfield 1986	*Joseph Wright of Derby*. Lichfield Festival 1986, Chapter House, Lichfield Cathedral (27 works)
Manchester, Whitworth 1988	*Travels in Italy 1776–1783. Based on the Memoirs of Thomas Jones*. Catalogue by Francis W. Hawcroft. Whitworth Art Gallery, Manchester
Milan 1975	*Pittura Inglese 1660–1840*. Milan, Palazzo Reale
Munich 1979–80	*Zwei Jahrhunderte Englische Malerei*. Haus der Kunst, Munich
National Gallery 1986	*Wright of Derby: Mr & Mrs Coltman. Acquisition in focus*. Exhibition booklet by Allan Braham. National Gallery, London
NGA 1970	*Joseph Wright of Derby. A Selection of Paintings from the Collection of Mr & Mrs Paul Mellon*. National Gallery of Art, Washington (20 works)
NGA 1985–6	*The Treasure Houses of Britain*. National Gallery of Art, Washington
Paris 1972	*La Peinture Romantique et les Pre-Raphaélites*. Petit Palais, Paris
Robins's Rooms 1785	*Pictures Painted by J. Wright, of Derby, and Exhibited at Mr Robins's Rooms (late Langford's) No.9 under the Great Piazza, Covent Garden* (25 works)
RA 1886	*Works by the Old Masters and by Deceased Masters of the British School, including a selection from the Works of Joseph Wright (of Derby) ARA . . .* Winter Exhibition, Royal Academy (12 works by Wright)
RA 1962	*Primitives to Picasso*, Winter Exhibition, Royal Academy
RA 1964–5	*Painting in England 1700–1850: from the collection of Mr & Mrs Paul Mellon*. Winter Exhibition, Royal Academy
Sheffield 1950	*Pictures by Joseph Wright of Derby*. Graves Art Gallery, Sheffield (60 works)
Smith College 1955	*Joseph Wright of Derby*. Smith College Museum of Art, Northampton, Massachusetts (21 works)
Sudbury 1987	*Wright in Italy: Joseph Wright of Derby's Visit Abroad, 1773–5*. Gainsborough's House, Sudbury (35 works)
Tate & Walker 1958	*Joseph Wright of Derby*. Arts Council, Tate Gallery and Walker Art Gallery, Liverpool (47 works)
Tate 1959	*The Romantic Movement*. Tate Gallery
VMFA 1963	*Painting in England 1700–1850: Collection of Mr & Mrs Paul Mellon*. Virginia Museum of Fine Arts, Richmond, Virginia
Yale 1965	*Painting in England 1700–1850: Collection of Mr & Mrs Paul Mellon*. Yale University Art Gallery, New Haven, Connecticut

LITERATURE

Bemrose 1885 — William Bemrose, *The Life and Works of Joseph Wright, commonly called 'Wright of Derby'*, London & Derby 1885

Buckley 1952 — Charles E. Buckley, 'Joseph Wright of Derby', *Magazine of Art*, April 1952, pp.160–7

Buckley 1955 — Charles E. Buckley, 'An English Landscape by Joseph Wright of Derby', *Art Quarterly*, Autumn 1955, pp.265–71

Busch 1986 — Joseph Wright of Derby. Das Experiment mit der Luftpumpe. Eine Heilige Allianz Zwischen Wissenschaft und Religion. Frankfurt am Main 1986

Cummings 1970 — Frederick Cummings, 'Folly and Mutability in Two Romantic Paintings: The Alchemist and Democritus by Joseph Wright', *Art Quarterly*, XXXIII no.3, 1970, pp.247–275

Cummings 1971 — Frederick Cummings, 'Joseph Wright at the National Gallery', *Art Quarterly*, XXXIV, 1971, pp.475–481

DPL — Local Studies Library, Derby Public Library

Fraser 1979 — David Fraser, *Joseph Wright of Derby: Derby Art Gallery*, Derby 1979

Fraser 1988 — David Fraser, ' "Fields of Radiance": the scientific and industrial scenes of Joseph Wright', in ed. D. Cosgrove & S. Daniels, *The Iconography of Landscape*, Cambridge [1988], pp.119–42

Gage 1969 — John Gage, 'Light Heavyweight?', review of Nicolson 1968, *Burlington Magazine*, CXI no.794, 1969, pp.304–6

Gordon — Catherine M. Gordon, *British Paintings of Subjects from the English Novel 1740–1870*, 1988

Hamilton 1772 — Sir William Hamilton, *Observations on Mount Vesuvius . . .*, 1772

Hamilton 1779 — Sir William Hamilton, *Campi Phlegraei, Observations of the Volcanoes of the Two Sicilies*, 2 vols., Naples 1779

Nicolson 1954 — Benedict Nicolson, 'Joseph Wright's Early Subject Pictures', *Burlington Magazine*, XCVI no.612, 1954, pp.72–80

Nicolson — Benedict Nicolson, *Joseph Wright of Derby, Painter of Light*, 2 vols., I Text and Catalogue, II Plates. 1968

Nicolson Addenda 1968 — Benedict Nicolson, 'Addenda to Wright of Derby', *Apollo*, vol.88, [Supplement] Notes on British Art 12, November 1968, pp.1–4

Nicolson 1988 — Benedict Nicolson (posthumously published), 'Wright of Derby: addenda and corrigenda', *Burlington Magazine*, CXXX no.1027, 1988, pp.745–758

Ribeiro 1984 — Aileen Ribeiro, *The Dress Worn at Masquerades in England 1730 to 1790, and its Relation to Fancy Dress in Portraiture*, New York & London 1984

Rosenblum 1960 — Robert Rosenblum, 'Wright of Derby: Gothick Realist', *Art News* vol.59 no.1, March 1960, pp.24–7 and p.54

Sartin 1983 — Stephen Sartin, *Polite Society by Arthur Devis 1712–1787*, exh. cat., Harris Museum and Art Gallery, Preston and National Portrait Gallery, London, 1983

Shurlock 1923 — F. W. Shurlock, 'The Scientific Pictures of Joseph Wright', *Science Progress*, 1923, pp.432–438

Stewart 1976 — J. Douglas Stewart, 'Kneller's Long Shadow: John Smith's Mezzotints and Joseph Wright of Derby', *Burlington Magazine*, CXVIII no.879, 1976, pp.410–3

Stewart 1983 — J. Douglas Stewart, *Sir Godfrey Kneller and the English Baroque Portrait*, 1983

Sunderland 1988 — John Sunderland, 'John Hamilton Mortimer: His Life and Works', *Walpole Society* LII 1986, 1988

I

Self-Portrait at the Age of about Twenty c.1753–4

Oil on canvas 30 × 25 (76.2 × 63.5)

PROVENANCE
Wright's daughter Anna Romana, who married James Cade in 1795; by descent in the Cade family until purchased through Leger by Derby Art Gallery 1984
EXHIBITED
Derby 1870 (793); Derby and Leicester 1947 (18); *Realism through Informality*, Leger Galleries 1983 (24, repr. in colour); National Gallery 1986 (1, repr. p.4)
LITERATURE
Harriet Wright, MS Memoir; Nicolson no.164, p.229; pp.21, 26, 103; pl.6

Derby Art Gallery

A related pencil drawing, in the collection of the Syndics of the Fitzwilliam Museum, is reproduced on p.30; it probably precedes the oil, but seems more assured than the painted version.

Nicolson dated this *c.*1758; but David Fraser (in a catalogue entry on the work for Leger's 1983 exhibition) convincingly argues that it is likely to be four or five years earlier. The artist (born in 1734), could well be nineteen or twenty years old here, rather than about twenty-four, as Nicolson's dating implies. Fraser draws attention to Hannah Wright's MS Memoir of her uncle (admittedly written about 1850) which states that 'upon his return to Derby' after his first period of training in Hudson's studio, 1751–3, Wright painted a series of portraits of his parents, brothers and sisters and himself. If Hannah's account is accurate, then this self-portrait was painted in or shortly after 1753, and is not only the first known self-portrait by Wright but, as she suggests, among the first known works he did outside Hudson's studio.

The 'Portraits of his parents, brothers and sisters' include a very able and sympathetic portrait of the artist's brother Richard Wright (fig.1, Introduction p.9; first published by Renate Burgess, 'A portrait by Wright of Derby', *Burlington Magazine*, CXXIV, 1982, pp.155–7, fig.32). Wright's portraits of his father and mother (each 30 × 25 ins), lent by a member of the Cade family to Graves's exhibition of 1910 (47, 57) are now known only in the forms of two drawings, on loan to Derby Art Gallery.

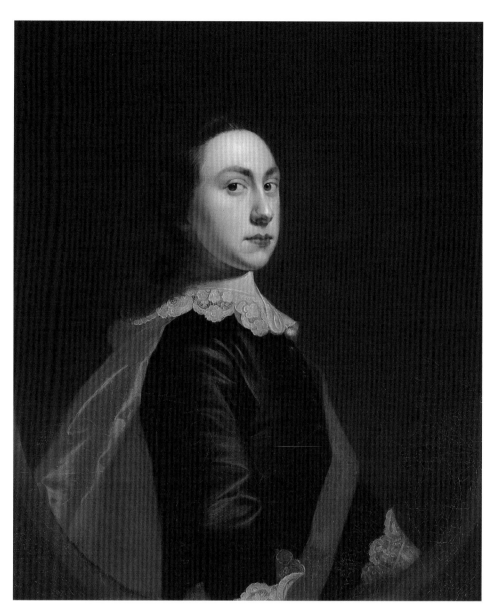

I

2

Anne Bateman, later Mrs John Gisborne dated 1755

Oil on canvas $30\frac{1}{2} \times 25\frac{1}{2}$ (77×65), in a feigned oval
Inscribed 'J.Wright pinx! | 1755'
PROVENANCE
In Wright's Account Book as 'Miss Bateman £3.3.0', the first entry in a list headed 'Sitters at Derby'; presumably commissioned by William Bateman, the sitter's father, then by descent to Mrs Fooks, Woodbridge, Suffolk, until sold Phillips, 17 December 1985 (69, repr. in colour), bt Lane Fine Art, by whom sold Sotheby's 9 March 1988 (41, repr. in colour), bt by the present owners
EXHIBITED
A Perfect Likeness, Lane Fine Art, 1987 (40, repr. in colour)
LITERATURE
Nicolson p.178, untraced, and as '*c.*1760'

Private Collection

Dated 1755, this recently rediscovered portrait is Wright's earliest known securely dated painting. The date, and his Account Book entry showing that he charged three guineas for it (his earliest fee), establish that he was in practice as a professional portraitist several years earlier than had been thought. The 'Self-Portrait' in Vandyke dress (No.1) previously thought to be Wright's earliest work, was dated by Nicolson *c.*1758, but is probably some five years earlier. The reappearance of 'Mrs Anne Bateman', dated 1755, and a reasonably accomplished if still immature work, adds to the mounting evidence that Wright got off to a quicker start than Nicolson thought, and suggests that many portraits which have so far been assigned to '*c.*1760' may have been painted within five years earlier.

The portrait of Anne Bateman is largely based on prototypes by Thomas Hudson, Wright's master. Wright spent two years studying under Hudson, from 1751 to 1753, possibly also assisting him in painting the draperies in various portraits. Then he went home to Derby to start work on his own; but in 1755, dissatisfied with his progress, returned to Hudson's studio for a further fifteen months. Wright would himself have been well aware that in the first portraits he painted on his own, his talent for painting satin and lace was not yet matched by the ability to convey the reality of the human body beneath the furbelows. Anne Bateman suffers from a want of shoulders, though there is grace and poise in her expression.

The sitter was the daughter of William Bateman, a Derby lawyer who was reputedly a friend of Wright's father, the attorney John Wright. Anne Bateman became the wife of John Gisborne, of Yoxall Lodge, Staffordshire, and the mother of Thomas Gisborne, born in 1758, who was to be portrayed with his wife in one of the most endearing of all Wright's portraits (No.146).

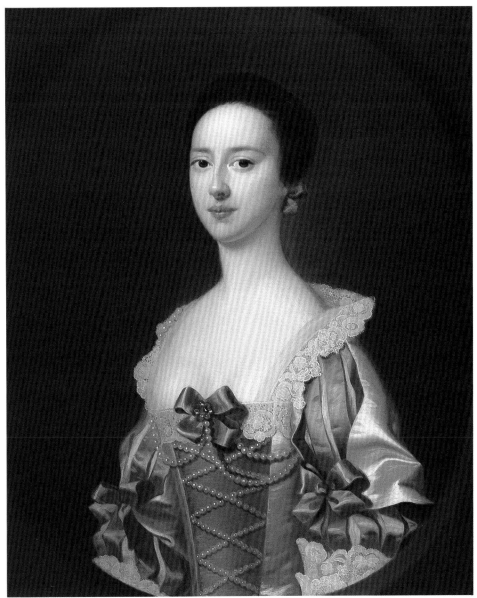

2

3
William Brooke 1760

Oil on canvas 50 × 40 (127 × 101.6)
PROVENANCE
In Wright's Account Book as 'Mʳ
Brooks', among sitters at Doncaster
repeated among sitters from 1 February
1760 onwards, as 'Mʳ Brooks £12.12.0'
and again as 'For a half Length of Mʳ
Brooks £2.12.0'; by descent to the pre-
sent owner
LITERATURE
Nicolson no.25 pp.184–5 pp.27, 95, 103,
185; pl.21

*Executors of the late R.D. Plant Esq. and Mrs
J.F.A. Plant*

William Brooke, born in 1694, was four
times Mayor of Doncaster (in 1736,
1743, 1746 and 1751) and Alderman
from 1733 until his death thirty years
later. He was not in office as Mayor in
the spring of 1760 when Wright was
working in Doncaster, but continued to
be a figure of importance there. Though
Wright never managed to spell this sit-
ter's name correctly, he succeeded brilli-
antly in portraying Brooke's robust
appearance and evidently forthright
character.

Nicolson gives the following pungent
description of Brooke as he sees him on
Wright's canvas: 'a self-made man . . .
happy to expose his unsophisticated ori-
gin, proud of his business acumen and
anxious that it should be written into his
face: William Brooke, dealer in fabrics,
Alderman and sometime Mayor of the
provincial town of Doncaster . . . with his
belly bursting out of his waistcoat and
his bulk threatening to overpower his
chair' (p.103).

Nicolson has some trouble with the
bourgeoisie. He sees Brooke's portrait as
a forerunner of Arkwright's (No.126),
assumes that Brooke too must be 'a self-
made man' and sees him as physically
'bursting' and 'threatening'. Wright
leaves us in no doubt that Brooke was fat.
And Brooke was certainly in trade, as a
mercer; but not all tradesmen are self-
made men, and Brooke in fact came from
a long line of merchants and haberdashers
established in London by the early seven-
teenth century, gradually moving north
and steadily prospering (a Brooke pedi-
gree is given in Clay, 1895, cited below).
William Brooke was the son of Thomas
and Frances Brooke, and inherited pro-
perty from his father. He may be a trades-

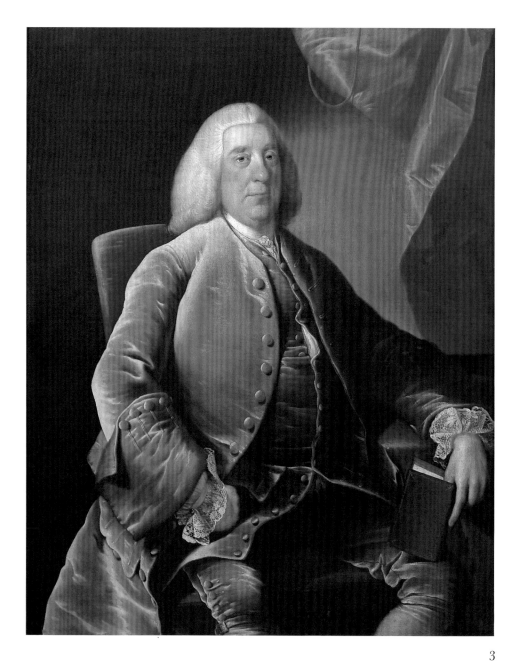

3

man, but he is no parvenu.

Undoubtedly Brooke's pose is inelegant,
but in this it is matched by much of the
forthright portraiture of the day, from
Hogarth's 'Captain Coram' on. Brooke's
pose is not far from that in which Hudson
had portrayed Handel (also 'a large and
very portly man') in the portrait engraved
by Faber in 1748–9 (repr. *Thomas Hudson*,
Kenwood exh. cat. 1979, no.34); Wright is
likely to have known the portrait, at least
in its mezzotint form, and may have
drawn on it for ideas.

Since Brooke was a mercer, the velvet
and lace he wears are likely to be of the
highest quality. Wright responds to the
pile and the creases of the old gold velvet,
to the two undone buttons and the huge
cuffs. His painting of Brooke's wig is fairly

mechanical; wig-painting was never
Wright's forte. The loop of rose-pink cur-
tain in the upper right corner is a wholly
uninventive baroque convention which
Wright was slow to discard. No title, alas,
is legible on the book Brooke holds; but it is
not a ledger.

Of Brooke's two surviving children,
John became a merchant in Wakefield.
Elizabeth married William Pigot, son of
the Vicar of Doncaster; Wright's portraits
of this pair are more elegant (and much
duller) than his portrait of William Brooke
(Nicolson pls. 23–4).

(For the Brooke pedigree, see John W.
Clay, *Familiae Minorum Gentium . . . 11, 1895
(Harleian Society vol.38), pp.763–7)*

4

Anne or Molly Cracroft *c.*1760

Oil on canvas 50 × 40 (127 × 101.6)
Inscribed in a later hand, probably in
the mid-nineteenth century, 'Rebecca
Waldgrave | second wife of Rob.̣ Cracroft
Esq. | Niece to the Rev.ḍ D.̣ Wilson | Obiit
AD 1801' lower l.
PROVENANCE
In Wright's Account Book as either 'Miss
Craycroft' or 'Miss Molly Craycroft',
among sitters at Lincoln 1760; presum-
ably commissioned by Robert Cracroft,
and thence by descent to the present
owner
LITERATURE
Nicolson no.45, pp.190–1; pp.28, 154;
pl.25

Private Collection

It is unlikely that the inscription on the
picture identifies the sitter correctly.
The date of the portrait must be about
1760; and Wright portrays a girl aged
twenty-five at the most. The Rebecca
Waldgrave who married Robert
Cracroft as his second wife in 1746
would have been nearer forty in 1760,
and probably a matronly figure, as she
bore him nine sons. Wright's sitter is no
matron. She is likely to be either 'Miss
Craycroft' or 'Miss Molly Craycroft',
whose portraits are listed in Wright's
Account Book but are now untraced,
unless this is one of them.

Nicolson identifies the Cracroft girls
who sat to Wright as Anne (1735–68)
and Mary (1737–1809); their ages
certainly make either girl eligible as
Wright's sitter. They were the only two
unmarried daughters by 1760 of Robert
Cracroft of Hackthorn Hall, near
Lincoln, by his first wife. Anne married
the Rev. John Langhorne, whose poem
Country Justice inspired Wright to paint
'The Dead Soldier'; she died in child-
birth a year after their marriage. Did her
portrait stay on in her father's house?
Mary or Molly Cracroft married a
Nelthorpe; but her portrait does not
appear to have left home with her.
Which Cracroft girl sat for this portrait
seems impossible now to determine.
Nicolson catalogued the portrait as
' "Rebecca" Cracroft' with sceptical
quotes round the Christian name; but
given the entries in Wright's Account
Book (which do not include a Rebecca
Cracroft) it seems justifiable to call it
'Anne or Molly Cracroft'.

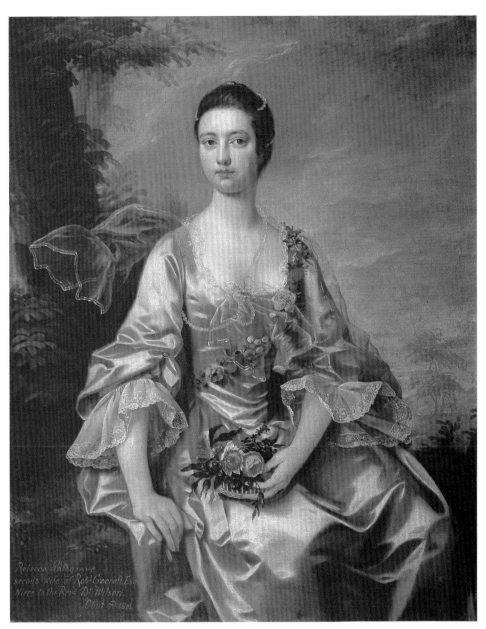

4

This is perhaps the key portrait in
Wright's development as an artist with
an individual style. From the neck
down, it could have been painted in
Hudson's studio, where Wright had
learnt how to paint shimmering folds of
satin and how to arrange loops of pearls
in the most flattering manner (though
the swag of fruit from shoulder to waist
seems to have been Wright's own idea).
But the face that looks out at us above the
finery is that of a plain but forthright
individual Derbyshire girl, who would
probably be much happier going off
hunting, like 'Mrs Wilmot' (No.9).
Wright portrays her as she is, with can-
dour and without flattery. The same

honesty informs the portrait of 'William
Brooke' (No.3); after these two portraits,
it rarely deserts him.

Portraits of Four Members of the Markeaton Hunt *c.*1762–3

Francis Noel Clarke Mundy; Harry Peckham; Nicholas Heath; Edward Becher Leacroft

On 18 June 1762, the 23-year old Francis Noel Clarke Mundy came into the inheritance of Markeaton Hall, near Derby, and its considerable estates. He decided to ask Wright to paint himself and five of his friends in the livery of the Markeaton Hunt. This idea of a visual record of friendship was no doubt inspired by the fact that in 1749, his father Wrightson Mundy had been one of a group of five friends who sat for their portraits to Arthur Devis, the link between those five being that they had all been at Oxford together (see Sartin pp.49–50). Wrightson Mundy also commissioned Devis to paint himself and his friends Sir Robert Burdett and Sir Charles Sedley; these three portraits (figs.1–3) offer an interesting contrast to Wright's Markeaton Hunt portraits of some twelve or thirteen years later.

Wright painted six members of the Markeaton Hunt (Nicolson pls. 33–8). We had hoped to exhibit the whole group here, but unfortunately that proved impossible.

The Markeaton Hunt may well have been Francis Mundy's own creation, a small private pack of hounds which he invited friends to follow, and for which he devised the hunt livery in which Wright portrays each of the six young men : royal blue velvet coat, scarlet waistcoat and yellow nankeen breeches. The Markeaton Hunt is not mentioned in the chapter on 'Sport' in the *Victoria County History of the County of Derbyshire*, 11, 1907, which dates the first printed record of hunting in Derbyshire to the 1790s; but Wright's portraits of members of the Markeaton Hunt, like his portrait of 'Mrs Wilmot' (No.9), provide evidence that hunting was enjoyed at least thirty years earlier. Wright's 'Earthstopper' (No.51) serves (though this is the least interesting of its qualities) as evidence that the local quarry was the fox. 'The Earthstopper' may very well have been a Markeaton hunt servant.

Most of the six members of the Markeaton Hunt were connected by ties stronger than shared pleasure in hunting. Nicholas Heath married Mundy's sister Mary. Mundy's mother was a Burdett, and he himself married

Francis Burdett's sister Elizabeth, Peckham had been a friend of Mundy's at Oxford, Rolleston and Leacroft, like Mundy and Burdett, all came from old Derbyshire families.

In the Markeaton Hunt portraits, Wright makes more effort at landscape backgrounds than he has hitherto done. It cannot yet be said that he is very successful. Mundy is portrayed against an incomprehensibly tilted wedge of rock. Peckham is portrayed against an insubstantial wall even odder than Mrs Wilmot's (No.9), with one perilously-balanced brick atop it. Rolleston leans on a fence as makeshift as that in 'Mr & Mrs Burdett' (No.40). The other Burdett (no relation) comes off best, with the most convincing landscape background Wright has so far painted.

Wright is far more successful in the variations he plays in the poses of six identically-dressed young men. The pose of Nicholas Heath, one leg flung casually over the other, his face half-shadowed by his hunting-cap, is the boldest Wright has so far essayed. Wright works throughout this series towards a new informality. Leacroft's hunting-cap is tossed on to a tree stump. The carelessly-crumpled, beautifully-rendered handkerchief which spills out of Harry Peckham's pocket is probably the best still-life detail Wright has so far brought off; it is repeated in Leacroft's portrait, and achieves its finest hour years later in the portrait of 'Christopher Heath' (No.137).

Mundy's pose is derived from John Smith's engraving of Kneller's portrait of Anthony Henley *c.*1690 (repr. Stewart 1983 pl. 32b), who stands, also against a great slab of rock, in much the same attitude, with the index finger of his right hand pointing downwards, as Mundy's does. Wright is likely to have had an impression of the Kneller engraving in his studio; he was to return to it for ideas for the portrait of 'Thomas Day' (No.60). As befits the Master of the Hunt, Mundy is portrayed with some of its attributes, a fox's brush and a tolerably convincing foxhound.

According to Hannah Wright's MS Memoir, Wright exhibited the six Markeaton Hunt portraits together in Derby Town Hall. They must have presented visitors with evidence of a new and striking talent in their midst, and perhaps prompted other commissions. All six portraits were last seen together in public, unforgettably, at Christie's in 1975, before the sale which dispersed them.

fig.1 Arthur Devis: 'Wrightson Mundy of Osbaston, Leicestershire and Markeaton, Derbyshire' 1750. Oil 29 × 24 *Priv. Coll.*

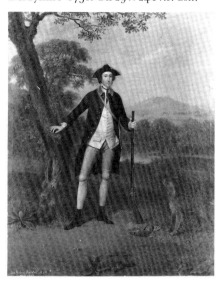

fig.2 Arthur Devis: 'Sir Robert Burdett, Bt., of Foremark, Derbyshire' 1750. Oil 29 × 24 *Courtesy of Christie's*

fig.3 Arthur Devis: 'Sir Charles Sedley, of Nuthall, Nottinghamshire' 1752. Oil 29 × 24 *Courtesy of Christie's*

5
Francis Noel Clarke Mundy *c.*1762–3

Oil on canvas 50 × 40 (127 × 101.6)
Inscribed (in a nineteenth century hand)
'F.N.C. Mundy Esq^re' lower l.

PROVENANCE
In Wright's Account Book, listed three
times, chiefly as 'For a hlf Length of M^r
Mundy £12.12.0 P^d'; by descent to Rev.
W.G. Clarke-Maxwell, Markeaton Hall,
sold Christie's 15 May 1936 (21), bt
Miller-Mundy; Major E.P.G. Miller-
Mundy M C sold Christie's 20 June 1975
(152, repr.), bt Roy Miles; private
collection

EXHIBITED
Derby Town Hall *c.*1762–3; Derby 1934
(147); *British Sporting Painting 1650–1850*,
Arts Council, London, Leicester &
Liverpool 1974–5 (66)

LITERATURE
Nicolson no.110 pp.212–3; pp.2, 26–8,
97; pl.34

Private Collection

Francis Mundy, originator and first
owner of the Markeaton Hunt series of
portraits, came from a family which had
owned the manors of Markeaton and
Mackworth for about two and a half
centuries, since their purchase in 1516 by
John Mundy, citizen of London and its
Lord Mayor 1522–3. The Mundys also
owned estates in Leicestershire. Francis
Mundy, born in 1739, was the eldest son
of Wrightson Mundy and his wife Anne
Burdett. Wrightson Mundy (fig.1),
reputedly a friend of Addison, Steele
and Swift, had been High Sheriff of
Derbyshire in 1737, and was M P for
Leicestershire 1747–51; it was he who
rebuilt Markeaton Hall in 1755, achiev-
ing (in Byng's unkind phrase, p.61) 'a
flaring red house without shade'. That is
the house in which we must imagine the
Markeaton Hunt portraits hanging,
after Wright had exhibited them in
Derby Town Hall *c.*1762–3, and until
they were consigned to Christie's in 1936.

Francis Mundy went up to Oxford in
1757, entering New College, where he
became a friend of Harry Peckham
(No.6). He developed a taste for poetry,
and naturally gravitated to the Lichfield
circle, 'like all Midlands intellectuals of
his generation' (Nicolson p.97). With
Erasmus Darwin's and Anna Seward's
encouragement, he published his poems,
first anonymously as *Needwood Forest*,
1776 and later in an enlarged edition

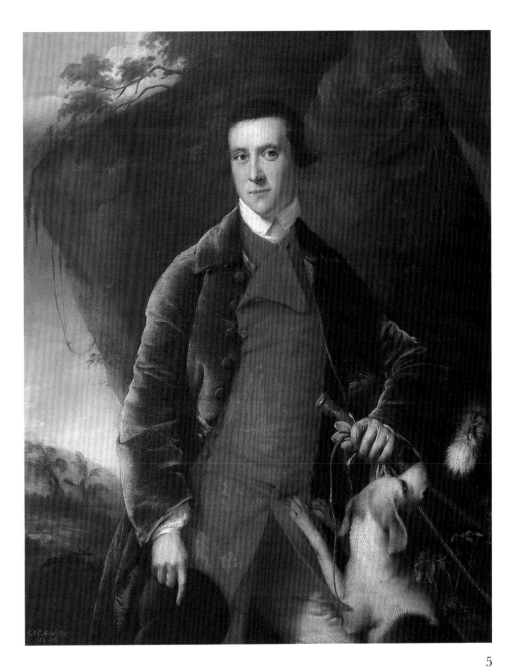

5

including *The Fall of Needwood*, 1808.
Anna Seward called *Needwood Forest* 'one
of the most beautiful *local* poems that has
been written' (a compliment balanced
on the edge of a cake-knife). Nicolson
picks out a verse describing an earth-
stopper at work, quoted under that
picture (No.51).

Mundy married Elizabeth Burdett,
sister of one of his Markeaton Hunt com-
panions, on 17 June 1770, at All Saints,
Mackworth, the ceremony being
conducted by Rev. John Pickering
(No.148), who also married Nicholas
Heath and Mary Mundy. Two of
Francis Mundy's sons, Francis and
Charles, were portrayed by Wright in
the picture exhibited at the Royal Acad-

emy in 1782 as 'Two Young Gentlemen
in the Character of Archers' (Nicolson
pl.222).

Towards the end of his life Francis
Mundy sat again for his portrait, this
time to Richard Ramsay Reinagle. The
portrait, dated 1809, sold from the family
collection in 1965, was exhibited at
Agnew's, *Realism and Romance in English
Painting*, 1966 (38, repr.) and is now at
the Yale Center for British Art. The
seventy-year old Mundy, still of erect
carriage, is recognizably Wright's sitter.
A young grandson stands beside him,
and on the table at which Mundy sits lie
volumes of his poems, *Needwood Forest*
and *The Fall of Needwood*.

Mundy died on 23 October 1815. A

bust by Francis Chantrey, signed and
dated 1820, is in the hall of the Court
House, Derby, where Mundy had pre-
sided for nearly fifty years.

6

Harry Peckham *c.*1762–3

Oil on canvas 50 × 40 (127 × 101.6)
Inscribed (in a nineteenth century hand)
'Harry Peckham Esqʳ.' lower l.
PROVENANCE
In Wright's Account Book as 'Ditto [half
length] of Mʳ. Peckham £12.12.0'; F.N.C.
Mundy, by descent to Rᵉᵛ W.G. Clarke-
Maxwell, sold Christie's 15 May 1936
(23), bt Miller-Mundy; Major E.G.P.
Miller-Mundy MC, sold Christie's 20
June 1975 (150, repr.) bt Roy Miles;
private collection
EXHIBITED
Derby Town Hall *c.*1762–3; Derby 1934
(154)
LITERATURE
Nicolson no.117 pp.216–7; pp.2, 28–9,
97–8; pl.35

Private Collection

Harry Peckham (the Christian name in
that form recurs in the family) was the
son of the Vicar of Amberley in Sussex.
Peckham seems to have been a particu-
larly good friend of Mundy's. Their
friendship probably began at Oxford,
where Mundy entered New College in
November 1757, at the age of eighteen,
and Peckham entered the same college
in August 1759, at the age of nineteen.
Peckham may still have been an under-
graduate when he sat to Wright.

Mundy evidently thought of asking
Wright to paint another portrait, in
which he would be depicted as if he had
just received a letter from his friend
Harry in Sussex. A note in Wright's
Account Book reads 'The letter in Mr
Mundy's Picture to be dated from
Amberley in Sussex. it may conclude
with "Your friend Harry Peckham" not
Henry – The Case upon the Latter's
Table may be directed "Francis Mundy
Esqʳ at Markeaton near Derby" '. If this
picture was ever painted, it is now
untraced.

After Oxford, Harry Peckham entered

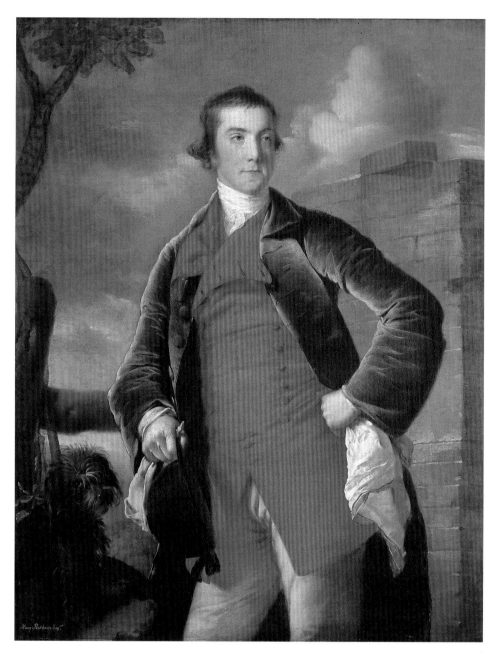

6

the Middle Temple; he was called to the
Bar in 1768, became a KC and Middle
Temple Bencher and in 1782 was
appointed Recorder of Chichester. He
continued to be fond of hunting; but
alas, on 10 January 1787 he broke his
neck in the hunting-field, and was
buried the following week in the Temple
Church. Mundy survived the friend of
his youth by nearly thirty years.

7

Nicholas Heath *c.*1762–3

Oil on canvas 50 × 40 (127 × 101.6)
Inscribed (in a nineteenth century hand)
'Nicholas Nicholas' lower l.

PROVENANCE
In Wright's Account Book as 'For a half
Length of M! Heath – £12.2.0 P^d, (an
earlier entry M! Heath £2.12.)' crossed
out; F.N.C. Mundy, by descent to Rev.
W.G. Clarke-Maxwell, Markeaton Hall,
sold Christie's 15 May 1936 (22), bt
Miller-Mundy; Major E.P.G. Miller-
Mundy MC sold Christie's 20 June 1975
(148, repr.) bt Agnew, from whom pur-
chased by the present owner

EXHIBITED
Derby Town Hall *c.*1762–3; Derby 1934
(19)

LITERATURE
Nicolson no.77 pp.202–3; pp.2, 29, 98;
pl.37

Private Collection

This portrait, with its relaxed pose and
the play of light and shade on the creases
and folds of the velvet suit, is arguably
the most exciting of the Markeaton
group.

It is not known how Heath and
Mundy became friends; possibly they
were at school together. Heath did not go
to Oxford, and does not appear to have
lived in Derbyshire, though he may have
had Derbyshire connections so far untra-
ced. He was described as 'of London' in
the Parish Registers of All Saints
Mackworth, close to Markeaton Hall,
when he went there on 17 September
1768 to marry Mundy's sister Mary,
some five years after the Markeaton
Hunt portraits were painted.

Nicholas Heath assumed the surname
of Nicholas on 15 February 1772, in
order to comply with a condition of
inheriting the manor of Boy Court in the
parish of Ulcombe, Kent. He thus
enjoyed the dubious pleasure of being
called Nicholas Nicholas. He appears to
have lived at Boy Court for the rest of his
life. For his wife's kindness to the poet
William Hayley's distraught wife, see
Nicolson p.92.

(Edward Hasted, *History and
Topographical Survey of the County of Kent*,
11, 1782, p.424)

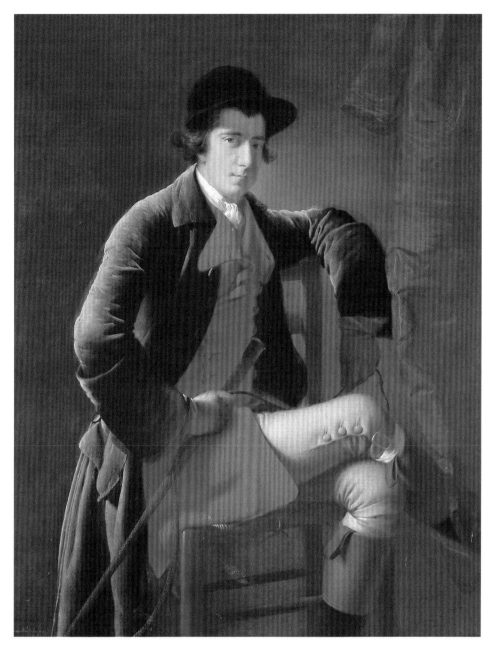

7

8

Edward Becher Leacroft

Oil on canvas 50 × 40 (127 × 101.6)

PROVENANCE
In Wright's Account Book as 'M. Leacroft £12.12.', crossed through and repeated as 'A half Length of M. Leacroft £12.12.'; F.N.C. Mundy, by descent to Rev. Clarke-Maxwell, sold Christie's 15 May 1936 (20), bt Miller-Mundy; Major E.P.G. Miller-Mundy MC, sold Christie's 20 June 1975 (149), bt Leggatt Brothers, from whom purchased Stanford University Museum of Art 1986

EXHIBITED
Derby Town Hall *c*.1763; Derby 1934 (83)

LITERATURE
Nicholson no.99 pp.208–9; pp.28–9, 34; pl.33; Benedict Nicolson, 'A Wright of Derby Portrait for the Stanford Museum', *The Stanford Museum*, VII–VIII, 1976–7, pp.19–21, fig.1

Stanford University Museum of Art, gift of the Committee for Art at Stanford

Edward Becher Leacroft was the eldest son of Robert Leacroft, attorney, of Babington House, Wirksworth, Derbyshire, and his wife Bridget, daughter of Edward Becher of Southwell, Notts. He was born on 30 September 1737, and was thus about two years older than his friend Francis Mundy of Markeaton Hall (No.5).

The only 'fact' given about Leacroft in the 1934 Derby exhibition catalogue is 'He went to Markeaton Hall for a short visit and stayed for fourteen years'; as the portrait was lent to that exhibition by a Mundy descendant, the story must spring from a Markeaton Hall tradition. Leacroft was reputedly an author and a poet, qualities which must have endeared him to Mundy, himself a poet; but unlike Mundy, Leacroft published nothing (or not under his own name, which is absent from the British Museum General Catalogue of Printed Books). When not at Markeaton, Leacroft lived nearby at Kirk Langley. He died unmarried on 15 June 1805.

That makes two poets among the six

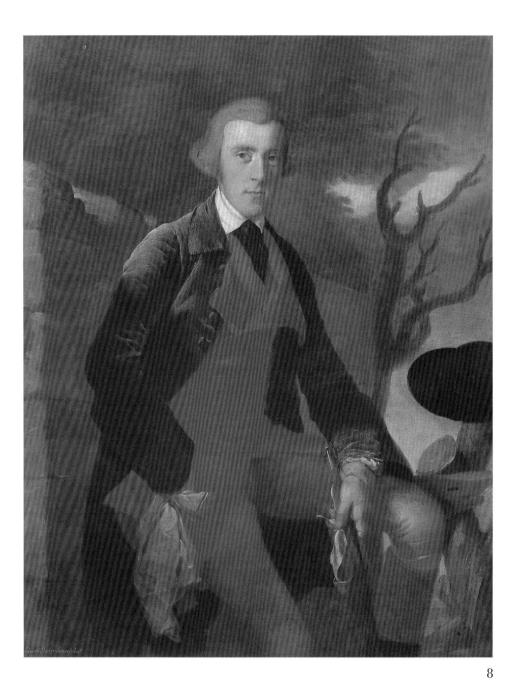

8

Markeaton Hunt sportsmen. There is a tendency among English art historians to think that anyone who is portrayed as a sportsman must be a philistine. It is a foolish assumption.

(The compiler is most grateful to Maxwell Craven for information about Leacroft)

9

Mrs Wilmot in Riding Dress
*c.*1762–3

Oil on canvas 50 × 40 (127 × 101.6)
PROVENANCE
In Wright's Account Book as 'M.ʳˢ
Wilmot £12.12.0', repeated as 'A half
Length of M.ʳˢ Wilmot £12.12.0', among
sitters of *c.*1760; by descent to the present
owner
EXHIBITED
Manchester Art Treasures, 1857 (82);
Derby 1866 (173); *National Portrait Exhi-
bition*, South Kensington Museum, 1867
(610, as 'Sarah Mead, Lady Wilmot');
Derby 1870 (779), Derby 1883 (79);
Graves' Galleries, London, 1910 (67),
'and on other occasions' (Nicolson p.227)
LITERATURE
Nicolson 1968, cat.no.148, pp.29, 98⁸,
158, 227; pl.50

Private Collection

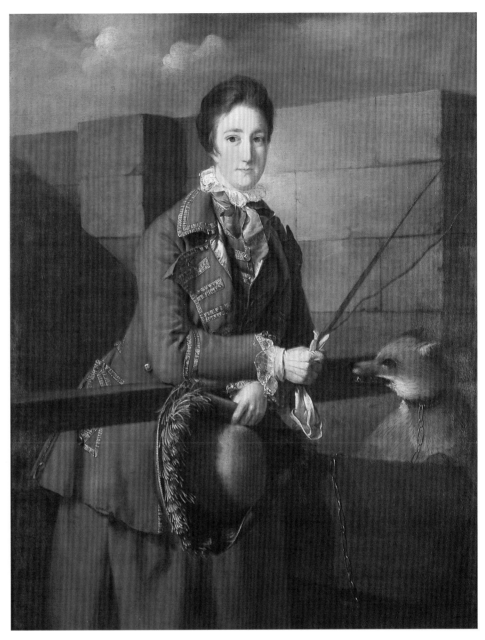

9

The sitter was born Mary Woollet,
daughter and heiress of William Woollet
of Harbledown, Kent. In 1759 she mar-
ried Robert Mead Wilmot, and settled
down in or near Chaddesden (now a
suburb of Derby) in the county of
Derbyshire. Her father-in-law Sir
Edward Wilmot MD FRS had been phys-
ician in ordinary to George II, Queen
Charlotte and the Prince of Wales;
rewarded with a baronetcy in 1759, he
retired the next year to Chaddesden,
his birthplace, with his wife Sarah,
daughter of his fellow royal physician
Dr Richard Mead, the celebrated collec-
tor and connoisseur (the DNB notice of
Dr Mead, presumably following the
National Portrait Exhibition catalogue of
1867, is mistaken in identifying this por-
trait as of Sarah Mead, who would have
been over 60 when Wright painted it).

Whatever Mrs Wilmot's pedigree, in
spirit she is surely first cousin to the mem-
bers of the Markeaton Hunt (Nos.5–8).
She looks perfectly capable of hunting all
day and enjoying every minute of it. She
has much more self-confidence than the
Cracroft girl (No.4), who was unfortunate
in sitting to Wright too early in his career.
As Nicolson observes (p.29) Mrs Wilmot
leans forward on her fence 'in the most
natural movement possible'. Her
mulberry-coloured riding habit is trim-
med with silver braid; one lapel curves
forward, giving Wright the excuse to
paint the silver braid as the light falls on it
and as it curves into shadow. But it is Mrs

Wilmot's hat that Wright most responds
to; he observes how each strand of its
blue curving plume catches the light, and
leaves the spectator knowing exactly
how that rounded crown would feel to
the touch.

For all the technical sophistication in
painting textures and effects of light
displayed here, the background Wright
provides for Mrs Wilmot is perfunctory,
almost naive. He brings her into the
open air, and then proceeds to block out
almost all its openness. What can that
wall be which is made of massive blocks
yet is not as high as Mrs Wilmot? Per-
haps it is the wall of the kennels, at

the back of which it might not be
inappropriate to keep a chained fox
(usually called a 'bagman') to supply the
hunt with a quarry in a county where
foxes were few.

The sitter was still 'Mrs Wilmot' when
Wright painted her. The portrait's
frame must have been lettered 'Mary
Lady Wilmot' years later, after her hus-
band had succeeded his father as 2nd
Bt, in 1786, and probably after her hus-
band's death in 1793, after which
their eldest son's wife would take the
title 'Lady Wilmot', 'Mary Lady
Wilmot' becoming a suitable title for a
dowager mother-in-law.

Nicolson notes (p.29) the similarities, which must be fortuitous, since 'Mrs Wilmot' was not engraved, between Wright's portrait and John Singleton Copley's portrait of 'Mrs Epes Sargent' (his fig.20), painted in America a year or so later.

(George Edward Cokayne, *Complete Baronetage*, v, 1906, p.110; Notice of Sir Edward Wilmot 1693–1786, DNB XXI 190, p.532

10

James and Mary Shuttleworth with one of their Daughters dated 1764

Oil on canvas 56 × 72 (142.2 × 182.9) Inscribed 'Wright Pinx! |1764' (possibly with an initial 'J' now hidden by the frame) at left below the urn

PROVENANCE
In Wright's Account Book as 'For a Conversation piece of M.ʳ M.ʳˢ & Miss Shuttleworth £42' (an earlier entry 'Family Picture of M.ʳ Shuttleworth £42' being deleted, with others on that page); by direct descent to the present owner

EXHIBITED
? Society of Artists 1765 (164, 'A Conversation Piece')

LITERATURE
Nicolson 1968 cat.no.129, pp.2–4, 17, 30–2, 34, 36–9, 67, 105⁵, 162, 220–1; pl.51

The Lord Shuttleworth

The sitters are James Shuttleworth MP, of Gawthorpe Hall, Lancashire and Forcett Park, Yorkshire (1714–1773), his wife Mary, daughter and heiress of Robert Holden of Aston Hall, Derbyshire, whom he married in 1742, and one of their two daughters, believed to be Elizabeth rather than her elder sister Mary. There were also four sons of the marriage.

With his own and his wife's inheritance, James Shuttleworth was a considerable landowner. He was MP for Preston 1741–54, High Sheriff of Yorkshire 1760–1 and MP for Lancashire 1761–8; though he is not known to have spoken in the House of Commons, he was classed as a Tory. In London he had a house in Downing Street; he belonged to White's Club and appears to have collected books and drawings, and was a subscriber to John Baskerville's first publication, a Latin Virgil, 1757.

During James Shuttleworth's lifetime the family seems chiefly to have lived in Forcett Park in Yorkshire; but it may well have been at Aston Hall, Derbyshire, Mrs Shuttleworth's old home, that Wright painted this family portrait. James Shuttleworth died at Forcett in 1773. After his death, his widow seems to have returned to Derbyshire; she is the 'Mrs Shuttleworth' whose name recurs in the diaries (unpublished) of her cousin Robert Holden of Darley Abbey. Elizabeth Shuttleworth (probably the child in this

picture) married Francis Hurt the younger in 1777, thus becoming the daughter-in-law of the industrialist Francis Hurt, portrayed by Wright in No.129.

Nicolson considers the Shuttleworth group of 1764 to be Wright's 'supreme achievement' of the early 1760s, proving that 'before the middle 1760s he had reached mastery in this branch of painting. This is the crucial date in Wright's career when he came into his own; when he first discovered his power, his originality and a sense of direction, and set off inspired, on a new career . . . a series of nightpieces' (op. cit. pp.2–3).

A measure of Wright's originality is offered by comparing his Shuttleworth group with Thomas Hudson's 'The Thistlethwayte Family' (fig.4; exh. *Manners & Morals*, Tate Gallery, 1987, 208, repr. in colour) of *c.*1757–8, only some eight or nine years earlier than Wright's picture. Wright, Hudson's former pupil, has succeeded in portraying his sitters in a relaxed, informal manner that makes the stock poses of Hudson's Thistlethwaytes seem stiff and their demeanour supercilious.

James Shuttleworth's pose hardly suggests the large landed proprietor, the county grandee or the MP; he neither challenges our gaze nor attempts to assert authority, but is content to stand at ease, holding his upturned gun by the barrel, looking across at his wife and child. As a reflection of a happy married life, this picture anticipates that of 'Mr & Mrs Thomas Coltman' (No.29). Mrs Shuttleworth, no great beauty, rests her arms comfortably over an illegible book

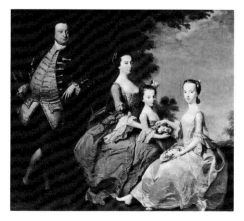

fig.4 Thomas Hudson: 'The Thistlethwayte Family' *c.*1757–8, oil on canvas 72¾ × 84½ (184.7 × 214.6) *Private Collection*

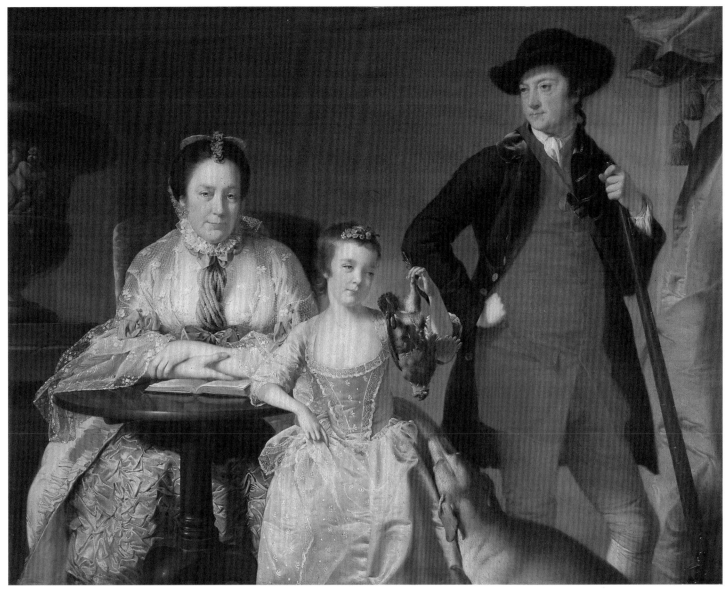

on a mahogany table; their daughter dangles a partridge by one of its legs (evidently one of the spoils of her father's shooting), just out of reach of a retriever. In their use of such props as guns, dogs and game, there is some similarity between Wright's picture and John Hamilton Mortimer's 'The Artist and his brother Charles, after Woodcock Shooting, with their father Thomas Mortimer' of the early 1760s (collection Mr Paul Mellon KBE, repr. Egerton 1978, colour plate 19). Wright and Mortimer, friends since their student days at Hudson's, both sought to introduce a new informality into the conversation piece.

Wright's Account Book also records single portraits of 'Mʳ Shuttleworth, Mʳˢ Dᵒ and Miss Dᵒ' at twelve guineas each,

among sitters at Derby, undated, from c.1760, and of 'Mʳ Holding Shuttleworth' (? James Shuttleworth's youngest son, Rev. Charles Shuttleworth, who took the name and arms of Holden) at ten guineas among sitters of c.1777–80 (see Nicolson 1968 p.220). James Shuttleworth's sister, Mrs John Crewe, also sat to Wright in the mid-1760s (Nicolson cat.no.130).

(Namier & Brooke III, 1964, p.438; unpublished notes by Sir Roger Fulford kindly made available by Lord Shuttleworth)

11

Simon Wilmot *c.*1760

Oil on canvas 20 × 16 (50.8 × 40.6)
PROVENANCE
In Wright's Account Book as 'Master
Simon & Harvey Wilmot £6.6.0',
among sitters from 1st February
onwards; thence by family descent
LITERATURE
Nicolson 1968 cat.no.146, pp.26, 69, 98
and 226; pl.13

Private Collection

See text below No.12

12

Harvey Wilmot *c.*1760

Oil on canvas 20 × 16 (50.8 × 40.6)
PROVENANCE
as for No.11
LITERATURE
Nicolson 1968 cat.no.147, pp.26, 69, 98 and
225; pl.10

Private Collection

The sitters are two of the six children of
Rev. Richard Wilmot and his wife
Dorothy Degge. Their father was Rector
of St. Matthews, Morley and Vicar of
All Saints, Mickleover, two parishes only
a few miles from Derby; he was also
sometime Canon of Windsor.

Wright painted similar portraits of
each of the six Wilmot children (all repr.
Nicolson pls.9–13 and 15). Four of the
boys are portrayed with the left hand
tucked into the waistcoat (like most
painters, Wright charged extra for 'a
hand'), while their only sister is por-
trayed, at the age of about twelve, in the
rigidly straight-backed pose and in the
gown and headdress of pearls in which
Wright was currently painting most of
his young but adult ladies.

Each of the children is portrayed as
intensely solemn, as if there were never
any fun at the vicarage: there is a long
way to go before both the artist and his
sitters relax, as they do in the portraits of
the Rastall boys of *c.*1762–4 (Nos.19,20).
But Wright's very individual talents can
nevertheless be seen to be emerging in
the unaffected candour of his portraits of
the Wilmot children, and in his love of
painting effects of light on buttons and
curving lapels. Wright's portraits of the
Wilmot children have some affinity with
Allan Ramsay's portraits of two of the

11

Erskine children, Anne and her sister Magdalen (private coll., on loan to the National Gallery of Scotland), which are signed and dated 1747. Wright, aged 26 in 1760, roughly the date of the Wilmot children, still (not surprisingly) lagged behind the confidence displayed by Ramsay, painting the Erskine children at the age of 34.

Simon Wilmot was born in 1752 and died in 1781; Harvey Wilmot, born in 1753, had an even shorter life, dying in 1774. Their father, Revd. Richard Wilmot, was the younger brother of Sir Edward Wilmot Bt., of Chaddesden, Derbyshire, who is briefly noticed under Wright's portrait (No.9) of his daughter-in-law, Mrs. Wilmot; she is thus related by marriage to the Wilmot children. It may have been general satisfaction in the Wilmot family circle with Wright's portraits of the Wilmot children that led to the commission to paint 'Mrs. Wilmot' in 1762–3.

12

*13

Mr & Mrs William Chase *c.*1762–3

Oil on canvas $54\frac{1}{2}$ × 75 (138.4 × 190.5)
Inscribed 'M.ʳ & M.ʳˢ Will.ᵐ Chase| m.ᵈ
[married] 1760' lower l.

PROVENANCE
In Wright's Account Book as 'For a Conversation picture of M.ʳ W & M.ʳˢ Chase –
£24.4.0'; S. Brewin, by 1883; Rev.
Harington O. Shore, sold Christie's 16
December 1911 (98), bt Sulley;
Wertheimer; Agnew's, 1912; Miss Faith
Moore, 1917; Viscount Lee of Fareham,
by 1934; Samuel Courtauld, by 1946; Lord
Butler; Agnew's, from whom purchased
by the present owner 1977
EXHIBITED
Derby 1883 (97); Derby 1934 (110)
LITERATURE
Douglas Cooper, *The Courtauld Collection*,
1954, no.244, pp.186–7; Nicolson no.37,
pp.188–9; pp.23, 30–1; pl.37

Private Collection, New York

This may be the earliest conversation piece
to be painted in Derby, by Wright or anyone else. Little is known of the sitters.
William Chase was almost certainly the
son of the William Chase who was
described by the *Derby Mercury* on his
death in 1784 as 'the eminent banker', and
probably carried on his father's business.
Two portraits by Wright of the elder
William Chase and his wife are in the Yale
University Art Gallery, but cannot be
described as a pair, if Nicolson is right in
dating 'Mrs. Chase' to *c.*1761–3 but the
elder 'William Chase' to 1779–81
(Nicolson pp.187–9, pls.41, 205).

This is the largest scale on which
Wright has so far worked. Nicolson sees the
picture as representing an important transitional stage in Wright's work. While the
picture is clearly not as accomplished as
the 'Shuttleworth' group of a year or so
later, 'nevertheless, if we are prepared to
overlook the clumsy relationship between
the figures, it remains an ambitious effort.
Wright appears to have sensed that for a
work on this scale and involving sitters of
some prominence, drapery alone was not
enough and that the background
demanded a more elaborate treatment:
hence the country house grandeur with
the Doric pillar, the heavy fold of curtain,
the red lacquer desk, the Rococo scrollwork on the wall' (p.31).

William Chase holds a flute, an instrument which Wright himself regularly
played and which was very dear to his
heart. An early item in Wright's Account
Book (? *c.*1760) is 'for a German Flute –
£55.11.0', an enormous amount of money,
well over twice what he charged the
Chases for this picture: but luckily for
Wright the bill was among those 'My
Father paid for me'. Mrs. Chase's attire
and headdress are close to those of 'Mrs.
Lindington' (No.28); perhaps her neckline
too conceals a 'tin funnel' for keeping her
flowers fresh. The play of light over the
edges of lace and ruchings of her dress
make it sparkle, as if encrusted.

In some ways, the room in which
Wright portrayed the Chases – whether or
not it is a real room – may have helped
him to form his thoughts about the
room in which he was to stage 'An Experiment on a Bird in the Air Pump' in four or
five years' time. The sash window and
heavy curtain would be used, though
Wright would make the room much wider
than the rather puzzling space the Chases
inhabit. The parrot and its domed wire
cage, which Wright paints with such loving detail in the Chase conversation piece,
may also have played their part in
Wright's mind, as he began to ponder the
scene he would most like to paint within
doors.

14

A Girl reading a letter by Candlelight, with a Young Man peering over her shoulder ? *c.*1760–2

Oil on canvas 35 × $27\frac{1}{2}$ (88.9 × 69.8)
PROVENANCE
In Wright's Account Book as 'A Girl reading a letter by Candlelight'; probably
purchased by one of the Sutton ancestors
(some of them sitters to Wright *c.*1760) of
the present owner, and likely to have been
in his house for at least two centuries
EXHIBITED
RA 1934 (303: *Commemorative Catalogue*
no.234 as 'The Coquette')
LITERATURE
Nicolson no.207, p.239; pp.27, 48–9, 104;
pl.45; Mary Burkett, 'Boy with a Candle',
Burlington Magazine, CXIX no.897, 1977,
p.857, figs.68–9

Lt Col R. S. Nelthorpe

Nicolson calls this 'Wright's earliest genre
piece' (p.27). It is probably also the earliest of all his 'candlelights': if so, his sureness in representing the light effects is
astonishing. A young girl sits at a table,
reading – or perhaps re-reading – a letter
addressed to 'Mrs Eliza Jeltem', evidently
herself; beside her is a letter which she has
just begun to write, with the aid of a book
lying on the table, its title-page reading
'The Art or Guide of Writing a Letter'.
The letter she has begun to write begins
'Dere Jack . . .' Is it what is sometimes
known today as a 'Dear John' letter, a
letter of dismissal from a girl to her boyfriend? Is the letter the girl is reading –
with absorption – a letter from a new love,
and is she now writing to cast off the old
one? Is the perturbed young man behind
her the one who is about to be rejected? In
choosing the name 'Jeltem' for the girl,
could Wright have intended to signify a
jilt? The allusive names of Restoration
comedy are not his usual style; and further
thoughts on the picture's story must now
be left to individual visitors.

In her *Burlington* note of 1977, Mary
Burkett draws attention to a small painting by Romney of a boy looking at a
candle-flame which he shields with his left
hand (fig.5). According to Romney's son
John, writing in 1830, this is a portrait of
James Romney, the artist's brother, and
was included in the lottery exhibition in
Kendal Town Hall in March 1762,
designed to help finance Romney's
move to London.

There is enough similarity between the

downward-glancing heads of Wright's girl and Romney's boy in these two candle-light pictures to pose the question of whether Wright influenced Romney or Romney Wright, though it cannot be answered definitively. Nicolson suggests (p.104) that Wright may have sold his picture 'in Newark or Retford [i.e. where he painted the ancestors of the present owner *c*.1760] before any of the great collectors had a chance to get hold of it', which suggests a date a year or two earlier than Romney's lottery exhibition of 1762. Wright's understanding of the effects of candlelight thrown upwards on the curves and hollows of faces is considerably superior to Romney's, though Romney's 'Boy with a Candle', with his moon face and hands hardly more than blocked in, makes no claim to being more than a sketch. Perhaps the most useful point to emerge from a comparison is that Wright demonstrates a concern with these effects of light which was to be recurring, whereas Romney's 'Boy with a Candle' (? like two other candlelights in his Kendal exhibition, 'A Group of Heads by Candlelight' and 'A Tooth Drawing by Candlelight') seems to have been a fairly impromptu essay in this genre, not thereafter repeated.

There is a pen and ink sketch of the girl in Wright's picture – roughly drawn, but all the elements of the finished painting are there – on a page of Wright's Account Book (repr. Nicolson p.49, fig.53); notes of a cough remedy, 'supposed to be D.r Darwins', were later jotted down over part of the sketch.

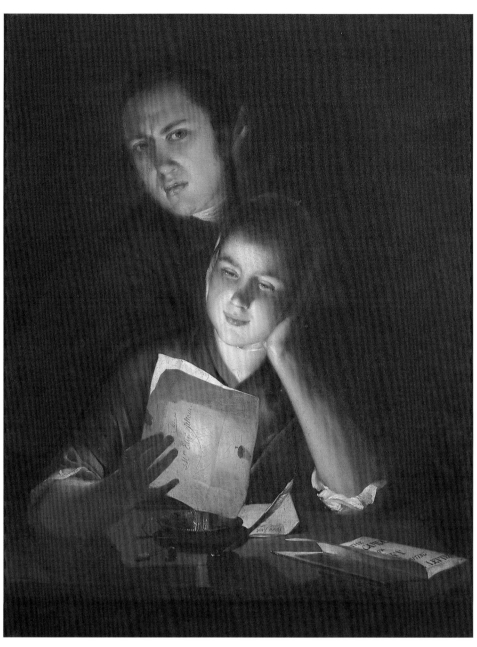

14

fig.5 George Romney: 'The Artist's Brother James holding a Candle' 1761, oil on canvas $15\frac{3}{4} \times 12\frac{3}{4}$ (40 × 32.4) *Abbot Hall Art Gallery, Kendal, Cumbria*

15

A Girl reading a Letter, with an Old Man reading over her shoulder *c.*1767–70

Oil on canvas 36 × 28 (91.5 × 71.2)
PROVENANCE
In Wright's Account Book as 'A Girl with a Letter & its Companion Boy [? pair] for my friend Coltman' (no price: the entry has been crossed through, possibly because Wright gave the pictures to Coltman); by descent to the present owner
EXHIBITED
? Society of Artists, either 1767 (189,190, 'A small candle-light' and 'Ditto, its companion') or 1768 (194, 'Two Candle-lights'); Tate & Walker 1958 (4)
LITERATURE
Nicolson no.205, pp.238–9; pp.50–1, 80; pl.77

Private Collection

The 'Girl Reading a Letter' develops the theme of Colonel Nelthorpe's picture (No.14). The candle which provides the source of light is even more concealed in this picture. The glinting rim of its candle-stock is just visible under the girl's right hand whose fingers, seemingly black against the light, are spread out rather like those of Romney's 'Boy with a Candle' at Kendal (see No.14): the candle must be burning low, otherwise the letter's curling edge would catch its flame. The letter itself is illegible, but may be a love-letter; the old man reading it over her shoulder, perhaps her father, may be apprehensive of its contents. Two more letter-reading scenes are among the set of four pictures painted as over-doors for Radburne Hall in 1772, and still inset there (repr. Nicolson pls.92, 94).

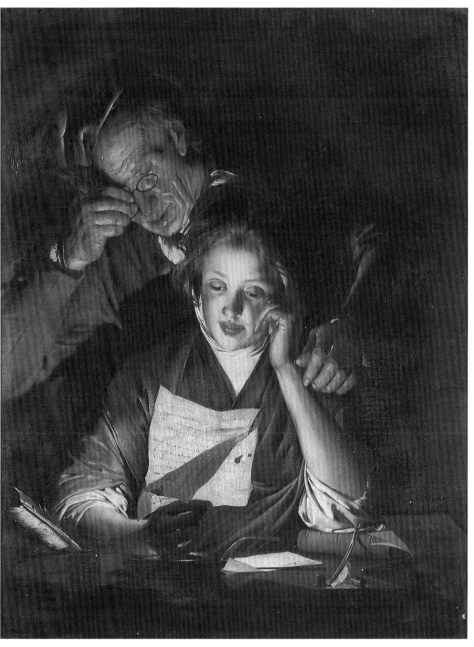

15

Two Boys Fighting over a Bladder *c.*1767–70

Oil on canvas 36 × 28 (91.5 × 71.2)
PROVENANCE
as for No.15
EXHIBITED
? Society of Artists, either 1767 (189, 190,
'A small candle-light' and 'Ditto, its com-
panion') or 1768 (194, 'Two Candle-
lights'); Graves 1910 (43); Tate & Walker
1958 (4)
LITERATURE
Nicolson no.206, pp.238–9; pp.50–1, 80;
pl.76

Private Collection

Nicolson justifiably calls the picture of two
boys fighting over a bladder 'the most
ferocious picture in Wright's oeuvre'
(p.50), and describes it thus:

> in their struggle the candle has been
> overturned and threatens to set the whole
> picture alight. The boys twist each
> other's ears and their bodies are
> contorted in pain. The light is directed
> upwards to cast furious shadows on the
> face of the further boy, causing the
> structure of his throat and mouth to be
> lost, and the crouching, serpentine
> movement of the boy against the light
> makes it difficult to sort out whose arm is
> whose – but these uncharacteristic
> ambiguities enhance our awareness of
> the turbulence of the game that is rapidly
> degenerating from a game into a
> disaster.

The colours are restricted to blacks, reds
and yellows. In its ferocity, this picture is
very different from Wright's other scenes
of boys (or in one case a girl) with a blad-
der (see Nicolson pp.239–40), and utterly
different from the two pictures of children
playing which Wright painted for the
other two over-doors at Radburne (repr.
Nicolson pls.93, 95). In his catalogue note
on 'Boys Fighting' for the 1958 exhibition,
Nicolson noted that 'the theme of children
with bladders was popular in many
seventeenth-century Netherlandish
studios, and this is undoubtedly Wright's
source'; however, he was unable then or in
1968 to identify the source, which remains
elusive.

Wright was one of the first British pain-
ters to paint candlelights, but he was not
unique. Romney's interest has already
been noted under No.14. Henry Robert
Morland's candlelights, mostly of single

figures, are well known; the first to be
exhibited, in 1764, was 'A Ballad Singer'
(singing by the light of a paper lantern).
Morland's *The Unlucky Boy*, engraved in
1772, has one or two echoes of Wright's
'Boys Fighting'. John Foldsone, a little-
known artist but luckily in Waterhouse's
invaluable *Dictionary*, 1981, produced
occasional candlelight subjects: his *Female
Lucubration* (a maid-servant with a

candle at a bookshelf), mezzotinted by
Philip Dawe, was published in 1771.

The pair of candlelights which Wright
exhibited at the Society of Artists in 1767
may have been the two exhibited here,
though it is impossible to be sure. The *Pub-
lic Advertiser's* reviewer on 1 May 1767
remarked only that 'Mr Wright of Derby's
Candlelights, have been always admired'.

17

Two Girls Dressing a Kitten by Candlelight *c.*1768–70

Oil on canvas 35¾ × 28½ (90.8 × 72.4)

PROVENANCE
Not in Wright's Account Book; anon. sale
(called 'Pictures of a Nobleman', but likely
to have consisted of different properties),
Christie's 24 January 1772 (82), £7.7.0 bt
Lord Palmerston; thence by descent until
sold at some point between 1938 and 1946
(Lord Mount Temple lent the picture to
an exhibition in 1938, and Leger's owned
it by 1946: but the sale of the picture is
recorded at Broadlands only in the note
'Sold 20th century' in an MS catalogue of
pictures); Leger Galleries, from whom
purchased by Agnew's 1946; sold by
Agnew's later that year to Miss Craze, and
thence to present owner

EXHIBITED
Winchester 1938 (50); on long loan to The
Iveagh Bequest, Kenwood

LITERATURE
Nicolson 1954, p.75; Nicolson no.212,
p.240; pp.48, 106; pl.75; Elizabeth
Fouchard-Walter & Pierre Rosenberg, *Le
Chat et la Palette dans la Peinture Occidentale de
XV a XX siècle*, Paris 1987, p.164, repr.

ENGRAVED
by Thomas Watson, published 20 February 1781; an impression exhibited as
No.166 (P21)

Private Collection

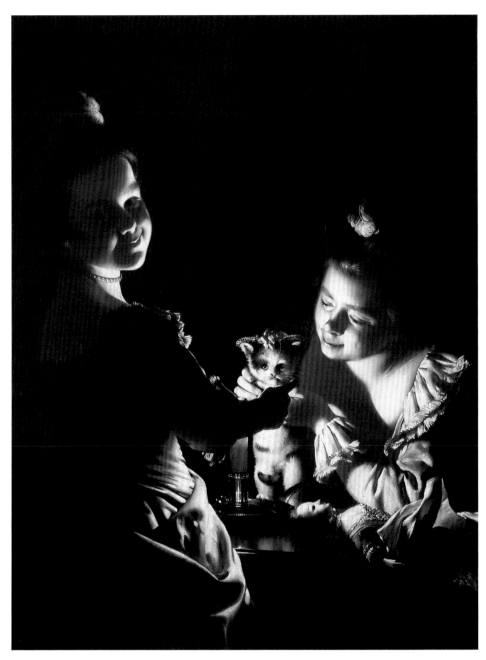

17

Nicolson suggested various influences for
this picture. Writing in 1954, he thought
Schalcken the strongest influence, and
suggested a comparison with his 'Lady in
front of a mirror by candlelight' (trying on
earrings) in the Mauritshuis (repr. *Maurit-
shuis Catalogue*, The Hague, 1977 no.159).
Later, in his great work on Wright of 1968,
Nicolson wrote: 'The picture of two girls
dressing up a kitten goes straight back to
Honthorst: that is to say, the reddish-
mauve sleeve of the girl on the left masking
the candle, the dull dark red colouring of
the faces, the saucy curl to the lips, the
slanting shadows on the nose of the other
girl, her eyes and eyelids, can all be
paralleled in Honthorst's work even if the
subject cannot' (p.48).

As for the subject, Nicolson mentioned
cat themes in Netherlandish painting and
also in the work of Philip Mercier; here he
adduced the 'Girl with a Cat', now in the
National Gallery of Scotland. But that pic-
ture has no playful element, and perhaps
a likelier comparison would be with

Mercier's 'Three Children setting a dog
sentinel' (Detroit Institute of Arts), where
the dog stands up on its hind legs behind a
group of three children. The Wright is not
close to the Mercier, but the Mercier could
have given Wright fresh ideas for subject-
matter.

A general influence from Honthorst, a
whiff of Mercier – what else? There must
also be a more direct influence from
Thomas Frye. Nicolson, who was the first
to demonstrate how much Wright derived
from Frye's mezzotints, is unlikely to have
seen two chalk drawings, one by Frye and
one by Wright, each of which must relate
to 'Two Girls Decorating a Kitten by

Candlelight', and both of which came to
light after the publication of Nicolson's
book. Frye's 'Portrait of a Girl holding a
Kitten' (fig.6) was acquired by the British
Museum in 1975, and was published by
Michael Wynne in 'A pastel by Thomas
Frye' *British Museum Yearbook* 11: *Collectors
and Collections*, 1977, pp.242–5, fig.202).
Wright's 'Portrait of a Young Girl with
Feathers in her hair' came to light in 1986;
it is exhibited here as No. 71.

Frye's 'Girl holding a kitten' is in his
most tender and most Piazzetta-like
manner, a long way from the impishness of
the two girls in Wright's painting, but the
slant of her head, the play of light over her

[53]

fig.6 Thomas Frye: 'A Girl holding a Kitten' *c*.1760, black and white chalk on paper 16$\frac{15}{16}$ × 12$\frac{1}{2}$ (43 × 31.8) *Trustees of the British Museum*

face and her downward-looking smile seem to have been picked up by Wright and distributed among the two girls in his picture. Even the kitten's markings are similar, though it would be silly to try to base a comparative argument on that. Wright's drawing (No.71) is more studied than Frye's. It must surely have been made in connection with his painting of the two girls decorating a kitten, perhaps as an alternative study of the girl on the right of the painting, who is dressed like the girl in the drawing, with soft fringes around the neckline and at the wrists, and feathers in her hair.

As for the meaning of the picture, Pierre Rosenberg poses two questions: 'Y-a-t-il pour Wright, au-delà de l'exercice de virtuosité (qui frôle le pastiche) quelque volonté moralisatrice? Et les deux fillettes vont-elles bientôt se livrer à d'autres jeux bien plus dangereux?' (Foucard-Walter & Rosenberg *loc.cit*, p.164).

The picture includes two beautifully-observed still-life details, the brass candlestick and the doll (which seems destined to lose all its garments to the kitten). Nicolson must have the last word on the doll: 'The picture is a pure enchantment on account of a discarded doll . . . dressed in the height of fashion of the late '60s . . . we are willing to excuse any amount of mawkishness when he [Wright] offers us a throw-away line of beauty like this' (p.48).

18

A Philosopher giving that Lecture on the Orrery, in which a lamp is put in place of the Sun exhibited 1766

Oil on canvas 58 × 80 (147.3 × 203.2)
PROVENANCE
In Wright's list of 'Candle Light pictures' in his Account Book as 'The Orrery to L.ᵈ Ferrers £210.0.0', i.e. purchased by Washington Shirley, 5th Earl Ferrers (d.1778); offered by 6th Earl Ferrers, Christie & Ansell, 3 June 1779 (113), bt in; sold Ferrers sale, Staunton Harold, 25 June 1787 and following days, 5th day (54), ? bt Bruce or bt in; offered 'by lot' by Messrs Woollat & Co., cabinet-makers and upholsterers, Derby, December 1851 (pamphlet advertised 100 tickets at 2 gns) ?few subscribers, ?sold to F. Wright for £50; Francis Wright of Osmaston near Derby, who later took the name of Osmaston; at the dispersal of his collection in 1884, purchased by public subscription and presented to Derby Art Gallery
EXHIBITED
Society of Artists 1766 (195); Derby 1843 (204); Derby 1870 (261); Derby 1883 (48); RA 1886 (10); Spring Exhibition, Whitechapel 1906 (76); Graves 1910 (79); *British Art*, RA 1934 (696); Derby 1934 (127, pl.XI); Sheffield 1950 (9); *The First Hundred Years of the Royal Academy*, RA 1951–2 (15); *Unbekannte Schönheit*, Zürich, 1956 (276); Tate & Walker 1958 (2); Derby 1979 (8)
LITERATURE
Shurlock 1923 pp.433–4; Francis Maddison, 'An Eighteenth–Century Orrery by Thomas Heath and some Earlier Orreries', *Connoisseur* CXLI no.569, 1958, pp.163–4, fig.2; Nicolson no.190 p.235; pp.39–42, 72, 105–6, 114–7; pl.54, details figs.37–8 p.41; Fraser 1979 p.2, repr.6–7, pl.9, in colour; Fraser 1988, pp.121–2, fig.1; Fraser's essay in this catalogue pp.16–19
ENGRAVED
by William Pether, published 20 May 1768; an impression exhibited as No.152 (PI)

Derby Art Gallery

The subject of the painting is fully discussed by David Fraser in his essay on 'Joseph Wright of Derby and the Lunar Society' in this catalogue, pp.16–19.

A few additional comments are offered here. First, in this picture as in 'The Air Pump', Wright depicts what is essentially a demonstration to laymen (including a woman and three children). The orrery is not, in the strict sense, a scientific instrument, like the astrolabe, for instance; it was specifically designed to demonstrate (not discover) the wonders of the universe. The essayist Sir Richard Steele, writing in 1713, praised the orrery because it 'administers the Pleasures of Science to any one' (quoted by Maddison p.164). Lectures upon the orrery and other scientific matters became increasingly popular from the mid-eighteenth century. As Fraser notes, the travelling lecturer James Ferguson FRS gave a course of lectures in Derby in 1762 which may well have inspired Wright's picture. The novelty in Wright's 'Orrery' lies not its subject, but in the fact that he was perceptive enough to see that there was abundant material for a painter in a scene which communicates 'the Pleasures of Science'.

Second, whose orrery does Wright depict here? He must (surely) be depicting a specific instrument whose every component he has carefully studied. It is unlikely to be the orrery used by James Ferguson in his travelling lectures, for that was evidently small and portable (like the air-pump and other apparatus he carried). It could have been an orrery within some unknown gentleman's library, designed for the 'leisured contemplation of the "World Machine" by the man of taste' (a contemporary phrase quoted by Maddison p.163). Or could it have been the orrery which Lord Ferrers constructed for himself? Lord Ferrers RN was a keen scientist whose observations on the transit of Venus, made from his home at Staunton Harold, had led to his election as FRS in 1761. He was the purchaser of Wright's 'Orrery'; he was already linked with the pictures as two of the figures in it are traditionally (and in their cases convincingly) identified as his nephew Laurence Shirley (b.1757), the boy with his back to us, and his friend Peter Perez Burdett, the man taking notes on the left. Burdett's portrait can be compared in this exhibition with that in 'Mr. & Mrs. Burdett', painted about the same time (No.40). Perhaps the scene is taking place in Lord Ferrers's house; perhaps Lord Ferrers (b.1722) is the rather detached figure on the right, though no portrait has been found for comparison.

Third, Wright seems deliberately to have given the figure of the philosopher a good deal of the physical appearance of Sir Isaac Newton himself. That is entirely appropriate. Newton's theory of the universe provided the foundation for demonstrations such as this; he was not only

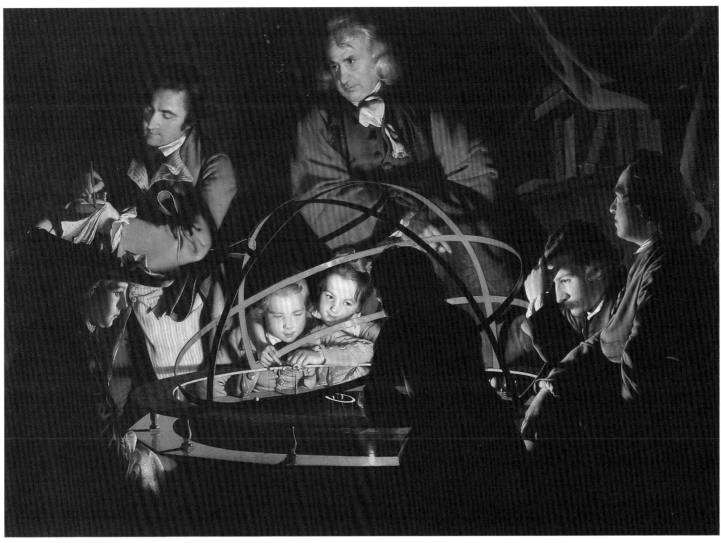

18

celebrated among his peers but revered by every Philosophical Society in England. Wright has not tried to copy a portrait of Newton – his scene after all is set in his own day and Newton died in 1727 – but he certainly seems to have looked at portraits of Newton in search of the ideal image of a philosopher. Wright's philosopher most nearly resembled Kneller's portrait of Newton of 1689, in a private collection (fig.7); though that portrait was not engraved, it is known to have been widely copied. Wright may also have looked at the portrait by Vanderbank engraved for Newton's *Mathematica Principia*, 1726.

fig.7 Sir Godfrey Kneller: 'Sir Isaac Newton' 1689, oil on canvas 30 × 25 (76 × 63.5) *Private Collection*

19

Samuel Rastall *c.*1762–4

Oil on canvas 30 × 25 (76.2 × 63.6)
PROVENANCE
In Wright's Account Book as '2 Masters
Rastall' at eight guineas each, among sit-
ters of *c.*1760; by descent to the present
owner
LITERATURE
untraced by Nicolson; William Hood,
'Four Early Portraits by Wright of Derby',
Burlington Magazine, CXXIV no.948,
1982 p.156, fig.37

Private Collection

See text below No.20

20

William Rastall *c.*1762–4

Oil on canvas 30 × 25 (76.2 × 63.6)
PROVENANCE
as for No.19
LITERATURE
as for No.19, fig.38

Private Collection

Samuel Rastall, the elder boy, was bap-
tised (and probably born) in 1749, and
William in 1754. Looking at their por-
traits, Samuel seems to be about thirteen
or fourteen years old and William about
nine or ten; if that estimate is right, that
suggests a date of *c.*1762–4 for their
portraits, or about the same time as the
portraits of 'Mrs. Wilmot' and the mem-
bers of the Markeaton Hunt (Nos.5–8).

The wholly unsentimental charm of the
Rastall boys and their readiness to concen-
trate (at least intermittently) on copying
and studying prints makes a strong con-
trast to other pictures of children which
Wright and many other artists painted in
the 1760s, in which children clasp woolly
lambs or hug reluctant spaniels (as in
Nicolson pls.48, 57 and 68). Working on
the Rastall boys' portraits probably made
Wright realize that childish portraiture
need not be sweet and sentimental; and it is
not too much to suggest that the portraits
of the two Rastall boys encouraged Wright
to include children in his great pictures of
a few years later, 'A Philosopher giving a
Lecture on the Orrery' of *c.*1766, 'An
Experiment on a Bird in the Air Pump',
dated 1768 and 'An Academy by Lamp-
light', *c.*1768–9 (Nos.18, 21, 23).

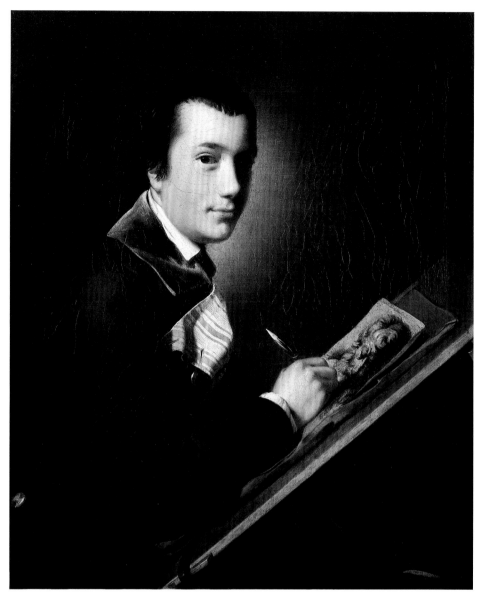

19

Samuel Rastall is copying what appears to be a baroque engraving; he holds a porte-crayon, its small claws holding chalks, probably black one end and white the other, and works with his paper resting on what looks like a small portfolio folded on to a drawing-board. William holds a sheaf of prints (alas, so far unidentified: the top one seems to be a river landscape) which are stitched into soft wrappers. If the boys were painted in Wright's studio, the prints may have been owned by Wright himself. The objects in front of William – paint-brushes, a stoppered phial of red ink, an oyster-shell for holding ground pigment – are painted in a manner which anticipates the precision of the still-life objects in 'The Air Pump'.

The portraits of the '2 Masters Rastall' complement two smaller earlier portraits of their parents Timothy and Elizabeth Rastall, of Newark, which must date from around 1760. Timothy Rastall's portrait has much in common with that of 'William Brooke' (No.3) – perhaps not surprisingly, since he belonged to a family which had for nearly two centuries 'filled the first offices in the corporation' (Dickinson p.322) – and his wife's with that of 'Anne or Molly Cracroft' (No.4). The four portraits were discovered and identified in 1982 by William Hood (op. cit.), who reproduces the portraits of the parents as well as the boys. Hood's fig.35 shows the original carved and gilt frame of Timothy Rastall's portrait, identical frames still holding the other three. Hood also notes other Rastall portraits listed in the Account Book but still missing.

The later fortunes of the Rastall boys are quickly told. Each of them went up to Cambridge (Peterhouse), Samuel in 1768 and William in 1772; each took Holy Orders. Samuel became Dean of Killaloe, Ireland, and died in 1781, aged 32. William, who looks the frailer in Wright's portrait, became Rector of Thorpe, Nottinghamshire, a living he held for nearly forty years; he married (twice), had ten children and died at the age of 73 at The Friary, Newark, his native town.

John Singleton Copley's 'Boy with a Squirrel', the first work he exhibited in England (he being still in his native New England) is reproduced here (fig.8) because when it was shown anonymously at the Society of Artists in 1766, many people 'considered [it] to have been painted by one M.ʳ Wright, a young man that has just made his appearance in the art in a surprising degree of merit' (Benjamin West to Copley, letter of

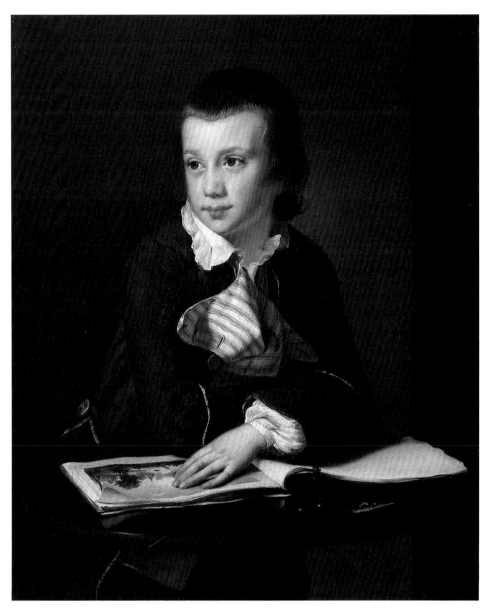

20

4 August 1766, Whitley, 1928, 1, p.217). Of all the comparisons which have since been suggested between Wright's and Copley's early portraits, Wright's rediscovered portraits of the Rastall boys and Copley's 'Boy with a Squirrel' perhaps show the most similarities, though these are fairly superficial, and must be fortuitous.

fig.8 John Singleton Copley: 'Boy with a Squirrel (Portrait of the artist's half-brother Henry Pelham)' c.1765, canvas 30¼ × 25 (76.2 × 63.5) *Museum of Fine Arts, Boston*

An Experiment on a Bird in the Air Pump dated 1768

Oil on canvas 72 × 96 (182.9 × 243.9)
Inscribed across the centre of the reverse of
the canvas 'Jo: Wright Pinxᵗ 1768'

PROVENANCE
In Wright's list of 'Candle Light pictures'
in his Account Book as 'The Air Pump
£200/pᵈ £200' (though price given as
£210 on a later page): a few pages on is
'Mem. Rec'd of Dᵣ Bates thirty pounds in
part payment for the Picture of the Air
pump'; Edward Tyrrell, offered anon.
Christie's 8 July 1854 (163, 'The Air
Pump. This picture, the finest the Artist
ever painted, was purchased of him by Dᵣ
Bates', bt in: presented by Edward Tyrrell
to the National Gallery 1863; transferred
to the Tate Gallery (while on long loan to
Derby Art Gallery 1912–1947) 1929;
reclaimed by the National Gallery 1986

EXHIBITED
Society of Artists 1768 (193), shown again
in September 1768 in a special exhibition
in honour of the King of Denmark (131);
on long loan to Derby Art Gallery 1912 to
1947; Derby 1934 (36, pl.xii); Derby &
Leicester 1947 (36); *The Eye of Thomas
Jefferson*, National Gallery of Art, Wash-
ington 1976 (109, repr. p.61, with detail
pp.44–5); *1700-tal: Tanke och form i rokokon*,
Nationalmuseum, Stockholm 1979–80
(128, detail repr. in colour p.18)

LITERATURE
Richard & Samuel Redgrave, *A Century of
British Painters*, 1966, ed. 1947 pp.107–8;
Shurlock pp.434–5; Ellis Waterhouse,
Painting in Britain: 1530–1790, 1953, ed.
1962, p.198; Eric Robinson, 'Joseph Wright
of Derby: the Philosopher's Painter', *Bur-
lington Magazine*, c, no.663, 1958, p.214;
Nicolson no.192 p.235; pp.43–6, 104–5,
112–4; pl.58; Busch 1986, *passim*; William
Schupbach, 'A Select Iconography of Ani-
mal Experiment', ch.14 in ed. Nicolaas A.
Rupke, *Vivisection in Historical Perspective*,
1989, pp.340–7; ed. Pierre-Marc de Biasi,
Gustave Flaubert, Carnets du Travail, Paris
1988, p.350; David Fraser, 'Joseph Wright
of Derby and the Lunar Society', in this
catalogue, pp.19–20

ENGRAVED
by Valentine Green, published 1769; an
impression exhibited as No.153(P2)

Trustees of the National Gallery

Ellis Waterhouse called this 'one of the
wholly original masterpieces of British art',
adding 'The passionate interest in science
of the Midlands is married to a complicated
and successful design in which the whole
group is both 'natural and true', and there
is a great variety of tender human feeling'.
'An Experiment on a Bird in the Air
Pump' was quickly recognized by
Wright's contemporaries to be a picture
out of the ordinary. The reviewer of the
Society of Artists exhibition of 1768 for the
Gazetteer, 23 May 1768, wrote: 'Mᵣ Wright,
of Derby, is a very great and uncommon
genius in a peculiar way. Nothing can be
better understood or more freely repre-
sented, than the effect of candle-light
diffused through his great picture'. It was
the only picture in the exhibition to take
the eye of the Austrian traveller Karl, Graf
von Zinzendorf, who noted in his journal,
29 April 1768, 'Puis à Spring Garden où la
Société des Artistes étale ses tableaux et
sculptures, il y a un tableau d'une Expéri-
ence avec la machine pneumatique, qui se
fait de nuit, qui est très beau' (quoted by
Robinson p.214).

Flaubert, in England in 1865–6, made
notes on many British pictures. His longest
note was on the 'The Air Pump': 'Wright:
Expérience de la machine pneumatique.
Effet de nuit. Deux amoureux dans un
coin, charmants. Le vieux (à longs
cheveux) qui montre l'oiseau sous le verre.
Petite fille qui pleure. Charmant de nai-
veté et de profondeur.' It must have been
about the same time that the Redgraves
announced 'great satisfaction' in being
able to give unstinted praise to 'The Air
Pump' ('a very clever and vigorous work'),
after a conscientious tour of Derbyshire in
which they had seen only disappointing
examples of Wright's work.

In electing to make a large and complex
painting out of a demonstration of the air
pump, Wright displayed the same orig-
inality and genius as in his 'A Philosopher
giving that Lecture on the Orrery, in
which a lamp is put in place of the Sun'
(No.18), exhibited two years earlier. There
had been nothing like these pictures in
British art, and they fitted into none of the
generally accepted categories. They were
neither history paintings nor conversation
pieces; they were not edifyingly grounded
in literature and appeared to have no high
moral content. But they were undeniably
compelling, particularly at a time when
popular interest in the wonders of science
was growing, disseminated by travelling
lecturers on pneumatics (the air pump),

astronomy (the orrery), optics and other
subjects.

As Fraser notes in his essay in this cata-
logue (p.16), Wright may himself have
attended the course of scientific lectures
given in Derby by James Ferguson in
1762; if he did so, those lectures may have
inspired both 'The Orrery' and 'The Air
Pump'. Wright was interested in science
('deeply interested' is going too far, for he
was first and foremost an artist), and had
many scientific friends, as Fraser shows in
his essay. It is abundantly clear from both
'The Orrery' and 'The Air Pump' that the
beauty of well-designed apparatus fasci-
nated him. If this picture had been a con-
ventional conversation piece, that table
would have carried tea-cups, perhaps a
silver tea-tray, books; instead, the air
pump (with other objects, discussed
below) dominates this family room almost
as much as the lecturer who operates it.
Wright's purpose in painting 'The Air
Pump' and 'The Orrery' may be com-
pared with the resolve of Matthew
Boulton, a Lunar Society member, to con-
struct a geographical clock: 'I am deter-
mined to make such like sciences
fashionable among fine folks' (letter to
John Whitehurst, 23 February 1771,
quoted by Nicholas Goodison, *Ormolu: The
Work of Matthew Boulton*, 1974, p.108).

The air pump was invented by Otto von
Guericke at Magdeburg in 1650. The first
English air pump was made for the Hon.
Robert Boyle in 1658–9. In the eight-
eenth century the air pump became 'a
common item in cabinets which included
instruments of experimental philosophy'
(Schupbach p.341). When William
Constable of Burton Constable, Yorkshire,
a keen amateur scientist, bought his air
pump in 1757 ('a neat double barrell Air
Pump with all ye usual apparatus'), it cost
him £21; but air pumps became cheaper
in response to popular demand. By
Wright's day, the experiment with the air
pump had become the pièce de résistance
of many travelling scientific lecturers.

The usual experiment with the air
pump consisted of placing a living animal
– bird, mouse, frog, kitten – in a glass
receiver attached to a pumping apparatus.
Air is pumped out, to demonstrate the ani-
mal's reactions to the deprivation of that
vital element without which we would all
die; but if air is re-admitted in time, the
animal will revive. Some demonstrators
used a bladder or 'lungs-glass' in the
receiver instead of a living animal; James
Ferguson considered the experiment on a

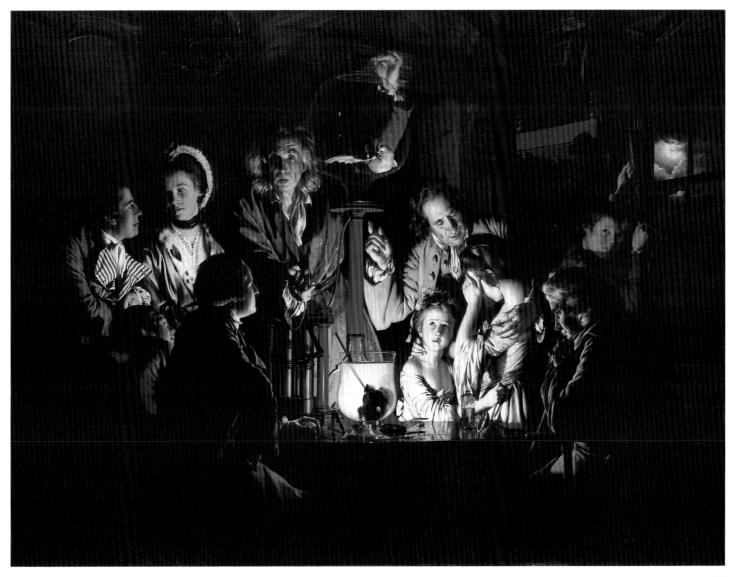

living animal 'too shocking to any spectator who has the least degree of Humanity' (quoted by Schupbach p.341). If Wright saw Ferguson's demonstration of the experiment in Derby in 1762, he would probably have witnessed the collapse only of a bladder or lungs-glass; but as that would have made a far less dramatic (and probably incomprehensible) picture, he depicted a bird in the receiver instead – and not just any bird, but a white cockatoo. Its presence in this experiment is far from realistic. As Schupbach points out, the birds used in such experiments were sparrows, larks or other common species, whereas the white cockatoo was 'a *rara avis* in the English Midlands', its life wholly unlikely to have been risked in such an experiment. But a few years earlier, Wright had painted 'M.r & M.rs William Chase' (No.13) with their white cockatoo, and had made at least one study of the bird alone ('The Parrot', £3). Its white plumage must have seemed to Wright just what he wanted to show to dramatic advantage against the shadows.

In Wright's picture, the 'shocking' form of the experiment is under way. The bird has been taken from its cage (now slung up by the window) and placed in the air pump's glass receiver. Air has already been pumped out of the receiver, by means of the handle attached to the barrels which encase pistons. The bird gasps, and sinks to the bottom of the cruellest cage it has ever known; but it is not yet lifeless. The lecturer's left hand is poised on the stop-cock on top of the glass receiver; if he turns it in time, the bird will revive; if not, it will die.

Wright leaves us uncertain of the outcome. That uncertainty is expressed in the ambiguous role of the boy by the window who holds the cords of the birdcage: is he to let it down to receive the revived bird, or sling it higher because the bird will have died? The reactions of the audience vary greatly, from the youngest child's first acquaintance with the possibility of death to the old man's evident reminder of its inevitability. The man who comforts the small girls may be reassuring them that all will be well, or expounding the inevitable laws of nature. A detached observer on the left of the table has taken out his watch to time the progress of the experiment. A boy stares upwards, fascinated. A young couple on the left clearly have their own more agreeable preoccupations (fig.9). The reactions of all these people have been (and no doubt will continue to be) variously interpreted.

By far the most interesting recent observation on 'The Air Pump' is William Schupbach's. He observes that there appears to be 'a carious human skull' in the large glass jar which stands on the table directly below the bird in the receiver, its cloudy liquid masking the candle's flame. The skull is not part of the lecturer's normal equipment, but as Schupbach suggests, must be a motif introduced by Wright as a symbol of death. 'The theme of mortality is echoed in the painting by the unexpected reflection of the candle snaking up the left side of the glass containing the skull. Skull and candle are traditional companions in iconography, the candle demonstrating the consuming passage of time, the skull its effect. The philosopher seems to point with his right index-finger down to this combined reminder of mortality. The function of the rod which stands in the flask is, at a formal level, to guide the viewer's eye from the philosopher's finger to the skull' (p.346). As Schupbach adds, this interpretation makes 'The Air Pump' in part a *vanitas* picture', reminding us that 'death is inevitable and its moment unpredictable', and so implying that the bird in the experiment will die.

Other objects on the table include a candle-snuffer, a tall phial of liquid, a cork and a pair of Magdeburg hemispheres (the small linked objects on the right), also invented by von Guericke; when they are placed together and the air between them is exhausted by the air-pump they become inseparable. Their presence here indicates that the demonstrator is giving a general lecture on pneumatics, of which the experiment with the air pump is the culmination.

In 1977 Michael Wynne published a chalk drawing by Thomas Frye of an old man leaning on a staff (fig.10) which is so close to the figure of the elderly man on the right in 'The Air Pump' that Wright must surely have known and been influenced by it (Michael Wynne, 'A pastel by Thomas Frye, *c.*1710–62', *British Museum Yearbook II: Collectors and Collections 1977*, pp.242–4, fig.204). As Wynne notes, Frye's drawing is inscribed on the back 'Mr Tate to Mr Benson'. The same inscription appears on the back of a copy of Wright's 'Study of a Young Girl in a Turban', probably made by Wright's pupil Thames Moss Tate of Liverpool (see note to No.72). If the Tate family owned drawings by Thomas Frye, that may well have given Wright the chance to see drawings by Frye, as well as the mezzotints which he so evidently admired. Nicolson had already convincingly shown that the face of the young boy on the left, looking upwards, was derived from Frye's mezzotint *Portrait of a Young Man* (repr. Nicolson p.44 fig.46); he also suggested that the expression of Wright's

fig.9 Detail from 'The Air Pump': ?Thomas Coltman and Mary Barlow

lecturer owes some debt to Frye's *Figure with a Candle* (Nicolson fig.48).

The traditional identification of the young couple on the left ('deux amoureux', in Flaubert's phrase) as Thomas Coltman and Mary Barlow, who were to marry in 1769 (and become the sitters in No.29) seems possible; these various figures need not after all be exactly delineated portraits (the neck of this girl above her many-stranded garnet necklace deserves study: Wright shows it most truthfully as slightly bulging, as it would above that choker). Other identifications have been proposed, such as Eric Evans's suggestion (type-script, National Gallery archives) that the audience is made up of the Darwin and Seward families, portrayed in Darwin's house; but the ages hardly tally, quite apart from the fact that other sources for the figures are gradually emerging.

Wright painted a fairly rudimentary first study for 'The Air Pump' on one side of the canvas later used for the 'Self-Portrait' owned by Thomas Coltman (No.94); in this study (Nicolson pl.59), the most important ingredients of the picture are already there, though there are only six figures and, as Schupbach notes, the bird in the receiver is a common songbird.

Interpretations of 'The Air Pump' will no doubt continue to vary. A recent poem by Jonathan Price entitled 'Experiment

with an Air Pump by Joseph Wright "of Derby"' begins: 'He made a work of art out of suffocation . . .' (*Everything Must Go*, 1985, p.31). Did he? Or did Wright paint a cliff-hanger, in which the lecturer will turn that stop-cock just in time to revive the bird and so demonstrate God's great gift of air? If the latter, then this is, after all, a moral history painting.

fig.10 Thomas Frye: 'An old man leaning on a staff' *c*.1760, black and white chalk on paper 16$\frac{15}{16}$ × 12$\frac{3}{4}$ (40 × 32.4) *Private Collection, Ireland*

22

Three Persons Viewing the Gladiator by Candle-light exhibited 1765

Oil on canvas 40 × 48 (101.6 × 121.9)
Inscribed 'I. Wright. Pinx.' on base of statue

PROVENANCE
In 'List of Candle Light Pictures' in Wright's Account Book as 'The Gladiator to D.r Bates £40.0.0.', i.e. purchased by Dr Benjamin Bates; Edward Tyrell, sold anon., Christie's 8 July 1854 (162, 'Wright, in his studio, drawing from a statue–candlelight'); 3rd Marquess of Lansdowne, by 1859, and thence by descent to the present owner

EXHIBITED
Society of Artists 1765 (163); B.I. 1859 (144, as 'The Artist and Two R.A.s examining a Statue'); National Portrait Exhibition 1867 (791); Derby 1883 (12, as 'The Gladiator, with portraits of Wright, Burdett and John Wilson'); Graves 1910 (86); BFAC 1932 (122); *The First Hundred Years of the Royal Academy*, RA 1951–2 (2); Tate & Walker 1958 (3); National Gallery 1986 (3)

LITERATURE
Nicolson no.188 p.234; pp.39–40, 57, 104–5, 117; pl.52

ENGRAVED
in mezzotint by William Pether, published 10 July 1769; an impression exhibited as No.154(P3).

Private Collection

This was Wright's first exhibited picture. It shows three men intently studying a copy of the Borghese Gladiator, whose original was then in the Villa Borghese (it is now in the Louvre). The 'Gladiator' was one of the most admired of all works of art of antiquity, and one of the most frequently copied. A bronze cast made for Charles I had in its turn become one of the most celebrated statues in England. By Wright's day there were numerous copies of differ-ent sizes in English collections (for a full account of the Gladiator, see Francis Haskell and Nicholas Penny, *Taste and the Antique*, New Haven & London, 1981, pp.221–4, fig.115). Wright may have stud-ied this copy in the Duke of Richmond's sculpture gallery in Whitehall, open to students; but other copies and casts were available.

The young artist on the right, holding up his own drawing for critical assessment, is generally believed to be Wright himself This identification goes back at least as far

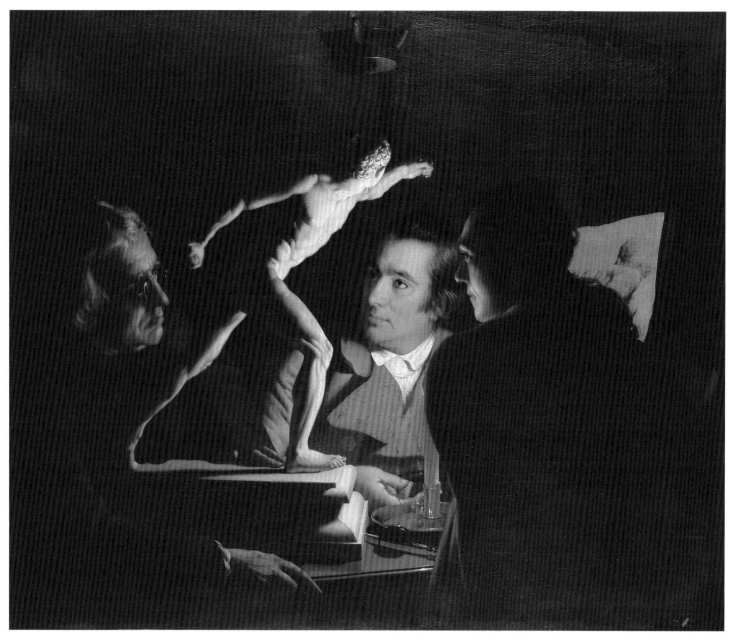

22

as Edward Edwards's *Anecdotes of Painters*, 1808, p.235, and seems very likely, if Wright's face has not filled out much from the lean-cheeked 'Self-Portrait' of *c.*1753–4, shown here as No.1. The man in the middle is thought to be Peter Perez Burdett, Wright's great friend at this period, and himself a draughtsman; he is portrayed with his wife in No.40, under which an account of him is given. The face seems wider than in the Burdett double portrait, but that may be partly an effect of candlelight. According to Bemrose (p.11), the model for the older man on the left was John Wilson, occupant of one of the almshouses in Derby endowed by the Dukes of Devonshire. Since the Gladiator's plinth does not revolve, it may be this man's role to turn it for the two younger men to study; evidently the drawing the young artist holds up, showing part of the muscles of the back, has already been made from a different angle.

The Gladiator was particularly admired for its truthful rendering of anatomy, and it is on this that the three men turn their scrutiny. Wright's left shoulder (assuming it is Wright) masks the flame of a candle; a lamp hangs overhead, unlit, for these three want light close at hand – and so does the painter in Wright, for his candlelight effects. Nicolson suggests a possible source in Volmarijn's 'Christ at Emmaus', where three figures are grouped by candlelight round a table, the figure on the left resting his hand on its edge, as in the Wright (Nicolson p.40, fig.35. The picture is now in the Ferens Art Gallery, Hull; to judge whether Wright could have known it, one would need to know where the picture was in the 1760s, or whether it was engraved).

Wright gives the spectator one of the Gladiator's most dramatic aspects, with the figure seen as a thrusting, diagonal image of great potency against the soft, velvety dark; his eternal energy contrasts with the three men's quiet study. As much as anything else, this picture is about the power of a great work of art.

A pen and ink drawing of the Gladiator, 20 × 16½ ins, is in the collection of Derby Art Gallery (repr. Nicolson p.22, fig.122). This shows the statue from an almost opposite viewpoint to that in Wright's painting. Nicolson considers that the drawing was made (perhaps with others now unknown) for the painting; but it is close in style (and size) to the antique studies which Wright made in Rome some ten years later, and may in fact have been made in the Villa Borghese from

the statue itself. It is difficult to think that Wright would not have taken the chance to draw the original Gladiator.

23

An Academy by Lamplight exhibited 1769

Oil on canvas 50 × 39⅜ (127 × 101.2)
Inscribed 'I.Wright Pinx!' lower l.
(now faint)

PROVENANCE
In the list of 'Candle Light pictures' in Wright's Account Book as 'The Academy to L.ᵈ Melbourne £150', i.e. purchased by the 1st Lord Melbourne, then by descent until purchased (? early this century) by Sir George Buckston Browne FRS, by whom presented to the British Association for the Advancement of Science, 1929; transferred to the Royal College of Surgeons, from whom purchased through Gooden & Fox by Paul Mellon 1964; presented by Paul Mellon to the Yale Center for British Art 1973

EXHIBITED
Society of Artists 1769 (197); BI 1817 (2); British Council tours, *A Century of British Painting*, Lisbon and Madrid, 1949 and *British Painting from Hogarth to Turner*, Hamburg and Scandinavia, 1949–50 (119); Tate & Walker, 1958 (6); on loan from Paul Mellon to the Tate Gallery 1964–78; *The Age of Neo-Classicism*, RA 1972 (282); *The Pursuit of Happiness*, Yale Center for British Art, 1977 (80, repr. p.102)

LITERATURE
Buckley 1952 p.163; Nicolson 1954 pp.72–5; Nicolson no.189 p.234; pp.45–7, 106; pl.60; Francis Haskell & Nicholas Penny, *Taste and the Antique*, New Haven and London, 1981, p.281

ENGRAVED
by William Pether, published 25 February 1772; an impression exhibited as No.159 (P9)

Yale Center for British Art, Paul Mellon Collection

In a vaulted room seemingly dominated by a half-smiling stone goddess, six boys, or youths (the eldest perhaps nineteen, the youngest five) are momentarily quiet. Two of the boys concentrate on their work, which is learning how to draw. The eldest, a born lecturer, one proprietorial hand on the statue's plinth, looks as if he may hold forth at any moment; the youth behind

him is content to gaze on the beauty of the statue, his enrapt expression suggesting that though he lacks the draughtsman's powers of concentration, he may become a connoisseur.

The statue is not of a goddess, but is a cast (or, Nicolson suggests, possibly a marble copy) of the antique marble 'Nymph with a Shell', then in the Villa Borghese and now in the Louvre; an account of the statue and its history is given by Haskell & Penny, op. cit. p.281 no.67, pl.148). The 'Nymph with a Shell' had become well-known in eighteenth-century England through casts and copies; the copy in Wright's 'Academy' seems more graceful than the original. Behind her, in the background on the right, is a full-sized cast of the 'Gladiator', the statue Wright had already depicted, on a smaller scale, in 'Three Persons Viewing the Gladiator' (No.22). In this academy, the students evidently learn by copying the best antique models.

As Nicolson points out, Wright's subject has a long and distinguished history. In *Academies of Art Past and Present*, Cambridge, 1940, Nikolaus Pevsner reproduces Agostino Veneziano's engraving, 1531, of Baccio Bandinelli's 'Academy' in Rome, in which students are evidently learning to draw by copying antique statues; if Wright ever saw this engraving, he would surely have liked the high shadows of human beings and statues thrown up by the light of a single candle. In eighteenth-century England, students were encouraged to draw from the finest antique models. As Nicolson points out, there is no evidence to indicate which of several London academies Wright may have depicted (though one of the best-known, the Duke of Richmond's sculpture gallery in Whitehall, open to students from 1758, is often proposed). Wright's 'Academy' may be imaginary, at least in its setting. The light, coming from the left, its source concealed, would have been approved of in Towneley's Gallery, where 'Lamps were placed to form the happiest contrast of light and shade, and the improved effect of the marble amounted by this almost to animation . . . To a mind replete with classical imagery the illusion was perfect' ('Elegant Memoirs of Towneley', in *General Chronicle and Literary Magazine*, 1811, quoted in *Age of Neo-Classicism* catalogue, 1972, p.180).

Nicolson reproduces 'The Drawing Academy' by Michael Sweerts (p.47, fig.54; Frans Halsmuseum, Haarlem): 'not of course Wright's source, but there are

analogies between it and the 'Academy by Lamplight' that cannot be ignored'. He also mentions, almost in passing, 'the Wallerant Vaillant in the National Gallery, of a boy half turned away from us seated reading on a low chair in the presence of statuary' (the National Gallery picture is in fact likely to be a copy of the picture in the Louvre). The Wallerant Vaillant becomes very much more interesting as a possible influence on Wright once we know that it was engraved; indeed it is one of the most beautiful of all Vaillant's mezzotints, the image of the boy, very appealing in itself, being conveyed in exquisitely subtle gradations of greys (fig.11). If Wright had come across it, it might well have been enough to inspire him, not to copy the figure, but to develop in his mind his own images of young students.

All the boys in Wright's 'Academy' wear the frilled and fringed collars and cuffs which here seem almost to be part of an Academy uniform, but which are to be found in other paintings and drawings by Wright around 1768, though not part of contemporary everyday dress. They can be seen in 'Two Girls Decorating a Kitten by Candlelight' (No.17), in the related 'Study of a Young Girl with Feathers in her Hair' (No.72) and in another chalk drawing now in the Yale Center for British Art, reproduced by Nicolson pl.69, there oddly called 'Self-Portrait?', and in the portrait of 'William Stafford' (Nicolson *Addenda* 1968 fig.8). There is some element of fantasy about all these 'fringed collar' works; they may share some other unknown significance.

Another version of 'An Academy by Lamplight', same size, in the collection of Lord Somerleyton, was lent to the *Childhood* exhibition, Sotheby's, 1988 (92, repr. p.67 in colour); in this there are some differences, the most obvious being in the architectural details of the room and in the omission of the statue of the 'Gladiator'.

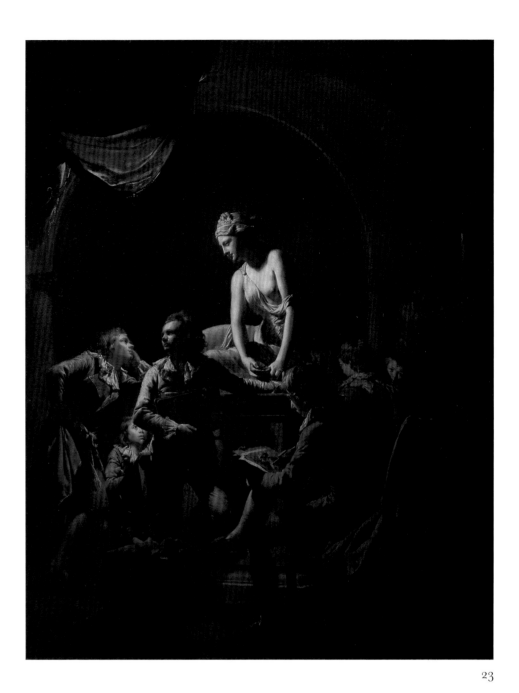

23

fig.11 Wallerant Vaillant: 'A boy reading in a studio', mezzotint $10\frac{7}{8} \times 8\frac{3}{8}$ (27.5 × 21.3)
James Miller

24

A Conversation of Girls (Two Girls with their Black Servant) exhibited 1770

Oil on canvas 50 × 40 (127 × 101.6)

PROVENANCE
In Wright's Account Book as 'Two Girls w.th their Black Servant in the hands of Pether Sold to M.^r Parker £40 pd'. This occurs in the list headed 'Candle Light pictures'; this entry was then crossed through (?because Wright realized the picture was wrongly listed among 'Candle Lights') except for 'M.^r Parker £40 pd'; . . . ; from before 1895, in the Watney family, on loan to Derby Art Gallery since 1987

EXHIBITED
Society of Artists 1770 (155, as 'A Conversation of Girls'); British Portraits, RA 1956–7 (336, as 'Two Girls, with a Negro Boy offering Flowers')

LITERATURE
Nicolson no.163, p.228; pp.35, 107; pl.73; David Dabydeen, Hogarth's Blacks. Images of Blacks in Eighteenth Century England, Denmark & UK 1985, p.32, repr. p.33 fig.19

Private Collection

The entry in Wright's Account Book recording the picture's sale to Mr. Parker, but partly crossed through, throws little light on the picture's early ownership. Edward Parker of Brigg, Lincolnshire owned several of Wright's pictures, including two now lost candlelights; but unlike those, this picture was not in Christie's sale after his death in March 1782. Wright's note that the picture was 'in the hands of Pether' presumably means that William Pether, who engraved several of Wright's pictures, had it in mind to engrave this subject; but no engraving is known.

Wright may have painted the picture during his sojourn in Liverpool in 1769, during which he painted the portraits of several slave-traders and presumably saw more black servants than he could have seen in Derbyshire. A sailing-ship on the distant horizon on the left may support the probability that the setting is near Liverpool, and may also hint at the fate which has brought the black child to these shores.

The first reasonably certain fact is that this was the picture exhibited at the Society of Artists in 1770 with the title 'A Conversation of Girls', against which Horace Walpole noted in his catalogue 'Exceeding fine'. Wright's title 'A Conver-

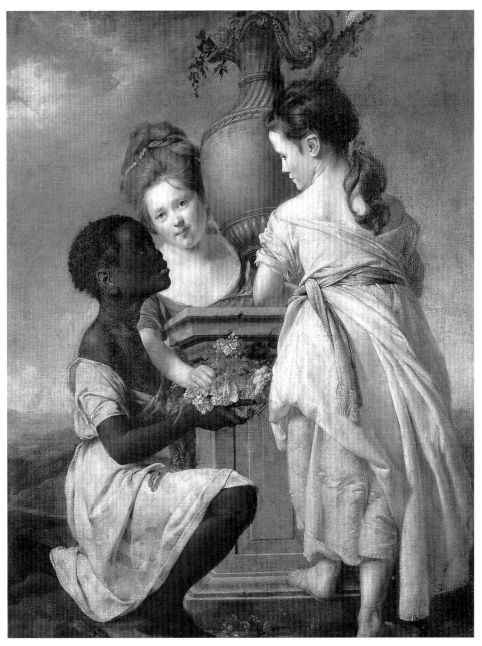

24

sation of Girls' establishes that the black child is also a girl, though pronounced a boy in the *British Portraits* exhibition of 1956–7. The black child's pose is deferential; though too young (and too unsuitably dressed) to be herself a servant yet, she is probably the child of black servants to the white children. There is something enigmatic about the children's attitude to each other; the subtle nuances in Wright's picture, not easy to analyse, perhaps spring from the fact that these are children, whose attitudes have not yet hardened into those of their elders. (Dabydeen, from whom one might have hoped for illuminating comment, mentions the picture only to class it with Lely's portrait of the Countess of

Dysart with a black page as 'works which place the black servant and white owner in an identical relationship of dominance and inferiority'.)

The cracks in the stone pillar supporting the urn are characteristic Wright details. The improbably large chest of the red-haired girl in the middle, compared to the short arm with which she leans round a really quite large plinth to grab some flowers, show Wright's occasional anatomical clumsiness.

25

Mrs John Ashton *c.*1769

Oil on canvas 49 × 39¾ (126.1 × 101)
PROVENANCE
Not in Wright's Account Book; probably
commissioned (like other Ashton portraits)
by the sitter's son Nicholas Ashton; by
descent to Joseph William Ashton, sold
Christie's 9 December 1905 (72, as an
unidentified portrait by Northcote), bt
Charles Fairfax Murray, by whom pre-
sented to the Fitzwilliam Museum 1908
LITERATURE
Nicolson no.6, p.177; pp.33–4, 99–100;
pl.64; J.W. Goodison. *Fitzwilliam Museum,
Cambridge: Catologue of Paintings*, III: *British
School*, 1977, pp.293–4, no.659

Syndics of the Fitzwilliam Museum, Cambridge

The sitter is the widow of John Ashton of
Liverpool, a rich merchant, slave-trader
and salt manufacturer. She was born in
Liverpool in 1710, the daughter of John
Brooks. Wright painted four other mem-
bers of the Ashton family while he was in
Liverpool; the others are Mrs Ashton's two
daughters, Anna and Elizabeth (Nicolson
pls. 65, 66), her daughter-in-law Mary,
Mrs Nicholas Ashton (pl.67) and her
grandson John, portrayed at the age of
four or five, with a shaggy dog, in a lost
painting (pl.68, from a copy). Only the
child's portrait appears in Wright's
Account Book, in the list of 'Sitters at
Liverpool 1769', probably the date (or
near it) of the others.

The portrait of Mrs Ashton is a compel-
ling one. Nicolson comments that she 'sits
stiffly erect in her upholstered armchair,
slightly above eye-level as though on a
dais, to suit her station as the wife of a
prosperous slave-trader' (p.34). She may
have been one of those *small* formidable
women; and Wright may therefore have
chosen a slightly flattering angle. Her stiff
black satin dress and the softer long white
drifts from her elbows demonstrate that it
is a long time since she had to do (if she
ever did) any household work. The faintly
menacing black and white of her dress and
cap (known as a Pulteney cap) make a
dramatic contrast with the opulent
tawny-red velvet spread over the table
beside her.

Most compelling of all are Mrs Ashton's
grey-green eyes. We know nothing per-
sonal about her except what Wright tells
us, and it may be unfair to link her too
strongly with the slave-trading activities
of her husband, who died (in 1759) about

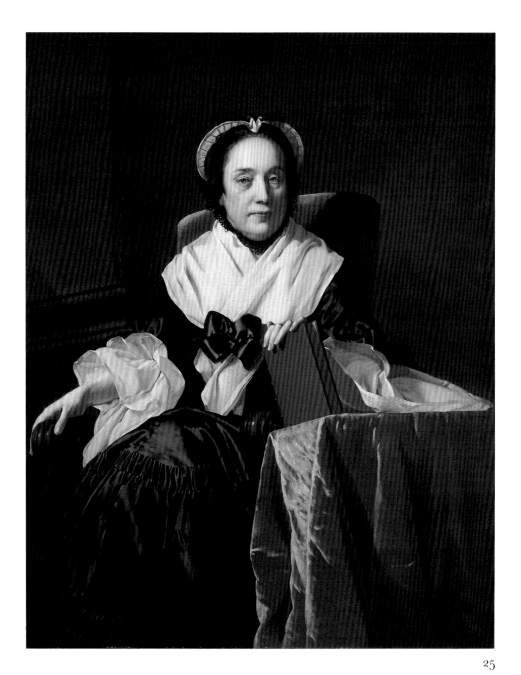

25

ten years before this portrait was painted;
nevertheless, something about Mrs
Ashton's seemingly ruthless gaze calls to
mind that infinitely chilling thought
expressed by the Revd William Bagshaw
Stevens when he visited Liverpool in 1797:
'throughout this large-built Town every
Brick is cemented to its fellow Brick by the
blood and sweat of Negroes' (ed. Galbraith
1965, p.436).

Mrs Sarah Clayton *c.*1769

Oil on canvas 50 × 40 (127 × 101.6)
PROVENANCE
Not in Wright's Account Book; painted for
the sitter (d. unm.), then passed to the
Parker family, Cuerdon Hall, Preston,
Lancashire, and from Robert Towneley
Parker by descent to R.A. Tatton, sold
Christie's 28 February 1947 (102), bt
?Daly; Dr Arnold Lyndon O B E, deceased,
sold Christie's 18 April 1947 (74), bt
Roland; anon. sale Christie's 25 June 1948
(135), bt Koetser; John Nicholson Gallery,
New York, 1952; Charles Childes, Boston,
1953; Miss Louise I. Doyle, by whom
presented to Fitchburg Art Museum,
Fitchburg, Mass.
EXHIBITED
Smith College 1955 (5); Durlacher Bros.,
New York 1960 (7) *Romantic Art in Britain*,
Detroit Institute of Arts and Philadelphia
Museum of Art, 1968 (26, repr.)
LITERATURE
Nicolson no.39 p.189; pp.34, 99; pl.63

Fitchburg Art Museum; gift of Louise I. Doyle

Like those of perhaps ten or more known
sitters to Wright in Liverpool, Mrs
Clayton's portrait is not listed in Wright's
Account Book; but there can be no doubt
of the authorship of this splendid portrait.
Nicolson considers (p.34) that the por-
traits of 'Mrs. Clayton' and 'Mrs. Ashton'
(No. 25) are 'among the finest in Wright's
entire oeuvre'.

Sarah Clayton (she became known in
Liverpool as 'Mrs.' Sarah Clayton, but
Nicolson points out that this was a cour-
tesy title) was the daughter of William
Clayton and his wife Elizabeth. Her father
was a prosperous Liverpool merchant who
was Mayor of the town in 1689 and M P
for Liverpool from 1690 until his death
in 1715. The family owned and leased
considerable property in the centre of
Liverpool (including Clayton Square,
which Sarah Clayton was to develop) and
were related to other prominent Liverpool
families, including the Parkers of Cuerdon,
the family to which Sarah Clayton's por-
trait passed.

Sarah Clayton (1712–1779) looks for-
midable but not unkind, like the best head-
mistresses. After her mother's death in
1745, she became a woman of business, in
an age when this was uncommon for a
woman, particularly an unmarried one;
but she evidently inherited a good head for
business. In 1745 she had inherited the

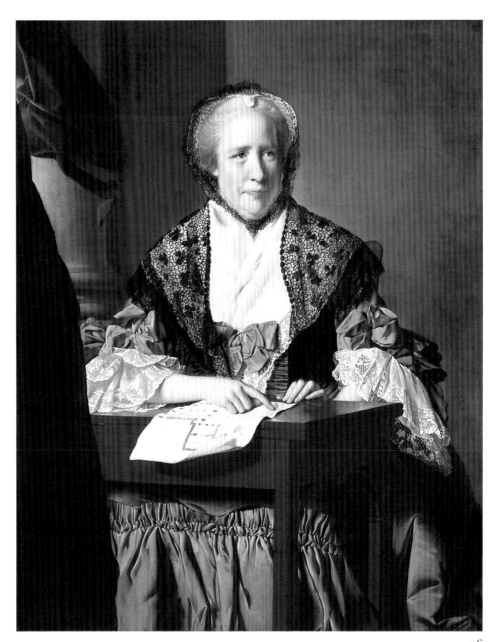

26

estate of Parr Hall, with a coal mine near St Helen's, the centre of the South Lancashire coal industry. By 1757, when the Sankey Navigation Works (England's earliest canal system, constructed primarily for the transport of coal) reached Parr, she had opened two new pits. With her nephews, the Case brothers (one of whom married the daughter of Mrs Ashton, No.25) Mrs Clayton established 'a leading position in the Liverpool coal market during the 'monopoly' period of *c.*1757–73' (Nicolson p.99).

Mrs Clayton took an active interest in the sound architectural development of Liverpool, in particular using her influence to secure the selection of the elder John Wood of Bath as architect for the New Exchange in 1749. She also developed Clayton Square, first leased to her father in 1690, but until Mrs. Clayton laid it out in the 1750s, consisting of open fields and gardens. In 1767 she herself took up residence in the largest of the four houses so far built in the square.

Wright shows Mrs Clayton studying the architect's plan for Clayton Square, whose details he has accurately transcribed. Her large kind head radiates intelligence of a blessedly practical sort; and she looks as if she will move purposefully in those clothes, not mince. She must be one of the most likeable, and most admirable, of all Wright's female sitters.

Mrs Clayton died in 1779, after having become bankrupt in 1778.

(There is an odd resemblance between Mrs Clayton's pose, seated behind a small table, and that of Sarah Malcolm the murderess, portrayed by Hogarth in Newgate in 1722–3 (National Gallery of Scotland). This is probably fortuitous, especially as the engravings of *Sarah Malcolm*, which were probably all Wright could have used, include only a small corner of the table)

27

John Milnes 1776

Oil on canvas 50 × 39¼ (127 × 101)

PROVENANCE
Not in Wright's Account Book; John Milnes, d.1810; . . . ; 12th Duke of St Albans, sold by the Trustees of the 12th Duke of St Albans's Settlement, Sotheby's 13 July 1984 (117, repr. in colour), bt Colnaghi, from whom purchased by the Musée du Louvre 1985

LITERATURE
Letter from Wright to his brother Richard, from Bath, 8 May 1776, published by Bemrose p.46 (but now untraced); Nicolson p.213, as untraced; Musée du Louvre, *Nouvelles Acquisitions du Département des Peintures (1983–1986)*, Paris, 1987, catalogue entry by Cécile Scailliérez, pp.42–4, repr. p.43

Musée du Louvre

This was for long known as 'Portrait of an Unknown Man', and as such it entered Sotheby's, Colnaghi's and the Louvre. The suggestion that it might be a portrait of John Milnes was first made by Alex Kidson, in a letter to Colnaghi's in 1985; he drew attention to the portrait's resemblance to that of 'Captain Robert Shore Milnes', and to Nicolson's reference to a letter from Wright of 1776 mentioning a portrait of Robert Shores Milnes's brother. This compiler, standing at about the same time in New York in front of the portrait of 'Captain Robert Shore Milnes' (No. 31), felt a strong sense that the 'Unknown Man' was indeed likely to be Robert Shore Milnes's brother.

The letter from Wright to his brother Richard, from Bath, 8 May 1776, as transcribed by Bemrose (p.46), includes the following report: 'Have in hand a small full-length of Mr. Miles, brother to Capt. Miles I painted at Derby some time ago. He is now in Town, but will be here, I expect, in a day or two to have his picture finished; a day will compleat it' (after which Wright plans to leave Bath for the summer).

The resemblance of the so-called 'Unknown Man' to 'Robert Shore Milnes', however strong, would not by itself justify a positive identification of the 'Unknown Man' as John Milnes. What does appear to establish that identification conclusively is George Romney's solidly-identified portrait of John Milnes, still in the collection of descendants of the family. Romney's portrait, very nearly full-face,

also a full-length but on a larger canvas (94 × 57½ ins.) was painted in 1790–2 (H. Ward & W. Roberts, *Romney*, 1904, p.106); but though painted fifteen years or more after Wright's, the distinctive nose, the various features, the fair complexion and pale eyelashes are the same. The compiler is most grateful to members of the family who have taken the trouble to compare the two portraits and who conclude that there is such a strong resemblance that Wright's 'Unknown Man' is indeed likely to be John Milnes.

Robert Shore Milnes and his younger brother John Milnes are portrayed in attitudes which make the two pictures comfortable but not contrived companions; the portraits are on the same scale, are similar in style and have similar backgrounds of large venerable oaks. The portrait of 'Colonel Heathcote' has a similar background (as noted under No. 31). There can be little doubt that 'Colonel Heathcote' and 'Captain Robert Shore Milnes' were the two pictures exhibited at the Society of Artists in 1772, each under the title 'Portrait of an Officer'. John Milnes's portrait is so much in the style of these two that it, too, might happily have been assigned to around 1772, if it were not for Wright's letter of 8 May 1776 from Bath, where, 'in a day or two', he expects the arrival of 'Mr. Miles . . . to have his picture finished'. There are no clues as to when the picture was begun, but it is unlikely to have been long before May 1776 (Wright's Italian journey, door to door, lasted from October 1773 to September 1775; he settled in Bath in November 1775). None of the portraits painted in Bath appear to have been listed in Wright's Account Book; possibly he kept a separate record, now lost.

John Milnes stands in front of a massive oak tree, much as his brother Robert does; but the landscape in John Milnes's portrait is more spacious and airy; that, and rather cooler colouring, are the chief stylistic differences between his portrait and those of Colonel Heathcote and Captain Milnes. John Milnes's gesture with his hat, presumably to the distant sailing-ship, must be telling us something, now elusive: is the ship carrying a cargo of cotton, foundation of his family's fortunes, and whither is it bound? The coastline has not been identified (not Merseyside, in Alex Kidson's opinion).

Starting off with a commission for his portrait, John Milnes became one of Wright's greatest patrons. Born on 15 December 1751, he was the third son of

John Milnes of Wakefield, a highly prosperous cotton manufacturer, who died in 1771 (Nicolson, p.158 and elsewhere, confuses the father with the son, believing that it was the elder John Milnes who was Wright's patron; but his death in 1771 precludes this). John Milnes's first purchase after his own portrait seems to have been the 'Firework Display at the Castel Sant' Angelo' (No. 104) and its companion 'Vesuvius' (now untraced), exhibited at the Society of Artists in 1776. He bought 'Edwin, from Dr. Beattie's Minstrel', exhibited in 1778 (No.57), and a series of landscapes including 'Neptune's Grotto', 'A View in the Alps' and 'Its companion, Morning', a 'Lake of Albano, Sunset', 'Cicero's Villa' and 'Moonlight on the Coast of Tuscany' (all untraced); he also bought a fairly late 'Cottage Scene in Needwood Forest' of c.1790 (Derby Art Gallery). And it was Milnes who bought the most expensive picture Wright ever painted (at 420 guineas), the picture which was to be the star turn of his one-man exhibition at Robins's Rooms in 1785: 'View of Gibraltar during the destruction of the Spanish Floating Batteries, 13 September 1782' (untraced since 1857; the picture in Milwaukee identified as this in the *Burlington Magazine*, CXVI, 1974, pp.270–2, fig.50, is now widely thought to be not by Wright).

John Milnes was a wealthy man with Radical sympathies, a not uncommon combination in his time. He expected much from the French Revolution; his eldest (illegitimate) son, born in Paris in 1792, was named Alfred Mirabeau Washington Milnes, one of the Ushers in the National Assembly standing godfather. Milnes lived chiefly in Wakefield, in a very grand house begun by his father and continued by himself, with a picture gallery seventy feet long, room enough for many Wrights. By the early 1790s, however, funds began to run low, and parts of the estate were sold. The contents of the house were sold by auction in 1808 (but no details of pictures included in the sale have survived), and the house itself was sold privately later that year (information in this paragraph is taken from John Goodchild, 'Fragments of an English Mansion', in ed. Clare Taylor, *Wakefield District Heritage*, 1, 1976, pp.78–9).

John Milnes died in 1810. What became

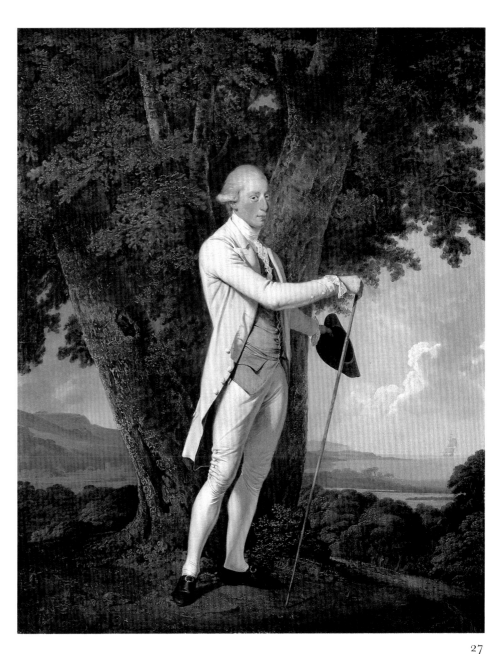

27

of this portrait is a mystery. When or how it entered the collection of the Dukes of St Albans (where it was thought to be a portrait of George III by Zoffany) is also a mystery. When sent to Sotheby's in 1984, it came from the Duke of St Albans's house in Co Tipperary, Ireland. John Milnes married Catherine Carr, from Co Carlow, who died in 1806: after Milnes's own death in 1810, could the portrait have been sent to Ireland?

Mrs Andrew Lindington *c.*1761–2

Oil on canvas 30 × 24⅛ (76.2 × 62.8)

PROVENANCE
In Wright's Account Book as 'Mᵣˢ
Lindington £6.6.0' in list headed 'Sitters
from ffeb: 1st 1760', then as 'Mᵣˢ Ligdinton'
in longer list headed 'Sitters at Derby',
n.d., and finally as 'a 3qrs of Mᵣˢ Lindegten
pᵈ £6.6.0'; . . . ; Vicars Brothers, from
whom purchased by Mr & Mrs Henry W.
Breyer, Jr; Gift of Mr & Mrs Henry W.
Breyer, Jr to Philadelphia Museum of Art
1968

EXHIBITED
75th Anniversary Exhibition, Shipley School,
Philadelphia, 1969

LITERATURE
Nicolson *Addenda* 1968, p.2, pl.7; Allen
Staley, 'British Painting from Hogarth to
Alma-Tadema', *Apollo*, vol.c, 1974, p.35;
Richard Dorment, *British Painting in the
Philadelphia Museum of Art*, Philadelphia
and London, 1986, no.118, pp.432–4, repr.
in colour p.433

*Philadelphia Museum of Art; gift of Mr and
Mrs W. Breyer, Jr*

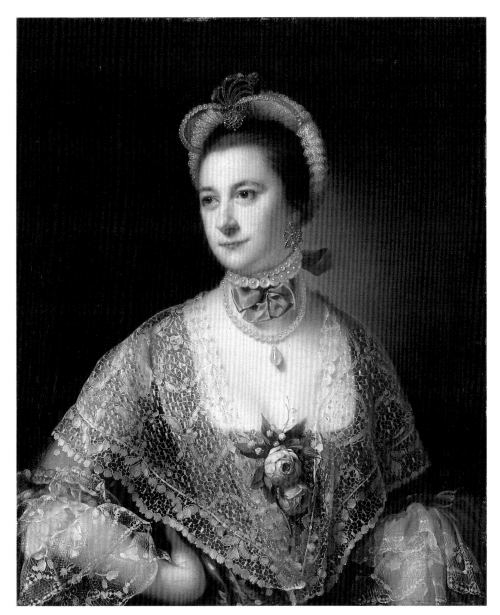

Dorment records an old MS label on the
back which reads 'Mrs Andrew
Lindington (nee Bentley)'. The sitter has
eluded further identification.

Nicolson compares this portrait with
that of 'The Hon. Mrs Boyle' in Auckland
City Art Gallery (Nicolson pl.46; a picture
not seen by this compiler), and suggests
that in portraits such as these, Wright is
seen to be 'moving out of Hudson's orbit
into that of Ramsay'. Dorment follows this
up by suggesting a comparison of 'Mrs
Lindington' with Ramsay's 'Miss
Woodford', probably early 1760s, exh.
Agnew's, *Realism and Romance in English
Painting*, 1966 (10, repr.). Discounting
similarities in the ladies' dress, which indi-
cate that both women were painted while
the same fashions prevailed, there is surely
not much similarity in style, palette or
mood between Ramsay and Wright in the
early 1760s (if ever). While Wright's per-
ception of character and his ability to
depict it developed quickly, in the early
1760s he still had much to learn; his palette
is less subtle than Ramsay's, his style more
forceful and his designs less elegant.
Ramsay, in short, seems a red herring in
Wright's path.

Mrs Lindington's attire is elaborate,
almost certainly costly and surely all her
own, unlike the gauze scarves and ropes of

pearls with which Wright seems to have decked some sitters. The most conspicuous part of her attire is an exquisitely-worked ivory-coloured silk lace shawl (probably French, according to Dorment). A similar lace shawl is worn by Reynolds's 'Mrs Fortescue (La Penserosa)', in the National Gallery of Ireland; the fact that the picture was exhibited at the Society of Artists in 1761 suggests that 'Mrs Lindington' and Ramsay's 'Miss Woodford', similarly-dressed, must also have been painted about the same date.

Mrs Lindington, Miss Woodford and Mrs Fortescue all wear fresh flowers at the breast – Mrs Lindington indeed sports a large bunch including roses and lily of the valley. Probably she (and the others) also wears an invisible 'tin funnel' low in the cleavage. In a letter of 16 November 1754 to his friend George Montague, Horace Walpole reported 'a new fashion which my Lady Hervey has brought from Paris. It is a tin funnel covered with green ribband, and holds water, which the ladies wear to keep their bouquets fresh – I fear Lady Caroline and some others will catch frequent colds and sore throats with over-turning this reservoir'.*

Dorment considers that Wright's interest in this portrait 'focuses on the still-life elements', instancing such passages as 'the obsessive description of the complex pattern of the interstices of the lace through which the arm and dress are visible; and the bunching of the tiers of lace sleeves on the left arm'. He also suggests that in this pose and in his fascination with details of the dress, Wright may have been influenced by Thomas Frye's mezzotint portrait of *Queen Charlotte*, published 24 May 1762 (repr. Dorment p.434). This seems very likely. As Nicolson demonstrated (pp.42–4), Wright was clearly familiar with Frye's work, deriving several details (e.g. in 'The Air Pump') from Frye's large mezzotint heads.

* (The quotation is from the *Yale Edition of Horace Walpole's Correspondence*, New Haven, IX, 1937–83, p.166. The compiler is indebted to John Riely for help in tracing it.)

29

Mr & Mrs Coltman
?exhibited 1771

Oil on canvas 50 × 40 (127 × 101.6)
Inscribed on the reverse of the canvas by a later hand (c.1840) 'Thomas Coltman and his first wife Mary' and, below his name 'Nat. 1747 Ob. 1826', below her name 'nee Barlow Ob. 1786 (?) aet. 39' and below both 'Wright of Derby pinx!'

PROVENANCE
In Wright's Account Book as 'Mr & Mrs Coltman a Conversation £63.0.0.', with 'Rᵈ – x – 100 –' between the picture's title and its price, suggesting that Coltman paid £100, made up of £63 for this picture and the rest for others purchased; thence by family descent until sold Christie's 23 November 1984 (94, repr. in colour), bt Agnew's for the National Gallery, by whom purchased with assistance from the National Heritage Memorial Fund and the Pilgrim Trust

EXHIBITED
Probably Society of Artists 1771 (203, 'A small conversation'); Graves 1910 (18); Derby 1934 (6); *British Portraits*, RA 1956–7 (306 pl.26); *British Painting in the Eighteenth Century*, British Council tour, Canada and USA, 1957–8 (18, repr. in colour); Tate & Walker 1958 (9); *The Conversation Piece in Georgian England*, Iveagh Bequest, Kenwood, 1965 (48, pl.VIIB); *Wright of Derby : Mr & Mrs Coltman*, National Gallery 1986 (4)

LITERATURE
Nicolson no.41 pp.188–9; pp.33, 36–8, 107; pl.91; David Fraser, 'Joseph Wright's Portraits of Mr and Mrs Coltman and Colonel Heathcote', in ed. Mark Wrey, *Christie's: Review of the Season 1985*, Oxford 1985, pp.48–50, repr. p.49 in colour; Allan Braham, *Wright of Derby: Mr & Mrs Coltman*, National Gallery exhibition booklet, 1986, *passim*, repr. frontispiece in colour; Martin Wyld and David Thomas, 'Wright of Derby's 'Mr and Mrs Coltman': An Unlined English Painting', in *National Gallery Technical Bulletin*, 10, 1986, pp.28–31, figs.1–5

Trustees of the National Gallery

Wright is not often a lyrical artist: but that is what he becomes with his matchless portrait of Thomas Coltman and his wife Mary. The lyrical vein was probably inspired by the fact that Coltman was his friend, though thirteen years younger. Thomas and Mary Coltman, both born in 1747, were both about twenty-four years

old when they sat for this portrait. Wright's sense of the happiness of their marriage, their pleasure at being in the open air, their youthfulness and their grace make this more than just a highly successful double portrait: it is also one of the most affectionate portraits of a happy marriage in the whole of British art.

Coltman and Wright probably became friends while Coltman was a young bachelor living in Derby. Fraser notes that Coltman's marriage licence shows that he was living in the parish of St Werburgh's, a short walk from Wright's house. Coltman bought two of Wright's early candlelight pictures, 'Boys Fighting over a Bladder' and 'A Girl Reading a Letter, with an Old Man reading over her shoulder' (both exhibited here, Nos.16, 15). The young man and woman on the left in 'The Air Pump', by no means engrossed in the experiment, and in Flaubert's opinion certainly lovers, are believed to represent Thomas Coltman and Mary Barlow before their marriage; this seems likely. They were married on 2 October 1769 at Astbury, Cheshire, Mary Barlow's home. Wright's pair of charcoal portraits of the Coltmans, made a year or so later but somewhat lacking in charm, are reproduced by Nicolson, (pls.118–9).

Thomas Coltman owned the best of all Wright's known self-portraits (shown here as No.94), probably given to him by Wright rather than purchased. It may have been partly as a gesture of thanks that Coltman persuaded Wright to accept a letter of credit for £300 on his departure for Italy in 1773 (he had offered £500, but Wright would not accept so much). In a letter to his brother of 23 October 1773 (DPL), written on his way to embark for Italy, Wright wrote 'My good friend Coltman has behaved wonderfully generous and genteel to me . . .' Wright wrote to Coltman from Rome at least once (a letter which seems not to have survived) and sent 'affec. compᵗˢ' to him in letters to his own family.

The double portrait, entered in Wright's Account Book as 'Mr & Mrs Coltman, a Conversation', was almost certainly the picture he exhibited at the Society of Artists in 1771 as 'A small Conversation'. The previous year, Stubbs had exhibited there the picture now known as 'The Milbanke and Melbourne Families', as 'A Conversation' (133). As Nicolson suggests, Wright probably derived ideas for Coltman's pose from that of John Milbanke (and his horse) in the Stubbs. Nicolson reproduces a detail of

John Milbanke's pose (p.27, fig.33); but as both Stubbs's picture and Wright's are now in the collection of the National Gallery, they can best be compared there after this exhibition.

Coltman's figure is charged with masculinity and with physical energy. He was as much a lover of country life and sports in 1771 as when he wrote to Sir Joseph Banks in 1797: 'I propose to go out with the Hounds in the Morning w.ᵗʰ I can do more easily than write a letter. No uncommon thing with a Sportsman.' His present pose is relaxed and seemingly natural, however carefully Wright must have worked out its every detail in relation to Mrs Coltman's. The eye is at once caught by the lavish but not ostentatiously new silver frogging on the deep blue of Coltman's waistcoat, painted with Wright's habitual delight in the intricacies of objects; each tassel's every strand is given its individual twist or turn, and the painting's superlative unlined condition means that none of this paintwork has been flattened. Wright also observes and meticulously paints the outline of a coin in (presumably) an inner pocket of Coltman's well-fitting breeches.

Mary Coltman's riding-habit is the colour of old rose, with gold braiding to contrast with her husband's. She rides side-saddle, of course. Braham is at a loss to find a source for her pose (representations of 'The Flight into Egypt?' the Queens of Spain painted by Velasquez?); but Wright would only have had to look about him to see that all women who rode (whether to hounds, or just to get from place to place) rode side-saddle. Seymour and Wootton had painted many women riding side-saddle in the hunting-field, the best known being Wootton's three large canvases of Lady Henrietta Harley hunting, hawking and coursing. But Wright probably drew this pose from life.

Mrs Coltman's reliable-looking grey hack is likely to be a portrait of her own habitual riding-horse. Excessive foreshortening of its neck seems to give it a crest as thick as a rampant stallion's, but otherwise it is a creditable animal portrait. Wright introduced horses into the backgrounds of several pictures of the early 1770s, e.g. the horses waiting to be shod in the two 'Blacksmith's Shops' (Nos.47, 48), the horse led by a groom in the portrait of 'Robert Shore Milnes' (No.31) and the patiently grazing horse in 'The Earthstopper' (No.51). Wright was more successful with dogs than with horses. The brown and white spaniel in the left foreground is probably also a portrait, and a

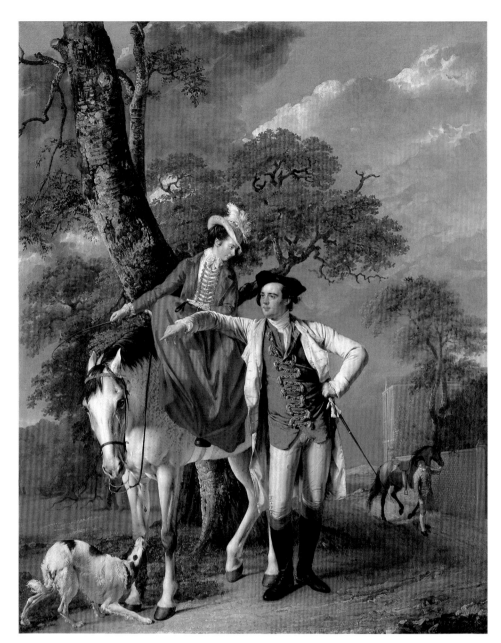

29

lively one. Fraser, noting that Mr & Mrs Coltman are seemingly unaware of the painter's presence, comments that 'Even Mrs Coltman's horse and the dog at its feet are relating to each other rather than to the artist or spectator, thus breaking down formality even further'.

The naturalistic representation of the landscape and the swiftly-moving diagonal clouds mark a significant advance in Wright's increasing interest in landscape painting. Wright's style is variable, even in works painted about the same time. Here the painting of the landscape is much more fluid and expressive than in the rather overwrought and excessively green backgrounds to the portraits of 'Robert Shore Milnes' (No.31) and his brother 'John Milnes' (No.27).

The house in the background is Gate Burton House, near Gainsborough, Lincolnshire, which the Coltmans appear to have leased for some years after their marriage. Gate Burton was built for the Hutton family in the late 1760s; according to Edward Saunders and Maxwell Craven (in correspondence), the architect was almost certainly Joseph Pickford of Derby, Wright's friend, but later additions by Detmar Blow make this difficult to establish. The Coltman 'seat' was Hagnaby Priory, near Boston, Lincolnshire, inherited by Thomas Coltman in 1768; but the Coltmans had been landed gentry for a comparatively short time. According to Braham, 'their fortune apparently derived from the revenue of Coltman's coffee-house, in the city of London, an establishment which survived in name until only a few years ago' (p.16); no 'Coltman's Coffee-House' is listed in Bryant Lillywhite's *London Coffee Houses*, 1963, so if a Coltman established a coffee-house he may have given it a name other than his own. Thomas Coltman's grandfather bought Hagnaby Priory in 1715–6. Thomas Coltman settled there in the 1780s.

Mary Coltman died in 1786, at the age of thirty-nine, with no surviving children. Coltman remarried in 1789. Glimpses of the life he lived in Lincolnshire are offered by a series of twenty-two letters from Coltman to Sir Joseph Banks, written 1791–7 and calendared by Warren R. Dawson, *The Banks Letters*, 1958, pp.224–6. By 1791 Coltman was Deputy Lieutenant of Lincolnshire, serving under the Duke of Ancaster (whom he refers to as 'our friend Plantaganet'), as well as a J P and chairman of the magistrates' bench. He sends Banks news of disputes over hunting rights, cures for sheep with rot, accounts of local riots in 1796 and the increasing urgency, as the war with France rolls on, of recruiting supplementary militia. He also sends Banks (3 November 1796) a flannel waistcoat as a precaution against gout. Coltman had no intellectual pretensions. To win the friendship of two such different men as Wright and Banks, he must have had an enormously likeable personality: and that is just what Wright's portrait tells us. Coltman died at Hagnaby Priory on 11 November 1826, aged eighty.

Mrs Catherine Swindell *c.*1769–71

Oil on canvas $28\frac{1}{8} \times 21\frac{7}{8}$ (71.4 × 55.7)
PROVENANCE
. . . Tooth, from whom bt Agnew's, and
sold to Mrs P.B.K. Daingerfield, New
York, 1931; bt back 1935 by Agnew's,
from whom purchased by Leicester
Museum and Art Gallery 1938
EXHIBITED
Derby 1934 (11); Derby and Leicester
1947 (22, repr. p.13); *Let's Face It*, London
Museum 1986 (no catalogue)
LITERATURE
Nicolson no. 134, p.223; p.36; pl.81, in
colour; David Piper, 'Joseph Wright of
Derby', *The Listener* 6 February 1969,
p.184

Leicestershire Museums and Art Galleries

The sitter's name is inscribed on a label on
the back, in what appears to be an early
nineteenth century hand; but so far she
had eluded all attempts at further identifi-
cation. She may be a Liverpool rather
than Derbyshire sitter; and Wright's list of
'Sitters at Liverpool 1769' is known to be
incomplete. She may of course appear in
Wright's Account Book under her maiden
name, so far unknown.

The portrait is one of the best and most
characterful of all Wright's portraits of
women. Inevitable changes in the pic-
ture's surface over two centuries enable us
to see how Wright modelled the face: in
particular, the greenish glazes around the
nose and cheekbones and the strengthen-
ing line round the jaw have become more
noticeable.

In his broadcast talk on Wright in 1969,
David Piper described Catherine
Swindell's portrait thus: 'She's shown to
the waist, in low-cut rose silk, dark hair
piled high, all got up in her best (the pearls
are perhaps not hers but supplied by
Wright). This so far is very conventional –
Thomas Hudson could almost have painted
it. But in the face, turned nearly profile
to the left, things start to happen that are
very unconventional. This is no flawless
oval, fashion-made – but a most individual
mouth pouting forwards, pinched in at the
sides; a grey-green eye cocked and apprais-
ing, and a nose as quirky, postulating
volubility, as a duck's tail. One can almost
hear the tone of chatter . . .'

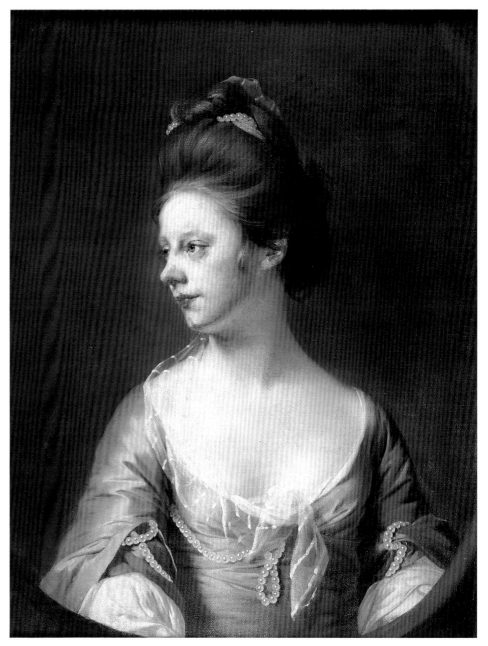

30

31

'Captain' Robert Shore Milnes
exhibited 1772

Oil and canvas 50 × 40 (127 × 101.6)
PROVENANCE
In Wright's Account Book as 'Cap.! Milnes
Ditto [i.e. small full length] £31.10.0', i.e.
'Captain' Robert Shore Milnes, later 1st
Baronet (d.1837); . . . ; purchased by Mr
and Mrs Lawrence Copley Thaw from
Arthur Tooth & Sons in the 1950s
EXHIBITED
Society of Artists 1772 (369 or 370);
Durlacher, New York, 1960 (9)
LITERATURE
Nicolson no.107, pp.212–3; pp.36, 159;
pl.114

Mrs Lawrence Copley Thaw, Senior

When Robert Shore Milnes sat to Wright,
he was about twenty-five years old, and an
officer in the Royal Horse Guards (The
Blues), whose uniform he wears here.
Milnes purchased his first commission as
Cornet in the Blues on 2 March 1770, his
second as Lieutenant on 14 November
1772 and his third as Captain on 10
December 1776. Nicolson pointed out that
Wright's Account Book styles him Captain
some years earlier than the Army Lists do;
but Army Lists give the date at which the
Army gazetted a new rank, which may
well have been some time after Milnes pur-
chased his captaincy within the regiment.
Wright may in any case have entered the
portrait in his Account Book after Milnes
had reached the rank of Captain.

Wright had already painted half-length
portraits of two of Milnes's young fellow-
officers of The Blues, probably a few years
earlier: Sir George Cooke (No.33) and
Richard French (Nicolson pl.85). Wright
also painted a small full length of Colonel
Charles Heathcote of the Thirty-Fifth
Foot, his figure portrayed on the same
scale as that of Milnes (Nicolson no.79,
untraced; the picture reappeared at
Christie's on 26 April 1985 (113, repr. in
colour)). Heathcote's commanding gesture
in the middle of a Derbyshire field is rather
absurd. Milnes's pose is at once more natu-
ral and more spirited; he stands there, an
image of latent energy and readiness for
valour, waiting for a groom to bring up his
horse, in a variation of the motif in the
portrait of 'Mr & Mrs Coltman' (No.29).

At the Society of Artists exhibition in
1772, Wright exhibited two portraits each
with the title 'A Portrait of an Officer, a
small whole length' (369 and 370).

31

Nicolson concludes, reasonably enough,
that one of these must be the portrait of
Heathcote and the other the portrait of
Milnes. In the *Morning Chronicle* for 29
May 1771 (p.4) a reviewer of the exhi-
bition comments (without giving the num-
ber of the picture he is commenting on):
'The Officer is a good bold figure; but the
tree near which he is supposed to stand, as
well as the Shrubbery, is by much too
glaring'. Probably the comment was made
about Colonel Heathcote's picture, if one
can call the clump of trees in the distance a
'shrubbery', and the Colonel's gesture of
command 'bold'. The most interesting

work in the reviewer's comment is the
word 'glaring'. These two portraits,
like 'John Milnes' (No.27) and others up
to 'The Earthstopper' (No.51), are painted
in a manner which Wright particularly
favoured around 1770–3; its essentials are
a fairly lavish use of paint which is then
overlaid with glistening dribbles of
impasto, which in its turn is scuffed and
scratched to give a lichenous, scaly effect.
The *Morning Chronicle* didn't like it; and
neither did Horace Walpole, who had only
one word to say about 'The Earth-stopper'
when it was exhibited in 1773: 'Hard'.

Robert Shore Milnes, born in 1747, was

the elder son of John Milnes of Wakefield, a wealthy cotton manufacturer, and his wife Mary Shore. Robert Milnes's younger brother, John Milnes (No.27), became one of Wright's staunchest patrons. Robert Shore Milnes's career can be briefly told. His name continues to appear among officers of The Blues until the Army List of 1788. After that he began a round of colonial service: Governor of Martiniquè, and later of Lower Canada, and Acting Governor of Quebec. He was rewarded with a Baronetcy in 1801. He died on 2 December 1837, one of the very few of Wright's sitters to have survived (just) into Queen Victoria's reign.

Having sat to Wright, Milnes later sat twice to Romney. The first Romney portrait, painted in 1780, also shows Milnes in the uniform of The Blues, by this date re-styled, with a much more close-fitting cut. Nicolson considered that Milnes's appearance in Romney's portrait was 'difficult to reconcile' with his appearance in Wright's. The likeness in the two portraits is close; perhaps Nicolson was puzzled by the greatly-altered uniform. Romney painted a pendant portrait of Milnes's wife, Charlotte Frances Bentinck, in 1785, the year in which they were married (both portraits were exhibited at Leger's in 1975, in *English Eighteenth Century Conversation Pieces, Portraits and Landscapes*, 1, as a pair, both repr. in colour, 'Robert Shore Milnes' on the front cover). Robert Shore Milnes and his wife sat to Romney again in 1788–92, for two full-length portraits; that of Robert Shore Milnes is still in the family collection, and that of Mrs (later Lady) Milnes is in the Frick Collection, New York.

32

John Whetham of Kirklington, Nottinghamshire painted 1781–2

Oil on canvas 50 × 40 (127 × 101.6)

PROVENANCE
In Wright's Account Book as 'Half length copy of M: Whetham £25.4.0', among pictures of *c*.1780–2; commissioned by Robert Holden (but eventually paid for by Mrs Whetham), and thence by descent to the present owner.

EXHIBITED
Graves 1910 (52)

LITERATURE
Christopher Hussey, 'Nuthall Temple, Notts., II', *Country Life* 5 May 1923, p.612, fig.2; Nicolson no.140, pp.224–5; pp.72, 124 n.1; pl.194

Robert Holden Esq.

John Whetham was probably born in London, and probably in 1732. When he went up to Trinity College, Oxford in 1750 (his age there recorded as 18, and his later residence as Kirklington, Notts.), he was described as the son of Thomas Whetham of St James's, Westminster: presumably the same as the Lieut.-Colonel Thomas Whetham who was described as of Turnham Green, Middlesex, when he purchased the manor of Kirklington, Nottinghamshire in 1736–7.

On his father's death (? early 1750s), John Whetham took over the management of the Kirklington estate, serving as High Sheriff of Nottinghamshire in 1759–60, and landscaping his park between 1766 and 1774 (Kirklington estate plans of these dates are held by Nottinghamshire Archives Office).

In 1769 John Whetham married Elizabeth, daughter of Colonel Evelyn Chadwick of West Leake, Nottingham-shire; the following year his sister Georgina married Thomas Willoughby, later Lord Middleton, of Wollaton Hall, Nottingham-shire. Marriage to two sisters was one of the bonds of friendship between Whetham and Middleton; they also had a mutual friend in Robert Holden of Darley Abbey, Derbyshire.

The three friends decided to sit for their portraits; and according to Hussey, each of them intended to commission a copy of the others' portraits (certainly true in Robert Holden's case). Lord Middleton took the lead, and sat to Romney in 1779 for a full-length portrait in peer's robes (H. Ward and W. Roberts, *Romney*, 1904, II, p.103). Whetham and Holden, being less

grand, chose to sit to Wright of Derby. Wright's quiet and sensitive portrait of Robert Holden *c.*1780 is reproduced by Nicolson, pl.193.

Whetham too probably sat to Wright in 1780, or early 1781, for a portrait of which there are two versions. The prime original (Nicolson pl.194), in which Whetham is shown with one arm around a Border Collie and a large hunting-spear, descended in his family until sold at Christie's, 19 July 1985 (98 repr.), bought for the Getty Museum. In the version exhibited here, the dog is mercifully (a favourite Ellis Waterhouse adverb) omitted, the large space it occupied now showing a cave-like opening. As Nicolson remarks (p.72), 'There is nothing to chose in grandeur between the two'. Whetham's costume – fur-trimmed bottle green coat, fur hat and canary-yellow waistcoat – is hardly the day-to-day dress of the English country gentleman. The catalogue of the 1910 Graves exhibition stated that Whetham is portrayed 'in otter-hunting costume': but his attire is surely too exotic for that wet and beastly sport. Hussey states that Whetham is depicted represented 'in the fancy dress he wore at a ball at Clumber' in 1778 – 9. The Nottinghamshire Archivist has records of a 'masqued ball' at Welbeck in 1768, though none of the later ball at Clumber. Masquerade costumes were devised from the very free use of the imagination; at the Countess of Moira's ball in about 1768, for example, the men came as 'Vandykes, Hussars, Croats, Pandours, Spaniards, ancient Frenchmen, Indians from the Lake Huron and River Senegal, Turks, Armenians, Moors . . .' (quoted by Ribeiro p.285). If Whetham is in fancy dress, perhaps he is masquerading as an Armenian.

Whetham, who looks so robust in Wright's portrait, died on 29 August 1781, before it was finished. Robert Holden's MS diaries record on 19 April 1782: 'Went down to M.ʳ Wright to settle about poor W's picture'. Wright was evidently still working on it; on 8 May Holden again called on Wright 'to see poor W's picture'. By the end of July, the picture was finished and installed at Darley Abbey; the entry for 29 July 1782 reads 'M.ʳ Wright break-fasted & fix'd poor Whetham's picture', which shows that Wright was not above hanging his pictures for his patrons. The frame for the portrait cost four guineas. Holden, who had himself commissioned this version of his friend's portrait, records that 'M.ʳˢ Whetham has quite out-manoeuvr'd us by paying for yᵉ picture'.

32

Hussey reproduces a photograph show-ing the portraits of the three friends as they hung together at Nuthall Temple (where a later branch of the Holdens lived), with Romney's portrait of Lord Middleton (a smaller version which Holden had com-missioned) hanging between Wright's portraits of Robert Holden and John Whetham.

(The compiler is most grateful to Robert Holden, for allowing her to read and quote from the MS diaries of the earlier Robert Holden, and Adrian Henstock, Notting-hamshire Archivist, for information.)

33

Cornet Sir George Cooke *c.*1766–8

Oil on canvas 30$\frac{3}{16}$ × 25$\frac{1}{8}$ (76.7 × 63.8)

PROVENANCE
Not in Wright's Account Book (unless it is
'Cap.ⁿ Coke of the Blues', an entry among
pictures painted some ten years later); by
descent to Sir William Cooke; M.
Knoedler & Co., New York, from whom
purchased, as by John Singleton Copley,
by The Nelson-Atkins Museum of Art
1930
EXHIBITED
Old and New England, Rhode Island School
of Design, Providence, Rhode Island, Jan-
uary 1954; Dallas Museum of Fine Arts,
1955; *Clothes Make the Man*, Denver Art
Museum, 1956
LITERATURE
*Handbook of the Nelson Gallery of Art-Atkins
Museum*, 1, 5th ed., Kansas City, Missouri,
1973, p.146, repr. (and earlier eds.);
Nicolson no.44 p.191; p.36; pl.86

*The Nelson-Atkins Museum of Art, Kansas
City, Missouri (Nelson Fund)*

33

The bright colours and their contrast with
a dark featureless background suggest to
this compiler a date of *c.*1766 – 8, several
years earlier than Nicolson's '*c.*1770 –1'.

The sitter is Sir George Cooke, Bart.,
born in about 1745, the only son and heir
of Sir Bryan Cooke, 6th Bart., of Wheatley
Hall, near Doncaster, Yorkshire, and his
wife Mary Foley.

On 4th April 1766, on his father's
death, George Cooke, then aged about 21,
succeeded as 7th Bart.; six days later, on
11 April 1766, he purchased his com-
mission as Cornet in the Royal Regiment
of Horse Guards ('The Blues'). His
decision to sit to Wright for his portrait
may have been to commemorate both
events, and possibly also his majority. The
regiment which he chose was one of the
most chic and most expensive in the whole
of the British Army. Two other sitters to
Wright already served in it: 'Captain'
Robert Shore Milnes (No.31) and Captain
Richard French (Nicolson pl.85).

Cooke's uniform is of a particularly styl-
ish and exuberant sort. Wright depicts,
faithfully and correctly, every detail of the
uniform as worn in 1766 – 8 (and for the
following terms the compiler is indebted to
experts at the National Army Museum):
dark blue coat trim med with gold lace,
cuffs slashed, one gold epaulette only, on
the left shoulder (officers in Infantry regi-
ments wore them on the right), red scarf

worn over the left shoulder, buff waistcoat,
black tricorne hat. Regimental dress was
considerably reformed by the Warrant of
1768 (though it was not of course changed
overnight) in the interests of practicality;
the uniform worn by Robert Shore Milnes
(No.31) is already very different to
Cooke's.

Wright's painting of Cooke's sword hilt
presents an interesting question, though an
unanswerable one since we do not know
what he charged for this picture. When
painting portraits, Wright invariably (like
other artists) charged more for 'a hand'.
The intricacies of Booke's sword hilt must
have taken him far longer to paint than
Cooke's hand would have done, but
Wright is evidently so fascinated by the

design of the thing and the way its dull
gleams respond to the light that he is
unlikely to have begrudged time spent on
it, content to paint the gleams and let the
guineas go.

Wright paints Cooke as if he were a
veteran emerging from the smoke of battle;
it takes a second glance to see that this
hero is hardly more than a boy of twenty-
one or so. Cooke's military career was in
fact brief; he did not progress beyond the
rank of Cornet, or most junior officer, and
he saw neither active service nor service
abroad. His last appearance in the Army
List is in 1770; either in that or the follow-
ing year he sold his commission and left
the Army to settle down at Wheatley
Hall in Yorkshire, marrying twice (pro-

ducing a son and heir by his first wife) and becoming Colonel of the 3rd Battalion of the West Yorkshire Militia. He died on 2 August 1823.

(The compiler is most grateful to Jenny Spencer-Smith and Sylvia Hopkins of the National Army Museum for advice over uniform, rank etc. in this portrait and in that of 'Captain' Robert Shore Milnes, No.31.)

34
Portrait of a Lady with her Lacework *c.*1770

Oil on canvas 49¾ × 40 (126.7 × 101.6)
PROVENANCE
. . .; gift of Heathcote Art Foundation to the Metropolitan Museum of Art 1986
LITERATURE
Recent Acquisitions: A Selection 1986–1987, Metropolitan Museum of Art, New York p.37, repr.

Metropolitan Museum of Art, New York; gift of Heathcote Art Foundation

This is the first time this picture has been included in an exhibition. It is well described by Lucy Oakley, writing in the Metropolitan Museum of Art's *Recent Acquisition . . . 1986–7:* 'Wright's fascination with light is evident here in the way he describes its effect on different surfaces: the gleaming wood table-top, with its still-life of shimmering satin workbag and glistening metal tools; the sparkling lacework in progress, so intricately described that we can almost count the stitches; the glistening gathers of satin in the dress and curtain; the translucent scarf; and the lustrous pearls, 'opportunities for those globules of light collecting on their surfaces', in the words of Benedict Nicolson.'

This portrait was unknown to Nicolson; and nothing is known of its early provenance. It must belong stylistically to *c.*1770; and for a 50 × 40 portrait like this, Wright would probably have charged ten guineas, or the same as he charged for Fleetwood Hesketh's portrait, No.37. 'Unclaimed' ladies in Wright's Account Book *c.*1769–71 include Mrs Hardman, Mrs Gore, Miss Knight, Miss Leice, Mrs Leigh, Miss Parr and Mrs Southward, all listed as sitters at Liverpool in 1769 at ten guineas each; but since Wright's lists of sitters are known to be incomplete, especially for this period (omitting, for instance, the portraits of Mrs Ashton,

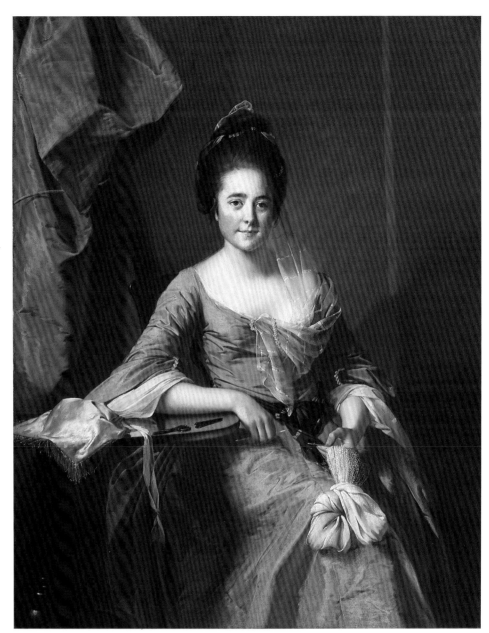

34

No.25 and Mrs Clayton, No.26), the lady in rose satin may well not be recorded there. It would have been nice to recognize a pictorial pun on Wright's part and to identify her as 'Miss Leice', but as it is, we can only hope that some clue to her identity will turn up.

The circle the lady moves in is evidently prosperous, possibly nouveau riche. She herself is at once more sophisticated and more beguiling than most of Wright's female sitters; her half-smile – rare in Wright's portraits, though matched by Mrs Coltman's – seems particularly winning after the formidable faces of Mrs Ashton and Mrs Clayton. Wright evidently found her an appealing subject.

35

Robert Vernon Atherton Gwillym dated 1766

Oil on canvas 50 × 40 (127 × 101.6)
PROVENANCE
Neither this nor the following portrait appears in Wright's Account Book. Presumably commissioned by the sitter, and thence by descent to 7th Lord Lilford, by whom sold to Sabin Galleries 1961, from whom purchased by the City Art Museum of St Louis, Missouri, 1965
LITERATURE
Nicolson no.68 p.201; pp.33–4, 49; pl.56

Saint Louis Art Museum; gift of Miss Martha I. Love in memory of Daniel K. Catlin

The sitter was the son of Robert Gwillym of Langston and Walford, Herefordshire and his wife Elizabeth, daughter of Richard Atherton, of Atherton in Lancashire; on the death of her father, the last surviving Atherton, her husband and his heirs succeeded to the Atherton estates. Robert Vernon Atherton Gwillym is portrayed as a child, standing on the right, in Devis's portrait of his father, Robert Gwillym of Atherton, with his family *c.*1745–7(D'Oench no.15, p.50, repr.; Sartin no.13, p.45, repr. p.81).

Robert Vernon Atherton Gwillym succeeded his brother to the Atherton estates in 1771, and that year assumed the name and arms of Atherton. From 1774 to 1780 he was MP for Newton, but is not known ever to have spoken in the House of Commons. Despite his robust look in Wright's portrait, he had bad health. He died in France in 1783, aged 42.

These two excellent portraits incidentally provide a good illustration of Wright's recurring disinclination to design two portraits as a pair, perhaps believing that this inevitably led to some loss of individuality in each. Here husband and wife are painted on a different scale, and each looks in the same direction rather than towards each other; the skylines are of different heights, and only the rather ominous grey clouds suggests that these two sitters occupy common ground. The balustrade in front of Gwillym, with its cracks, its two missing balusters and the beautifully-observed iron clamp which alone ensures that the coping will not collapse, flouts all contemporary conventions

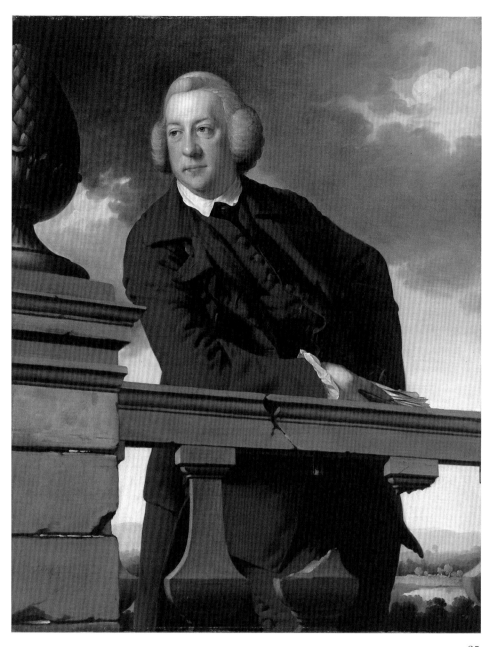

35

of elegant portraiture. Without a surviving exchange of letters between patron and painter, we can only assume that it was Wright's idea to pose his patron thus. Presumably it amused Gwillym, though not every patron would have liked to be portrayed as if his property was in such poor repair.

Robert Gwillym's head has undergone considerable restoration.

36

Mrs Robert Gwillym dated 1766

Oil on canvas 50 × 40 (127 × 101.6)
Inscribed 'J. Wright Pinx' 1766' lower l.
PROVENANCE
as for No.35
LITERATURE
Nicolson no.69, p.201; pp.33–4, 49; pl.55;
J. Douglas Stewart 1976, p.410, figs 90, 93

*Saint Louis Art Museum; gift of Miss Martha
I. Love in memory of Mr Daniel K. Catlin*

The sitter, born Henrietta Maria Legh,
daughter of Peter Legh of Lyme Hall, Co.
Chester, married Robert Gwillym in
January 1763. Their only son to survive
infancy died unmarried in 1789; of their
three daughters, the eldest married
Thomas Powys, 2nd Baron Lilford, and in
that line the portraits descended.

Mrs Gwillym is holding an English
guitar, an instrument which had little in
common with the guitar proper, being
similar in shape to the cittern, and plucked
with the fingers. English guitars came into
fashion about the middle of the eighteenth
century (Robert Bremner published his
tutorial to them in 1758). They were hand-
somely made, and became extremely
popular, especially with fine ladies. Charles
Burney, writing in 1819, speaks of the
'guitar paroxysm' of about fifty years ear-
lier: 'All the ladies disposed of their harpsi-
chords at auction for one-third of their
price, or exchanged them for guitars'.

Mrs Gwillym, portrayed in 1766, is thus
up to the minute in her possession of an
English guitar. It should however be
observed that she is not actually playing
the instrument she holds. In this she seems
to lack the musical ardour of the plain but
endearing Mrs John Lockwood, playing
her guitar in a romantic wilderness and
portrayed by Devis *c*.1757 (repr. Sartin
p.105, no.36); and she is by no means as
enrapt as Arabella Hunt, in Kneller's lost
painting of *c*.1690. As J. Douglas Stewart
points out, Wright derived Mrs Gwillym's
pose from John Smith's mezzotint after the
Kneller (repr. Stewart 1976 p.411 fig.91);
the pose, the turn of the head and the far-
away look are all clearly derived from the
engraving, and like Arabella Hunt in her
bosky grove, Mrs Gwillym sits out of doors.
But Wright, himself a musician, has taken
pains precisely to depict Mrs Gwillym's
English guitar in place of Arabella Hunt's
lute. The new instrument is beautifully
full-bodied, with a brassy ornamental rose
and a square finial decorated with

mother-of-pearl and tortoiseshell. Wright
observes it so carefully that the portrait is
selected by the editor of *The New Grove* to
illustrate the section on the English guitar.
Mrs Gwillym may have been shy of per-
forming before her portraitist, or perhaps
she was no great player. She has taken the
trouble to position her fingers correctly; for
the rest, she looks meditative rather than
enrapt.

(ed. Stanley Sadie, *The New Grove Diction-
ary*, VI, 1980, pp.199–200, the portrait
repr. p.200; VII, 1980, p.834. An English

guitar very like Mrs Gwillym's, *c*.1770, is
described and illustrated in Anthony
Baines, *Catalogue of Musical Instruments*,
Victoria and Albert Museum, II, 1978,
p.51, II/6, fig.72, right)

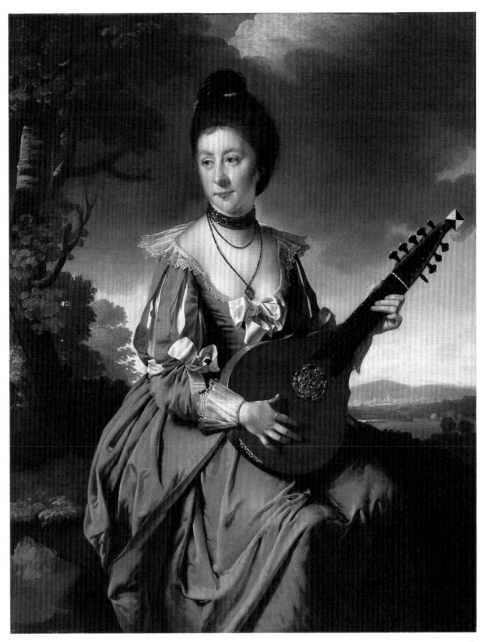

36

37 (not exhibited)

Fleetwood Hesketh painted in 1769

Oil on canvas 50 × 40 (127 × 101.6)
PROVENANCE
In Wright's Account Book, with a a por-
trait of the sitter's wife, as 'M.ʳ & M.ʳˢ
Hisketh £21' (i.e., ten guineas each); by
descent from the sitter
EXHIBITED
Local Art Treasures, Festival of Britain exhi-
bition, Atkinson Art Gallery, Southport,
1951 (153, repr.); *Treasure Houses of Britain*,
National Gallery of Art, Washington,
1985–6 (447, repr. in colour)
LITERATURE
Nicolson no.81, pp.204–5; p.99; pl.61

Private Collection

Fleetwood Hesketh, born in 1738, was the
son and heir of Roger Hesketh and his wife
Margaret Fleetwood; both his parents had
inherited large estates, and their union
placed them among the most considerable
landed families in Lancashire. Devis's
'Roger Hesketh and his Family' *c.*1742–3
includes Wright's sitter at the age of four or
five, a hardly recognizable manikin (repr.
D'Oench pl.7 and Sartin pl.11). At that
stage the family lived in Preston,
Lancashire; but as Wright's Account Book
includes the portraits of 'M.ʳ & M.ʳˢ Hisketh'
in his list of 'Sitters at Liverpool 1769' it
may be that Fleetwood Hesketh and his
wife had established themselves at Meols
Hall, at Southport near Liverpool, which
had once been and was from about 1840
again to become the Hesketh family's prin-
cipal seat.

Fleetwood Hesketh, at the age of thirty-
one, is portrayed by Wright in a more
informal and relaxed version of his portrait
of Edward Becher Leacroft of the
Markeaton Hunt (No.8) of six or seven
years earlier, though Fleetwood Hesketh's
gun and the powder flask slung over his
shoulder indicate that he is dressed for
shooting. The crumpled handkerchief
recalls that in Leacroft's portrait and in
that of Harry Peckham (No.6); it will recur
in the portrait of Christopher Heath of
*c.*1781 (No.137).

In the companion portrait of Mrs
Hesketh (in the same collection; Nicolson
pl.62), the pose is much more conven-
tional. Like his father, Fleetwood Hesketh
married an heiress, Mary Bold, daughter
of Peter Bold, of Bold; their eldest son was
named Bold Fleetwood Hesketh, which
may not have pleased him as much as his
parents. Fleetwood Hesketh died in 1769,

the year in which he sat to Wright. As
High Sheriff of Lancashire, his grandson
attended the opening of the Liverpool-
Manchester railway in 1830: a fact only
worth recording here as a reminder that
Wright painted this protrait only two gen-
erations earlier than the railway age.
Would he have found congenial subjects in
it?

(for a history of the Heskeths as well as the
house, see John Cornforth, 'Meols Hall.
Lancashire, 1', *Country Life* 25 January
1973, vol.153 i, pp.206–9)

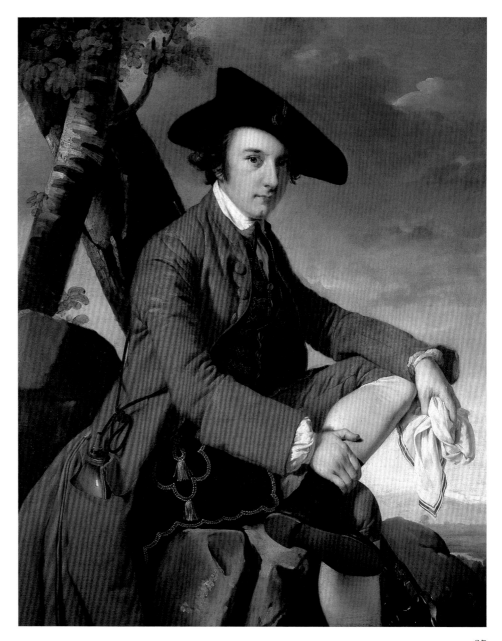

37

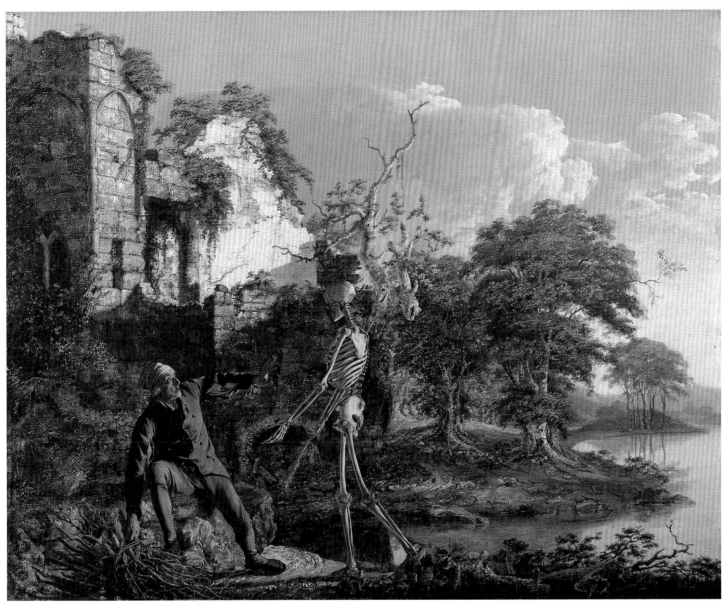

38

The Old Man and Death exhibited 1774

Oil on canvas 40 × 50 (101.6 × 127)
PROVENANCE
In Wright's Account Book as 'The Old Man & Death £63'; remained on the artist's hands; offered in Wright's posthumous sale, Christie's 6 May 1801 (58, as 'The Allegory of the Old Man and Death in a picturesque Landscape, a River Scene with Gothic Ruins – a very correct Knowledge of Anatomy is displayed in the Figure of Death; the Alarm of the old Peasant is finely expressed, and the Lights throughout the Picture are uncommonly brilliant'), bt in £51.9.0; sold Shaw, Derby, 11 October 1810 (5), bt Sir Robert Wilmot of Chaddesden £84, and thence by descent until 1952; H. J. Spiller, London; purchased by the Wadsworth Atheneum, Hartford, Connecticut 1953
EXHIBITED
Society of Artists 1774 (321); Derby 1843 (224); Derby 1866 (177); Derby 1870 (267); Derby 1883 (30); RA 1886 (6); Smith College 1955 (12); *Romantic Art*, Trinity College, Hartford, Conn. 1955 (5); Durlacher NY 1960 (11); *Sublimity and Sensibility*, Fogg Art Museum, Harvard University, Cambridge, Mass. 1965 (39); Detroit & Philadelphia, 1968 (29, repr. p.29); Paris 1972 (341)

LITERATURE
Rosenblum 1960 p.27, fig.8; Robert Rosenblum, 'Sources of Two Paintings by Joseph Wright of Derby', *Journal of the Warburg and Courtauld Institutes*, xxv, nos.1–2, 1962, pp.135–6, figs a and c; F. C[ummings], entry in 1968 Detroit & Philadelphia catalogue (cited above), pp.28–9; Nicolson no.220 p.243; pp.55–6 (figs.68–9), 59, 62; pl.123

Wadsworth Atheneum, Hartford, Ella Gallup Sumner and Mary Catlin Sumner Collection

The subject is taken from one of Aesop's Fables, or possibly from La Fontaine's later rendering of that fable; both authors

were available in numerous English translations in the eighteenth century. In this fable, a poor old man, bowed down by a load of faggots, drops his bundle and calls on Death to release him from his misery: but when Death appears, he is so appalled that he pretends that all he wanted was help in hoisting his bundle on his back again. 'Better to suffer than to die', is the moral.

Rosenblum believes that Wright may have used an edition of *Select Fables of Esop and other Fabulists* published in Birmingham in 1761, since this contains a (crude) illustration (his fig.c) which Rosenblum suggests provides 'the simple schema' for Wright's work. Nicolson (p.56) finds it 'inconceivable' that Wright should have 'derived any visual satisfaction from this beastly little circular print', and suggests instead Marcus Gheeraerts' engravings for a Dutch edition of Aesop first published in 1567. Wright's imagination was quickly aroused, and the 'beastly little circular print' may have been enough to trigger it off; but a more convincing source may yet be discovered. Nicolson points out, incontestably, that Wright's skeletal figure of Death is largely taken from the third table of Bernhard Siegfried Albinus's *Tables of the Skeleton and Muscles of the Human Body*; an English edition was published in 1749, of which Mortimer owned a copy, and which Stubbs also used. Nicolson reproduces the Albinus walking skeleton (p.56, fig.69).

Wright's skeleton holds the arrow of death in a 'reversed arms' position, so that the arrow's pointed end points backwards over its shoulder. Cummings very sensibly suggests that the reversed position of the arrow's point indicates that 'death in this case is a matter of choice and is not being inflicted'.

Perhaps the strangest aspect of Wright's picture is the fact that he stages this macabre scene in broad daylight. Death appears literally out of the blue, on a fine day, in a calm river landscape. The trees are in full leaf: one tree only is blighted, behind Death, and perhaps because Death has passed by. Wright has his own unpredictable ways of driving home a moral, and rarely does the obvious thing. When he paints a dramatic night sky and a lurid, lantern-lit landscape, it is as the background for the prosaic work of 'The Earthstopper' (No.51); but it is not too late for the Old Man to learn that Death can come on a fair day as much as on a foul one. Rosenblum comments that 'to eyes accustomed to the Surrealist combination of irrational subject and photographic

detachment in Magritte, Roy or Delvaux, the objective recording of a sun-flooded landscape in Wright's painting paradoxically underscores the frightful and unexpected apparition of death' (1960, p.27). The picture evidently made Wright's contemporaries uneasy. The *Middlesex Journal* 30 April – 3 May 1774, reviewing the Society of Artists' exhibition in which this picture hung, commented on the expressiveness of the Old Man's head, but considered 'the rest of the picture out of nature'.

By the time that 'The Old Man and Death' appeared in the exhibition, Wright was in Italy. In a letter of 13 April 1774 to his sister Nancy (Bemrose p.32), Wright hopes that the picture is 'hung advantageously' and that it will sell; 'I have set 80 guineas upon it, but I would take 70 rather than not sell it'. This may partly reflect Wright's anxiety about the cost of the Italian trip. He must have been disappointed that 'The Old Man and Death' did not sell, either during the exhibition or (as it turned out) during his lifetime.

Rosenblum compares the precise painting of detail in the landscape to the 'crystalline exactness of the Pre-Raphaelite vision of nature' (1960, p.27). To this compiler, those precise details seem rather to be a little heavy-handed, as if Wright were not yet sufficiently at home with landscape painting to know how much detail needed to be precise, and how much could be suggested.

The ruined building may allude, as has been variously suggested, to the transience of human life. It seems insufficiently fantastic to be a 'Gothick ruin' drawn from imagination, and may be part of a derelict abbey somewhere in Derbyshire; we would not be wholly surprised to find another part of it giving temporary shelter to a blacksmith's shop.

A version (25 × 30 ins.), showing only the central part of the picture, is reproduced by Nicolson (p.56 fig.68 and cat.no.221, in the collection of the Walker Art Gallery, Liverpool).

39

The Alchymist, in Search of the Philosopher's Stone, Discovers Phosphorus, and prays for the successful Conclusion of his operation, as was the custom of the Ancient Chymical Astrologers exhibited 1771; re-worked and dated 1795

Oil on canvas 50 × 40 (127 × 101.6)
Inscribed 'J.W.Pinx? 1795' at extreme right
PROVENANCE
In Wright's Account Book as 'The Chymist £105'; unsold by 1773, so taken by Wright to Italy, unsold there and brought back 1775; remained on his hands; offered in Wright's posthumous sale, Christie's 6 May 1801 (62, as 'The Alchymist in his Elaboratory with Assistants . . . companion to lot 63 'The Hermit''), bt in; sold Wright sale, Mr. Shaw, Derby, 11 October 1810, bt Mr Tate of Liverpool, for Colonel Wilson; Christie's, 5 February 1881 (665), bt McLean; F. Beresford Wright, from whom purchased by subscription for Derby Art Gallery 1883
EXHIBITED
Society of Artists 1771 (209); British Institution 1817 (118); Derby 1883 (19); Graves 1910 (84); Derby 1934 (4, repr.); Derby 1947 (28); Sheffield 1950 (5); Tate & Walker 1958 (10); Derby 1979 (14)
LITERATURE
Shurlock p.435–8; Klingender pp.53–4; Nicolson no.195, p.236; pp.52, 118–120; pl.106; Frederick Cummings, 'Folly and Mutability in Two Romantic Paintings: The Alchemist and Democritus by Joseph Wright', *Art Quarterly*, XXXIII no.3, 1970, pp.247–271
ENGRAVED
by William Pether as *An Alchymist*, published 1775: an impression exhibited as No.163 (P15)

Derby Art Gallery

The long and presumably carefully-worded title (above) which Wright gave this picture when exhibiting it in 1771 largely explains its subject-matter, while posing some questions. The chief pursuit of alchemists had traditionally been the search for 'the philosopher's stone' which would miraculously transmute base metals into gold. The experiments of Wright's Alchymist had begun with the hope of producing that elusive philosopher's stone; but to his amazement and, indeed, to his awe, he finds himself on the verge of discovering a hitherto unknown, purely scientific substance, phosphorus.

Perhaps the chief enigma of Wright's paintings arises from uncertainty about what age we are in. Nicolson maintains that Wright's Alchymist is 'not a relic of a pre-scientific age but a modern scientist' (p.52). Cummings pours scorn on this phrase, insisting that Wright depicts 'a scene from ages past rather than a contemporary event' (p.252). In using the phrase 'a modern scientist', Nicolson (as his later comments on the picture make clear) may have been going too fast for some readers; he should perhaps have prefaced the phrase with 'essentially' or 'in spirit' (but he is never a writer to labour his points).

To this compiler, the most illuminating comments on 'The Alchymist' are Klingender's: 'Despite its Gothic setting and picturesque embellishments, this work is utterly opposed to its seventeenth century predecessors. Without a trace of satire, its mood is as serious as that of the 'Orrery' and 'Air Pump'. Its purpose is not to ridicule the superstitions of the past, but to commemorate the birth of modern science from those superstitions. For it was the discovery of phosphorus that stimulated the research of Robert Boyle (1627–91) and his contemporaries into the nature of combustion, and marks the beginning of chemistry as a modern science' (p.54).

Wright may also be celebrating the fact that in the history of science, some discoveries have been accidental. The *Elements of the Theory and Practice of Chemistry*, by Pierre Joseph Macquer, published in 1749–51 and in an English translation in 1758, made this very point (as Nicolson shows, p.119). Alchemists, Macquer wrote in his preface, are rightly discredited for believing that chemical experiments will produce gold: but 'those experiments, though quite useless with regard to the end for which they were originally made, proved the occasion of several curious discoveries'. Phosphorus was first discovered in 1676; perhaps that date, some sixty years before his own birth, was roughly what Wright had in mind when portraying his 'Alchymist'.

Macquer's work could have been discussed with Wright by his scientifically-minded friend Peter Perez Burdett (portrayed here with his wife in No.40), whose advice Wright was to seek over details in this picture, or by James Keir, translator of Macquer's *Dictionary of Chemistry* in 1771, Lunar Society member and glass-maker (see Nos.44,45).

Klingender, Nicolson and Cummings all cite various seventeeth-century paint-

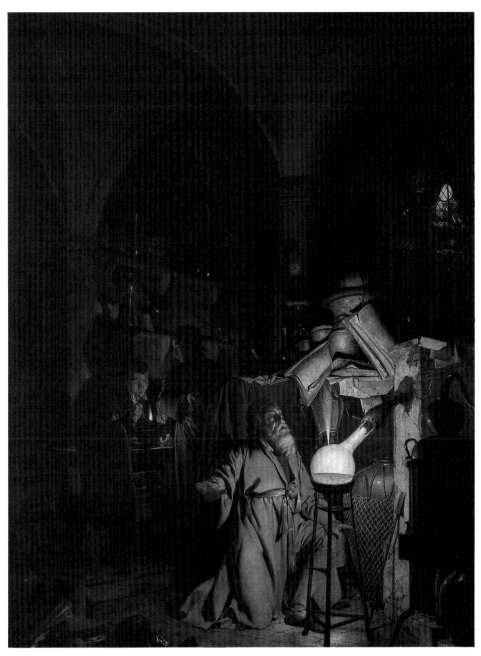

39

ings on the theme of the alchemist, usually a half-crazed figure in a cobwebbed room full of alembics and stuffed crocodiles. Nicolson suggested that Wright could have seen two pictures of 'The Alchemist' by Thomas Wyck, then hanging at Ham House (p.52, one repr.); but John Gage pointed out (1969 p.305) that that collection was 'virtually inaccessible' between 1727 and 1799.

What is far more likely to prove a key influence on Wright's picture (if it can be traced) is an 'Alchymist' by Thomas Wyck which David Fraser spotted in the catalogue of the sale of Wright's patron John

Leigh Philips, conducted by Winstanley & Taylor, Manchester, 31 October 1814 (17 in list of Paintings): 'T.Wyck - The Laboratory. One of the best pictures known of the master; it was once the property of Mr. Wright of Derby, and very highly valued by him'.

When the picture was nearly complete, Wright asked P.P. Burdett's advice over certain details of the Alchymist's apparatus. Burdett replied on 4 February 1771, in a letter written on the back of a sketch for 'The Alchymist' (? by Burdett, or by Wright); reproduced fig.12.

Macquer's account of the process of

manufacturing phosphorus – which took twenty-four hours – is quoted by Nicolson (pp.118–9). The close correspondence between Wright's details and Macquer's account strongly support the probability that Wright drew heavily from Macquer (quotations and linking passages are taken from Nicolson):

'Place your retort . . . in a reverberating furnace, so proportioned, that there may be an interval of two inches all round between the sides of the furnace and the bowl of the retort, even where it contracts to form the neck, which should stand inclined at an angle of sixty degrees . . . Fit on to the retort a large glass balloon two thirds [sic] full of water, and lute them together . . . In the hinder part of this balloon, a little above the surface of the water, a small hole must be bored . . . The operation lasts four and twenty hours. [He goes on to describe the rising of the vapours in the balloon, the forerunners of the phosphorus. Then:] the first volatile Phosphorus . . . appears in about three hours after the white vapours first begin to rise . . . there will issue out through the little hole of the balloon a stream of blueish light, which continues of a greater or shorter extent to the end of the operation ... from time to time [it] darts out to the length of seven or eight inches, snapping and emitting sparks of fire . . .

Nicolson adds: 'Wright's jet is shown at about its fullest extent. We could have trusted him to catch his alchemist at the most dramatic moment. What is more, his jet is *Bluish*'.

Interpretations of the Alchymist's behaviour in the face of his awesome discovery might alone inspire several theses and four or five Shorter Notices. He can hardly know what substance he is on the verge of discovering; he does know (or appear to know) that he is about to go through the equivalent of the sound barrier. The younger assistant behind him is terrified. The Alchymist shows no terror, though he is evidently in awe of what is happening. He falls to his knees and, in Wright's phrase, 'prays for the successful conclusion of his experiment': not, perhaps, a prayer to God for assistance and protection, but to Providence that all may go well. His attitude has been likened to that of St Francis receiving the stigmata, or other saints transfixed by visions; but the direction of the Alchymist's gaze should be carefully observed. He does not roll his eyes upwards to heaven. His gaze is keenly fixed upon the

fig.12, recto

jet of phosphorus which issues from his apparatus.

To this compiler, one of the strangest things about this picture is the Alchymist's spotless robe. Cummings, oddly, writes that his 'clothes are tattered' (p.251); not so. That sea-green robe and its silken sash are entirely free from the splashes and stains of the average white lab-coat of today, though the Alchymist has probably been working in his 'elaboratory' for nearly twenty-four hours. Perhaps he has donned a spotless robe for the moment of discovery.

'The Alchymist' and the so-called 'Hermit' have been thought of as pendants since Wright's posthumous sale of 1801, when they were described as 'companions'. However, we now know that the 'Hermit' (No.41) was exhibited in 1769, two years before 'The Alchymist'; while this does not rule out the idea that Wright painted 'The Alchymist' as a pendant to the earlier picture, it makes it perhaps less likely.

'The Alchymist', exhibited in 1771 and engraved in 1775, is dated 1795, presumably after some re-working.

fig.12, verso: Letter from P. P. Burdett to Wright, from Liverpool, 4 February 1771, advising on 'The Alchymist', on the back of a pen, ink and wash sketch of the subject (repr. above); paper size $13\frac{1}{4} \times 10\frac{3}{4}$ (33.7 × 27.4) *Derby Art Gallery*

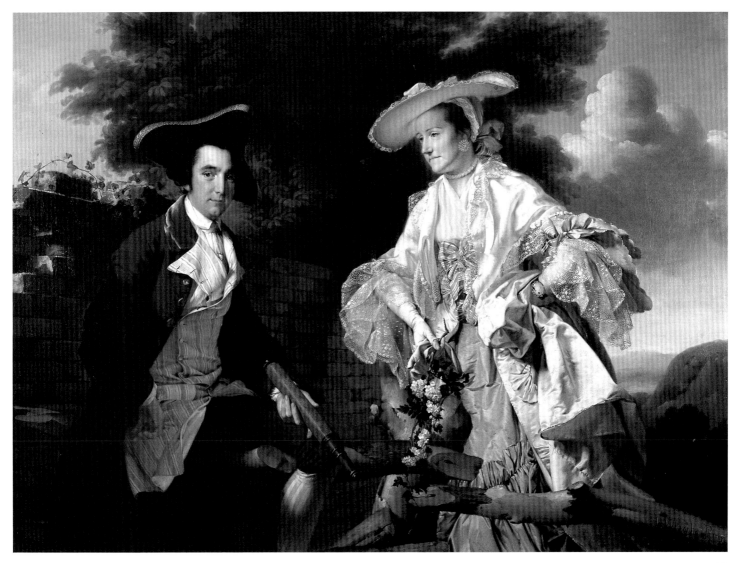

40

Peter Perez Burdett and his first wife Hannah dated 1765

Oil on canvas 57 × 80¾ (145 × 205) Inscribed 'I. Wright Pinxᵗ / 1765' on paling fence lower r.; inscribed on the reverse of the canvas, in black over traces of the same earlier wording, 'The portraite, of Peter Perez Burdett / and Hannah, his Wife: being / yᵉ Admirable performance / of Friendly Testimony, / of Joseph Wright of Derby / Whose merit as a Painter. / is exceeded by his Worth as / a Man: as his Art is exceeded by Nature.'

PROVENANCE
Evidently painted as a gift to the sitters (and not in Wright's Account Book), and taken with them to Baden 1774; passed on

Burdett's death in 1793 to his daughter Anne (by his second wife), who married Count Friedrich Nostitz and moved with the portrait to Prague, then by descent until acquired by the National Gallery, Prague, 1945

LITERATURE
Gustav Parthey, Deutscher Bildersaal II, Berlin 1864, p.814; Theodor von Frimmel, Von der Galerie Nostitz in Prag, Blätter für Gemäldekunde V, 1910, p.4; Jaromí Šíp, Anglické maliarstvo v Galerii hlavného mesta SSR Bratislavy, Výtvarný život 19, 1974, p.27; Milan Žd'ársky, Anglické malířství 18. století ze sbírek Národní galerie v Praze, Umění XXIII, 1975, p.777; Jiří Kotalík and others, *Die National galerie in Prag*, 1, 1988, p.236, repr. p.237 in colour

Národní Galerie, Prague

The sitters are Wright's friend Peter Perez Burdett, cartographer and engraver (though two words hardly sum up his various ambitions), and his first wife Hannah. She is said to have been older than Burdett, and looks it; he may have found it expedient to marry a widow with funds.

This brilliant if strange double portrait has not previously been exhibited nor published outside Prague. It is characteristic of Burdett that he should dominate it, with his restlessly-perched pose and his sardonic expression. It is equally characteristic of him that he remains an elusive, rather tricky figure. In this portrait, he holds a telescope, suitably enough, as his chief profession was that of cartographer. Mrs Burdett holds a branch of flowering may, or hawthorn. Burdett looks as if he doesn't care a fig for appearances, Mrs Burdett as if she cares a great deal. The

immediate setting in which this oddly assorted couple find themselves is bizarre, and may spring from Wright's perception that the Burdetts' was hardly a stable union. The sharp-edged palings, none meeting, yet effectively separating the wife from the husband, are perhaps more unnerving than the precarious brick wall. The portrait was painted as a gift to the sitters. The slightly double-edged inscription on the back can have been added only by Burdett.

This catalogue has not generally offered a detailed list of sources for its subjects, but in the case of the still half-obscure and exceptionally interesting figure of Burdett, it seemed worthwhile (though by no means all-inclusive). J.B. Harley & P. Laxton, *Introduction* to a facsimile reprint of P.P. Burdett, *A Survey of the County Palatine of Chester*, 1777, Historic Society of Lancashire and Cheshire, Occasional Series 1, 1974; pp.1–7 of the *Introduction* give the fullest account of Burdett's activities and character to date, followed by an assessment of his work as a county surveyor. *Burdett's Map of Derbyshire 1791* [i.e. a new edition of his map of 1767], Introduction by J.B. Harley, D.V. Fowkes & J.C. Harley, Derbyshire Archaeological Survey, 1975, examines Burdett's work on the Derbyshire map; see also J.B. Harley, 'William Yates and Peter Burdett: their role in the mapping of Lancashire and Cheshire' *Transactions of the Historic Society of Lancashire and Cheshire*, 115; 1963, pp.117–9. There are notes (now out of date) on Burdett in E. Rimbault Dibdin, 'Liverpool Art and Artists in the Eighteenth Century' *Walpole Society*, VI, 1917–8, pp.56–6, 77–8.

For Burdett's approaches to the potteries, see Ann Finer & George Savage, *The Selected Letters of Josiah Wedgwood*, 1965, pp.115–20 (and MSS correspondence at Barlaston, not seen by this complier); also Knowles Bony, *Liverpool Porcelain of the Eighteenth Century and its makers*, 1957, pp.162–3 . For Burdett as printmaker, see Richard T. Godfrey, *Printmaking in Britain*, pp.58–9; Christopher Mendez, *Fine English Prints*, catalogue 45, 1980, pp.10–11, pls.8 and 9; John Sunderland, 'John Hamilton Mortimer', *Walpole Society*, LII, 1986, 1988, p.134, p.150 No.69b–70, fig. 110.

For Burdett in Baden, see Alfons Schäfer, 'Die erste amtliche Vermessung und Landesaufnahme in der Markgrafschaft Baden um 18 Jahrhundert', in *Veroffentlichungen der Kommission fur geschichtlich Landeskunde in Baden–Württemburg . . .* 1968, pp.154–65. Microfilm of documents relat-

ing to Burdett in the Baden Generallandesarchiv, Karlsruhe (mostly copies of letters and accounts) has been lent to the compiler by Paul Laxton.

In assembling this material, the compiler has depended, even more than usual, on the help of others, particularly Paul Laxton, who most generously put all his material at her disposal, and also David Fraser, Martin Hopkinson and Lubomir Slavicek of the Národní Galerie, Prague.

Peter Perez Burdett was about the same age as Wright. The only child of William and Elizabeth Burdett, he was baptized at Eastwood, Essex in 1735, deriving his Christian names from his maternal grandfather, Rev. Peter Perez, the Vicar of Eastwood.

By the late 1750s, or *c*.1760, Burdett seems to have been living in or near Derby. What training he had as a cartographer and surveyor is not known, but it must have been sound, for in 1762 he applied for and won a premium of £100, offered by the Society of Arts 'to any Person or Persons, who shall make an accurate Survey of any County upon the scale of one inch to a Mile'. Burdett's project was 'a survey of the County of Derby', and he seems to have begun work on it early in 1763. He took as his central meridian the line of longitude running, probably, through All Saints Church, Derby, then proceeded to determine 'the exact Geometrical Situation of every place remarkable' by the method of triangulation. The great advances made during the eighteenth century in the design and construction of surveying instruments, particularly of theodolites, gave maps of this period a new precision. *A MAP OF DERBYSHIRE, from an actual Survey, By P. P. BURDETT'*, engraved by Thomas Kitchin and dedicated to the President, Vice-Presidents and members of the Society of Arts, was published on 24 April 1767. The *Derby Mercury* announced that day that copies, price one guinea each, could be had from the Author 'at his House in Derby' in All Saints' Close (very near Wright's house in Irongate).

Burdett claimed that his map contained 'The exact Situation of every Place remarkable or curious in the said county, as Towns, Villages, Churches, Noblemen and Gentlemen's Seats, extraordinary Mountains; the Origin and Course of Rivers, Bridges, Ferries, Towns, Fords, Mills, all Main and Cross Roads, with their Measure by the Perambulator . . . ' He had of course promised more than he could fulfil, and his map ignores much

fig.13 Detail of Wright's signature, from the portrait of Mr & Mrs Burdett

industrial development; nevertheless Burdett's *Map of Derbyshire* is a solid achievement, fully up to the work of his peers in the field and establishing him as one of the leading county cartographers.

Wright's double portrait of 1765 shows Burdett on the crest of a wave, halfway through his survey of Derbyshire and expecting to reap kudos and money from it. Wright was probably impressed by the way Burdett spoke of his profession, of related scientific subjects and of art; Burdett was a habitual draughtsman. They also shared a love of music, and took part in the weekly concerts given in his house by Mr Denby, organist of All Saints, Derby, in which Wright played the flute and Burdett the violoncello. Wright introduced his friend's portrait into 'A Philosopher giving a Lecture on the Orrery' (No.18, exhibited 1766, fig.14), in which Burdett is the man taking notes on the left; the identification of this figure as Burdett is of long standing, and is now (surely?) established by the emergence of the double portrait. Burdett is also believed to be the man who faces us in 'Three Persons Viewing the Gladiator by Candlelight' (No.22, exhibited 1765); though the face appears wider, this too is probably Burdett.

'The Orrery' was purchased by Washington Shirley, 5th Earl Ferrers, Captain RN, FRS. It may well have been Burdett who encouraged Lord Ferrers to buy it; he seems to have been a friend of Lord Ferrers, from time to time living at his house at Staunton Harold, Leicestershire. On 11 July 1763 Lord Ferrers and Burdett were joint signatories to a bond (published by Bemrose p.77) to repay Wright £160 plus interest. Bemrose states that this bond was for the larger part of the purchase price of 'The Orrery' (£210); but it is much more likely to be for money

fig.14 Detail from 'The Orrery' (No.18): Burdett as model for the man taking notes on left

borrowed from Wright by Burdett, for which Lord Ferrers agreed to be jointly bound.

This was not the only sum to be borrowed by Burdett from Wright, who kept a page in his Account Book for 'Burdett's Account' (after the £80 lent in July 1763, he lent his friend ten guineas in September 1764, twelve guineas in November 1765 and £50 in December 1771: with interest, and minus £17.11.1 apparently sent from Liverpool, Burdett owed Wright £175.10.11, never paid). Burdett's survey of Derbyshire had evidently cost him more than he made out of sales of the map. He had to finance all the field work himself, and find the wages of his assistant Whyman; the Society of Arts premium of £100 soon vanished in costs. He was lucky in having a friend like Wright to stake

him. In Burdett's favour, it should be said that he constantly tried to find purchasers for Wright's work, even using his influence to get the 'Iron Forge viewed from Without' and the 'Hermit' into Catherine the Great's collection (though Burdett's Russian contacts remain a mystery).

In 1768 Burdett moved to Liverpool, where Wright too was based from the end of 1768. It says much for Burdett's plausibility that in his first year there, he was elected President of the newly-founded Liverpool Society of Arts. He contributed eight superb views of public buildings in Liverpool (or views superbly engraved, by Michael Angelo Rooker: where are Burdett's original drawings?) to William Enfield's *Essay towards the history of Liverpool*, 1773; and he completed a map of Liverpool begun by George Perry (who

had died). In 1769 he surveyed a route for the Liverpool promoters of the Leeds – Liverpool canal, and in 1771 published a Chart of the Harbour of Liverpool. He began work on an unpublished survey of Lancashire (his MS material for it is in the Nostitz Archives, Prague) and embarked on a rather hasty survey of the County Palatine of Chester, completed by others (1777) after his departure from England.

Burdett was based in Liverpool from 1768 until the spring of 1774. Wright had returned to Derby by the summer of 1770 (with some return visits). The two friends kept in touch through letters. Wright, whose confidence in his work occasionally needed boosting, had come to rely on Burdett's advice. Wright wrote to ask it over 'The Alchymist' (No.39). Burdett responded with a letter of 4 February 1771, beginning 'Dear Joe . . .' (like all his letters to Wright), and including on the back a wash drawing for the setting of 'The Alchymist' which Wright largely followed (fig.12, p.86). Wright sent at least three drawings for his painting of 'The Captive' to Burdett for criticism during the autumn and winter of 1772–3. Burdett's superiority in all matters to do with perspective made Wright nervous, needing Burdett's sanction before making any changes.

Burdett's 'Alchymist' letter of 4 February 1771 ended 'You must wonder when you are told that I am *painting* History without figures, Landscape without Trees and Shipwreck without water'. This cryptic, highly Burdettish sentence must refer to Burdett's current preoccupation with new techniques of engraving, and in particular aquatint engraving, his keenest interest in the early 1770s. The aquatint process of engraving had been invented in France, and was envied in England as 'Le Prince's Secret'. Burdett went to France in 1771, but whether he managed to learn the 'secret' there or whether he deduced the method from its results is not known. His use of the new technique was amazingly successful. In 1771 he produced the first aquatint to be published in England, after John Hamilton Mortimer, 'Banditti robbing Fishermen' (Sunderland cat. no.69b, fig.112); the date 1771 is etched on the plate. Paul Sandby is usually credited with producing the first aquatints in England, but there can be no doubt that Burdett's published work preceded his. A near-contemporary account states that Burdett, 'then run low in cash', *sold* the aquatint 'recipe' to Sandby, via a pupil, for £40; for this, and a suggestion that Gainsborough may have learnt the process

from Burdett, see John Hayes, *Gainsborough as Printmaker*, 1972, (pp.11–12).

Like Wright, Burdett became a friend of Mortimer. It was with a Mortimer design that he launched his first aquatint engraving upon a startled world; he also aquatinted Mortimer's wonderfully weird 'Composition with a Skeleton on a Seashore' (Sunderland cat.no.70, fig.110: repr. here as fig.15). It was probably these two aquatints after Mortimer that Burdett exhibited at the Society of Artists in 1772, as 'An Etching in imitation of a wash drawing' and 'An etching from a design of Mr Mortimer' (10 and 11). The following year he exhibited what must have been another aquatint, 'The effect of a stained drawing attempted by printing from a plate wrought chemically, without the use of any instrument of sculpture'(4). The cryptic phrases Burdett had used to Wright can now be seen to refer to what he called, in the titles of the aquatints exhibited at the Society of Artists, 'the effect of a stained drawing' or the 'imitation of a wash drawing', without '*Painting*', i.e. without a brush, and achieved by a chemical process, i.e. without engraving tools (but in his aquatints after Mortimer Burdett does in fact use etching as well as aquatint). For Burdett's aquatints after Wright, see this catalogue pp.242–3, P13–14.

Printmaking after his friends' work appealed to one side of Burdett's nature; but he also determined to explore the commercial possibilities of the new process and to secure maximum financial advantage for himself. He evolved a method of transferring aquatint designs to pottery and porcelain. In November 1771 he approached both Wedgwood & Bentley at Etruria and their Liverpool associates Sadler & Green. To both, he offered the same package: aquatinted designs of his own for the decoration of pottery and porcelain, and his own chemical process for transferring the designs to the ware (this was expanded by Burdett in a letter of 1773 to the King of Prussia, quoted by Bony p.163, in which he claimed that he could 'make impressions transferable to porcelain which, when vitrified, resemble and equal the most delicate paintings').

Wedgwood was interested (the Liverpool firm was not), and arranged to call on Burdett for discussions. Burdett, believing he had won the day with Wedgwood, must have written to Wright announcing success. A letter from Wright to his sister Nancy, ? of November 1771 (DPL) reports that 'Burdett's tour to France proves highly advantageous to

fig.15 Peter Perez Burdett: 'Composition with Skeleton on a Seashore' ? Exhibited 1772. Aquatint 13⅝ × 8⅛ (34.5 × 46) with (in this apparently unique state) pen and ink additions by Mortimer, including spectres in the clouds, a flying skeleton with a bottle, faces in the rocks etc. (Sunderland no.70)
Trustees of the British Museum

him. He is to etch plates for Wedgwood & Bentley to be printed upon their ware–an employ that in all probability will last him for life–by which he will or may make four to six hundred a year . . .'

An account of Burdett's negotiations at Etruria is given by Finer & Savage (pp.115–20); their conclusion is that this was 'one of those associations which teased and bothered Wedgwood & Bentley and tried their patience to breaking-point' (p.115). Wedgwood was impressed by his first discussions with Burdett, reporting to Bentley from Liverpool on 23 November 1771 that Burdett is 'fully perswaded that he can, by his new method of ingraving, produce upon our ware, *Vases* and *Tablets*, the *full* and *complete* effect of painting *in one colour* . . .' Burdett had his 'case of instruments' with him: Wedgwood was particularly impressed by 'a little machine' which could 'edge our Dishes and plates . . .' 6 or 8 for one, and ten times as well, which I think is no small discovery for us . . .' A few days later, Wedgwood hints at 'stumbling blocks' over the designs of his own for transfer to pottery which Burdett, probably unwisely, had made part of the deal; one design was of dead game, the other of seaweed and shells, neither very suitable for a dinner service. Neither Wedgwood nor Bentley seems to have considered that Burdett's 'new ingraving' was very satisfactory, and Wedgwood was worried that 'the idea of *printing*' might damage their business; he wrote to Bentley on 17 February 1772 that 'great caution should be taken that the idea of *printing* does not get abroad, as that may do us more harm than

the printing itself can ever benefit us'. Negotiations broke down in March 1772, with Wedgwood & Bentley apparently simply telling Burdett that his engraving process was not yet satisfactory. Burdett, exasperated, countered with exorbitant demands for expenses, and reputedly became 'insolent and violent and exacting'. The dashing of his hopes for at last making money must have been a bitter blow, particularly as his debts were mounting.

Burdett now tried a very high throw. He wrote to Frederick the Great of Prussia offering the secrets of his 'chemical experiments' for printing on porcelain; the letter, dated 21 February 1773, ends 'Could I be encouraged to hope that abilities like mine deserve much honour ?' (Joseph Mayer, *History of the Art of Pottery in Liverpool*, Liverpool 1855 p.36). The answer was discouraging. Burdett then wrote to Benjamin Franklin (to whom he wrote several times between 1773 and 1787), who was interested, but regretted that the colonies were not yet ready for Burdett.

Help arrived at last in the form of a young engineer named Vierordt, from the Margraviate of Baden in south Germany. He arrived in Liverpool in the spring of 1774 to study mechanics and the engraving of plans. Probably Burdett had already made overtures to Baden; Vierordt's mission to Liverpool was not only to study but also to report back on Burdett, which he proceeded to do, in a letter of 8 April 1774 to 'son frère le Sécrétaire' (copy in Baden archives). After reporting on Burdett's surveying work in Liverpool, he added 'M. Burdett avec une théorie profonde dans toutes les mathématiques en general, est bon Peintre, bon Musicien et bon graveur'. Burdett talks of moving to Germany (? to Prussia), but has had 'insufficient' offers; he has also had propositions from America. Veirordt then gets to what is presumably the nub of the matter: Burdett's 'latest demands' (so there must have been earlier negotiations) for moving to Baden, which include the costs of travelling and special allowances for his wife. It is from Vierordt that we have confirmation of what Wright's double portrait shows us: that Burdett's wife is 'plus âgée que lui et valétudinaire'.

After that things moved quickly. Wright, in Rome, wrote on 13 April 1774 to his brother in Derby: 'Mʳ Burdett has sold his goods and if off. Mʳˢ Burdett and her dear Miss Fredried are gone into lodgings, over head and ears in debt. I stand no chance of being paid at present–well, if ever . . .' Wright minded more, perhaps,

about the loss of a drawing by Mortimer which he had lent Burdett, and 'w^ch I would not lose on any account'.

Burdett seems to have fallen on his feet in Baden. The Margrave, Charles-Frederick of Baden-Durlach, who had succeeded in 1771, was keenly interested in having his territories surveyed. Burdett was given the rank of Captain (later Major), and put in charge of a team which included Vierordt and four junior surveyors; they were based in Karlsruhe. One surveying project after another was carried through. The heads of the team came to be Burdett, Schwenk and Vierordt. Burdett was reckoned to be the 'ideas man' ('genialischer Kopf', Schafer p.164), Schwenk the practical man and Vierordt the manager. Between them, the three established a school of cartographers and surveyors which was the precursor of the Karlsruhe Technical College. It was a destiny few of Burdett's friends would have predicted for him.

There are still glimpses of the unregenerate Burdett among the Baden papers–complaining about the quality of his wine allowance, or the rapacity of landladies–but he seems at last to have settled down. He had, for the first time, a regular stipend; he had military rank, and probably a Mozartian uniform. Perhaps team-work provided the discipline and orderliness which he had needed all along. It is not clear whether his wife Hannah followed him to Baden, or when she died. On 11 June 1787 Burdett married Friedericke Kottewski; it was their daughter Anne who was to marry Count Friedrich Nostitz and take Wright's portrait to Prague. Burdett died on 9 September 1793.

41
A Philosopher by Lamp Light
exhibited 1769

Oil on canvas 50½ × 40½ (128.2 × 102.9)
Inscribed 'I. Wright Pinx! lower l.
PROVENANCE
Wright's Account Book as 'The Hermit £105'; offered (? and sent on approval) to the Empress of Russia, but remained on the artist's hands; Wright's posthumous sale, Christie's 6 May 1801 (63, as 'The Hermit', companion to 'The Alchemist'), bt Borrow £70.17.0, thence by descent until bequeathed by Col. J.G. Burton Borough to Derby Art Gallery 1961
EXHIBITED
Society of Artists 1769 (196, as 'A Philosopher by Lamp Light'; Tate & Liverpool 1958 (11, pl.II); *Salvator Rosa*, Arts Council, Hayward Gallery, 1973 (142)
LITERATURE
Nicolson no.196, p.236; pp.52–3, 55; pl.105; Frederick Cummings, 'Folly and Mutability in Two Romantic Paintings: The Alchemist and Democritus by Joseph Wright', *Art Quarterly*, XXXIII No.3, 1970, pp.262–271; Fraser 1979, p.2, pl.4
ENGRAVED
by William Pether as *An Hermit*, published 14 May 1770; an impression exhibited as No.156 (P5)

Derby Art Gallery

The compiler is indebted to David Solkin for establishing that this is the picture exhibited at the Society of Artists in 1769 (196) with the title 'A Philosopher by Lamp Light'. The evidence for this identification is in a review of the exhibition in *Lloyds Evening Post*, 3–5 May 1769 (p.435), which singles out Wright for its first praise: 'The pieces that seem to possess the greatest share of merit are, a Philosopher contemplating the human Skeleton by the light of a Lamp, and a number of Students drawing from a Model, painted by Mr. Wright of Derby . . .' The reviewer goes on to mention works by Zoffany, Seton, Stubbs, Marlow etc.

The fact that this picture was exhibited in 1769 helps to date it; previously it was thought to have been painted *c*.1771–3, but it must in fact have been painted before the Society of Artists exhibition opened in April 1769, and probably within the year or so before that. It thus becomes the earliest of all Wright's 'outdoor' (or partly outdoor) 'candlelights': several years earlier than the blacksmiths' shops of 1771 and 1772 (Nos.47, 48) and four years

earlier than either 'the Earthstopper' (No.51) or 'An Iron Forge Viewed from Without' (No.50), both dated 1773.

Wright largely derived his principal figure from Salvator Rosa's image of 'Democritus in Meditation'; in Rosa's painting (Nicolson fig.64, p.52), the philosopher Democritus sits, in a head-on-hand pose which itself derives from Castiglione's etching *Melancolia* (Cummings fig.13, p.265), surrounded by classical statuary which once signified glory, and by dry bones which are the inevitable end of human aspiration. Nicolson is at some pains to point out that Wright could have seen Rosa's painting (now in Copenhagen) when it was in English ownership at Foot's Cray in Kent; but from what is beginning to emerge of Wright's fairly wide knowledge of prints, it is at least as likely that Wright based his painting on the etching (repr. *Salvator Rosa*, exh. cat. cited above, pl.26), which might have been shown to him or discussed with him by his friend John Hamilton Mortimer, a great admirer of Rosa.

Wright had exhibited his picture as 'A Philosopher by Lamplight'; but he soon began to refer to it as 'Democritus' or 'A Hermit Studying Anatomy', perhaps because he found that his source was readily recognized as Rosa's 'Democritus'; and Pether's engraving of it was published in 1770, presumably with Wright's full authorization, as *An Hermit*.

Democritus was a Greek philosopher chiefly remembered for perceiving the folly of human creatures; Juvenal speaks of him as 'ever laughing at the follies of mankind'. While Rosa's Democritus can certainly not be called a merry old soul, the expression Wright gives his philosopher is more enigmatic. It is possible that one of the literary friends whose detailed advice Wright so often sought reminded him that Democritus was sometimes known as 'the laughing philosopher', prompting an expression which is by no means unrelievedly gloomy. Democritus was probably most familiar to English readers through Robert Burton's *Anatomy of Melancholy*, first published in 1621. Burton, who styled himself 'Democritus Junior', saw the ancient Democritus as 'a little wearish old man, very melancholy by nature, averse from company in his latter days, and much given to solitariness . . .' (ed. Holbrook Jackson 1964, 1, p.16). Wright may have had Burton's verbal image in mind as well as Rosa's visual one.

Wright's hermit or Democritus contem-

plates an incomplete human skeleton beside him on a rock ledge, and seems to be brooding over a loop of string apparently designed as a substitute tendon for the upper and lower bones of an arm (? or leg). Though Pether's engraving was entitled *A Hermit Found Studying Anatomy*, it is difficult to share Nicolson's belief that this picture and 'The Alchymist' (No.39) 'both show old men engaged in scientific research' (p.52). Wright's Hermit is no more researching anatomy than Hamlet is when he muses over Yorick's skull. As Cummings observes (p.269), the Hermit's contemplation of the skeleton is 'not serious anatomical investigation for the purpose of discovering new information'.

The picture seems to fuse elements from the past and present. Cummings (p.267) finds a source in Lucian for the two youths who, in some trepidation, approach the Hermit's cave. The scallop shells in their hats indicate (jumping about a dozen centuries forward from ancient Greece) that they are pilgrims, come to see 'a holy one'. Wright may have based his design of the Hermit's cell on his knowledge of caves in the Derbyshire Peak District. The Hermit's gown, hardly Grecian, is similar to that of 'The Alchymist' (No.39); it is certainly cosier than that of Rosa's Democritus, his feet are shod and he is generally less ascetic. Other emblems of mortality beside the skeleton surround him: a lamp which will be extinguished when its wick is spent; an hour-glass, still the most visually terrifying of all time-pieces; and a dark river, or mini-Styx, recalling those lines from Isaac Watts's hymn, 'Time like an ever-rolling stream Bears all its sons away', which Wright could have joined other members of the congregation of St Alkmund's, Derby in singing.

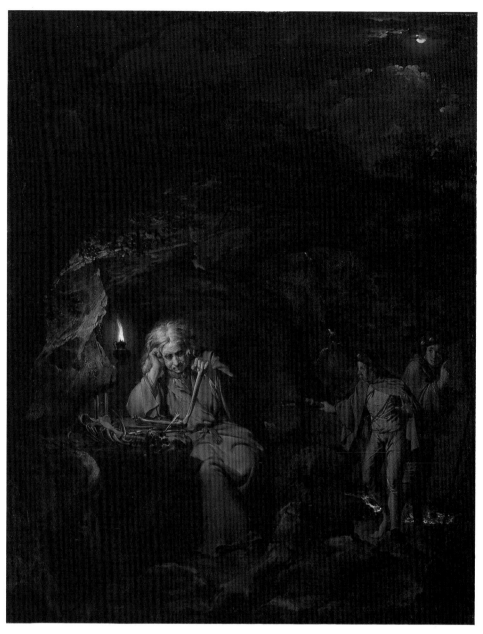

41

42

Miravan Breaking Open the Tomb of his Ancestors dated 1772

Oil on canvas 50 × 40 (127 × 101.6)
Inscribed 'I. Wright. pinxᵗ 1772' lower r.
PROVENANCE
In Wright's Account Book as 'The young
Nobleman in his Ancestors Tomb Mr.
Milnes £105'; . . .; E Coulson, offered
Christie's 7 May 1830 (41), bt in
at 9 gns., offered again 19 March 1831
(102), bt in; . . .; Mr. & Mrs. A.L.
Nicholson, by whom presented through
the National Art Collections Fund to
Derby Art Gallery 1937
EXHIBITED
Society of Artists 1772 (417, as 'An history,
Miravan, a young nobleman of Ingria,
breaking open the tomb of his ancestors in
search of wealth. (Incited by this equivocal
inscription, "in this tomb a treasure
greater than Croesus possessed"), found on
entering it the following: Here dwells
repose. Sacrilegious wretch, searchest thou
for gold among the dead! Go, son of ava-
rice – THOU canst not enjoy repose'. The
erratic punctuation and mis-spelling of
'Jezra' as 'Ingria' suggest that Wright sent
in his title by letter, misread by the exhi-
bition's cataloguers); Derby & Leicester
1947 (41); Sheffield 1950 (10); Tate &
Walker 1958 (12); Derby 1979 (2)
LITERATURE
E.K. Waterhouse, *Painting in Britain 1530 to
1790*, 1953, 2nd ed. 1962, p.198, pl.176;
Nicolson no.222, p.243; pp.53–4, 107, 129;
pl.107; Cummings 1970, p.269, fig. 15;
Benedict Nicolson, 'Wright of Derby,
Houasse et un conte orientale' *Revue de
l'Art*, no.30, 1975, pp.35–38; Fraser 1979,
p.2, repr. back cover in colour
ENGRAVED
by Valentine Green, published 18
December 1772; an impression exhibited
as No.160 (P11)

Derby Art Gallery

Wright called this subject 'an history. . .'
when he exhibited it at the Society of Arts
in 1772. Certainly the picture qualifies as a
'history painting' in the accepted sense of
the day; but whether Wright's source was
a historical account, a legend or a literary
tale has never been discovered. Wright left
copious notes on the subject, but no clue to
its source. What may be his first jottings of
the story of Miravan occur on a page also
used for a sketch of two girls (Derby Art
Gallery). A longer and more orderly
account is transcribed in Wright's

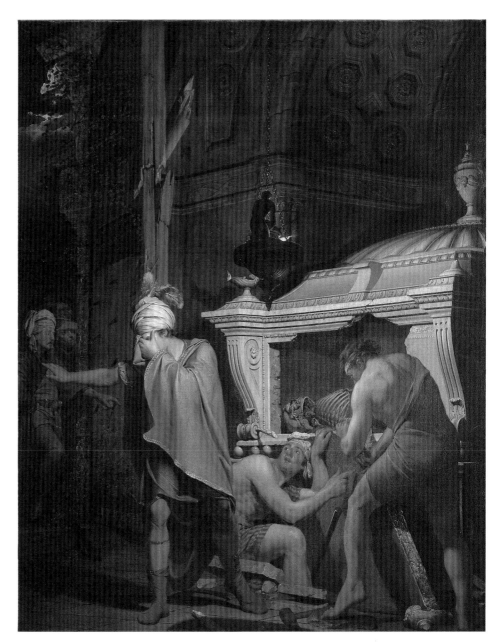

42

Account Book (repr. Nicolson 1975 figs.1–2), complete with the text (in English) of two inscriptions which he was to letter in Persian characters in the painting.

The key passage as given in the Account Book recounts how Miravan, young, noble, beautiful, already enjoying all the good things of this world, was walking one day among the tombs of his ancestors. An inscribed tablet arrested his attention: it read 'In this tomb is a greater Treasure than ever Croesus possessed'. 'Inflamed immediately with the very lust of Avarice', Miravan ordered 'the Marble jaws' of the tomb to be opened: but instead of finding immense treasures, 'he was struck speechless with disappointment to behold nothing but a heap of Bones & Dust with this inscription over it. Here would have dwelt *eternal repose* a treasure that Croesus never possessed which thou hast driven hence being excited by an insatiable love of Gold, to disturb the sacred remains of thy progenitor. Had not thy reason been deluded by a false fancy she wou'd have told thee that the grave contains nothing but dust & ashes'.

A letter from Wright to his sister Nancy *c.*1772 (DPL) relates that he is at work on 'Miravan'; Wright briefly summarizes the subject, and adds 'This, I think, will be a favourite picture'. No contemporary comment, not even a reviewer's brief mention, seems to have survived to throw light either on the subject or on the public reaction to it. The fact that Valentine Green's engraving was published within seven or eight months of the painting's exhibition at the Society of Artists may reflect (as well as Valentine Green's speed and skill) Wright's confidence that this would be 'a favourite picture' and that engravings of it would sell well.

The source for 'Miravan' remains elusive. Waterhouse pointed out in 1953 that the story occurs, with other names, in Herodotus. Nicolson expanded this in 1968 with a summary of Herodotus's account of how Darius, son of Hispaspes, opened the tomb (similarly-inscribed) of Nicotris, Queen of Babylon, but instead of treasure found only a decomposing corpse; and he reproduced (fig.66) a bronze relief of the subject as 'unknown school'. Cummings in 1970 reproduced without comment (fig.15) a copy of a painting of the same subject in the Musée d'Orleans, the original now correctly attributed to Houasse but the subject described simply as 'A tomb violated by a soldier'. Nicolson in 1975 pulled these and other threads together in his brilliant *Revue de l'Art* article. This positively identified the subject of various copies and engravings as a lost painting by René-Antoine Houasse (*c.*1645–1710) of 'Darius opening the Tomb of Nicotris'. Here, Nicolson demonstrated, and probably in the form of Baudet's engraving of 1686, was Wright's pictorial source for 'Miravan'.

Nicolson also showed that the two inscriptions copied out by Wright in his Account Book in English appear in his finished painting in perfectly correct and legible Persian script. 'In this tomb is a greater Treasure than Croesus ever possessed' is painted in Persian characters on the wall of the tomb chamber, just above Miravan's turban; and 'Here would have dwelt eternal repose . . . Child of Avarice, you will never enjoy rest!' is lettered in Persian on the massive stone slab wrenched from the front of the tomb, to which one of the workmen now points. These Persian inscriptions were revealed only when the picture was cleaned, some years after the publication of Nicolson's great Wright book. In his *Revue de l'Art* article, Nicolson points out that the cursive Persian lettering must come from a manuscript source rather than a printed book, and therefore one of Wright's friends or acquaintances must have helped him with the lettering. As for the story itself, Wright may have come across it in some untraced 'Eastern tale' (probably narrated by a European rather than a Persian, who would be unlikely to include a reference to Croesus). Wright may then have decided to paint it, and determined to give it authentic detail – this would have been characteristic of Wright – by adding Persian lettering. Perhaps some one in William Hayley's wide literary circle agreed to help.

The stage on which the drama of 'Miravan' is played out is an exotic one. It is dominated by the vast and elaborate tomb: 'a Wedgwood nightmare', in Waterhouse's memorable phrase. Miravan and his fellow-Persians have honey-coloured, 'Levantine' skins; their dress is gaudy, their turbans ornate. Miravan stands 'speechless', seemingly rooted to the ground, one arm outstretched in an attitude clearly derived from Houasse's Darius: but unlike him, Miravan cannot escape from what he has done. Only by moments does he realize the enormity of his actions and the endlessness of his penance. The two muscular workmen hardly know what to do for the best; they were only carrying out orders, and it is unlikely that their sleep will be troubled, or not for long. Two of Miravan's bodyguard wait on the threshhold; they have probably been given orders to advance no further, and cannot comprehend what iron has entered their master's soul. Nearby a huge wooden door (its pair out of sight) has been violently smashed. Beyond is the night, but not a serene one: trailing ivy blows across the sight of the moon scudding behind clouds.

'Miravan' includes one of Wright's most beautiful details, recalling the 'hushed mystery' of 'An Academy by Lamplight' rather than the gaudy world of Miravan: a bronze figure in a hanging lamp, forever and imperturbably turning its back on the world to tend the low light above the tomb.

43

Self-Portrait *c.*1765

Black and white chalks on paper laid on
canvas $18\frac{1}{2} \times 15\frac{1}{2}(47 \times 39.4)$
Inscribed on the stretcher 'Joseph Wright
of Derby/ Copied by W.ᵐ Pether'
PROVENANCE
H. Cheney Bemrose Bequest to Derby Art
Gallery 1954

Derby Art Gallery

This drawing has not been previously
published or exhibited. The identity of the
sitter is beyond question (compare other
self-portraits in this exhibition, Nos.1, 94,
149). But there is an enigmatic quality
about the face. At first glance, the
expression seems self-confident, even
inventive and intrepid, with some affinity
to that of Peter Perez Burdett as Wright
portrays him in No.40; more slowly, one
becomes aware of at least a hint of that
wary and worried look which increasingly
haunts Wright's later self-portraits.

Wright uses his chalks very skilfully,
with an ability (by holding them at various
angles) to convey various textures of skin,
hair and clothing as well as sharper angles
such as those of the nose. The similarity of
Wright's chalk drawings to the effects of
mezzotint engravings has been noticed
under Wright's early chalk copy of a
mezzotint after Allan Ramsay, No.70.

The inscription on the stretcher
'. . . Copied by W.ᵐ Pether' suggests that
Pether may have had it in mind to engrave
this portrait, but neither a drawing nor an
engraving of it by him is now known.
Pether engraved in mezzotint some of the
finest of all prints after Wright, including
The Orrery, [The Gladiator], *An Hermit, An
Academy, An Alchymist* and *A Farrier's Shop;*
an impression of each is exhibited here.

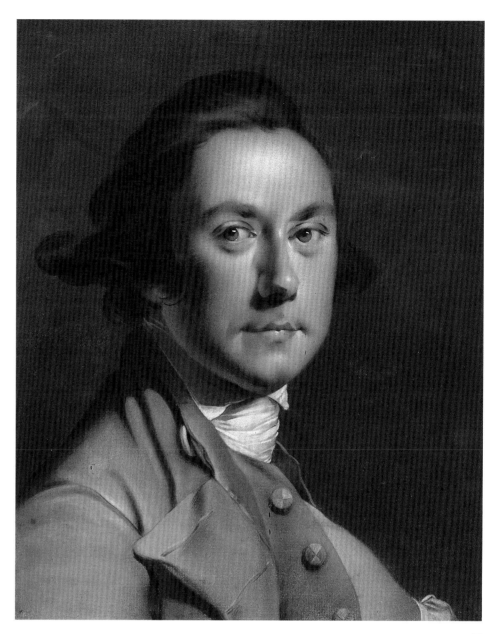

43

44

**Study of the Interior of
 Glass-House** ?*c.*1770−2

Pen and ink and grey wash heightened
with white on paper 14¼ × 20½
(36.2 × 52.1)
PROVENANCE
. . .; William Bemrose by 1883; Charles T.
Bemrose; part of the Bemrose Gift to Derby
Art Gallery 1914
EXHIBITED
Derby 1883 (115 or 147);? Sheffield 1950
(56); Tate & Walker 1958 (37, pl.x; *Art and
the Industrial Revolution*, Manchester City
Art Gallery, 1968 (72), Derby 1979 (63)

Derby Art Gallery

See text below No.45

44

45

**Study of the Interior of a
Glass-House** ?*c.*1770−2

Pen and brown ink and grey wash on
paper 14⅜ × 20⅞ (36.5 × 53)
PROVENANCE
as for No.44
EXHIBITED
Derby 1883 (115 or 147); Derby 1979 (64)

Derby Art Gallery

In the catalogue of the Wright exhibition
at Derby in 1979, David Fraser suggested
that these studies may have been made in
the glass factory established *c.*1769 by
James Keir. Keir, a member of the Lunar
Society, an old friend of Erasmus Darwin
and the translator of Macquer's *Dictionary
of Chemistry* (as noted under 'The
Alchymist', No.39) was continually experi-
menting to try to eliminate the imperfec-
tions of contemporary glass-making,
primarily in order to produce purer glass
for optical instruments; he conducted these
experiments in glass-houses in Liverpool,
London and also at Etruria, where he dis-
cussed possible solutions with Wedgwood.
Wedgwood was keenly interested since he
used frits of ground glass (produced in a
glass-house) in glazing his ceramics. Keir
convinced him that frits of the raw
materials of flint glass were more suitable.
Wedgwood's Memorandum Books
include a note of 'Mr Keirs composition for

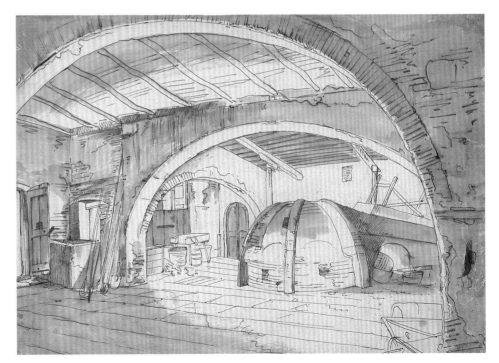

45

Flint Glass, given me by himself July 13th 1779'; in return, Wedgwood suggested to Keir ways in which imperfections (streaks and veins, or 'cords', as Wedgwood called them) might be reduced in glass manufacture. Such a pooling of knowledge was characteristic of members of the Lunar Society.

After a series of experiments of his own, Wedgwood consolidated his ideas in a paper entitled 'An Attempt to discover the causes of cords and waviness in Flint Glass, and the most probable means of removing them. By Josiah Wedgwood, F.R.S. and Potter to Her Majesty'. The completion of the paper must date from 1783 (or after), when Wedgwood was elected to the Royal Society.

Given Wedgwood's keen interest in improving glass manufacture, it seems possible that Wright made these studies in Wedgwood's glass-houses at Etruria. The drawings have been assigned to *c.*1770 – 2, since they seem to reflect the same interest in manufacturing processes that Wright showed in his paintings of iron forges and blacksmiths' shops of those years; but they could have been made during the years 1779 – 84, when Wright was working on 'The Corinthian Maid' and 'Penelope' for Wedgwood, and making occasional visits to Etruria.

Wright's posthumous sale at Christie's, 6 May 1801, included 'The Glass-House, a Sketch: the Fire exceedingly well expressed' (24), sold to Vernon, £3.10.0, but now untraced. The two studies may have been made in connection with that painting.

(Much of the information above is taken from Robert Schofield, *The Lunar Society*, 1963, pp.171–3, to which the reader is referred for fuller discussion of a subject of which this compiler has a very limited understanding)

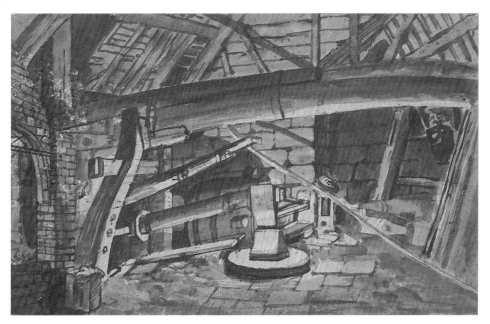

46

46
Study for 'An Iron Forge', 1772
dated 1772

Pen and brown wash heightened with white on paper $12\frac{3}{4} \times 20\frac{1}{2}$ (32.4 × 52)
Inscribed 'Original study for the Iron Forge|J. Wright 1772' lower centre
PROVENANCE
. . .; William Bemrose; Charles T. Bemrose, by whom presented to Derby Art Gallery 1914
EXHIBITED
Sheffield 1950 (52); Tate & Walker 1958 (36); Derby 1979 (62)
LITERATURE
Nicolson 1954 p.76, fig.9; Nicolson p.121, pl.99

Derby Art Gallery

This is a study for 'An Iron Forge' of 1772, No.49 in this exhibition. Comparison between the two shows how faithfully Wright based the painting on this preliminary study. The study shows every sign of being drawn on the spot, in a forge which has evidently been converted from an old stone barn, with wooden rafters and a brick archway on the left; the huge beam across the space was probably installed to strengthen the structure before the installation of the new machinery. The water-powered hammer is here seen at rest on the anvil; as the drawing shows even more clearly than the painting, the anvil which receives the blows of the powered hammer is very much lower than those on which the blacksmiths swing their hammers in Nos.47 and 48.

47–50
Blacksmith's Shops and Iron Forges

GENERAL LITERATURE
Klingender, 2nd ed. 1968, pp.54–61; Nicolson pp.50–1, 120–1; K.Z. Cieszkowski, 'Joseph Wright, Painter of the Industrial Revolution', *History Today*, 33, 1983, p.46; Busch 1986, pp.22–49; Fraser 1988, pp.129–34; David Fraser, 'Joseph Wright of Derby and the Lunar Society' in this catalogue, pp.20–22

At some point probably in the late 1760s, Wright jotted down in his Account Book some ideas for 'Night Pieces'. The first was 'A Blacksmith's Shop': and this is how he saw the picture in his mind's eye:

Two Men forming a Bar of Iron into a horse shoe – from whence the light must proceed. An Idle fellow may stand by the Anvil, in a time-killing posture, his hands in his bosom, or yawning with his hands stretched upwards – a little twisting of the Body. Horse Shoes hanging upon ye walls, and other necessary things, faintly seen being remote from the light – Out of this Room, shall be seen another, in wch a farier may be shoeing a horse by the light of a Candle. The horse must be Sadled and a Traveller standing by The Servant may appear with his horse in his hand – on wch may be a portmanteau – This will be an indication of an Accident having happen'd, & shew some reason for shoeing the horse by Candle Light – The Moon may appear and illumine some part of the horse if necessary –'

In the three years 1771–3, Wright was to find that his initial thoughts quickened into enough life to produce not just one but five pictures, each exhibited, each quickly sold. Four of those pictures – two 'Blacksmith's Shops', 'An Iron Forge' and 'An Iron Forge viewed from without' are included in the exhibition; the fifth, 'A Blacksmith's Shop viewed from without', is untraced. In portraying men at work by night, the most conspicuous source of light being the white-hot iron they themselves have produced (though a far-off moon acts as a secondary light source in most of the scenes), Wright discovered not only dramatic material for 'Night Pieces' but also contemporary subjects for realistic pictures almost as unusual as the subjects of 'The Air Pump' and 'The Orrery'.

Both the 'Blacksmith's Shops' are dated 1771. Perhaps the closest to his original ideas, and the first to be exhibited, was the picture now at Yale (No.47). The Derby 'Blacksmith's Shop' (No.48), while it has many differences, is sufficiently similar to make it likely that even before the first version was exhibited, Wright was aware of sufficient interest to paint a second version.

With his first 'Blacksmith's Shop', Wright exhibited in 1771 'A small Ditto [i.e. Blacksmith's Shop] viewed from without'. This painting seems to have been untraced since it was lent by A. Buchanan to Graves's exhibition of 1910, there described as oil on canvas, 25 × 30 ins. The picture was engraved by William Pether as *A Farrier's Shop*, published 1 December 1771 (see No.158 (P8)).

Two 'Iron Forges' followed, in a different, 'landscape' format. Lord Palmerston's 'Iron Forge', dated 1772 (No.49), was followed by 'An Iron Forge viewed from without' (No.50), just as the first 'Blacksmith's Shop' had been followed by 'Ditto, viewed from without'.

In each of the four paintings shown here, Wright uses 'a most extraordinary light source, the blinding white glow of a newly-forged iron bar' (Rosenblum 1960, p.26), though in 'An Iron Forge viewed from without' (No.50) the figure of the smith stooping over his work, his back to us, means that we do not see the white-hot bar, but only the light it emits. In a similar way, the boy with his back to us in the 'Orrery' conceals the candle which lights the room.

While the setting for the 'Iron Forge' of 1772 seems solid enough, Wright's blacksmiths seem to have established their forges in some derelict church or abbey, where carved angels can be seen above the arch. The engraved *Farrier's Shop* appears to have a similar setting (the painting was exhibited in 1910 with the note 'Scene, Dale Abbey', perhaps because this is Derbyshire's best-known ruined abbey). Klingender and others after him, particularly Busch, have noted the seemingly makeshift settings, suggesting parallels with those in which the Holy Family is depicted in sixteenth century Italian paintings of the Nativity and Adoration. David Fraser discusses some of these suggestions in his essay in this catalogue, pp.20. Nicolson insists (p.121) that Wright 'accurately transcribed' the blacksmiths' shops and iron forges that he depicted; and that accuracy – allowing for the enlargement of a few holes in walls or rafters to admit glimpses of the moon – would have been characteristic of Wright.

Fraser notes the 'contemporary practice of improvising workshops from disused buildings' (1988, p.133), in villages and on country estates. Wright's preliminary study for the 'Iron Forge' (No.46) and his two 'Glass House' drawings (Nos.44, 45), all drawn from direct observation, free from picturesque gloss and empty of figures, are further evidence of improvised settings for small industrial enterprises. The setting of Wright's 'Iron Forge' of 1772, and the study for it, is remarkably similar to that of J.M.W. Turner's 'Interior of an Iron Foundry' of c.1797 (fig. 16). Turner's watercolour, based on a pencil study in his 'North of England' sketchbook, depicts ironsmiths at work in what may formerly have been a hay-barn, with a water-wheel (seen on the left) now installed to provide power. Turner's drawing, made some twenty-five years after Wright's study, suggests that industrial operations were still frequently conducted on improvised sites. Purpose-built industrial premises like 'Arkwright's Mill', portrayed by Wright in No.127, seemed strange and alarming to contemporaries. But the art historian needs the industrial archaeologist here, to furnish evidence from the sites of old smithies and forges to show how 'real' Wright's settings really are.

Fraser 1988 points out that while the 'Blacksmiths' Shops' depict a craft which had scarcely changed for centuries, the two 'Iron Forges' show a more modern process, using water-powered forges driving tilt-hammers. Wright clearly illustrates the machinery in the 'Iron Forge' of 1772, showing the large drum which is turned by the water-wheel outside to lift the hammer beam. Such initially expensive machinery, beyond the means of the average ironworker, would be installed by ironmasters, often leasing buildings from local landowners, and allotting to different forges a different stage in the ironworking process; thus Wright's forges could be preparing large ingots for rolling and slitting mills (Fraser pp.133).

Various antecedents for Wright's pictures have been proposed. Klingender suggested works by the Le Nain brothers, both the classical subject of 'Vulcan's Forge' and the contemporary 'The Forge', now in the Louvre, which Wright could have known in the engraving of 1761. Nicolson considered that the closest 'Forge' to Wright was the picture attributed to Jan Molenaer, which he reproduces as fig.60 (p.51). Possibly Wright picked up an idea or two from Edward Penny's 'The Gossiping Blacksmith', which he could have seen

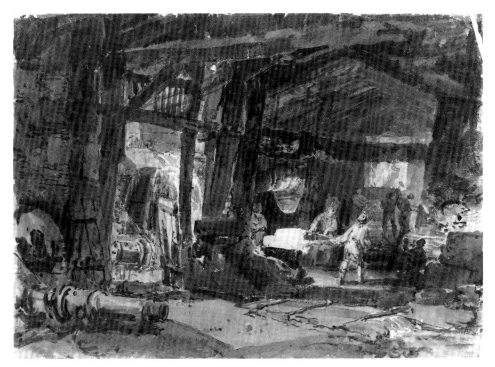

fig.16 J. M. W. Turner: 'Interior of an Iron Foundry' c.1797, watercolour $9\frac{11}{16} \times 23\frac{9}{16}$ (24.7 × 34.5) *Tate Gallery (Turner Bequest)*

47

A Blacksmith's Shop dated 1771

Oil on canvas $50\frac{1}{2} \times 41$ (128.3 × 104)
Inscribed 'Jo.° Wright/ Pinx.° 1771'
lower r.

PROVENANCE
In Wright's Account Book as 'the Blacksmith's Shop to L.° Melbourne £150.0.0', thence by descent until sold to Sir George Buckston Browne FRCS, by whom presented to the British Association for the Advancement of Science, 1929; transferred to the Royal College of Surgeons, from whom purchased by Paul Mellon 1964; presented by Paul Mellon to the Yale Center for British Art 1981

EXHIBITED
Society of Artists 1771 (201); British Council, Lisbon and Madrid 1949; Hamburg and Scandinavia 1949–50 (119); Canada and USA 1957–8 (82); Tate & Walker 1958 (8); British Council, British Paintings, USSR 1960 (36); Paris 1972 (340); *Selected Paintings, Drawings and Prints,* Yale Center for British Art, New Haven, Conn. (handbook, no cat. nos., p.33, repr.)

LITERATURE
Nicolson no.199, p.237

ENGRAVED
by Richard Earlom, published 25 August 1771; an impression exhibited as No.157 (P7)

Yale Center for British Art, Paul Mellon Collection

in the Royal Academy's first exhibition in 1769 (it is now in the Tate), since this picture includes the quietly heroic figure of the blacksmith's assistant, his white shirtsleeves rolled up. Nicolson, loth to admit any influences on these scenes, maintains that 'there is nothing in the forge pictures that has not been anticipated in embryo in the scientific scenes' (p.51).

In each of the smithy and forge scenes, one man is depicted standing or stooping at his work with his back to us. These seemingly-dark figures, placed between the light source and the spectator, are chiefly designed to add to the pictures' already complex chiaroscuro effects; but their positions also emphasize their concentration on their work and their indifference to the spectator. With each of the blacksmiths and their assistants, including the notable young apprentice in No.47, concentration on the work in hand is further invested with the dignity of honest labour and pride in the exertion of particular skills. This is of course a bourgeois vision of manual work, but it evidently appealed to the wealthy, aristocratic and in one case Royal purchasers of the pictures.

Those purchasers were mostly people of eminence. The first 'Blacksmith's Shop'

was bought by Lord Melbourne, for £150. The now untraced 'Blacksmith's Shop viewed from without' was bought by Edward Parker of Brigg, Lincolnshire, a collector of pictures, for £42 (it was smaller than the others). The second 'Blacksmith's Shop' went to the Edinburgh banker and intellectual Robert Alexander, for £157.10.0; the 'Iron Forge' was bought by Lord Palmerston, for £200. The 'Iron Forge viewed from without' was purchased, for £136.10.0, for Catherine the Great, Empress of Russia. As each of the pictures was quickly snapped up by purchasers outside Derbyshire, it is impossible to say whether they might have been regarded as desirable by Wright's Derbyshire patrons, particularly those with industrial interests.

Lord Melbourne purchased the picture while it was still on the easel, some seven or eight months before it was exhibited at the Society of Artists. His letter of 17 October 1770 to his agent asks him to arrange for the immediate payment to Wright of one hundred guineas, in part-settlement. Lord Melbourne adds 'it is worth your while when you go to Derby to see the picture he is painting for me. It is thought to be the Best ever painted in the Country – ' (Melbourne MSS; quoted by kind permission of the Trustees).

The purchaser was the 1st Lord Melbourne (1744–1828), who married Elizabeth Milbanke and sat to Stubbs with her, her father and her brother, for 'The Milbanke and Melbourne Families', c.1770 (National Gallery). He looks languid in Stubbs's painting, but clearly acted perceptively and decisively in buying the earliest of Wright's smith and forge pictures. He assembled a good collection of pictures in the saloon at Brocket Hall, Hertfordshire, and commissioned Wright's

friend John Hamilton Mortimer to paint
its ceiling (Sunderland 1988 pp.40–3). He
also asked the Derby architect Joseph
Pickford (father of the boys portrayed in
No.141) to draw plans for another room at
Brocket.

There is a very great deal to admire in
this subtly-lit picture, from the entirely
credible poses and working-clothes of the
three men working at the anvil to the fig-
ures waiting with a horse by candlelight on
the left for the newly-forged horseshoe. For
the 'Idle Fellow . . . in a time-killing pos-
ture' of his first musings on the subject,
Wright substitutes an elderly, meditative
man on the right. The two boys who stand
near the anvil should be noted (fig.17).
The one in front turns away from the
sight, the heat, the noise; the other, whose
working dress suggests that he is probably
an apprentice, looks on unperturbed,
almost enrapt, his expression recalling that
of the boy on the left in 'The Air Pump'.

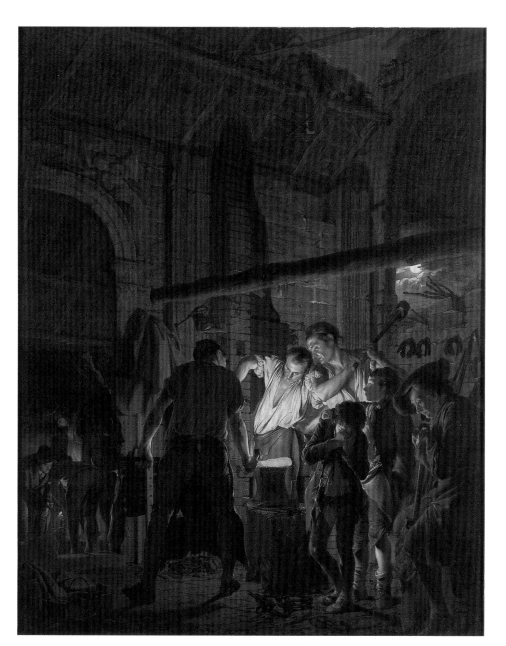

47

fig.17 Detail of the two boys in
'A Blacksmith's Shop' (No.47)

[100]

48

A Blacksmith's Shop dated 1771

Oil on canvas 49½ × 39 (125.7 × 99)
Inscribed 'Jos. Wright Pinx.' 1771' on tool
box lower l.

PROVENANCE
In Wright's Account Book as 'A Black-
smith's Shop to M.' Alexander £157.10.0',
i.e. Robert Alexander of Edinburgh; sold
by his executors, Christie's 31 March 1775
(72, as 'The much esteemed picture of the
Smith's forge', bt Martin £68.5.0; (it is
assumed that the next two entries also
relate to this picture): Richard Price Jones,
Esq., deceased, late of the Custom House,
his sale Christie's 26 February 1791 (91),
bt £51.9.0; John Allnutt deceased, sale
Christie's 19 June 1863 (223, as 'Interior of
a Blacksmith's Forge, with figures of
peasants and children round the fire'), bt
Graves £7.7.0'; Robert Hyde Greg, before
1875, and thence by descent until
purchased from the last owner's executors
by Derby Art Gallery 1979

EXHIBITED
Society of Artists 1772 (372); on loan to
City Art Gallery, Manchester, c.1950 – 61;
Art and the Industrial Revolution, Manchester
City Art Gallery 1968 (71); on loan to
Derby Art Gallery 1978 until purchased
1979; exh. Derby 1979 (13, on loan)

LITERATURE
Nicolson no.200 p.238; pp.50 – 1, 121;
pl.101

Derby Art Gallery

Robert Alexander, the picture's first
owner, was a wealthy Edinburgh mer-
chant and banker. He was a patron of
Alexander and John Runciman, and was a
member of the Select Society, a debating
society formed in Edinburgh by David
Hume and Allan Ramsay. Later he joined
in the American War of Independence, on
the colonial side (Duncan Macmillan,
Painting in Scotland, The Golden Age, 1986,
p.49).

Nicolson notes that 'between one version
of the 'Blacksmith's Shop' [No.47] and the
next [this picture], Wright takes the liberty
of removing a prominent beam'. Other
differences, e.g. in the group at the left, will
be apparent. The two contrasted nine or
ten-year old boys in No.47 have been

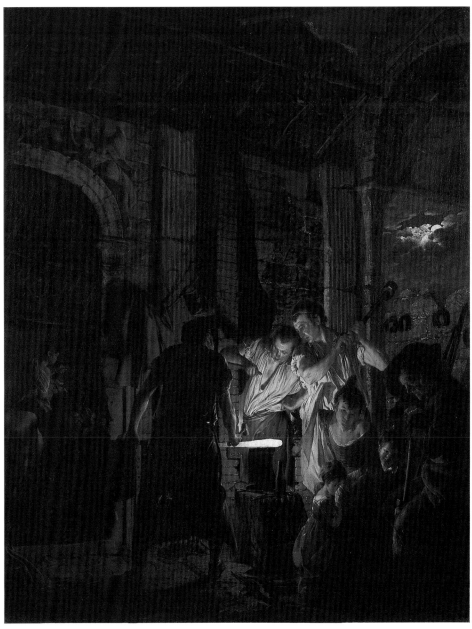

48

replaced by a group of three younger
children, two of them only about three and
four, all of them turning away from the
centre of activity. This group dilutes the
realism of the scene, if only because no
blacksmith in his senses would allow
young children within range of the heat of
his fire or the swing of his hammer. Prob-
ably Wright intended their youth and fra-
gility to be a contrast to the knowledge and
strength of the blacksmiths.

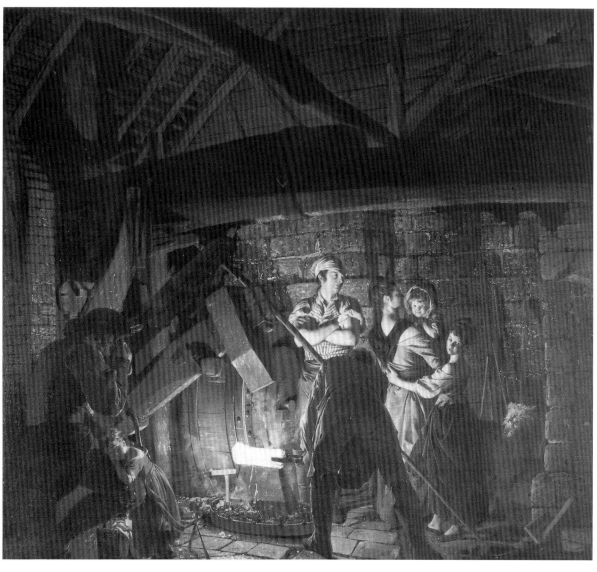

49

49

An Iron Forge dated 1772

Canvas 48 × 52 (121.9 × 132.1)
Inscribed 'Jo. Wright Pinx.ᵗ 1772' lower r.
PROVENANCE
In Wright's Account Book as 'The picture
of the Iron Forge to L.ᵈ Palmerston £210'
(Lord Palmerston's MS notebook records
the price paid as £200); i.e. 2nd Lord
Palmerston, and thence by descent to the
present owner
EXHIBITED
Society of Artists 1772 (373); BI 1817 (97),
1845 (142); International Exhibition 1862
(124); RA 1871 (245); *Exposition Universelle
et Internationale*, Tate & Walker 1958 (13);
Durlacher, New York 1960 (10); Detroit
and Philadelphia 1968 (28); Paris 1972
(34); *Pittura Inglese 1660–1840*, Palazzo
Reale, Milan 1975 (113); *Georgian Canada,*

Conflict and Culture, Royal Ontario
Museum, Toronto 1984 (195); NGA
Washington 1985–6 (485, repr. in
colour); *Pintura Britannica de Hogarth a
Turner,* The Prado, Madrid 1988–9 (33,
repr. in colour p.173), and others
LITERATURE
Nicolson no. 197 p. 237, where Lord
Palmerston's MS catalogue of his collec-
tion and notes of 'pictures bought at home'
are quoted; pp. 50–1, 106, 121; pl.103
ENGRAVED
by Richard Earlom, published 1 January
1773; an impression exhibited as No.161
(P12). The painting was also reproduced
by Matthew Boulton's mechanical process
for reproducing oil paintings, of which
little is now known.

Lord Romsey, Broadlands Collection

The hero of this picture is partly the iron-
founder himself, pausing in his work to
cast a proud eye towards his wife and
children, and partly the power-driven
machinery of his forge, which makes the
'Blacksmith's Shops' look already old-
fashioned. The huge drum, turned by a
water-wheel outside the forge, drives the
tilt-hammer and saves much of the effort
seen in the two earlier pictures in the swing
of the blacksmiths' hammers. Fraser's com-
ments on the machinery are given here on
p.21.

The man's relaxed attitude, even his
faintly dandyish striped waistcoat, suggest
that revolutionary changes in his forge
have brought about a lightening of his
load. The presence of his wife and chil-
dren, one of whom has run to the elderly
man seated (this time) on the left, suggests
that in this picture, and probably also in

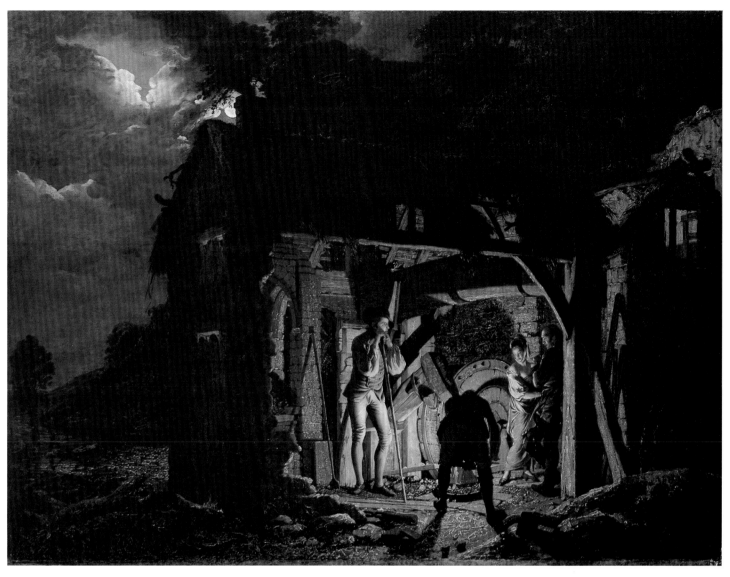

the two 'Blacksmith's Shops', Wright may have introduced (in a subtle, understated manner) a 'three generations' motif. The elderly man, in what seems in all three pictures to be a habitual seat, may be the smith's father, perhaps himself once the smith, but now of the old order and, in this picture, hardly able to take in the new machinery.

The reviewer of the Society of Artists exhibition of 1772 in the *Morning Chronicle*, 29 May 1772 (p.4) remarked that 'the face of the principal figure in the Iron Forge has the *Apollo* and *Hercules* as truly blended as we have seen, and the child in the woman's arms in the same piece, is a model of prattling innocence'. He considered both the 'Blacksmith's Shop' and the 'Iron Forge' to possess 'much merit; tho' even here we think the reflection too strong, and the sparks of the fire too regular'.

50

An Iron Forge viewed from without
dated 1773

Canvas $39\frac{5}{8} \times 55\frac{1}{8}$ (105 × 140)
Inscribed 'J. Wright Pinx.' 1773' on iron bolt lower r. of centre
PROVENANCE
In Wright's Account Book as 'Picture of an iron Forge viewed from without – to the Empress of Russia £136.10.0'; by descent in the Russian royal family until becoming state property earlier this century
EXHIBITED
Society of Artists 1773 (373)
LITERATURE
Nicolson no.198 p.237; p.121; pl.104; Larissa Dukelskaya, *The Hermitage, English Art Sixteenth to Nineteenth Century*, Leningrad, London & Wellingborough, 1979, no.137, repr. in colour, and with colour detail of

figures on right; Richard W. Wallace, *The Etchings of Salvator Rosa*, Princeton, 1979, p.118

Hermitage Museum, Leningrad

This picture was purchased for Catherine the Great, Empress of Russia, who employed agents abroad to build up a large and magnificent collection of pictures. According to Larissa Dukelskaya, the agents in this case were apparently 'the Russian consul Baxter and the engraver P. Burdett', the latter being Wright's friend Peter Perez Burdett (portrayed with his wife in No.40), whose extremely complex operations had not yet reached that point of financial collapse which drove him to leave England for Germany in the mid-1770s.

The 'Iron Forge viewed from without' was probably initially reserved for

Catherine the Great rather than purchased outright for her. Baxter and Burdett (if they were indeed the agents in this case) no doubt had to seek approval, if not from the Empress herself, then from a higher guardian of her collection. Wright sent the picture to the Society of Artists exhibition which opened in April 1773; on 12 February 1774 (by which time he was in Rome) he wrote to his brother saying that he has heard 'the Empress of Russia has taken ye picture of the Iron forge, but does not like the Hermit' (No.41 in this exhibition).

1773 was the third successive year in which Wright had sent smithy and forge subjects to the Society of Artists' annual exhibition, and this probably dulled the reaction to this picture of the reviewer of the *Morning Chronicle*, 1 May 1773: he considered it 'a good painting, but not superior to those of the same stile exhibited last year . . .'.

Nicolson notes that in the 'Forge viewed from without', Wright has 'broken open an outside wall in order that the spectator should be allowed a glimpse inside: this was a pictorial convention understood by scientist and artist alike, just as in any treatise on hydraulics one might find engravings where for the purpose of elucidation, sections have been laid bare to reveal the hidden mechanism'.

The revolving drum which drives the tilt-hammer is clearly seen; and outside the walls, on the left, is the river which provides the power to drive it. If David Fraser is right (in the essay contributed to this catalogue, p.21), then this forge is on the banks of the river Derwent; he believes that this picture has 'an almost identical background to that in 'The Earthstopper on the Banks of the Derwent'', exhibited the same year, and shown here as No.51. If this identification can be established, Fraser will have made a major contribution to assessing the 'reality' of this and Wright's other scenes of blacksmiths' shops and iron forges.

Fraser suggests that the man on the left, not in working-clothes, may be the iron-

fig.18 Salvator Rosa: 'Woman carrying a baby' from the *Figurine series c*.1656–7, etching $5\frac{1}{2} \times 3\frac{9}{16}$ (13.9 × 9.1) *Trustees of the British Museum*

master or his overseer, on a visit of inspection. The man and woman on the right are an unlikely pair. Richard W. Wallace points out that Wright has taken the woman and her baby straight from an etching in Salvator Rosa's *Figurine* series (no.87, repr. Wallace p.226). Wright makes the woman more matronly, changes her headress and puts her into unsuitable shoes, but she is essentially a Rosa figure (fig.18).

The man who slouches with his back to the wall is an enigmatic figure. In the earlier 'Blacksmiths' Shops' and 'Iron Forge', Wright had depicted the men in a fairly straightforward manner as strong, purposeful and handsome figures in near-heroic roles. This man is middle-aged, his leather apron well-worn, his hair lank, his pose unheroic; yet he undoubtedly has magnetism, and astonishing realism.

The Earthstopper on the Banks of the Derwent dated 1773

Oil on canvas 38 × 47½ (96.5 × 120.6)
Inscribed 'J. Wright P/1773' lower l.
PROVENANCE
In Wright's Account Book as 'Picture of an Earthstopper to Lord – £52.10.0'; purchased after the Society of Artists exhibition of 1773 by Philip, 2nd Earl of Hardwicke; by descent to the 5th Earl of Hardwicke, his sale Christie's 7 August 1880 (75, as 'J.Wright . . . A river scene, with a man and dog'), ? bt in; anon. sale Christie's 17 March 1950 (123), bt ? Scully; Benedict Nicolson, from whom purchased by Derby Art Gallery, with the aid of a contribution from the National Art Collections Fund, 1955
EXHIBITED
Society of Artists 1773 (372); *English and French Paintings between 1770 and 1920*, Roland Browse & Delbanco, 1950 (32); Festival of Britain Exhibition, Derby 1951; *Le Paysage Anglais*, British Council, Orangerie, Paris 1953 (98, repr.); *British Life*, Arts Council 1953 (88, repr.); *European Masters of the Eighteenth Century*, RA 1954–5 (389); Tate & Liverpool 1958 (14); Derby 1979 (18); *British Sporting Painting 1650–1850*, Arts Council, London, Leicester, Liverpool 1974–5 (67, repr. p.59)
LITERATURE
National Art Collections Fund Report 1955, 1956, p.39; Nicolson no.242 p.247; pp.50, 55, 72, 97; pl.113; Fraser 1979, p.2, pl.7

Derby Art Gallery

The earthstopper, acting for the local hunt, is working by moonlight, when foxes prowl, to stop up their earths so that they will be unable to return to them and will perforce provide sport for the hunt in the morning. He works steadily, capably, despite his cracked and mended spade (details Wright lovingly observes); his dog sniffs for further fox-holes while his grey horse, tethered behind him, grazes patiently.

But if all these actions are prosaic, Wright has made something thrilling and mysterious of them, largely by deploying moonlight. Already he had used a moon riding high to add a further note of intensity to such pictures as his 'Blacksmith's Shop', 'An Iron Forge', 'A Philosopher by Lamplight' and 'The Alchemist' (all in this exhibition); but in the 'Earthstopper' moonlight is the key to the whole scene,

illuminating in different ways the different surfaces of rock, bark, stony path and swirling river. Light from the earthstopper's lantern quite naturally counterpoints the effects of moonlight, and throws a ruddy glow on the earthstopper's face. Elsewhere the effect is of weird glitter. As Nicolson observes, 'this is one of Wright's wildest landscapes, streakier, starker, more nervous even than the moonlights of the early 80s' (p.55). For David Fraser's suggestion that the setting is Church Rocks on the Derwent River, see his essay in this catalogue, p.21.

Conversation with the young members of the Markeaton Hunt when they had sat to him some ten years earlier (see Nos.5–8) may have given Wright the idea of paint-ing an earthstopper; or he may have observed such a scene, riding home to Derby from or near Markeaton one night. A dutiful compiler should mention other pictures of outdoor servants at work, all painted a few years earlier, such as 'Nathan Drake's 'The Earthstopper' of 1769 (exh. *British Sporting Painting*, Arts Council 1974–5, 39, repr. p.42) and Stubbs's well-known series of portraits of Southill hunt servants, gamekeepers and brickmakers. But it is unlikely that Wright saw any of these works, and they are in any case too decorous to be compared with his 'Earthstopper'.

Wright, who was to draw many of his ideas from poetry, may with this picture have inspired a minor poet. Francis Noel Clarke Mundy of Markeaton, portrayed by Wright in No.5, published a collection on poems entitled *Needwood Forest* in 1776. Nicolson brilliantly links the following lines with Wright's 'Earthstopper' painted three years before:

> Whilst, as the silver moon-beams
> rise . . .
> His lantern gleaming down the glade,
> One, like a sexton with his spade
> Comes from their caverns to exclude
> The mid-night prowlers of the
> wood . . .

Equally brilliantly, Nicolson spots a foot-note in Mundy's third edition of 1801 iden-tifying the 'sexton with his spade' as 'Manuel . . . the Forest earthstopper in the

hunting days of the author'. In those hunting days, it would probably not have occurred to Mundy to think that an earth-stopper could be a poetic sight; it seems to have been Wright's picture which taught him to perceive it so.

'The Earthstopper on the Banks of the Derwent', exhibited at the Society of Artists in 1773, was purchased the following year by the 2nd Earl of Hardwicke. The transaction went through the Society of Artists' Secretary, since Wright had left for Italy on 23 October 1773. Whitley quotes a letter from Wright dated 6 June 1774 instructing that the picture is to be delivered to Lord Hardwicke without the frame:

> The shabby price his Lordship is to pay for it will leave no room for his Lordship to expect the frame with it; but if he should say anything about it pray inform his Lordship that the Earth-stopper was exhibited in an old Italian moulding frame which I have had by me for many years and keep for the use of the exhibition, and on no account let him have it. (W.T. Whitley, *Artists and their Friends in England*, 1, 1928, p.247).

Philip, 2nd Earl of Hardwicke, (1720–1790) was perhaps the most unlikely man in England to have purchased Wright's 'Earthstopper'. Languid, aloof, in poor health, he was in Horace Walpole's words 'a bookish man, conversant only with parsons'. He sat to both Reynolds and Gainsborough, and particularly admired the work of Angelica Kauffmann, buying many of her works. At the Hardwicke seat, Wimpole Hall in Cambridgeshire, he employed Capability Brown to extend his park. With Angelica Kauffmann within and Capability Brown without, the 'Earth-stopper' must have struck an odd note at Wimpole Hall. But perhaps Lord Hardwicke derived some barely-admitted pleasure in the occasional contemplation of Wright's wild, exciting, unmannered scene.

52

Maria, from Sterne dated 1777

Oil on canvas 39½ × 49½ (100.3 × 125.7)
Inscribed 'I. Wright pinx.'
1777' on tree-trunk lower l.

PROVENANCE
Not in Wright's Account Book; Mr Bird, offered Christie's 11 March 1780 (98), bt in at £30.9.0; Edward Pickering by 1790, remaining with his descendants until earlier this century; anon. sale Sotheby's 13 July 1949 (93), bt anon., from whom purchased by the present owner

EXHIBITED
Garrick, Johnson and the Lichfield Circle, Museum Building, Lichfield, 1953 (24, repr.); *Royal Academy of Arts Bicentenary Exhibition 1768–1968*, RA 1968–9 (10)

LITERATURE:
Nicolson no.236 p.246; pp.62–3, 65, 68, 87, 151; pl.184; Gordon 1988, pp.74–6, pl.51

Private Collection

'And who is *poor Maria?*' asks Tristram Shandy in Sterne's book of that name when, on his travels through France, he hears, near Moulines, 'the sweetest notes I ever heard', and learns that they come from the pipes of 'poor Maria'. The postillion tells her story. Three years ago, an intriguing curate forbade the banns of her marriage, and her lover deserted her; her father died, and now it is feared that 'her senses are lost for ever'. When they draw level with Maria, they see her sitting on a bank with her pet goat. 'She was in a thin white jacket, with her hair, all but two tresses, drawn up into a silk-net, with a few olive leaves twisted a little fantastically on one side'. She played upon her pipes with cadences 'so melancholy, so tender' that Shandy was much moved.

Maria reappears in Sterne's *A Sentimental Journey*, and it is from this work that Wright drew both this 'Maria' and his 'Maria' of 1781 (No.58). Parson Yorick, to whom Shandy has related Maria's misfortunes, makes a detour in his own travels to see her. He finds Maria 'at a little opening in the road leading to a thicket . . . sitting under a poplar – she was sitting with her elbow in her lap, and her head leaning on one side within her hand – a small brook ran at the foot of the tree . . . She was dress'd in white, and much as my friend described her, except that her hair hung loose . . . a pale green ribband . . . fell across her shoulder to the waist; at the end of which hung her pipe. – Her goat had been as faithless as her lover; and she had

got a little dog in lieu of him, which she had kept tied by a string to her girdle: as I look'd at her dog, she drew him towards her with the string. – "Thou shalt not leave me, Sylvio", said she . . .'

Maria's pitiable condition has a powerful effect on Yorick: he feels 'such unbearable emotion' that he declares 'I am postive that I have a soul'. *A Sentimental Journey* was to have a similar effect on a large number of Sterne's readers, inculcating in them new sensibilities. Wright was one of the first artists to perceive that episodes recounted by Sterne offered rewarding subjects to artists. First he designed a pair of subjects from *A Sentimental Journey*, composed of this 'Maria' and 'The Captive' of 1774 (No.53), which should therefore be seen as companions. Later he returned to the subject of 'Maria', painting in 1781 a different, upright picture of her (No.58) as a companion to 'Edwin, from Dr Beattie's Minstrel' (No.57).

In this picture, Wright is faithful to most of the details of Sterne's narrative. Maria is dressed in white; her ribbon and sash are pale green, which both Sterne and Wright would have known to be the classic melancholy colour. Attached to the green ribbon is Maria's dog Sylvio, faithful and alert. A brook, specified by Sterne, runs through a sylvan landscape – perhaps Wright's finest landscape to this date (1777).

As this 'Maria' was to be a companion for 'The Captive', Wright had to ensure that both the designs and the moods of the two pictures harmonised. Both figures are seated on the ground; Maria turns to the right, the Captive to the left. Within the circumstances of their pitiable plights, each is an almost elegant figure. There is no cue in Sterne for melodramatic horrors. Maria is no Crazy Jane, nor does his Captive rave. Sterne wants to invoke pity, not shuddering. Wright exercises the same restraint.

A chalk study of the head and shoulders of a young woman, sold Sotheby's 19 March 1981 (152) seems to have been used for 'Maria', though possibly not made specifically for that purpose.

Maria's dog Sylvio, both in this version and in the version of 1781, is, according to Jeremy Rex-Parkes (in correspondence) a Bolognese: a lap-dog bred for centuries in Italy, not uncommon in eighteenth century England as they were brought back by Grand Tourists but, since the introduction of quarantine regulations, now extremely rare in this country. The painting of this dog is probably the best bit of

animal painting in the whole of Wright's work. Not only does he portray the animal so exactly that an expert can confidently identify it from a very rare breed, but he also conveys the animal's natural instincts. Jaws on his mistress's pale green ribbon as if on a leash, the dog evidently thinks a brisk walk would do them both a power of good.

Catherine Gordon shows that for many artists of the 1770s and 1780s, Sterne was 'above all the source of Maria – a subject seemingly tailored to fit . . . the sensibility of the late eighteenth century spectator . . .' Gordon notes that twenty paintings of

'Maria' were exhibited and/or engraved between 1777 and 1819. She reproduces the 'Marias' of Daniel Gardner, Angelica Kauffmann, Richard Hurleston (Wright's pupil) and John Russell (pls.47, 49, 46, 48). Of them all, the most popular was Angelica Kauffmann's 'Maria', of which she painted several versions, and of which there were various engravings. Gordon quotes Joseph Moser's report that the Kauffmann design was 'transferred to a variety of articles of all sorts and sizes, from a watch-case to a tea-waiter'.

53

53

The Captive, from Sterne painted in 1774

Oil on canvas $40\frac{1}{8} \times 50\frac{1}{4}$ (102×127.5)

PROVENANCE
Begun before 10 August 1774 and completed by 3 September 1774 in Rome (see below); unsold, and brought back to England 1775. By 1780 in the possession of 'Bird' (unidentified), by whom offered Christie's 11 March 1780 (99, as 'The Royal Captive, its companion', i.e. companion to 'Maria from Sterne's Sentimental Journey', lot 98: No.52 in this exhibition), bt in at £51.9.0; Edward Pickering by 1790, remaining with his descendants until earlier this century; . . . ; anon, sale Sotheby's 6 July 1983 (296, repr.) bt Colnaghi, from whom purchased by Vancouver Art Gallery, 1987

EXHIBITED
Art, Commerce, Scholarship. A Window onto the Art World – Colnaghi 1760 to 1984, Colnaghi 1984 (61, repr.)

LITERATURE
MSS letters of 10 August and 3 September 1774 from Father Thorpe, Rome, to Lord Arundell, transcripts in Sir Brinsley Ford's archive of material relating to artists in Rome, Paul Mellon Centre, London; Nicolson no.216, pp.241–2 (as untraced); pp.8–9, 60–1, 150–1; Lorenz Eitner, 'Cages, Prisons and Captives in Eighteenth-Century Art', chap. 2 in ed. K. Kroeber & W. Walling, *Images of Romanticism: Verbal and Visual Affinities*, New Haven & London 1978, p.34; David Fraser, *Wright in Italy*, exh. cat., Gainsborough's House 1987, fig.1 and note; Gordon 1988, p.78.

ENGRAVED
by Thomas Ryder, published 1 October 1786; an impression exhibited as No.165 (P19)

Vancouver Art Gallery

Wright appears to have painted four different 'Captives' in the 1770s though only the last two were taken from Sterne. The earliest 'Captive' was exhibited at the Society of Artists in 1773 as 'A Captive King' (370); Walpole thought the figure 'bad and inexpressive' and noted that he had 'a lanthorn hanging over him'. Nicolson thinks this captive was probably the crusader Guy de Lusignan (Nicolson no.214; still untraced). Wright exhibited a painting entitled 'Lusignan in Prison' at Robins's Rooms in 1785 (21), which Nicolson thinks was 'no doubt a second

version' (Nicolson p.241, no no., described below no.215; still untraced). Wright's source for the story of Guy de Lusignan is unknown.

Two versions of 'The Captive, from Sterne' followed. Father Thorpe's letters from Rome to Lord Arundell (op. cit.) report that Wright had arrived in Rome laden with 'The Alchymist' and 'The Captive King' which had not sold in England, but which Wright hoped to sell in Rome. On 10 August 1774, Father Thorpe reported that 'Mr Wright of Derby is painting *The Captive* described in Sterne's *Sentimental Journey*'; on 3 September 1774 he relates that 'Mr Wright of Derby has finished (the) picture of Sterne's *Captive* with more success than his other pieces and shows that he is improved by coming thither: he is very dear, gives nothing for less than a hundred guineas and indeed is thought to have more genius than any of the great number of English painters in town; but he has come late to this School . . . '

Sterne's 'Captive' was not (like his 'Maria': see Nos.52,58) a 'real' person encountered by his narrator, but a product of the mind's eye. He is an image produced by the sequence of thoughts which pass through Parson Yorick's mind when, in *A Sentimental Journey*, he discovers that he has lost his passport in Paris, and is visited by a police-lieutenant. At first Yorick jokes to himself about being 'clapp'd up into the Bastile', and makes light of his fears of that prison: 'And as for the Bastile, the terror is in the word'. Then he walks into the street, where he hears 'a voice which I took to be of a child', which complained "it could not get out". He saw it was 'a starling hung in a little cage – "I can't get out – I can't get out", said the starling'. Yorick's most strenuous efforts could not release the captive; and the bird's chanting 'in one moment overthrew all my systematic reasonings upon the Bastile'.

Yorick could now think of little else but the idea of captivity. Back in his hotel room, 'leaning my head upon my hand', he brooded upon the 'miseries of confinement'; and since he found he could not concentrate on the miseries of multitudes, he fixed his thoughts upon a single figure, and 'gave full scope to my imagination'. This was the 'picture' which resulted:

I took a single captive, and having first shut him up in his dungeon, I then look'd through the twilight of his grated door to take his picture.

I beheld his body half wasted away with long expectation and confinement and felt what kind of sickness of heart it was which arises from hope deferr'd. Upon looking nearer I saw him pale and feverish: in thirty years the western breeze had not once fann'd his blood – he had seen no sun, nor moon, in all that time – nor had the voice of friend or kinsman breathed through his lattice . . .

He was sitting upon the ground upon a little straw, in the furthest corner of his dungeon, which was alternatively his chair and bed: a little calendar of small sticks were laid at the head, notch'd all over with the dismal days and nights he had passed there – he had one of these little sticks in his hand, and with a rusty nail he was etching another day of misery to add to the heap . . .

Wright's 'Captive' corresponds in some details to Yorick's 'portrait': he sits upon the ground (or a raised step), there is a token amount of 'a little straw' and instead of a 'grated door' there is a barred and overgrown aperture in the wall (that Wright's 'Captive' is illuminated from some additional, unperceived light source is artist's licence). Listlessly, Wright's captive holds a tally-stick on his knee, just visible below his left hand; but he does nothing so melodramatic as to etch a notch on it with a rusty nail. This captive bears his sufferings with something more akin to resignation than to despair. Lorenz Eitner's allusion (p.34) to the Man of Sorrows is by no means inapt. It is impossible to think that Wright's captive is a common felon: he must be a political prisoner, or the victim of some palace intrigue . . . But it may well be that to speculate thus is to deny Wright's compassion in painting from his mind's eye what Yorick had 'pictured' with his: an image of the deprivation of liberty.

Wright may have discussed the idea of 'The Captive' (in this picture or in 'The Captive King' exhibited in 1773 but now lost) with John Hamilton Mortimer, his friend since the days when they were fellow-students at Hudson's; but it is now impossible to say which of them may have influenced the other. A drawing of Sterne's 'Captive' by Mortimer, now lost, was exhibited at the Society of Artists in 1774 (177), and later owned by Richard Payne Knight. Another small drawing by Mortimer of the subject (fig.9), now in the Oppé Collection, is discussed by Sunderland (p.159, no.89a, fig.162; repr.

Nicolson p.61, fig.76). A different Mortimer 'Captive' from Sterne, ill-kempt and half-demented, was etched by R. Blyth, published 1781. Benjamin West's 'The Captive from Sterne', now known only from the engraving by Henry Moses published in 1801, is the wildest image of all: near to madness, with matted locks that writhe upwards from his head, and frightful feet ending in claw-like toes.

In 1773, when Wright showed his 'Captive' at the Society of Artists, Reynolds exhibited 'Count Hugolino and his Children in the Dungeon', from Dante's *Inferno*, a rather histrionic work in comparison with which Wright's 'The Captive, from Sterne' seems intensely still and far more poignant: but then Sterne's narrative, though deeply affecting, does not have the appalling consequences (family cannibalism) of Dante's (the Reynolds is discussed and repr. in ed. Nicholas Penny, *Reynolds*, exh. cat. 1986, no.82 p.252).

Wright made at least four oil studies of the head of a bearded man, almost certainly John Staveley, which he used both for this 'Captive' and for another version; two of the studies are reproduced here, as Nos.55,56.

A second version of 'The Captive', from Sterne', probably painted a few years later, is now in Derby Art Gallery (Nicolson no.217, pl.162): in this less restrained conception the prisoner looks like a fairly well-nourished gondolier. The Derby version is almost certainly the picture exhibited at the Royal Academy in 1778 (360), when the reviewer of the *General Advertiser and Morning Chronicle* remarked that the prisoner's body was 'plump, hale and lusty'.

Wright also painted several small 'Prison Scenes', two of them appearing in his Account Book around 1787–90, but not easily identifiable. One is shown here (No.64); and see Nicolson pls.215, 219 and 286. Nothing is now known about 'The Prison of the Capitol' exhibited by Wright at the Royal Academy in 1789 (67).

While Wright's preoccupation with prisons seems chiefly to derive from Sterne, he may also later have read John Howard's first-hand report *State of Prisons* (1777, with appendices). Certainly Howard's reports had a profound effect on Romney, who made numerous drawings of prisons and lazarettos, some of which Wright may have seen, but whose dark and turbulent lines are very different from the melancholy reticence of Wright's images of the desolation of infinite solitary confinement.

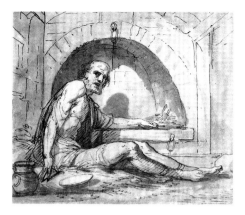

fig.9 John Hamilton Mortimer: 'The Captive', pen and ink $4\frac{1}{4} \times 5\frac{1}{8}$ (10.8 × 13) *Private collection*

54

Self-Portrait in a Black Feathered Hat *c.*1767–70

Charcoal heightened with white chalk on paper 21 × 14½ (53.3 × 36.8)
PROVENANCE
? J.L. Philips, sold Winstanley & Taylor, Manchester, 31 October 1814 (51, in section of drawings by Wright, 'Portrait of himself in a fancy dress. Capital', bt Bolton £4.4.0; . . .; William Bemrose by 1883; . . .; Frost & Reed, Bristol, from whom purchased by Derby Art Gallery 1953
EXHIBITED
Derby 1883 (43); Derby 1979 (56)
LITERATURE
Nicolson no.168 p.229; pl.70

Derby Art Gallery

Wright painted and drew several self-portraits in romantic attire in the late 1760s early 1770s, the finest being the portrait in oils exhibited here as No.94. In that portrait, Wright wears a fur hat under a striped kerchief, possibly the same hat which in essence appears in this drawing: but here it is elaborated into a fantasy of jet black feathers, in keeping with the exaggeratedly black and brooding eyes, sensuous lips and attenuated nose, as if Wright felt himself that day to be the embodiment of melancholia.

The melancholy intensity of this self-portrait compels attention, recalling the portrait of the poet John Donne, by an unknown artist, in oil on panel (repr. Roy Strong, *The English Icon: Elizabethan and Jacobean Portraiture*, 1969, p.37, fig.30), in which an inscription explains that Donne is melancholy because he is love-sick; but that portrait was not engraved, and it is most unlikely that Wright could have seen it. But it is clear from his portrait of 'Brooke Boothby' of 1780–1 (No.59) that Wright was familiar, at least through engravings, with some of the key images of melancholy in English portraiture (see Strong 1964; Cummings 1968, more fully cited under No.59), In many of those, the black hat recurs and the sitter's eyes stare out under it, at once penetrating and ill at ease.

Though he may have had images from the melancholy tradition in mind here, this self-portrait is probably otherwise wholly original, begotten by the artist out of long contemplation, in a certain mood, in his looking-glass. But there are perhaps other echoes, for instance from the engraved work of Piazzetta and, following him, Thomas Frye; Rembrandt has also been suggested. As for the technique of this wonderfully skilful exercise in chiaroscuro, Martin Royalton Kisch suggests (in discussion) that Wright may have been looking at the mezzotints of Wallerant Vaillant, whose work, as we have seen, may already have inspired certain figures in Wright's 'Academy by Lamplight' (No.23).

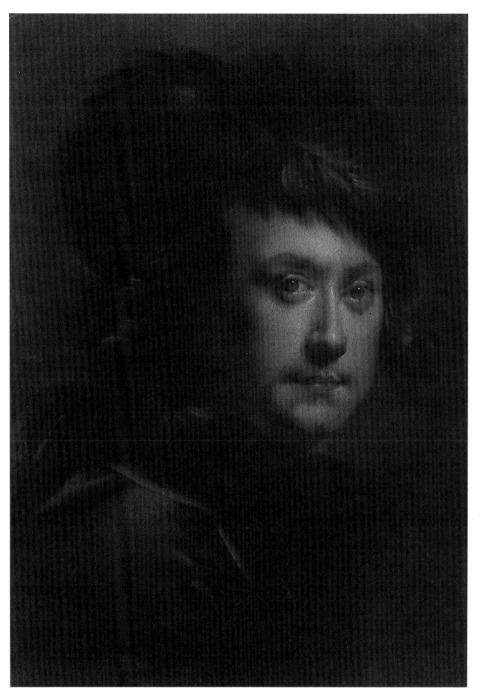

54

55 (not exhibited)

Study of John Staveley's Head, for 'The Captive, from Sterne', 1774
(No.53) *c.*1773

Oil on paper 19 × 12 (48.2 × 35.5)
PROVENANCE
Wright's daughter Anna Romana, who
married James Cade in 1795, and thence
by descent
EXHIBITED
as one of a group of four, Derby 1883 (20,
22, 26, 28); one of the four is probably the
work lent by a member of the Cade family
to Graves's exhibition, 1910 (23), there
called 'Sketch of a Jew's face'; Derby 1934
(51)
LITERATURE
Nicolson nos.183–6, p.233; pl.161 (for
another study of Staveley seen full face
looking downwards see Nicholson pl.160)

Private Collection

Wright used this study, with some differ-
ences, in his first version of 'The Captive,
from Sterne', painted in Rome in 1774
(exhibited here as No.53).

See text below No.56

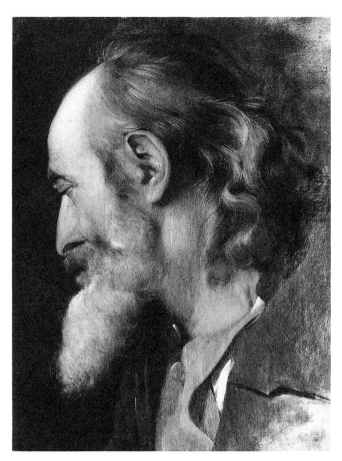

55

56

Study of John Staveley's Head, for Wright's second version of 'The Captive, from Sterne', 1775–7 *c.*1773
looking upwards to the right

Oil on paper 18¾ × 14¼ (47.5 × 36.2)
PROVENANCE
as for No.55
EXHIBITED
as one of a group of four, Derby 1883 (20,
22, 26, 28); Derby 1934 (62); *Realism
Through Informality*, Leger Galleries, 1983
(25), repr. in colour.
LITERATURE
as for No.55

Private Collection

These are two of a group of four studies in
oil on paper from the same model. Nicolson
wrote of them 'So Italianate are they in feel-
ing that we can hardly believe they were
done anywhere but in Italy – not necess-
arily in Rome, if we are correct in guessing
that he has appealed for help to Piazzetta'
(p.64). But the model is undoubtedly John
Staveley, who sat for Wright on other
occasions; and since Wright used No.55
almost directly for the 'Captive, from
Sterne' (No.53) on which he was working in

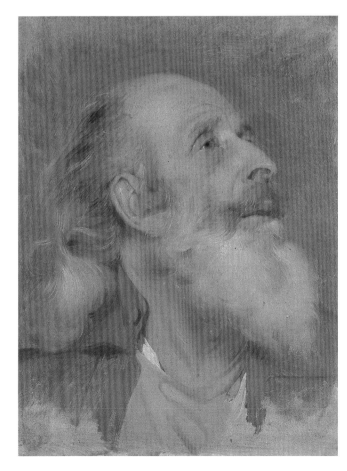

56

Rome in the summer of 1714, all four studies may have been made before he left for Italy. The second study, shown here, was used for the version of the 'Captive, from Sterne' now in Derby Art Gallery (Nicolson pl.162).

Staveley was also the model for 'The Old Man and the Ass, from Sterne', now known only in the drawing (shown here as No.91), where Wright's inscription indentifies him. Nicolson states that he is also the model for 'A Philosopher by Lamplight' c.1778–81 (his pl.226: destroyed by fire since Nicolson wrote), though that model has rounder features and a very different nose.

57
Edwin, from Dr Beattie's
Minstrel 1777–8

Oil on canvas 63 × 46 (160 × 116.8)
Inscribed 'exulting view'd in Nature's frame/Goodness untainted, wisdom unconfined/Grace grandeur and Utility combined' upper left on the rock behind Edwin's right shoulder
PROVENANCE
In Wright's Account Book as 'The Minstrel sold to Mr Milnes £84', i.e. John Milnes of Wakefield, thence by descent (changes of name by ennoblement including the titles Houghton and Crewe) to Sir John Colville, sold Christie's 27 June 1980 (135, repr.), bt present owners
EXHIBITED
RA 1778 (359); Derby 1883 (58); RA 1886 (9); Derby 1934 (10)
LITERATURE
Hugh Honour, 'Two Letters from Joseph Wright of Derby', *Connoisseur*, CXXXVIII no.557, November 1956, p.188; Nicolson 1968, cat. no.235, pp.63, 151–2, 159, 246; pl.179
ENGRAVED
(i) in mezzotint by John Raphael Smith, published 30 December 1778; an impression exhibited as No.164 (P17); (ii) etched by Seymour Haden, repr. Bemrose, 1885, following p.68

Hambros Bank Limited

The subject is taken from Book I of Dr James Beattie's long poem *The Minstrel; Or, The Progress of Genius*, written in 123 Spenserian stanzas. Book I was published anonymously in 1771. Book II was added to it and published in a new edition (probably the edition Wright used) in

1774, under Dr Beattie's name, and the whole poem, though unfinished, was received so enthusiastically that it went into numerous editions in the author's lifetime. When Wright showed 'Edwin' at the Royal Academy in 1778 – his first exhibit there – many visitors could be expected to have read or heard of *The Minstrel*.

Throughout Book I, from which Wright drew his subject, Edwin is still a boy. The child of 'a shepherd-swain of low degree' and his wife 'the blameless Phoebe', Edwin grows up free to roam and responsive to all nature's moods:

> . . . Whate'er of beautiful, or new
> Sublime, or dreadful, in earth, sea, or sky
> By chance, or search, was offered to his view,
> He scanned with curious and romantic eye . . . (stanza LVIII)

Beattie is emphatic that Edwin is no wild boy:

> And yet poor Edwin was no vulgar boy;
> Deep thought oft seemed to fix his infant eye.
> Dainties he heeded not, nor gaud, nor toy,
> Save one short pipe of rudest minstrelsy;
> Silent when glad; affectionate, though shy;
> And now his look was most demurely sad;
> And now he laughed aloud, yet none knew why . . . (stanza XVI)

Edwin, 'the visionary boy', sensitive and solitary, prefers above all to frequent 'the deep untrodden groves', and it is there that Wright chooses to depict him, musing in solitude rather than acting out any specific episode in the poem. Wright sees Edwin as a youthful image of melancholy, perhaps taking his cue from stanza XXII:

> Even sad vicissitude amused his soul:
> And if a sigh would sometimes intervene
> And down his cheek a tear of pity roll
> A sigh, a tear, so sweet he wished not to control . . .

Edwin's clothes – rather more genteel than the average reader of *The Minstrel* might have envisaged – are painted in colours associated with melancholy rather than rude health: jacket and stockings of palest blue and breeches of pinkish-brown as pale as a pigeon's breast. Oddly enough, this seems to have been Wright's idea of 'the old English dress' (see his letter to Beattie, quoted below). It is not

surprising that a version or copy of this picture was thought to represent Mrs Siddons as Rosalind.

Nicolson shows (p.63, figs.80, 8) that two studies in Wright's Roman sketch-book of 1774, one of a seated boy asleep with his head on his arms, the other of a boy standing with one foot on a low wall, his head supported by his hand, prove to be 'the unexpected source for Edwin'. Nicolson also reproduces (p.62 fig.79) a pencil study in which the young Thomas Haden (later a surgeon in Derby) poses for 'Edwin' in Van Dyck dress, seemingly leaning against a wall. Eventually Wright evolved the most soulful pose for 'Edwin' and for later contemplative figures: seated, head on hand, one knee crossed over the other. He was to repeat this pose in his 'Maria' of 1781, in 'Mrs Morewood' and in the 'Indian Widow'.

When 'Edwin' was at an advanced stage, Wright suddenly (but characteristically) sought advice from the author. On 18 January 1778 (some three months before it was due to be sent in to the Royal Academy) Wright wrote to Dr Beattie; 'Sir, I have always found men of genius ready of access, and ready to assist in any work of art . . . '. The letter, printed by Honour, shows Wright in one of his not uncommon failures of nerve, combined with his wish to be scrupulously faithful to the author. He begins by describing his picture of Edwin: 'I have made him a beautiful youth of 16 or 17 years of age, sitting under a rock on ellevated ground which cuts upon a Mountainous Distance. He holds a small pipe in his right hand and reclines his Cheek on his left, he looks Contemplative and penetrating – his dress is plain and simple, something of the old English dress with a loose Cloak and his hair in wavy locks about his Shoulders . . . '. Wright was afraid that he had given insufficient clues to the Minstrel's identity: 'The pipe alone will not characterize it sufficiently', i.e. the small pipe or recorder in Edwin's right hand, not instantly visible. Should he 'engrave' a few verses on the rock behind Edwin, as if Edwin himself had written and engraved them there? 'If so, I wish you would think of such as would strongly mark his character and explain the picture . . . A Harp or Lyre would do well lying by him, was there Room for such instruments would it not?'.

In an age long before snapshots (and there is nothing to indicate that Wright sent him a sketch), Dr Beattie, in Aberdeen, can have had only the vaguest idea of Wright's picture. But he responded

by suggesting lines to 'engrave' on Edwin's rock (those which Wright added), and he must have been generally encouraging, for on 16 February 1778 Wright wrote to thank him for his 'ingenious observations', adding 'As far as I could, consistent with the situation of the picture (for it was far advanced) I have made alterations agreeable to your remarks, have introduced a Gothic spire, terminated the distance with the Sea and made a bright streaky light on the Horizon - but for the Harp the great characteristick of Minstrel I cannot find room for, indeed I have been hard set to bring in the scrolls of manuscripts without hurting the composition and effects of the picture, have been obliged to lay them in the foreground, as a light spot in the bottom corner of the picture would much hurt the repose and keeping of it . . . '.

Wright appears to have been the first artist to find a subject in *The Minstrel* (illustrators to later editions of the book include E.F. Burney and Richard Westall). Horace Walpole's comments on Wright's picture when he saw it at the R A exhibition of 1778 were: 'The head finely expressive of passion and enthusiasm – very new' (Whitley 1928 II p.397).

The Minstrel deserves to be better known as a comparatively early romantic response to the sublime aspects of nature. As a narrative of a young poet drawing his education and his inspiration from nature, it foreshadows Wordsworth's *Prelude* by many decades. And it may have had a more profound influence on Wright than he was aware of at the time, for the late 1770s were the very time in which Wright was becoming increasingly aware of landscape as a paintable presence.

J.R. Smith's mezzotint *Edwin* (see No.164) incorporates two sets of verses from *The Minstrel*, those which Wright 'engraved' on the rock and four lines beginning 'And yet poor Edwin was no vulgar boy . . . ' (from stanza x v i quoted earlier). J. Smith's mezzotint probably attracted copyists. Three copies, one previously thought to represent Mrs Siddons as Rosalind, were reported by E.K. Waterhouse to Honour (op. cit., one, coll. Montagu, repr.), all unseen by this compiler.

Dr Beattie (1735–1806), born the year after Wright, became professor of moral philosophy at Marischal College, Aberdeen. His great work as a philosopher

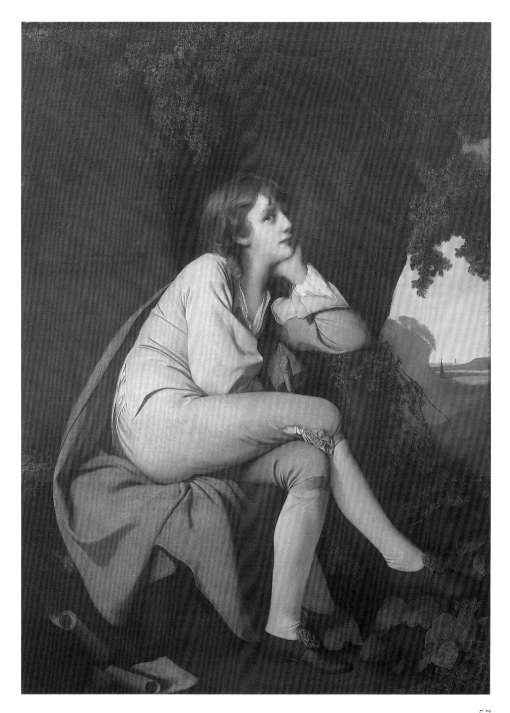

57

was his *Essay on the Nature and Immutability of Truth* (1770), and it is in this role that Reynolds portrayed him in 1774, in his doctoral robes, his *Essay* under his arm, while the personification of Truth thrusts down the frightful figures of Prejudice, Scepticism and Folly (coll. Aberdeen University, repr. E.K. Waterhouse, *Reynolds*, 1973, pl.67).

58

Maria, from Sterne, a Companion to the Picture of Edwin dated 1781

Oil on canvas 63 × 45½ (160 × 115.6)
Inscribed 'I.W. Pinx!/1781' lower r.

PROVENANCE
In Wright's Account Book as 'A full length of Maria £84'; remained on the artist's hands; offered in Wright's posthumous sale, Christie's 6 May 1801 (49), bt in at £38.17.0; . . . ; W. Bemrose by 1870; C.L.Bemrose; Agnew's 1918; Arthur Tooth & Sons, from whom purchased by Derby Art Gallery by subscription and with assistance from the National Art Collections Fund 1926

EXHIBITED
RA 1781 (100); Derby 1870 (319); Derby 1883 (64); Graves 1910 (3); Derby 1934 (16); Derby & Leicester 1947 (38); Sheffield 1950 (8); RA 1951–2 (64); Derby 1979 (27)

LITERATURE
Bemrose p.69; Nicolson no.237 p.246; pp.62–3, 151, 159; pl.220; Fraser 1979, p.15, pl.15; Gordon 1988, pp.74–6; pl.52

Derby Art Gallery

In the Royal Academy exhibition catalogue of 1781, Wright described this 'Maria' as 'a Companion to the Picture of Edwin exhibited three years ago'. 'Edwin' is shown here as No.57. Wright had already painted one version of 'Maria', in 1777 (No.52, under which her story and its source in Sterne are given); that is a smaller picture, showing the sad lady seated full-length on the ground. For 'Maria' to be a pendant to 'Edwin', she must be on a larger scale, younger (for Edwin is still a boy), seated on a mossy bank with one leg crossed over the other and facing left. 'Edwin' was purchased by John Milnes, but he was evidently unmoved by 'Maria', or, as Nicolson observes, 'Perhaps he was not sufficiently drenched in literature to want both' (p.159). The two pictures were never seen together in Wright's lifetime.

A large, very deliberate pen and ink 'Study of a Melancholy Girl' (No.90), made in Italy in 1775, gave Wright the outline of the idea for this 'Maria', though the pose itself ultimately derives from Durer's engraving *Melencolia 1*, dated 1514, a source drawn upon by many other artists. Wright still needed a model to turn the drawing into a large painting. According to Bemrose, his model was Mrs Bassano of Derby, further identified by the Derby

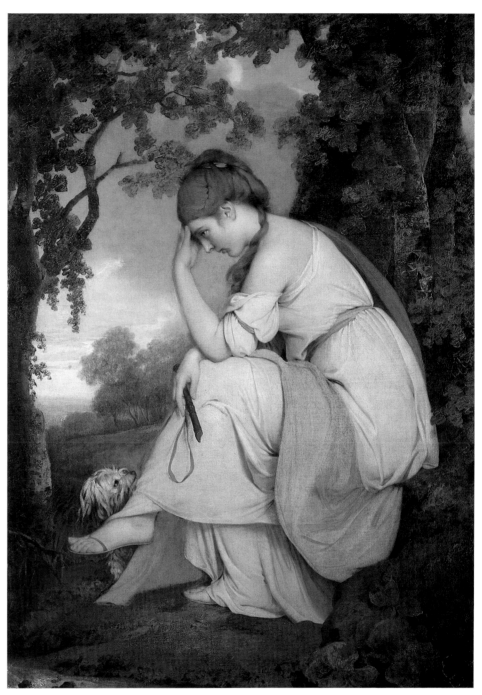

58

1934 Bi-centenary Exhibition catalogue as Mary, wife of Richard Bassano. The Bassanos are a particularly interesting family who had arrived from Italy in the early sixteenth century as Court Musicians to Henry VIII; later that century, it has been suggested, Emilia Bassano was Shakespeare's Dark Lady of the Sonnets. The family moved to Derby in the seventeenth century; a pedigree is given in Glover, II, pp.375–7. Mary, born in 1759, daughter of Philip Waterfield of Derby and wife of Richard Bassano, was certainly

the right age to pose for this 'Maria'. The prominence Wright gives to Maria's pipe, unmistakably a recorder (Edwin's pipe is partly visible above his right knee) may partly be a compliment to the musical gifts of the Bassano family.

The Bolognese dog, faithful attendant of the first 'Maria', reappears here: possibly he was a Bassano family pet. The landscape is autumnal, and close in style to that in 'Brooke Boothby' – by no means the only affinity between the two pictures.

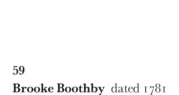

59

Brooke Boothby dated 1781

Canvas 58½ × 81¾ (148.6 × 207.6)
Inscribed 'I. Wright Pinx.ᵗ/1781' on tree
trunk lower r.

PROVENANCE

In Wright's Account Book as 'A large
picture of Mᵣ Boothby £50.8' and also, in
a list of works purchased (on credit, paid
for by 1787) headed 'Brooke Boothby Jun.
Esqᵣ Dᵣ to Josʰ Wright. Sepᵗ 30.ᵗʰ
1780', as 'A full length of himself £50.8.';
by descent to Sir William Boothby, 8th
Bt., sold Ashbourne Hall, 11–12
November 1847, (5) in supplementary
catalogue of paintings; . . . ; Miss Agnes
Ann Best, by whom bequeathed to the
National Gallery 1925; at the Tate

Gallery from 1949 until 1956, when
returned to the National Gallery; trans-
ferred to the Tate Gallery 1961

EXHIBITED

RA 1781 (245, as 'Portrait of a
Gentleman'; Tate & Walker 1958 (22);
Tate 1959 (380); *Rousseau*, 250th
Anniversary Exhibition, Bibliothèque
National, Paris 1962 (478)

LITERATURE

Martin Davies, *National Gallery
Catalogues: The British School*, 1946, p.182;
Nicolson no.20 pp.182–3; pp.72, 127–8;
pls.219 (in colour), 219a; Frederick
Cummings, 'Boothby, Rousseau and the
Romantic Malady', *Burlington Magazine*,
CX no.789, 1968, pp.659–666

Tate Gallery

Brooke Boothby's chief claim to fame lay
not in his own works (he was a minor
poet) but in the fact that he was there
when Rousseau needed him – or some-
one like him. Although it is misleading to
describe Boothby as 'a personal friend of
Rousseau' (Cummings p.160), the two
had become acquainted in 1766–7,
when Rousseau visited England and
stayed for fifteen months at Wootton
Lodge, Staffordshire, not far from
Boothby's home, Ashbourne Hall,
Derbyshire. Boothby was then aged 22
or 23.

Nearly ten years later, returning from
a visit to Italy, Boothby passed through
Paris, and on 6 April 1776 called on
Rousseau in the rue Plâtrière. Rousseau
was then anxious to find someone,

preferably an Englishman, to whom he could entrust the manuscript of his autobiographical *Dialogues*. When Boothby appeared, Rousseau recalled, 'Je me dis: Voilà le dépositaire que la Providence m'a choisi' (*Oeuvres Complètes*, Paris, 1, 1959, p.923). Boothby returned to England with the first part only (all that was ready), and honoured Rousseau's trust by publishing, evidently at his own expense, *Rousseau. Juge de Jean Jacques – Dialogues . . . Premier Dialogue d'Après le Manuscrit de M. Rousseau laissé entre les mains de M. Brooke Boothby*, Lichfield, 1780. It was the first publication of the work to appear anywhere. Rousseau had died in 1778. Boothby gave Rousseau's manuscript to the British Museum (where it is Add. MS 4925) the year after publication, and the year in which Wright finished his portrait.

In Wright's portrait, a vellum-bound volume beneath Boothby's right hand becomes the seeming pivot of his pose. Its spine is lettered 'Rouſseau'. It fastens with tapes, and is unlikely to be a copy of the newly-published *Dialogues*; but as Boothby would hardly have allowed the precious manuscript to lie crumpled beneath his hand by the damp edge of a brook, the volume itself is probably a studio prop. The image of Rousseau's work in his hands, as it were, probably had great significance for Boothby. He who, as he grew older, could hardly bear to think of acting 'life's sad inanities anew', may well have realised that his own finest hour had been in the rue Plâtrière: Wright's portrait would continually remind him of that.

'Brooke Boothby' is one of the most imaginative of all Wright's portraits, and the most deeply imbued with melancholy imagery. As Cummings shows, it is in the melancholy tradition in British portraiture which goes back to the Elizabethan age. The origins of that tradition have been discussed by Roy Strong, 'The Elizabethan Malady: Melancholy in Elizabethan and Jacobean Portraiture', *Apollo*, LXXLX, no.26, 1964, (pp.264–9); and as he shows, in two of the most potent images of that tradition, Nicholas Hilliard's 'Henry Percy, 9th Earl of Northumberland' (p.283) and Isaac Oliver's 'Edward Herbert, first Baron Herbert of Cherbury' (pl.11), the sitters are portrayed lying full length on the ground, each propping up his head on his right hand, in a setting of trees which obscure the light. Cummings notes

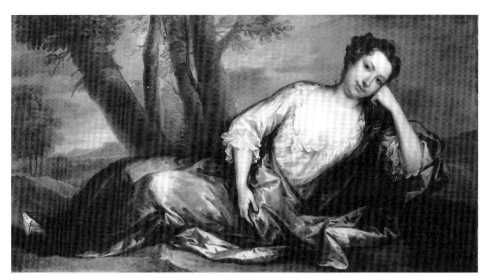

fig. 20 Charles Jervas: 'Jane Seymour Conway', oil on canvas $35\frac{1}{2} \times 66\frac{1}{8}$ (92 × 168)
National Gallery of Ireland

that the Oliver was engraved by Anthony Walker as the frontispiece to Horace Walpole's edition of *The Life of Lord Herbert of Cherbury*, written by himself, published at Strawberry Hill in 1764, in a limited edition of 200 copies. It is possible that Wright could have seen it.

'Melancholy' as an attitude in portraiture signified not low spirits, but rather the capacity to muse on subjects other than the petty preoccupations of this world; it thus had flattering implications of intellectuality. Wright may never have seen the Hilliard and Oliver miniature portraits mentioned above; but the tradition was kept alive, for instance, in portraits by James Maubert of 'The Duchess of Bolton' and by Charles Jervas of 'Jane Seymour Conway' (both in the National Gallery of Ireland); the Jervas, reproduced here as fig.20) comes close to the Wright. Probably Wright's chief source, as J. Douglas Stewart notes, was Kneller: the portrait of 'Lady Howard', likely to have been known to Wright in the form of John Smith's mezzotint of 1693 (Stewart 1976, p.410, fig.98).

The setting of woods and water, and the air of solitude, go back to the literary fountain-head of the melancholy tradition, Robert Burton's *Anatomy of Melancholy*, first published in 1621: 'Most pleasant it is . . . to such as are melancholy given . . . to walk alone in some solitary grove, betwixt wood and water, by a brook side, to meditate upon some delightsome and pleasant subject . . . to melancholize, and build castles in the air,

to go smiling to themselves . . .' (Everyman ed., 1, 1964, p.246). Boothby lies in just this Burton-esque position, 'betwixt wood and water, by a brook side . . .', at ease among the burdocks. He does not affect a 'communion with nature', in Rousseau's sense: his pose remains that of a civilised Englishman who has learnt much from Rousseau and is content to retire to a quiet place to think.

Cummings suggests that Boothby's unbuttoned waistcoat and coat sleeves are deliberately 'dishevelled' in a melancholy manner: possibly, but Boothby's elegance is not lessened thereby. Aileen Ribeiro (p.117) sees Boothby's clothes as an example of a new simplicity in dress at this date, all the items – double-breasted frock-coat, very short double-breasted waistcoat, broad-brimmed hat, plain muslin instead of lace cravat – exemplifying the change in style from ornate to plain.

When 'Brooke Boothby' was exhibited at the Royal Academy in 1781, as 'Portrait of a Gentleman', the reviewer of the *Public Advertiser* for 2 May 1781 noted that most of Wright's exhibits were 'his *usual* Contrivances . . . Light to Light, and Shadow to Shadow', but added 'what is *not* usual with Mr Wright, he shews in the whole Length of the gentleman lying down, the Powers of a *Portrait* Painter in the *first* Class. The portrait, if we recollect right, is Mr *Brook Boothby*, lately a little known as the Editor of the Posthumous Works of J.J. Rousseau . . .' The *London Courant* noted on 8 May that the 'Gentleman' in Mr Wright's portrait

'lies in a very easy posture, but there is a little heaviness about the eyes'. Boothby's heavy-lidded look recurs in Sir Joshua Reynolds's portrait of him, painted three years later, and now in the Detroit Institute of Arts (repr. Nicolson p.128, fig.126).

Boothby bought various works from Wright, chiefly landscapes: two copies after Cozens, two views of bridges near Rome, two views of Matlock and two of Dovedale, a relica of Erasmus Darwin' portrait and a small prison scene; none of these are now indentifiable. He seems to have liked Wright, and used his influence to attract eminent visitors to Wright's one-man exhibition in London in 1785.

Brooke Boothby succeeded his father as 6th Baronet in 1789, and spent money on refurnishing Ashbourne Hall and laying out its grounds. He wrote poetry, and published two long political esssays, *A letter on Burke's Reflections on the French Revolution*, 1791 and *Observations on* Burke's *Appeal from the New to the Old Whigs . . . and on Mr Paine's Rights of Man*, 1792; he also published his own translation of Racine's *Britannicus, a tragedy*, 1803 and *Fables and Satires . . . with a preface on the Aesopian fable*, 1809. He was one of the 'Lichfield circle' which included Erasmus Darwin and Anna Seward (who wrote maliciously about him).

Boothby had married Susannah Bristow; they had one child, Penelope. Penelope's death at the age of five plunged Boothby into bitter and lasting grief. For the chapel of Ashbourne Church, Thomas Banks sculpted a monument (it is his finest work) which shows the stone child lying full-length (as her father lies in his portrait), as if asleep, inscriptions in French, Latin and English declaring 'She was in form and intellect most exquisite. The unfortunate parents ventured their all on this frail Bark. And the wreck was total' (repr. David Irwin, *English Neoclassical Art*, 1966, pl.157).

This loss left Boothby unable to settle. In 1796 he published a volume of poems entitled *Sorrows. Sacred to Penelope*. The last twenty or twenty-five years of his life seem to have been spent abroad, 'a solitary wanderer', in his own phrase, as his wife chose not to accompany him; money worries began increasingly to loom. Boothby died at Boulogne in 1824, aged 78.

60

Thomas Day painted in 1770

Oil on canvas 48 × 38½ (121.9 × 97.8)

PROVENANCE
One of two portraits entered by Wright in his Account Book as 'M! Day 2 half lengths—£42' (i.e. 20 guineas each); this one (?) commissioned by Richard Lovell Edgeworth, or perhaps given to him by Day; certainly in Edgeworth's possession at the time of Day's death, then by descent to Mrs Rose B. Montagu, sold Sotheby's 10 December 1930 (115), bt Mrs G. Halliwell; Harold Hill, from whom purchased by the National Portrait Gallery 1931

EXHIBITED
The Lunar Society of Birmingham, City Museum and Art Gallery, Birmingham, 1966 (55)

LITERATURE
Anna Seward, *Memoirs of the Life of Dr Darwin, chiefly during his residence at Lichfield*, 1804, p.20; Richard Lovell Edgeworth, *Memoirs of Richard Lovell Edgeworth, Esq. begun by himself, and concluded by his daughter, Maria Edgeworth*, 1820, I, pp.105 – 6; Nicolson No.57 pp.194 – 5; pp.341, 3 – 6, 101 – 2; Ribeiro 1984 p.198

ENGRAVED
by Henry Meyer for publication in Edgeworth, *Memoirs*, 1820, p.350 (P45)

National Portrait Gallery, London

Thomas Day, now chiefly remembered as the author of *Sandford and Merton*, must have been the least conventional of all Wright's sitters. Born in 1748, son of the Collector of Customs in the Port of London, he inherited sufficient money to support him while he wrote books, evolved radical ideas and advanced cherished reforms. At Oxford he made a lifelong friend in Richard Lovell Edgeworth, who later introduced him to Erasmus Darwin. Day and Darwin found each other's conversation so interesting that from about 1770 – 6 Day rented a house within easy reach of Darwin's. Through his friendship with Darwin, Edgeworth and also Dr Small, Day became a member of the Lunar Society of Birmingham, but announced from the start that his own preoccupation was 'the study of man', and made no pretence of being a scientist. He lent money to Lunatics like Boulton, Small and Keir, and bought shares in the Birmingham Canal Company, but was

otherwise far removed from the practical world.

Darwin sat to Wright in 1770 (No.144), and it was probably he who suggested to Day that he too should sit for his portrait. According to Anna Seward, Day sat to Wright 'in the course of the year 1770': probably in the latter part of the year, for Day was making one of his frequent tours of France during the spring of 1770.

Wright seems largely to have based Day's pose and even his dress on John Smith's mezzotint *c*.1694 after Kneller's portrait of Anthony Henley (Stewart 1983 pl.32b; Chaloner Smith 126). There can be no doubt that Wright was familiar with this print, as he had already based his portrait of 'Francis Noel Clarke Mundy' *c*.1762 – 3 (No.5) even more closely on it. Nicolson suggests (p.34, footnote 1) that the prototype for Day is Reynolds's 'Lord Fortescue' (repr. E.K. Waterhouse, *Reynolds*, 1973, pl.35; painting destroyed), and indeed there are similarities both in the pose and in the setting; but 'Lord Fortescue', 1756, is too early to have been exhibited, and does not appear to have been engraved, which must make Wright's knowledge of it doubtful.

Day's physical appearance must have presented problems to any portraitist. To begin with, he was famously unkempt. A passionate admirer of Rousseau, he despised the conventions of polite society. Edgeworth, his best friend, admitted that 'Mr Day's exterior was . . . not prepossessing, he seldom washed his raven locks, though he was remarkably fond of washing in the stream' (p.180). Anna Seward adds that Day's face bore 'the traces of a severe small-pox', and that his 'meditative and melancholy air' was increased by 'a sort of weight upon the lids of his large hazle eyes' (p.20; but Miss Seward's recollections of the portrait itself are clearly faulty, since she states that the column was inscribed to the patriot John Hampden and that Day held one of Hampden's orations in his hand).

Wright did his best with the portrait of an awkward sitter whom he can hardly have known. He caught the 'meditative and melancholy air' convincingly, and provided a stormy background for a sitter with reputedly radical views. He applied higher colouring to the pockmarked face than he would normally have used. And as Day may well have wandered into the studio in clothes that

seemed unpaintable, Wright instead devised for him what Aileen Ribeiro calls 'a totally imaginary Van Dyck dress of tight-fitting silk with arm slits and an open shirt collar, more pastoral and open-air in feeling than historical'.

As for the book in Day's hand, we can be virtually certain that it is by Rousseau, and probably a copy of *Emile*. Day wrote to Edgeworth in 1769 (the year before this portrait) that if all the books in the world were to be destroyed, the second book he would wish to save after the Bible would be *Emile*. 'Rousseau alone . . . has been able . . . to look through the human heart . . . Every page is big with important truth' (quoted by Edgeworth p.221).

Day himself published at least eleven works, on a wide variety of subjects. The first was *The Dying Negro*, 1773, which aligned him with the anti-slavery movement; in others he was pro American Independence and pro constitutional reform. Several of his books were moral tales for children, the most popular being *The History of Sandford and Merton* (i.e. horrid rich Tommy Merton and kind Harry Sandford the farmer's son), 3 vols, 1783–9, which went into many editions and was translated into several languages.

One of Day's wilder ideas was that of training up a wife. To this end, he extracted two twelve-year old girls from a foundling-home and tried to instil into them education, morality and stoicism (the latter by dropping hot sealing-wax on to their arms). When this experiment failed, he hastily apprenticed one to a milliner and the other to a shop-keeper. Eventually he married Esther Milnes of Wakefield (? a sister of Wright's patron), a woman of literary tastes who seems to have adapted admirably to a husband who believed that 'luxury corrupts', and would therefore allow neither a carriage nor servants, and who never stopped talking; as Edgeworth wrote, 'From the deepest political investigation, to the most frivolous circumstance of daily life, Mr Day found something to descant upon' (p.346).

Thomas Day died at the age of 41, martyr to one of his own theories. He had consistently denounced cruelty to animals, and became convinced that if an animal was well-treated it needed no training. On 28 September 1789 he set off on an unbroken colt; it threw him, and he died within the hour. In a letter

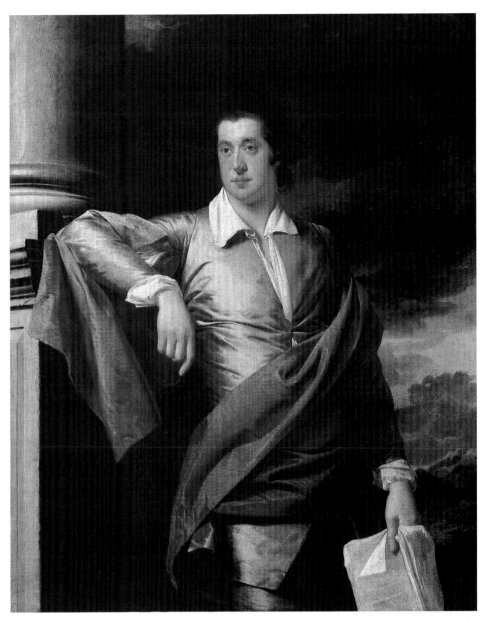

60

of 21 October 1789 to Day's nephew (National Portrait Gallery archives), Edgeworth wrote 'I have an excellent picture of M⋮ Day, by Wright; if M⋮ Day should wish for it, it is at her service – She may be sure no other person shall have it but one of my children'. The fact that Edgeworth should offer to give Mrs Day his portrait of her husband suggests that he, who visited Day frequently, knew that the Day household did not already own a version of it. It is in any case difficult to imagine Day doing anything so conventional as hanging a portrait of himself in his house.

The other version recorded in Wright's Account Book (Nicolson no.58, pl.80) entered the Strutt Collection, passed by descent to Lord Belper and was

later purchased by Manchester City Art Gallery. As it has been frequently exhibited and is the version reproduced by Nicolson, it is probably better-known than the National Portrait Gallery version; but in this compiler's opinion it is less sensitively handled, and likely to be the repetition rather than the prime original.

Virgil's Tomb, with the Figure of Silius Italicus dated 1779, and probably exhibited 1779

Oil on canvas 40 × 50 (101.6 × 127)
Inscribed 'I.W. 1779' lower r.
PROVENANCE
In Wright's Account Book as 'Virgil's
Tomb £63' among pictures of c.1778–9;
. . . ; Mrs C.E. Arkwright; Col. Sir John
Crompton-Inglefield, and thence by
descent
EXHIBITED
Almost certainly RA 1779 (359, as 'Virgil's
Tomb, with the Figure of Silius Italicus,
who bought an estate enriched with this
very tomb. He was frequent in his
Visitation to this monument of his mas-
ter'); Derby 1934 (37)
LITERATURE
Nicolson no.287 p.258; pp.83–4; pl.232;
Lance Bertelsen, 'David Garrick and
English Painting', *Eighteenth-Century Studies*,
11, 1977–8, pp.320–4; J.B. Trapp, 'The
Grave of Vergil', *Journal of the Warbourg
and Courtauld Institutes*, XLVII, 1984,
pp.1–31; J.B. Trapp, 'Virgil and the
Monuments', *Proceedings of the Virgil Society*,
18, 1986, pp.1–17

Private Collection

Shortly before his death, the celebrated
poet Virgil reputedly wrote his own epi-
taph, in a single elegaic couplet translated
long afterwards by Dryden as:

I sing Flocks, Tillage, Heroes;
Mantua gave
Me life; Brundisium death;
Naples a grave.

Virgil died at Brindisi on 21 September in
the year 19 BC. As he had wished, his
remains were carried to Naples for burial;
but classical sources are vague about
where his grave was. Professor Trapp has
traced the slow identification of the
location of the tomb as upon the hillside
above the Grotto of Posillipo; he also
records the comments of some of its count-
less visitors and discusses the work of some
of the artists, including Wright, who drew
or painted it.

Virgil's tomb, on the hillside above the
Grotto of Posillipo, became 'an obligatory
stop on the Grand Tour' (Trapp p.23).
The least learned sightseers came primar-
ily for the Grotto, a tunnel through the hill
constructed in antiquity to shorten the
route between Naples and Pozzuoli; the
entrance was a favourite subject for
draughtsmen. Virgil's Tomb, frequently
restored over the centuries but by the late
eighteenth century again in a pleasing state
of decay, attracted both reverent and
irreverent visitors. Some carved their
names on the tomb; the Duchess of
Devonshire buried a beloved lap-dog
there. Legend arose around a bay tree
which grew on top of the tomb and was
said miraculously to renew itself; almost
every tourist took a leaf or sprig from it,
Addison attempting to uproot a whole
bush. When Wright exhibited another
'Virgil's Tomb' at the Royal Academy in
1781, almost the only comment the
reviewer for the *St James Chronicle* made
was 'I looked with eagerness for the Bay
Tree' (but could not find it).

Wright probably painted six versions of
'Virgil's Tomb' (listed under No.62). In
this and in the Yale version, Wright intro-
duces the figure of Silius Italicus, seated
within the tomb, declaiming Virgil's verses
to an invisible audience, probably in hon-
our of the poet's birthday. Once one of
Nero's consuls, Silius Italicus retired in the
later seventies AD to the Naples country-
side, where he owned several houses. He
also acquired one of Cicero's villas and the
land on which Virgil's tomb stood, so that
he might cherish the monuments associ-
ated with his heroes. A letter from the
younger Pliny to Caninus Rufus c.101 AD
reporting Silius Italicus's death recalls that
'he would visit Virgil's tomb as if it were a
temple', celebrating Virgil's birthday
more solemnly than his own; but his own
verses were 'uninspired' (trans. Betty
Radice, *The Letters of the Younger Pliny*,
1963, III, 7, p.91).

There had been many representations of
Virgil's Tomb before Wright's; but
Wright appears to have been the only art-
ist to introduce the figure of the elderly
acolyte within the tomb. Wright was not
given to enlivening his scenes with such
details as the goatherd and his flock in
David Allan's treatment of the subject in
1773 (Trapp pl.6 b), or the graceful pas-
toral figures in Hubert Robert's painting
of 1778 (Trapp pl.7 b). The presence of
Silius Italicus provided the sort of recon-
dite allusion which appealed to Wright;
but over and above that, the introduction
of Silius Italicus *reading* within the tomb at
night meant that he must have light to read
by, and so gave Wright the chance to
deploy 'candlelight' within the tomb.
Virgilian verses echo in a glowing, golden-
orange shell; outside, moonlight traces a
path down the crumbling stone steps, and
silhouettes the wild plants growing on top
of the tomb.

Two sources for Wright's treatment of
the subject have been proposed. Professor
Trapp draws attention to what must
surely be Wright's chief source, an engrav-
ing in Paolo Antonio Paoli's *Antichita di
Pozzuoli: Puteolanae Antiquitates*, 1768, a
handsome publication used by many art-
ists. All Wright's versions are very close to
the engraving of the exterior of the tomb
(Trapp pl.5 a), not only in general compo-
sition but in details of the shape of the
tomb, its opening and its rocky superstruc-
ture; Wright also follows the wild plants
growing on the top of the tomb, and the
trees on the right, though he tidies up the
steps on the right (and the figure of Silius
Italicus is his own). Trapp allows that
Wright must surely have visited and per-
haps sketched Virgil's Tomb while he was
in Naples; but as we know, that visit was
very brief – about one month – much of it
spent studying Vesuvius and, to a lesser
extent, the grottoes. Professor Trapp very
reasonably argues that when Wright came
to paint Virgil's Tomb, 'he must have had
before him Paoli's volume, or at least the
engraving of the tomb from, or copied
from it' (p.26).

Lance Bertelsen (op. cit.) working from
the version in the Yale Center for British
Art which, like this picture, includes the
figure of Silius Italicus in a dramatically-lit
interior of the tomb, suggests that Wright
was influenced by Ravenet's engraving of
Benjamin Wilson's *Garrick and Mrs Bellamy
in Romeo and Juliet*, published in 1753 and
1765 (Bertelsen fig.4). The engraving
depicts a scene added to Shakespeare by
Garrick, in which the lovers meet for the
last time within the lighted tomb, while
moonlight reigns without. Wright cer-
tainly knew this engraving: it crossed his
imagination while he was working on his
own 'Romeo and Juliet' for Boydell' (see
No.63). If the engraving in Paoli gave him
the basis for the composition of 'Virgil's
Tomb', recollection of the Benjamin
Wilson may well have influenced the
dramatic presentation and lighting of
Wright's image of Silius Italicus within
the tomb. Bertelsen suggests that the
Benjamin Wilson may also have influ-
enced the cavern setting in Wright's 'A
Philosopher by Lamp Light' (No.41) and,
more generally, that 'In the Gothic gloom,
dramatic lighting, and cavern-like setting
of Garrick's stage, Joseph Wright of Derby
found models he would use throughout his
long career' (p.324).

Wright probably painted five versions of

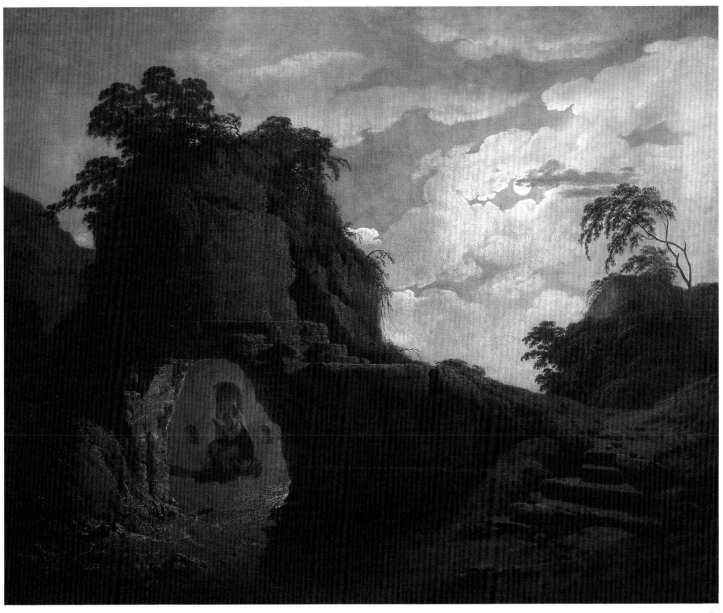

61

'Virgil's Tomb' in which the tomb is seen by the light of a full moon appearing between conveniently-drifting clouds. A single version by daylight is shown here as No.62. All the moonlight versions were sold. Many gentlemen who had been on the Grand Tour were predisposed towards acquiring paintings of classical sites; the *literati* among them would also have had a particular reverence for Virgil. In addition, the scene probably appealed to a rising Romantic generation who liked to look upon ruins as matter for meditation. When Wright added the heady ingredient of moonlight, the appeal to the Romantic imagination must have been powerful. One or other of his moonlight versions of

'Virgil's Tomb' may well have influenced, for instance, Philip de Loutherbourg's 'Philosopher in a Moonlit Churchyard' of 1790 (Yale Center for British Art, repr. *Ruins in British Romantic Art*, Castle Museum, Nottingham, 1988, p.18).

No.61 is probably the earliest of all Wright's versions of the subject.

Virgil's Tomb : Sun Breaking through a Cloud dated 1785

Oil on canvas 18½ × 25 9/16 (47 × 65)
Inscribed '1785/J.W.P.' in descending
order on two of the lower steps at r.
PROVENANCE
In Wright's Account Book as 'Virgil's
Tomb, Sun breaking thro' a Cloud —
small picture — £31.10.0'; ? in Wright's
posthumous sale, Christie's 6 May 1801
(37, as 'Virgil's Tomb — a pleasing high-
finished picture'), bt Rawlinson £17.6.0;
Joseph Strutt (b.1765, third son of
Jedediah Strutt), and by descent to 4th
Lord Belper, by whom sold to Agnew's,
from whom purchased by the Ulster
Museum 1975
EXHIBITED
Derby 1843 (233); Derby 1870 (245);
*Pictures . . . in the Midland Counties Art
Museum*, The Castle, Nottingham, 1878
(83); Derby 1883 (11)
LITERATURE
*Catalogue of Paintings, Drawings . . . in the
Collection of Joseph Strutt, Derby*, Derby 1827
(63); Nicolson p.259 (as untraced); Trapp
1984 (fully cited under No.61); Nicolson
1988, p.755 fig.46

Ulster Museum, Belfast

Wright probably painted six versions of
'Virgil's Tomb'. This is the only known
version in which the tomb is seen by day-
light. The idea that 'Sun breaking
through a cloud' might provide a new
light in which to depict the scene may have
been prompted by Wright's work on 'The
Lady in Milton's Comus' (No.66) of 1784,
the previous year; in that picture, the
whole scene turns on the fact that
moonlight manages to break through a
'sable cloud' to restore the Lady's ebbing
courage.

In all his other versions of the subject,
Wright presents Virgil's Tomb in a
carefully-staged light, in which, as both
Nicolson and Bertelsen (see No.61)
observed, there is a strong element of
theatricality. Arguably, the 'Sun breaking
through a Cloud' makes Virgil's Tomb an
even nobler ruin than it seems by moon-
light, and reveals all the encrusted textures
of its crumbling surfaces. The two tiny
figures at the tomb's further mouth seem to
have no special role to play other than that
of visitors.

Wright's six known versions of 'Virgil's
Tomb' are briefly summarised below.
Apart from this daylight version, all the

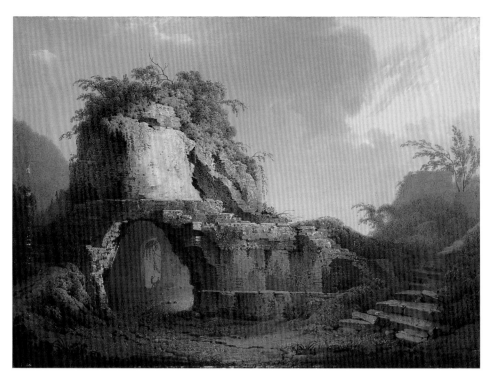

62

others (if Nicolson is right in identifying
an untraced picture given by Wright to
William Hayley as a moonlight scene)
show the tomb under the light of a full
moon. These were evidently more popular,
as apart from the picture give to Hayley,
all the moonlight versions were quickly
sold. The daylight version remained
unsold during Wright's lifetime. Wright's
versions of 'Virgil's Tomb' are arranged
here in probable order of date.

1. Moonlight, with Silius Italicus. 40 × 50;
 s.&d. 1779. Private coll.
 Nicolson no.287 pl.232. Exhibited
 here as No.61
2. Moonlight. 39 × 49; *c.*1780. Private
 coll. ?Exhibited RA 1781 (224).
 Nicolson no.286
3. Moonlight. 40 × 50; s.&d. 1782. Now
 Derby Art Gallery. Nicolson no.288
 pl.231
4. ? Moonlight. Size unknown. Presented
 by Wright to his friend the poet
 William Hayley, see undated letter
 from Wright to Hayley *c.*1783. Nicolson
 no.289
5. Moonlight, with Silius Italicus.
 40¼ × 50 13/16? exhibited at the Society
 for Promoting the Arts in Liverpool,
 1784 (115). Yale Center for British
 Art. Nicolson 1988 pp.755–6, fig.47
6. Sun breaking through a cloud: the pic-
 ture exhibited here.

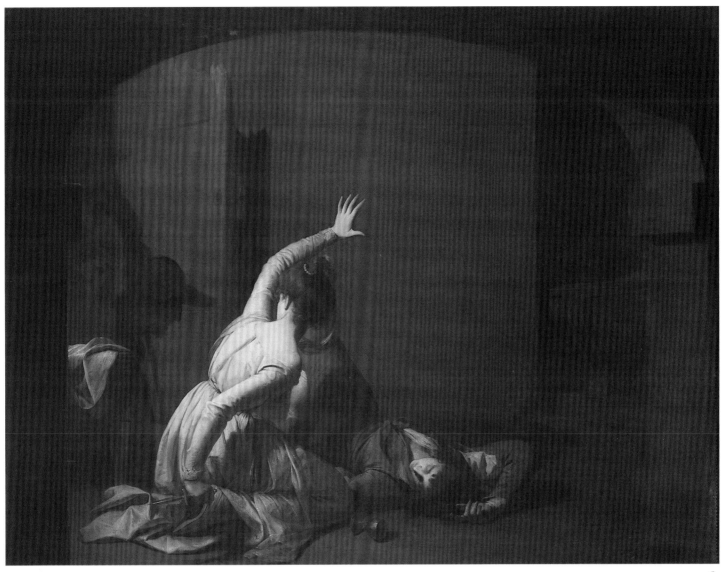

63

63

***Romeo and Juliet.* The Tomb Scene. 'Noise again! then I'll be brief'** exhibited 1790 and 1791

Canvas 70 × 95 (177.8 × 241.3)
PROVENANCE
Not in Wright's Account Book; ? painted on his own initiative for Boydell's Shakspeare Gallery; rejected by Boydell, and remained on Wright's hands; offered in Wright's posthumous sale, Christie's 6 May 1801 (51), bt in at £47.5.0; offered Derby 11 October 1810 (7), bt in; purchased from Wright's executors by Robert Mosley and his nephew, by whom raffled during the 1843 exhibition; Henry Mosley,

later its owner, from whom purchased . . . ; Mrs Thomas Hope; Thomas Haden Oakes by 1883, by descent to James Oakes, from whom purchased by Derby Art Gallery 1981
EXHIBITED
RA 1790 (1, as 'Romeo and Juliet, Act 5, Scene last'); re-worked 1790–1 and exh. Society of Artists 1791 (220, title as above); Derby 1839 (87); Derby 1843 (166); Derby 1883 (93)
LITERATURE
Nicolson no.232, p.245; pp.66, 155–7; pl.305

Derby Art Gallery

John Boydell, a London printseller (and Alderman) conceived the idea of a Shakespeare Gallery, open to the public; he would commission paintings from distinguished artists, then commission engravings of them which he hoped to sell in great numbers (but in this he was disappointed, and had to sell off the paintings in 1805).

Wright had already painted two Shakespeare scenes for Boydell, 'Antigonus in the Storm, from *The Winter's Tale*', 1789–90 (Nicolson nos.230–1, including a second version painted for Henry Philips; pls. 302, 304) and 'Prospero in his Cell, showing a visionary Spectacle to Ferdinand & Miranda, from

The Tempest', shown here in the form of an impression of Robert Thew's engraving (No.172 P41).

Wright may have painted 'Romeo and Juliet: The Tomb Scene' on his own initiative, or with no clear encouragement from Boydell. When Boydell rejected the picture, Wright was extremely incensed. Derby Public Library's collection of letters from Wright (and other collections) include many diatribes from Wright, some written directly to 'the Alderman' (as he usually called Boydell), others on the same bitter subject to his friends. Underlying Wright's wrath was the conviction that the Alderman had 'classed the painters', and had put Wright in a lower class, and thus meriting lower payment, than West and Reynolds. These accusations, and the Alderman's counter–accusations, had gone on for some years (e.g. Wright's letter to Alderman Boydell of 12 December 1786); thereafter, nothing proceeded smoothly. If it is not surprising that Boydell rejected 'Romeo and Juliet', neither is it quite clear why; probably he regarded it as too dark, and possibly also the wrong size for his Shakespeare Gallery.

Wright exhibited 'Romeo and Juliet' at the Royal Academy in 1790 (1), but was disgusted (not for the first time) with 'the *most illiberal behaviour* of the Royal Academicians', who 'put my pictures in places they could not be seen' (Wright to J.L. Philips, 11 June 1790). Wright determined to re-work the picture (and also the second version of 'Antigonus', also shown at the Royal Academy in 1790) and to exhibit them both at the Society of Artists the following year. He admitted to J.L. Philips (letter of 14 February 1791) that 'The two pictures I exhibited last year in the Royal Academy of Romeo & Juliet & Antigonus in the Storm were certainly painted too dark, sad emblems of my then gloomy mind — I have simplified the background of the former, inlarged the parts & thrown more light into the Tomb, so that Juliet is now bright without being a spot . . . '

On to the next battle. Wright sent the pictures to the Society of Artists with, it seems, the draft of a catalogue note fulminating against the Royal Academy; but this the necessarily diplomatic Society of Artists declined to publish. A compromise wording was then agreed: 'The above Pictures were exhibited last year in the Academy; but having been placed in an unfortunate position, owing (as Mr Wright supposes) to their having arrived too late in London, and have since received alterations, he is desirous they should again meet the public eye'.

Wright depicts the final moments of the final scene of Romeo and Juliet (Act v Scene 111). Romeo's murder of Paris, his own fatal draught of poison, Friar Lawrence's vain urgings to Juliet to flee, the Friar's departure, are all over: only Romeo and Juliet are left in the centre of the stage. Wright picks up the threads of the tragedy (as his 1791 title, quoted above, indicates) at the point where Juliet hears the close approach of the watch, or guards, represented by Wright as the shadow of a figure ascending a stair on the left. Juliet whispers 'Yea, noise? then I'll be brief' – and, almost uniquely among tragic heroines, she is brief. 'O happy dagger! (snatching Romeo's dagger) This is thy sheath; (stabs herself) there rust, and let me die (falls on Romeo's body, and dies).' In thirteen short words from hearing the approach of the watch, she is dead. Wright brilliantly communicates the urgency of Juliet's fate in those final brief moments.

To the shadows and urgency of Wright's scene, the Alderman preferred the more decorous deployment of four figures (or five, if one counts the effigy of a long-dead knight in full armour on top of a tomb) provided for the Shakespeare Gallery by James Northcote, engraved by P. Simon: Friar Lawrence with a flambeau and an outsize spade, Romeo (dead, left), Juliet half-lying on a low bier, centre, Paris (dead, right). It looks like an operatic pile-up in an ill-directed production.

While working out the form which his own 'Romeo and Juliet' should take, Wright wrote to William Hayley (letter of 23 December 1786, private coll.): 'When I think of the subject, a print after Ben: Wilson, which you have seen I suppose, crosses my imagination – I sometimes fancy there is no way so good of telling the story'. The print after Benjamin Wilson which Wright had in mind is reproduced by Bartelsen, 1977–8, fig.4. It depicts a final passionate encounter between the lovers in the tomb, a scene which does not of course take place in Shakespeare but which was incorporated by Garrick to general satisfaction in eighteenth century productions of the play. In his own very different painting of the final scene, Wright remained scrupulously faithful to Shakespeare's text; but as Bartelsen shows, Wright was strongly influenced by the Benjamin Wilson in painting 'Virgil's Tomb' (see No.61). Wright's mention of the 'print after Ben: Wilson' is thus of great interest in showing how readily engravings 'crossed' Wright's imagination, and what varied and unexpected uses he made of them.

64

Small Prison Scene *c.*1787–90

Canvas 16 × 18½ (40.5 × 47)
Inscribed 'I W' lower r.
PROVENANCE
Presumably one of the following in
Wright's Account Book: (i) 'A small prison
Scene sold to M.^r Boothby £12.12.0', just
before a note of 1787; 'A small prison
£16.16.0', among pictures of *c.* 1787–90;
(iii) 'An internal View of a Prison',
£23.2.0', among pictures of 1787–90. Two
works in Wright's posthumous, Christie's 6
May 1801 (60, 61) were each described as
'A small Prison scene, with a single
Figure'. It is difficult to know whether the
picture exhibited here is identifiable with
any of these; . . . ; Sabin Galleries, from
whom purchased by Paul Mellon; pre-
sented by him to the Yale Center for
British Art 1981.
LITERATURE
Nicolson no.218 p.242; p.63; pl.284

*Yale Center for British Art, Paul Mellon
Collection*

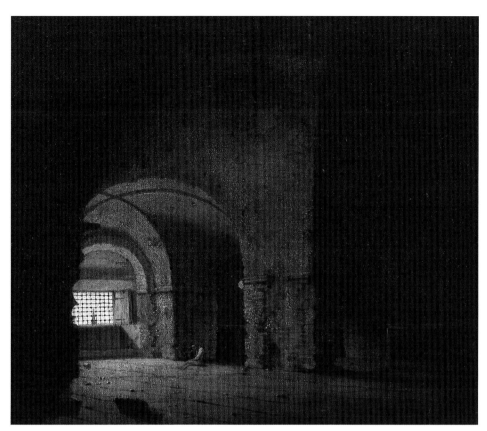

64

Ten years or more after his highly finished
paintings of 'The Captive', from Sterne
and other sources (see under No.53),
Wright again took up the theme of prisons
and, in particular, the theme of solitary
confinement. In 1787 he exhibited 'The
Prison of the Capitol' at the Royal
Academy (67), a work at present untraced.
He also painted several 'Small Prison
Scenes', including this one. Nicolson repro-
duces another as pl.285, a vaulted
chamber with a slumped figure; Nicolson
also reproduces (pl.286) an ink and grey
wash drawing for it which shows the prison
chamber empty, a chilling drawing which
oddly recalls the emptier drawing of 'The
Glass-House' (No.45).
 Wright's 'Small Prison Scenes', with
their very large spaces occupied by a
single figure, are difficult to account for.
If the lost 'Prison of the Capitol' were
found, it might throw some light on the
small scenes. They are not studies but
finished pictures in their own right. They
are surely not to be read as documentary
evidence of the state of the prisons in
contemporary England. John Howard's
report on *The State of the Prisons in
England and Wales* (1777) and *The Principal
Lazarettos of Europe* (1789) may have played
a part in Wright's pre-occupation with
prison scenes in the late 1780s. But
Howard's accounts are mostly of intoler-
able overcrowding. Wright's prison scenes
by contrast are always of solitary con-
finement. They may reflect his increasing
bouts of depression, that bleak and solitary
state in which the sufferer thinks, like the
caged starling in Sterne's 'Captive', 'I
can't get out – I can't get out. . .'

65

Lady Wilmot and her Child dated
1788

Canvas 84 × 62 (213.4 × 157.5)
Inscribed 'I·W·P·'' on long side of the stool
and '1788' on its short side
PROVENANCE
In Wright's Account Book as ' a full
Length of Lady Wilmot & her Child
£73.10.0', and on the reverse of a letter in
the Account Book dated August 1788 is an
account made out to 'Sir R! Wilmot',
including 'Lady Wilmot & her Child as a
Madona', for this price; by descent from
Sir Robert Wilmot to the present owner
EXHIBITED
Derby 1883 (29); RA 1886 (5); Lichfield
1986 (10, detail repr. in colour on cover)
LITERATURE
Nicolson 1986 no.149 pp. 226–7; pp.74,
125; pl.280

Private Collection

The picture was commissioned by Sir
Robert Wilmot, 2nd Bt, of Osmaston-by-
Derby. It shows his wife Juliana Elizabeth
with their only child, Robert John, born
21 December 1784. Juliana Wilmot was
the daughter of the Hon. Admiral John
Byron (he who famously reported 'giants'
on a voyage to Patagonia: see *DNB*) and
his wife Sophia Trevannion; she was thus
related to Lord Byron the poet, though he
was hardly two months old when she died.
Byron mentions her in a letter of July
1823, recalling the deplorable behaviour of
the 5th Lord Byron, whose son William
was Juliana's first husband; but William
died young. Juliana's second marriage,
to Sir Robert Wilmot, took place on
23 February 1783.

This is one of the grandest and yet stran-
gest of all Wright's portraits. Wright
accepts a commission to portray a mother
and child in a tranquil manor house, and
carries it out as a dramatically-lit picture in
a sombre classical setting and on a scale
seven feet high. The mood and the noctur-
nal lighting are probably linked to
'Penelope Unravelling her Web'– and
watching over her sleeping son – painted
four or five years earlier (No.68). Wright
may have been influenced by some of
Reynolds's portraits of mother and chil-
dren which are in similar intimate and
tender mood, such as 'The Hon. Mrs
Edward Bouverie and her child' (repr.
Nicholas Penny, *Reynolds*, RA exh. cat.
1986, p.243), or 'Madonna col Bambino',
painted in 1787 (the year before Wright's

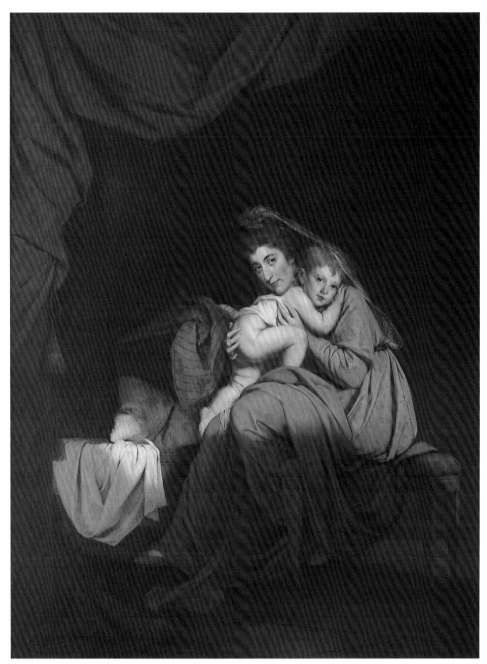

65

picture), engraved in 1791, but not exhibited in either Reynolds's or Wright's lifetime (the engraving is repr. John Gage, *George Field and his Circle*, Fitzwilliam Museum exh. cat., 1989, p.13). Could Wright have seen 'Madonna col Bambino' in Reynolds's studio, and did it make him think of painting Lady Wilmot 'as a Madona'?

The intensity of the portrait has more in common with Wright's subject pictures than with most of his portaits. In particular, it has something in common with 'Romeo and Juliet', on which Wright was working at the same time (No.63): in each, an attenuated figure acts out a fugitive moment in a deeply-shadowed setting. Lady Wilmot in fact died on 18 March 1788. Wright's picture is dated 1788; it may have been unfinished when she died, gaining in poignancy as he worked on it.

The rich blue lap-robe over Lady Wilmot's knees is the traditional blue used by Italian Old Masters for Madonnas' cloaks; Wright had noted in his Account Book that this portrait was to be 'Lady Wilmot . . . as a Madona'. The soft pink shot silk of her dress and the grey-green gauze of the scarf flowing from her hair are more familiar as Wright colours. The unostentatious neo-classical stool at once supports the characters and contributes to the quietness and privacy of the room. Light from some unknown source heightens the tenderness of the pose; beyond the mother and child, the corners of the room are quite dark.

Life had not been particularly kind to Lady Wilmot; but her son appears to have led a reasonably happy and certainly active and meritorious life: Eton, Oxford, the House of Commons, then the Colonial Office; knighted, married (adding his wife's family name Horton to Wilmot) succeeded as 3rd Baronet 1834; he died in 1841, aged 56.

66

The Lady in Milton's *Comus*
exhibited 1785

Oil on canvas $39\frac{3}{4} \times 50$ (101 × 127)

PROVENANCE
In Wright's Account Book as 'A moonlight from Comus £84.0.0'; purchased by Josiah Wedgwood before June 1785; ? Thomas Moss Tate ; William Rathbone, by 1881; presented by Mrs Rathbone, on behalf of her late husband, William Rathbone LL.D, to the Walker Art Gallery, Liverpool, in 1902

EXHIBITED
Robins's Rooms 1785 (1); Liverpool Art Club 1881 (24); Derby 1934 (139); Tate 1959 (381); RA 1962 (299)

LITERATURE
Nicolson 1962, pp.113–7, figs.20, 21; Nicolson no.234, p.245; pp.65, 148, 153; pl.246; Marcia R. Pointon, *Milton & English Art*, Manchester, 1970, pp.70–3, fig.63 p.71; Eric Adams, *Francis Danby : Varieties of Poetic Landscape*, 1973, pp.19, 26, pl.9

ENGRAVED
by John Raphael Smith in mezzotint, published 30 February 1789 ; an impression exhibited as No. 169 (P30)

*Trustees of the National Museums and Galleries on Merseyside
(Walker Art Gallery, Liverpool)*

Wright exhibited the painting in 1785 with the following quotation:

> Was I deceiv'd, or did a sable cloud
> Turn forth her silver lining on the night?
> I did not err, there does a sable cloud
> Turn forth her silver lining on the night,
> And cast a gleam over this tufted grove.

Wright's source is the pastoral drama in verse which Milton titled merely 'A Mask Presented at Ludlow Castle 1634 ; on Michaelmasse Night . . .', but which is generally called *Comus*, as Wright calls it. The lines he quotes are spoken by the Lady, for whom moonlight breaking through the clouds is the only comfort in an increasingly perilous predicament. She is lost in a 'wilde wood'; her two brothers were with her, but have gone in search of sustenance, and she fears she may never see them again. She hears nearby the noise of raucous merriment, and thinks it comes from 'late Wassailers'; she does not yet know that the truth is far worse, for the noise comes from Comus and his rout. Comus, a deplorable pagan god invented by Milton, son of Bacchus and Circe,

waylays travellers and transforms them into brutish shapes ; he has a special penchant for virgins.

Wright depicts the moment when the Lady, who had been fearful and apprehensive of 'calling shapes, and beckoning shadows dire', rallies her strength, and utters her conviction that 'he, the Supreme Good' will 'send a glistring Guardian if need were / To keep my life and honour unassail'd'. Then follow the lines which Wright quotes:

> Was I deceiv'd, or did a sable cloud
> Turn forth her silver lining on the night?
> I did not err . . .

Moonlight gives her 'new enliven'd spirits'; and from the moment of the moon's appearance, she does not falter. It is true that for the next seven hundred lines or so she is in a pretty pickle, continually menaced by Comus, 'the aidless innocent lady his wish't prey'; but the moral of *Comus* is that Chastity can and will prevail. Chastity gives the Lady 'a hidden strength' ; 'Virtue may be assail'd' but never hurt'.

Wright is rarely diffident about his abilities as an artist ; but when interpreting subjects from literature, he often showed less than complete confidence. He had written to Dr Beattie about 'Edwin' (No.57) and William Hayley about 'The Corinthian Maid', 'Penelope', 'Romeo and Juliet' (Nos.69, 68 and 63); such correspondence, generally embarked on when he had already half-completed a picture, probably helped to clarify his ideas and encourage him to proceed. With 'The Lady in *Comus*', he turned to Mrs Beridge, whose portrait he had painted in 1777 (Nicolson pl.192). Writing to William Hayley in April 1784, he reported 'I have nearly finished a companion to the Indian Widow, the burst of light in wch picture, suggested to Mrs Beridge those lines from Comus, Was I deceived ? or did a sable Cloud . . .' It is not clear from this whether 'The Indian Widow' inspired Mrs Beridge to suggest a moonlight companion from *Comus* or whether her role was limited to choosing the most apt lines from *Comus* for Wright's 'nearly finished' picture. Wright was a well-read man, with a taste for poetry ; it seems more likely that he devised the *Comus* scene himself and then, characteristically, asked a friend to lend support in choosing the precise quotation with which the picture must be launched on the world in Robins's Rooms.

Wright can have had few qualms about the success of this picture. In the same

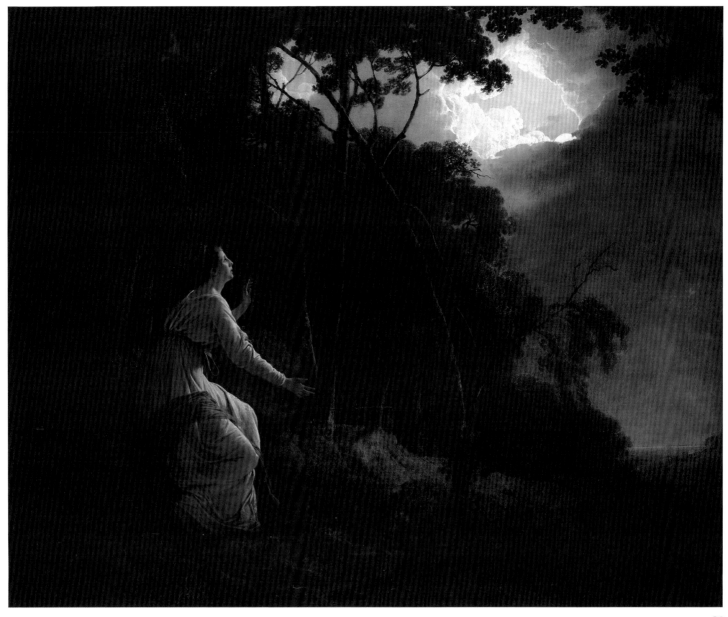

letter to Hayley, he wrote 'I have never painted a picture so universally liked'. The 'Lady' had in fact been purchased by Wedgwood before the exhibition opened. Nicolson considers the work ideally suited to Wedgwood; he remarks of the 'Lady' and the 'Indian Widow' that the two women are 'fixed in position by their stylized gestures, their clear-cut contours and profiles — posed so artificially that they seem not to inhabit their landscapes at all but to have been clamped down there like figures in relief on Wedgwood plaques. No wonder the benighted porcelain lady gazing at the sable cloud took the fancy of Josiah Wedgwood!' (1962, p.117).

Eric Adams sees 'The Lady in *Comus*' as one of the antecedents of Francis Danby's 'Disappointed Love' of 1821, and links it to the image of a 'disappointed female in a white dress and neo-classical attitude, and often in a wild spot which was one of the commonplaces of sentimental illustration in the 1790s'.

But Wright's 'Lady' of course shares her scene with moonlight; and it was probably moonlight rather than the Lady which inspired it. Wright's representation of moonlight here is subtle and poetic, lacking all the histrionic effects of such earlier moonlit scenes as the Detroit 'Matlock High Tor' or the 'Virgil's Tomb'

of 1782 (Nicolson pls.217,231). As Wright remarked to his friend and patron Daniel Daulby in a letter of 25 March 1786 (DPL), 'Moonlight pictures require a good light but not a glaring one'.

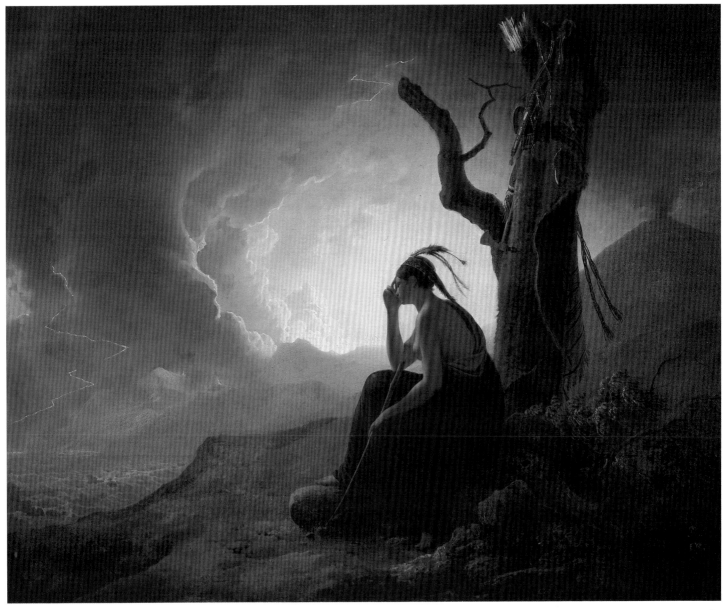

67

67

**The Widow of an Indian Chief
watching the Arms of her deceased Husband** dated 1785

Oil on canvas 40 × 50 (101.6 × 127)
Inscribed 'I.W. 1785' lower l.
PROVENANCE
In Wright's Account Book as 'an Indian
Chiefs Widdow £63.0.0.', unsold, and
remained on the artist's hands ; Wright's
posthumous sale, Christie's 6 May 1801
(64), bt Borrow £73.10.0, then by descent
in the Borrow (later Borough) family until
bequeathed by Col. J.G. Burton Borough
to Derby Art Gallery 1961

EXHIBITED
Robins's Rooms 1785 (2); Derby 1843
(272); RA 1962 (301); *Angelica Kauffmann
and Her Times*, Bregenz, Vorarlberger
Landesmuseum and Vienna, Museum fur
Angewandte, 1968 (486); *English Landscape
Painting of the Eighteenth and Nineteenth
Centuries*, National Museum of Western Art,
Tokyo and National Museum of Western
Art, Kyoto, 1970–1 (57); *The European
Vision of America*, National Gallery of Art,
Washington, 1975–6, Cleveland Museum
of Art, 1976, Grand Palais, Paris, 1976–7
(184, colourplate 5); Derby 1979 (32)
LITERATURE
Theodore Crombie, 'Wright of Derby's

"Indian Widow"', *Apollo* LXX, 1959,
p.107; Benedict Nicolson, 'Two
Companion Pieces by Wright of Derby',
Burlington Magazine CLV no.708, 1962,
pp.113–7; Robert Rosenblum,
Transformations in Late Eighteenth Centure Art,
Princeton, 1967, p.45; Nicolson no.243,
p.247; pp.65, 148–9, 152; pl.247
ENGRAVED
in mezzotint by John Raphael Smith,
published 29 January 1789; an impression
exhibited as No.170 (P31)

Derby Art Gallery

The title given above (now generally shortened to 'The Indian Widow') is the title Wright chose when the picture was first exhibited at Robins's Rooms in 1785. His exhibition catalogue added the following explanation:

> This picture is founded on a custom which prevails among the savage tribes of America, where the widow of an eminent warrior is used to sit the whole day, during the first moon after his death, under a rude kind of trophy, formed by a tree lopped and painted ; on which the weapons and martial habiliments of the dead are suspended. She remains in this situation without shelter, and perseveres in her mournful duty at the hazard of her own life from the inclemencies of the weather.

The subject had been proposed by William Hayley in 1783, and eagerly taken up by Wright. The literary source eluded Nicolson, but has been identified by Hugh Honour, in his illuminating catalogue of the exhibition *The European Vision of America*, 1975, as James Adair's *The History of the American Indians*, 1775; pp.185–6 relate:

> Their law compels the widow, through the long term of her weeds, to refrain all public company and diversions . . . And if he is a war-leader, she is obliged for the first moon, to sit in the day-time under his mourning war-pole, which is decked with all his martial trophies . . .

In a footnote to the passage Adair added:

> The war-pole is a small peeled tree painted red, the top boughs cut off short; it is fixt in the ground opposite his door, and all his implements of war, are hung on the short boughs of it, till they rot.

Adair's book was not illustrated, and gave no written description of the Indian widow's dress. It was 'for want of knowing the dress of a Mourner' that Wright again sought Hayley's help in April 1784, when the picture was nearing completion; but Hayley's reply is untraced. Nicolson notes the authenticity of many of the details in the picture: 'the form of her head-band, the treatment of the feathers, the quilled cords and knife-sheath, and the buffalo robe painted on the skin show knowledge of Indian technology from at least as far West as the upper Great Lakes' (p.148). There were collections of Indian attire and weapons in England by the late eighteenth century. Nicolson suggests that Wright

may have known the collection of the Shirleys at Stratford; Honour suggests knowledge of the Indian dress in which Sir John Caldwell of Snitterton Hall, Derbyshire had himself portrayed as an Indian chief in 1780.

Many of those who see Wright's picture today see it primarily as a dramatic landscape with a vortex of storm hardly to have been expected before Turner. As the catalogue of Wright's posthumous sale in 1801 puts it, 'The contest of the Day is over, but the War is still raged among the Elements'. The Indian widow's mutely grieving pose and her seeming indifference to the storm make the forked lightning, the volcano and the wild sea seem almost hysterical in contrast. Rosenblum comments 'Pitted against this malevolent nature, the Indian Widow appears all the more solemn and implacable in her devotion, her cleanly modeled silhouette recalling a melancholic mourner from a Neoclassic tomb'; his footnote 142 adds that the most obvious analogy would be with the grieving figures from Canova's exactly contemporaneous *Tomb of Clement* XIV in Rome, or with the figure of Sabina from David's *Horatii* of 1784.

Wright painted 'The Lady in Milton's *Comus*' (No.66) as a companion to 'The Indian Widow'. Wedgwood, who bought 'The Lady in *Comus*' before Wright's exhibition of 1785, seems to have been uninterested in 'The Indian Widow', which remained unsold in Wright's lifetime. It is sad that two pictures designed to hang together should have been almost instantly parted. This is only the second time (the first was the Royal Academy exhibition of 1962) since 1785 that they have hung together.

Both the 'Lady' and 'The Indian Widow' are in their different ways women of mettle. They are not, as Nicolson would have it, 'both done down by circumstances over which they have no control', nor are they pathetic females in distress. Certainly they have ordeals to survive; but they survive them with dignity.

Wright painted a second version of 'The Indian Widow' (Nicolson no.244), destroyed by fire this century. Other versions or copies, not seen by this compiler, exist in American collections. One, formerly thought to be by the American Joseph Wright, exhibited at Durlacher's in 1960, is reproduced by Rosenblum, 1960 (fig.4); others are discussed and mostly dismissed by Crombie.

68

Penelope Unravelling her Web, by Lamp – Light exhibited 1785

Oil on canvas 40 × 50 (101.6 × 127)
PROVENANCE
In Wright's Account Book as 'Penelope unravelling her Web-Candlelight-for M.ʳ Wedgwood-Pᵈ £105' i.e. purchased by Josiah Wedgwood, and thence by descent until sold, as 'The Property of a Gentleman', Christie's 24 April 1987 (106, repr. in colour), bt Baskett & Day for the J. Paul Getty Museum
EXHIBITED
Robins's Rooms, 1785 (14); Smith College 1955 (13) Durlacher N.Y. 1960 (20); *Josiah Wedgwood: 'The Arts and Sciences United'*, presented by Josiah Wedgwood & Sons Limited at the Science Museum, London, 1978 (234)
LITERATURE
MS. letters from Wright to William Hayley 3 December 1783 (private collection) and from Wright to Wedgwood 31 December 1783, Wedgwood Museum, Barlaston; Nicolson no.225 p.244; pp.64–5, 146–7; pl.242

J. Paul Getty Museum, Malibu

The painting illustrates an episode from Homer's *Odyssey*, Book II. Penelope is the patient and virtuous wife of Ulysses; although he has been absent for ten years, she will not believe him dead. In her palace at Ithaca, she is besieged by suitors, island princes who urge her to remarry. Homer's Penelope is no empress: instead of commanding the suitors to go, she resorts to 'feminine wiles'. She tells them that she cannot think of remarrying until she has woven a winding-sheet for Laertes, father of Ulysses. She weaves the shroud by day, but by night unravels all her work of the previous day. Amazingly, this stratagem works for three years. Eventually Ulysses returns and slays the suitors.

The picture was included in Wright's one-man exhibition at Robins's Rooms in 1785, with a long quotation (twenty-two lines) from Pope's translation of the *Odyssey*; only the last four lines are given here:

> The work she ply'd; but studious of delay,
> By night revers'd the labours of the day;
> While thrice the sun his annual journey made,
> The conscious lamp the midnight fraud survey'd.

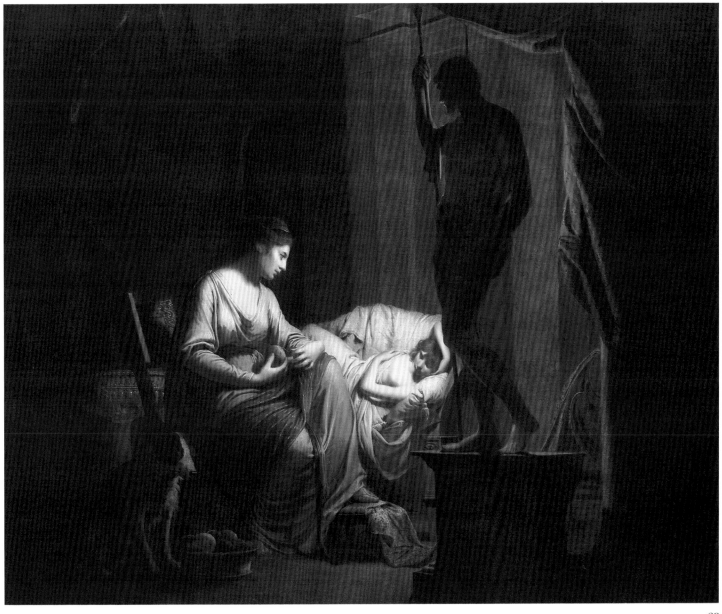

Wright's picture, begun in the spring of 1783, was conceived of from the start as a companion to 'The Corinthian Maid' (No.69). That picture had been bought by Josiah Wedgwood. It is not wholly clear whether Wedgwood actually commissioned 'Penelope'; but as Wedgwood was in correspondence with Wright about it from as early as May 1783, and as he certainly purchased the picture well ahead of Wright's one-man exhibition in 1785, it looks as if Wedgwood did commission Wright to paint, not 'Penelope' in particular, but a suitable companion for 'The Corinthian Maid (The Origin of Painting)'. Wright's friend William Hayley stepped in to suggest two suitable subjects:

'The Origin of Music' (an idea quickly dropped) and 'Penelope Unravelling her Web'. As the latter subject met with Wedgwood's approval, work on 'Penelope' began.

Hayley was full of ideas for 'Penelope'. 'I think you may introduce a young Telemachus, a Boy about 10 or 11 sleeping on an antique Bed, you may venture to give him a sickly or feverish appearance and represent his mother . . . turning her head wth a look of anxiety towards the Boy. The chamber may be decorated wth a statue of Ulysses . . .' Wright adopted both Hayley's suggestions, though he was worried that Homer did not say that Telemachus was 'sickly or feverish'.

Hayley reassured him by declaring that 'in such kind of historical or rather poetical subjects, you may take any liberties you please' (letters from Wright to Wedgwood, 29 May 1783 and 23 October 1783, quoting Hayley's letters; Barlaston MSS).

The chief attraction of 'Penelope' as a subject for Wright is likely to have been the fact that it is by night and by candlelight that Penelope works ('By night revers'd the labours of the day'). Wright worked out a very successful composition which groups three figures as a family, though Ulysses, the long-absent father, is represented only in stone. Penelope, a gentle creature, carries out her suitor-defeating, shroud-unravelling work while keeping a watchful

eye on her son Telemachus. A basket of wools in beautifully-muted colours lies at her feet, with a guardian spaniel. The statue of Ulysses has a dual role in the picture: not only does it represent the absent Ulysses, but it also conceals and diffuses the light source. The lighting was the most important part of this picture to Wright. He wrote to Hayley on 3 December 1783:

'I wish . . . to compose the picture of Penelope, in wch there is full latitude, with a strong effect of Candle light, I have therefore brought the Statue of Ulysses forward, & right before the Lamp for I always conceal the Cause when I can do it naturally, that the effect may be the brighter . . .' (Wright to Hayley, 3 December 1783, Inglefield MS). Wright may be said to have succeeded in his 'strong effect of Candle light', which pervades this golden-brown scene and contributes to its hushed atmosphere and its dignified pathos.

Wright's letter to Hayley of 3 December 1783 reports that the statue of Ulysses threatened to pose problems: Hayley's friend Dr John Beridge asserted that its nakedness was 'unfit for the chaste eyes of our English Ladies'. Wright did a little quick thinking, and came up with a solution: 'I am not fond of covering the figure wth Drapery. but I have an expedient if you approve it, that will conceal the part wch may give offence — As Ulysses was famous for his Bow and Arrows, the Sculptor might wth propriety make him rest upon an arrow, wth one hand, & hold his Quiver wth the other, wch might cross the bottom of his belly & render him perfectly decent to the chastest Eye . . .' This expedient was adopted. The picture was praised by many reviewers of Wright's exhibition in 1785, unstinted praise coming from the *General Evening Post* 23 − 26 April 1785: 'The composition is grand and elegant; the sleeping Telemachus exquisitely beautiful; Penelope interesting and delicate; the dog and the statue judiciously introduced; and the disposition of the lamp (the *effect* from which we only see) happily imagined . . . If elegance of composition, breadth of light and shadow, a happy assemblage of objects, a peculiar *chastity* and *grace* of character, with the most brilliant finishing, are essential to a good picture, this is one of the first productions in modern art'.

69

The Corinthian Maid painted *c*.1782-5

Oil on canvas $41\frac{7}{8} \times 51\frac{3}{4}$ (106.3 × 130.8)

PROVENANCE
In Wright's Account Book as 'The Corinthian Maid £105'; painted for Josiah Wedgwood, who paid for this and other pictures 4 July 1785 (Wright's receipt of that date in Keele MSS); John Greaves, Manchester, by 1831; Charles Meigh, offered Christie's 21 June 1850 (108), bt in; ? J.P. Pike, by 1866; John Bentley, sold Christie's 15 May 1886 (72), bt McLean; William Bemrose, by descent to Colonel W. Wright Bemrose, by 1910; A. Ralph Robotham by 1947, sold to Gooden & Fox, from whom purchased by Paul Mellon 1962; presented by Paul Mellon to the National Gallery of Art, Washington, 1983

EXHIBITED
Robins's Rooms 1785 (13); Manchester Institution 1831 (130); ? Derby 1866 (386, 'The Origin of Portrait Painting'); Graves 1910 (93); Derby 1934 (35); Derby & Leicester 1947 (37); Tate & Liverpool 1958 (35, pl.XI); VMFA 1963 (372), pl.221); RA 1964–5 (234); Yale 1965 (235); NGA Washington 1969–70 (10, repr.); *Pintura Británica de Hogarth a Turner*, British Council, Museo del Prado, 1988–9 (34, repr. in colour p.175)

LITERATURE
MSS letters from Wright to Hayley, one undated, one (exhibited here in a showcase) dated 22 December 1784 (private collection); MSS correspondence between Wright and Wedgwood, Barlaston MSS (unseen by the compiler; briefly summarized in Tate & Liverpool exh. cat. 1958, pp.29–30; much quoted by Nicolson); letter of 29 April 1784 from Wedgwood to Wright published by Ann Finer and George Savage, *The Selected Letters of Josiah Wedgwood*, 1965, pp.276–7); Robert Rosenblum, 'The Origin of Painting: A Problem in the Iconography of Romantic Classicism', *Art Bulletin*, XXXIX no.4, 1957, pp.279–90, fig.5 (and *passim*); David Irwin, *English Neoclassical Art*, 1966, pp.79–80, pl.2; Nicolson no. 224, p.243; pp.64–5, 143–9; pl.245

National Gallery of Art, Washington
Paul Mellon Collection

The survival of Wright's correspondence about this painting with Josiah Wedgwood and William Hayley makes it the best documented of all his works; and Robert Rosenblum's characteristically brilliant 1957 article throws abundant light on the iconography of the subject before and long after Wright. The following notes attempt to summarize information, with no claim to original research.

Rosenblum shows that the legend of 'The Corinthian Maid, or the Origin of Painting' goes back to Pliny, who tells the story of a maid of Corinth who was moved by love to invent the art of portraiture. 'Knowing that her lover was to leave the country, she traced the shadow that her lover's face cast upon the wall by lamplight. The story then goes on to tell how this mimetic image, which was to solace the Corinthian maid in her lonely days to come, was further improved by her potter father, Butades, who filled in the outline with clay and baked it with his other pottery' (Rosenblum p.281). The Corinthian Maid is sometimes called Dibutades, from her father's name. The legend passed into literature and into such works as Diderot's *Encyclopédie*. It evoked a particularly strong response from artists during the period of Romantic Classicism, *c*.1770–1820.

The first neo-Classical treatment of the subject by a British artist appears to have been John Hamilton Mortimer's 'The Origin of Drawing', now known only from Ravenet's engraving of 1771, (Sunderland 1988 cat.53, 53a-b, p.143, fig.80). Rosenblum illustrates (fig.4) an intensely Romantic treatment of the theme by Alexander Runciman in 1771, pointing out that Runciman's source must be Athenagoras, who added a grace-note to Pliny's tale by recounting that the Corinthian maid 'drew her lover's picture on a wall as he lay by asleep', thus giving artists the cue to paint the scene by night — a cue Wright was not slow to take. David Allan's oval version (our fig.21) is dated 1775, and was painted in Rome, as Runciman's may have been. Wright may have seen Allan's painting before his departure from Rome in June 1775; he could certainly have seen Cunego's engraving of it, published in 1776, after his return to England.

While Wright's version owes some debt to David Allan's, his chief inspiration was provided by the following lines from his friend William Hayley's poem *An Essay on Painting*, first published in 1778:

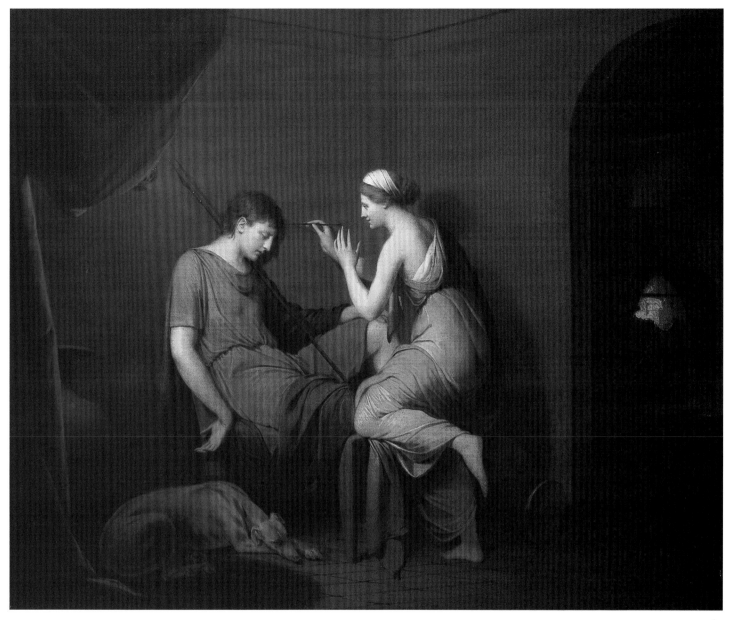

69

fig.21 David Allan: 'The Origin of Painting'
1775, oil on panel 15 × 12 (38 × 30.5)
National Gallery of Scotland

Inspir'd by thee [LOVE], the soft Corinthian maid
Her graceful lover's sleeping form portray'd:
Her boding heart his near departure knew,
Yet long'd to keep his image in her view:
Pleas'd she beheld the steady shadow fall,
By the clear lamp upon the even wall:
The line she trac'd with fond precision true,
And, drawing, doated on the form she drew;
Nor, as she glow'd with no forbidden fire,
Conceal'd the simple picture from her sire:
His kindred fancy, still to nature just,
Copied her line, and form'd the mimic bust.
Thus from thy power, inspiring LOVE, we trace
The modell'd image, and the pencil'd face!

Wright later wrote to Hayley (letter of 22 December 1784): 'I have painted my picture from your Idea'.

Wright seems first to have proposed that he should paint 'The Corinthian Maid' for Wedgwood in 1778. Wright was enthusiastic, especially as the subject concerned a potter's daughter. Over the next few years, many letters on the subject passed between them. Wright, by no means averse to pleasing a patron, proposed to 'show thro' an arch . . . another Room filled with elegant Earthen vessels', though Wedgwood, a literal-minded man, privately wondered how 'our Vases . . . could be supposed to exist in the infancy of the Potter's Art?' (letter of 5 May 1778 to his partner Bentley). Wedgwood, much later, suggested that a potter's oven might be introduced; it duly appeared. When the picture was finally completed, its sparse details included two large pottery vases in the lovers' room and, behind them, more pots on shelves and a glowing Gothick kiln, perhaps symbolizing the origin of Etruria.

Wright had taken several years over 'The Corinthian Maid' partly because from 1783 he was working at the same time on a companion picture for Wedgwood, 'Penelope Unravelling her Web' (No.68), and partly because he was also working on a large (now lost) painting depicting the Siege of Gibraltar in 1782, and was determined to finish it and exhibit it while the subject was still reasonably topical (he showed it at Robins's Rooms in 1785).

Gradually 'The Corinthian Maid' progressed. There was a fairly late hitch when Wedgwood escorted some ladies to Wright's house to inspect the picture. They were uneasy; and in a letter to Wright of 29 April 1784, Wright explained why:

> The objections were the division of the posteriors appearing too plain through the drapery and its sticking so close, tho' truly Grecian, as you justly observe, gave that part a heavy hanging-like (if I may use a new term) appearance, as if it wanted a little shove up . . .

Wright replied undertaking to 'cast a further drapery upon the Corinthian Maid wch will conceal the Nudity'. Wedgwood expressed unalloyed admiration for the figure of the sleeping lover. Rosenblum reproduces (fig.7) the bas relief of Endymion, from the Museo Capitolino in Rome, from which this figure is largely derived, and of which Wright had made a drawing in his 1774 Rome sketchbook (repr. Nicolson fig.83, p.64).

When 'The Corinthian Maid' was at last finished, both Wedgwood and Wright himself seem to have been pleased with it. As early as February 1782, Wright had written to Wedgwood: 'it will certainly make the best Candlelight picture I have painted'. But in this picture, though letters suggest that he was tempted towards bolder effects of light and shadow, he kept the lighting gentle rather than dramatic, taking his cue from Hayley's lines (quoted more fully above):

> Pleas'd she beheld the steady shadow fall
> By the clear lamp upon the even wall:
> The line she trac'd with fond precision true . . .

As Rosenblum comments (p.285), 'One could hardly ask for a tidier list of Neoclassic stylistic attributes: the shadow is steady, the lamp clear, the wall even and the line precise'. In this steady, subdued light, Wright's muted colour seems (as David Irwin suggests, p.80) to owe something 'to Poussin in its use of chrome, brown and prussian blue'.

Wright had determined from the start that 'the elegant simplicity of the subject should be disturbed as little as possible by other objects' (letter to Wedgwood, 11 February 1782). He exercised the same restraint in painting the maid herself: 'I once thought rapturous astonishment was the expression to be given to ye Maid, but now I think it too violent . . . her figure shou'd fall into a loose & easy swing' (Wright to Hayley, ? February 1782). Restraint prevailed. As Nicholson observes (p.65), 'Wright never produced another picture so austerely neo-classic' as this.

The sleeping greyhound, itself a creature with pretensions to neo-classical elegance (no other dog would have done in this design) is very close to the greyhound in similar foreground pose in Stubbs's paintings of the Southill labourers with a brick-cart, one of which he executed for Josiah Wedgwood in 1781, in enamel on Wedgwood earthenware (repr. in colour *Stubbs*, Tate Gallery exh. cat. 1984–5, p.77). Wright could easily have seen this on his many visits to Wedgwood.

In pursuit of later variations on the theme of the Corinthian maid, Rosenblum reveals a series of increasingly erotic treatments by French artists, among them Regnault, Suvée and Girodet (his figs.ix,xi,xii). A more homely version by Mulready was exhibited in 1826 as 'The Origin of a Painter'. Rosenblum ends with Daumier's hilarious fusion of 'The Corinthian Maid' and 'Penelope', to the destruction of any solemnity that might have been left in either subject. In 1970 Marcia Allentuck added her discovery of a small ink and wash drawing by E.F. Burney in the Metropolitan Museum of Art (*Burlington Magazine* CXII, 1970, pp.539–40, fig.64). To this ever-growing 'Corinthian' team may be added Carlo Maria Mariani's 'Il Mano Ubbidisco all' Intelletto' of 1983, in which two laurel-wreathed men, more or less in the pose of Wright's lovers, trace each other's features in a narcissistic trance (repr. Charles Jencks, *Post-Modernism. The New Classicism in Art and Architecture*, 1987, p.51, col.pl.2.13).

Doubts about the authenticity of No.69 have been expressed, by Nicolson (but later retracted by him: see Irwin p.79 n.5; Nicolson p.65 n.1), and by some reviewers of the NGA 1969–70 exhibition. These doubts may have been prompted by pentimenti about the girl's figure, and by areas of discoloured retouchings. This compiler has no doubts about the picture's authenticity.

70

Boy with Plumed Hat and Greyhound: copied from a mezzotint by Faber after Allan Ramsay 1750 or 1751

Charcoal and stump, $13\frac{1}{4} \times 9\frac{1}{4}$
(33.6×23.5)
Inscribed 'Delineata à Joseph Wright
Anno Atatis sua 16' along lower edge
PROVENANCE
. . . ; A. Whitworth of Cheltenham, antiquarian bookseller, from whom purchased by Derby Art Gallery 1920

Derby Art Gallery

This drawing has not been previously exhibited or published. The compiler is very grateful to David Alexander, who (instantly!) identified Wright's source as the portrait of Master John Prideaux Bassett engraved by John Faber junior after Allan Ramsay, *c.*1750 (John Chaloner Smith, *British Mezzotinto Portraits.* 1, 1883, p.308, Faber jun. no.26).

Wright's inscription records that he drew this at the age of 16. Like many other eighteenth-century artists, Wright evidently taught himself to draw by copying prints. Another example in Derby Art Gallery is the study of a head, half-finished (repr. Nicolson pl.1), a subject later identified by John Ingamells as the portrait of Archbishop Hutton engraved (also in mezzotint) by Faber junior *c.*1748 (Nicolson 1988 p.756).

Wright's early study of mezzotints contributed powerfully to his increasing fondness for paintings in which he could introduce strong contrasts of light and shade.

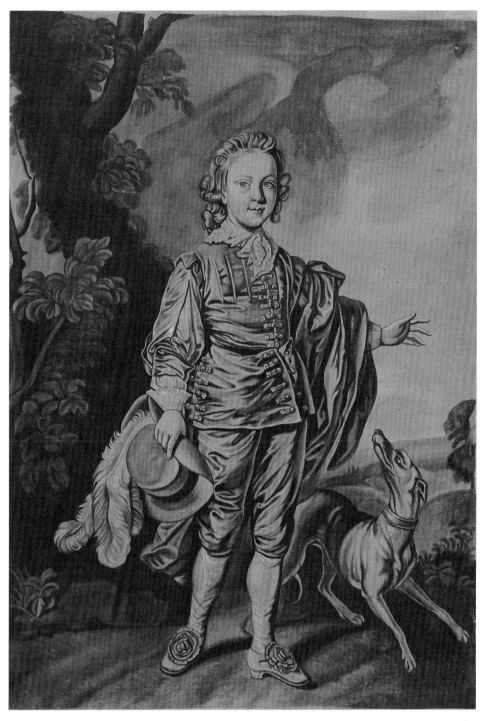

70

**Study of a Young Girl with Feathers
in her Hair** *c.*1768

Black and white chalks on prepared grey
paper laid on canvas, then glued to a
wooden border, the drawing being
continued on the border, $14\frac{15}{16} \times 11\frac{7}{16}$
(43.1×29.1)

PROVENANCE
. . . ; Capt. Henry Reitlinger; by *c.*1940;
Trustees of the late Capt. Henry
Reitlinger [to have been offered Sotheby's
20 November 1986 (46, repr.), but with-
drawn from sale]

Trustees of the Henry Reitlinger Bequest

This drawing is likely to have been made
in connection with the painting 'Two Girls
Decorating a Kitten by Candlelight' of
*c.*1768–70 (No.17), in which Wright
depicts two girls of about eleven or twelve
dressed in similar costume, also with
feathers in their hair. Though not directly
related to the painting, this may be a study
of the girl on the right, drawn about the
same time. The frilled and fringed collar
and cuffs, which seem to have some
element of fantasy, recur in several of
Wright's paintings and drawings around
1768, particularly in the costume of the
boys in 'An Academy by Lamplight'
(No.23, under which other examples are
noted); the 'Young Girl in a Turban'
(No.72) also wears a fringed collar.

'A Young Girl with Feathers in her
Hair' has some affinity with the chalk
studies of Thomas Frye (d.1762), though
Wright's handling is more confident. Both
artists took pleasure in the expressive
power and chiaroscuro effects which could
be achieved in the medium of black and
white chalk, Wright's drawing of 'A Young
Girl with Feathers in her Hair' indeed
achieving a strange, almost seductive
power. Three chalk drawings by Frye
acquired by the British Museum in 1975
are discussed by Michael Wynne, 'A pastel
by Thomas Frye', *British Museum Yearbook
11, Collectors and Collections*, 1977 pp.242–3,
figs.202–4). One of these is a 'Portrait of a
girl holding a kitten' (Wynne fig.202).
Nicolson has shown (pp.42–4, 48–9) that
Wright clearly derived ideas from Frye's
mezzotints; it is likely that he also knew
and was influenced by Frye's chalk
drawings.

71

72
Study of a Young Girl in a Turban and Frilled Collar ?1768

Black and white chalk and stump on grey paper $17\frac{1}{4} \times 11\frac{3}{4}$ (43.8 × 29.2)
Inscribed on the original backboard 'Joseph Wright of Derby 1768 delin. . .', presumably by a later hand
PROVENANCE
Possibly one of the Tate family of Liverpool; . . . ; Miss A. Loughlin, sold Sotheby's 19 March 1981 (153 repr.), bt Spink, from whom purchased by the present owner 1981
EXHIBITED
English Portraits, Spink 1981, unnumbered p.26, repr. p.27

Private Collection

The date 1768 inscribed on the original backboard (not by Wright, who did not sign himself 'Wright of Derby') seems absolutely right for this drawing. The girl wears the same frilled and fringed collar as the young students wear in 'An Academy by Lamplight', exhibited in 1769, and which appear (as noted in the catalogue entry for that picture) in other works of about 1768, including 'Two Girls Decorating a Kitten' (No.17). The delicately-rippling collar with its thick soft fringe must have been deeply satisfying to draw, particularly in chalk.

This drawing is close in style to the 'Study of a Young Girl with Feathers in her Hair' (No.71), but this study has little element of fantasy. The girl's expression is intelligent and resolute. In Sotheby's sale catalogue of 1981 it was suggested that this might be a portrait of the artist's sister Anne; but she was born in 1739 and would thus have been aged twenty-nine in 1768, which may be as much as ten years too old for this sitter.

A copy, also in chalks and approximately the same size, from the collection of Capt. Henry Reitlinger, is inscribed on the backboard 'Mʳ Tate to M Benson' (the same inscription appears on the back of a Thomas Frye drawing discussed under 'The Air Pump'). This suggests that Wright's drawing may have been copied by one of the Tate family of Liverpool. During his stay there from towards the end of 1768 to the autumn of 1771, Wright boarded with Richard Tate, merchant and amateur artist, whose son Thomas Moss Tate became Wright's friend and pupil.

72

All the Tates, including Richard's brother the portraitist William Tate, are known to have made copies after Wright, some of which they exhibited at Liverpool. As Thomas Moss Tate is known to have exhibited some 'crayon heads', he may be the likeliest copyist of this drawing.

73

An Open Hearth with a Fire

*c.*1770–2

Brown ink and wash on paper, sight size
11 × 12 (27.9 × 30.4)
PROVENANCE
. . . ; William Bemrose; Charles T.
Bemrose, by whom presented to Derby Art
Gallery 1914
EXHIBITED
Derby 1979 (65)

Derby Art Gallery

This displays all the vigorous draughts-
manship and love of effects from shadows
as the 'Glass House' drawings (Nos.44, 45).
It should perhaps be noted that a painting
entitled 'A romantic cottage, with some
Derbyshire peasants warming themselves'
was in Wright's posthumous sale in 1801
(92); but it is now untraced, and those
Derbyshire peasants may have been warm-
ing themselves at a fire out of doors. This
hearth does not seem to belong to an ordin-
ary cottage. Though the cooking-pots are
fairly humdrum, that firedog was made by
someone with a feeling for elegant, even
neo-classical, design; the long handled
shovel also looks well-wrought. Wright
was painting blacksmiths' shops in 1771; it
may be that this study was made in a
blacksmith's living quarters.

73

74

**Blot drawing in the manner of
Alexander Cozens** ?*c.*1770

Brush and black ink on paper 10 × 15¼
(25.4 × 38.7)
PROVENANCE
. . . ; William Bemrose; presented by
Charles T. Bemrose to Derby Art Gallery
1914
EXHIBITED
Landscape in Britain c.1750–1850, Tate
Gallery, 1973–4 (128, repr.); Derby 1979
(120); *Alexander and John Robert Cozens*,
Victoria and Albert Museum, 1986–7,
(34) and Art Gallery of Ontario, 1987 (31)
LITERATURE
Nicolson pp. 75 n.2, 88; Kim Sloan,
*Alexander and John Robert Cozens, The Poetry
of Landscape*, New Haven and London,
1986, pp.35, 83, repr. p.33, fig.37

Derby Art Gallery

See text for No.75

74

75

Landscape study developed from a blot *? c.*1770

Pencil, brush and black ink wash on paper, $10\frac{5}{8} \times 15\frac{1}{4}$ (27×38.7)

PROVENANCE

H. Cheney Bemrose Bequest to Derby Art Gallery 1937

EXHIBITED

Derby 1979 (121); *Alexander and John Robert Cozens*, Victoria and Albert Museum, 1986–7 (34), and Art Gallery of Ontario, 1987 (32)

LITERATURE

Nicolson pp. 75 n.2, 88; Kim Sloan, *Alexander and John Robert Cozens, The Poetry of Landscape*, New Haven and London, 1986, pp.35, 83, repr. p.33, fig.38

Derby Art Gallery

75

Alexander Cozens (1717–1786) first published his idea of 'rude black sketches' or 'blots' – half-accidental forms taken from nature but with 'some degree of design' – in his *Essay to Facilitate the Inventing of Landskips, intended for Students in the Art*, published in 1759. Cozens's aim was to stimulate the landscape artist's imagination. The exceedingly rare publication of 1759 was rediscovered by Kim Sloan, and is fully described in her book (pp.30–5). Later Cozens developed his ideas and published them in the much better-known *A New Method of Assisting the Invention in Drawing Original Compositions of Landscape*, 1786, illustrated with 43 plates engraved by William Pether.

Wright was evidently keenly interested in Cozens's ideas, and may well have seen Cozens's own drawings and paintings. Kim Sloan considers that the two Wright drawings exhibited here suggest that Wright 'appears to have seen a copy of the 1759 version of the blot method, since his own blot and drawing after it are more the black sketch type of the 1759 *Essay* than the dark blots on wrinkled paper of the later publication'.

If the 1759 *Essay* had not been rediscovered, Wright's 'blot' and 'development from a blot' would have been assumed to date from after the publication of Cozens's *A New Method for Assisting the Invention . . .* in 1786. Suggesting a date for them now becomes more difficult, especially as Wright's 'personal hand-writing' is to some extent obscured by Cozens's. Their

date may be as early as *c.*1770, especially if we consider Cozens's exciting ideas as partly contributing to that astonishing breakthrough into landscape painting which Wright achieved with his 'Rocks with Waterfall' of *c.*1771–2.

In 1778 Wright was one of the subscribers to the publications of Cozens's *Principles of Beauty Relative to the Human Head*, as was Lord Scarsdale of Kedleston in Derbyshire. Two Derbyshire landscapes in oils by Cozens, dated 1756, once hung at Kedleston. One was of 'Matlock High Tor' at dusk, the other of 'A Vale near Matlock', at sunset; they were among pictures listed by Pilkington in his *View of Derbyshire*, 1789,11, p.124, so Wright could have seen them (now private collection; Sloan pls.42,43 in colour). They reappeared in an anonymous sale in Derbyshire some thirty-five years ago, bought by a London dealer. He also bought in Derbyshire the three small but deeply poetic oils on paper which were later sold at Christie's 4 March 1975 (13–15).

Each of the three small Cozens oils sold in 1975 depicts a different 'Circumstance' affecting landscape. 'Before Storm' is now in the Tate Gallery, 'Close of Day' is in the Yale Center for British Art and 'Rising Sun' is in Stanford University Museum of Art (repr. Sloan pls.70,71,72 in colour). While most of Cozens's drawings are monochrome, his sunrises, storm clouds, twilights and sunsets in oils are vividly painted. If Wright saw them, they can

hardly have failed to stimulate him towards landscape and its 'circumstances'.

In the late 1780s, Wright painted both for Brooke Boothby and for Sir Robert Wilmot what were probably 'Cozens-like' landscapes, rather than copies of Cozens; as each work cost £31.10.0, they must have been finished paintings (they are now untraced). For Sir Robert Wilmot, he painted 'The close scene from Cozens' blot' (i.e. on the theme of pl.14 of Cozens's *A new Method*, 'A close or confined scene, with little or no sky') and 'A sunset, or bold sea shore, 3 qrs., from Cozens'; for Brooke Boothby, he painted 'A close scene, morning, from Cozens'. Wright's Account Book also lists 'sunset from Cozens', painted for his friend Holland.

(The compiler is indebted to Kim Sloan for information and for much helpful discussion)

76

Roman Sketchbook dated 1774

Paper size 9½ × 6½ (24 × 17)
Inscribed on front cover 'Jo: Wright/
Book of Sketches/Feb^y 1774' and below
this, upside down, 'xii' (in two different
inks)
PROVENANCE
. . . presented by Edward Croft-Murray to
the British Museum 1939
EXHIBITED
Classical Sites & Monuments, British
Museum 1971 (71); Kenwood 1974 (53);
Sudbury 1987 (8)
LITERATURE
Nicolson p.7, some pages repr. pls.126,
134, 137, 139, 140, 141

Trustees of the British Museum

76

The sketchbook is made up of 46 ff.,
numbered by the British Museum
1939–8–14–1 (1) – (46), on which there
are drawings, mostly on both sides, plus
three blank pages.

The sketchbook has not yet been fully
catalogued. The following notes aim to
give a general idea of its contents without
attempting to identify any of the antique
subjects drawn by Wright. The subjects fall
into three categories:

(i) about thirty-five studies after the
antique, made in the Capitoline
Museum and elsewhere, e.g. one
drawing is noted as having been
made in the French Academy in
Rome.

(ii) about thirty-five studies of figures
chiefly observed in the streets of
Rome, including several studies of
boys sleeping on benches or steps.
Many of these are inscribed 'from
memo?', presumably indicating that
Wright observed such figures as he
wandered about Rome, but drew
them later on, rather than on the
spot. One or two studies of a baby
sleeping, e.g. 1939–8–14–1 (23
verso), may be of Wright's daughter
Romana, born in Rome on 24 June
1774.

(iii) about twenty-one studies of land-
scape, sky, details of buildings etc.
This group includes three rather
careful pencil studies of skies
(1939–8–14–1) (15, recto and verso,
16) and a more spontaneous sky study
on the lower half of a page chiefly
devoted to a classical goddess
(1939–8–14–1 (10, verso). There
are several studies of crumbling
stonework, probably made in the
Colosseum, studies of a villa in the
country, an archway, a tower among
trees a sandy bank etc.

At least two of the studies were used for
finished compositions. The boy resting his
head on his arms (1939–8–14–1 (30) was
used for the large finished drawing of
'Belisarius' which Wright made in

Rome (No.89). The study of 'Endymion'
from a relief figure in the Capitoline
(1939–8–14–1 (2); Nicolson p.64 fig.83)
was used for the figure of the sleeping lover
in 'The Corinthian Maid' (no.69).

The sketchbook is open here at
1939–8–14–1 (34 verso – 35) to show two
studies in sepia, one of a barefoot boy, a
sack slung over his right shoulder, his
clothing tattered and his hair bursting
through the crown of his hat, the other of a
market boy in a huge hat, curled up by a
wicker hamper and large jar. The first is
inscribed 'Rome 27 April 74 Mem? and
the other 'ditto'.

*77

Two Sketchbooks, ? both used in Rome
1774

(i) 43 drawings (including 2 on versos) on
44 folios (3 folios unused) $6\frac{3}{4} \times 9\frac{1}{4}$
(17.2 × 23.5); vellum binding (ii) 11 draw-
ings on 94 folios (83 folios unused) $8 \times 10\frac{5}{8}$
(20.3 × 27.1); vellum binding

PROVENANCE
. . . anon. sale, Sotheby's 15 May 1957
(69), bt Agnew's for the Metropolitan
Museum of New York

LITERATURE
Louis Hawes, 'Constable's Sky Sketches',
*Journal of the Warburg and Courtauld Insti-
tutes*, XXXII, 1969, pp.350 – 1, plates p.52
fig.d

*Metropolitan Museum of Art, New York,
Rogers Fund*

The drawings are either in pencil or pen
and grey or brown ink or wash. Some of
the drawings in (i) and most of the draw-
ings in (ii) appear to have been made in
Rome; three of the drawings in (ii) are
inscribed 'Rome May 7–1774'.

Sketchbook (i) includes many sky
studies. Reproduced on this page (above)
is 57–102–1–m, which is inscribed 'an
Opening in a Cloudy Sky the middle part
Blue / the edges of the Cloud very Light &
surrounded by / Blueish Grey'. Two sky
studies on the following two pages are
inscribed 'P Plain Part faint Blue warm
Clouds dusky warm Yellow Purplish /
Grey deep Grey. the light opening glowing
yellow' (57–102–1–n) reproduced on
p.142; and 'the Lᵗ part of the Mountain of
a warm bloom & tint the shade Aerial wᵗʰ
breaking / of the Light. the plain pᵗ of the
Sky greenʰ blue broke wᵗʰ a lighter / warm
reddish light the shadow of the lower part
purplish / the shades of the upper
darker & greyer' (57–102–1–oo)
reproduced on this page (below).

These sketchbooks, used in Rome in
1774, are particularly remarkable for their
sky studies, a little-known aspect of
Wright's work to which Louis Hawes first
drew attention in 1969; there are also three
sky studies in the British Museum's
Roman Sketchbook (No.76). None of the
sky studies seems to be for a particular
painting. Probably Wright made them
chiefly to teach himself to observe various
cloud formations and to note their
gradations of colour under different
atmospheric conditions.

In this apparently recent interest,
Wright must surely have been stimulated

77

77

by the work of Alexander Cozens. Cozens was deeply interested in observing skies, both for their intrinsic interest and because he believed that the sky governed the colouring of landscape. He included 'a collection of skies' in *A New Method of Assisting the Invention in Drawing Original Compositions of Landscape*, published *c.*1786: too late to have influenced Wright in 1774, but Wright may well have known Cozens earlier (see No.107). Cozens exhibited many landscape drawings at the Free Society and Society of Artists between 1760 and 1771, mostly unidentifiable. Two were entitled 'A landscape before a storm' and 'A landscape after a storm', and it is reasonable to suppose that among the others were landscapes with remarkable skies, such as those reproduced by Kim Sloan 1984 as figs.31, 32, 39, 46 and 47, all of which must have seemed original and stimulating in the 1760s. Wright may also have known Cozens's even more exciting sky studies in oil on paper (Sloan pls.70–2, in colour).

Wright's sky studies of 1774 do not seem to have borne immediate fruit. For most of the decade after his visit to Italy, the skies in his landscapes and subject pictures are coloured by recollections of Vesuvius and the Girandola, or heightened by the drama of plights such as that of 'The Indian Widow' (No.67). The earliest landscapes in which Wright's observation of skies from nature prevails are the two very beautiful landscapes 'Matlock Tor, Daylight' (No.113) and 'Landscape with Dale Abbey' (No.117), both of the mid-1780s. Thereafter, though drama will keep obtruding, Wright's skies are painted with increasingly studious knowledge: note, in particular 'Bedgellert' (No. 118), 'Landscape with a Rainbow' (No. 124) and 'Ullswater' (No.139).

77

78

Part of the Colosseum seen in Sunlight *c.*1774–5

Pen and brown ink and wash on paper
15 × 21⅜ (38.1 × 51.7)
PROVENANCE
. . . ; H. Cheney Bemrose Bequest to Derby Art Galley 1937
EXHIBITED
Derby 1883 (119); Derby 1979 (92); Lichfield 1986 (14, repr. p.14 in colour); Manchester, Whitworth 1988 (38)
REPRODUCED
Nicolson pl.146

Derby Art Gallery

This drawing expresses something of Wright's first reaction to strong Roman sunlight on ancient Roman ruins. Like many another British artist in Rome, Wright found abundant subjects for drawing in the Colosseum, with its vast bleached and decayed walls, and the picturesque contrast provided by trailing plants finding precarious harbour among its chipped and fissured stones. Wright has responded to the subject eagerly, choosing

not an obvious angle for a 'view', but an off-beat 'Bit of the Ruins', to use his own later phrase; there he can concentrate on the physical presence of the stonework and the effects of sunlight upon it.

Four paintings of the Colosseum are recorded in Wright's Account Book in the 1780s: 'parts o the Colleseum sunshine; Dᵒ its Companion Moonlight', and two pictures each described as 'A bit of the ruins of the Coleseo sunshine'. Nicolson identifies the latter pair as the pictures exhibited at the Royal Academy in 1789 (74 and 109). But as David Fraser notes in the Sudbury exhibition catalogue, none of Wright's Colosseum paintings has been satisfactorily identified, though a damaged canvas in Derby Art Gallery (Nicolson pl.256) may be one of the 'sunshine' views.

For this and the following Roman drawings, the compiler uses Nicolson's dating of *c*.1774–5. Wright was certainly in Rome from January 1774 to June 1775 (with breaks e.g. for visiting Naples); but the 'circa' no doubt indicates Nicolson's wise caution over the fact that some of the subjects may have been worked up after Wright's return to England.

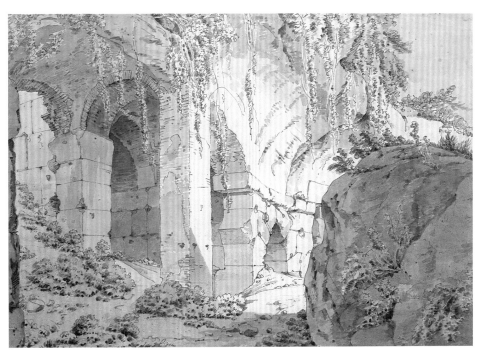

78

79

Inside the Arcade of the Colosseum *c*.1774–5

Pen and brown ink and wash on paper
14⅞ × 19⅝ (37.8 × 49)
PROVENANCE
. . . ; purchased by A.P. Oppé 1913, and thence to the present owner
EXHIBITED
The Paul Oppé Collection, RA 1958 (1); Sudbury 1987 (16, repr. p.15); Manchester, Whitworth 1988 (39, repr. p.43)
LITERATURE
Nicolson p.249, noted under no.247

Private Collection

In this drawing Wright concentrates on the monumentality of the ruins and the play of sunlight and shadows upon them. In his catalogue of the 1988 Whitworth exhibition, Francis Hawcroft suggests the influence of Piranesi (and gives examples). This may be an instance of a Roman subject drawn after Wright's return to England; a nearly identical drawing, now in the Henry E. Huntington Library and Art Gallery, San Marino, California (repr. Nicolson pl.145) was originally in the

79

Wright-Hurleston portfolio of drawings made (according to a label on its front cover) 'when on Italian travels'. Wright might have been asked to repeat the subject for a patron.

80

Roman Ruins
? 1774

Grey wash on paper 18½ × 12½ (47 × 31.8)
PROVENANCE
. . . ; H. Cheney Bemrose, by whom
bequeathed to Derby Art Gallery 1954
EXHIBITED
Derby 1979 (89)
REPRODUCED
Nicolson pl. 149

Derby Art Gallery

Wright, who had introduced broken and
chipped stone details into the backgrounds
of such earlier portraits as that of 'Robert
Vernon Atherton Gwillym' (No.35), must
have found ancient Roman ruins such as
these very congenial; but his draughts-
manship remains observant, and he does
not overplay the picturesqueness of the
ruins.

80

81

View through an Archway, Rome
? 1774

Grey wash on paper 20½ × 13⅝ (52 × 34.6)
PROVENANCE
. . . ; William Bemrose; Charles T.
Bemrose, by whom presented to Derby
Art Gallery 1914
EXHIBITED
Sheffield 1950 (54); Tate & Walker 1958
(41); Derby 1979 (90); Sudbury 1987 (17)
REPRODUCED
Nicolson pl. 158

Derby Art Gallery

The dappling of sunlight on ancient stone
and foliage provided Wright with many
subjects in Rome. The scale of this subject
is difficult to judge; at first sight the arch-
way seems some eight foot high, but this
could equally be a close-up view of some-
thing much smaller. The drawing is
characteristic of Wright's preference for
rather off-beat subjects.

81

Fireworks (? or Fire) in Rome ? 1774

Pen and bistre wash on yellow tinted
paper 11 × 16½ (28 × 42)
(said in the 1958 and 1974 exhibition cata-
logues to be inscribed 'Rome 4th June
1774': but not inscribed)
PROVENANCE
. . . ; H. Cheney Bemrose, by whom be-
queathed to Derby Art Gallery 1954
EXHIBITED
Sheffield 1950 (51); Tate & Walker 1958
(39); Kenwood 1974 (28); Derby 1979
(100); Lichfield 1986 (21); Sudbury 1987
(7, repr.)
REPRODUCED
Nicolson pl.159

Derby Art Gallery

82

This has previously been known as 'Fire in
Rome'; but it probably represents the
smoky glow from a large firework display,
seen at some distance. The 'capriccio'
drawing of fireworks (No.83) shows similar
billows of smoke.

This drawing is made from a higher
vantage point than most of Wright's
'Girandola' views. Wright's lodgings in
Rome were on the Trinita de' Monti,
above the Piazza di Spagna; the drawing
(or a study for it) may have been made as
he walked away from the spectacle and
back uphill to his temporary home.

Goethe, who watched fireworks in
Rome on 29 June 1787, recorded in his
journal that the spectacle began with St
Peter's 'outlined in fire', but after an hour
became 'one glowing mass' (J.W. Goethe,
Italian Journey 1786–1788, trans.
W.H.Auden & Elizabeth Mayer, 1962,
p.344).

It has been suggested that the church
whose dome is just visible through the
smoke, left of centre, is S. Ivo alla
Sapienza, Borromini's masterpiece.

83

**Girandola at the Castel Sant'
Angelo, Rome** dated 1774

Pen and sepia ink with brown-grey wash
on tinted paper 13¼ × 19¼ (33.6 × 48.9)
Inscribed 'Rome June 4ᵗʰ 1774' upper l.
and 'J W' at upper l. edge
PROVENANCE
. . . ; H. Cheney Bemrose, by whom be-
queathed to Derby Art Gallery 1954
EXHIBITED
Derby 1983 (125 or 129); Sheffield 1950
(50); Tate & Walker 1958 (40); Derby
1979 (99); Sudbury 1987 (27); Manchester,
Whitworth 1988 (29)
LITERATURE
Nicolson pp.9, 80, 280 (Appendix B,
under no.8), pl.154; Judy Egerton, *English
Watercolour Painting*, 1979, pp.6–7, pl.9 in
colour

Derby Art Gallery

This exciting but nevertheless deliberate
drawing must have been worked up from a
sketch made on the spot two months ear-
lier. The earliest Girandola which Wright
could have watched in Rome was the
spectacle annually staged on Easter
Monday, which in 1774 fell on 4 April
(C.R.Cheney, *Handbook of Dates*, 1970,
Table 13, pp.108–9); the next was on the
Feast of SS Peter and Paul on 29 June.
Wright's inscription 'June 4ᵗʰ 1774' must
therefore record the date on which he com-
pleted the drawing, not that of the
spectacle he records.

 There is an element of capriccio in
Wright's scene, since he has promoted the
Pantheon and Trajan's column on the left
into positions quite close to the best-known
landmarks, the Castel Sant' Angelo and St
Peter's, from which they could not have
been seen. Perhaps this capriccio element
seemed admissible in depicting the fire-
works, themselves conjured up by illusion-
ists. The rockets which seem to ricochet off
the clouds and burst into stars have a
magical effect, repeated in the large
'Girandola' in the Walker Art Gallery
(No.104), which is very largely based on
this drawing.

 Wright's drawing of architecture is not
his strong point. The over-simplified
shapes of the buildings here, particularly
those on the left, produce the same unreal
effect as those in his 'View of Mount Etna
and a Nearby Town' (No.108).

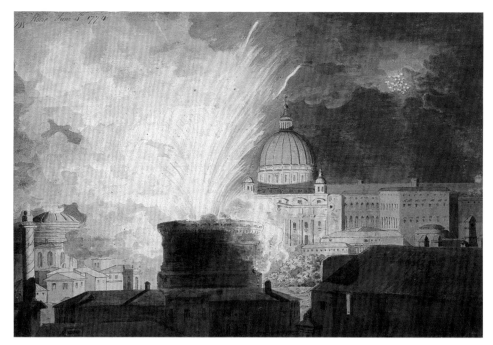

83

84

A Letter from the artist in Rome, with a view of Castel Sant' Angelo and St Peter's 1774

Pencil, pen, brush and wash on paper 9¼ × 15¼ (23.5 × 38.7); on the verso, a slighter pencil and pen and ink sketch of the same view, with some details and colour notes.
Inscribed below
PROVENANCE
. . . ; H. Cheney Bemrose Bequest to Derby Art Gallery 1937
EXHIBITED
Sudbury 1987 (23, recto repr. front cover, verso repr. p.16)
LITERATURE
Nicolson p.80, pls.152–3

Derby Art Gallery

84

The finished view on the recto was used for 'Firework Display at the Castel Sant' Angelo', which Nicolson believes Wright may have painted in Rome *c.*1774–5; that painting is now in the collection of Birmingham Art Gallery (Nicolson no.249, pl.166 in colour). On the verso, the most conspicuous detail is St Peter's, dotted with torches; there are various notes of the light effects of the fireworks: 'blackish | red transparent' where the fireworks take off from the roof of the Castel Sant' Angelo', 'Puce' in the sky between St Peter's and the Castel, 'bluih | Smoak of the Cannon' [sic.] below the ramparts of the Castel, etc.

The text of the letter follows:

(recto)
'The Collour'd drawing I will do for you must be upon a large scale and sent by a friend as I dont wish to do them as letters but I presume the Inclos'd sent as Skitches of observation or possibly to remove any doubts in regard to particular objects as I take them as faithfully as I can and shall do the others also. in the mean time I beg you will make no Scruple in mentioning any particular objects that you wish as I have justly every reason to have the greatest esteem for You and having experienc'd your Sincerity and friendship, I beg you will mention no more about the prices. have you heard any more about the Bishop he told me he was to take Derby in his way to Irland and talk to you about the Pictures I should be glad to know; when I go to Naples, as I must go some time hence

to make a View of the Lake of Avernus as a Companion for the lake of albano for the Duke of Chaboud I shall now send you some drawings that you would wish'

(verso)
'The dots signifies the torches on the Church; before the Girandola begin the reflection of the Dome was seen on the watter over the bridge the bridge being in Shady but in the time of the Girandolo it was seem'd (?) sun the watter being so Illumin'd if you chuse to represent the Girandolo at the finishing you may represent the Pesce which is thrown out at the same time, You cannot imagine how vex'd I am at my disappointment in regard to the presents you was so kind as send to Mr Cooper for me. Mr Petty the Gentleman who was to have brought them cal'd at Mr Coopers as I gave him the Direction but he wrote that he has been at Mr Cooper's who has chang'd his Lodgings and having not left notice with the neighbours where he has gone so that he cannot find him and oblig'd to sett out without them. I am much Surpris'd at Mr Cooper as a man of business not to have left word where he was gone to lodge'
The name of the recipient of the letter is not given. He is someone for whose 'sincerity and friendship' Wright has recent good reason to be grateful; he is evidently acting as intermediary between Wright and the Bishop of Derry (who wished to commission a 'Vesuvius' painting: this was to lead to a famous row, noted under No.103), and he appears to be an amateur

artist who may himself essay a 'Girandola' drawing. He may be the Rev. Thomas Gisborne.

The Duke of 'Chaboud' mentioned towards the end of the second page has been identified by Duncan Bull as the Duke of 'Chabot'. Bull notes that the Chabot pictures do not now survive (review of the Sudbury exhibition, *Burlington Magazine*, CXXIX, 1987, p.762). Wright may not have carried out this commission.

85

Vesuvius in Eruption ? painted on the spot in 1774

Gouache on paper $12\frac{3}{4} \times 18\frac{3}{8}$ (32.4 × 46.7)
PROVENANCE
. . . ; H. Cheney Bemrose Bequest to Derby
Art Gallery 1954
EXHIBITED
Tate & Walker 1958 (43); Norwich 1959
(49); Paris 1972 (344); Whitworth 1973 (6,
repr.); *De Gainsborough a Bacon: La Peinture
Britannique*, Galerie des Beaux-Arts,
Bordeaux, 1977 (65); *Visions of Vesuvius*,
Museum of Fine Arts, Boston, 1978 (cata-
logue unnumbered; entry p.17); Derby
1979 (106); Munich 1979 (109, repr.);
Detroit & Chicago 1981 (73); *Earth,
Waves, Wind and Fire*, Brighton Art Gallery,
1986 (no catalogue); Sudbury 1987 (28);
Whitworth 1988 (114, repr. in colour p.97)
LITERATURE
Nicolson p.64, pl.163, in colour; Fraser
1979 p.6, pl.13, in colour

Derby Art Gallery

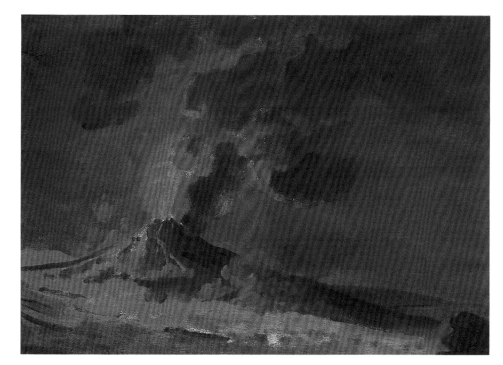

85

As Nicolson remarks, this is 'too spon-
taneous and slapdash to have been done
anywhere but on the spot'. The viewpoint
is looking out to sea, at dusk, with the
Sorrento promontory on the left. Wright
seemingly gets much closer to his subject
than in the more studious pencil drawing
from a similar viewpoint, now in a private
collection (Nicolson pl.165). The sense of
the terrible beauty of Vesuvius is conveyed
with urgency and without pictorial
contrivance.

This gouache was in the collection of
H. Cheney Bemrose (d.1933; bequests to
Derby from his collection arrived over the
next twenty years). No other gouache by
Wright is at present known. This seems
entirely acceptable as his work, though the
attribution is difficult to prove – or to dis-
prove, unless a closely comparable work
by another artist should turn up. Gouache,
or body-colour (the reinforcement of
watercolour by the addition of 'body' in
the form of opaque white) was an under-
standably popular medium for artists who
wanted to work in colour on the spot,
without the 'sticky inconvenience' of oil
paints (Lawrence Gowing's phrase, in
Painting from Nature, Fitzwilliam Museum
and RA exh. cat., 1981, p.3).

86

**Study of the Terrain near
Vesuvius** 1774

Pencil on paper $12\frac{1}{4} \times 17\frac{3}{4}$ (31.1×45)
PROVENANCE
Rev. Thomas Gisborne; Mrs Griffiths,
Yoxall Lodge; . . . ; E. Crossland, dealer
and artist of Derby, from whom purchased
by Derby Art Gallery 1921
EXHIBITED
Sudbury 1987 (29, repr. p.17)
LITERATURE
Nicolson p.76, pl.164

Derby Art Gallery

This is the most detached and observant of
all Wright's studies of Vesuvius, and can
only have been made on the spot, and
without haste. Nicolson notes that Wright
'has set out to register every crinkle in the
smooth rock face, treating it scientifically
as though it were a specimen of volcanic
matter to be submitted to Whitehurst's
analysis' (p.76. For Whitehurst, see No.147
in this catalogue). Vesuvius itself is for
once not the artist's chief concern; he con-
centrates instead on the formation and
texture of its surrounding hill-clopes. Two
tiny figures on the ridge are probably
there only to indicate the vastness of the
scene, not to enliven it.
 Wright used this study in his painting
'An Eruption of Vesuvius, with a View of
Islands in the Bay of Naples' (No.102);
details of the formation of the hill-slopes on
the left in that painting are virtually identi-
cal with those in the drawing. But for all
the truthfulness to nature evident in the
drawing, when it came to the painting
Wright wilfully swung Vesuvius into a
position much nearer the hill-slopes, then
introduced a prominent foreground ridge
in front of them all. Wright's fidelity to
nature is almost as variable as that of any
other contemporary landscapist.

86

87

Interior of a Cave, probably near Naples *c.*1774

Pencil and wash on paper $8 \times 11\frac{1}{2}$ (20.3 × 29.2)

PROVENANCE
From a portfolio of drawings inscribed on the cover in a near-contemporary hand 'J.Wright's & Richd Hurleston (his pupil) Drawings . . . when on Italian travels . . .', sold (with many already torn out, and 19 remaining) Sotheby's 20 July 1966 (209), bt Colnaghi; broken up and shared between Colnaghi and Agnew; this drawing purchased from Colnaghi by Benedict Nicolson 1966; thence by descent

Vanessa Nicolson Collection

This may have been drawn in one of the caves or grottoes along the coast of Salernum, near Naples. These caves evidently exercised a deep fascination for Wright, and out of them he made some of his most haunting pictures, such as the 'Grotto in Naples with Banditti' and the 'Grotto with Julia' in this exhibition, both based on detailed drawings of the interiors of caves, shown here as Nos.99, 100. Those drawings are highly finished; this one is sketchy. Here Wright seems to be looking into a shallow cave, perhaps having crawled in to do so. The cave appears to be lit from above, presumably by a fairly large opening, for it admits sufficient light to sustain plant life on the rock face. It is characteristic of Wright to draw a subject because it interests his mind rather than because it is picturesque. The drawing has nevertheless a curious beauty.

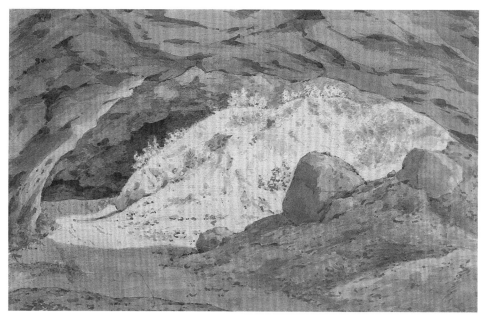

87

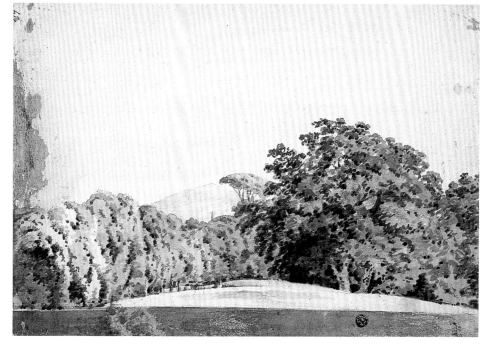

88

88

Landscape with Trees ? 1774

Brush and brown wash on paper $10\frac{3}{8} \times 15$ (26.4 × 38)
Inscribed '119' upper l.

PROVENANCE:
. . . ; Professor F.E. Gurley (his collector's mark lower r. of centre)

The Art Institute of Chicago; gift of Mrs William F.E. Gurley

This drawing has not been previously exhibited or published. The landscape is almost certainly Italian, and possibly near Naples, the umbrella pine in the centre of the middle distance recalling similar trees in Thomas Jones's landscapes near Santa Maria de' Monti near Naples (the umbrella pine is not of course peculiar to that area).

This drawing is at once solid and spontaneous, as if Wright has transcribed the landscape exactly as he saw it, with no wish to order its components into a conventionally tidy or picturesque arrangement.

89

Belisarius Receiving Alms dated
1775

Pen and grey ink with sepia washes over
pencil on paper 20 × 27 (50.8 × 68.6).
image size 15 × 12¼ (38 × 31.1) Inscribed
'Rome Feb 75. JW–' lower r. on the
stone between Belisarius and the young
boy, and lettered on the wall above
'DATE OBOLUM BELLISARIO'
PROVENANCE
. . . ; sale Sotheby's 16 July 1981 (59,
repr.), bt Agnew's for Derby Art Gallery
EXHIBITED
Sudbury 1987 (21, repr. p.15)

Derby Art Gallery

The date in Wright's inscription estab-
lishes that this drawing was made in
Rome, four months before his departure
for England. He had already made numer-
ous studies after the antique, many of
them in a sketchbook begun in Rome in
1774 (No.76) Here he essays a finished
drawing of a classical subject from Roman
history. The story of Belisarius would cer-
tainly have been familiar to him before
leaving England, since it was one of two
subjects which his friend John Hamilton
Mortimer had painted in 1770–2 for the
saloon at Radburne Hall, Derbyshire
(Sunderland pp.71–2, no.64 p.147,
fig.101) while Wright himself was working
there.

Belisarius, once a great general in the
Emperor Justinian's army, was through
envious intrigues dismissed and disgraced.
According to some accounts, he was blind
(or blinded), was led about by a boy and
had to beg for a living (Gibbon dismisses
that part of the story as fictitious). All
sources agree that whatever humiliations
Belisarius suffered, his dignity did not
desert him. Belisarius's fate inspired many
artists; among the thirty or so listed by
Pigler (*Barockthemen*, 11, 1974, pp.445–6)
are Veronese, Cavallino, Giordano,
Salvator Rosa, Van Dyck – and, arguably
producing the finest of all variations on this
theme, Jacques-Louis David. David's
'Belisarius' of 1781 is the chief focus of
Albert Boime, 'Marmontel's *Bélisaire* and
the Pre-Revolutionary Progressivism of
David', *Art History*, 111 no.1, 1980,
pp.82–98, the David repr. fig.41. As Boime
shows, Belisarius became 'a favourite
antique model for the social and religious
stands of liberals, moderate conservatives
and conservatives masquerading as
moderates' (p.82). Marmontel's morali-

89

zing narrative, *Bélisaire* (1766), trans-
formed Belisarius into 'a cult hero of the
philosophes . . . an image of a persecuted
innocent man which was very appealing to
the sentimental bourgeois audience of his
time' (p.83). Marmontel's novel was cer-
tainly known to Mortimer, who exhibited
his 'Belisarius' in 1772 as 'Belisarius, from
Marmontel, Chap.4' (choosing a different
episode to Wright's).

Belisarius probably appealed to
Wright's 'sentiment' in much the same
way as Sterne's 'Captive' No.53) did.
Wright's drawing owes little to Mortimer
(except perhaps the 'armour' of the young
centurion on the left), and nothing to
Salvator Rosa, whose 'Belisarius', an
upright picture, was in Wright's day at
Raynham Hall, Norfolk (though Rosa
inspired other works by Wright). David
Fraser suggests (in the 1974 Sudbury exh.
cat.) that Wright's drawing owes some-
thing, especially in Belisarius's pose, to the
painting at Chatsworth formerly attri-
buted to Van Dyck, or more likely to
Scotin's engraving of it (Boime fig.42); he
also notes that Belisarius's boy, cradling his
head on his arms on the right, is adapted
from a study (surely made from life) in
Wright's Roman sketchbook (repr.
Nicolson pl.134). The appeal DATE
OBOLUM BELISARIO ('Give a penny to
Belisarius': Wright incorrectly spells the
name with a double L), which appears as

if carved into the stone wall in the back-
ground of Wright's drawing, also appears
in the David, 'carved' on a stone block in
the foreground. This phrase does not
appear to be in Marmontel. Wright and
David must each have taken it from the
same untraced source, possibly one of the
classical sources noted by Gibbon *(Decline
and Fall of the Roman Empire*, v, 1838,
p.334).

Wright's purpose in making this draw-
ing remains obscure. No painted version
by him is known. Most of the drawing is in
the rather bloodless outline manner of
many of his drawings after the antique
(e.g. those in Derby, some repr. Nicolson
pls.127–133), with similar unreally stylized
muscles, e.g. in the young men's legs. It
lacks the monumentality and vigour of
'Maria' (No.90), drawn in Italy a few
weeks later. Possibly this was a commission
from a patron who wanted a 'truly classi-
cal' drawing. Wright may have hoped to
sell his 'Belisarius' in Rome, to one of his
many fellow-countrymen on the Grand
Tour. He may even have made it for him-
self, as a 'classical' souvenir of Rome.

Study of a Melancholy Girl dated
1775, later used for 'Maria' of 1781

Pen and grey ink over faint preliminary
pencil outlines on paper $21\frac{1}{2} \times 16\frac{1}{4}$
(55×41.3)
Inscribed 'P:G 16. March 1775' lower l.,
and (not in Wright's hand) 'W.T. 32' side-
ways on the back upper l.
PROVENANCE
. . .;? acquired by one of the Tatlock
family in 1832; Miss Tatlock, by whom
presented to the British Museum 1873

Trustees of the British Museum

The drawing has not been previously exhi-
bited or published. When presented to the
British Museum in 1873, it was registered
as by Anon.; it was identified as by Wright
by Andrew Wilton *c*.1970. Probably the
initials in the inscription long impeded
recognition of the artist; they remain
puzzling, but 'P:G' may stand for the
name of the model.

The drawing, dated 16 March 1775,
must have been made towards the end of
Wright's stay in Rome. While its strong
outlines and vigorously hatched back-
ground strokes indicate the influence of his
friend John Hamilton Mortimer's draw-
ings, its intensity seems also to echo that of
works by other British artists working in
Rome while Wright was there, such as
John Brown's study of the deeply medita-
tive 'Alexander Runciman' in the National
Gallery of Scotland (repr. Nancy Pressley,
The Fuseli Circle in Rome, New Haven, 1979,
p.63, fig.63). Unlike most of the figure
studies in Wright's Roman Sketchbook
(No.76), this very deliberate, carefully-
controlled and large-scale drawing is prob-
ably a development in his lodgings of a
sketch made on the spot. The closest simi-
larities of style and deliberation are with
Wright's well-documented study for 'The
Old Man Grieving over his Ass, from
Sterne' (No.91).

In making this drawing of a young girl
in the classic head on hand pose of melan-
choly, Wright may already have had it in
mind to paint the subject of 'Maria', from
Sterne's *Sentimental Journey*; while in Rome
he was after all continuing to work on 'The
Captive', from the same source. But in his
first painted version of 'Maria' in 1777
(No.52), the melancholy heroine is in a
different pose, seated on the ground. For
his second version of 'Maria' of 1781
(No.58), Wright referred back to this
drawing, made in Rome some six years

90

earlier; but since the 'Maria' of 1781
was to be the companion of the already-
completed 'Edwin' (No.57), who faces
right, he reversed the image of the draw-
ing, so that 'Maria' could face left. There
are differences in Maria's attitude in the
painting, but the essentials of the pose
were already contained in Wright's
drawing of 1775.

91

Study for 'The Old Man Grieving over his Ass', from Sterne *c.*1775

Pen and black ink over traces of graphite on paper $21\frac{5}{8} \times 13\frac{3}{4}$ (55.4×34.9) Inscribed in various hands 'Nampont' in pen and brown ink upper r. and '*Nampont* Mr Wright of Derbys . . . Sterns Old Man and . . . The Study' in pen and brown ink lower r., cut off at r. edge; 'Portrait of John Staveley who came from Hertfordshire with M.ʳ French & sat to M.ʳ Wright in the character of the old man & his ass in the Sentimental Journey' in graphite r.; on the back, 'Mr Wright of Derby's Study for Sternes Old Man & Ass' in pen and brown ink lower r., and below that in different ink 'Joseph Wright Derby'

PROVENANCE
John Leigh Philips, sale Winstanley & Taylor, Manchester, 31 October 1814 (42), bt Magnall; . . . ; anon. sale Christie's 8 June 1976 (10, repr.), bt Baskett & Day for Paul Mellon, by whom presented to the Pierpont Morgan Library 1976

LITERATURE
Eighteenth Report to the Fellows of the Pierpont Morgan Library 1975–1977, New York 1978, p.297; Gordon 1988, p.77, pl.54

Pierpont Morgan Library, New York; gift of Mr Paul Mellon

This is a study for a painting of unknown date which Wright left unfinished. Correspondence published in Bemrose pp. 73–4 shows that [?Henry] Corbould added a landscape to Wright's figure; the painting was then exhibited at the Manchester Institution in 1831, but is now lost.

The subject is taken from Sterne's *A Sentimental Journey*, which had already provided Wright with the subjects of 'Maria' (Nos.52, 58) and 'The Captive' (No.53). Travelling to a French village called Nampont, near Amiens, Sterne's narrator Yorick passes a dead ass in the road; on reaching Nampont, he sees an old man grieving over the death of his ass. Yorick's heart is touched by 'the simplicity of his grief'.

' "And this, said he, putting the remains of a crust into his wallet – and this should have been thy portion, said he, hadst thou been alive to have shared it with me." . . . The mourner was sitting upon a stone-bench at the door, with the ass's pannel and its bridle on one side, which he took up from time to time – then laid them down – look'd at them and shook his head.

91

He then took his crust of bread out of his wallet again, as if to eat it; held it some time in his hand – then laid it upon the bit of his ass's bridle – looked wistfully at the little arrangement he had made – and then gave a sigh.'

In recounting Yorick's reaction to this commonplace, unheroic incident, Sterne demonstrates how easily the truly feeling heart is affected by the distress of others.

The old man's pose is similar to that of the melancholy girl in No.90, a drawing which is close in spirit and in handling to this drawing, which is thus likely to have been made about the same date of 1775. The subject of 'The Old Man and his Ass' was also treated, as Catherine Gordon shows, by George Carter in 1773 (Gordon pl.55) and by Benjamin West *c*.1800, in a painting now in the Museum of Fine Arts, Boston (Gordon pl.57).

As the inscriptions on Wright's drawing record, his model for the old man was John Staveley, who also posed for 'The Captive, from Sterne' (No.53); his features can be closely observed in the oil study for 'The Captive' exhibited here (No.56). Staveley frequently sat to Wright, whose Account Book includes 'a Kit cat of old John Staveley for Mr Holland'. 'A small head of Old Staveley' and 'A large head of Jno Staveley'. Staveley was the model for Wright's painting of (?) 'An Apostle', in a fur-trimmed gown (Nicolson pl.228; in a Canadian private collection), for 'A Philosopher by Lamplight' (Nicolson pl.226; later destroyed by fire) and for Prospero in a scene from *The Tempest* (a lost painting; the engraving is exhibited here, No.172).

92

92

Study for a painting of 'Dovedale' 1786

Pencil and sepia wash on paper $14\frac{1}{4} \times 21$ (36×53)
PROVENANCE
Thomas Gisborne; . . . ; E. Crossland, Derby picture dealer and artist, from whom purchased by Derby Art Gallery 1921
EXHIBITED
Derby 1934 (68, pl.XVL); Derby 1979 (115)
LITERATURE
Nicolson p.90, repr. pl.253

Derby Art Gallery

This is a study for the painting (25×33 in.), dated 1786, now in the collection of the Yale Center for British Art (repr. Nicolson pl.252). The study has a freshness which is largely lost in the oil painting, in which the foliage appears unpleasantly dense, and to which superfluous details such as a pair of swans and fishermen wading in the foreground have been added.

The study gains by being uncluttered by detail. The foliage is wonderfully airy and lacy, recalling the work of the younger George Barrett, at his best in similar monochromes. The drawing is also indicative of Wright's influence on the landscape drawings of his friend and patron Thomas Gisborne, who owned this study.

93

Wright's Account Book

*c.*1755 – *c.*1795

77 ff. $7\frac{5}{8} \times 6\frac{1}{4}$ (193 × 160), re-bound
(? early in the nineteenth century), with
some pages wrongly ordered

PROVENANCE
Presumably remained with the artist's
descendants for a long time, with Wright's
MS Italian Journal, Hannah Wright's MS
Memoir of her uncle and the two sketch-
books now in the Metropolitan Museum of
Art (no.77), all of which were also at
Sotheby's sale 15 May 1957 (67–69); . . . ;
M. Bernard; anon. sale Sotheby's 15 May
1957 (66)

LITERATURE
Bemrose 1885 pp.116–24 publishes the
contents, with some errors and rearrange-
ment; Nicolson quotes from the Account
Book *passim*

National Portrait Gallery Archive and Library

'Account Book', the term used by
Nicolson, seems more appropriate than the
National Portrait Gallery's title 'Joseph
Wright of Derby's Sitters' Book', since the
book lists subject pictures and landscapes
as well as portraits, and also includes
accounts of rents received, bills paid and
various memoranda.

Early lists of sitters under the headings
Newark, Lincoln, Boston, Retford and
Doncaster, undated (*c.*1755–60) and
unpriced, are followed by 'Sitters from
ffeb: 1st 1760'; at that point columns on the
right are used for prices, which then con-
tinue throughout the book (with some
blanks). From the 1770s, names of patrons
and purchasers are frequently given, but
dates rarely. Sometimes the same picture is
entered twice (? when begun, and when
paid for); in the 1755–60 period, a sitter's
name may appear three times. Some
works which Wright is known to have
painted (e.g. at Bath) do not appear in his
Account Book, and he apparently kept no
record of his drawings; but otherwise, the
Account Book provides a largely complete
record of his *oeuvre*.

Early on (? *c.*1755) Wright noted 'M.
Phelps's way of making a pallet': ? perhaps
Richard Phelps *c.*1710–1785, unlikely to
have been more than a passing influence on
Wright. More interesting is the later entry
(? 1780s) headed 'The Contents of ye Pal-
let' used in his own work (see p.267). There
is a transcript of a method 'To line a
Picture'; there are payments of framers'
and carvers' bills (Mr Dubourg, & 'Mr

A page in Wright's Account Book listing some of his 'Candle light pictures',
including 'The Orrery' and 'The Air Pump', each priced at £210

93

John Sotheby Carver & Gilder' of London: see p.274–5).

Records of pictures are interspersed with various memoranda, among them 'Subjects for Night Pieces', quoted in this catalogue on p.98); the story of 'Miravan' (No.42); a list headed 'Candle Light Pictures'; 'Burdett's Account' (see No.40) and 'Mores Account from Sep.ʳ 85', kept for his friend the artist Jacob More, then in Rome, including sharing a lottery ticket No. 26,185 which 'came up' with a prize of £19.14.0.

A large group of pages chiefly lists rents and interest received, suggesting (but this compiler has not analysed these) that Wright and his brother inherited various properties in Derby which they let ('closes on yᵉ Kedleston Road . . . yᵉ Burton Road' etc.). Payments of household accounts are noted.

Wright was evidently a methodical man, but not one to waste paper. Some notes are made in spaces on pages used years earlier; a page headed 'Sitters at Newark' (c.1758) was used thirty years later for the note 'My little Mare Jenny was cover'd by Repulse on the 21 May 1788 & again that day week'. Similarly, a note of what must be Wright's entire stock of personal linen – '20 Shirts 13 Stocks 9 Neck Cloths – 14 Handkerchiefs 6 P of work's Ruffles' – was later followed by a memorandum of the size of the panel for Mrs Pole's portrait.

There are three sketches: (i) a girl reading by candlelight, roughly drawn over part of a transcript for a cough remedy, 'said to be Dʳ Darwin's': this sketch is the basis for the painting exhibited here as No.14; (ii) a rural wayfarer; (iii) three naked male figures, one pulling an arrow from his eye, all presumably copied from a painting.

94

Self-Portrait at the age of about Forty ?c.1772–3

Canvas 30 × 25 (76.2 × 63.5); on the reverse is a study for 'The Air Pump'
PROVENANCE
Thomas Coltman (probably given to him by the artist rather than purchased), and thence by descent to the present owner
EXHIBITED
Graves 1910 (27); National Gallery 1986 (3, fig.2)
LITERATURE
Nicolson no.167 p.229; pp.38, 103, 108; Frontispieces, and p.21 fig.6; Allan Braham, *Wright of Derby: Mr & Mrs Coltman*, National Gallery exhibition booklet, 1986, p.12

Private Collection

A rough and thinly-painted sketch for 'The Air Pump' of 1768 on the reverse of the canvas (Nicolson pl.59) appears to be Wright's first thoughts for that picture, suggesting that he first used this piece of canvas in about 1767; to Nicolson, that sketch 'indicates (though it does not establish) a date not later than 1768' for the self-portrait on its other side. But in the self-portrait, the artist (born in 1734) looks older than thirty-three or -four, and is perhaps nearer forty. Self-portraits are mostly spontaneous works, done when the artist feels in the mood, or has some time between works painted as commissions or for exhibitions; several years could well have passed before Wright decided to turn the canvas with 'The Air Pump' sketch over (and upright) to see what he could make of a self-portrait. Details of the exotic costume in which he decided to pose (see below) probably link this picture with that of 'Miravan breaking open the Tomb of his Ancestors' of 1772 (No.42), suggesting that Wright may have painted 'Miravan' and this self-portrait at about the same time. A date of c.1772–3 for the self-portrait is therefore proposed here.

This is the only self-portrait now known in which Wright specifically depicts himself as an artist, holding the draughtsman's most useful implement, a porte-crayon with black chalk at one end and white the other. He is likely to have included some such attribute in the self-portrait which he included under the title 'Portrait of an Artist' in his one-man exhibition at Robins's Rooms in 1785 (20). That portrait, painted the previous year and pur-

chased by Josiah Wedgwood, is now untraced.

Nicolson called this 'a magnificent Rembrandtesque, almost Poussin-esque, image of Wright' (p.38), and used it as his Frontispiece, but says little more about it. The picture is usually called 'Rembrandtesque'. Allan Braham goes slightly further in saying that 'the turban and the projecting elbow recall Rembrandt's self-portraits': but which ones?

'Rembrandtesque' in this context seems to be an adjective prompted by two different elements in Rembrandt's self-portraits. The first is Rembrandt's love of painting himself (and often his models) in exotic garments and headgear; this element is seemingly echoed in the striped and fringed 'Eastern' scarf which Wright winds about his fur hat. Wright also wears a 'Persian' cloak with a criss-cross border, probably the same piece of studio costume in which he portrays 'Miravan' in that highly dramatic but elusive story 'Miravan Breaking Open the Tomb of his Ancestors' which Wright depicted and exhibited in 1772 (No.42). The 'Self-Portrait' may well have been painted about the same time as 'Miravan', around 1772, or perhaps shortly before Wright set out for Italy.

Secondly, the poses in one or two of Rembrandt's etched self-portraits may well have influenced Wright – and it is of course through the etchings that Rembrandt's work would have been most easily accessible to him. Wright's self-portrait comes closest to (without following) Rembrandt's *Self-Portrait leaning on a stone sill*, 1639 B21, repr. Christopher White, *Rembrandt as an Etcher*, 1969, pl.158), and Wright may also have known the *Self-Portrait with Saskia*, 1636 (B19, repr. White pl.152). The etchings may have given Wright some ideas, but his own self-portrait is neither slavishly nor reverently based on either of them.

In using the phrase 'Poussin-esque', Nicolson may be thinking of Poussin's self-portrait in the Louvre, but there is not much in common between this and the Wright except a directness of gaze (which most self-portraits have), an incipient frown and one prominent hand.

94

95

Cavern in the Gulf of Salerno 1774
Study used for 'A Cavern, Morning' and
'Grotto . . . with Banditti'

Black chalk on paper $11\frac{1}{4} \times 18\frac{1}{2}$
(28.5×46.9)
PROVENANCE
Presented with No.96 by the executors of
Wright's estate in 1798 to John Leigh
Philips; his posthumous sale, Winstanley &
Taylor, Manchester, 31 October 1814 (50,
'Two Caverns on the shores of Italy. Fine
and highly finished Drawings made on the
spot, and are the Originals from which the
two celebrated Pictures in the Collection
of the late William Hardman, Esq. were
painted') £10.10.0 bt (? Thomas)
Hardman; Thomas Hardman sale,
Manchester, 19 October 1838, bt Wayne;
thence by descent
EXHIBITED
Georgian House, Edinburgh, on loan to
the National Trust for Scotland; Sudbury
1987 (32)
LITERATURE
Nicolson p.81, pl.171

*National Trust for Scotland, The Georgian
House (Francis Wayne Trust)*

See text below No.96

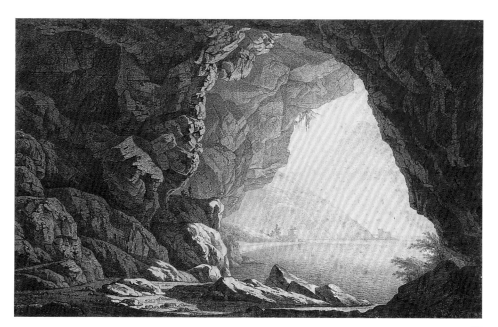

95

96

Cavern in the Gulf of Salerno 1774
Study used for 'A Cavern, Evening' and
'Grotto with . . . Julia'

Black chalk on paper $11\frac{1}{4} \times 18\frac{1}{2}$
(28.5×46.9)
PROVENANCE
as for No.95
EXHIBITED
Georgian House, Edinburgh, on loan to
the National Trust for Scotland
LITERATURE
Nicolson p.81, pl.172

*National Trust for Scotland, The Georgian
House (Francis Wayne Trust)*

These caverns are real places, drawn from
nature, not imagination. Wright's draw-
ings of them are studiously observed and
minutely detailed. Although these two are
exceptionally highly finished, they belong
essentially to that category of drawings
defined by Wright as 'Sketches of obser-
vation . . . to remove any doubt in regard
to particular objects as I take them as faith-
fully as I can' (in 'Girandola letter' of
1774, see No.84). At the same time, there is

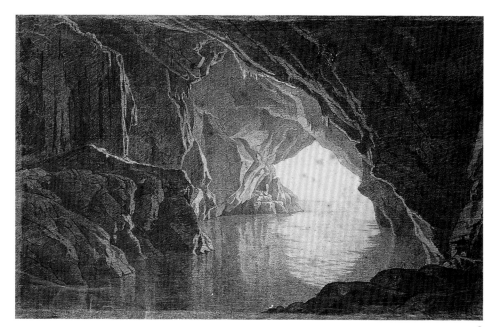

96

a sense of controlled excitement about them, as if, even while Wright's eye and hand noted minute details, his mind teemed with ideas about what drama might be portrayed within these seeming voids.

Wright was to develop the two studies of empty caverns into at least six paintings. First, he produced 'A Cavern, Morning' and 'A Cavern, Evening' (Nos.97, 98 in this exhibition), which are also 'empty' in the sense that no human figures are introduced, but which are filled with contrasting light. Secondly, he developed the studies into two large and intensely dramatic subjects, 'A Grotto by the Sea-side, in the Kingdom of Naples, with Banditti; a Sun-set', exhibited 1778, and 'A Cavern, with the Figure of Julia, banished thither by her grandfather, Augustus', exhibited 1780 (Nos.99 and 100 in this exhibition). Thirdly, probably in the early 1780s, Wright painted a pair of 'Grottos' for William Hardman of Manchester, described in his Account Book as 'Grotto in the Gulf of Salernum moon light' and 'D?. its companion Sun set' (this is the pair described in J.L. Philips's sale catalogue (see Provenance, above) as 'the two celebrated Pictures' painted from the two cavern studies; they were in Thomas Hardman's sale in 1838, according to Nicolson, but are now untraced, unless the 'grotto . . . Sunset' (said to have shown a boat at anchor) is the picture now in the Yale Center for British Art. For the Hardman pair, see Nicolson nos. 279–80). One or two other grotto subjects by Wright are known.

Wright evidently referred constantly to these drawings, and would not part with them in his lifetime. After Wright's death, his former friend and patron John Leigh Philips asked if he might buy them; John Holland wrote to Philips on 16 January 1798 that he and his co-executors of Wright's estate want Philips to have 'the two black chalk drawings of caverns' as a present, in return for his devotion to Wright's interests (DPL). Philips wrote the *Memoirs of the Life and Principal Works of the late Joseph Wright Esq. of Derby*, published in the *Monthly Magazine*, October 1797, pp.289–94, and had been a kind and supportive friend during Wright's lifetime.

Though the caverns themselves were undoubtedly specific places in Wright's day, ceaseless tides and crumbling rocks have either engulfed them or rendered them now unidentifiable. The round tower beyond the left opening of the cavern in No.95 is typical of the sixteenth-century

watchtowers which studded the coast around Naples; as Francis Hawcroft pointed out (1988, p.107), some of them are prominently featured in the work of Thomas Jones, 'Warwick' Smith and J.R. Cozens.

More peculiar to Wright are the two tiny figures just visible, one seated, one standing, on a rock ledge left of centre in No.95. Figures are rare in Wright's landscapes; when they are introduced (as in 'Rocks with Waterfall', No.107, a 'Vesuvius' drawing, No.86 and 'Matlock Tor, Daylight', No.113), they are invariably on this diminutive scale, perhaps partly to emphasize the grandeur of the scale of natural objects, but perhaps even more because Wright was not interested in introducing contemporary figures into his landscapes. It will be a different matter when he allows full-scale Banditti to occupy his stage in No.99.

Both studies are exhibited in the gallery devoted to prints and drawings, since they require lower light levels than oil paintings.

97

A Cavern, Morning dated 1774

Oil on canvas 40 × 50 (101.6 × 127)
Inscribed 'J. Wright | 1774' lower r.
PROVENANCE
In Wright's Account Book as one of 'Two Grotto's by the Sea side in the Gulf of Salerno for M? Hodges £105'; i.e. purchased by Thomas Hallett Hodges, by descent to Thomas Law Hodges MP; Haskett Smith, 'who has left London', offered Christie's 28 May 1864 (41, 'A Cavern Scene in the Bay of Naples, Morning'), bt in at 26 gns., then evidently kept by Haskett Smith for the rest of his life; the late H. Haskett Smith of Trowswell, Goudhurst, Kent, sold Christie's 9 May 1896 (113), 21 gns.; . . . ; Durlacher Bros., New York, by 1950; Mr & Mrs R. Kirk Askew Jr., by descent to the present owner
EXHIBITED
Durlacher NY 1960 (12); *Alumni Treasures*, Addison Gallery of American Art, Phillips Academy, Andover, Mass., 1967 (222)
LITERATURE
Rosenblum 1960 p.54; Nicolson no.281 p.257; pp.81–2, pl.175

Pamela Askew

'A Cavern, Morning' and its companion, 'A Cavern, Evening' (below) both dated 1774, are probably Wright's first landscape paintings after the 'Rocks with Waterfall' (No.107). They are closely based on the two chalk studies shown here as Nos.95 and 96. It is characteristic of Wright that he should have resolved to be as faithful to the exact faces and fissures of these particular rock formations in paint as he had been when scrutinising their every detail to record in chalk. Nicolson writes of these two paintings 'It is not easy to imagine two more Wright-like visions than these. The pelvis-shaped arch held all that was most precious to him, appealing both to his scientific and to his romantic temperament (and as we know there was no contradiction between the two): on the one hand, the logic of a firm structure of rock . . . on the other, the marvel of iridescent light. To his mind's content he established his solid design, and then proceeded to play about to his heart's content with colour' (p.82).

The colour Wright introduces is subtle and very beautiful, the effects made up of countless flickering touches of paint on the encrustations of the cavern's roof and walls. Rosenblum, reviewing the 1960 chNew York exhibition for *Art News*, remarked that in this and its companion 'Cavern, Evening', Wright captures 'the suffusion of pink dawn or bluish dusk with breathtaking tonal nuance that looks forward to Monet'.

These paintings are empty of people, empty of incident, but filled with light. It is difficult to think of any other British eighteenth century artist whose work combines such a faithful record of part of the earth's surface with such a delicate perception of the elements which affect it. Six years later, Wright was to turn the 'empty' space of the 'Cavern, Morning' into the setting for one of the most mysterious of all his paintings, the 'Grotto by the Sea-side, in the Kingdom of Naples; with Banditti' (No.99).

That Wright's grottoes really existed, 'by the Sea-side, in the Kingdom of Naples', is borne out not only by the detailed realism of his drawings of them but also by an account in the Abbé Richard de Saint-Non's *Voyage Pittoresque ou description des royaumes de Naples et Sicilie*, III, 1783, p.44. An engraving facing p.44 (our fig.22) shows the interior of a grotto near Naples called the 'Grotto di Polignano' or 'Grotta di Palazzo'. This was a very large grotto, 150 feet deep and 80 feet high, with three arches formed by the outgoing

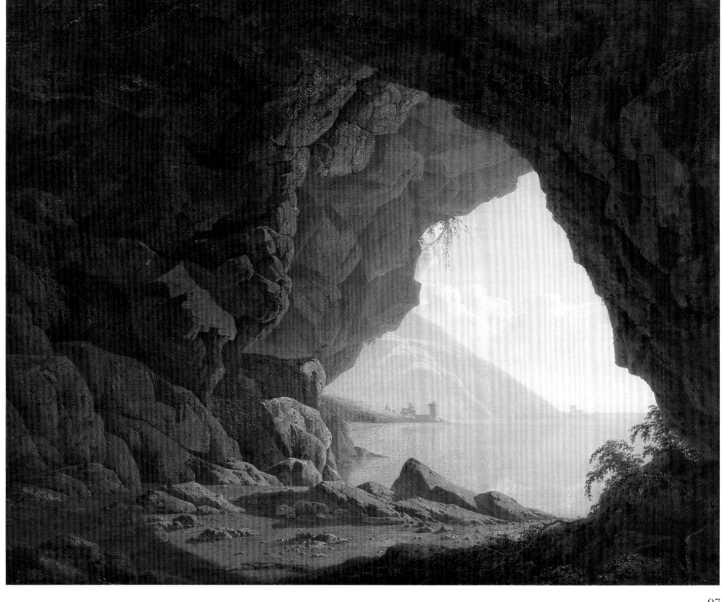

97

tides on their way to the sea; the rock formations are very like Wright's. The description reads: 'nous sûmes étonnés de la limpidité de l'eau qui remplit l'interieur de la Grotte, aussi les reflets mysterieux qu'elle y produit ajoutent encore à la richesse des tons dont la nature l'a embelli depuis les siècles . . . On doit sentir qu'un effet qui lient en plus grande partie à la magie de la couleur, ne peut être rendu que très imparfaitement dans les dessins, & surtout par des Gravures qui ne sont point coloriées'.

Saint-Non's artists, travelling and recording views some eight years after Wright's visit to Naples, evidently also sensed that a cavern interior would be a wonderful subject for a painter – '. . . la limpidité de l'eau . . . les reflets mystérieux . . . la magie de la couleur . . .', elements which Wright had already perceived for himself.

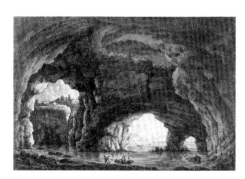

fig. 22 Artist working for Abbé Richard de Saint-Non: 'Vue intérieure de la . . . Grotta de Palazzo'. Engraving, published in *Voyage Pittoresque*, 111, 1783 *Trustees of the British Museum*

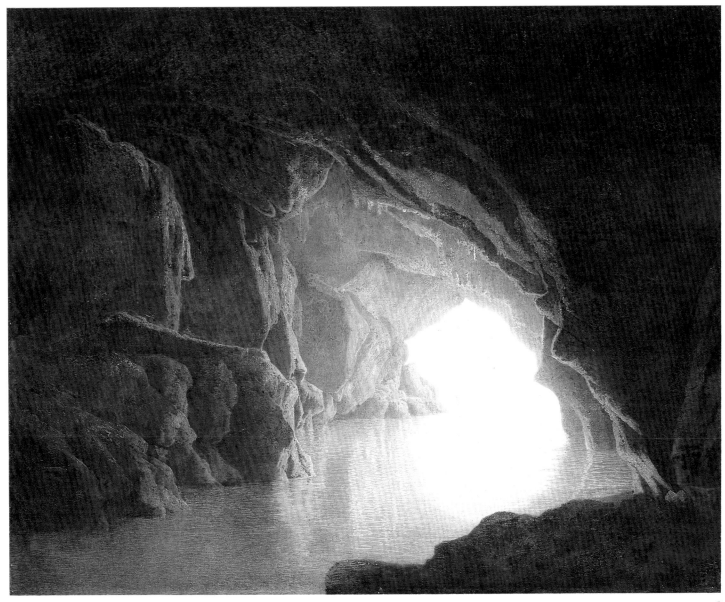

98

98

A Cavern, Evening 1774

Oil on canvas $40\frac{1}{4} \times 50\frac{3}{4}$ (101.6 × 127)
Inscribed 'J. Wright 1774' lower r.
PROVENANCE
In Wright's Account Book as one of 'Two
Grotto's by the Sea side in the Gulf of
Salerno for M.ʳ Hodges £105', i.e.
Thomas Hallett Hodges, by descent to
Thomas Law Hodges MP; Haskett Smith,
'who has left London', offered Christie's
28 May 1864 (42, 'A Scene in the Bay of
Naples – evening'), bt in at 22 gns., then
evidently kept by Haskett Smith for the
rest of his life; the late H. Haskett Smith of
Trowswell, Goudhurst, Kent, sold

Christie's 9 May 1896 (114), 18 gns. ; . . . ;
Durlacher Bros., New York, from whom
purchased by Smith College Museum of
Art 1950
EXHIBITED
Romanticism in Eighteenth Century England,
Durlacher Bros., New York, 1953 (3);
*Paintings and Drawings from the Smith College
Collection*, Knoedler Galleries, New York,
1953 (45); Smith College 1955 (9); *Eight-
eenth Century British Painting*, Fitchburg Art
Museum, Mass., 1955 (2); *British Painting
in the Eighteenth Century*, Montreal Museum
of Fine Arts, National Gallery of Canada,
Ottawa, Art Gallery of Ontario, Toronto
and Toledo Museum of Art, 1957–8 (123);
Durlacher N.Y. 1960 (13); *The Romantic

Era, Herron Museum of Art, Indianapolis,
1965 (19, repr. in colour), and other US
exhibitions
LITERATURE
Buckley 1952, p.164, repr. p.165; Buckley
1955, pp.265-6, fig.2; Rosenblum 1960.
p.54; Nicolson no.282 p.257; pp.81-2;
pl.174

*Smith College Museum of Art, Northampton,
Massachusetts*

Like its companion, 'A Cavern, Morning'
(No.97, above), this was based on a chalk
drawing probably made on the spot
(No.96); again like its companion, from
which Wright developed the subject of 'A

Grotto by the Sea-side, in the Kingdom of Naples, with Banditti . . .' (No.99), the 'Cavern, Evening' inspired Wright to develop from it, six years later, the subject of the 'Grotto with the Figure of Julia' (No.100).

Both 'A Cavern, Morning' and 'A Cavern, Evening' are highly-finished pictures in their own right, on which Wright has bent the full force of his attention, using minutely-detailed brush strokes and variations in colour to suggest the nature of rock and the reaction of its various surfaces to light. Buckley, writing of this picture in 1952, observes that Wright 'allows his fertile imagination to reflect on the mysterious enchantment of the light-struck interior. Massive rocks arch overhead, and through a small opening, pelvis-shaped with its accompanying reflection, is the sea, iridescent in the soft evening light. While he has expressed a feeling of wonder and reverence in the presence of a natural phenomenon, he has also observed the countless subtle variations in the color and form of the rocks'.

99

A Grotto by the Sea-side in the Kingdom of Naples, with Banditti; a Sun-set exhibited 1778

Oil on canvas 48 × 68 (122 × 172.7)

PROVENANCE

In Wright's Account Book as 'A Grotto with a Banditti £157.10': a later note 'Sold to Mᵣ Cookshut' below the entry must date from around 29 August 1780, when Wright sent a bill to 'Josʰ Cockshutt Esqᵣ Chaddesden [near Derby]' for this picture and two others, 'A Cavern wᵗʰ the figure of Julia' and a 'Virgil's Tomb'; the three pictures passed from Cockshutt to C. Heathcote, until 1840, when all three were accepted from Heathcote, in lieu of payment for a debt, by Godfrey Meynell, Meynell Langley, near Derby; thence by descent until this picture was sold, as the Property of a Gentleman, Sotheby's 9 July 1986 (82, repr. in colour), bt Agnew's

EXHIBITED

RA 1778 (358); Tate & Walker 1958 (16, wrongly stated to be signed and dated, pl. VI); Salvator Rosa, Hayward Gallery, 1973 (141); Derby 1979 (23)

LITERATURE

Buckley 1952, p.164, repr. p.165; Nicolson no.277, p.256; pp.82–3, 158; pl.211; Richard W. Wallace, The Etchings of Salvator Rosa, Princeton, 1979, pp.27, 116, 117 fig.29

Thos Agnew & Sons Ltd

A strange blend of reality and imagination has made this one of the most haunting and mysterious of all Wright's paintings. The grotto itself was evidently a real cavern on the Neapolitan coast. After two centuries of the sea's pounding, the cavern itself is no longer recognisable; but its shape, and that of another nearby cavern, are precisely recorded in two black chalk drawings which Wright made on the spot during his visit to Naples in 1774 (Nos.95, 96), meticulously noting every detail of the rock formation and its fissures.

Using the drawings as a basis, Wright began to develop his ideas about the caverns into paintings. First he painted 'A Cavern, Morning' and 'A Cavern, Evening', both dated 1774, and thus painted while he was in Italy (Nos.97, 98). In these, the caverns are 'empty' of figures and incident, but filled with light and colour. Then, two or three years after his return from Italy, but still following every detail of the caverns' physical appearance as recorded in his chalk drawings, he

painted two larger and more dramatic companion pictures, 'A Cavern, with the Figure of Julia, banished thither by her grandfather, Augustus' (No.100) and 'A Grotto . . . in the Kingdom of Naples, with Banditti'. The two pictures hung together until 1986, when this picture was sold. The possibility that there may be some relationship between the subjects of the two is discussed below.

In the 'Grotto with Banditti', one half of Wright's canvas is commanded by light, the ethereal light of sunset floating in over a soundless sea. The other half is dominated by the 'banditti' of Wright's title: five men and two youths in exotic but archaic costume, with helmets, swords and spears. To determine why they are there, where they have come from or what they mean to do next, is hardly possible.

The word 'banditti' of course suggests the work of Salvator Rosa, greatly admired by Wright's friend John Hamilton Mortimer and less ardently by Wright himself. Wright had derived his image of 'A Philosopher by Lamplight' (No.41) from Rosa's 'Democritus in Meditation', and may have had Rosa in mind when painting his (?) first pure landscape, the 'Rocks with Waterfall' of c.1772 (No.107). On his visit to the King

fig.23 Salvator Rosa: 'Four warriors and a standing youth', from the *Figurine series*, c.1656–7. Etching (Wallace 59/11) 5¾ × 3¹¹⁄₁₆ (14.7 × 9.4) *Trustees of the British Museum*

fig.24 Salvator Rosa: 'Two warriors', from the *Figurine series*, c.1656–7. Etching (Wallace 60/11) 5½ × 3⁹⁄₁₆ (14 × 9.1) *Trustees of the British Museum*

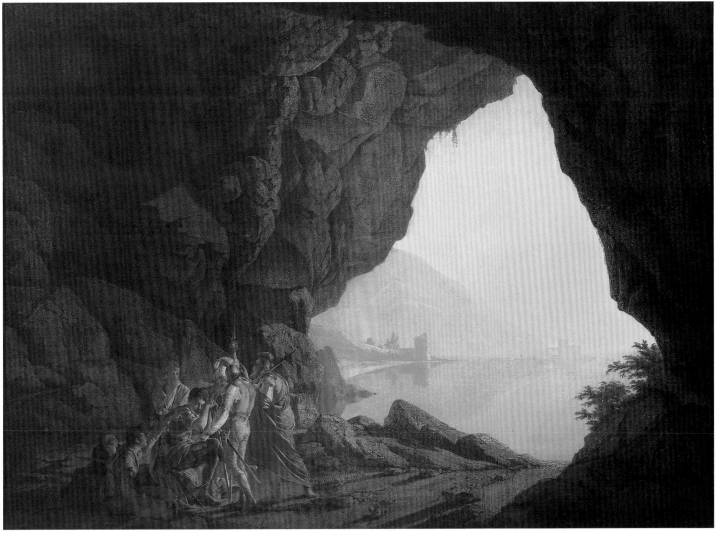

of Naples's palace in 1774, Wright had noted (and perhaps sketched) 'two fine oval pictures of Sal. Rosa, the subjects, Banditti, very highly finished, and painted with great force and spirit' (MS. Italian Journal, quoted by Bemrose p.38). These do not appear to be identifiable in Luigi Salerno, *L'opera completa di Salvator Rosa*, Milan, 1975, but may well have been similar to the two oval 'Landscapes with Banditti' now in the Los Angeles County Museum of Art (Salerno nos.201–2).

The banditti grouped enigmatically in Wright's 'Grotto' do not have 'the great force and spirit' of those in Rosa's paintings. They are however very close in spirit to Rosa's *Figurine*, the series of sixty-two etchings made around 1656–7 which included many figures of soldiers standing, seated, seen from behind etc. (fig.23)

Richard W. Wallace observes that the *Figurine* belong to no narrative, and illustrate no text. 'They remain fugitive and elusive, implying more than they state and evoking a larger context that seems to hover just beyond the range of the viewer's comprehension. Consequently the *Figurine* in general and the soldiers in particular have an air of mystery, conspiracy and what might be called a romantic incompleteness' (p.27). Wallace's comments on the *Figurine* are so apt to Wright's banditti that it comes as no surprise when Wallace points out that Wright has in fact made specific borrowings from the *Figurine*, the most direct being for the helmeted figure in yellow with his back to us, which is essentially a copy in reverse of [60] in the series (fig.24; Wallace p.196, repr.), with ideas for the two other figures derived from

[55]. As Wallace notes, Wright had made an even more direct borrowing from the *Figurine* for the 'Iron Forge Viewed from Without' (No.50), painted in 1773 (before his Italian journey), so he evidently already knew the *Figurine*, which had been many times reprinted. But although there are some specific borrowings among Wright's banditti, as a group they have a mysterious if still elusive imaginative force of their own. That force is not at odds with the fact that the banditti haunt a cavern drawn from reality. It is precisely the blend of reality and imagination which gives Wright's picture its highly individual quality, which is a long way from Rosa's more feverish dramas.

Are the Banditti in Wright's grotto playing out some specific drama? Nicolson suggests (only half-seriously) that 'The

bandits are not of this world at all but belong to the classical stage, plotting, we would say, not a routine robbery but the murder of Hector' (p.83). This compiler would suggest that Wright may have intended some link between this subject and that of its companion, 'Grotto with the Figure of Julia, banished' (No.100). Julia was banished from Rome to Pandateria, an island off the coast of Naples; Wright used his other Neapolitan cavern drawing as the place of her exile, and in his painting we see her sitting in that cavern, lamenting her fate as the tide comes in. Can the banditti be a troop of mercenaries who took her there, and are they now reacting with different feelings to that deed? The curly-headed seated man is ill-at-ease, but whether he is experiencing remorse, anxiety or exhaustion is impossible to say. His expression is as complex as that of the blacksmith as we know it from William Pether's engraving of *The Farrier's shop*, 1771, after a now untraced picture (for an excellent detail, see Richard T.Godfrey, *Printmaking in Britain*, 1978, fig.4). All that we can be sure of – and this is perhaps what the boy on the left points to – is that the sun is setting and that it will soon be too dark for further action.

In choosing the colours for the banditti's costumes, Wright might almost be paying homage not to Rosa, but to another Neapolitan painter, Cavallino. The rose, amber, cinnamon, ochre, lemon-yellow and apple-green are astonishingly beautiful. The painting of the cavern itself is made up of minutely-varied and subtly-placed touches of colour, not immediately discernible (which is as it should be) in the overall golden-brown effect. At the cavern's mouth, where the setting sun is beginning to effect swift changes in earthly appearances, Wright paints flat patches of an astonishing violet on the rocks. These are probably his earliest experiments with those flat patterns of seemingly strange but telling colour which were eventually to produce the brilliantly unorthodox 'Italian Landscape' of 1790 (No.119).

100

A Grotto in the Gulf of Salernum, with the figure of Julia, banished from Rome exhibited 1780

Oil on canvas 45 × 69 (114.3 × 175.3)

PROVENANCE
In Wright's Account Book as 'A Grotto in the Gulf of Salernum with the figure of Julia. Companion to that w.ᵗʰ Banditti sold to M.ʳ Cockshutt £105';

EXHIBITED
RA 1780 (203, as 'A cavern, with the figure of Julia banished thither by her grandfather Augustus'); then as for No. 99, but No.100 remains with the family which acquired it in 1840

LITERATURE
Nicolson no.278, p.256; pp.83, 158; pl.215

Private Collection

Like the 'Grotto . . . with Banditti' (No.99), this shows Wright evolving a drama from the haunting image of a cavern on the coast near Naples, whose physical appearance he first recorded in a chalk drawing made on the spot in 1774 (No.96). From that drawing he painted, probably later that year, 'A Cavern, Evening' (No.98), in which the cavern is 'empty' except for light, air and sea. Wright sold both 'A Cavern, Evening' and its companion, 'A Cavern, Morning', but kept the two cavern drawings all his life; and it is chiefly on these (with, no doubt, the 'Morning' and 'Evening' caverns clear in his mind's eye) that he allowed his imagination to dwell in creating the 'Grotto . . . with Julia' and 'Grotto . . . with Banditti' five or six years later.

Three errant Julias were banished from Rome within forty years or so, all for adultery and all to virtually inaccessible islands. In his RA 1780 exhibition title for this picture, Wright states that his Julia was banished by 'her grandfather Augustus', which would indicate Julia, daughter of Agrippa and his wife Julia, daughter of Augustus. She was banished to the island of Trimerus, off the Apulian coast of Italy, in AD 9 (and died there in AD 28).

But Wright used a different title for a second large version of this picture when he included it in his one-man exhibition in Robins's Rooms, 1785 (7). There he called it 'Julia, the daughter of Augustus, and supposed mistress of Ovid, deploring her exile, by moon-light, in a cavern of the island to which she was banished'.

Julia, daughter of Augustus, is a much

better-known figure, and thus a likelier candidate for Wright's scene. She was the only child of the Emperor Augustus and his wife Scribonia. As the Emperor's only child, she was a rich matrimonial prize. She first married the great general Agrippa; on his death, Augustus arranged her marriage to Tiberius (who was to succeed him as Emperor). Julia's blatant adulteries made her daughter's pale into insignificance; the scandal became so great that Augustus was forced to take action. In the year 2 BC Julia was banished to the island of Pandateria, off the coast of Campania, near Naples.

The probability that it is Julia, daughter of Augustus, whom Wright has in mind is increased by the fact that she was exiled off the coast near Naples, a coast which Wright had explored and where he made the drawings of the two caverns. Wright may have heard the story of the banished Julia while he was in Naples, not fully establishing Julia's identity until 1783, when he discussed the picture with William Hayley.

In the *Wright* exhibition at Derby in 1866, a version of this picture (178) bore the title 'Empress Julia awaits her death by the rising tide'; but though it looks as if the incoming tide will be her executioner, Julia survived. In the note to No.99 above, it is suggested that it may have been the banditti in that picture who (in Wright's imagination) brought Julia to the cavern, left her there and are now stricken with remorse; but that of course is mere conjecture. Julia in fact lived on in exile until AD 14, dying in the year that her former husband Tiberius became Emperor. (The third errant Julia, daughter of Germanicus and Agrippina, was banished in AD 39 to the Pontian Islands.)

Wright's later large version of this picture, exhibited at Robins's Rooms in 1785 and bought by Daniel Daulby, is now untraced. Wright was particularly pleased with it, writing to Daulby on 14 November 1985 that the picture was 'esteemed by the artists the most sublime picture I ever painted and so I think myself. A rising moon always conveys to me great majesty' (DPL). Wright described the picture in a letter to William Hayley of 28 December 1783 (Nicolson pp.256–7): 'The picture is a dark cavern, faintly illuminated w.ᵗʰ a large glowing Moon, almost clear of the Horizon, the figure of Julia given up to despair, sits on a part of the Rock in the foreground, w.ᵗʰ her head down to her knees . . .'. A small (15½ × 20 in.) 'Grotto with the figure of Julia' corresponds to that

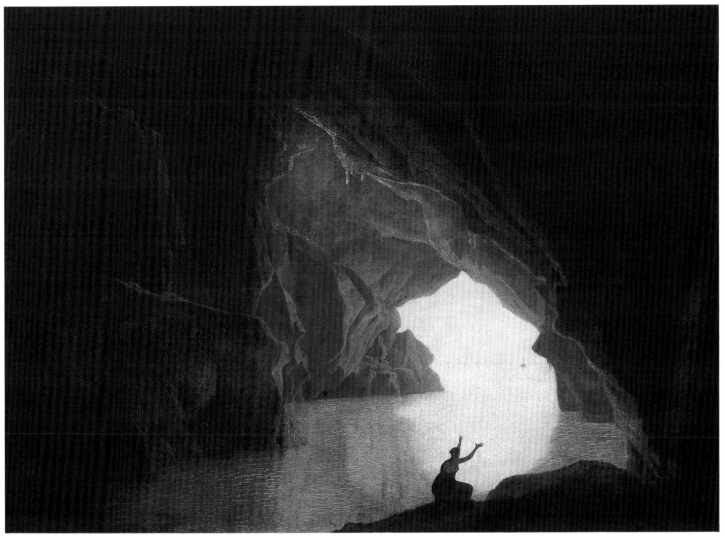

description (Nicolson no.283 pl.216; sold
Christie's 14 July 1989 (56), repr. in
colour), but the large version is lost.

A further sad lack in our knowledge of
Wright's grotto and cavern sequences is
caused by the seeming disappearance of
'Grotto in the Gulf of Salerno, Moonlight'
and its companion 'Grotto . . . Sunset',
sold to William Hardman, of which
Wright and his contemporaries thought
highly. Nicolson catalogues them as
nos.279–80, but they appear to have been
untraced since the Hardman sale of 1838.

An Eruption of Vesuvius, seen from Portici ? *c.*1774–6

Oil on canvas 40 × 50 (101.6 × 127), left edge irregular

PROVENANCE

not identifiable amongst the various Vesuvius subjects in Wright's Account Book; probably John Leigh Philips, sold Winstanley & Taylor, Manchester, 31 October 1814 (26, as 'An Eruption of Vesuvius, destroying the Vineyards; presumed, by Mr. Wright, to be the best picture he painted of the subject') bt 'H. & A.W.', ? members of the Wright family, who bought other works by Wright in this sale; . . . ; Sir John Williams, by *c.*1860; presented by Sir John Williams to University College of Wales, Aberystwyth, 1926

LITERATURE

Nicolson no.274 p.255 and Appendix B p.283 no.32; pp.77–8; pl.169

University College of Wales, Aberystwyth

This picture can almost certainly be identified as the 'Eruption of Vesuvius, destroying the Vineyards' in the posthumous sale of Wright's friend and patron John Leigh Philips. The view is from Portici on the coast (? with the village of Pugliano in the middle distance); the relationship to each other of Mount Vesuvius and Mount Somma to its left is echoed in John Robert Cozens's water-colour 'Vesuvius from the Myrtle Plantation of Sir William Hamilton's Villa, Portici', 1782 (repr. Hawcroft 1988 p.102), though Wright's view is from considerably nearer to Portici. The soil of the plain between Vesuvius and Portici was very fertile, enriched by volcanic deposits from the very eruptions which from time to time devastated its produce. Sir William Hamilton noted that 'large trees, and excellent grapes' grew all around Vesuvius. If this painting can indeed be identified as 'Eruption . . . destroying the Vineyards', perhaps the billows of smoke towards the right in the middle distance come from the blighted vineyards.

Thomas Jones vividly describes an excursion to Vesuvius from Portici some four years after Wright's visit, on 16 September 1778:

> . . . at Portici . . . we hired 2 mules & a couple of *Ciceroni* or guides, with torches, to conduct us up the Mountain . . . road very rough & stony – fine Vineyards all round loaded with large Clusters of red Grapes . . . Some time after, came to the Spot where the Lava of this last Eruption had advanced – It roll'd & tumbled forward with a Slow motion in a Stream about as wide as the *Tiber* at Rome . . . came to a Vineyard the greatest part of which had been destroy'd by the present Eruption . . . it was curious to observe the Bunches of grapes shrivel up like raisons and the leaves wither & take fire upon the approach of this tremendous burning River . . . The whole Scene having a grand & wonderful Effect. . .' ('Memoirs', ed A.P. Oppé, *Walpole Society* XXXII, 1951, p.78).

Thomas Jones's excursion was made within a year of the major eruption of Vesuvius in 1777, and he was able to see 'the Lava still boiling out'. There was no true eruption of Vesuvius while Wright was in Naples (early October – early November 1774) and there had not been an eruption since 1767. But Sir William Hamilton reported that since 1767 'Vesuvius has never been free from smoke, nor ever many months without throwing up red-hot SCORIAE . . . usually follow'd by a current of liquid Lava'; and according to Hamilton, 'at Naples, when a lava appears, and not till then, it is styled an eruption' (Hamilton 1779, Supplement p.2 and Hamilton 1772 p.20). It seems that no precise records exist for the behaviour of Vesuvius while Wright was in Naples. We would like him to have seen something 'grand & wonderful': but did he? Vesuvius may have been dormant, or merely smoking: if so, the truest reflection of what Wright actually saw for himself may be the drawing reproduced here on p.149. Or, as Nicolson suggests, Wright may have witnessed 'lava pouring down the mountain side' (Nicolson p.10). He cannot have seen the white-hot jet of molten liquid hurled upwards from the heart of the volcano as in the Aberystwyth painting; the force with which it seems to turn the landscape into a vast candlelight painting is the force of Wright's imagination – probably assisted by documentary evidence of the appearance of Vesuvius in eruption in paintings by other artists working in Naples, such as Pierre-Jacques Volaire and Pietro Fabris.

Nicolson dates this picture *c.*1775–7, 'either late on the Italian trip or soon after his return'. This compiler, feeling that it may be one of Wright's earliest paintings of Vesuvius – possibly the earliest – proposes a slightly earlier date, a date which would in fact admit the possibility that he got down to work on this as soon as he returned from Naples to Rome. As Nicolson remarks of this picture, 'it can only have been done while the force of the mountain was still upon him'. It seems to have more freshness and spontaneity than any other Vesuvius by Wright so far known. The dense banks of smoke are less controlled by design; the unobtrusive, hardly-risen moon behind low hills on the left seems to be following its own naturally detached course rather than turning up to oblige Wright with that secondary source of light which he so likes to deploy. There are also some subtle and very beautiful passages of colour, particularly in the deep olive greens to which night and the glare of burning light have turned the trees in the wood.

Note: Nicolson suggests that a close-up view of Vesuvius in Derby Art Gallery (his no.275, pl.168) is 'very likely the picture painted in the winter of 1774–5', as reported by Father Thorpe to Lord Arundell in a letter of January 1775. If so, that picture would be the earliest of Wright's Vesuviuses. When exhibited in Washington in 1969–70, the picture was doubted by Cummings, who suggested Volaire; but Nicolson reasserted that the style was 'unmistakably Wright's' (Nicolson 1988 p.755).

Strong doubts about the attribution to Wright of Nicolson's cat.275 are also felt by David Fraser of Derby Art Gallery and by this compiler, who wonders whether the Derby picture may be the work of the Austrian painter Michael Wutky (1739–1822), whose 'Volcanic Eruption' in the Kunstmuseum, Basel reveals a similar combination of exaggeratedly jagged rocks with unnaturally flabby textures (repr. *Visions of Vesuvius*, exh. cat., Boston Museum of Fine Arts, 1978, front cover in colour).

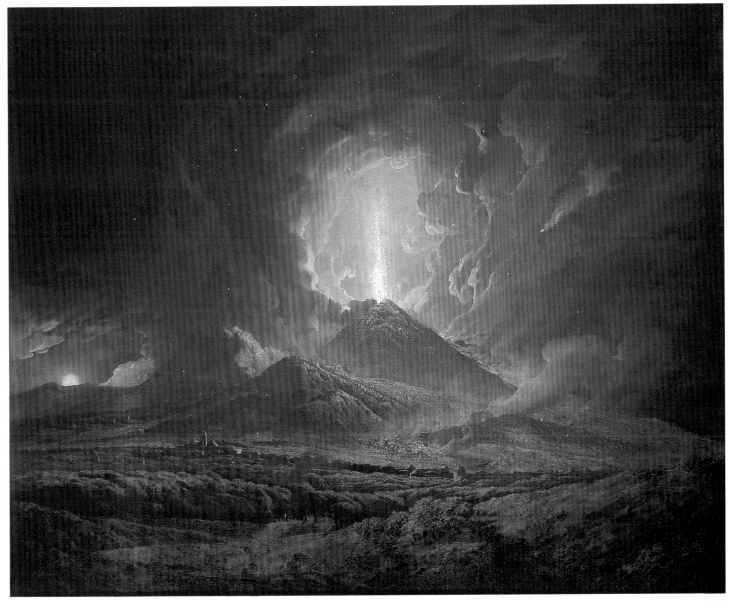

101

102

Vesuvius in Eruption, with a View over the Islands in the Bay of Naples *c.*1776–80

Oil on canvas 48 × 69½ (122 × 176.4)
PROVENANCE
In the collections of the Earls of Antrim since at least 1850, when it is listed (simply as 'Vesuvius') in an inventory of the contents of Glenarm Castle, Co. Antrim, Northern Ireland

The Viscount Dunluce

This painting is exhibited and published here for the first time. The compiler is indebted to Sir Brinsley Ford for establishing Wright's viewpoint: 'The picture is painted from the foothills of Mount Vesuvius. The promontory to the left is Sorrento, and the island to the right of it is Capri. From this angle the islands of Ischia and Procida would not also be visible, but Wright has taken the licence of including them on the right of his picture'.

In a letter of 11 January 1780 to his Liverpool patron Daniel Daulby (DPL), Wright describes a 'Vesuvius' which he offers to send for Daulby's inspection. From Wright's description, this picture (Nicolson p.282 (16): untraced) must have had a closely similar, possibly identical viewpoint; but it was comparatively small (*c.*29 × 34 ins.): '. . . it is a near view of ye Mountain w.^{ch} shews the Lava to great advantage, & the distance is made up of the Bay of Naples, the Island of Procita Ischia Capria &c &c – the necks of land breaking into the Sea, w^{th} the reflection of ye moon, playing between them has a pleasing effect . . . somewhere about 2 ft. 10 by 2 ft. 5 in.'.

It thus seems probable that Wright, evidently pleased with the effect of moonlight over Sorrento and the islands in the Bay of Naples, painted this view twice, in larger and smaller versions, though until the small view appears, it is impossible to say which was painted first, or whether the more incidental details were the same. The artistic licence to which Sir Brinsley Ford draws attention makes it likely that both pictures were painted after Wright's return to England, with the help of studies made on the spot, particularly the study (shown here as No.86) of the hill slopes on the left. Wright left Italy a year before the publication of Sir William Hamilton's *Campi Phlegraei*, 1779, containing Hamilton's reports to the Royal Society 'on the Volcanoes of the Two Sicilies' and

illustrated with fifty-four hand-coloured plates by Pietro Fabris; as Ford points out, Pl. XIII helps to identify Wright's viewpoint in this picture. Possession of this authoritative and very beautiful work ('to be had of the Editor M^r Pietro Fabris Painter of Naples') would have been extremely useful for an artist who intended to add Vesuvius to his stock in trade (and Wright was to paint over thirty views of Vesuvius); but there is no record of his having owned the *Campi Phlegraei*, and it may not have been available in England.

As in his other paintings of 'Vesuvius', Wright depicts a full-scale eruption of the volcano, though he did not himself witness this. The dense and lurid wreath of smoke streams out across the Bay, politely leaving an opening for the moon. These Neapolitan effects were to colour some of Wright's English landscapes of the late 1770s, such as the 'Matlock Tor by Moonlight' in Detroit (Nicolson pl.218).

But perhaps the most memorable detail in this picture occurs in its dark foreground: two men bearing, shoulder-high, the body of a victim of the volcano's wrath, followed by a mourning woman. These sombre bearers to some extent recall those in Poussin's 'Landscape with the Body of Phocion carried out of Athens'. Duncan Bull suggests (in correspondence) that the group in Wright's painting may represent the death of the elder Pliny in the great eruption of Vesuvius in AD79. That episode was introduced by some artists into Vesuvius scenes (a later example is Pierre-Henri de Valenciennes, 'The Eruption of Vesuvius and the Death of Pliny' of 1813 (Musée des Augustins, Toulouse, repr. *Visions of Vesuvius*, 1978, p.12); but Wright's group appears to be of contemporary rather than classical figures.

Nicolson did not know that this version of 'Versuvius' existed; had he known of it, he would hardly have written of Wright's Vesuvius pictures (p.77) that their author 'fails to anticipate the concept of compassion and there is never a suggestion of personal tragedy in any of his renderings'.

The present owner thinks it possible that this picture may have been acquired for Glenarm Castle from one of other of the two Irish mansions built by the Earl-Bishop of Derry, either Downhill, Co. Londonderry or Ballyscullion on the shores of Lough Beg. The Earl-Bishop, an incurable collector of works of art (mainly Italian), was also a particular expert on volcanoes. Wright had refused to sell him one of his paintings of Vesuvius, the picture shown here as No.103, under which is

a fuller account of the Earl-Bishop's rare failure to get what he wanted. It is possible that he bought a different Vesuvius by Wright, perhaps in the saleroom, before or after that contretemps. The disposal of much of his collection from his Irish houses is incompletely documented; no evidence has been found to prove that he owned this picture.

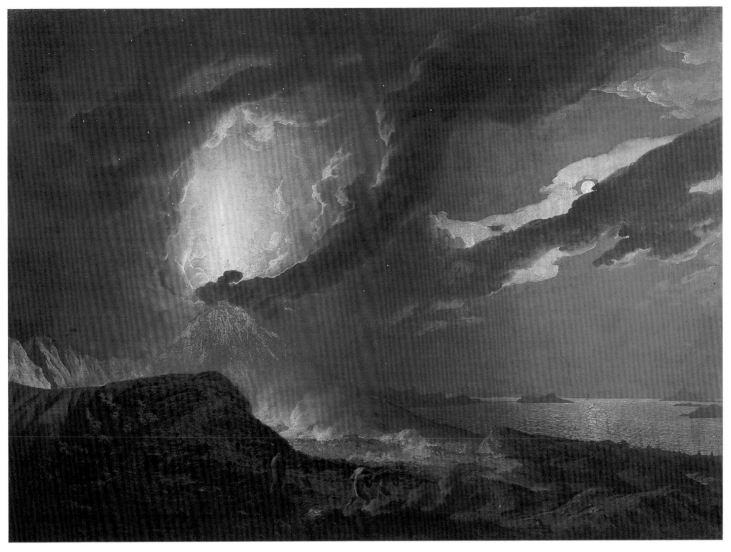

102

Vesuvius in Eruption *c.*1777–80

Oil on canvas 49 × 71 (124.4 × 180.3)
PROVENANCE
In Wright's Account Book as 'Vesuvius for
the Bp Dery £105.0.0': entry crossed out, as
Wright declined to let the Bishop of Derry
buy the picture; in Wright's posthumous
sale, Christie's 6 May 1801 (65, as 'A
grand eruption of Vesuvius, seen across the
Bay by moonlight – This magnificent
scene so often attempted by the Pencil of
Various Masters, has surely, never been
expressed with more Grandeur than in this
Effort of Mr. Wright – the effect is awful
beyond Description – Earth, Air and
Water appear as but one Element. It is
thus that real Genius can manage Nature
at its will, and the Artist who transfers her
to the Canvas with so much Truth, kindles
a Light, which will ever be reflected with
Lustre upon his own Name', bt in at
£304.10.0; offered in second Wright
studio sale, Mr. Shaw, Town Hall, Derby,
11 October 1810 (9, with same eulogy)
bt in; has since remained in the collection
of the artist's descendants
EXHIBITED
? RA 1780 (158); BI 1817 (130); Derby 1866
(168)
LITERATURE
Nicolson no.266 p.254 and Appendix B
p.283 no.29; pp.77, 80; pl.170; Brinsley
Ford, 'The Earl-Bishop, An Eccentric and
Capricious Patron of the Arts', *Apollo*
XCIX, 1974, pp.426–7

Private Collection

This picture was the occasion of a cele-
brated fracas between Wright and the
Bishop of Derry, who commissioned it.
The story has often been told, but never so
well as by Brinsley Ford, whose chosen
adjectives 'eccentric and capricious' sum
up the wayward character of Frederic
Hervey, fourth Earl of Bristol and Bishop
of Derry (1730–1803). The Bishop, who
spent as much time in Italy as he could,
considered himself an expert on the subject
of Vesuvius; the volcano is prominently
seen in his portrait by Mme Vigée le Brun
(Ickworth). The Bishop's commission to
Wright to paint a Vesuvius for him seems
to date from 1774; Wright's letter-drawing
of that year from Rome to an unidentified
friend who was evidently looking after his
interests in Derby (transcribed under
No.84) reports that the Bishop is 'to take
Derby in his way to Irland and talk to you
about the picture'.

Wright worked on the Bishop's picture
after his return from Italy, but it was in an
unfinished state when the Bishop (in about
1777) again passed through Derby and
went to see it in Wright's studio. The
Bishop was reputedly most offensively
critical, possibly trying to get the price
reduced, possibly suggesting that Wright's
knowledge of Vesuvius was nothing com-
pared to his. What he said is not recorded,
but it was enough to make Wright refuse
point-blank to let the Bishop have the pic-
ture, and to score through his name in his
Account Book. Wright's friend the poet
William Hayley, indignant over the
episode, sprang to Wright's defence with a
poem which included the following lines
(given to Wright):

> You black dilettante! hence learn to
> your shame
> No mortal can give more expression to
> flame!
> If on flashes more brilliant your eyes
> wish to dwell
> Your lordship must go for your
> picture to ———

As Ford points out, this was not the only
occasion on which the Bishop behaved
shabbily to an artist; his behaviour in
reneging on commissions to the sculptor
Thomas Banks was if anything worse.

Wright seems to have taken the incident
to heart, refusing to sell the picture in his
lifetime. After his death, it was included in
the two studio sales of 1801 and 1810, but
was bought in each time, presumably
because it carried an exaggeratedly high
reserve. The long eulogy in the 1801 sale
catalogue, considerably longer than that
accorded to any other picture (quoted
under *Provenance*; repeated in the 1810
sale) probably largely reflects a Wright
family tradition of loyal but extravagant
defence of its merits, continuing long after
the *rencontre* with the Bishop of Derry.

Looking at the picture itself, it would
seem fair to say that it is a fine but not
superlative work. As Nicolson observes
(p.77), it is more contrived than the
Aberystwyth picture, which it probably
follows, but it has exciting passages: 'Light
collects in a nervous glitter on tree trunk
and mountain slope, vegetation catches
fire, and smoke rises from sizzling lava at
the crater's edge'. The sizzling lava sug-
gests that this may be the picture exhibited
at the Royal Academy in 1780 (158),
described by a reviewer in the *Morning
Chronicle* 6–9 May as 'The different lights
of the Moon, and of the Lava, contrasted
by the Clouds which it raises from the Sea,

have an astonishing Effect . . .'. The view is
from the Mole with its lighthouse on the
waterfront. The prominent cross is an
uncharacteristic piece of symbolism in
Wright; it may actually have been there
(though it has not yet been found in simi-
lar views by other artists), or Wright may
have added it, thinking to please the
Bishop – the least spiritual of clerics.

Of all Wright's Vesuvius paintings, this
one comes closest, superficially, to the work
of Pierre-Jacques Volaire (1729–*c.*1790).
Wright's paintings of Vesuvius were inevi-
tably compared to those of Volaire, from
as early as 11 February 1775, when Father
Thorpe, writing from Rome to his patron
Lord Arundell, reported that Wright was
working on a painting of the summit of
Vesuvius: but, he added, largely to please
Lord Arundell, who had recently com-
missioned a work from Volaire, Wright's
painting 'does not hurt Volaire'
(Thorpe-Arundell MSS, transcripts in Sir
Brinsley Ford's Archive, Paul Mellon
Centre, London).

Volaire had moved to Naples in 1769
after working in Claude-Joseph Vernet's
studio. He spent the rest of his life in
Naples, specialising in painting decorative
and rather theatrical scenes of Vesuvius,
with none of Wright's interest in the physi-
cal aspect of Vesuvius or its surrounding
terrain; he would ring the changes by call-
ing one 'The Eruption of Vesuvius 1737'
(when Volaire was aged eight) or 'The
Eruption of 1771' (engraved in the Abbé de
Saint Non's *Voyage Pittoresque de Naples et de
Sicilie*, 1781–5). Volaire usually enlivened
his Vesuvius pictures with vivacious little
figures, gaily conversing as if at a spectacu-
lar outdoor evening party (fig.25: cata-
logue notes for such pictures often read
'The figure in the foreground may be Sir
William Hamilton . . .').

Wright would almost certainly have
seen some of Volaire's work while he was
in Naples; if he did so, he cannot have
failed to have been stimulated by its var-
iety. Volaire favoured a wide format for
most of his Vesuvius pictures; Wright 'bor-
rowed' the wide format (not one he had
previously used) for some of his own
Vesuvius pictures, e.g. for this work and
No.102. In both these pictures, Wright
introduces, as a secondary light source to
offset the brilliant glare from Vesuvius, a
full moon seen in a clearing of clouds; this
was a motif he had already, before leaving
for Italy, used in such pictures as the two
'Blacksmiths' Shops' and the 'Philosopher
by Lamplight'. Volaire also deploys such a
moon, at least in works of the early 1780s

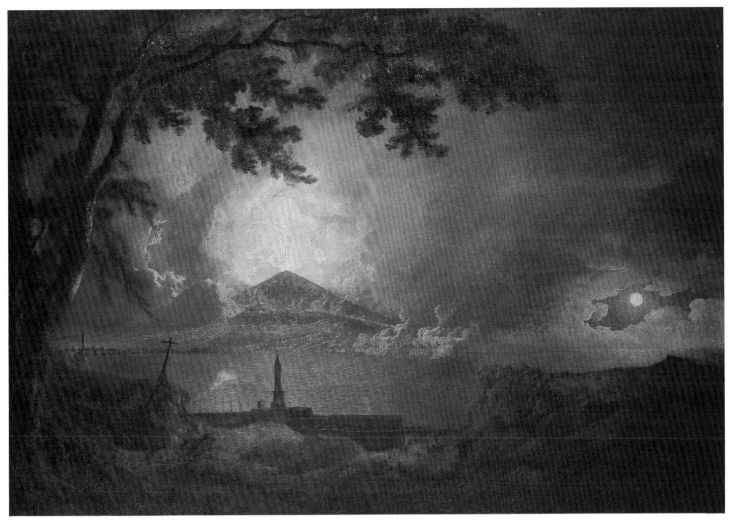

103

(e.g. in his 'Eruption of Vesuvius' *c.*1782, 29 × 64 ins, Virginia Museum of Fine Arts, exh. *The Romantic Era*, Indianapolis, 1965, 21, repr. in colour; 'Eruption of Mount Vesuvius from the Ponte della Maddalene', dated 1782, $51\frac{1}{2} \times 102\frac{1}{4}$ ins, Gallerie Nazionale di Capodimonte, Naples, exh. *Imagination and Reality*, Edinburgh, 1988. 34, repr. in colour p.72; and in the Vesuvius engraved for the *Voyage Pitturesque.* . . published 1781–5, date of Volaire's painting unknown).

The moon is of course no one artist's property; but it would be interesting to know whether there are comparable moonlight effects in Volaire's work before Wright visited Naples, or whether Volaire might have learned something from Wright.

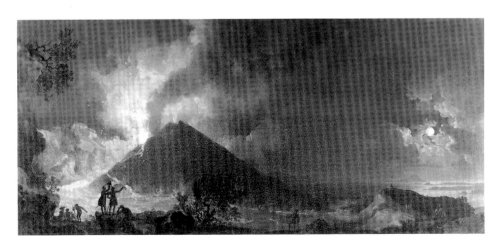

fig.25 Pierre-Jacques Volaire: 'Vesuvius in Eruption', oil on canvas 29 × 64 (73.7 × 162.6) *Virginia Museum of Fine Arts*

The Annual Girandola, at the Castle of St. Angelo, Rome ? exhibited 1776

Oil on canvas 54⅛ × 68⅛ (137.5 × 173)

PROVENANCE
Not in Wright's Account Book; ? purchased by John Milnes at the Society of Artists exhibition, 1776 (148, with its companion 'Eruption of Mount Vesuvius', 147); . . . ; Robert Neilson, by whom presented to the Corporation of Liverpool 1880

EXHIBITED
? Society of Artists 1776 (148, title as above); Derby 1883 (49); Tate & Walker 1958 (15); *Il Settecento a Roma*, Rome 1959 (690); *Italian Art and Britain*, RA 1960 (213); *RA Bicentenary Exhibition*, RA 1968–9 (31); Derby 1979 (21)

LITERATURE
Nicolson no.250, p.250; Appendix B nos.1–2, p.279, no.8, p.280; p.80; pl.210

Trustees of the National Museums and Galleries on Merseyside (Walker Art Gallery, Liverpool)

Firework displays or 'Girandole' (the name taken from the revolving wheel from which rockets were fired) were staged every year in Rome from the Castel Sant' Angelo. They were customarily presented on Easter Money and in celebration of the Feast Day of SS Peter and Paul (29 June). More rarely, there were firework displays in honour of the inauguration of a new Pope; Wright, in Rome in mid-February 1775, was able to witness the Girandola in honour of the new Pope Pius VI. Astonishment at the ingenuity and magnificence of the Girandola filled the letters home of many an Englishman on the Grand Tour. Robert Adam, in Rome twenty years earlier than Wright, in June 1755, wrote that the Girandola 'exceeded for beauty, invention and grandeur anything I had ever seen . . .' – rather a decorous beginning, rising in excitement – 'the grandest part . . . being thousands of rockets which were sent up one at a time, which spread out like a wheat sheaf in the air, each one of which gives a crack and sends out a dozen burning balls like stars, which fall gently downwards till they die out . . .' (John Fleming, *Robert Adam and his Circle in Edinburgh and Rome*, 1962, p.177).

Wright considered that a 'Girandola' was an ideal companion for a 'Vesuvius': 'the one of the greatest effect of Nature the other of Art that I suppose can be', he wrote on 15 January 1776 (see below). But Vesuvius proved by far the more popular subject of the two. Wright probably painted over thirty pictures of Vesuvius; but so far only four 'Girandola' paintings by him are known. These are:

(1) 'The Annual Girandola, at the Castle of St. Angelo, at Rome', exhibited at the Society of Artists in 1776 (148), with ('An Eruption of Mount Vesuvius' 147). This pair was bought at the exhibition by John Milnes of Wakefield, for 100 guineas each, 'therefore quite large' (Nicolson p.279). The 'Girandola' may well be the picture exhibited here; the 'Vesuvius' is untraced.

(2) 'The Girandola, a grand firework exhibited at the Castle of St. Angelo in Rome', exhibited at the Royal Academy in 1778 (361), and (?) in Liverpool in 1784 (117) or 1787 (118). This is the picture in Wright's Account Book as 'A small picture of the Girandola sold to M.ʳ Daulby £84'. A MS list of Daulby's pictures *c.*1790 (Liverpool Public Library) gives the size as 48 × 38 ins. (but likely to be landscape format). Untraced.

(3) 'The Girandola, or Grand Fire Work at the Castle of St. Angelo in Rome; companion to the Vesuvius he painted last year', exhibited at the Royal Academy 1779 (358). This is the large pair purchased for the Empress of Russia, and exhibited here as Nos.105 and 106.

(4) A 'Girandola', 16¾ × 28 ins, not exhibited in Wright's lifetime; in the collection of Birmingham Art Gallery and now a much-exhibited picture (Nicolson no.249, p.250, Appendix B no.5 p.280, pl.166 in colour). A companion 'Vesuvius' is in a private collection (Nicolson No.273, pl.167).

The 'Girandola' shown here is largely based on the semi-capriccio drawing in Derby dated 'June 4.ᵗʰ 1774' (shown here as No.83). Wright closely follows the drawing's composition and its architectural details, but the medium of oils softens the over-precise lines of the drawing; and Wright feigns a viewpoint from further back, in order to introduce the natural grandeur of two tall trees, seemingly laced with rockets.

Wright was working on a 'Girandola' and 'Vesuvius' pair in late 1775–early 1776, in Bath, where he was trying (unsuccessfully) to establish himself as a fashionable portrait-painter. In a letter of 15 January 1776 (? to his brother; DPL), he reported first on the 'Vesuvius': 'As to the picture of Vesuvius the Town rings with commendation of it', with several gentlemen making acquisitive noises. Wright adds 'I have just now finished a companion to it. The Exhibition of a great Fire work from the castle of St. Angelo in Rome, the one is the greatest effect of Nature the other of Art that I suppose can be. This last picture I have painted to keep me from Idleness'. Wright sent this pair to the Society of Artists exhibition in 1776, where they were bought by John Milnes (No.27), in part-exchange for a smaller pair, 'Mount Etna' (No.108) and its companion 'Vesuvius'.

It seems to this compiler (and to the compilers of a draft catalogue entry in the Walker Art Galley files, kindly made available to her) that the Liverpool 'Girandola' shown here is likely to be the picture which Wright painted in Bath, the picture he exhibited in 1776 and the picture purchased by John Milnes. It is closely based on a drawing of 1774 (though that could have been used as a study at a later date), and its style is what one would expect from a picture begun in 1775 and completed in 1776 (Nicolson dates it *c.*1775–8). Nicolson considers that it is 'far from being one of his most inspiring works' (p.80); unsurprising, since Bath proved not only an uninspiring but a very frustrating milieu to Wright. Nicolson discounts the possibility that the Liverpool picture could be the 1776–exhibited Milnes–purchased picture on the entirely hypothetical role which he assigns to the Birmingham picture of *c.*1774 (no.4, above) as a study for the 'Girandola' picture exhibited in 1776; since the Liverpool picture is patently not based on the Birmingham picture, he considers that it cannot be the picture exhibited in 1776 and bought by Milnes (Nicolson for once is less than clear over this).

Until fresh evidence appears, it seems reasonable to suppose that this picture is the 'Girandola' exhibited in 1776 and bought by Milnes. Knowledge of the fate of Milnes's collection might throw further light on this.

104

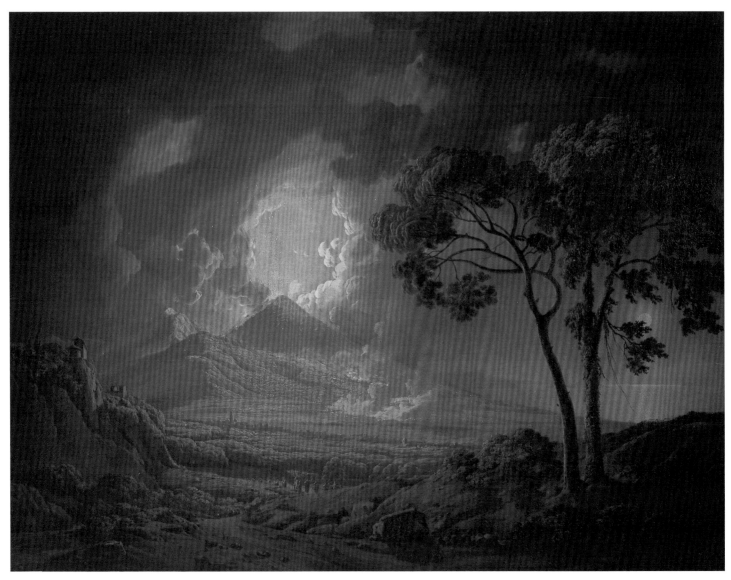

105

**An Eruption of Mount Vesuvius,
with the Procession of St Januarius's
Head** exhibited 1778

Canvas 63¾ × 84 (162 × 213.4)
PROVENANCE
In Wright's Account Book as 'A large
Mount Vesuvius sold to the Empress £300',
i.e. Catherine the Great, Empress of
Russia; by descent in the Russian royal
family until becoming state property
earlier this century
EXHIBITED
RA 1778 (357)
LITERATURE
Nicolson no.268 p.255, Appendix B
pp.279–30 no.3; pp.77, 81; pl.214

Pushkin State Museum of Fine Arts, Moscow

The majestic size of this picture, the wide
sweep of the circle of clouds and, perhaps,
the brave foreground trees which seem to
defy Vesuvius to do its worst, make this at
once the grandest and the most sombre of
all Wright's representations of Vesuvius.
He deploys a certain amount of rich
colour, with blazing lava spreading into
thick impastoed deposits, and a red-gold
light pervading the scene; but the moon is
behind a haze, its gleams on the water
muted and foliage turned unreally olive.

In the middle of the picture a procession
wends its way towards Vesuvius. Four men
bear on their shoulders a canopied ark or
reliquary; inside it is the head, or more
precisely the skull, of Saint Januarius or
Gennaro, bishop and martyr, who died in
the year 305. Both the skull and the dried
blood of St Januarius were (? are)
preserved in the cathedral of Naples, the

blood miraculously liquefying from time to
time, and the skull, when pointed in the
right direction, miraculously quelling
eruptions. Sir William Hamilton, describ-
ing the fury of the eruption of Vesuvius in
1767 to the President of the Royal Society,
reported: 'In the midst of these horrors, the
mob growing tumultuous and impatient,
obliged the Cardinal to bring out the head
of Saint Januarius, and go with it in pro-
cession to the Ponte Maddalena, at the
extremity of Naples, towards Vesuvius;
and it is well attested here, that the erup-
tion ceased the moment the Saint came in
sight of the mountain; it is true, the noise
ceased about that time, after having lasted
five hours . . .' (*Campi Phlegraei* p.35).

Those who had no access to the sainted
relic made do with plaster images.
Hamilton, a compassionate man, was dis-
tressed during the eruption of the previous

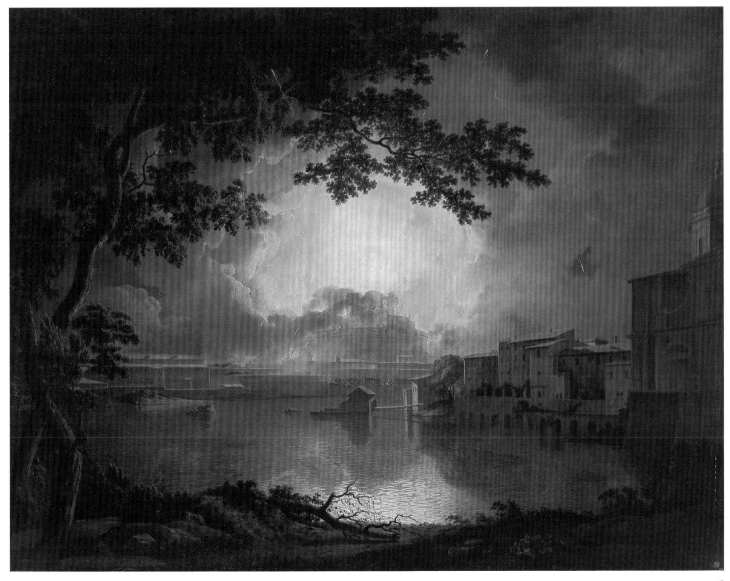

106

year by watching the flow of lava destroy a poor man's vineyard and his cottage, 'notwithstanding the opposition of many images of St Januarius, that were placed upon the cottage, and tied to almost every vine' (*Observations* p.6).

Thomas Jones witnessed a rather more impromptu recourse to the Saint than Wright's ritual procession, and one which deployed a bronze bust rather than the revered skull: on an excursion to Portici on 16 September 1778 'we overtook two porters, attended by a great number of people, carrying a bronze bust of S. Gennaro (the tutelar saint of Naples) towards the Mountain, in order to put a stop to the further depredations of the Lava . . .' (*Memoirs* p.78)

The reviewer of the Royal Academy exhibition of 1778 for the *Morning Post*, 29 April 1778, called this picture and a now

lost 'Girandola' 'wonderful examples of sublimity'.

Three years earlier, on 4 May 1775, Wright had reported from Rome to his sister Nancy that he had delayed his departure from that city for a month, to wait for an answer from 'Mr Baxter, the Russian Consul' as to whether the Express of Russia wished to buy a picture he had painted in Rome of 'Mount Vesuvius in a great eruption, 'tis the grandest effect I ever painted'. The price was to be 100 guineas. That sale fell through (which picture it was is unknown); but Wright was evidently gratified by the Empress's later purchase of this large Vesuvius (for 300 guineas), with its companion 'Girandola' (No.106).

106

The Girandola, or Grand Fire Work at the Castle of St. Angelo in Rome exhibited 1779

Oil on canvas $63\frac{1}{4} \times 84$ (162.5 × 213)
PROVENANCE
In Wright's Account Book as 'A Large picture of the Girandolo – companion to the Vesuvius w.ch was sold to the Empress of Russia – £200'; purchased for the Empress of Russia, and by descent in the Russian royal family until becoming state property earlier this century
EXHIBITED
RA 1779 (358), title as above followed by 'Companion to the Vesuvius he painted last year'
LITERATURE
Nicolson no.251, p.250 and Appendix B no.4, pp.279–80; pp.81, 85; pl.213; Larissa

Dukelskaya, *The Hermitage, English Art Sixteenth to Nineteenth Century*, Leningrad, London & Wellingborough, 1979, no.136, repr. in colour

Hermitage Museum, Leningrad

Wright must have been gratified to be able to report to his friend and patron Daniel Daulby in a letter of 31 December 1779 (DPL): 'The Empress of Russia has taken into Her capital collection my two pictures of Vesuvius & the Girandolo, & given me 500 Gs for 'em w.ch is a good reward accompanied w.th high honour'. The 'Vesuvius' is marked in Wright's Account Book at £300, the 'Girandola' at £200; to make up the 'good reward' of 500 guineas, Wright must have rounded up the prices from pounds to guineas, probably largely to include the frames in the total price to the Empress.

Nicolson is at some pains to establish that the 'Vesuvius' (No.105), which was exhibited first, dictated what form its companion 'Girandola' had to take: 'the smoking Castello with its bright yellow halo had this time to be pushed into the distance in order to harmonise with the smoking crater; the tree had to fill the left foreground to balance its companion in Moscow on the right; the Tiber had to occupy an open space in the middle ground to match the Neapolitan valley; and the little boathouse with its delicate drawbridge proved as useful an interruption in the expanse of water as the procession of St Gennaro's head had proved in an expanse of scrub'. While these are good points, it is difficult to believe that Wright embarked on the 'Vesuvius' without already having the composition of the 'Girandola' in mind, if not on paper. To design a pair, it would have been prudent to make at least rough preliminary sketches of both; but if Wright did this, his sketches have not survived.

Nothing seems contrived in this 'Girandola'; indeed, though not the most spectacular of Wright's four known representations of the subject, it is in many ways the noblest (irrespective of size) and the most original. The Castel Sant' Angelo seems ablaze, as if a powder magazine had exploded on its roof; but the large expanse of water between that seemingly red-hot crucible and the artist's viewpoint distances us from the glare, the heat and the acrid smells. Instead we are offered the rare privilege of being seemingly alone. This riverbank may usually have teemed with spectators, for it commands a mag-

nificent view of the fireworks, but we have the illusion of having it to ourselves. Distance transmutes the hot reds of the other fireworks pictures into russets, golds and bronzes. There are a few rockets, but they seem far off. Even the moon is half-hidden by the tree; the Tiber, transformed into a russet-gold lake, reflects both moonlight and fireworks. From this viewpoint, the little boat-house in the middle of the picture becomes as interesting as the Castel Sant' Angelo; and we do not miss St Peter's while we have the church of San Giovanni dei Fiorentini (begun by Sansovino early in the sixteenth century) to look at on the right bank. Buildings are not usually Wright's forte, but here he gives an accurate and satisfying view of the church.

Nicolson is of the opinion that this 'Girandola' and its companion 'Vesuvius' show 'the first clear signs' of Wright's 'loss of urgency' in communicating the facts of his Italian experience, and of his 'relapsing into generalisations' (p.85). It is not an opinion this compiler shares.

Describing this picture as he saw it in the Royal Academy exhibition of 1779, the reviewer for the *St. James's Chronicle* 29 April – 1 May 1779 wrote: 'This picture must be seen to have any idea of its Excellence; we have no Method of describing Mr Wright's Art of painting Flames, Sparks and the Reflection of Light by Fire.'

107

Rocks with Waterfall *c.*1772

Oil on canvas 31$\frac{7}{8}$ × 43 (80.7 × 109.2)
PROVENANCE
Not in Wright's Account Book; ? presented by the artist to Colonel Edward Sacheverell Pole, and thence by descent
EXHIBITED
? Society of Artists 1772 (371, 'A landscape'; NGA Washington 1985–6 (325, repr. in colour)
LITERATURE
Nicolson no.328, p.269; pp.55, 75; pl.112; Kim Sloan, *Alexander and John Robert Cozens*, 1986, p.99

Private Collection

Anyone who has followed Wright's progress to this point must suddenly feel thrown by this extraordinary picture. For the first time, Wright is painting pure landscape: and he is painting it well, as if seized with the conviction that the rocky mass in front of him is a sufficient subject in itself, with no need of being peopled with figures from literature or from real life. As Nicolson remarks of this picture, there is 'no attempt to tidy up the barbarity of nature, but the vision is rushed down on to canvas in all its incoherence, and yet makes a coherent picture . . . the decorum of contemporary art is brushed aside in order to preserve the wildness intact. Nothing in his own work is quite comparable to this, and we recall few examples of the kind in British painting before the early nineteenth century'.

At the last moment, or so it seems, Wright adds three tiny figures of banditti with spears in the foreground on the left, almost invisible below the massive rock face. If Wright did indeed exhibit this picture in 1772, he may have added the banditti to make the subject a little more conventional, in the Salvator Rosa mode (though this work is far too direct and compelling to be a Salvator Rosa pastiche). Unfortunately no contemporary reviewer of the exhibition of 1772 seems to have commented upon Wright's 'Landscape'.

The actual handling of paint in 'Rocks and Waterfall' is as bold as its subject-matter. Thick brushfuls of creamy, rusty, greenish paint are laid on to form the rock face, then scraped and modelled and pulled about to give it texture. The fall of water is wild and almost juicy; the shrubs and plants are depicted in a different, drier manner as crinkled, wiry and tenacious.

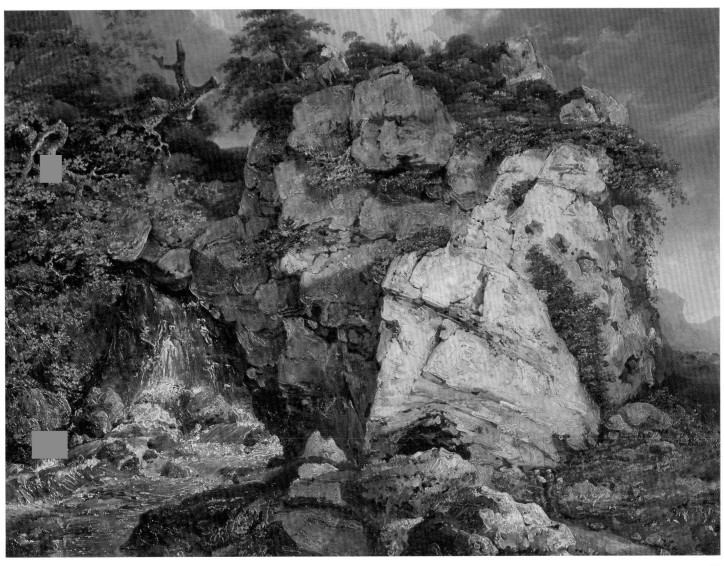

It is an exciting picture: but who or what can have sparked it off? Landscape backgrounds had slowly become an important part of Wright's work since about 1770. The background of 'Mr & Mrs Coltman' of *c*.1771–2, for instance, is an integral part of the portrayal of the two sitters and the life they lead; and landscape is even more important in 'The Earthstopper' of 1773. 'Rocks and Waterfall' probably shortly precedes 'The Earthstopper'; the two pictures have in common not only dramatic landscapes but also forceful brushwork.

Alexander Cozens's Matlock landscapes (noted under No.75), which Wright could have seen at Kedleston, may have helped Wright towards this new direct vision of landscape. Kim Sloan suggests that Wright's 'Rocks and Waterfall' comes close to confirming that Wright must also

have known John Robert Cozens and his work. 'The similarity in subject and approach to the series of chalk drawings of rocks by John Robert Cozens is striking. Like Cozens, Wright positions himself right up against the face of a wall of rocks and makes the texture, shapes, crevices and clinging vegetation the only subject of his painting'. But as Sloan remarks, more facts are needed if an association between Wright and the Cozenses is to be established.

A View of Mount Etna and a Nearby Town *c*.1775

Oil on canvas 26 × 34⅞ (66 × 88.5), with an extra ⅝ (1.5) of painted surface turned over stretcher at top and either side

PROVENANCE
Purchased by John Milnes early in 1776 as one of a pair, the other being a 'Vesuvius' by moonlight, but returned to the artist after Milnes's purchase of a large 'Vesuvius' and 'Girandola' pair at the Society of Artists' exhibition 1776; (the 'Vesuvius', 'size . . . about 2 feet 10 by 2 ft. 5 in.' was offered by Wright to Daniel Daulby January 1780, but not purchased by him); offered by Bird, ? acting as agent for Wright, Christie's 11 March 1780, in a sale called 'Property of a Nobleman', but mainly consisting of different properties (100, 'The Eruption of Vesuvius') bt in at £65.2.0 (101, 'Ditto Mount Aetna, its Companion') bt in at £49.7.0; again offered by Bird, ? this time acting both for Wright as vendor and for Lord Palmerston as purchaser, Christie's 15 March 1783, in a sale called 'Charles Hamilton, deceased' but mainly consisting of different properties, lot 53, as 'View near Naples', bt in at £32.11.0; lot 54, 'The Companion, Vesuvius', sold for £43.1.0 to Bird, evidently for Lord Palmerston; both pictures noted as purchases of Christie's 1783 in Lord Palmerston's MS notebook, Broadlands (quoted Nicolson p.282), the 'View near Naples' correctly entered in the Notebook as 'A View of Qtna [Etna]', £32.11.0, (the bt in price in the sale) and 'A View of Vesuvius during an Eruption by night', £43.1.0 (the hammer price); . . .; Meynell family, Meynell Langley, Derbyshire, until sold by Godfrey Meynell, Sotheby's, 18 November 1970 (40, repr.), bt Herner Wengraf, from whom purchased by the Tate Gallery 1971.

EXHIBITED
Sudbury 1987 (33, repr.).

LITERATURE
Nicolson p.282; *The Tate Gallery 1970–72*, 1972, pp.68–70, catalogued as 'A View of Catania with Mount Etna in the Distance'; Nicolson 1988, pp.753–4, figs 40, 41, as 'View of Catania with Etna'.

Tate Gallery

This subject, of which there is a larger version, 33 × 49 in., with some differences (repr. Nicolson 1988 fig.41), poses a problem. Wright, who was in Italy from February 1774 to July 1775, kept a fairly full journal of his travels, specifying places visited; but although he was in Naples in the autumn of 1774, neither in his journal nor in any correspondence then or later does he mention a visit to Sicily. Neither of the Etna views seems to be listed in his Account Book, and neither was exhibited. Wright's only reference to a painting of Etna occurs in a letter of 11 January 1780 to his friend and patron Daniel Daulby (DPL), in which he offers Daulby a 'Mount Etna' as 'companion to a 'Mount Vesuvius' . . . about 2 feet 10 by 2 ft. 5 in.', which Mr Milnes had purchased but now wished to return, having bought 'a pair of larger ones of Vesuvius & the Girandola' in the exhibition of 1776 (these complex transactions have been relegated here to *Provenance*). That letter at least establishes that a painting of 'Mount Etna' existed by the spring of 1776; it must have been painted either in Italy or soon after Wright's return. As David Fraser points out in the catalogue of the Sudbury exhibition of 1987, a daylight view of Etna, 'bathed in a strong Mediterranean light . . . would have made a fitting contrast to the moonlight view of Vesuvius erupting with which Wright paired it'.

It begins to look as if Wright had no first-hand knowledge of the scenery near Mount Etna and must therefore have based his paintings on another artist's view of the place. There is nothing very unusual in that, and certainly nothing reprehensible; Turner, for instance, made three different finished water-colours of 'The Siege of Seringapatam' (one in the Tate Gallery) without having been to India, and on the basis of an amateur's sketches; and other examples could be cited.

The work on which Wright based his Mount Etna views has not been traced. Wright's willingness in principle to work from another man's sketches is nicely documented in a letter from Charles Parker to Roger Newdigate, from Rome, 18 February 1784 (Warwickshire Record Office: copy in the archives of Sir Brinsley Ford, who kindly acquainted the compiler with it). Parker reports to his friend:

> one of my drawings is like to be Honour'd. Wright of Derby the Painter . . . has a thought of Painting a Scene from Sir W: H: [Sir William Hamilton's] Journal of the

Earth-Quakes of Calabria – for the next Exhibition. He has chosen for his Subject Sir W's Description: of the Mother sitting upon the Ruins of her own House, bewailing the loss of her only Child buried in Ruins, & waiting every Stroke of the Labourer who was removing the Rubbish. It is a fine Moment for a Painter – He has writ to a friend Painter at Rome to know if it be possible to get any authentic Sketch of the Town of Palmi where it happen'd & the country around – It happen'd luckily that my View of the Straits of Messina was taken just below Palmi, so I have given him leave to copy it for him – Which will make a good addition to his Picture, to have a real view of the Country –

No painting by Wright using Parker's view ('a View of the Straits, the Mountains behind Messina & Etna's smoking Top above all') is known; but the letter offers fresh insights into the ways in which Wright was ready to work, and the extent to which he kept up to date with material relating to Italy. Sir William Hamilton's account of 'the Mother . . . bewailing the loss of her only Child buried in Ruins' occurs in his (published) *Account of the late Earthquakes in Calabria, Sicily, &c . . . as communicated to the Royal Society 1783*, p.21. That Wright should immediately see in it a subject for a painting disproves Nicolson's assertion (p.77) that Wright was unresponsive to the human suffering inflicted by volcanic eruptions.

Wright's painting has previously been called 'A View of Catania, with Mount Etna in the Distance'. Catania is a sea-port; it is much closer to Etna than the town shown here; and it is and was then a large baroque town, the second largest town in Sicily after Palermo. If Wright was working from a fairly amateur sketch (and it seems that he cannot have drawn this view at first-hand), then Catania might emerge as the strange, bleak, straggling, almost desert-like town which Wright depicts. It should be noted that an engraving of Catania in Abbé Richard de Saint-Non, *Voyage Pittoresque ou description des royaumes de Naples et Sicilie*, IV, 1785, pt i facing p.81, shows the town similarly surrounded by deep deposits of lava; but Catania itself is depicted (correctly) as close to Etna, as much larger and as architecturally more complex. The compiler is grateful to Duncan Bull for suggesting that Wright's town might be Randazzo, Bronte or Adrana, each smaller than Catania and

108

further from Etna. But it is of course not
the town so much as the surrounding
deposits of lava that engage Wright's
attention. He depicts the expanse of lava as
endlessly grey, deeply furrowed, and ideal
matter for very thick paint and much
modelling with his brush and palette-
knife.

109

Sunset on the Coast near Naples *c.*1785–90

Oil on canvas 25 × 29⅞ (63.5 × 75.9)

PROVENANCE
? In Wright's Account Book, after a 'moonlight Vesuvius' sold to Mr Bacon, as 'The Companion Sun Set in the Bay of Salerno sold to my friend Holland £21.10.0' (reduced from £18.18.0);? Same picture, in MS inventory of James Rawlinson's collection *c.*1850 as 'Gulph of Salerno Sun Set'; . . .; Ralph Robotham, by 1934; purchased *c.*1950 by Sir Gilbert Inglefield, and by descent

EXHIBITED
Derby 1934 (104, as 'Grotto in the Gulf of Salernum – Sunset'); NGA Washington 1985–6 (326, repr. in colour)

LITERATURE
Nicolson no.284 p.258; p.83; pl.287 (in colour)

D.G.C. Inglefield Esq. & C.S. Inglefield Esq.

Like the paintings of 'Lake Albano' and 'Lake Nemi' shown here (Nos.114, 115) and like many of Wright's other Italian landscapes, this was probably painted at least ten years after Wright's return from Italy in 1775. The scene has been called 'the Gulf of Salerno', but is probably painted from recollections of the coast near Naples rather than from anything Wright observed or drew on the spot. The picture suggests that Wright's imagination was hovering between Alexander Cozens and Claude-Joseph Vernet. His Account Book records a 'Sun Set a bold Sea Shore from Cozens', a work now untraced, perhaps copied from something like Cozens's 'Rocky Bay Scene', a small oils on paper reproduced by Kim Sloan 1986 (fig.93, in colour). The dramatic contours of Wright's rocky headland and cliff in this painting have some echoes of the fantastically-shaped coastlines of Claude-Joseph Vernet, whose work could have been familiar to Wright since Vernet was one of the most prolifically-engraved painters of eighteenth-century France.

Wright became increasingly fond of sunset effects in which low rays very lightly gild the edges of cloud. His sunsets become increasingly ethereal, until they attain the purity of the sky above 'Ullswater' (No.139).

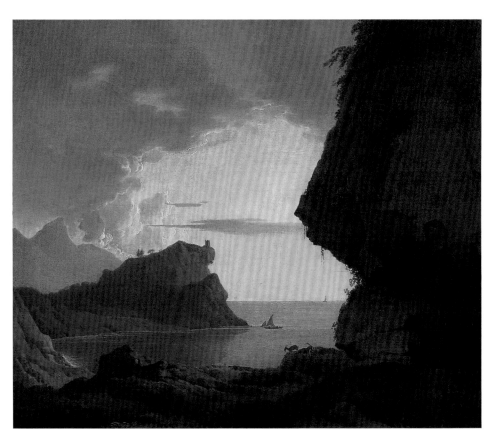

110

Dovedale by Moonlight exhibited
1785

Oil on canvas $24\frac{5}{8} \times 30\frac{5}{8}$ (62.5 × 77.8)
Inscribed 'I.W.' lower centre
PROVENANCE
In Wright's Account Book as the second
item in 'A View in Dove Dale Morn.
Companion in D? Moonlight 3grs sold to E?
Mundy Esqre £31.10 each', i.e. sold to
Edward Miller Mundy; . . . ; William
Martin; Capt. and Mrs R. Langton
Douglas; purchased by the Allen
Memorial Art Museum, Oberlin College,
1951
EXHIBITED
Robins's Rooms 1785 (19); Durlacher
Bros New York 1960 (22)
LITERATURE
Nicolson no.317 pp.265–6; pp.90–1;
pl.261; Chloe Hamilton, 'A landscape by
Wright of Derby', Allen Memorial Art
Museum Bulletin, Fall 1954, pp.17–22,
repr. p.18

*Allen Memorial Art Museum, Oberlin
College; R. T. Miller Jr Fund*

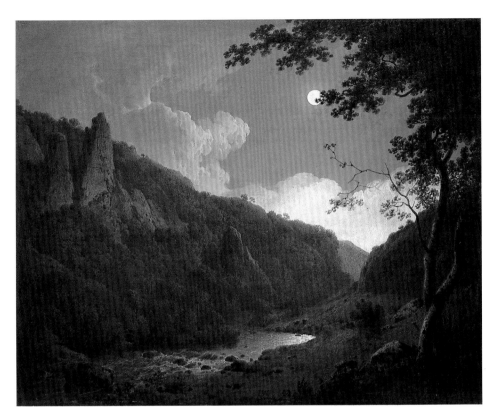

110

The view is looking northwards along the
course of the Dove. The rocks on either side
at this point are known as Tissington
Spires, presumably because they have a
fancied resemblance to the pinnacles of
mediaeval architecture, and to those of the
Derbyshire church of St Mary's Tissington
in particular. Dovedale, as Pilkington
observed in 1789, is full of 'rocks of the
most singular and extraordinary shape . . .
In some places they are seen rising up to
the perpendicular height of thirty or forty
yards in the form of pyramids, or spires of
churches . . . In other parts, they lean over
the river, and seem to threaten immediate
destruction . . .'
 As in his 'View in Matlock Dale'
(No.123), Wright is not interested in paint-
ing generalised scenery, but concentrates
on what is 'singular'. He ignores all the
accepted tenets of picturesque com-
position, and instead paints just what he
sees. The view is by moonlight, but with-
out melodrama. The companion 'View in
Dovedale, Morning' (Nicolson pl.258;
private collection) is equally realistic and
unconventional.

III

A Cottage on Fire *c.*1787

Oil on canvas $22\frac{7}{8} \times 30$ (58×76.2)

PROVENANCE
? painted for Mr and Mrs Morewood,
Alfreton Hall, Derbyshire; bequeathed by
Mrs Morewood with the house to her
nephew William Palmer, later
Palmer-Morewood, then by descent until
sold by the Trustees of the R.C.A.
Palmer-Morewood Trust, Christie's 16
July 1982 (36. repr. in colour), bt Agnew's,
from whom purchased by the Minneapolis
Institute of Arts 1984

EXHIBITED
Derby 1934 (96); *The Heroic Age*, Agnew's,
1984 (16, repr.)

LITERATURE
Nicolson no.334 pp.269–70; p.92; pl.293
in colour

*Minneapolis Institute of Arts, Putnam Dana
McMillan Fund and Bequest of Lillian
Malcolm Larkin, by exchange*

III

Wright's 'Cottage on Fire' subjects, first
essayed *c.*1787 and frequently repeated
over the next five years, proved very popu-
lar. Nicolson lists at least nine of them, not
all now known, and not easy to identify in
Wright's Account Book. This picture has a
'companion', the 'Moonlight, with a Lake
and a Castellated Tower', exhibited here
as No.112. Nicolson's identification of these
two as the pair of pictures which Wright
sent on approval to Mr Cutler in London,
in March 1787, seems only partly correct.
Mr Cutler liked and kept that 'Cottage on
Fire', but not the 'Moonlight'; Wright
therefore asked for its return, 'as I have the
like Companion to paint for a Gent. in the
neighbourhood'. Given the fact that the
two pictures exhibited here were formerly
in the Palmer-Morewood collection, it is
likely that Wright sold a freshly-painted
'Cottage on Fire' and the rejected
'Moonlight' to George Morewood of
Alfreton Hall near Derby (certainly quali-
fying as 'a Gent. in the neighbourhood').

To Nicolson, the various 'Cottages on
Fire' seem repetitive and 'removed from
reality'. Perhaps the subject (of which
there are versions in Derby Art Gallery,
the Yale Center for British Art and the
Agnes Etherington Art Center, Kingston,
Ontario, to mention only those in public
collections) would be better appreciated if
it were unique. To this compiler, the
Minneapolis picture, likely to be one of the
earliest versions, has real drama in the air,
as well as the almost audible disintegration
of wood and thatch into acrid smoke. The
cottagers salvage what they can; but the
burning of a cottage perhaps seems hum-
drum to Wright's admirers after the
Girandolas of Rome and the eruptions of
Vesuvius. Gibbon remarked: 'If we are
more largely affected by the ruins of a pal-
ace than by the conflagration of a cottage,
our humanity must have framed a very
erroneous estimate of the miseries of
human life'. Could Gibbon's remark have
provided Wright with his cue?

A 'Village on Fire' in Wright's posthum-
ous sale, Christie's sale, 6 May 1801 (40),
was described as a 'Scene in Holland': is
there a Netherlandish source for these
subjects?

Moonlight, with a Lake and a Castellated Tower ? dated 1787

Oil on canvas 22⅞ × 30 (58 × 76.2)
Inscribed 'I. W. Pinx! 178(?)7', the last
figure indecipherable
PROVENANCE
sent by Wright on approval to Mr Cutler,
surgeon, London, in March 1787, but
rejected by him; ? sold to George
Morewood, Alfreton Hall, Derbyshire;
bequeathed by Mrs Morewood with the
house to her nephew William Palmer,
later Palmer-Morewood, and by descent
until sold by the Trustees of the R.C.A.
Palmer-Morewood Trust, Christie's
16 July 1982 (35, repr. in colour), bt
Agnew's; Noortman and Brod, from whom
purchased by the present owner
EXHIBITED
Derby 1934 (94); *The Heroic Age*, Agnew's,
1984 (14, repr.) Waterhouse ed. 1953,
pp.189–90, fig.171 A;
LITERATURE
Nicolson no.333 p.269; p.92; pl.292 in
colour

Private Collection, Montreal

A companion to 'A Cottage on Fire'
(No.111), contrasting cool moonlight with
lurid glow. Understandably, the figures in
the 'Fire' scene are agitated; those in the
'Moonlight' scene, barely visible on the
left, are meditative. Nicolson comments:
'This beautiful moonlight scene has the
gently undulating vegetation of an aqua-
rium'. The tower must be imaginary.

112

113

Matlock Tor by Daylight mid-1780s

Canvas 28½ × 38⅞ (72.4 × 98.7)

PROVENANCE
. . . ; Haskett Smith, 'who has left London', offered Christie's 28 May 1864 (32, as 'A View of Dovedale'), bt in at 39 gns., then evidently kept by Haskett Smith for the rest of his life; the late H. Haskett Smith of Trowswell, Goudhurst [Kent], sold Christie's 9 May 1896 (113), 17 gns.; . . . ; Roland, Browse and Delbanco, London, from whom bt (Fairhaven Fund) by the Syndics of the Fitzwilliam Museum 1955

EXHIBITED
Landscapes from the Fitzwilliam Museum, Hazlitt, Gooden & Fox, 1974 (65, pl.11); *British Paintings 1600-1800,* British Council Art Gallery of New South Wales, Sydney, and National Gallery of Victoria, 1977–8 (47, repr.)

LITERATURE
Charles E. Buckley, 'An English Landscape by Joseph Wright of Derby', *Art Quarterly,* Detroit, Autumn 1955, pp.268, 270, fig.3 p.269; Nicolson 1968, cat.no.310; pp.88, 90, 264; pl.258, in colour; J.W. Goodison, *Fitzwilliam Museum, Cambridge, Catalogue of Paintings,* III, *British School,* Cambridge, 1977, pp.294–5, pl.21

Syndics of the Fitzwilliam Museum, Cambridge

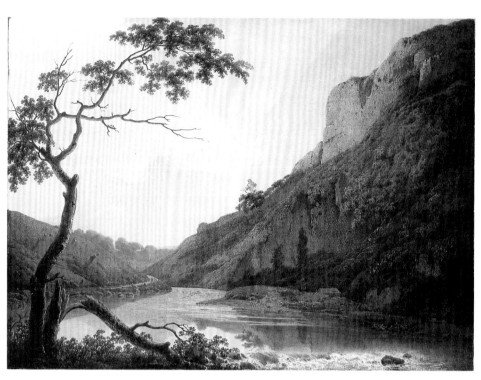

113

Wright had already twice painted this same scene by moonlight, in pictures which Nicolson dates to *c.*1778–80, and which now belong respectively to the Yale Center for British Art and to the Detroit Institute of Arts (Nicolson 1968, cat. nos.308 and 309, pls.217 and 218). The Detroit picture is highly dramatic, with greenish clouds building up, with something of the body and force of the night clouds in Wright's Vesuvius scenes, into a seemingly solid arc against which the moon seems to hurl itself (repr. in colour, *Wright of Derby, The Great Artists,* Part 65, Marshall Cavendish, 1986, p.2057). Nicolson's dating of *c.*1777–8 for the two moonlight views, and of some five or six years later ('mid-1780s') for this daylight view, is surely correct. Wright's landscapes grow less melodramatic, less dependent on 'effects', as he grows more thoughtful and more confident as a landscape painter.

In 'Matlock Tor by Daylight', Wrights's mood is serene, indeed lyrical, a rare mood for Wright. Matlock Tor rises on the right, but it neither looms nor frowns; instead its cliffs are bathed in sunlight. As Buckley points out (p.270), in this picture Wright has chosen a moment of stillness, 'when the landscape has fallen under the spell of the light itself'. So complete is the illusion of stillness, and so satisfyingly does the landscape fill the picture, that it is at first almost with disbelief that the eye picks out two tiny figures (one with a red sunshade, reinforcing the feeling of langour) walking along the bend of the path on the left. A tall tree on the left (not present in the moonlight versions) is, as Nicolson observes, ' a picture-making tree': it balances the Tor on the right, and 'its broken bough curtsies to the river'. But most artists took at least minor liberties with landscape.

If the river, trees and almost all things on earth are still, the heavens are not. The sun, calmly descending through a patch of cloud, sends out unhurried, valedictory rays which tinge the nearby sky with palest yellow and creamy pink. It is a tribute to Wright that we are left feeling that within moments after we have looked at this landscape, it will have changed.

Wright's interest in observing and depicting skies were probably sparked off by Alexander Cozens (as suggested on p.142). The sky studies in Wright's two sketchbooks in the Metropolitan Museum (No.77) testify to a continuing interest demonstrated in almost all his landscape paintings of the next decade.

114

Lake Albano *c.*1790–2

Oil on canvas $14\frac{1}{4} \times 21\frac{1}{2}$ (36.2 × 54.5)
PROVENANCE
In Wright's Account Book, with No.115,
as 'Two sketches of ye. Lakes of Albano &
Nemi sold to McNevin 21.0.0', i.e. 10 gns
each, sold to Mr McNiven of Manchester;
by descent to Mrs Burrows, by whom sold
to Agnew's 1965; purchased from Agnew's
by Paul Mellon 1965, and presented by
him to the Yale Center for British Art 1981
EXHIBITED
NGA Washington 1969–70 (17);
Classic Ground, Yale Center for British Art,
New Haven, Conn., 1981 (15)
LITERATURE
Nicolson no.257, p.251; p.84; pl.316 (in
colour); Duncan Bull, *Classic Ground* (1981
exh. cat. cited above), p.30

*Yale Center for British Art, Paul Mellon
Collection*

See text below No.115

114

115

Lake Nemi *c.*1790–2

Oil on canvas $14\frac{1}{4} \times 21\frac{1}{2}$ (36.2 × 54.5)
PROVENANCE
as for No.114
EXHIBITED
NGA Washington 1969–70 (18);
Classic Ground, Yale Center for British Art,
New Haven, Conn., 1981 (3)
LITERATURE
Nicolson no.258, p.251; p.84; pl.317;
Duncan Bull, *Classic Ground* (1981 exh. cat.
cited above), p.24

*Yale Center for British Art, Paul Mellon
Collection*

Nicolson's dating of *c.*1790–2, followed
here, means that these works were painted
at least fifteen years after Wright left Italy.
These are not 'views' but dream-like recol-
lections. Nicolson writes (p.84): 'No land-
scapes in his entire work are more poetical
than these final evocations of Claude. Two
of the purest are the small companions in
the Mellon collection, characteristically
early morning and sunset, where full use is
made of the low sun for lyrical effects'. A
debt to Richard Wilson and thus, in
Nicolson's phrase, to 'Claude at one
remove', is evident; but as Duncan Bull
points out, Wright is more concerned with

115

the colourful effects of light than Wilson. Albano is seen in a cool morning light, while in Wright's painting of Nemi, 'he has saturated the atmosphere with the pink glow of sunset'.

In 'Lake Albano', the lake is seen from the north-west, looking towards Monte Cavo and the Alban Hills; in 'Lake Nemi', the town of Nemi is visible on the left, with Genzano on the right. For a painting of 'Lake Nemi' by Richard Wilson to which Wright's is close, see W.G.Constable, *Richard Wilson*, 1953, pl.91a and pl.206. Constable illustrates three of Wilson's 'Lake Albano' subjects, pls.64b–65b.

A larger version of 'Lake Nemi' by Wright is exhibited here (No.116). Wright's other versions of 'Albano' and 'Nemi' are catalogued and discussed by Nicolson, pp.250–2.

116

Lake Nemi at Sunset ?*c.*1790

Oil on canvas $39\frac{3}{8} \times 50\frac{3}{8}$ (100 × 128)

PROVENANCE

? in Wright's Account Book as 'A Sun Set of the Lake of Nemi £52.10.0'; . . .; anon. sale Sotheby's 18 March 1970 (47, as by Thomas Wright), bt Agnew's, from whom purchased (correctly attributed) by the Louvre 1970

LITERATURE

Nicolson p.252 (untraced); Benedict Nicolson, 'Un Tableau de Wright of Derby au Musée du Louvre', *Revue du Louvre*, 1971, no.45, pp.247–50, fig.1

Musée du Louvre

Nicolson 1968 catalogues five versions of 'Lake Nemi'; he also quotes four further (untraced) Nemi subjects in Wright's Account Book. When the Louvre picture came to light, he was able to suggest in his 1971 article that it could well be the 'Sun Set of the Lake of Nemi' in Wright's Account Book; not only was there a veritable sunset in the rediscovered picture, but also the price of £52.10.0 was appropriate to its size. The identification seems very likely; indeed the question-mark before the identification should perhaps be removed.

The Louvre picture is the largest version of the subject so far known. The viewpoint, looking over the lake with the mediaeval town of Nemi on the left and Gensano high on the right, is closest to that in the much smaller 'Lake Nemi' exhibited here with its companion 'Lake Albano' (Nos.114, 115). The Louvre picture is also closely linked by Nicolson to the 'Lake Nemi' which Wright largely based on a work by Richard Wilson (Nicolson no.252, pl.237; Nicolson 1971 fig.2). Wright has introduced some fresh details which are not in either of the versions just mentioned, such as a seemingly-pointless arch halfway down the hillside path on the left. He has also introduced some cows in the foreground, presumably bent on watering. Cows are mercifully rare in Wright's work.

The most remarkable aspect of the Louvre picture is Wright's remarkable control over atmospheric effects. The sun, invisible somewhere to the right, has very nearly set; it still strikes the face of buildings in Nemi on the left, catches ridges of hillside in the middle distance and imparts a rosy glow overall; but these effects are not exaggerated. The foreground is already in deep shadow, and the sky is very pale blue, almost drained of other colour.

The view was painted by many British artists, including Francis Towne, Thomas Jones and William Pars. Pars's beautifully limpid watercolour of *c.*1780, from a similar viewpoint, is in the collection of the Whitworth Art Gallery, Manchester (reproduced in colour in Francis W. Hawcroft, *Travels in Italy 1776-1783*, exhibition catalogue, Whitworth Art Gallery, 1988, no.69 repr. p.75).

Nicolson noted that the Louvre picture was 'signée en toutes lettres mais d'une manière peu lisible', and gave its date as '1790'; but examination by the curators of the Louvre has found evidence neither of a signature nor of a date.

Versions of 'Lake Nemi' not recorded by Nicolson include (i) canvas 44.2 × 67.5, private collection, from a similar viewpoint to that in the Louvre picture, but showing a wooded hill on the left without the town; (ii) small oval, sold Christie's 28 January 1983 (119), similar to Nicolson pl.234; (iii) canvas 36.9 × 43.4, signed and dated 1792, collection Royal Albert Museum, Exeter, (repr. *Catalogue of Paintings*, 1978, p.137).

116

Landscape with Dale Abbey and Church Rocks *c.*1785

Oil on canvas $28\frac{1}{2} \times 39\frac{3}{4}$ (72.4 × 99)
PROVENANCE
. . .; Frederick Seymour Clarke, sold
Christie's 10 February 1933 (39, as 'River
Scene', by Richard Wilson), bt J.G.
Graves, and included (as by Richard
Wilson) in his founding gift to the Graves
Art Gallery 1935
EXHIBITED
Landscape in Britain c.1750-1850, Tate
Gallery 1973-4 (124), repr. p.66; Derby
1979 (33); *Ruins in British Romantic Art*,
Nottingham, Castle Museum, 1988 (26)
LITERATURE
W.G. Constable, *Richard Wilson*, 1953,
pp.149, 250, pl.159 c; Nicolson no.331
p.269; pp.893, 90, 92. pl.249; Patricia R.
Andrew, 'A landscape by Joseph Wright
of Derby', *Burlington Magazine*, CXXVIII
no.1003, 1986, pp.741–3, fig.34

Sheffield City Art Galleries

The ruins are those of Dale Abbey, foun-
ded about the year 1200 by canons of the
Premonstratensian order. The Abbey's
chief surviving glory is the great arch of
the east window of the chancel, over seven-
teen feet high, which Wright makes the
keystone of his painting. (Dale Abbey is
described by Nikolaus Pevsner, revised
Elizabeth Williams, *Derbyshire*, ed. 1986,
p.162; pl.12 shows the arch in its present
state.)

Dale Abbey is situated roughly between
Derby and Ilkeston. It is set among sand-
stone cliffs; but as David Fraser has poin-
ted out (in correspondence), Wright has
'transported' Dale Abbey from its own
surroundings, and set it down in Matlock
Dale, some twenty miles away. The river
we see is the Derwent; the rocky cliffs are
Church Rocks, near Matlock, readily
recognisable from engravings, such as the
engraving after Chantrey reproduced by
Fraser in his essay in this catalogue (p.21).
Fraser suggests that Wright also used
Church Rocks in the setting for 'The
Earthstopper' and 'An Iron Forge seen
from without' (Nos.51 and 50).

'Dale Abbey with Church Rocks' is thus
a 'Derbyshire capriccio', in Fraser's phrase.
Though the scene looks as solid and satis-
fying as 'Matlock Tor, Daylight' (No.113),
it proves not to have the same basis in
reality; but otherwise the two pictures are
close in date and in serenity of mood. Like
many other artists, Wright sometimes

manipulated minor details of landscape to
achieve a more satisfying design; but
Church Rocks are no minor details, and it
is odd that he should have transferred such
a large and prominent landscape feature
from Matlock Tor to Dale Abbey,
especially when both the Abbey and
Church Rocks were well-known sights.
Perhaps Wright wanted his picture to offer
a contrast between the ruin of Dale Abbey
and the endurance of natural rock forma-
tions. If so, he may have decided that
Church Rocks offered a nobler contrast
than anything nearer the Abbey. He may
also have found their shapes better suited
to his design.

Nicolson calls this 'the most beautiful of
all his [Wright's] Wilson-like landscapes',
full of Wilson-like air. It is not surprising
that it should have entered the Graves Art
Gallery as by Wilson. It was reattributed
to Wright in 1953, 'justly', in W.G.
Constable's opinion: 'the lights, especially
in the foliage, are more spotty than
Wilson's, the impasto on the rocks and tree
trunks less rich and unctuous, while the
sharp dark touches on the rocks, and the
use of rich greens and occasional strong
blues are characteristic of Wright' (p.149).
The detailed trickles and blobs of impasto
which give texture to the rock faces are
indeed unmistakeably Wright's; so are the
reflections of rock and sky in water and the
colouring of the approach to sunset. Light
still falls on the Abbey, but the clouds are

pink, as are the distant hills. The fore-
ground figure in his mauve-brown clothes,
also Wilson-like, is sketchily painted but
holds his own place in the composition;
that insubstantial fishing-net temporarily
held over the water acts as an effective
counterweight to the massive cliffs on the
further bank.

Patricia Andrew's 1986 article brings to
light a previously-unpublished Wright
'River Landscape, with Cliffs and Houses
in the distance' (her fig.5; Towner Art
Gallery, Eastbourne) which is very similar
to the Sheffield picture except that Dale
Abbey has been replaced by a group of
houses. Thanks to David Fraser's findings,
the rocky cliffs in the Eastbourne picture
can now be identified, like those in the
Sheffield picture, as Church Rocks; they
also appear in 'Landscape with ruins, by
moonlight' (Nicolson no.305, pl.236).

118

Landscape near Bedgellert, North Wales *c.*1790–5

Oil on canvas 23 × 31 (57.1 × 76.3)
Inscribed 'Bathellert N.W. Wales' verso on
the stretcher
PROVENANCE
. . . ; Sabin Galleries, from whom pur-
chased by the present owners 1989

Drs Caroline & Peter Koblenzer

This picture, surely unquestionably by
Wright, came to light only recently; it has
never before been exhibited. A date of
*c.*1790–5 is suggested for it here because
the handling of paint seems to have much
in common with that in 'Landscape with a
Rainbow' (No.124), which is dated 1794.
Here Wright may have most enjoyed
painting the red-earth, muddy, rutted
river-bank, using paint lavishly and then
modelling it, probably with his palette-
knife, producing effects similar to those of
the lava in the foreground of many of his
paintings of Vesuvius, and of Mount Etna
(No.108). Wright's painting of the moun-
tain produces a satisfying solid effect; and
he combines this with the depiction of
swiftly-passing atmospheric effects. The
great banks of cumulus cloud body forth
and swell upwards in an entirely convinc-
ing manner.

A question which must at once obtrude
is whether Wright ever actually visited
Wales. Neither his own letters nor his niece
Hannah Wright's MS Memoir mention a
visit. Wright's Account Book includes two
Welsh subjects. The first is 'A small picture
of Canarvon Castle. Night, £10.10.0', the
painting now in Manchester Art Gallery;
but David Solkin has conclusively proved
that this picture is very largely taken from
Paul Sandby's aquatint of the scene,
published in 1776 (David H. Solkin, 'A
"Caernarvon Castle by Night" by Joseph
Wright of Derby', *Burlington Magazine*,
CXIX, 1977, pp.284–5; fig.88 is Sandby's
aquatint, fig.89 Wright's painting). The
other Welsh landscape in Wright's
Account Book is 'A View in Wales. Storm
sold to my friend M.ͬ Tom.ˢ Tate £31.10.0',
so far untraced. However dramatic the
build-up of cloud over blue sky is in
'Bedgellert', this picture could hardly be
said to represent 'Storm'.

The question of whether Wright actu-
ally visited Wales and saw this view of
Bedgellert for himself must remain open,
though at present it seems unlikely. The
compiler is indebted to Paul Joyner,

118

National Museum of Wales, for discussing
this picture. Mr Joyner points out that
Bedgellert was well-known to eighteenth
century travellers in search of the pictur-
esque, and lay on the route recommended
for such travellers in Wyndham's *Tour of
Wales*, 1781; he finds it difficult to believe
that if Wright visited North Wales, 'he
would only produce one landscape in such
a sublime and poetic landscape', ignoring
such nearby dramatic views as
Aberglaslyn and Snowdon.

Though several artists produced water-
colours or engraved views of Bedgellert
after Wright's death, no view has so far
been found which is early enough to have
served Wright as a model; but it may turn
up. Another possible explanation is that
'Bedgellert' was painted from a sketch
made on the spot by one of Wright's
friends. This possibility is suggested by the
Account Book entry for 'A View in Wales.
Storm sold to my friend M.ͬ Tom.ˢ
Tate . . .'. Thomas Moss Tate, once
Wright's pupil and later a friend, was a
Liverpool merchant and amateur artist
who occasionally exhibited his work,
mainly landscapes, at the Liverpool
Society; possibly he, or someone in a simi-
lar relationship to Wright, brought back a
sketch from Wales and asked Wright to
paint a finished picture from it.

119

Italian Landscape dated 1790

Oil on canvas 40¾ × 51⅜ (103.5 × 130.4)
Inscribed 'I Wright | Pinx | 1790' lower l.
PROVENANCE
'Mr Mills, Yorkshire', according to
Bentley sale catalogue of 1886 (Nicolson
notes that this suggests John Milnes of
Wakefield, though not identifiable with
any picture known to have belonged to
him); A.J.Bentley by 1831, his sale
Christie's 15 May 1886 (71), bt
F.B.Benedict Nicolson; Agnew's, from
whom purchased by Paul Mellon 1960;
presented by Paul Mellon KBE to the
National Gallery of Art, Washington,
1983

EXHIBITED
Manchester Institution 1831 (45, as a view
of the Convent of St Cosimato); VMFA
1963 (39, pl.222); Washington 1969–70
(15, repr.)
LITERATURE
Nicolson no.292, p.260; p.92; pl.311;
Cummings 1971 p.477; Martin Butlin,
*Aspects of British Paining 1550–1800 from the
Collection of The Sarah Campbell Blaffer
Foundation*, Houston, Texas, 1988, p.116

*National Gallery of Art, Washington. Paul
Mellon Collection*

This was called a view of the Convent of St
Cosimato when exhibited in 1831, pre-
sumably because of an imagined resem-
blance to other Italian landscapes by
Wright which do indeed show the Convent

of St Cosimato, such as the picture exhib-
ited here as No.121 (other versions noted
there). Apart from the fact that the
Washington picture also includes a cluster
of (surely different) buildings on a hill-top,
there seems little resemblance to St
Cosimato. Nicolson describes this as 'an
imaginary scene, half English, half Italian,
where Roman villas have incongrously
come to settle on the Derbyshire hills'
(p.92).

The colouring of the Washington pic-
ture is far in advance of the work of
Wright's contemporary landscape pain-
ters. Mauves, fresh-peeled greens and dark
greens predominate. If the colouring is
unconventional, so is Wright's method of
applying it, thinly and unmodelled, so that
passages like the slopes of the hills

across the middle distance are almost silky. These patterns of flat colour seem, in Nicolson's memorable phrase, 'freakishly prophetic of experiments conducted 100 years later by a group of young men in the Breton valley of Pont Aven'.

A smaller version of the picture, with light coming from the right, reappeared at Sotheby's in 1978 and is now in Texas (repr. Butlin, p.117). Cataloguing it, Butlin argues that 'the subtlety of the observation of the same scene under different conditions of light surely betokens a real landscape, observed by the artist in Italy'. But these landscapes were painted some fifteen years after Wright's return from Italy. If they are based on drawings made on the spot, those drawings have not survived; and in any case, Wright no longer needed a 'real' landscape to work out subtle variations of light. These landscapes of 1790 are surely a romantic recollection of Italy, just as the 'Italian scene, of great picturesque beauty, enriched with Classical Italian Buildings' (Nicolson no.294; sold Christie's 18 November 1988, 294, repr. in colour) is a recollection, that picture leaving reality even further behind.

120

120

View in Dovedale dated 1786

Oil on canvas 18 × 25 (45.7 × 63.5)
Inscribed 'I.W.P. 1786' lower l.
PROVENANCE
In Wright's Account Book, with No.121, as 'A view in Dove Dale & its Comp. of Cosmato for Mr Gisborne at 50 Gns & 52.10.0'; commissioned by Revd Thomas Gisborne, Yoxall Lodge, Staffs.; acquired as part of the contents of Yoxall Lodge by Mrs Griffiths; Marquess Curzon, by 1922, and thence by descent
LITERATURE
Nicolson no.315, p.265; pp.89–90, 134; pl.255

Trustees of the Kedleston Estate Trusts

As Wright's Account Book makes clear, this 'View in Dovedale' and its companion view of 'San Cosimato' (No.121), one depicting a Derbyshire view, the other a view in Italy, were commissioned by his friend the Revd Thomas Gisborne in the same year that Wright painted the endearing double portrait of Gisborne and his wife (No.146). The two pictures were designed as 'companions'; fortunately they have remained together ever since. They might almost have been painted to demonstrate the point Lord Byron was to make thirty years later, when he wrote

to Thomas Moore: 'Was you ever in Dovedale? I can assure you that there are things in Derbyshire as noble as Greece or Switzerland' (letter of 31 March 1817, in ed. Leslie A. Marchand, *Byron's Letters and Journals*, v, 1976, p.201).

Dovedale is here depicted on a fine day; all is quiet and peaceful, so that one can almost hear that most soothing of all Derbyshire sounds, that of the River Dove rippling over its rocky bed. Here Wright deploys only gentle greys, greens and browns; the harsh colours and knobbled surfaces of 'The Earthstopper' (No.51) seem far away. Pilkington, writing only three years after the date of this picture, refers to Dovedale landscapes 'touched by the sweet and magic pencil of Mr Wright of Derby' (1789, p.25): possibly the only time that Wright's landscapes have been called 'sweet', but the word's use in the context of 'Dovedale' is apt.

The Convent of San Cosimato and part of the Claudian Aqueduct near Vicovaro in the Roman Campagna
*c.*1786

Oil on canvas 30 × 25 (76.2 × 63.5)
PROVENANCE
as for No.120
EXHIBITED
? 'The Convent of San Cosimato . . .' RA
1788 (98)
LITERATURE
Nicholson no.262, p.252; pp.83–4, 89, 134;
pl.257

Trustees of the Kedleston Estate Trusts

This is the 'companion' to 'View in Dovedale' (No.120), and is thus likely to have been painted about the same time. Two other versions are known, one in the Walker Art Gallery, Liverpool (Nicolson no.264 as *c.*1787–90, pl.282) and the other, a larger picture dated 1789, in a private collection (Nicolson no.263, pl.283). Probably the Kedleston or possibly the (?later) Liverpool version was exhibited at the Royal Academy in 1788 (89). The title of the work shown in that exhibition is quoted by Nicolson as 'The Convent of St. Cosimato, near Vicobaro, and remains of the Claudian Aqueduct, on the river Arno', which seemed to make the place impossible to identify; but either Wright or, more likely, the Royal Academy Cataloguers mis-spelled 'Vicovaro' as 'Vicobano', and though the original 1788 catalogue got 'the River Anio' right, its name was subsequently mis-transcribed (and quoted by Nicolson) as 'the River Arno'. This compiler is most grateful to Alex Kidson of the Walker Art Gallery, Liverpool, who kindly reported John Jacob's earlier identification of the scene when cataloguing the Liverpool version: thus it was established that this is not some

elusive scene in Umbria but a view in the Roman Campagna.

Vicovaro is a small town some thirty-two miles from Rome, in the same general direction as Tivoli (of which Wright painted several views), but seven miles further on. The ancient Convent of San Cosimato is on a hillside beyond the town of Vicovaro, near part of the Claudian Aqueduct (the Aqua Claudia begun by Caligula and completed by Claudius in AD 52) The river Anio (now sometimes called the Aniene) flows through a fertile valley of chestnut trees and olive groves. The greys, greens and browns may well have made Wright think of Dovedale.

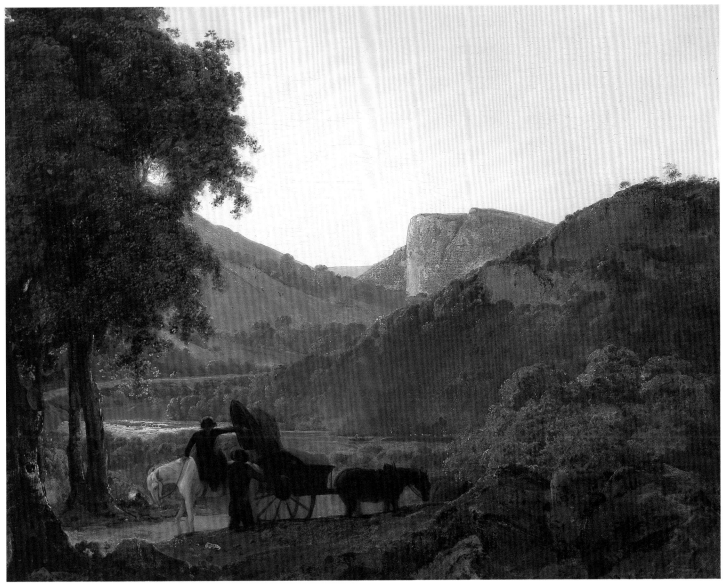

122

122

**Landscape with Figures and a
Tilted Cart: Matlock High Tor
in the Distance** *c.*1790

Oil on canvas 40 × 50 (101.6 × 127)
PROVENANCE
Unsold in Wright's lifetime; in his
posthumous sale Christie's 6 May 1801
(28: full title given below), bt in at
£51.9.0; . . . ; Col. O. Mosley Leigh,
Cheshire; Roland Browse & Delbanco (by
whom included in two selling exhibitions
1951–2 as 'Landscape in the Lake
District') from whom bt Southampton Art
Gallery 1952
LITERATURE
Nicolson no.299, p.262; pp.89–90; pl.309;
Helen Luckett, *Landscapes: An Anthology*

from Southampton Art Gallery, 1979, no.17 (as
'Landscape'), p.21, repr. in colour

Southampton City Art Gallery

Nicolson called this 'Landscape with
Figures and Waggon', cataloguing it with
landscapes 'in and around Derbyshire' but
adding (perhaps because he was aware
that it had twice been shown at Roland
Browse & Delbanco's as 'Landscape in the
Lake District') 'The river valley has not
been identified, and it may not even be
Derbyshire'. But Matlock High Tor in the
background is unmistakeable, and the
compiler believes that the picture can
safely be identified as 'A Landscape, and
Figures with a tilted Cart; a View of
Matlock High Tor in the Distance – very

rich and glowing Effect', lot 28 in Wright's
posthumous sale of 1801. (A 'tilted cart' is
one so constructed that its body can be
tilted, e.g. for unloading stones from a
quarry.)

The 'very rich and glowing Effect' noted
in the 1801 sale catalogue can certainly be
perceived here. The landscape is steeped in
light, except in the foreground, where the
trees, figures and cart are seen almost
contre-jour. Elsewhere, Wright deploys
colours which are rich, astonishing and yet
not incredible as the colours produced by
the rare day-long build-up of heat in a
valley. Rain will make this glowing land-
scape quickly revert to greys and muted
greens.

The colours Wright uses here are even
more astonishing than the purples and

light greens of his 'Italian Landscape' in Washington (No.119). Wright demonstrates that in certain conditions of light, these Derbyshire hillsides can become coral, pink and magenta; greens are intensified, while the High Tor becomes so seemingly incandescent that we think back for a moment to the 'Iron Forge' (No.49).

This landscape appears to be hardly known outside Nicolson's book and outside Southampton Art Gallery, where it is regularly displayed and where something about the quality of the light enables it to show to very good advantage. Exhibitions and books on the theme of British landscape painting tend, when it comes to Wright, to use and re-use old favourites, such as 'Landscape with a Rainbow' (No.124). 'Matlock Tor by Daylight' (No.113) and 'Landscape with Dale Abbey' (No.117). Perhaps this exhibition will help to make the strange brilliance of the Southampton picture better-known.

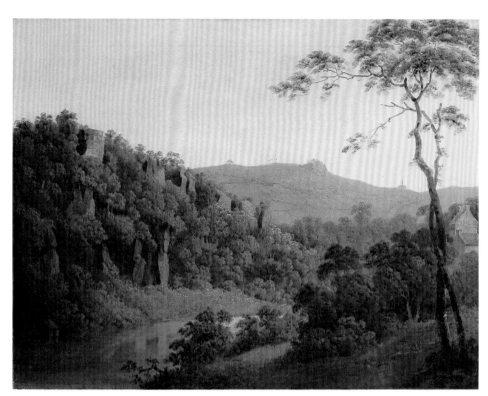

123

123

View in Matlock Dale, looking south to Black Rock Escarpment *c.*1780–5

Oil on canvas 23 × 30 (58.5 × 76)
PROVENANCE
? In Wright's Account Book as one of 'Two views of Matlock for Mʳ Emes £63' *c.*1780, almost certainly William Emes of Derby, landscape gardener and designer of the Matlock Walks; . . . ; Sabin Galleries, from whom purchased by Paul Mellon 1966; presented by Paul Mellon to the Yale Center for British Art 1981
EXHIBITED
NGA Washington 1969–70 (16); *Presences of Nature*, Yale Center for British Art, New Haven, Conn., 1982–3 (iv.2, pl.43)
LITERATURE
Nicolson no.303 pp.263–4; pp.89–90; pl.259; Louis Hawes, *Presences of Nature*, 1982, pp.53, 160–1

Yale Center for British Art, Paul Mellon Collection

Nicolson catalogued this as 'View of the Boathouse near Matlock', a title followed in the exhibitions noted above. While Wright's Account Book mentions 'A view of the boathouse near Matlock Town' and

'View by the Boathouse, Matlock', neither title can possibly relate to the landscape depicted in this painting.

This view is looking south along a stretch of the Derwent from in or near the village of Matlock Bath towards Cromford (out of sight behind trees in the dip of land in the middle distance), with Black Rock escarpment on the horizon. Possibly the small thatched hut in the foreground on the left was deemed to be 'the Boathouse'; but while one fisherman might have kept a boat there, the phrase 'the Boathouse' would have been generally understood at the time to be the rambling set of buildings just outside Matlock Town which served both as an inn called 'The Boat House' (there is still a pub of that name on the site) and as a place where boats could be hired. The sketch which Kim Sloan attributes (surely convincingly) to John Robert Cozens and which she identifies as 'The Boat House, Matlock' was probably made at the same time as Cozens's sketch of 'Matlock near the Boat House', in 1772; both depict views very different to that in Wright's painting (both repr. Sloan 1986 p.94).

This is probably Wright's most literally-transcribed landscape. Its only conventional grace-note is the pair of

criss-crossing saplings on the right. The range of rocks on the left appears to be precisely observed. The house on the right is still there. Black Rock escarpment on the skyline is just as it is seen from this viewpoint. To its right, also on the skyline, is the chimney of a lead mine, like a remote harbinger of a more widespread industrial age.

(The compiler is grateful to David Fraser for helping to identify the view)

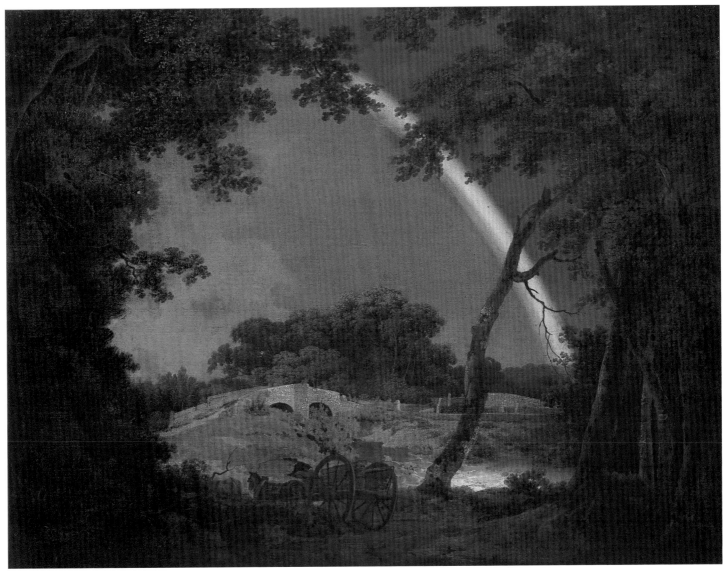

124

Landscape with a Rainbow
dated 1794

Oil on canvas 32 × 42 (81.2 × 106.7)
Inscribed 'I.W. 1794' lower l.

PROVENANCE
In Wright's Account Book as 'picture of a bridge w.ᵗʰ the effect of a rainbow – zz 111' (the cryptic letters may indicate that this picture was not for sale); in Wright's posthumous sale, Christie's 6 May 1801 (46, as 'A Landscape with a Rainbow, View near Chesterfield in Derbyshire'), bt in at £59.17.0; Mrs Cade (Wright's daughter), remaining for some time in the Cade family; . . . ; A.J. Keene, Derby picture dealer and artist, from whom purchased by Derby Art Gallery 1913

EXHIBITED
Derby 1934 (33, repr.); Derby & Leicester 1947 (52); Sheffield 1950 (15); *European Masters of the Eighteenth Century*, RA, 1954–5 (408); Tate & Walker 1958 (32); Tokyo & Kyoto 1970–1 (58); Tate 1973–4 (127, repr. in colour p. 63); *Pittura Inglese 1660–1840*, Palazzo Reale, Milan, 1975 (94); *Turner and the Landscape of his Time*, Kunsthalle, Hamburg, 1976 (150); *La Peinture Britannique de Gainsborough à Bacon*, Galerie des Beaux-Arts, Bordeaux, 1977 (66); Derby 1979 (43); National Gallery, London, 1986 (7, fig.2)

LITERATURE
Nicolson no.298 p.262; p.93; pl.347; Geoffrey Grigson, *Britain Observed*, 1973, p.72, repr. p.73; Louis Hawes, *Presences of Nature*, Yale Center for British Art, New Haven, Conn. 1982, p.54

Derby Art Gallery

'I am trying my hand at a rainbow effect', Wright adds as a postscript to a letter of 30 May 1793 to his friend and patron J.L. Philips (DPL). The 'rainbow' picture must have pleased him, for he made two versions of it. The first to be entered in his Account Book (with the same title as this) was sold for £52.10.0 to J.L. Philips's relative, Nathaniel Philips, who intended to send it to America, and seems to have done so (it is now untraced). Knowledge that it was to leave the country contributed to Wright's determination to paint a second version, apparently for himself; as he said in a letter to J.L. Philips of 27 December 1794, he was sorry that the picture should leave the country.

This is one of the finest of all Wright's landscapes, seemingly unstudied, and free from all picturesque conventions. The rainbow is neither a romantic nor a con-

trived effect, but rather a carefully-studied phenomenon. Louis Hawes writes: 'No British artist before Wright gave quite such prominence . . . to the full arc of a rainbow—an evanescent phenomenon that was to attract various romantics of the next generation, especially Turner and Constable. Wright correctly makes the sky within the arc slightly lighter than that without, something which most artists (along with the public) overlooked until the appearance of Luke Howard's and Thomas Forster's meteorlogical treatises in the early nineteenth century. But given Wright's lively curiosity about natural phenomena and his strongly empirical bent, one is not surprised.'

This picture is signed and dated 1794 (revealed during cleaning by Viola Pemberton-Pigott in 1977, and not previously known), and it is reasonable to conclude that Wright's work on it was finished during 1794. The other version fell, like 'Rydal Waterfall' (No.138) into that dreadful trough of depression which affected Wright for the greater part of 1795, lasting ten months from January. But by November 1795 he had finished the 'Rainbow' bespoken by Nathaniel Philips, and sent it off to Nottingham, the first stage of its journey to America. It may be still extant there, perhaps under the name of Joseph Wright the American artist.

The phrase 'View near Chesterfield' in the picture's title in Wright's posthumous sale of 1801 was presumably added by someone in Wright's circle of family and friends, but has never been substantiated.

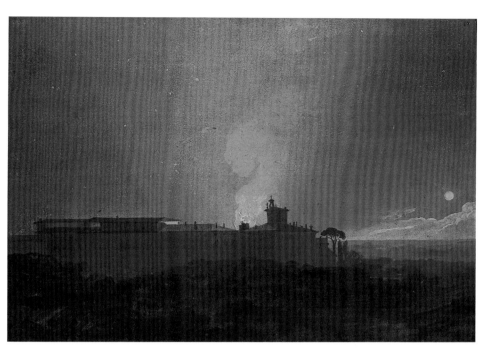

125

125

Fire at a Villa seen by Moonlight, probably in the Roman Campagna
*c.*1774–5

Oil on paper $10\frac{1}{2} \times 15\frac{1}{2}$ (26.7 × 39.4), mounted on cardboard $12\frac{1}{8} \times 16\frac{7}{8}$ (30.8 × 43)
Inscribed 'Jos. Wright' in ink on reverse of cardboard support
PROVENANCE
John Holland of Ford Hall, Derbyshire; Hall family of Parkhall, Mansfield, Nottinghamshire by descent to Flora C. Hall, estate sale 1946 (760); . . . ; Dr & Mrs William S.A. Dale, Canada, from whom purchased by the Agnes Etherington Art Centre, 1988
LITERATURE
Nicolson no.248 p.249 (as 'Quirinal (?) by Moonlight); pp.84 n.6, 138; pl.348

Agnes Etherington Art Centre, Queen's University, Kingston, Canada; purchased with the assistance of Dr Alfred Bader and the Government of Canada

Unlike those in his later 'Cottages on Fire' (such as No.111), the fire at the villa is of secondary interest to Wright. His attention is chiefly caught by the mysteriously-angled veil of smoke ascending in a moon-lit sky, a curious optical effect.

The work has a strong feeling of immediacy. The villa itself has the look of an individual place, probably in the Roman Campagna, which Wright saw and painted on one of his excursions while in Rome 1774–5; the bell-tower and long range of buildings (possibly converted from an old convent) have a particular appearance, unlike the generalised 'Italianate' villas introduced into some of Wright's landscapes after his return from Italy. Nicolson catalogued this as 'Quirinal (?) by Moonlight', and called it 'a late view'; but this is surely not the Quirinal Hill, in Rome itself, nor its Palace. Both Nicolson's title and his dating seem inappropriate.

This is one of a group of eight small landscapes, variously dated by Nicolson 'from the 1780s to the end of Wright's life', which belonged to John Holland, Wright's friend and one of his executors. The entire group is now in the collection of the Agnes Etherington Art Centre. Holland owned other works by Wright, including portraits of himself and his wife (Nicolson pls.274–5); he also (with permission from Wright in his lifetime, and later from his fellow-executors) made copies of some of Wright's work.

126

Sir Richard Arkwright
painted 1789–90

Oil on canvas 95 × 60 (241.3 × 152.4)
PROVENANCE
In Wright's Account Book as 'A full length
of S.ʳ R.ᵈ Arkwright £52.10'; commissioned
by the sitter, and thence by family descent
to the present owner
EXHIBITED
New Gallery 1891 (147); Graves 1910 (2);
Derby 1934 (113); *Works of Art from
Midland Houses*, Birmingham Art Gallery,
1953 (83); Tate and Walker 1958 (29)
LITERATURE
Nicolson no.1 pp.174–5; pp.27, 74, 168–9;
pl.323; R.S. Fitton, *The Arkwrights, Spinners
of Fortune*, Manchester, 1989, pp.201–2,
repr. frontispiece in colour
ENGRAVED
in mezzotint by J.R. Smith, published
5 May 1802; an impression exhibited as
No.173 (p.42)

Private Collection

Prominently displayed on the polished table
beside Arkwright, casting as delicate a
reflection as if it were a piece of Sèvres, is a
set of cotton-spinning rollers, the funda-
mental part of the machine which made
Arkwright's fortune and which, in Fitton's
words, 'contributed more than any other
to the transformation of the industrial face
of England' (p.202). Was it the sitter's or
the artist's idea to include this small but
immensely significant attribute of the great
industrialist? Whether or not Arkwright
himself actually invented the machine was
then a very tricky question, and is still
unresolved. Arkwright's talents were
chiefly those of the entrepreneur; in
building cotton mills, establishing the
factory system and developing markets, he
was immensely successful.

Arkwright, born in Preston, Lancashire
in 1732, began as a barber and peruke-
maker; on his death in 1792 the
Gentleman's Magazine recorded that he 'died
immensely rich, as he has left manufactor-
ies the income of which is greater than that
of most German principalities . . . His real
and personal property is estimated at little
short of half a million'. It added that 'Sir
Richard . . . with the qualities necessary
for the accumulation of wealth, possessed,
in an eminent degree, the art of keeping it'
(vol.LXII pr.ii, 1792, pp770–1); in this
Arkwright differed from Samuel Oldknow
(No.128), who lacked 'the art of keeping it'.
This is not the place to try to summarise

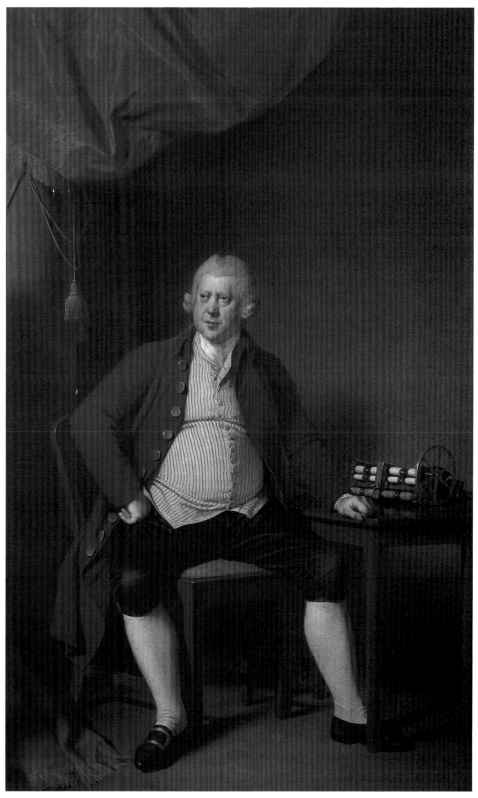

126

Arkwright's career or the complexity of his operations; these are fully discussed by Fitton (op. cit.). Wright's painting 'Arkwright's Cotton Mills by Night' (No.127) speaks volumes as an illustration of Arkwright's physical impact on the landscape of Derbyshire.

Wright's commission to paint Arkwright seems first to have been discussed in 1783. On 29 May 1783 Wright wrote to Wedgwood 'As soon as M.ʳˢ Wright is brought to bed, w.ᶜʰ she expects hourerly I shall set off to Cromford by appointment to paint M.ʳ Arkwright and his daughter'. But for unknown reasons the portrait was postponed until 1789, by which time Wright had probably already painted the portraits of Arkwright's daughter 'Susannah Hurt and her Child' and her husband 'Charles Hurt' (Nos.135, 134). Sittings for Arkwright's portrait took place in 1789. It was to hang in his son Richard's house at Bakewell, near one of Arkwright's cotton mills; a letter of 21 January 1790 from Wright to the younger Richard Arkwright announces that the portrait had been completed, and it was delivered to Bakewell by 3 March 1790 (Nicolson p.175).

'Sir Rich.ᵈ was much pleased w.ᵗʰ the execution of his picture', Wright reported to the sitter's son in his letter of 21 January 1790. It is to Arkwright's credit that he was 'much pleased', for it is a portrait without flattery. Wright's portrait invariably provokes comparison with Carlyle's famous pen-portrait of Arkwright's appearance: 'a plain, almost gross, bag-cheeked, pot-bellied Lancashire man, with an air of painful reflection, yet also of copious free digestion . . . ' ('Chartism', 1839, in *Critical and Miscellaneous Essays*, IV, ed. 1899, p.182). Nicolson, for instance, writes that 'Wright's vision of him [Arkwright] was the same as that of Carlyle' (p.168), but in fact it can only have been the other way round. Carlyle, born in 1795, can never have seen Arkwright, who died in 1792, and is unlikely to have seen Wright's painted portrait. His description of Arkwright must have been evoked by the power of Wright's image as transmitted through J.R. Smith's mezzotint.

Wright painted at least three replicas of Arkwright's head and shoulders from this portrait, each approximately 30 × 25 ins.; one is in the family collection, one in the National Portrait Gallery and one (Nicolson no. 2, formerly in the collection of Lord Belper) entered the collection of the Science Museum in 1989. A different portrait of Arkwright, in a red coat, seated with his right arm on the back of his chair, *c*.56 × 40 ins., is in a private collection.

Wright also painted very large portraits of 'Richard Arkwright, his Wife and Child', 'Three Children of Richard Arkwright with a Goat' and 'Three Children of Richard Arkwright with a Kite' (Nicolson pls.325, 328, 329, all still in the family collection). Like Arkwright's daughter Susannah Hurt and her husband (Nos.134, 135), Arkwright's son Richard and his family are portrayed as members of the prosperous and civilised gentry, which indeed they were, having enjoyed all the educational and social advantages which Arkwright lacked. Success had never enabled Arkwright to be at ease in society; he marred his triumphs, such as his knighthood in 1786 and his appointment as High Sheriff of Derbyshire, by ostentatious celebrations, and was too preoccupied to enjoy lesser parties. His son Richard, who took life more easily, nevertheless managed (largely through shrewd investments) to end up with a fortune ten times that left by his father.

Arkwright was also painted by Mather Brown. The portrait, reproduced by Dorinda Evans, *Mather Brown* (Middletown, Connecticut, 1982, fig.74 and detail, fig.75), and dated by her to 1790, strongly suggests, as she notes, that Brown must have seen Wright's recently-completed portrait.

127
Arkwright's Cotton Mills by Night
c.1782–3

Oil on canvas 39¼ × 49½ (99.7 × 125.7)

PROVENANCE
In Wright's Account Book as the second item in 'A View of Cromford Bridge Its Companion of Arkwright's Mills – sold to D: P: Coke £52.10', i.e. purchased by Daniel Parker Coke MP; given or bequeathed by him to the sons of Rev. D'Ewes Coke, and thence by descent until *c*.1967 when disposed of by R.G.S.Coke of Brookhill Hall

EXHIBITED
Graves 1910 (88); *The Romantic Movement*, Tate Gallery, 1959 (382, certainly this picture, but mistakenly titled 'View of Cromford Bridge, near Matlock'); *La Peinture Romantique Anglais et les Préraphaélites*, Paris, Petit Palais, 1972 (343); *Landscape in Britain c.1750–1850*, Tate Gallery, 1973–4 (125); *Pittura Inglese 1660–1840*, Milan, Palazzo Reale, 1975 (114); Derby 1979 (30); *Arkwright – The Man, his Mills and the Industrial Revolution*, Masson Mill, Cromford, Derbyshire 1983 (no catalogue)

LITERATURE
Klingender ed. 1968, p.55 (fig. 28 reproduces what is probably a copy); Nicolson no.311, p.265; pp.90–1, 125, 165–7; pl.244; Fraser 1988, pp.135–7, fig.9; R.S. Fitton, *The Arkwrights, Spinners of Fortune*, Manchester 1989, pp.30, 50, 146, 201–2

Private Collection

This shows Arkwright's first two cotton mills; built at Cromford in Derbyshire, they were the foundation of his industrial empire and his vast fortune. The first mill, nearer the spectator, was built in 1771; Wright depicts five storeys and an attic floor, with at least nine windows per floor. The design was simple and functional; as Fitton notes (p.30), the mill's long narrow proportions and large areas of comparatively unbroken interior space 'had no counterpart in English architectural history, and became the basic design in industrial architecture for the remainder of the eighteenth and throughout the nineteenth centuries'.

A second, larger mill, built in 1776, is seen in Wright's picture partly behind the first and at an angle to it; this mill was 120 feet long and seven storeys high. Both were close to the river, the source of power via overshot wheels in a twenty foot deep pit. In 1783 Arkwright built a third Derbyshire

mill, above Cromford at the entrance to Matlock Dale. By 1816, when the first reliable figures were gathered for the evidence on Peel's factory legislation, the number of workers in Arkwright's three Derbyshire mills was 1,150.

Nicolson dates Wright's painting to *c*.1782–3. That dating indicates that Wright allowed years to pass – eleven or twelve years since the construction of the first mill, and six or seven before the second – before he felt moved to paint the scene. This would be surprising if we were to believe that Wright was keenly interested in the Industrial Revolution, as is sometimes alleged. But Wright was not a documentary reporter. He was essentially a creative artist, seizing eagerly on some subjects – blacksmiths' shops and iron

forges – which aroused his imagination and gave him scope for deploying dramatic effects of light, but wholly ignoring others (such as the Silk Mill in Derby, almost on his doorstep).

The impulse to paint the mills may have come from within Wright himself (riding past the mills at night, and suddenly perceiving a subject there) or it may have been prompted by the fact that by May 1783 he had accepted a commission to paint Arkwright himself. Fitton (p.201) quotes part of a letter from Wright to Josiah Wedgwood, 29 May 1783: 'As soon as M̄ʳˢ Wright is brought to bed, w̄ᶜʰ she expects hourerly [sic] I shall set off for Cromford by appointment to paint M̄ʳ Arkwright and his daughter . . . ' The Arkwright portraits were in fact postponed

for some six years (see No.126). It seems unlikely that Arkwright commissioned the portraits because he knew Wright was painting his mills (Arkwright seems to have shown no interest in buying that picture or commissioning another), and more likely that Wright's interest in the mills as a subject for painting was quickened by the commission to portray their owner. In either case, the date of May 1783 on Wright's letter to Wedgwood seems to support Nicolson's dating of *c*.1782–3 for Wright's painting of the mills.

The phrasing of Wright's Account Book entry for this picture and its 'Cromford Bridge' companion – 'Sold to D: P: Coke' – indicates that these were not commissioned works. Their purchaser, Daniel Parker Coke, M P for Derby and then

Nottingham over a period of thirty-six years, is portrayed in No.142. Coke had a collection of Old Master paintings, and had not hitherto been a patron of Wright. 'Arkwright's Mills' may have appealed to him primarily, as Nicolson suggests, because he was interested in the new factory system which was quickly becoming established in his cotton-spinning constituency of Nottingham.

That Wright should choose to paint Arkwright's mills by night is not of course surprising, given his interest in effects of light. Here every window is alive with light from candles or oil lamps. Work at the mills was continuous, the night shift succeeding the day. The Hon. John Byng's observations at Cromford in 1790 suggest that Wright's picture was by no means fanciful: 'These cotton mills, seven stories high, and fill'd with inhabitants, remind me of a first rate man of war; and when they are lighted up, on a dark night, look most luminously beautiful' (p.196). He found little else to admire in the progress of industrialisation: 'these vales have lost all their beauties; the rural cot has given place to the lofty red mill . . . Every rural sound is sunk in the clamours of cotton works . . . ' (p.195). The intrusion of cotton mills into the landscape made many a theorist of the picturesque shudder, and provoked Sir Uvedale Price to coin a new verb:

When I consider the striking natural beauties of such a river as that at Matlock, and the effect of the seven-story buildings that have been raised there, and on other beautiful streams, for cotton manufactories, I am inclined to think that nothing can equal them for the purpose of dis-beautifying an enchanting piece of scenery; and that economy had produced, what the greatest ingenuity, if a prize were given for ugliness, could not surpass. They are so placed, that they contaminate the most interesting views; and so tall, that there is no escaping from them in any part.' (*Essays on the Picturesque*, 1810, p.198)

This picture is one of the most potent of all images of the Industrial Revolution. It is unfortunately not in good condition, but it is undoubtedly an authentic work. What appears to be a copy rather than a version of it, in a private collection, was exhibited in *Art and the Industrial Revolution*, Manchester, 1968 (72) and is reproduced in Klingender, ed. 1968 (28), and elsewhere.

The companion 'View of Cromford Bridge' (?showing the mills) has disappeared; so has a small picture of 'Arkwright's Cotton Mills by Day' (23 × 30 in., formerly in Colonel Grant's collection, Nicolson no.312, pl.331).

128

Samuel Oldknow *c.*1790–2

Oil on canvas 96 × 60 (243.9 × 152.4)
PROVENANCE
In Wright's Account Book (after 'A full length of the late M.ʳ [Thomas] Oldknow – £52.10.0') as 'D.ᵒ of M.ʳ Sam. Oldknow – £52.10.0'; . . . ; Mrs C.J. Pooley, from whom on long loan to Leeds Art Gallery from 1900; Lady Sutcliffe Smith, from whom purchased by the Gallery 1950
LITERATURE
Leeds City Art Gallery & Temple Newsam House, Catalogue of Paintings, 1, 1954, p.89; Nicolson no.115 pp.314–5; p.163; pl.335; Gage 1969 p.306

Leeds City Art Galleries

Samuel Oldknow's career illustrates how fortunes might be made out of the Industrial Revolution, then lost because of the economic effects of the Napoleonic Wars. Born in Lancashire in 1756, the elder son of Samuel Oldknow (d. 1759), draper and small-scale manufacturer of cotton stuffs, he was apprenticed to his uncle Thomas in Nottingham, who specialised in the manufacture of muslins. That manufacture was greatly speeded by Samuel Crompton's invention of the spinning mule, available to others by 1780. Samuel Oldknow installed these machines in his own works at Stockport, near Manchester. By 1786, at the age of 30, he had become the biggest manufacturer of fine muslins in the country, with a rapidly-increasing output, most of it absorbed by the London market.

A fully-documented account of Oldknow's enterprises is given by George Unwin, *Samuel Oldknow and the Arkwrights*, from which these notes are taken. Oldknow's most flourishing period was in the five years culminating in 1790, during which he built a steam-powered spinning factory at Stockport and bought land at Mellor in Derbyshire, where he built a large water-powered mill and a fine house nearby for himself. But according to Robert Owen, his contemporary (quoted by Unwin p.124), Oldknow was over-ambitious:

being ambitious, he desired to become a great cotton spinner, as well as the greatest muslin manufacturer. He built a large, handsome and very imposing cotton mill, amidst grounds well laid out, and the mill was beautifully situated, for he possessed general good taste in these

matters. In fact he was preparing and had made great advances to become a first-rate and leading cotton lord. He had however expended his capital so freely in building this mill, fitting it with machinery and purchasing land around it, in addition to splendid buildings in and near Stockport for carrying on his extensive muslin manufacture and for its sale, that when the trying time of 1792 arrived, he was too wide in his plans to sustain their expenditure . . .

'The trying time of 1792', when the effects of the Napoleonic Wars began seriously to cripple trade, was a year of crisis for Oldknow, as for many others. He had over-spent capital and over-stretched credit, borrowing heavily from Sir Richard Arkwright in particular. By the beginning of 1793 his affairs were in a desperate state, as Unwin explains (p. 179): 'he had invested an immense amount of capital in the fixed forms of land, buildings and machinery which could not yield any return without the assistance of commercial credit – and owing to the outbreak of war commercial credit had almost ceased for the time being to exist'. By the middle of 1795 Oldknow had given up his manufacture of muslins and let his Stockport mills, but continued to run the mill at Mellor. He was saved from actual bankruptcy by Arkwright, who entered into partnership with him on terms that left management and ostensible ownership to Oldknow, but gave the essentials of ownership to Arkwright. Full title to the mill passed to the Arkwrights when Oldknow died, at Mellor, unmarried, on 18 September 1828.

On Unwin's evidence, Oldknow was an exceptionally humane employer, and a man of 'creative and aesthetic gifts', who owned what was probably the first English pianoforte to be heard in the north of England. The instrument was sent up from London by his eccentric agent S. Salte, who wrote to Oldknow on 15 December 1786: 'I have sent you the Piano Forte, packed up very carefully by Pickford's wagon – I hope you will find sweet music in it that will wrap your Soul as Milton says in Elizium'.

Wright's portrait of Oldknow was probably painted *c.*1790–2. It is likely to have been commissioned in emulation of Sir Richard Arkwright's portrait (No. 126), which was completed by January 1790, and is on a similar large scale. Oldknow appears in his portrait as a man who is not without worries, and the fact that he

128

evidently paid for it in instalments (Wright's Account Book records a payment from Oldknow of £10 'on account' in June 1794) suggests that the portrait may have been painted in 1792, or a little later, when his financial worries were becoming acute.

Just as Arkwright's portrait prominently includes a model of the spinning frame which provided the foundation of his wealth, so Oldknow's portrait includes a large bolt of the fine muslin on which his fortunes were founded, and on which he rests his right arm with pride. Nicolson writes that 'conventional studio props are . . . mocked by this ungainly bundle'. Gage goes further, and writes that in the portrait of Samuel Oldknow, Wright has created 'the unforgettable and ludicrously gauche image of a young *beau* lounging, à la Romney, on a swag of muslin from his mill'. Leaving aside the question of whether, with any accuracy, the muslin can be described as an 'ungainly bundle', or Oldknow's pose as 'lounging', we should try to understand why Oldknow agrees to sit (or perhaps proposed to sit) with his muslin, and Arkwright with his spinning frame. The answer is surely that these attributes are primarily emblems of progress, on which the sitters look with pride; they have no wish to ape the idleness of the gentleman. Even if their emblems are viewed more materialistically, as

agents of production which have raised them to riches, both Oldknow and Arkwright are proud to proclaim, in 95-inch high canvases, their dependence on these material objects. There may in fact be something of now lost historical significance in the particular length of muslin Oldknow displays, e.g the first superfine length produced by a new machine (like the first piece of muslin woven by waterpower in his new factory at Doncaster which Dr Cartwright presented in 1785 to the wife of the Bishop of Durham). Wright was never a portraitist who relied wholly on conventional studio props (though one or two of those are included here, in the column and drape of a curtain). He was interested in various aspects of industry, just as many of his friends among members of the Lunar Society were, and evidently saw much of significance and nothing of incongruity in Oldknow's length of muslin.

Wright's portrait of Oldknow the industrialist may be compared with Romney's portrait of William Beckford, author, dilettante and rentier, which is on a similar scale (fig 26; 93 × 57 in.). This may well be the portrait Gage had in mind.

Wright also painted an equally large but very much more subdued portrait of Samuel Oldknow's brother and partner, Thomas (d.1791), reproduced by Nicolson pl.334, and now in a private collection.

fig.26 George Romney: 'William Beckford' 1781, oil on canvas 93 × 57 (236.2 × 144.8) *Upton House, National Trust*

129

Francis Hurt painted *c*.1780

Oil on canvas 50 × 40 (127 × 101.6)
PROVENANCE
In Wright's Account Book with No.130, as
'M.ʳ & M.ʳˢ Hurt £42'; commissioned by
Francis Hurt, thence by descent to the
present owner
LITERATURE
Nicolson no.92, pp.206–7; pp.70, 161–2;
pl.204

Michael Hurt Esq.

Francis Hurt came from an old
Derbyshire family whose senior branch
had been settled at Ashbourne since at
least the fifteenth century. He himself was
descended from Roger Hurt, who in the
sixteenth century is described as of
Castern, a few miles from Ashbourne.
A seventeenth-century Hurt married
Elizabeth Lowe of Alderwasley, that
estate giving later Hurts the style 'of
Alderwasley'. Charles Hurt of
Alderwasley, High Sheriff of Derbyshire in
1714, married Catherine Rosel; Francis
Hurt, Wright's sitter, born *c*.1722, was
their seventh son.

As the seventh son, Francis Hurt could
hardly have expected to succeed to the
Alderwasley estate; and so, while his eldest
brother Nicholas (High Sheriff in 1756)
ran the estate, Francis prudently occupied
himself with lead-smelting, chiefly at
Wirksworth, three miles south of
Cromford, and not far from Alderwasley.
It is not clear to what extent the Hurt
family already owned lead-mines, though
Francis seems to have added to them. A
large collection of Hurt papers in the
Derbyshire Record Office, Matlock (only
glanced at by this compiler) would repay
study of Hurt's assets and the lead-smelting
industry in his day.

By 1767 the unexpected had happened:
all Francis Hurt's six elder brothers had
died (some in infancy, all childless), and he
succeeded to the Alderwasley estate. He
moved from Wirksworth to Alderwasley
Hall, described by Glover (II, p.6) as 'a
handsome and substantial built stone man-
sion, situated on rising ground on the west
bank of the river Derwent . . . A deer park
and rich lawn, adorned with venerable
oaks, spread before the mansion . . . with
excellent vineries, pineries, &c . . .'. It is
now a school.

Francis Hurt evidently did not intend to
let his translation to the role of lord of the
manor of Alderwasley interfere with his

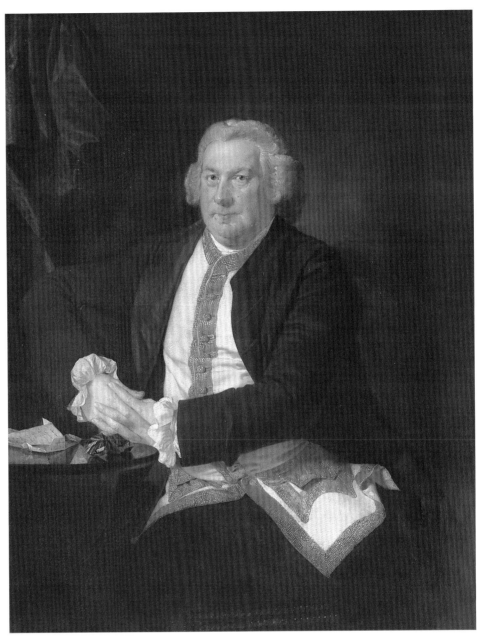

129

management of his lead-smelting works.
That he was in no sense ashamed of this
preoccupation is evident from the fact that
he sits to Wright with a lump of lead ore
on the table beside him (the compiler is
grateful to a descendent of the family for
pointing out that this is not iron ore, as
Nicolson states, but a lump of galena, a
sulphide of lead, the commonest lead ore
found in Derbyshire).

Nicolson seems to have become mesmer-
ized by his own phrase 'sits with a lump of
his own iron ore beside him', concluding
that in painting Hurt Wright was 'faced
with power unaccompanied by social
refinement' (p.70). But Hurt's own back-

ground was more complex than Nicolson
allows for, and Derbyshire class distinc-
tions in the late eighteenth century were by
no means a simple affair of gentry v.
industrialists: there were too many gentle-
men with industrial concerns for that, as
Wright was well aware.

Francis Hurt died on 7 August 1783.

130

Mrs Francis Hurt painted *c.*1780

Oil on canvas 50 × 40 (127 × 101.6)
PROVENANCE
as for No.129
LITERATURE
Nicolson no.93, pp.206–7; pl.203

Michael Hurt Esq.

The sitter is Mary, daughter of Thomas
Gell of Gatehouse, Wirksworth, apothe-
cary. She married Francis Hurt on 17
August 1751. Four children of the mar-
riage survived childhood. Francis, the eld-
est son, became High Sheriff of Derbyshire
in 1777, while still in his twenties, and the
following year married Elizabeth
Shuttleworth, the child in No.10. Charles
Hurt, the second son, married Susannah
Arkwright; they are portrayed by Wright
in Nos.134 and 135. Catherine Hurt mar-
ried Rev. George Holcombe; her younger
sister Cassandra married her cousin Philip
Gell.

Mrs Hurt, in a golden gown, is here seen
holding a tortoiseshell and (?) gold snuff-
box. She died on 6 March 1801, aged
eighty-one.

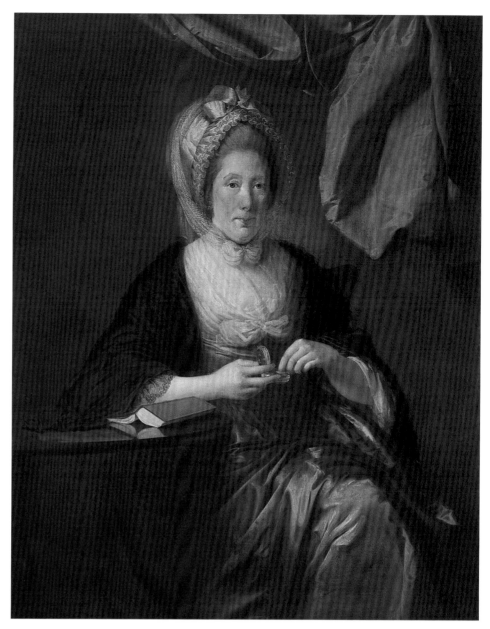

130

131
Jedediah Strutt *c.*1790

Oil on canvas 50 × 40 (127 × 101.6)
PROVENANCE
In Wright's Account Book as 'An half
length of M.' Strutt £25.4.0', among pic-
tures of *c.*1790, listed again among por-
traits of the late 1780s; by descent to the
4th Lord Belper, by whose Trustees sold
1975 to Agnew's from whom purchased by
Derby Art Gallery 1976
EXHIBITED
Manchester Art Treasures, 1857 (84);
National Portrait Exhibition, 1867 (861);
Derby 1870 (821); Nottingham 1878 (20);
Derby 1883 (62); Graves 1910 (55); Derby
1934 (135, pl. VIII); Derby 1979 (35)
LITERATURE
Nicolson no.133, pp.222–3; pp.74, 96,
163–4; pl.324; Fraser 1979 p.16, pl.16

Derby Art Gallery

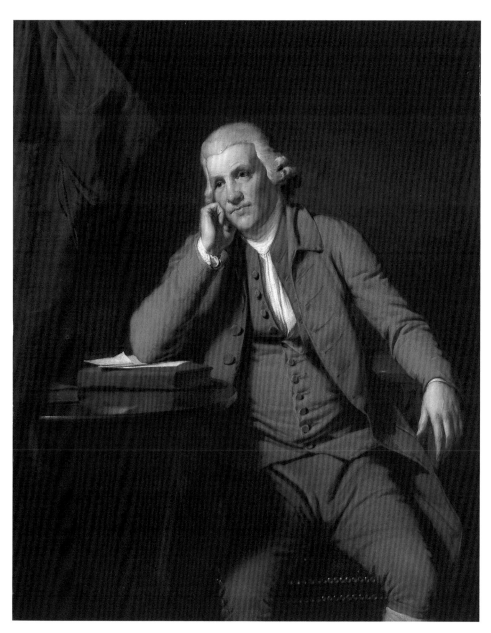

131

If Richard Arkwright was the most impor-
tant driving-force behind the Industrial
Revolution in the Midlands, Jedediah
Strutt was not far behind him. In R.S.
Fitton & A.P. Wadsworth, *The Strutts and
the Arkwrights 1758–1830* (on which the fol-
lowing notes are based), the authors give a
full account of Jedediah Strutt's life and
industrial operations. Historical accident,
in the form of the survival of several hun-
dred Strutt family letters (DPL), means
that Strutt's life, personality and family
relationships are very much better docu-
mented than Arkwright's: but had no
letters survived, and we had only Wright's
portraits to reflect the characters of the
two men, would our conclusions be any
different?

Jedediah Strutt, second son of William
Strutt, a small farmer and maltster, was
born in 1726 at South Normanton, near
Alfreton in Derbyshire. He was brought
up a Dissenter. He served his apprentice-
ship as a wheelwright, and then, inheriting
some farm stock from an uncle, became a
farmer, and in 1755 married his 'dear
Betty', sister of a Derby hosier called
William Woollat. At Woollat's suggestion,
Strutt was consulted about a 'rude and
imperfect' machine for manufacturing rib-
bed stockings, made by a man named
Roper. Strutt bought the machine,
devised substantial improvements to it and
then, with Woollat his brother-in-law and
two other Derby hosiers, successfully
applied for a patent (enrolled 19 April
1758). The invention of a process for mak-
ing ribbed stockings by machine instead of

by hand greatly expanded the hosiery
industry, and was Strutt's chief contri-
bution to the Industrial Revolution. As the
machine came into use, it expanded
Strutt's stock of capital, and he was able to
build hosiery mills at Belper, Melford and
Derby.

By 1769, when he was 43, Strutt went
into partnership with Arkwright, six years
his junior, providing money at a critical
moment when Arkwright needed it to
establish large-scale mills at Cromford
driven by water-power. During the 1770s
Strutt established his own water-powered
mill at Belper. The Strutt-Arkwright part-
nership was amicably dissolved in 1781;
each had his own enterprises to run. As

Fitton & Wadsworth observe, the diffi-
culties (particularly the labourers' 'great
reluctance to enter factories') which
confronted both Strutt and Arkwright in
establishing their mills in the 1770s and
1780s make their achievements appear all
the greater (p.103).

With Wright's portraits of Strutt and
Arkwright before us, we hardly need the
evidence of letters to tell us that the two
men represent two very different faces of
capitalism. Arkwright looked and behaved
like a captain of industry. Strutt looked
and behaved more like a Dissenting minis-
ter of the more mournful kind, and might
have been happier had he been one. As his
letters show, he believed in the virtues of

frugality, temperance, hard work and plain living. In a letter reproving his daughter Elizabeth for an 'enormous bill' for new clothes, Strutt contrasted such extravagance with his own inconspicuous way of life: '. . . from having but little pride & no ostintation of my own, not being fond of finery & dress, not thrusting myself into what is called Genteel Company, not frequenting Assemblies, Ball, Concerts plays & shews, not going every summer at no little expence to see & be seen as the fashion is to some or other of the polite Watering places . . . I am but little known & little regarded' (letter of 23 March 1786, Fitton & Wadsworth pp.164–6). The letter is written from his New Mills; but the turning of their wheels seems to have brought Strutt little joy.

Towards the end of his life, lonely and introverted, Strutt composed his own epitaph (never used: found among his papers; Fitton & Wadsworth p.108)

> Here rests in Peace J S – Who, without Fortune, Family or friends raisd to himself a fortune, family & Name in the World – Without having wit had a good share of plain Common Sense – Without much genius enjoyed the more Substantial blessing of a Sound understanding – With but little personal pride despisd a mean or base Action – With no ostentation for Religious Tenets & Ceremonies he led a life of honesty & Virtue – & not knowing what woud befall him after death, he dyed resignd in full Confidence that if there be a future State of retribution it will be to reward the Virtuous & the good
> This I think is my true Character
> J Strutt

Strutt died on 7 May 1797, aged 70. He was buried in a vault under the Unitarian Chapel at Belper, near his New Mills, which he himself had financed; a plain tablet read simply:

> Jedediah Strutt
> The Founder of this Chapel
> Died A.D. 1797, aged 70 Years

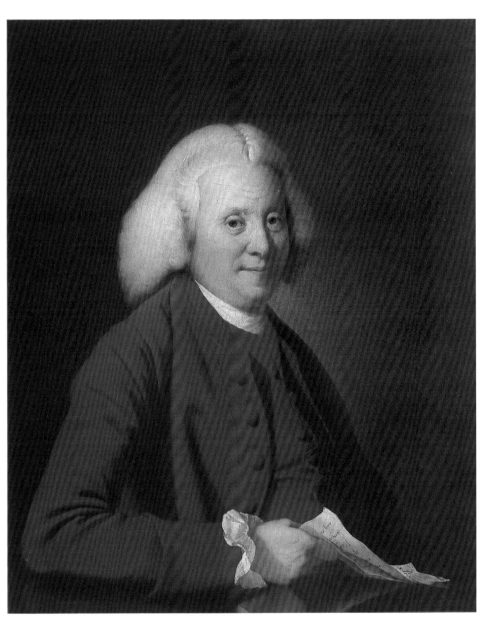

132

132

Samuel Crompton *c.*1780

Oil on canvas 30 × 25 (76.2 × 63.5)
PROVENANCE
In Wright's Account Book, with No.133,
as 'M. Crompton £10.10.0' and 'M.
Crompton £10.10.0', among pictures of
*c.*1777–80 (for replicas listed by Wright, see
below); by descent to the present owner
EXHIBITED
Derby 1866 (210); Derby 1870 (767);
Derby 1883 (14a); Graves 1910 (59);
Derby 1934 (9); Tate & Walker 1958 (18,
Plate VII)
LITERATURE
Nicolson nos.46, p.191; pp.69, 129; pl.206

Private Collection

See text below No.133

133

Mrs Samuel Crompton *c.*1780

Oil on canvas 30 × 25 (76.2 × 63.5)
PROVENANCE
as for No.132
EXHIBITED
Derby 1866 (212); Derby 1870 (774);
Derby 1883 (15); Graves 1910 (69); Derby
1934 (8); Tate & Walker (19)
LITERATURE
Nicolson nos.47, p.191; pp.69, 129; pl.207

Private Collection

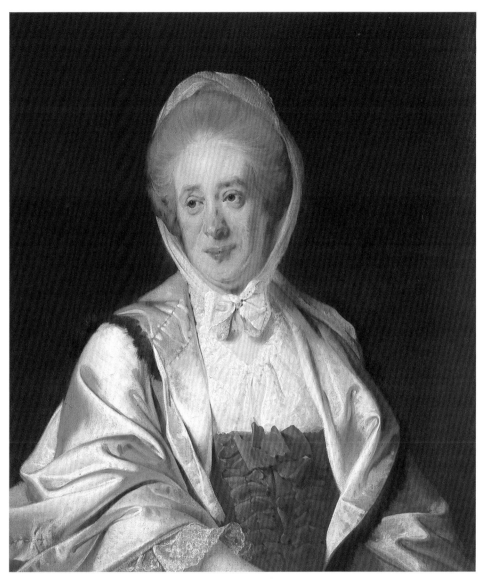

133

Samuel Crompton (*c.*1720–died 1782)
belonged to a family which perpetuated
Christian names (but he was apparently
no relation of the Samuel Crompton of
Bolton 1753–1827 who invented the spin-
ning mule). Wright's sitter was the son of
Samuel Crompton, founder of a bank
in Derby, which he carried on and
expanded. Prosperous and respected, he
served twice as Mayor of Derby and in
1768 as High Sheriff of Derbyshire, and
was Receiver-General of the county.

In 1744 Crompton married Elizabeth,
daughter of Samuel Fox of Osmaston Hall
near Derby. The Cromptons lived in one of
the most substantial houses in Derby, built
*c.*1730 in Friargate, on the site of a Domini-
can friary; the house survives, now in use
as the Friary Hotel.

In Wright's portrait, Samuel Crompton
holds a letter which begins 'Sir . . .', and

may allude to his position as Receiver-
General. Nicolson's judgment of Wright's
portrait of Samuel Crompton as 'one of
the finest of all his half-lengths' is perhaps
over-enthusiastic. Of the two, the portrait
of Mrs Crompton is surely the more orig-
inal, with the body slightly turned and the
head further slightly turned within that
pose. A good deal of character – kindliness
and common-sense, not without know-
ledge of sadness — is conveyed, without
exaggeration, within that pose; and
Wright also subtly conveys, by the shape
of the arms under the folds of the silken
jacket, that Mrs Crompton is short and
probably plump. There is no parade of
opulence in her clothes, as in the portrait
for instance of 'Mrs Ashton' (No.25);
instead Wright concentrates on observing

the gathers of lace at the neck, and the
stitching revealed by the jacket's turned-
back lining.

Wright made, probably in the early
1780s, two separate sets of entries in his
Account Book for copies of these portraits:
'Copy of M. Crompton 3 q. w. a hand
£15.15.0 — A 3 q. of M. Crompton
£12.12.0', and 'Copy of M. Crompton
£12.12.0, D. of D. £12.12.0, D. of M.
Crompton £14.14.0'. One of these pairs
was recently with Martyn Gregory, to
whom a second pair was reported. As the
Cromptons had five children (the eldest
named Samuel), the copies may have been
commissioned for them, perhaps shortly
after Samuel Crompton's death in January
1782.

134
Charles Hurt of Wirksworth
*c.*1789–90

Oil on canvas 90½ × 54½ (229.8 × 138.4)
PROVENANCE
In Wright's Account Book as 'A full length
of M.ʳ C. Hurt £52.10.0', among pictures of
*c.*1790; by descent to the present owner
EXHIBITED
Derby 1866 (172); Derby 1883 (47);
Graves 1910 (4)

Private Collection

Untraced by Nicolson, who reproduced
the picture from an old photograph pasted
into an extra-illustrated Bemrose, 1885
(Eardley-Simpson collection). Charles
Hurt, born on 5 October 1768, was the
second son of Francis Hurt of Alderwasley
and his wife Mary (Nos.129, 130). He may
have gone to Eton, as Arkwright's sons
did, and as many of his own grandchildren
were to do, for there were at least three
Eton school books in his library; but while
there is a 'Hurt' in the Eton College lists
for 1768–70 (ed. R. Austen-Leigh, *Eton
College Lists 1678–1790*), the mere surname
is inconclusive evidence.

 Charles Hurt inherited part of his father's
lead works, and established his
own lead-smelting business at Wirksworth,
a few miles south of Cromford. He
developed a considerable knowledge of
lead-mining and lead-smelting, no doubt
acquiring much of it from his father, a
dedicated industrialist, but himself repu-
tedly becoming something of a mining
engineer, especially in the construction of
soughs, tunnels bored into the hills for two
miles or more to extract water from areas
where mines were being sunk. The rescue
of a miner in 1797, largely due to Hurt's
expert knowledge, became part of
Derbyshire history (recounted in Stephen
Glover, *History of the County of Derby*,
2,i,p.328). Two miners were trapped
underground by falls of rock and earth;
one was brought up dead, and the search
for the other would have been given up
but for 'the influence and persuasions of
Charles Hurt of Wirksworth', who
believed there was a chance of survival.
Boden, the miner, was found alive, after
eight days (and lived on). The story may
contribute to an alternative reading of
Hurt's portrait, on which Nicolson (who
knew it only from an old photograph)
comments that Hurt, 'out walking with
hat, cane and gloves', appears to be a typi-
cal second-generation industrialist, 'in a

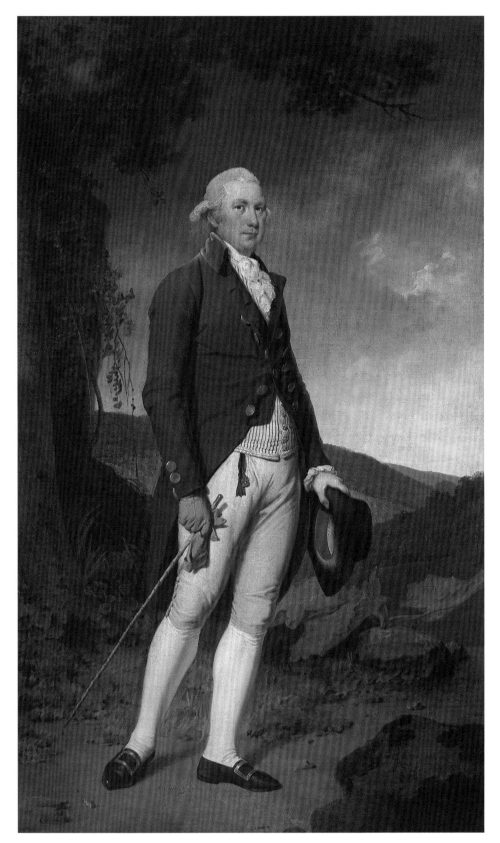

134

position to take life more as it comes'.

Charles Hurt was High Sheriff of
Derbyshire in 1797 (the year of Boden the
miner's rescue), as three of his forebears
had been before him: his grandfather
Charles Hurt in 1714, his uncle Nicholas
Hurt in 1756 and his elder brother Francis
in 1778.

A major enthusiasm in Charles Hurt's
life appears to have been book-collecting.
The five-day sale of his library after
his death (6–10 October 1835, at
Wirksworth) comprised some 1,500 lots,
including books on astronomy, mathe-
matics, natural history and other sciences,
as well as classical, French and Italian
literature. Hurt was evidently particularly
interested in mathematics and astronomy;
his three-inch achromatic refracting
telescope, a very sophisticated instrument
for his time, is still in his descendants'
possession. Two of his sons, Charles and
Edward, also became book collectors.

Charles Hurt died on 30 August 1834.

135

Susannah Hurt with her daughter Mary Anne *c.*1789–90

Oil on canvas $90\frac{1}{2} \times 54\frac{1}{2}$ (229.8 × 138.4)
PROVENANCE
In Wright's Account Book as 'A full length
of Mʳˢ C.Hurt & her Child £81.18.0',
among pictures of *c.*1787–90; by descent
to the present owner
EXHIBITED
Derby 1866 (189); Derby 1883 (53);
Graves 1910 (8)
LITERATURE
Nicolson no.96, pp.208–9; pp.162, 164;
pl.301

Private Collection

Untraced by Nicolson, who reproduces
the picture from a stipple engraving com-
missioned by Henry Graves & Co. at the
time of their 1910 exhibition. Susannah,
Richard Arkwright's only surviving
daughter by his second wife Margaret
Biggins, was born on 21 December 1761.
We catch a few glimpses of the young
Susannah, and Arkwright's indulgence to
her, in the Strutt papers. The 15-year-old
Martha Strutt writes a little enviously to
her austere father on 2 July 1775: 'Mr
Arkwright came here on wednesday
night & brought his daughter a very

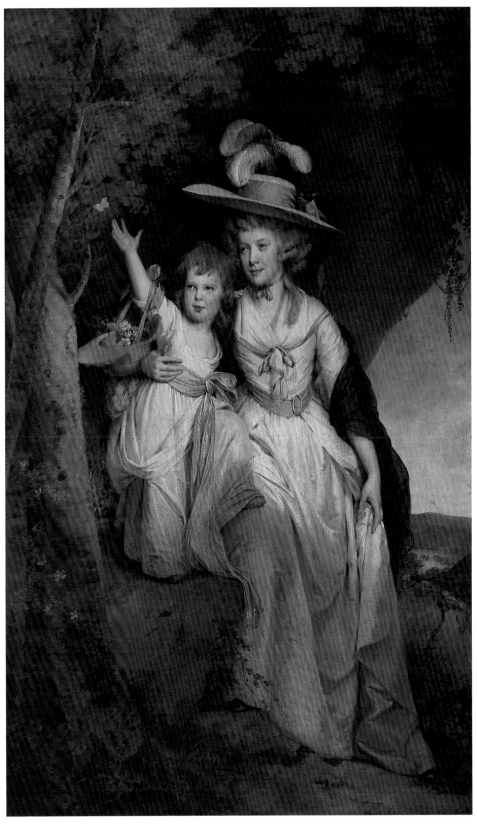

135

pretty letter from her Brother & – would you believe it – a very elegant little watch which he bought for her at Manchester – on thursday morning they sett off from here to Birmingham my sister & Miss Arkwright in genteel riding dresses & provided with pen & ink & Memorandum Books that they may see which writes the best journal. They seem'd very happy & I hope will have a deal of pleasure . . . ' (for Strutt letters, see Fitton & Wadsworth pp.77, 155, 162).

Keeping a journal on a tour, even to Birmingham, was of course *de rigeur* for young ladies. But Susannah's girlhood was not wholly given over to 'a deal of pleasure'. Six months after her little tour, her brother escorted her to Derby to enter the school of Mr Latuffiere (himself a sitter to Wright, in a now untraced portrait of *c.*1776), where she was probably a schoolmate of Maria Edgeworth, the future novelist, in the late 1770s.

At the age of nineteen, at Wirksworth on 12 June 1780, Susannah Arkwright married Charles Hurt. They had eleven children. Susannah is seen with a child who seems to be about four and is probably a girl (guessing from the flowers in her hat), and is therefore most likely to be Mary Anne, born 17 March 1786. Mary Anne Hurt was later to marry her cousin Peter Arkwright; Edward, Susannah and Charles Hurt's tenth child, was to marry Jedediah Strutt's youngest daughter Caroline in 1823.

The present owner notes that the background includes a view of Cromford Bridge, and suggests that it may be a fairly free representation of the grounds of Rock House, Cromford, where the Hurts and the Arkwrights lived for many years.

On Sir Richard Arkwright's death in 1792, Susannah Hurt's share of her father's huge fortune was £100,000 in India Stock, to be divided on her death among her eleven children. She died on 4 May 1835.

The compiler is greatly indebted to the anonymous owner of Nos.134 and 135 for abundant help with information relating to all four of the Hurt sitters, Nos.129, 130, 134 and 135.

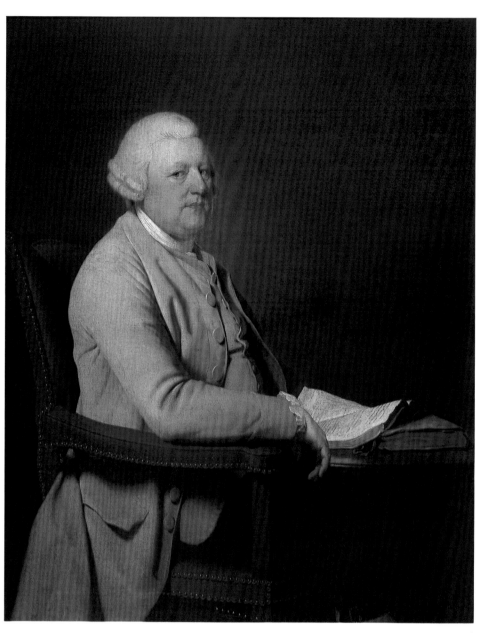

136

136

Richard Cheslyn painted in 1777

Oil on canvas 50 × 40 (127 × 101.6)
PROVENANCE
In Wright's Account Book, 25 July 1777 'Rec.ᵈ of Rich.ᵈ Cheslyn Esq.ʳ on account for this Picture £21.0.0'; passed on the sitter's death to his nephew Richard Cheslyn, thence by descent to the present owner
EXHIBITED
Derby 1866 (176); Derby 1870 (306); Derby 1883 (18); Derby 1934 (98); Tawney House, Matlock, 1964; on long loan to the Tate Gallery from 1988
LITERATURE
John Nichols, *The History and Antiquities of the County of Leicester*, III Pt II, 1804, pp.863–4; Nicolson no.38 pp.188–9; pp.71, 124.144; pl.190

Private Collection

Richard Cheslyn belonged to a family whose fortunes exemplify that popular historical concept 'the rise of the gentry'. His grandfather, a Londoner, was a metal-founder who became rich through being involved in several projects, particularly that for the Whitechapel Waterworks. In 1686 he bought, from the family which had owned it since the dissolution of the monasteries, Langley Priory in Leicestershire. For the next century the

priory, renamed Langley Hall, was the Cheslyns' 'seat' (always a popular word with the rising gentry). An engraving of 'Langley Hall, the seat of Richard Cheslyn Esq.ʳᵉ, is reproduced in Nichols facing p.860.

Wright's sitter was born at Langley Hall on 18 July 1717. He was admitted to the Middle Temple in 1722–3 and called to the Bar in 1740; he was later appointed remembrancer to the City of London and registrar of the Orphans' Stock. In about 1770 he made a prudent marriage to Catherine Bainbrigge, widow of a past Sheriff of Leicester and an heiress in her own right, worth £30,000. About the same time, Cheslyn spent £5,000 on improving 'the plantations, gardens and pleasure grounds' at Langley. Cheslyn died in 1787. He had no children; his portrait passed, with his estates, to his nephew and namesake.

Nicolson calls Cheslyn's portrait 'start-lingly life-like' (p.144). The degree of realism Wright achieves is indeed remark-able, especially given the two probabilities that Cheslyn sat for the portrait in Wright's studio and that Wright had never set eyes on him before. Success depended (as in all portraiture) on how accurately Wright could assess the character of his sitter. He quickly caught the look of cold appraisal from those hooded eyes; he observed the habitual downward curve of the right hand, as if its fingers were about to drum testily on the arm of his chair, impatient to return to the important busi-ness of his (indecipherable) books and ledgers. He noted every fold of that pale grey coat, though it lent little colour to the man. Cheslyn is clearly not prepared to give much away. In deciding to portray him in a brass-studded armchair, Wright achieves a psychological masterstroke. He underlines Cheslyn's buttoned-up charac-ter by focussing on the relentless march of those cold metallic studs up and down the chair he sits in. It may be the same chair in which Frances Hurt sits, in No.129; but Hurt is a genial, untidy, extrovert figure, and the chair (we see only part of the rows of studs at its front edge) does not 'frame' him as it does Cheslyn.

The first recorded comment on the por-trait is that of John Nichols in 1804, who pronounced it to be 'an excellent portrait'. What Cheslyn himself thought of it is not known. It seems typical that he, a rich man, should have paid for his portrait in instalments.

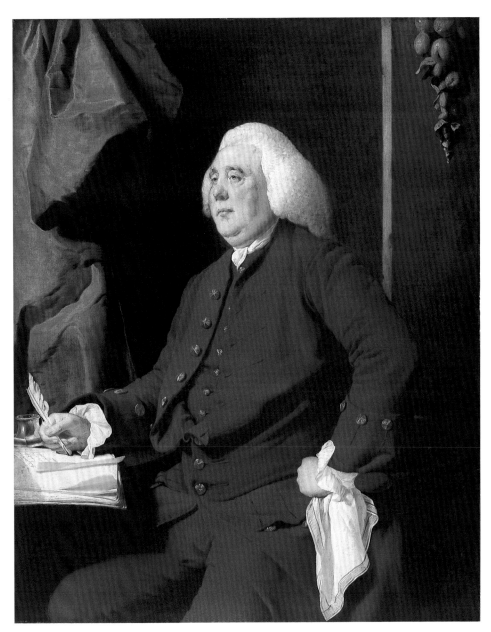

137

137

Christopher Heath dated 1781

Oil on canvas 50 × 40 (127 × 101.6)
Inscribed on a document under the sitter's right hand 'Derby Mar . . . 1781'
PROVENANCE
Not in Wright's Account Book; presum-ably painted for the sitter; . . . J. Hudson, by 1886; H. Barber, by 1883; John Curzon, Lockington Hall, Derby, by 1934; Property of the late John Curzon, sold Christie's 21 March 1975 (82), bt Agnew's for the present owner
EXHIBITED
Derby 1866 (187); Derby 1870 (811); Derby 1883 (2); Derby 1934 (102, as a portrait of Dr Johnson); Derby & Leicester 1947 (5, as do.)
LITERATURE
Nicolson no.78 p.203; pp.36, 72–3; pl.209; Nicolson *Addenda* 1968 pp.1–2

Professor Philip Rieff

Christopher Heath (born *c*.1718 – died 1815) and his elder brother John were the sons of a tenant farmer in the village of Duffield, a few miles north of Derby. The brothers became prominent bankers in Derby, and also played their parts in civic life. John Heath was Mayor of Derby in 1763–4 (his portrait by Wright, repr. Nicolson *Addenda* 1968 p.1 fig.2, must date

from about that time) and again in 1772–3; Christopher Heath was Mayor in 1774–5. John Heath was partner in the China Works in Derby, and also had a stake in the Cockpit Hill Pot Works which made creamware and other pottery; though not as actively involved in these enterprises as his brother, Christopher Heath also seems to have had an interest in them.

For unknown reasons, the Heaths' bank failed in 1779. The China Works survived the crash (more than survived: full ownership was conveyed to William Duesbury, under whom the China Works won considerable renown); but the failure of Heath & Company caused a small furore. Mary Ann Denby wrote in a letter of March–April 1779: 'Our town is filled with moanings and complaints by the failure of Messrs. John and Christopher Heath, bankers, who have involved the whole town and country in ruin! It is about a month since they stopped, and it has laid open such a scene as would never have been thought on, had not the affair been discovered and brought to light. Their proceedings have been most unjust and villainous . . . I look upon such people as to be worse than highwaymen . . . ' (quoted by F. Williamson, 'Derby Pot Manufactory known as Cockpit Hill Pottery, *Journal of the Derbyshire Archaeological and Natural History Society*, 11, 1930, pp.71–2).

Bankruptcies were not uncommon, and that of the Heath brothers seems hardly to have damaged their standing in the community. Christopher Heath commissioned Wright to paint his portrait only two years after the crash, and when he died, in his native Duffield in 1815, he was pronounced by the *Derby Mercury* (and the *Gentleman's Magazine*, which repeated the more newsworthy items from local magazines), to have been 'formerly, and for many years, a highly respected inhabitant of Derby'.

Wright portrays Christopher Heath as a man of business, attending to his correspondence and his ledger. The document beneath his left hand is inscribed 'Derby Mar (? May) 1781'; the rest is illegible. There is certainly no attempt on the sitter's part to retreat from any recent stigma of bankruptcy into posing as a country gentleman; perhaps he hoped the portrait would inspire confidence in his creditors. The massive face, full of worldly experience, gives little of the sitter's private life away. Wright records its fleshy contours centimetre by centimetre; introduces a grace-note in the carved swag of fruit behind a studiously-observed wooden partition; and adds a superlative flourish in the form of a large handkerchief with a striped border, worn with all the panache of a musketeer's sword.

138

Rydal Waterfall dated 1795

Oil on canvas $22\frac{1}{2} \times 30$ (57.2 × 76.2)
Inscribed 'I.W. Pinx.ᵗ 1795' on a stone
lower r.

PROVENANCE
In Wright's Account Book as 'A smallish
one of the little Cascade at Sᵗ Mic la
Flemings [identified by Nicolson as Sir
Michael le Fleming's house, Rydal
Mount], sold to Mᵗ L. Philips & paid for
£31.10.0'; John Leigh Philips, his sale,
Winstanley & Taylor, Manchester, 31
October 1814 (31), bt H.W. (?Wright);
Cade family until presented by Miss
D.M.R. Cade to Derby Art Gallery 1939

EXHIBITED
Derby 1866 (199); Derby 1934 (125);
Derby & Leicester 1947 (61); Sheffield
1950 (19); Derby 1979 (45); *William
Wordsworth and the Age of English
Romanticism*, New York Public Library,
Indiana University Art Museum and
Chicago Historical Museum, 1987 (263,
repr. in colour pl.84, p.94)

LITERATURE
MSS correspondence from Wright,
1794–5 (DPL); Nicolson no.324, p.267;
p.93; pl.352; Fraser 1979, p.17, pl.18

Derby Art Gallery

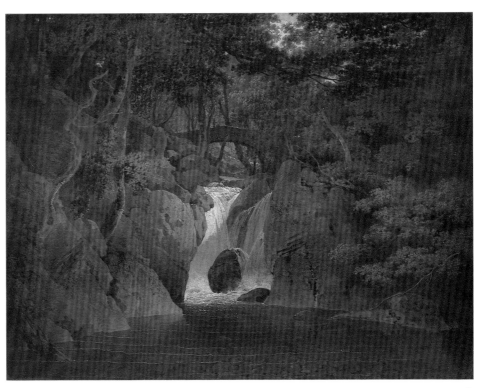

138

This seems to have been started, in the form of a drawing or perhaps a lay-in, on Wright's visit to the Lakes in the summer of 1794, accompanied by his daughters Romana and Harriet and his old friend William Moss Tate. On 23 August 1794 Wright wrote to his brother Richard (DPL) to report their safe return to Liverpool, 'having explored the most stupendous scenes I ever beheld' – adding, in a marginal note, 'they are to the eye, what Handels Choruses are to the ear'. Wright, now very nearly sixty, added feelingly, 'to have done these Tremendous Scenes any justice, I shᵈ have visited them twenty years ago . . .'

The scene Wright now intended to paint was the Lower Fall at Rydal. Other artists, Joseph Farington and Francis Towne among them, had already made watercolour versions of the same scene, and Julius Caesar Ibbetson was to paint a view closely similar to Wright's (Nicolson p.93, fig.113). All chose the same, the obvious viewpoint, a viewing-hut which in the seventeenth century had been a grotto. From there, too, William Mason had admired the waterfall, noting that 'the little central chasm, dashing down a cleft of

the darkest coloured stone, produces an effect of light and shadow beautiful beyond description'; and Revd William Gilpin pronounced upon the picturesqueness of the scene 'appearing through the window like a picture in a frame' (quotations from *William Wordsworth and English Romanticism*, exh. cat. 1987, pp.94, 231).

The letter expressing Wright's Handel-struck enthusiasm for the grandeur of the Lakes was written in August 1794. Inevitably, on his return home, he found work waiting to be finished, preventing him from getting on with 'Rydal' and other Lakes subjects. Then, early in 1795, he was struck by one of the longest and most disabling of all his bouts of depression: '5 months without exercising my pencil', he wrote to J.L. Philips on 29 May 1795 (DPL) as he began to revive.

Work on 'Rydal Waterfall' seems to have been resumed around May 1795. Wright wrote on 2 October 1795 to J.L. Philips, who wished to purchase it, conscientiously reporting that the picture is 'not near being finish'd, the water indeed is farther advanced than the rest of yᵉ picture' – adding what is perhaps the most-quoted passage from Wright: 'I was keen to pro-

duce an effect wᶜʰ I had never seen in painting of shewing the pebbles at the bottom of yᵉ water wᵗʰ the broken reflections on its surface, but I have not succeeded to my wish . . . so highly finish'd is that little bit of nature, that to do it justice, it shᵈ be painted upon yᵉ Spot'. In a later letter to Philips, written on 18 December 1795, Wright declared that 'Rydal Waterfall' had proved 'a very intricate subject & I never wished myself out of a wood so much in my life'.

139

Ullswater *c.*1795

Oil on canvas 18⅛ × 21⅛ (46.3 × 53.7)
PROVENANCE
? not in Wright's Account Book; . . . ; Cyril
Plant, and by descent until sold Christie's
14 July 1989 (55, repr. in colour), bt by
the present owner
EXHIBITED
Viewfinders, Abbott Hall Art Gallery,
Kendal, 1980 (176)
LITERATURE
Nicolson no.323; p.93; pl.355

James Mackinnon

Wright visited the Lakes (a phrase more
widely used in his day than 'the Lake
District') in two successive years, 1793 and
1794. According to Hannah Wright's
Memoir, the visit in 1793 was made with
the encouragement of the Rev. Thomas
Gisborne. Wright had been staying at
Bootle, near Liverpool, with his two
daughters, his younger son and his friend
and former pupil Thomas Moss Tate;
Gisborne persuaded the little party to jour-
ney to the Lakes and meet him there for a
week's sketching tour. Wright returned to
Liverpool in 1794, and again set off with
Tate to the Lakes.

 Wright's reaction to the grandeur
of the scenery of Cumberland and
Westmorland is expressed in a letter to his
brother Richard Wright, written from
Liverpool on 23 August 1794 after the
second tour of the Lakes: 'The best parts of
Derbyshire suffer much by the compari-
son: there it is beautiful nature on a small
scale, here all is grandeur and magnifi-
cence. Mountains piled on mountains &
tossed together in wilder form, than
imagination can paint or pen describe – To
have done these tremendous scenes any
justice, I sh.ᵈ have visited them twenty years
ago, when my mind & body were more
vigorous. Weak knees & a giddy head are
but ill befitted to traverse such a rude
surface . . .' (quoted by permission of
J.M. Eardley-Simpson).

 This painting may have been inspired
by Wright's visit of 1793 or by that of
1794. In either case, it has the air of recol-
lection rather than immediacy. It may
well be one of Wright's last works, painted
*c.*1795. Wright was sixty years old in 1794,
and his health was beginning to fail; he
had only three more years to live. It is not
just our knowledge of this that gives the
painting an elegiac air. The work itself,
with its utterly still water, the gradual

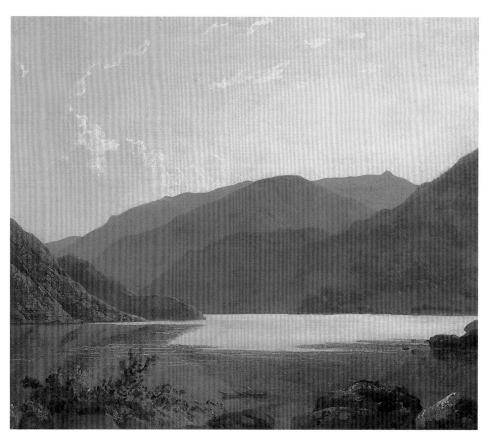

139

recession of the sombre hills and the clouds
lightly gilded by the setting sun, seems to
suggest that the artist is taking leave of
nature, with the same wistful resignation
that Mahler takes his leave of it in the last
phrases of *Das Lied von der Erde*.

 Nicolson lists two other Ullswater
scenes, both of *c.*1795, both now untraced:
'View of the head of Ullswater Lake',
*c.*63 × 70 in., formerly in the Arkwright
Collection, and 'Ullswater, Sunset',
described in Wright's Account Book as 'A
smallish picture . . . to Mr Hardman £42'.
Though the latter picture also includes a
sunset, it cannot be the same as the picture
exhibited here, since Wright would not
have charged as much as £42 for a picture
18⅛ × 21⅛ in.

 According to the *Viewfinders* exhibition
catalogue of 1980, this is a view of
Ullswater from Scale How Wood, looking
towards Silver Point; this precision of the
viewpoint suggests that the painting must
have been based on sketches made on the
spot.

140

Old John, Head Waiter at the King's Head in Derby *c.*1780

Oil on canvas $29\frac{1}{4} \times 24\frac{1}{4}$ (74 × 61.5)

PROVENANCE

In Wright's Account Book as 'Old John at the King's Head Raffled for & paid £12.12'; won in a raffle at Derby Town Hall by Daniel Parker Coke MP (d.1825); Joseph Strutt, by 1835, then by descent to the Hon. Peter Strutt, offered at Agnew's September 1985–July 1986, then sold Sotheby's 19 November 1986 (54, repr. in colour), bt by the present owners

EXHIBITED

Derby 1870 (800); Derby 1883 (106); Derby 1934 (91)

LITERATURE

A Catalogue of the Paintings and Drawings . . . in the Collection of Joseph Strutt, 1835 (66); Bemrose 1885 p.10; Nicolson no.182 (untraced), p.233

Zankel/West Collection, New York

The commission (for which Wright took a fee of twelve guineas) was to produce a portrait of Old John which was then to be raffled, presumably for Old John's benefit and perhaps on his retirement as Head Waiter at the King's Head. According to Bemrose, the picture was placed on view in Derby Town Hall, and tickets for the raffle were ten guineas (which seems improbably high). The picture was won by Daniel Parker Coke MP, himself portrayed by Wright in the Coke conversation piece of 1781–2, exhibited here as No.142.

Old John looks a benign and tolerant man (as all good waiters must be); the flowers in his buttonhole further suggest that he has his own debonair style. Nothing is known of him, not even his surname, beyond what Wright tells us. The King's Head on the other hand was very well-known, as one of the two great coaching inns in Derby (the other being the George); established in 1681, it became the centre for auction sales and, in the alarms of 1745, the focus for meetings to plan the defence of Derby against Jacobite invasion.

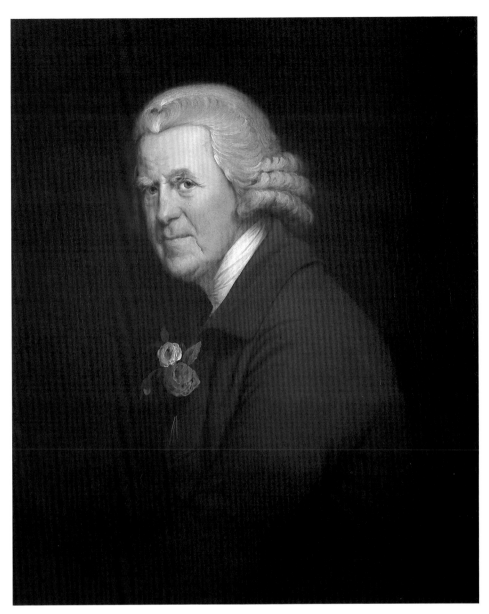

140

Thomas and Joseph Pickford as Children *c.*1777–9

Oil on canvas 58 × 48 (147.3 × 122)
PROVENANCE
In Wright's Account Book as 'A
Conversation piece of two of M.ʳ Pickford's
Children £63.0.0'; painted for Joseph
Pickford (d.1782), by descent to his
younger son Rev. Joseph Pickford
(dsp.1844); . . .; Mrs Curzon, by 1866;
N.C.Curzon, thence by descent to the
present owner
EXHIBITED
Probably RA 1779 (361, as 'Two Boys,
Whole Length'); Derby 1866 (180); Derby
1870 (310); Derby 1883 (61); Derby 1934
(130)
LITERATURE
Rev. T.Mozley, *Reminiscences*, 1, 1882,
p.65; Nicolson no.119 pp.216–7; pl.185

Private Collection

The boys are two of the children of the
architect Joseph Pickford and his wife
Mary Wilkins. The elder boy is Thomas,
baptised at St Werburgh's, Derby 16
December 1769; he died at the age of
twenty in 1790. The younger boy is
Joseph, baptised in July 1772; he went up
to Oxford in 1790, took Holy Orders and
became a Fellow of Oriel College in 1794
('Lucky youth!' remarked his cross-grained
friend Rev. William Bagshaw Stevens,
Journal . . ., ed Georgina Galbraith, 1965,
p.524). He became Rector of Cholderton
in Wiltshire, and perpetual curate of Little
Eaton and Quarndon. The Rev. Thomas
Mozley called on Rev. Joseph Pickford in
Derby in about 1815, saw Wright's por-
trait of the Pickford children in his sitting-
room and could not help sighing to himself
at 'what a beautiful child might come
to . . .'.

Joseph Pickford (d.1782), father of the
boys and a personal friend of Wright, had
a flourishing architect's practice in the
Midlands. This is not the place to attempt
to summarise his work (which is the subject
of research by the architect Edward
Saunders of Derby). Two of Pickford's
houses may however be mentioned. The
first was the house Pickford built for him-
self soon after 1768 in Derby, a large and
elegant brick house whose pediment is
proudly ornamented with carvings of
architects' instruments (No.41 Friargate,
still standing). The second was Etruria
Hall, built for Josiah Wedgwood in 1779;
an image of Pickfords' Etruria Hall went to

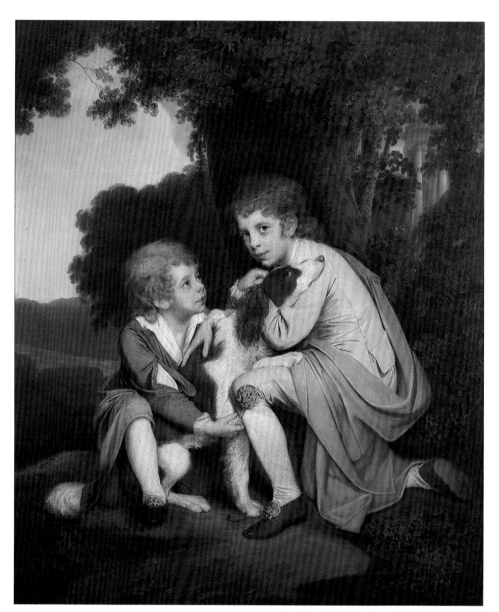

141

Russia soon after that (like some of Wright's paintings) in the form of a design on one of the pieces in the 'Frog' dinner service designed by Wedgwood for Catherine the Great. Etruria Hall also still stands, though it no longer commands the view which Wedgwood enjoyed.

Wright depicts the Pickford children in much the same mood as he depicts the 'Girl in a Tawny Dress' of about the same date (No.143): isolated from normal family life and unaccountably unescorted in the dying light. 'Edwin', the visionary boy (No.57), probably painted about the same time, probably powerfully affected the way in which Wright saw the real flesh and blood Pickford boys. The presence of Edwin in his mind, in his pale, melancholy colours, may have influenced Wright's choice of palest lilac and yellow, pale green and light ochre, for the Pickford boys' dress; but equally, these colours may have been chosen primarily to make delicate contrasts against the darkening sky. A soulful dog ('rather a snipey-looking spaniel', in Jeremy Rex-Parkes's phrase) is introduced to provide a focus for the boys' attention as, unlike Edwin, they are clearly as yet unsuited to meditation.

Wright's commissions to portray children increased over the next decade or so, producing such works as 'The Synnot Children' (Nicolson pl.221), 'Two Young Gentlemen in the character of Archers' (do.pl.222), the Romney-esque 'Leaper Children' (do. pl.243), 'The Thornhill Children' (do.pl.278), 'The Wood Children' (do.pl.279: in Derby Art Gallery) and two groups of 'Arkwright Children' (do.pls.328–9). Compared with any of these, 'Thomas and Joseph Pickford' may be more sombre, but is very much more real.

The compiler is most grateful for information from Maxwell Craven and David Fraser. Maxwell Craven suggests that the temple glimpsed through trees in the background of the portrait may be a folly designed and built by Pickford, but so far untraced.

142

The Rev. D'Ewes Coke, his wife Hannah and Daniel Parker Coke MP
*c.*1781–2

Oil on canvas 60 × 70 (152.4 × 177.8)
PROVENANCE
In Wright's Account Book as 'A Conversation Picture of D: P: Coke, the Rev.ᵈ Mʳ Duse Coke & his Lady £75.12.0'; commissioned by Rev. D'Ewes Coke (the receipt dated January 1783 is displayed here), and thence by descent until purchased from R.G.S.Coke, with assistance from the National Art Collections Fund, by Derby Art Gallery 1965
EXHIBITED
Graves 1910 (16); Derby 1934 (116); Derby & Leicester 1947 (3); Sheffield 1950 (2); on long loan to Derby Art Gallery 1954–65; Tate & Walker 1958 (23, pl.IX); *Pittura Inglese 1660–1840*, Palazzo Reale, Milan, 1975 (96); Derby 1979 (26)
LITERATURE
Waterhouse 1953, ed. 1962 p.199; Nicolson no.40 pp.188–9; pp.72–3 (with detail figs. 93–4) pl.225; Nicolson 1988 p.756; Fraser 1979 p.15, repr. p.5 in colour

Derby Art Gallery

Ellis Waterhouse justifiably called this Wright's 'masterpiece of group portraiture'; and Nicolson writes (p.72): 'All Wright's long training as a portrait painter is summed up in this large canvas: his interest in light, expressing itself in Mrs Coke's green dress turning yellow as the sun catches it, and in that transparent scarf which remained his signature for over thirty years; the very different personalities of the two men, brought out by touches to eyelids, by the slope of brow and mouth; the naturalness of their movements; the still life with its sunshade and portfolio where every ring and tape has its logical place in the sun . . .'

The sitters are almost certainly portrayed in the grounds of Brookhill Hall, Derbyshire, a house which Rev. D'Ewes Coke had inherited from his guardian in 1780. They have carried out an endearingly workmanlike table, which now serves as a basis for their conversation — perhaps about one of Mrs Coke's drawings, taken from the portfolio she holds, or about a design for landscaping the park in her husband's recently-inherited property. The two men were distant cousins and firm friends; Rev. D'Ewes Coke's sons in time became Daniel Parker Coke's heirs. Their careers illustrate two very different

aspects of service: in one case, public and parliamentary, in the other hardly ranging beyond the borders of a parish.

Daniel Parker Coke (1745–1825), only son of Thomas Coke of Derby, barrister, and his wife Matilda Goodwin, went from Derby Grammar School to Oxford, where he became a Fellow of All Souls, and then to Middle Temple; he was called to the Bar in 1768 and was a practising barrister, for many years attached to the Midland Circuit. He chiefly made his name as an independent MP, representing Derby 1776–80, then Nottingham 1780–1802 and 1803–12; he also served as one of the commissioners for settling American claims 1782–5. He spoke often, well and wittily in the House. His parliamentary career, spanning thirty-six years, is recounted by Namier & Brooke (11, 1964, pp.232–3); they quote a tribute to Daniel Parker Coke in the *English Chronicle* of *c.*1780 as 'as independent in his parliamentary conduct as any man in the House'.

Rev. D'Ewes Coke (1747–1811) by contrast led a seemingly uneventful life. The only son of Col. George Cooke, 3rd Dragoons, of Kirkby Hall and Pinxton, Derbyshire, and his wife Elizabeth, he went to school at Repton, read for Holy Orders at Cambridge (St. John's), was ordained in 1771 and spent the remainder of his life as Rector of Pinxton and South Normanton, two parishes of which he was patron, both lying within a mile of his home at Brookhill Hall. He married a local heiress, Hannah Heywood, in about 1772. As Nicolson observes, they look an ill-assorted pair, 'he with his benevolent eyes, she with her hard, sulky mouth'. According to the family history, Mrs Coke was spoilt as a child, and became disagreeable. Wright's portrait of her is certainly unflattering; but then he is rarely if ever an ingratiating portraitist.

Rev. D'Ewes Coke found pleasure in two occupations in particular. The first was etching; in Wright's portrait he appears to be holding a stylus, for transferring the lines of a drawing to a copper-plate (or it may be a porte-crayon). The other was natural history, the pastime of many another rural clergyman. When James Pilkington was compiling his *View of the Present State of Derbyshire . . .*, *c.* 1789, he invited several gentlemen to contribute to it, notably 'Dr Darwin of Derby', who provided an account of 'the natural history of the Buxton and Matlock waters'. Rev. D'Ewes Coke contributed 'A catalogue of some plants growing spontaneously in Derbyshire' (pp.319–496): a succinct

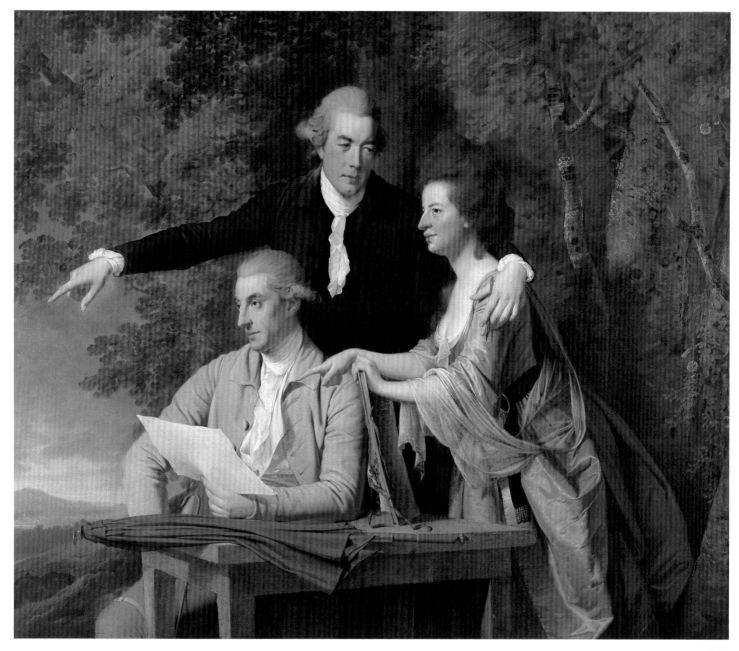

142

account of where various wild plants were to be found, what medicinal uses they might have and how farm animals reacted to them (e.g. Elder flowers: 'fatal to turkies'; Ladies' Bedstraw: 'Cows sheep and horses eat it. Goats and swine refuse it'). All this is based on careful personal observation, and must have been of some value, even though the research is pursued at hedgerow rather than Lunar Society level.

The prevailing spirit of commercial enterprise in Derbyshire passed Rev. D'Ewes Coke by but manifested itself in his third son John, who established the Pinxton Porcelain Manufactory on the family estate at Pinxton; it operated with considerable success between 1796 and 1813.

Rev. D'Ewes Coke died on 12 April 1811, by then suffering from blindness said to have been caused by too much concentration on etching. Daniel Parker Coke died on 6 December 1825, and was buried in the Cathedral Church of All Saints, Derby, where a monument commemorates, among other virtues, his 'most disinterested independence'.

143

Portrait of a Girl in a Tawny-Coloured Dress *c.*1780

Oil on canvas 48 × 39 (122 × 99)

PROVENANCE

. . . ; Sir John Thursby, Ormerod House, Burnley, Lancs, by *c.*1900, then by descent to Ruth Aspinall, by whom sold (as 'The Property of a Lady'), Sotheby's 6 July 1983 (229, repr. in colour, bt Agnew's for the present owner

Private Collection

The picture has not been previously exhibited or (apart from Sotheby's sale catalogue) published. Attempts to identify the sitter have alas been unsuccessful. David Fraser suggested in Sotheby's 1983 catalogue that she might be Miss Parker, listed in Wright's Account Book as a sitter *c.*1780–1. This raised a further hope that she might be a daughter of Wright's patron Edward Parker, of Brigg, Lincolnshire; but despite keen research by the picture's present owner in the Lincolnshire Archives Office, no eligible Miss Parker could be found in that family.

Ruth Aspinall, the picture's former owner, told the compiler that no records relating to the picture's provenance or the sitter's identity had been preserved, and added that her grandfather Sir John Thursby had been in the habit of buying pictures; thus there may be no connection between the sitter and the Thursby family.

The style of the portrait and its landscape must make it of approximately the same date as 'The Pickford Children' of *c.*1780 (No.141). In each picture, the hour is the sombre one after sunset, an odd time to choose as the aura either for a nineteen- or twenty-year-old girl or for two young boys. This girl, with her spaniel at her side, is graceful and alert, but too English and too well-bred to impersonate Diana in the darkling light; instead she fiddles with the velvet band at her wrist, which carries a locket containing either the hair of a loved one, or some veined stone: it is difficult to make out which. Her dress is of self-patterned brocade, its rich and unusual colour hardly to be summed up in a word: tawny? old gold? deep amber?

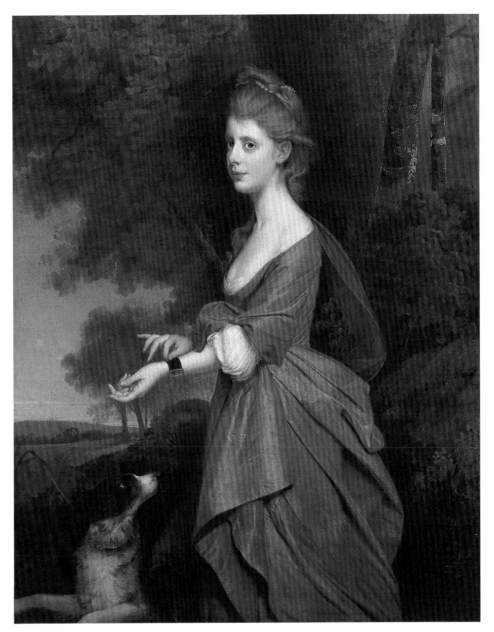

143

144
Erasmus Darwin *c.*1770

Oil on canvas 30 × 25 (76 × 63.5)
PROVENANCE
Painted for the sitter (? as a gift: not in
Wright's Account Book), and thence by
descent to G.P. Darwin, from whom on
permanent loan to Darwin College,
Cambridge
EXHIBITED
Derby 1870 (782); *Genial Company*,
Nottingham University Art Gallery and
Scottish National Portrait Gallery, 1987
(37, repr.)
LITERATURE
Nicolson no.50 p.193; pp.100–1; pl.78

Darwin College, Cambridge

The fertility of Darwin's mind and the
breadth of his interests are hardly to be
summed up in a catalogue entry. As well as
being a doctor of medicine, he was an
inventor, scientist, poet, wit; a Fellow of
the Royal Society by the time he was
thirty, and the friend of Wedgwood,
Matthew Boulton, Richard Lovell
Edgeworth, Thomas Day and James Keir,
he also became like them a member of the
Lunar Society. He discussed steam-engines
with James Watt, and windmills with
Wedgwood, inventing for him a horizontal
windmill for grinding colours, long in use
at Etruria. His other inventions (not all
workable) ranged from carriages, seed-
drills and electrical machines to a tele-
scopic candlestick and a polygrapher for
making multiple copies of documents and
drawings. Darwin's contributions to the
Philosophical Transactions of the Royal
Society included papers on the formation of
clouds, on squinting and on 'Colours seen
in the Closed eye'.

Darwin also wrote poetry, expounding
physical laws and philosophical specu-
lations in heroic couplets. *The Botanic
Garden*, a long poem (almost 4,500 lines)
made him celebrated in his own day. In his
Advertisement for the poem, Darwin
declared that his aim was 'to inlist
Imagination under the banner of Science'.
Part II, *The Loves of the Plants* (1789, publi-
shed before Part I) is a whimsically-
phrased analysis of processes of fertilization
in various classes of plants, drawn from
Darwin's own observations in the seven-
acre botanic garden he had made at
Lichfield. Part I deals with lightning, rain-
bows, limestone, porcelain, clouds, cotton
mills and almost every subject of interest to
Darwin himself or to fellow-members of the

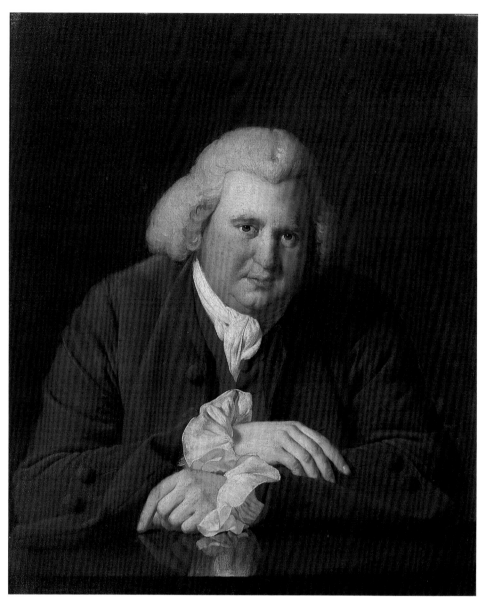

144

Lunar Society. It includes a famous passage in which Darwin foresees rapid progress from his friend James Watt's invention of the steam-engine to an entire age of steam:

Soon shall thy arm, UNCONQUER'D STEAM! afar
Drag the slow barge, or drive the rapid car;
Or on wide-waving wings expanded bear
The flying-chariot through the fields of air.
— Fair crews triumphant, leaning from above,
Shall wave their fluttering kerchiefs as they move;
Or warrior-bands alarm the gaping crowd,
And armies shrink beneath the shadowy cloud. (1.289–96)

Although Darwin became a celebrated figure in his own lifetime, most people who saw him on his daily rounds would have known him primarily as a G.P. Darwin established a practice in 1756 in Lichfield (where this portrait was probably painted), moving in 1783 to Derby. Many of the people portrayed in this exhibition were Darwin's patients, including Wright himself. Darwin's fame as a doctor with almost miraculous curative powers became widespread. In his biography of his grandfather, Charles Darwin FRS reports that George III used to repeat, over and over again, 'Why does not Dr. Darwin come to London? He shall be my physician if he comes'.

Darwin was probably approaching forty when he sat to Wright for this portrait. His physical appearance was a challenge for any painter. 'He was a large man, fat, and rather clumsy', in his friend Richard Lovell Edgeworth's blunt phrases; his face was severely marked by smallpox, and the early loss of his front teeth emphasized the fact that his tongue tended to slide from his mouth (he also stammered badly). Wright's portrait neither dwells upon nor glosses over these superficial defects; instead, it concentrates on Darwin's intelligence. The pose, with the patient spread of the arms on the table and the attentive tilt of the head, expresses that faculty for listening which made Darwin such an incomparably good doctor; but while there is kindness in the face, there is also large sagacity, and little doubt that the sitter is potentially formidable.

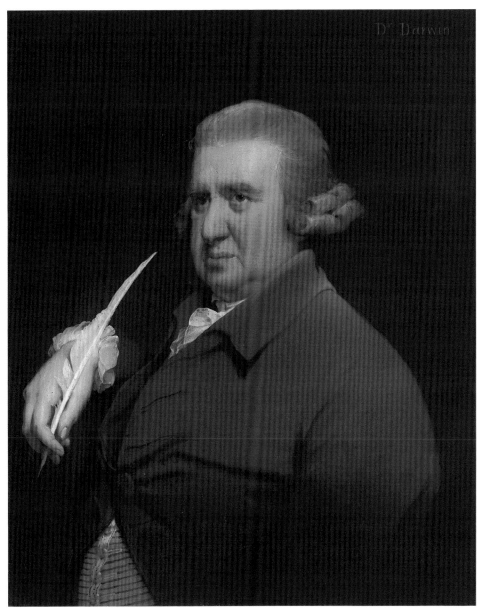

145

(The best succinct biography of Darwin is Desmond King-Hele, *Erasmus Darwin*, 1963, from which the quotations above from Charles Darwin (p.32) and Richard Lovell Edgeworth (p.16) are taken; see also ed. Desmond King-Hele, *The Letters of Erasmus Darwin*, Cambridge, 1981. In both, the frontispiece is the version of this portrait in the National Portrait Gallery, not certainly by Wright)

145

Erasmus Darwin 1792–3

Oil on canvas 30 × 25 (76.2 × 63.5)
PROVENANCE
In Wright's Account Book as 'A 3 qr. of Dr. Darwin wth a hand 15 Gs £5.15.0'; commissioned by Sacheverell Pole, the sitter's stepson (himself a sitter to Wright c.1794: Nicolson pl.342), and thence by descent
EXHIBITED
The Lunar Society of Birmingham, Birmingham Museum & Art Gallery, 1966 (56); Derby 1979 (41)
LITERATURE
Nicolson no.52 pp.192–3; pp.109, 132;

pl.338; ed Georgina Galbraith, *The Journal of the Rev. William Bagshaw Stevens*, 1965, p.65

Private Collection

This portrait was probably painted twenty or twenty-five years after No.144. The prominence given to the quill pen salutes Darwin's growing fame as a writer. *The Botanic Garden*, published in 1792 (see above) was proving a bestseller. Other publications were to follow, notably *Zoonomia; or, The Laws of Organic Life*, in prose, in 1794–6, and *The Temple of Nature; or, The Origin of Society*, published in 1803, just after his death, a long poem expounding a theory of evolution which contains the germ of much of his grandson Charles Darwin's *Origin of Species*. Erasmus Darwin's love of expounding scientific ideas in poetry may have obscured the originality of many of his theories; heroic couplets were not after all the usual vehicle of exposition for a FRS.

With the passage of time, Darwin had become not only more famous but also more fat. Though he avoided alcohol (and urged his patients to), he believed that heavy eating promoted good health, and consumed prodigious quantities of sweetmeats, butter and cream. He no longer regularly attended the meetings of the Lunar Society in Birmingham, thirty-five miles from Derby, instead becoming the shining light of the Philosophical Society which he had founded in Derby in 1783.

A letter of 25 October 1792 to his friend Richard Dixon (published by King-Hele 1981, cited above, pp.225–6) conveys something of Darwin's activities about the time this portrait was painted. 'I go on as usual to practice physic, and to write books': in the latter sphere, he reports that he has sold the publication right of *The Botanic Garden* for £900 (an enormous sum), adding modestly (and tactfully): 'it is a poem; perhaps you may borrow it from some circulating library'. Darwin expresses his elation at the progress of the French Revolution: 'The success of the French against a confederacy of kings gives me great pleasure, and I hope they will preserve their liberty, and spread the holy flame of freedom over Europe'. But he adds: 'The worst thing I find now is this d − − n'd old age, which creeps sliiy upon one, like moss upon a tree, and wrinkles one all over like a baked pear'.

Rev. William Bagshaw Stevens, Headmaster of Repton, went with other visitors to Wright's studio on 2 February 1793 to see the portrait of Darwin, which by then was presumably finished, or virtually so: he considered it 'a strong but severe likeness . . . His [Darwin's] countenance is seldom without a smile playing around it' (p.65). There is nothing either ingratiating or flattering about Wright's portrait; it seeks rather to catch the sitter in the process of thought (as Wright had done most successfully of all in his portrait of John Whitehurst, No.147). As Stevens was to note of Darwin in his Journal for 10 January 1794 (p.126), 'Few men have so much exercised their Minds'. As Darwin lived until 1802, this was not intended as an epitaph; all the same, it is an apt one.

Wright painted at least one replica (Darwin family collection). The portrait catalogued by Nicolson as no.54, exhibited at Derby 1934 (25, pl.VII), Strutt Collection, is almost certainly a copy, probably by James Rawlinson, whose MS inventory lists a portrait of Dr Darwin. Other copies exist.

146

Rev. Thomas Gisborne and his Wife Mary dated 1786

Oil on canvas 73 × 60 (185.5 × 152.5)
Inscribed 'I.Wright Pinx! 1786' lower r.

PROVENANCE
In Wright's Account Book as 'A
Conversation picture of M.' and M.'
Gisborne £100.16'; commissioned by Rev.
Thomas Gisborne (d.1846); apparently
taken over with Yoxall Lodge by Hon.
Mrs E.W. Griffith; . . . ; William Haffety,
sold Christie's 26 March 1926 (127); Mrs
Florence H. Crane, Ipswich, Mass.,
Durlacher Bros., New York, from whom
purchased by Agnew's 1960 and sold later
that year to Paul Mellon; presented by
Paul Mellon to the Yale Center for British
Art 1981

EXHIBITED
Derby 1883 (82); VMFA 1963 (256); RA
1964–5 (253); Yale 1965 (263); NGA
Washington 1969–70 (12, repr.)

LITERATURE
Benedict Nicolson, 'Thomas Gisborne and
Wright of Derby', *Burlington Magazine*,
CVII, 1965, pp.58–62 (fig.1); Nicolson
no.67 pp.198–9; pp.72–3, 134, 137 pl.269

*Yale Center for British Art, Paul Mellon
Collection*

Thomas Gisborne, born on 31 October
1758, was the eldest son of John Gisborne
and his wife Anne Bateman (subject of one
of Wright's earliest portraits, No.2). The
Gisborne family was well-to-do. The chil-
dren were chiefly brought up at Yoxall
Lodge in Needwood Forest, some ten miles
south of Derby, over the county border
into Leicestershire, a house which had
been a hunting-lodge but which John
Gisborne had rebuilt as a comfortable
Georgian country house. Yoxall Lodge
was to be the centre of all the Rev. Thomas
Gisborne held most dear.

Thomas Gisborne's early career was
outstanding. As a boy he was tutored
for six years by Rev. John Pickering
(No.148), then went to Harrow. In 1776
he entered St John's College, Cambridge
in 1776, where his lifelong friendship with
William Wilberforce began. Gisborne later
recalled 'My rooms and his were back to
back, and often when I was raking out my
fire at ten o'clock, I heard his melodious
voice calling aloud to me to come and sit
with him before I went to bed' (R.I. & S.
Wilberforce, *The Life of William Wilberforce*,
I, 1838, pp.10–11). Gisborne left
Cambridge as sixth wrangler in the

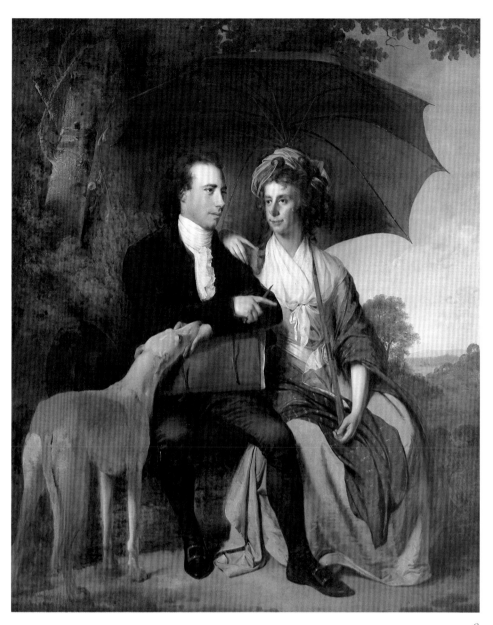

146

Mathematical Tripos, also winning the
Chancellor's Gold Medal for Classics and
Sir William Browne's Gold Medal for a
Latin ode. Wright's portrait of young
Gisborne in academic robes, com-
missioned by a proud Headmaster of
Harrow, is reproduced by Nicolson
(pl.191); it reflects not only Gisborne's
intelligence but also his remarkable good
looks. A brilliant career was predicted for
Gisborne, and a parliamentary seat
offered him; instead he chose to take Holy
Orders.

In 1783, the year he was ordained priest,
Gisborne was presented to the perpetual
curacy of the parish of St James,
Barton-under-Needwood. The next year
he married Mary, daughter of Thomas

Babington of Rothley Temple,
Leicestershire, and sister of Thomas
Babington who had been at
St John's with Gisborne and Wilberforce
(Babington was to marry Zachary
Macaulay's sister, and to become the uncle
of the yet unborn historian Thomas
Babington Macaulay). Thomas Gisborne
settled down with his wife at Yoxall
Lodge, inherited from his father a few
years earlier, with a considerable amount
of money.

In worldly terms, it might be thought
that nothing worth reporting happened
thereafter in the life of the perpetual
curate. That would be presumptuous.
Gisborne's was a quiet life; but its
pleasures included a remarkably happy

marriage (and fathering eight children), serving God and his parish (and upon occasion exchanging his curate's robes for those of a Prebendary of Durham Cathedral), living where he most wanted to live and cultivating friendships.

Wright's double portrait, dated 1786, was painted two years after the Gisbornes' marriage, when Thomas Gisborne was twenty-eight and Mary Gisborne (born in 1760) was twenty-six. Given Gisborne's abiding love for his home, the young couple can only be depicted outside Yoxall Lodge, whose immediate surroundings consisted of a wilderness rather than a park. The introduction of a devoted greyhound makes Gisborne the 'central' figure. The large green umbrella, with its handle almost as long as a pilgrim's staff, seems to protect the Gisbornes from adversity as well as from the weather. The portfolio balanced on Gisborne's knees and the porte-crayon in his hand are the attributes of an enthusiastic sketcher after nature.

In his essay on 'The Clapham Sect', that band of philanthropists, evangelicals and campaigners for the abolition of slavery, Sir James Stephen included Gisborne (whom he knew) with Wilberforce, Zachary Macaulay and others *(Essays in Ecclesiastical Biography*, 11, 1849, pp.299–307). Gisborne published his *Remarks on the Decision of the House of Commons on 2 April 1792, respecting the Abolition of the Slave Trade*, shortly after that debate. His other publications (listed in *DNB*) include *An Inquiry into the Duties of Men in the Higher Ranks and Middle Classes*, 1794 and *An Inquiry into the Duties of the Female Sex*, 1797. He was a learned and eloquent preacher; several volumes of his sermons were published.

Yoxall Lodge, in the heart of Needwood Forest, surrounded by oaks and chestnuts and with no close neighbours except deer, gave the Gisbornes quietness and peace of mind. Gisborne celebrated the beauties of Needwood in *Walks in a Forest*, a slim volume of blank verse published in 1795, describing forest scenery at different times of the day and in different seasons. He became deeply interested in natural history and ornithology. Sir James Stephen described Gisborne's study as 'a chamber which it might seem no dealer in household furniture has ever been permitted to enter, but where books and manuscripts, plants and pallets, tools and philosophical instruments, birds perched on the shoulder, or nestling in the bosom of the student, or birds curiously stuffed by his own hands, usurped the places usually assigned to the works of the upholsterer' (p.305).

William Wilberforce became a regular visitor to Yoxall Lodge from about 1794; according to his first biographers, he made Yoxall Lodge 'his summer residence', arriving with vast amounts of papers, knowing that this was the one place in England where he could digest them in perfect peace (R.I. & S. Wilberforce, op. cit., p.278). A later biographer of Wilberforce offers a glimpse of Mary Gisborne, evidently an intelligent woman: 'When he sat with the family sipping tea, and the words poured forth as his mind jumped from point to point in that bubbling spontaneous thinking aloud which captivated his hearers, she would seize a pad and afterwards present him with her notes' (John Pollack, *Wilberforce*, 1977, p.145).

All this adds up to a seemingly uneventful but deeply satisfying life, already reflected in Wright's double portrait of 1786. Wilberforce was probably not the only one to leave Yoxall Lodge thinking that in preferring a backwater to public life, Gisborne was to be envied. Wilberforce thought, as he was 'plunging once more into a dinner circle of cabinet ministers, how did I regret the innocent and edifying hilarity of the Lodge!' (quoted by R.I. & S. Wilberforce p.284).

Wright had been a personal friend of Gisborne since the early 1780s. It was for Gisborne that he painted companion views of 'Dovedale' and 'San Cosimato' (Nos.120, 121) to prove that Derbyshire had landscape scenery as fine as that of Italy. The extent of their friendship is shown by the fact that in 1793 Wright presented Gisborne with a self-portrait, inscribed (in Latin) 'to his friend T. Gisborne'; this is now known only from a copy (Nicolson p.22 fig.9). Gisborne persuaded Wright to join a small sketching party to the Lakes in 1794, rallying Wright's spirits with the sight of 'stupendous scenery'. Gisborne was himself an amateur artist, as the portfolio in the portrait suggests; there are examples of his work in the British Museum (one repr. Michael Clarke, *The Tempting Prospect*, 1981, p.114 fig.73). Gisborne became a friend of the Rev. William Gilpin, high priest of the Picturesque, discussing landscape scenery and the vexed question of bodycolour with him. Gilpin gave a perceptive account of Gisborne in a letter of 17 September 1792 (quoted by Nicolson 1965, p.60 n.13): ' . . . You can enter his mind without lock or key. He is a man of considerable fortune; but went into orders, not with any view of preferment but merely, as it appears to me, to have a better pretence to be serious . . . '.

Wright painted this picture as a portrait of two particular people, whom he happened to know and like. He has conveyed their appearances and their amiability so well that we may feel that we know them; but of course we don't. What the portrait perpetuates for us is the image, in Nicolson's finely-turned phrase (1965, p.161) of 'a decent middle-class couple, high-minded, dedicated to learning, the arts and the cause of freedom'.

147
John Whitehurst FRS *c.*1782–3

Oil on canvas 36¼ × 28 (92.1 × 71.1)
Inscribed 'Section of the Strata at Matlock
High Tor' with brush along lower edge of
Whitehurst's drawing

PROVENANCE
In Wright's Account Book as 'M.ʳ
Whitehurst Kit Cat £18.18': price crossed
out, and note added 'He has paid 6 Gs';
passed to the sitter's nephew; William
Bemrose, by 1867, and by descent until
acquired by present owners this century

EXHIBITED
Robins's Rooms 1785 (11, as 'Portrait of a
gentleman', identified as Whitehurst in
Hannah Wright's MS Memoir); Derby
1839 (29); Derby 1886 (388); National
Portrait Exhibition 1867 (714); Derby
1870 (803); Derby 1883 (9); Graves 1910
(53); Derby 1934 (21); *Lunar Society of
Birmingham*, Birmingham Museum & Art
Gallery, 1966 (57); Derby 1979 (28);
Genial Company, Nottingham University
Art Gallery and Scottish National Portrait
Gallery, 1987 (56, repr.)

LITERATURE
Nicolson no.141 pp.224–5; pp.116, 154
pl.227; Fraser 1988 pp.124–8, pls.3–5;
Fraser's essay in this catalogue p.15

ENGRAVED
as frontispiece to *The Works of John
Whitehurst F.R.S. with Memoirs of his Life and
Writings*, 1792; see catalogue of engraved
works (P27)

Private Collection

Whitehurst's was the keenest intelligence in
Derbyshire in Wright's lifetime; yet
Richard Lovell Edgeworth described
Whitehurst himself as 'one of the most sim-
ple, unassuming philosophers I have ever
known' (*Memoirs*, 1820,1,p.180). Wright's
portrait brilliantly catches both these
aspects of the man.

Whitehurst, born in 1713 in Congleton,
Cheshire, son of a watch- and clock-maker,
had little formal education. He settled as a
clock-maker in Derby in 1736, and soon
acquired a reputation as an excellent and
ingenious maker particularly of turret
clocks, time-clocks and astronomical
clocks, and also of instruments such as bar-
ometers, hygrometers and pyrometers.
This portrait usually hangs next to a
supremely elegant barometer made by
Whitehurst and dated 1774. At Matthew
Boulton's request, Whitehurst designed
and constructed a geographical clock
which showed the motions of the earth,

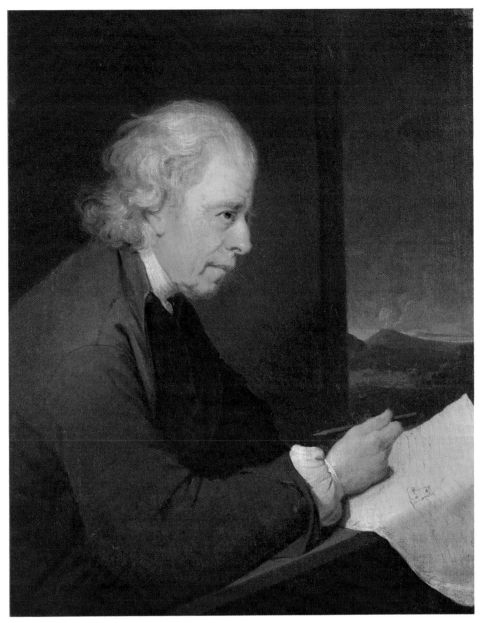

147

sun, planets and stars: Boulton had
written to Whitehurst on 23 February
1771 'I am determined to make such like
sciences fashionable among fine folks'.
Whitehurst's clock, surmounted by a
revolving globe, was set in one of Boulton's
grandest ormolu cases, the globe itself sup-
ported by three Italian Renaissance fig-
ures modelled by John Flaxman. Boulton
hoped to sell it to Catherine the Great of
Russia, but in this he was unsuccessful (a
detailed account of the clock is given by
Nicholas Goodison, *Ormolu: The Work of
Matthew Boulton*, 1974, pp.108–9, from
which the quotation above from Boulton's
letter of 1771 is taken. The clock is repr. by
Goodison, frontispiece, in colour).

Whitehurst, whose scientific interests
and ever-open mind made him a welcome
associate of Erasmus Darwin, Matthew
Boulton and Josiah Wedgwood, was like
them a member of the Lunar Society. The
wide variety of his interests, which
extended to the ventilation of chimneys,
the design of water-closets and the
vibration of bells, made him one of the
most versatile of the Lunatics.
Increasingly, his chief study came to be
geology. Whitehurst's *Inquiry into the Original
State and Formation of the Earth*, based on
twenty years' work, was published in 1778;
he was elected FRS the following year.
Whitehurst had been appointed Stamper
of the Money Weights in 1775, and had

moved to London, but made frequent return visits to Derby. His daughter married the artist William Hodges (but died within months of her marriage). Whitehurst died in London in 1788. He is sometimes thought to be the lecturer in 'The Orrery', an identification which Nicolson is inclined to accept, but David Fraser and this compiler are not.

In *The Original State and Formation of the Earth*, Whitehurst attempted to reconcile his own first-hand observations with accepted beliefs in the Creation and its Creator; the dilemma, shared by more and more scientists in the nineteenth century, is discussed by Fraser 1988 (pp. 124–8). Whitehurst was keenly interested in volcanoes, believing that 'subterraneous fires' existed under the earth: this is the background to Wright's much-quoted comment, in a letter to his brother from Rome 11 November 1774 (DPL): 'When you see Whitehurst, tell him I wished for his company when on Mount Vesuvius, his thoughts would have center'd in the bowels of the mountain, mine skimmed over the surface only . . . '

Wright's portrait shows Whitehurst at the age of about seventy. It celebrates Whitehurst's achievements as a geologist. As Fraser explains, Whitehurst is shown seated at his desk drawing his pioneering 'Section of the Strata at Matlock High-Tor', which illustrated the Appendix to his *Inquiry*; Fraser reproduces (as well as the portrait itself) a detail of Whitehurst's hand at work on the drawing and the illustration as published (1988 figs. 3–5). In the background is a smoking volcano, a tribute to Whitehurst's deep interest in 'subterraneous fires' which made Wright feel that in painting Vesuvius, he himself merely 'skimmed over the surface'. Whitehurst's face, which Wright has clearly studied with reverence but also with professional detachment, exudes that 'expression at once of penetration and mildness', described in Charles Hutton's memoir of Whitehurst *(The Works of John Whitehurst FRS with Memoirs of his Life and Writings*, 1792, p.18).

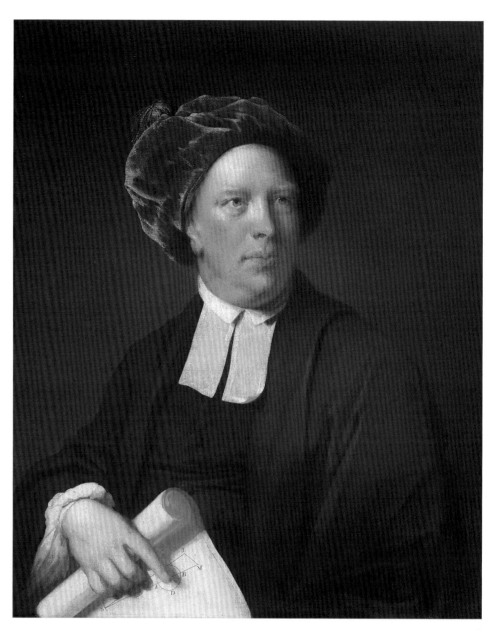

148

148

Rev. John Pickering *c.*1777–80

Oil on canvas $31\frac{7}{8} \times 27\frac{3}{8}$ (81 × 69.5)

PROVENANCE
Wright's Account Book lists 'A copy of the late M.^r Pickering w.th a hand – for M.^r Tho.^s Gisborne – £15.15.', early 1790s (no original of the portrait is listed in the Account Book or now known); . . . ; C.Sandars, ? of Mackworth, by 1866; . . . ; Lady Inglefield by 1934, and thence by descent to the present owners

EXHIBITED
Derby 1866 (99); Derby 1934 (149); Derby & Leicester 1947 (14); Sheffield 1950 (32); *Pictures from Country Houses*, Bedford 1952 (32); Tate & Walker 1958 (27)

LITERATURE
Nicolson no.118 pp.216–7; pp.69–70; pl.197; Stewart 1976, p.410, fig.91

D.G.C. Inglefield Esq. & C.S. Inglefield Esq.

Rev. John Pickering, second son of John and Anne Pickering of Mackworth, was born in 1706 into a family of Derbyshire yeoman stock who had long served as stewards and farm-managers to the pre-eminent local family, the Mundys of Markeaton Hall. John Pickering went to Derby Grammar School (later marrying the only daughter of the Headmaster, the Rev. Anthony Blackwall) and then to Cambridge, where he read for Holy Orders. In 1731, the year he was ordained, Wrightson Mundy gave him the living of All Saints, Mackworth. There Pickering served for nearly sixty years, until his death on 17th December 1790.

Rev. John Pickering was succeeded as Vicar of Mackworth by his son Rev. William Pickering (1741–1802), and he in turn by his son Rev. George Pickering (1780–1805). Each of these three has been proposed as the subject of this portrait; but Nicolson's dating of *c.*1777–80 seems absolutely right, and only the Rev. John Pickering was at that time the right age to be its sitter. He would have been about seventy-one to seventy-four years old in 1777–80 (and is the only one who could be described, in Wright's Account Book of the early 1790s, as 'the late M.^r Pickering'). Rev. William Pickering (Nicolson's preferred candidate) would have been aged thirty-six to thirty-nine, surely at least twenty years too young to be Wright's sitter; and Rev. George Pickering was still unborn.

The Rev. Thomas Gisborne, who, with his wife, is the subject of one of the most affectionate of all Wright's portraits (No.146), commissioned a copy of the Pickering portrait soon after the Rev. John Pickering's death in 1790. That commission strongly supports the identification of the sitter as Rev. John Pickering. When Gisborne was a boy, Rev. John Pickering was his tutor for six years 1768–73, until Gisborne went to Harrow; Leslie Stephen considered this relationship important enough to include in his *DNB* notice of Gisborne. Pickering's tuition is likely to have played a part in Gisborne's future academic brilliance. On the evidence of Wright's portrait, Pickering's interest in mathematics may have helped his pupil to emerge from Cambridge as Sixth Wrangler.

Pickering's role as tutor, or possibly as lecturer or demonstrator to a wider audience, probably accounts for the mathematical diagram which he holds. The compiler is grateful to Dame Margaret Weston for explaining that the diagram is, alas, meaningless by itself, without the text of a lecture or demonstration in which it would have been displayed. Nicolson, fastening on the diagram, concludes that it identifies the sitter as the Rev. William Pickering, since he was a member of the Derbyshire Philosophical Society in the 1780s. But perhaps all the Pickerings were natural philosophers.

Later, in 1783, Rev. Thomas Gisborne settled down at Yoxall Lodge, as Perpetual Curate of Barton-under-Needwood, over the Derbyshire border into Staffordshire, but still within easy visiting distance of Rev. John Pickering at All Saints, Mackworth. He must have felt a considerable bond with his old tutor to have asked Wright to paint him a copy of this portrait.

Wright's handling of the folds and highlights of Pickering's ancient-looking green velvet turban is particularly admirable. The turban itself seems to belong to a bygone age, the age of Jonathan Richardson or Roubiliac; Wright may have chosen to portray Pickering in it to emphasise his venerability. Stewart shows that Wright has 'borrowed a Kneller design' for the lower part of the portrait, his likeliest source being John Smith's mezzotint of 1716 after his own portrait by Kneller (Stewart fig.94).

As always, Nicolson writes brilliantly about the portrait: 'Many portrait painters would have rested content, once they had captured Pickering's splendid ugliness, to leave the rest of him a suggestion of form to be filled in by the mind, but Wright goes on from his face to investigate with equal ardour the light on cap and scroll, and to make every inch of him solid as though he were a bust in the round, liberated from stone. He does not care to fall back on the portrait painter's short-hand – those seductive squiggles that serve for modelling – but must always insist on what is there' (p.69).

149

Self-Portrait at the age of about Fifty *c.*1782–5

Oil on canvas $24\frac{1}{2} \times 20\frac{3}{4}$ (61.6 × 52.7)
PROVENANCE
Probably given by the artist to his daughter Romana, who married James Cade, thence in the Cade family until acquired by Gen. W. Wright Bemrose *c.*1900; W.A.W. Bemrose, from whom purchased by the National Portrait Gallery 1959
EXHIBITED
Derby 1870 (793 or 798); Derby 1883 (44); Graves 1910 (32); Derby 1934 (77)

National Portrait Gallery, London

Here the artist, born in 1734, seems to be approaching fifty, or is perhaps just past that age. A date of *c.*1782–5 is therefore suggested. The work is too incomplete for comparison with finished portraits to help with its dating, but the cut of the collar and coat seem to be about the same as in such portraits as 'Samuel Ward' (Nicolson pl.229) of *c.*1782–3 or later.

This is not a great portrait. The handling is almost perfunctory, and the work lacks finishing touches; the condition of the picture is only fair, with old retouchings showing through, especially on the left side of the mouth. But it remains a telling image of Wright as he begins the last fifteen years or so of his life. The hair is thinning, and turning grey, and the gaze is troubled. The artist's friend and obituarist John Leigh Philips noted that Wright's eyes were 'prominent and very expressive' (*Monthly Magazine*, 17 October 1797, pp.289–94). The pink chalkiness of the face would have benefited from further modelling.

Wright included a 'Portrait of an Artist' in his one-man exhibition at Robins's Rooms in 1785 (21): also a self-portrait, painted the previous year and purchased by Josiah Wedgwood. Besides Wedgwood's liking for Wright's work, the portrait may have had an additional, almost technical appeal to him because, in the words of the *Evening Post*'s reviewer, 28–30 April 1785, it 'possesses a softness similar to a fine enamel' (the reviewer added that 'the head is highly finished'). That 'Portrait of an Artist' is now untraced; but although that work and the self-portrait shown here must have been painted about the same time, they can hardly be one and the same. Quite apart from the reviewer's comments and

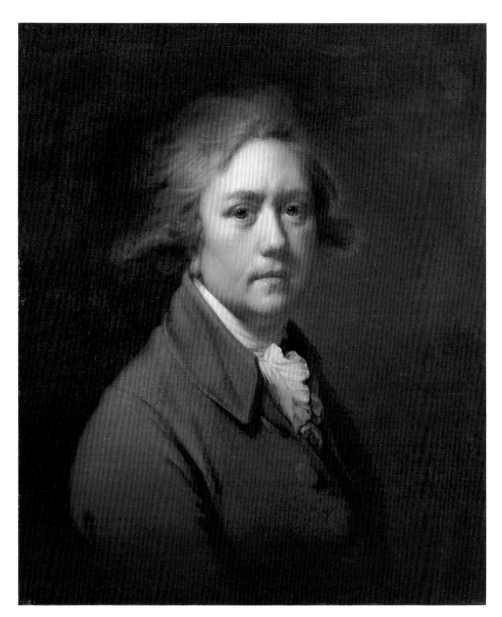

149

questions of provenance, this work has a private, intimate quality (and a lack of finish) which would have made it an inappropriate choice as the one self-portrait which Wright included in that one-man exhibition of 1785 which he hoped would truly establish his fame.

Nicolson catalogues nine self-portraits (pp.229–230), of which three are untraced, though his no. 170 is known through James Ward's engraving, an impression of which is shown here, No.174 (P43). Two charcoal studies included by Nicolson, nos.165–6, seem most unlikely to be self-portraits; he does not include the charcoal self-portrait in Derby Art Gallery shown here as No.43.

Nicolson's omission of the National Portrait Gallery's self-portrait, both from

his book and from *Addenda* to it, is puzzling. If he doubted its authenticity, then he would quite properly have omitted it from his catalogue of works certainly by Wright; but he also discusses various copies which are sometimes the only evidence of a lost original. When the acquisition of this self-portrait for the National Portrait Gallery was discussed, its Director asked Nicolson to join the discussion. From a memorandum in the Gallery's files, it is clear that no doubts about the portrait's authenticity were raised. Its omission from Nicolson's book may have been a simple oversight.

150

**Harriet Wright, the Artist's
Daughter** *c.*1790–3

Brown monochrome on panel 10 × 8⅜
(25.4 × 21.3)
PROVENANCE
According to an old label on the back
(fully quoted by Nicolson p.231), given by
Wright to 'his favourite friend Mary
Tunnaley', and by her to her daughter
Harriet; . . . ; T.A.G. Pocock, from whom
purchased by Derby Art Gallery 1967
LITERATURE
Nicolson no.178 p.231, p.20; pl.322

Derby Art Gallery

Wright's second daughter Harriet was
born on 12 May 1778. Almost nothing is
known of her life. She may or may not be
one of the 'two children of the artist' in the
portrait formerly in the Cade collection
(Nicolson no.177), exhibited in 1883 (75)
as 'John and Maria', but reproduced by
Bemrose facing p.56 as 'Joseph and
Harriet'.

 In the portrait exhibited here she
appears to be between twelve and fifteen
years old. Her mother died in 1790.
Nicolson supposes, reasonably enough,
that after her elder sister Romana married
the Derby surgeon James Cade in April
1795, 'the burden of looking after him
[Wright] in his last illness fell chiefly
on . . . Harriet'. She would have been
nineteen when her father died. Harriet is
not known to have married. At some
unknown date (and in an unknown
capacity) she went to Australia and,
according to the Wright pedigree pub-
lished in Bemrose facing p.4, died there on
8 July 1860 near the River Plenty, which
could be either a tributary of the river
Yarra in Victoria or a tributary of the river
Derwent (named after the chief river of her
native Derbyshire) in Tasmania.

 This is the only monochrome oil sketch
by Wright known, though one might
reasonably have expected others.

150

151

GEORGE MONEYPENNY *d.*1807

Design for a Memorial Tablet to Joseph Wright of Derby ?1797

Pen and brown ink and grey wash on paper 8 × 6¼ (22.3 × 15.4), including ruled ink borders

PROVENANCE
. . . ; Abbott & Holder *c.*1975, from whom purchased by Richard Godfrey; given by him to Judy Egerton 1989

Judy Egerton

This is the design for the memorial tablet to Wright in St. Alkmund's Church, Derby, where he is buried. The compiler is grateful to Edward Saunders for identifying the designer as George Moneypenny of Derby, who carved for the architect Joseph Pickford and also did some work at Kedleston. Edward Saunders and David Fraser have kindly supplied most of the following information.

The finished memorial tablet, probably carved by Moneypenny himself, was mounted on a black marble base and placed 'on a pillar on the south side of the middle aisle' of St Alkmund's (R.Simpson, *History and Antiquities of Derby*, 1826, 11, pp.323–4); some idea of how it looked *in situ* on the curve of the pillar is given in an engraving reproduced by Bemrose, 1885, p.104. With its snake-handled and gadrooned urn and foliate base, the design has a chaste neo-classical simplicity which would probably have appealed to Wright, at least in his 'Corinthian Maid' mood. The memorial tablet was removed, probably in 1843, when St Alkmund's was rebuilt. Wright's tombstone was discovered in 1967, during demolition works; it bears only his name.

The inscription for the memorial tablet reads:

> *In the middle Iſle oppoſite this Pillar*
> *are depoſited*
> *the remains of*
> *Joſeph Wright Eſq.*
> *Painter*
> *He died Auguſt 29ᵗʰ 1797.*
> *Aged 62.*
> *His well earned Merit in his Works is ſhewn*
> *Where Taſte and Genius mark him for their own*
> *Here are Likewiſe Interred*
> *Anne wife of the ſaid Joſeph Wright*
> *Who died Auguſt 17ᵗʰ. 1790.*
> *Aged 41.*
> *John their Son who died March 22ᵈ 1798*
> *Aged 17.*
> *And Joſeph who died in his Infancy*

151

A CATALOGUE OF THE ENGRAVED WORKS OF JOSEPH WRIGHT OF DERBY

This catalogue includes all early prints after Wright; those shown in the exhibition are numbered in catalogue sequence. It is as complete as time and resources allowed: since it has not been possible to study the prints in every public collection it is not so much a catalogue raisonné as a provisional list and a number of problems remain unresolved. The prints are arranged in chronological order with copies described under the print from which they derive.

The first measurement is that of the plate, height before width. The exact size of individual impressions will be found to vary because of paper shrinkage but the dimensions given should be accurate to within 2–3 mm. Measurements given in inches are taken from secondary sources.

The original picture is identified by reference to Nicolson's catalogue and, if it has been exhibited, to the present catalogue of paintings. References to the prints in the principal relevant catalogues of engravings are cited in chronological sequence. Full details of these works are given in the bibliography that precedes the catalogue. The successive states of each print are then described, and the location of the impressions that have been consulted is given in brackets.

I should like to thank Judy Egerton and David Fraser for their help and encouragement at all times; Christopher Lennox-Boyd for his extensive co-operation and for allowing me to research Wright in Germany and France while ostensibly working on Stubbs; the staff of all the print rooms I have visited; David Kiehl at the Metropolitan Museum for patient answers to my enquiries; Christopher Mendez; Martin Hopkinson for selflessly sharing his research on Burdett; David Alexander for advice, hospitality and for checking the prints at Philadelphia.

ABBREVIATIONS

ABBREVIATIONS OF COLLECTIONS

Alexander	Collection of David Alexander, York
Aschaffenburg	Schlossmuseum, Aschaffenburg
Ashmolean	Ashmolean Museum, Oxford
BL	British Library, London
BM	British Museum, London
Caen	Musée de Beaux Arts, Caen
Derby	Derby Art Gallery
Hermitage	Hermitage State Museum, Leningrad
Fitzwilliam	Fitzwilliam Museum, Cambridge
Hunterian	Hunterian Art Gallery, Glasgow
Karlsruhe	Staatliche Kunsthalle, Karlsruhe
Lennox-Boyd	Collection of the Hon. Christopher Lennox-Boyd, London
MMA	Metropolitan Museum of Art, New York
NPG	Library, National Portrait Gallery, London
PMA	Philadelphia Museum of Art
RA	Library, Royal Academy of Art, London
Rijksmuseum	Rijksprentenkabinet, Rijksmuseum, Amsterdam
Royal Library	Collection of Her Majesty the Queen, Royal Library, Windsor Castle
SM	Science Museum, London
V & A	Victoria & Albert Museum, London
Veste Coburg	Veste Coburg, Coburg
Whitworth	Whitworth Art Gallery, Manchester

ABBREVIATIONS OF LITERATURE

YCBA	Yale Center for British Art, New Haven
Aitken	W. C. Aitken, 'Francis Eginton', *Transactions of the Birmingham Institute, Archealogical Section*, 1872, pp.28–34
Alexander	David Alexander, 'Rembrandt and the reproductive print in England' in C. White, D. Alexander and E. D'Oench, *Rembrandt in Eighteenth Century England*, Yale 1983
Bemrose	William Bemrose, *The Life and Works of Joseph Wright, A.R.A., commonly called 'Joseph Wright of Derby'*, London 1885
Booth 1787	Joseph Booth, *A Catalogue of Pictures Copied by a Chymical and Mechanical Process; the Invention of Mr. Joseph Booth; Exhibited with the Originals from which they have been taken . . .*, exhibition catalogue, London, Polygraphic Rooms, Strand, 1787
Booth 1790	Joseph Booth, *A Catalogue of Pictures . . .*, 1790
Booth 1792	Joseph Booth, *A Catalogue of Pictures . . . being their eighth . . .*, 1792
Booth 1793	Joseph Booth, *A Catalogue of Pictures . . . being their tenth . . .*, 1793
Boydell 1773	John Boydell, *1773. A Catalogue of Prints Published by John Boydell*, London 1773
Boydell 1803	John and Josiah Boydell, *An Alphabetical Catalogue of Plates . . . which Compose the Stock of John and Josiah Boydell*, London 1803
Boydell 1818	R.H. Evans (auctioneer), *A Catalogue of More than Five Thousand Copper Plates . . . Comprising the Entire Stock of Messrs. John and Josiah Boydell, Deceased*, 1 June 1818 and next five days
Bretherton	James Bretherton, *James Bretherton's Catalogue of Prints for the Year 1775*, London 1775
Bruntjen	H. A. Bruntjen, 'John Boydell (1719–1804): a Study of Art Patronage and Publishing in Georgian London', doctoral dissertation, Stanford University, 1974
Buckley	Charles E. Buckley, 'Joseph Wright of Derby in mezzotint', *Antiques*, (November 1957)
Chaloner Smith	John Chaloner Smith, *British Mezzotinto Portraits*, 4 vols, London 1883
Dayes	F.W. Brayley (ed.) *The Works of the late Edward Dayes*, London 1805
Dibdin	E. Rimbault Dibdin, 'Liverpool art and artists in the eighteenth century', *The Walpole Society*, VI, 1917–18, pp.59–93
Edwards	Edward Edwards, *Anecdotes of Painters who have Resided or been Born in England*, London 1808
Frankau	Julia Frankau, *John Raphael Smith, his life and works*, London 1902

Friedman Winifred H. Friedman, *Boydell's Shakespeare Gallery*, New York and London, 1976

Goodwin Gordon Goodwin, *British Mezzotinters, Thomas Watson, James Watson, Elizabeth Judkins*, London 1904

Green *A Catalogue of New Plates Engraved and Published by V. Green, Mezzotinto Engraver to His Majesty and to the Elector Palatine, No. 29 Newman Street, Oxford Street*, London [*c*.1780]

Hind Arthur Mayger Hind, 'Notes on the early history of soft-ground etching and aquatint', *The Print Collector's Quarterly*, XVIII (1921), pp.377–405

Hooper & Davis Samuel Hooper and William Davis, *A Catalogue of Prints and Books of Prints both Ancient and Modern . . .* , London [*c*.1777]

Huber 1787 Michael Huber, *Notices Générales des Graveurs divisés par Nations et des Peintres rangés par Écoles*, Dresden and Leipzig, 1787

Huber 1794 Michael Huber, *Catalogue Raisonné du Cabinet d'Estampes de feu Monsieur Brandes, Secretaire intime de la Chancellerie Royale de Hannovre contenant une Collection de Pièces Anciennes et Modernes de toutes les Écoles dans une suite d'Artistes depuis l'Origine de l'Art jusqu'a nos Jours*, 2 vols, Leipzig 1793–4

Huber and Martini Michael Huber, C.C.H. Rost and C.G. Martini, *Manuel des Curieux et des Amateurs de l'Art*, 9 vols, I–II London 1797, III–IX Zurich 1800–8

Joubert F.E. Joubert, *Manuel de l'Amateur d'Estampes*, 3 vols, Paris 1821

Karlsruhe Burkhard Richter, *Schwarze Kunst: Englische Schabkünstler des 18. Jahrhunderts*, exhibition catalogue, Staatliche Kunsthalle Karlsruhe, 1976

Lansdowne Leigh & Sotheby (auctioneers), *A Catalogue of the Extensive Collection of Maps, Charts and Books of Prints of the late Most Noble William, Marquis of Lansdowne . . .* , 14 April 1806 and next five days

Le Blanc Charles Le Blanc, *Manuel de l'Amateur d'Estampes*, 4 vols, Paris 1854–89

Lennox-Boyd, Dixon and Clayton Christopher Lennox-Boyd, Rob Dixon and Tim Clayton, *George Stubbs: The Complete Engraved Works*, London 1989

Moon, Boys & Graves Moon, Boys & Graves, *A Catalogue of Engravings by the Most Esteemed Artists, after the Finest Pictures and Drawings of the Schools of Europe . . . Forming Part of the Stock of Moon, Boys and Graves*, London 1829

Morris Roy Morris, 'Engravings after Joseph Wright A.R.A.', *The Print Collector's Quarterly*, XIX (1932), pp.94–115

Nagler G. Kaspar Nagler, *Neues Allgemeines Künstler-Lexicon*, 22 vols, Munich 1835–52

Pether Hutchins (auctioneer), *A Catalogue of the Valuable Copper-Plates, with their Impressions of an Artist Quitting that Part of the Profession . . .* , 18 May 1785

Raimbach T.S. Raimbach (ed.), *Memoirs and Recollections of the late Abraham Raimbach Esq., Engraver*, London 1843

Robinson and Thompson Eric Robinson and Keith Thompson, 'Matthew Boulton's mechanical paintings', *The Burlington Magazine*, CXII (1970), pp.497–507

Russell Charles E. Russell, *English Mezzotint Portraits and their States: Catalogue of Corrections of and Additions to Chaloner Smith's 'British Mezzotinto Portraits'*, 2 vols, London and New York, 1926

Shropshire Walter Shropshire, *Walter Shropshire's Catalogue of Prints for the Year 1771*, London 1771

Smith John Raphael Smith, *A Catalogue of Prints Published by J.R. Smith*, London [*c*.1800]

Thane John Thane, *John Thane's Catalogue of Prints for the Year 1774*, London 1774

Thompson Thomas Dodd (auctioneer), *A Catalogue of the very Extensive and highly Superior Stock of Engraved Copper Plates. . . . the Property of Mr. J. P. Thompson of Gt. Newport Street who is declining this branch of the profession*, 28 March 1810 and next day

Watson [Sale of Thomas Watson's Plates and Prints], 25 January 1792

Wessely Ignazius E. Wessely, *Richard Earlom: Verzeichniss seiner Radierungen und Schabkunstblätter*, Hamburg 1886

Whitley William T. Whitley, *Artists and their Friends in England 1770–1799*, 2 vols, London 1928

Whitman Alfred Whitman, *Valentine Green*, London 1902

A Philosopher Giving a Lecture on the Orrery

Drawn and engraved by William Pether
Published by John Boydell 20 May 1768
Mezzotint, 480 × 580 mm (image
446 × 580 mm)
Nicolson 190; this cat. No.18
Huber 1794, Wright; Huber and Martini,
Pether no.21; Joubert, II, p.349; Nagler,
Wright no.9; Chaloner Smith no.48;
Bemrose no.4; Le Blanc, Pether no.39;
Russell no.48

I

Finished proof before title or coat of arms
with the scratched inscription: *Jos^h, Wright
Pinx^t, Jn°, Boydell Exc^t, W^m. Pether fecit 1768.*
(Karlsruhe III, 1871)

II

Finished proof with a coat of arms added
and the scratched inscription: *Jos^h, Wright
Pinx^t, J Boydell, Exc^t, W^m. Pether fecit 1768
1768.* The second *1768* is much smaller
than the first and faintly scratched to the
right of, and below, the first. The coat of
arms bears no motto. The earlier, central,
J Boydell Exc^t has been almost entirely
erased to make way for the coat of arms
(BM 1862–5–17–192; Derby 936–20–24;
Lennox-Boyd; PMA 54–73–21; V & A
29445.2)

III

The image reworked and the above
inscription rescratched slightly larger. The
second *1768* is now larger and closer to the
first. A motto added: *MALGRE
L'ENVIE.* (BM 1862–5–17–192; 2
Lennox-Boyd; SM 1976–340; Veste Coburg
XI, 36,16)

IV

With the engraved inscription: *Joseph
Wright Pinxit. J. Boydell excudit. W^m. Pether
delin^t et fecit. A PHILOSOPHER
GIVING A LECTURE ON THE
ORRERY. From the Original Picture painted
by M^r Joseph Wright; In the Collection of the
Right Honourable the Earl of Ferrers. Publiſhed
May 20^th 1768.* (Aschaffenburg E 7,12; BM
1872–10–12–1642; Derby 219–9–54 and
859–7–1889; Lennox-Boyd; MMA
53.600.565; Veste Coburg XI, 36,15)

V

Very worn; the plate edges bevelled eras-
ing the base of the coat of arms and the
edges of the image which now measures
440 × 575 mm (Lennox-Boyd P13080)

In May 1768, two years after the showing
of Wright's painting, Pether exhibited

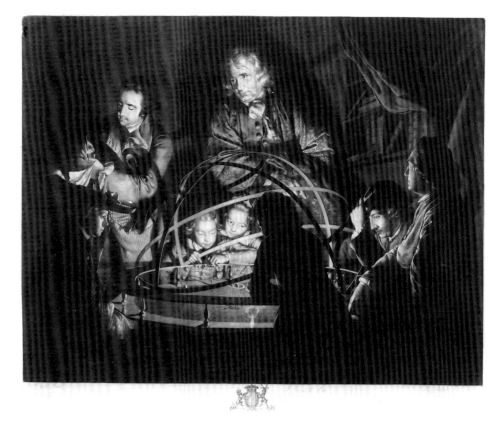

P I

this engraving at the Society of Artists
(no.271) as 'A proof print of a philosopher
giving a lecture on the Orrery; from Mr.
Jos. Wright of Derby.' Publication of the
print on 20 May 1768 was evidently timed
to coincide with the exhibition, making the
most of the interest excited by the print on
show and by Wright's latest major exhibit,
'The Air Pump'. The two year gap
between the showing and the publication
of *The Orrery* is, nevertheless, rather puzz-
ling and it is difficult to guess who first
suggested that a print should be made of
Wright's painting and what their reason
was. The inscription on the print includes
the relatively uncommon acknowledge-
ment that Pether made a drawing of the
original picture. Although engravers nor-
mally made some sort of reduction of a
picture before working on their plate, this
formal acknowledgement probably
implies that Pether was unable to borrow
the original picture and therefore drew a
careful finished copy at the house of its
owner, Earl Ferrers, from which he later
engraved the mezzotint.

In Boydell's catalogue of stock for 1773
The Orrery was priced at 15s. (p.24, no.11)
and this remained the standard price for

ordinary impressions until at least 1803
(see Hooper & Davis no.860 and Boydell
1803). Proofs, however, might be more
expensive and the impression bought by
John Milnes from Pether in 1778 cost
1 guinea.

The plate was sold in the 1818 Boydell
sale (sixth day, lot 338) with 14 proofs and
3 prints. The final state of the print
certainly post-dates this sale.

State II exhibited
The Hon. Christopher Lennox-Boyd

153

P2

A Philosopher Shewing an Experiment on the Air Pump

Drawn and engraved by Valentine Green
Published by Green 1769
Mezzotint, 480 × 585 mm (image
445 × 585 mm)
Nicolson 192; this cat. No.21
Green no.68; Huber 1794, Wright; Huber
and Martini, p.266; Joubert, II, p.114;
Nagler, Wright no.10; Chaloner Smith no.
163; Bemrose no.5; Le Blanc, Green no.40;
Whitman no.167

I

Finished proof with the scratched inscription: *Jos. Wright Pinxit, 1768. Val. Green fecit, et excudit, 1769* (Derby; v & A)

II

Finished proof with the scratched inscription: *Jos. Wright Pinxit, 1768. J. Boydell, excudit, Val. Green fecit, Londini 1769. Londini* replaces the previous *excudit* and the result looks like *Londinit*. (BM 1867–10–12–600; Fitzwilliam; with Fred Mulder, 1989; SM 1982–808; Veste Coburg XI 54,99)

III

With the title in closed letters and the engraved inscription: *Joseph Wright pinxit. J. Boydell excudit 1769. Valentine Green del & fecit. A PHILOSOPHER SHEWING AN EXPERIMENT ON THE AIR PUMP. From the Original Picture, Painted by Mr. Joseph Wright. Publiſhed June 24th. 1769.* (Aschaffenburg III E5,27; Lennox-Boyd P5355; MMA 53.600.567; YCBA, B1978.43.1114)

IV

The edges of the plate bevelled and the image consequently reduced in size to 440 × 580 mm and the base of the publication line partly erased. The plate inked so heavily that most of the details in the shadows are obscured (Lennox-Boyd P13078)

A year after Wright's painting was exhibited at the Society of Artists, Green showed this engraving there (no.271). The inscription on the print ('Valentine Green del & fecit') indicates that Green based his mezzotint on a close copy of the original picture, presumably drawn at the house of its owner, Dr Benjamin Bates. It is likely, therefore, that Green had admired the painting at the 1768 exhibition and had asked permission of Wright and Bates to engrave it during the following year. Green's initial issue was probably timed to coincide with the 1769 exhibition (which

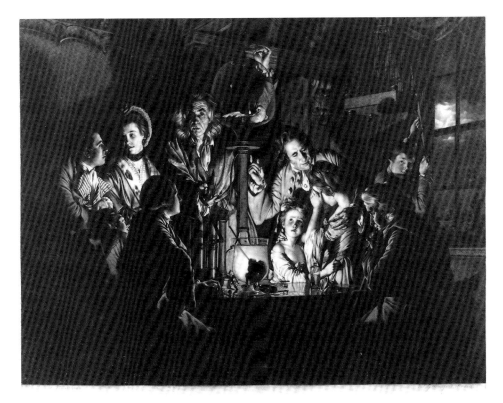

P 2

lasted from May 1 to June 2) by which means he would have derived maximum benefit from the interest aroused by the exhibition and the opportunity to display the print. Indeed, the exhibition probably drew John Boydell's predatory attention to the *Air Pump* since he had purchased the plate from Green and republished the engraving by late June 1769.

The plate remained in the hands of Boydell's firm until the death of John Boydell's nephew Josiah in 1817, priced throughout the period at 15s. (Boydell 1773, p.24, no.12). Green also sold impressions at the same price (Green no.68). Fine impressions of the *Air Pump* have always been expensive and as early as 1777 a proof in Hooper & Davis's catalogue of stock (no.504) was priced at £1 7s.

The plate was sold in the 1818 Boydell sale (sixth day, lot 338). The bevelling of the plate edges in the print's final state post-dates that sale and it is clear that bad impressions continued to be printed for much of the nineteenth century.

State I exhibited
Board of Trustees of the Victoria & Albert Museum

P3

[Three persons viewing the Gladiator by Candlelight]

Engraved by William Pether
Published by Pether 10 July 1769
Mezzotint, 480 × 555 mm
(image 440 × 555 mm)
Nicolson 188; this cat. No.22
Huber 1794, Wright; Huber and Martini,
Pether no.22; Joubert, II, p.349; Nagler,
Wright no.16; Chaloner Smith no.45;
Bemrose no.6; Le Blanc, Pether no.37;
Russell no.45

I

Finished proof with the upper half of the inscription space still grey and the scratched inscription: *Jos*, Wright, Pinx*, Published July, 10*, 1769, & sold by W, Pether in Ruffell Str*, Bloomsb*, Wm. Pether, fecit.* The letters *ly 10** appear to be an alteration from earlier ones (Aschaffenburg III E7,11; BM 1868–8–8–2661; Fitzwilliam; Karlsruhe III, 1872; Lennox-Boyd P2819 and another; Rijksmuseum; Veste Coburg XI 36, 18; V&A 29445.3)

II

Finished proof with the upper half of the inscription space burnished clean; the scratched inscription strengthened (Derby 859–15–39)

III

With the engraved inscription: *Done from a PAINTING, of M* Jos*. Wright's of DERBY, by his Oblig'd Friend & Humble Servant Wm. Pether. In the Collection of B. Bates M.D. of Aylesbury. Publifh'd July 10*. 1769. & Sold by W* Pether in Ruffel Street Bloomfbury.* (BM 1867–3–9–1722; Derby; Lennox-Boyd; MMA 53.600.564 and 53.600.4469)

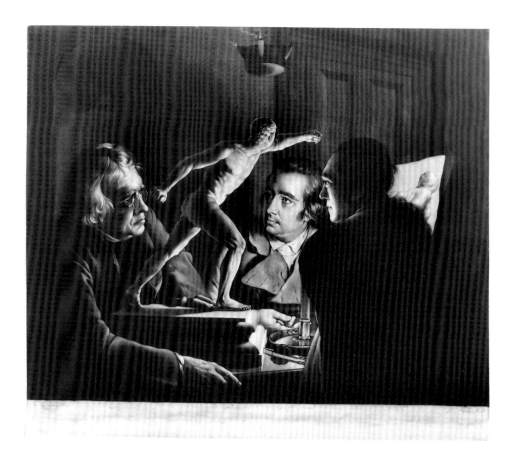

P3

Wright's painting was shown at the Society of Artists in 1765 but Pether's print, published four years later, was not exhibited. It must have been clear by 1769 that there was a demand for prints of Wright's paintings and the inscription on *The Gladiator* suggests that Pether had asked permission to engrave this picture which, like the *Air Pump*, was in the collection of Dr Benjamin Bates, a friend of both Wright and Pether.

Pether's original price for this print is not recorded but known retail prices vary between 6s. charged for an ordinary impression in the printseller John Thane's 1774 catalogue (no.1218) and the 15s. paid by John Milnes to Pether in 1778 for what was presumably a proof (Bemrose, p.125).

The plate was sold in Pether's 1785 sale (lot 44 with 20 impressions) for £1 4s. The low price suggests that it was worn out.

State I exhibited
The Hon. Christopher Lennox-Boyd

155

P4

[The Bradshaw Children]

Engraved by Valentine Green
Published by Ryland & Bryer 1769
Mezzotint, 475 × 380 mm
(image 445 × 380 mm)
Nicolson 24
Huber 1794, Wright; Bemrose no.2;
Whitman no.11

I
Unfinished proof (recorded by
Whitman, not seen)

II
Finished proof with the scratched inscrip-
tion: *Jos. Wright pinxit. Val. Green fecit.*
(YCBA, B1970.3.698)

III
Finished proof with the additional scrat-
ched inscription: *Ryland & Bryer ex.*
between the artists' names (Aschaffenburg
II E21,14; Derby 936–3–24 and 219–2–54;
Fitzwilliam P24.1981; Lennox-Boyd)

IV
With the engraved inscription: *Publishd*
According to Act of Parlt. 1769 Jos. Wright
pinxit Val. Green fecit, Sold by Ryland & Bryer
No.27 Cornhill. (Lennox-Boyd P2389; MMA
53.600.4470; Royal Library)

Copies:
4a
Mezzotint by S. Paul *c.*1770 showing only
the two girls and the lamb, 352 × 250 mm
(image 322 × 250 mm), inscribed: *Wright*
*Pinx.t ſ Paul fecit Miſs Wrighte. (*NPG)
4b
Mezzotint by Richard Brookshaw *c.*1770
showing only the two girls and the lamb,
148 × 112 mm (image 130 × 112 mm),
inscribed: *Wrights Pinx.t R. Brookshaw fecit*
Miss Wright's, Printed for John Bowles No.13
in Cornhill. (Derby 936–1–24;
Lennox-Boyd P6767)

P4

If, as I suspect, Wright's painting was the
subject listed as 'A Conversation' in the
Society of Artists' 1769 catalogue
(no.199), the existence of this engraving
can be more easily explained. In the
absence of any title the print was generally
assumed to portray 'Mr Wright's
Children' and it is difficult to imagine that
the true sitters, the children of Joseph
Baggaley of Holbrook who had recently
assumed the name and fortune of the
Bradshaws (see Nicolson p.98), would
have been satisfied with such anonymity
had they commissioned the print. It is
more likely that Green the engraver, or

Ryland the publisher, saw the picture at
the exhibition and recognised the com-
mercial potential of such a pretty portrait
of children. The fact that the engraving
was soon pirated twice confirms their
judgment and its appeal.

This print was not in Green's 1780 cata-
logue and so its original price is unknown.
Early retail prices range between 6*s.*
charged by John Thane in 1774 for an
ordinary impression and 10*s.* 6*d.* asked by
Walter Shropshire in 1771 for a proof.

State III exhibited
Derby Art Gallery

P 5

An Hermit

Engraved by William Pether
Published by Pether 14 May 1770
Mezzotint, 580 × 455 mm (image
562 × 455 mm)
Nicolson 196; this cat. No.41
Huber 1794, Wright; Huber and Martini,
Pether no.25; Joubert, II, p.350; Nagler,
Wright no.14; Chaloner Smith no.47;
Bemrose no.7; Le Blanc, Pether no.40

I
Finished proof with the inscription etched
on a whitened panel: *Published May 14ᵗʰ,
1770, & sold by Wᵐ, Pether in Gᵗ, Ruſſel Stᵗ,
Bloomsbʳ*, and in white with etched edges
on a dark grey ground either side: *IOSᴴ.
WRIGHT PINXᵗ. W. PETHER
FECIT*. (BM 1877–8–11–987; Caen,
Collection Mancel; Derby 902–23;
Karlsruhe III, 1873; Lennox-Boyd; Veste
Coburg XI 36,19)

II
With the title in closed letters and the
engraved inscription: *Josᵗ. Wright Pinxit.
Wᵐ. Pether Fecit. AN HERMIT. Publish'd
May 14ᵗʰ. 1770. and Sold by Wᵐ. Pether, in Great
Ruſſell Street Bloomsbury*. (Aschaffenburg II
E23,37; Derby 936–17–24; Lennox-Boyd
P1682 and another; MMA 53.600.4467)

Wright's painting 'A Philosopher by
Lamp light' was exhibited with the Society
of Artists in 1769 and Pether exhibited the
print there the following year (no.234, 'An
hermit; a mezzotinto proof (nearly
finished), from a painting of Mr Joseph
Wright.'). *An Hermit* was published on the
final day of the 1770 exhibition which
lasted from April 26 to May 14. During
this period Wright seems to have been
staying with Pether since his address in the
exhibition catalogue was 'At Mr Pether's,
Great Russell Street, Bloomsbury'. The
exhibition and Wright's presence must
have provided very good publicity for an
engraving which was evidently at the very
least officially sanctioned by the painter.
An Hermit and its later companion *An
Alchymist* are the only prints after Wright
engraved in the reverse direction to the
original painting. Pether's standard price
for this print is not known but he sold an
impression to Milnes in 1778 for 15*s*. The

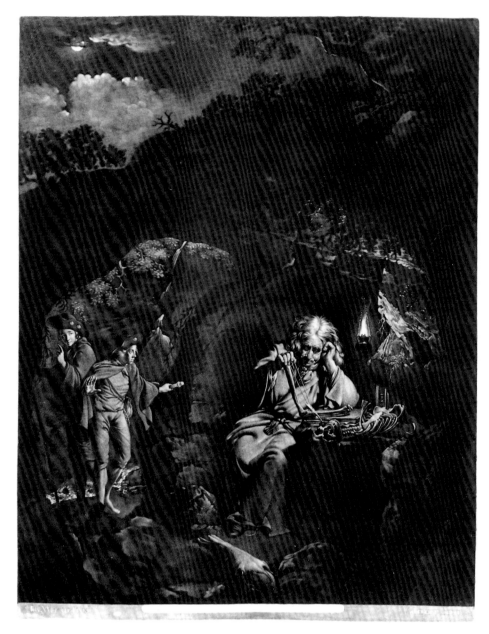

P 5

plate was sold at auction in 1785 (lot 41,
with 6 impressions) for 14*s*., the very low
price suggesting that the plate was worn
out. However, it was acquired by the
engraver-printseller William Dickinson
and was presumably reworked, for when
Dickinson's stock was eventually dispersed
in 1794 the plate was sold for 6 guineas
(third day, lot 87).

State I exhibited
Derby Art Gallery

P 6

Master Ashton

Engraved by William Pether
Published by Pether 26 November 1770
Mezzotint, 505 × 350 mm (image
460 × 350 mm)
Nicolson 10
Huber 1794, Wright; Nagler, Wright no.1;
Chaloner Smith no.1; Bemrose no.10; Le
Blanc, Pether no.8
I
Finished proof with the scratched inscrip-
tion: *Jos^h,.^h. Wright Pinx^t. Published Nov^r, 26^th.
1770 & Sold by W Pether in G^t. Russell S^t.
Blooms^y. – W. Pether. Fecit 1770.* The inscrip-
tion space not burnished clean
(Aschaffenburg II E23,21; Fitzwilliam;
Lennox-Boyd P2803)
II
With the title in closed letters and the
engraved inscription: *Jos^h. Wright Pinx^t.
W^m. Pether Fecit. MASTER ASHTON.
Publish'd as the Act directs Nov^r. 26. 1770. by
W^m. Pether in Gr. Ruſsel Str. Bloomsbury.* (BM
1873–7–12–634; Derby 936–21–24 and
859–6–39; 3 Lennox-Boyd; MMA
53.600.4471; NPG)

Wright's painting was exhibited with the
Society of Artists in April and May 1770
(no.303) as a 'Child with a Dog'. It shows
the son of Nicholas Ashton, a Liverpool
ship owner and salt manufacturer, of
whose family Wright painted a number of
portraits (see No.25). Pether's print was
published six months after the exhibition
and was not itself exhibited. Ordinary
impressions probably sold originally for 6s.,
the price Pether charged John Milnes in
1778. The printseller Walter Shropshire
had a proof in stock in 1773 at 7s. 6d.
(no.2490).

The plate was sold by Pether at auction,
18 May 1785, lot 37, with 43 impressions
for 15s.

157

P 7

A Blacksmith's Shop

Engraved by Richard Earlom
Published by John Boydell
25 August 1771
Mezzotint, 610 × 430 mm (image
555 × 430 mm)
Nicolson 199; this cat. No.47
Huber 1787, p.688; Huber 1794, Wright;
Huber and Martini, Earlom, subjects, no.8;

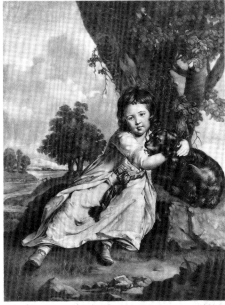

P 6

Joubert, II, p.23; Nagler, Wright no.13;
Chaloner Smith no.47; Bemrose no.13;
Wessely no.122; Le Blanc, Earlom no.42
I
Finished proof before any inscription
(Fitzwilliam)
II
Finished proof with the scratched inscrip-
tion: *Jo^s, Wright Pinxit R^d Earlom fecit J
Boydell Excudit Publish'd August 25; 1771.* The
upper area of the inscription space still
grey (BM 1868–8–8–2651; Derby
859–18–39; Hermitage 138665;
Lennox-Boyd P2801 and another; Veste
Coburg XI 94, 42; V & A 19974)
III
With the engraved inscription: *Joseph
Wright pinxit. John Boydell excudit 1771. Rich^d.
Earlom ſculpsit. A BLACKSMITH'S
SHOP. From the Original Picture, Painted by
M^r. Joseph Wright; In the Collection of the
Right Honourable Lord Melbourne. Size of the
picture 3^F. 4^I by 4^F. 2^I in Height. Publiſhed Aug^t:
25^th. 1771, by John Boydell, Engraver in
Cheapſide London.'* (Derby 219–10–1954
and another; Karlsruhe III,1866; MMA
53.600.569; SM 1980 – 348; PMA,
A–M–22; YCBA, B1977.14.14589)

Copy:
7a
Wood-engraving by H.S. Barton, 74 × 124
mm (Derby 86–3–27)

Wright's painting was exhibited at the
Society of Artists from May 15 to June 3
1771 and Earlom must have worked fast to
have the print ready for late August if he
had not started before the exhibition.

In Boydell's 1773 catalogue of stock this
print is listed at 15s. (p.24, no.10) and the
print was still in Boydell's stock in 1803 at
the same price. The plate and 5 prints were
offered for sale in 1818 (sixth day, lot 339)
and were bought by Moon, Boys & Graves
who listed the print in 1829 still at 15s.
Nineteenth-century impressions are, need-
less to say, rather the worse for wear. Fine
impressions, however, commanded high
prices and Shelburne's example made £2
13s. in 1806 (Lansdowne, fifth day, lot
456).

State II exhibited
Trustees of the British Museum

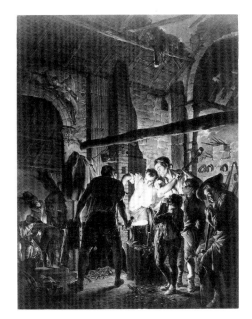

P 7

P8

A Farrier's Shop

Engraved by William Pether
Published by Pether 1 December 1771
Mezzotint, 500 × 350 mm (image
450 × 350)
Nicolson 199, small version
Huber 1794, Wright; Chaloner Smith
no.49; Bemrose no.9

I
Finished proof with the inscription in
white letters on a dark inscription space:
*Ios^h^: Wright Pinx^t^. Publish'd Dec^r^. 1^t^, 1771. W:
Pether. Fecit.* (Alexander; BM
1870–5–14–485; Derby 219–11–54;
Karlsruhe; MMA 53.600.563)

II
With the additional inscription: *A
FARRIER'S SHOP. Sold by W. Pether
G^t^. Russell S^t^. Bloomsbury.* The inscription
space grey (illustrated in Christopher
Mendez, *Fine English Prints*, exhibition
catalogue, November 1980, no.69)

III
The date altered to: *Dec^r^. 2^d^.*
(Aschaffenburg II E23,38; Derby
818–5–21; Lennox-Boyd P3172; Veste
Coburg XI 36,13)

Wright's painting was exhibited at the
Society of Artists in 1771 (no.202) as 'A
small Ditto [Blacksmith's Shop], viewed
from without' and was bought by Edward
Parker of Brigg in Lincolnshire at or soon
after the exhibition. It was sold at Christie's
after his death in 1782 to 'Stears' for 10
guineas (see Nicolson 1988, pp.757–8) and
is now lost.

Pether's original price for the print is not
known but he supplied John Milnes with
an impression in 1778 for 10s. 6d.

The plate was sold at auction by Pether,
18 May 1785, lot 47, with 17 impressions,
for £1 8s. In the same sale he sold a framed
proof for 8s. 6d. (lot 57).

State I exhibited
Derby Art Gallery

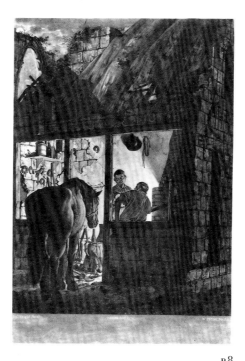

P8

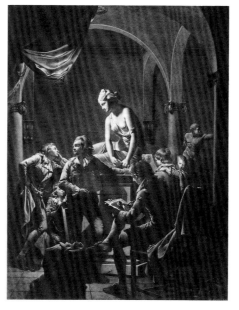

P9

P9

An Academy

Engraved by William Pether
Published by Pether 20 February 1772
Mezzotint, 580 × 455 mm
Nicolson 189; this cat.No.23
Huber 1794, Wright; Huber and Martini,
Pether no.23; Joubert, II, p.349; Nagler,
Wright no.17; Chaloner Smith no.46;
Bemrose no.11; Le Blanc, Pether no.36

I
Finished proof with the inscription in
white at bottom: *Ios^h^ Wright, Pinx^t^ W Pether,
Fecit.* (Derby 859–16–39; with Rob Dixon,
1989; Karlsruhe III, 1872;
Lennox-Boyd; PMA, A–M–23)

II
With the additional engraved inscription
on the portfolio carried by the artist left
centre: *An Academy. – Published by W Pether,
Feb^y^, 25^h^, 1772*, and at the foot of the seated
artist, bottom centre: *Done from a Picture in
the Collection of the R^t^. Hon, L^d^. Melburne.*
(Derby 936–16–24; Lennox-Boyd; MMA
53.600.566; PMA 50–33–3; Veste Coburg
XI 36,17; V&A, E443–1889)

Copy:
9a
Etching by Normand (Bemrose no.12),
108 × 90 mm, published in G. Hamilton,
The English School, 1831 etc., p.232,
inscribed: *J. Wright Normand fils. THE
DRAWING ACADEMY. L'ECOLE
DE DESSIN*

There appears to have been a three year
gap between the exhibition of Wright's
painting at the Society of Artists in 1769
and the publication of Pether's print,
which was not itself exhibited. Pether pre-
sumably copied the painting at Lord
Melbourne's house.

Bretherton had an impression in stock in
1775 priced at 1 guinea (p.68, no.2492),
but 15s., the price Pether charged John
Milnes in 1778, was probably standard.

Pether sold the plate at auction in 1785,
lot 39, with 7 impressions, for 3 guineas
to Williams.

State I exhibited
Derby Art Gallery

[Kneeling Figure]

Engraved by Peter Perez Burdett
Engraved *c*.1772
Aquatint with etching
Previously unrecorded print

I
With no inscription (Liverpool University
Library, Gregson collection)

The attribution of this design to Wright
rests on an inscription on the impression in
the Gregson collection at Liverpool
University. Matthew Gregson
(1749–1824), an upholsterer by trade,
exhibited designs for Chinese, Palmyrean
and Gothic beds at the Society of Artists in
Liverpool in 1774 and was a founder
manager of the Society in its next incar-
nation in 1783 (see Dibdin pp.74–6). In
that capacity he would have come into
contact with Wright who exhibited in
Liverpool in 1784 and 1787, if indeed he
had not already met Wright when the
painter was working in Liverpool between
1768 and 1771. Gregson came to own a
number of plates and prints by Peter Perez
Burdett, a leading light of the earlier
Liverpool Society, and was as well placed
as anyone to know whose design they
reproduced. Stylistically this design is
sufficiently anonymous to render positive
attribution impossible.

It is difficult even to identify the subject
of the print – a monk is as plausible as a
detail from a crucifixion – but it may be a
drawing from an old master. It is not
unlike Wright's Italian drawings but could
not have been made so late: Wright was in
Italy when he heard of Burdett's precipi-
tous departure for Germany in 1774, there
was little time to have sent him a drawing
and in any case this print seems to be of an
earlier date.

Burdett was the first artist to discover
the aquatint process in England. It is
generally accepted that the 'etching in
imitation of a wash drawing' and its com-
panion that he exhibited with the Society
of Artists in 1772 (nos.10–11) simulated
the effect of wash with aquatint grain, and
that Hind correctly identified one of them
with a print of *banditti* after Mortimer by
Burdett dated 1771 (see Hind pp.402–5).
Burdett's next goal was to work purely in
aquatint, relying on transitions of tone
rather than on lines. The appearance of
this plate suggests technical uncertainty,
with an etched outline and crudely
executed, perhaps unfinished, aquatint
tone. It might, therefore, predate

the already accomplished aquatint grain
on the plate of 1771 or it might be associ-
ated with the quest for pure aquatint
which reached fruition in 1773 (see no.13).
The plate is now in Liverpool University
Library.

160

Miravan

Engraved by Valentine Green
Published by John Boydell
18 December 1772
Mezzotint, 500 × 355 mm
(image 460 × 355 mm)
Nicolson 222
Green no.80; Huber 1794, Wright; Huber
and Martini, Green, subjects, no.34;
Joubert, II, p.114; Nagler, Wright no.3;
Chaloner Smith no.162; Bemrose no.3;
Le Blanc, Green no.49; Whitman no.174

I
Finished proof before any inscription
(BM 1868–8–8–2633)

II
Finished proof with the inscription in
scratched letters: *Jos. Wright pinxit. Pub-
lish'd Decemr. 18th. 1772. by J. Boydell,
Cheapside. V. Green fecit.* The inscription
space partly cleaned with the lower area
white (BM 1912–6–12–20; Derby 807–21;
Lennox-Boyd P2802; MMA 53.600.4465;
Veste Coburg XI 54,105; YCBA,
B1977.14.14596)

III
With the title in closed letters and the
engraved inscription: *Joseph Wright pinxit.
John Boydell excudit 1773. Val. Green fecit.
MIRAVAN, a young Nobleman of Ingria,
breaking open the Tomb of his Ancestors in
search of Wealth (incited by this equivocal
Inscription, "In this Tomb is a Treasure greater
than Croesus possessed") found on entering it the
following: "Here dwells Repose, Sacrilegious
Wretch, searchest thou for Gold among the dead!
Go, Son of Avarice, THOU can'st not enjoy
Repose. Published Dec:–18th 1772, by
J. BOYDELL Engraver in Cheapside
LONDON.* (Aschaffenburg II E21,22;
BM 1870–5–14–484; Derby; Karlsruhe
III, 1865; Lennox-Boyd P7066; RA, BS
no.129; V&A, E1740–1952)

Boydell published this engraving six
months after Wright's painting was exhibi-
ted at the Society of Artists between

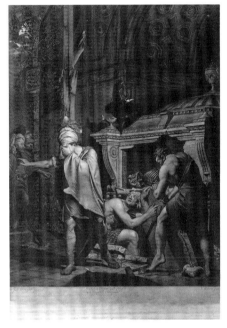

13 May and 20 June 1772 and this inter-
val, apparently characteristic of Boydell's
methods, suggests that once again he had
obtained the right to publish the picture
after having seen it exhibited. His standard
price for the print from 1773 to 1803 was
7s. 6d. (Boydell 1773, p.24, no.9) although
Pether charged Milnes 10s. 6d. in 1778.
The plate was sold in 1818 after the death
of Josiah Boydell with 37 proofs and 1
print (sixth day, lot 340).

State II exhibited
*Metropolitan Museum of Art, New York,
Harris Brisbane Dick Fund 1953*

161

P I 2

An Iron Forge

Engraved by Richard Earlom
Published by John Boydell 1 January 1773
Mezzotint, 480 × 590 mm
Nicolson 197; this cat.No.49
Huber and Martini, Earlom, subjects,
no.9; Nagler, Wright, no.12; Chaloner
Smith no.48; Bemrose no.14; Wessely
no.121; Le Blanc, Earlom no.43

I

Finished proof before title. In white on
black on separate blocks at the bottom
right: *Jo Wright Pinxt. 1772 Rd Earlom. Sc.
J Boydell, Excudit Publish'd Jany 1. 1773*. The
h of *publish'd* is reversed (Alexander; Derby
859–17–39; Fitzwilliam; M M A 53.600.568;
Veste Coburg X I, 94,41)

I I

With the addition of a title in white, cen-
tre: *An I R O N F O R G E* (Aschaffenburg
II E4,35; B M 1873–8–9–452; Derby
818–2–21; Karlsruhe III,1869; Veste
Coburg X I 94,47; V & A 29445.4)

As with the last print, *Miravan*, Wright's
painting was exhibited with the Society of
Artists between 13 May and 20 June 1772
and publication by Boydell followed six
months later. At this point, therefore, it
would appear that he had employed
Valentine Green and Richard Earlom
simultaneously on different prints after
Wright.

Boydell was selling *An Iron Forge* in 1773
(p.23, no.8) for 15s. and was still asking
the same price in 1803. The plate was sold
with 6 prints in 1818 (sixth day, lot 339)
and was eventually acquired by Moon,
Boys & Graves who listed the print in
1829, still at 15s. Impressions were, there-
fore, probably still being printed in the
middle decades of the nineteenth century.

State I exhibited
David Alexander

P I 2

162

P I 3

[Boys Blowing the Bladder]

Engraved by Peter Perez Burdett
Engraved 1773
Aquatint, ? 287 × 214 mm
Nicolson 208
? Chaloner Smith, appendix: additions
and corrections to p.124, erroneously
described as a mezzotint

I

Before all letters (M M A 68.589A inscribed
'*J: Wright Pinxt P.P. Burdett Fect 1773*')

Wright's painting was possibly one of the
'Candle-lights' exhibited at the Society
of Artists in 1767 (nos.189–90) or 1768
(no.194).

This print differs from Burdett's earlier
aquatints (see P 10) in that no etched
outline is used and it may therefore be
the first pure aquatint made in England.
It was probably the print exhibited by
Burdett at the Society of Artists in 1773
(no.4), described in the catalogue as 'The
effect of a stained drawing attempted by
printing from a plate wrought chem-
ically without the use of any instrument
of sculpture'.

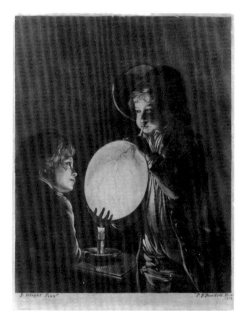

P I 3

State I exhibited
*Metropolitan Museum of Art, New York,
The Elisha Whittelsey Collection, The Elisha
Whittelsey Fund, 1968*

[Boys Blowing the Bladder]

Engraved by Peter Perez Burdett
? Engraved 1774
Aquatint with etching, 330 × 252 mm
(image 265 × 210 mm)
Nicolson 208
Bemrose no.1

I

With no inscription (BM 1918–10–12–3;
Hunterian; Liverpool Public Library)

This print is slightly larger than the pre-
vious one and details of the composition
are different. The plate is in the Gregson
collection, Liverpool University Library.
Gregson printed a number of impres-
sions from it after 1800: indeed, it is likely
that examples in the British Museum and
Liverpool Public Library (both bearing
inscriptions written by Gregson) and in
the Hunterian Art Gallery (presented by
Gregson to the Liverpool auctioneer
Thomas Winstanley in 1818 and printed
on Whatman paper watermarked 1800)
were all printed for Gregson. It is conceiv-
able that Gregson's plate was a copy of an
original by Burdett, but in the absence of
any commercial motive for such a piracy it
is much more likely that Burdett, experi-
menting with the aquatint process, made
two similar plates.

 It was probably this, Burdett's second
Bladder print, that was exhibited by the
Society of Artists in Liverpool in 1774 as
'A Print of Two Boys blowing a Bladder by
Candlelight, from a painting by Mr.
Joseph Wright (Wright of Derby)'. An
inscription in Matthew Gregson's hand on
an impression of *Boys Blowing the Bladder* in
Liverpool Public Library describes it as
'the first specimen of aquatinta invented in
Liverpool by P.P. Burdett, 1774, assisted
by Mr S. Chubbard [Samuel Chubbard,
carver and gilder in Liverpool, brother of
the painter Thomas Chubbard].' Another
note, signed by Gregson, on the British
Museum's impression, states that Burdett
went on to sell the secret of aquatint to
Charles Greville for £40. Greville then
revealed the method to Paul Sandby, who
has often been credited with the invention.

163

An Alchymist

Engraved by William Pether
Published by Pether 1 September 1775
Mezzotint, 575 × 455 mm
(image 560 × 455 mm)
Nicolson 195
Huber 1794, Wright; Huber and Martini,
Pether no.26; Joubert, II, p.350; Nagler,
Wright no.15; Chaloner Smith no.44;
Bemrose no.8; Le Blanc, Pether no.38

I

Progress proof before the scratched writing
on the books, papers charts and dial of
clock and before the leading on the win-
dow and the shading between the tiles in
the foreground (BM 1868–8–8–2648)

II

Finished proof before all letters. The
inscription space grey (SM 1976–425)

III

Finished proof with the scratched inscrip-
tion: *Josh, Wright Pinxt. Wm, Pether fecit,
Published Sepr, 1t, 1775 & sold by WPether
in Broad Stt, St James's–'.* The *S* of *Street*
is reversed. The inscription space cleaned
only around the artists' names
(Aschaffenburg II E23,36; BM
1862–5–17–178; Caen, Collection Mancel;
Derby 936–19–1924; Karlsruhe III 1870;
Lennox-Boyd P23260; Veste Coburg XI
36,20)

IV

With the engraved inscription: *Josh.
Wright Pinxit Wm Pether Fecit. AN
ALCHYMIST. Publiſh'd Decr. 1st. 1775. by
Wm. Pether, Broad Street Near Carnaby Market.*
(Derby; MMA 53.600.4468)

V

Republished by Edward Orme with the
date erased and the additional inscription:
*Republished March 1801, by Edward Orme, 59
New Bond Street* (described in P & D
Colnaghi & Co, *The Mezzotint Rediscovered*,
exhibition catalogue, June–August 1975,
no.77, not seen)

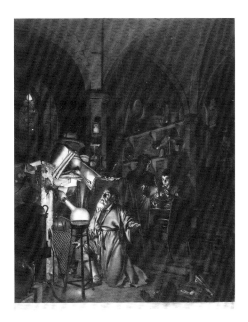

P15

Wright exhibited this picture at the
Society of Artists in 1771 and then in 1773
took the painting with him to Italy.
Presumably he persuaded Pether to
engrave it, having failed to sell it by any
other means. However, there is consider-
able doubt over when exactly it was
engraved. Wright did not return from the
Continent until September 1775 and
although the print was not published until
November it had been exhibited by Pether
at the Society of Artists the previous Spring
(no.188, 'An Alchymist') so either Wright
must have sent the picture home early or
Pether must have engraved it before
Wright left for Italy but delayed publi-
cation until his return.

 Pether sold the plate at auction in 1785,
lot 40, with 20 impressions, for 1 guinea.
He had sold a single impression to Milnes
in 1778 for the same price.

State I exhibited
Trustees of the British Museum

P16

The Forge

? Engraved by Francis Eginton
Manufactured by Boulton & Fothergill,
1777–80
Transfer-printed aquatint, 4 ft. 3 in. ×
3 ft. 6 in.
Possibly Nicolson 200
Aitken p.32

About 1777 Boulton & Fothergill pro-
duced a 'mechanical painting' or 'poly-
graph' of this subject after a painting by
Wright which they sold on 23 April 1781
to Captain David Arthur for 300 guineas
(Boulton & Fothergill letter book 1777–82,
A O L B). This painting is quite likely to
have been that which Wright exhibited at
the Society of Artists in 1775 (no.223).
Alternatively it could have been 'The
Blacksmith's Shop' (Nicolson 200) which
was sold at Christie's in 1775 and is
approximately the right size. The poly-
graph was priced at 22 guineas.

The glass paintings mentioned by
Nicolson which seem also to be Soho pro-
duction were probably copied from this
design.

P17

164

P17

Edwin

Engraved by John Raphael Smith
Published by Smith 30 December 1778
Mezzotint, 505 × 352 mm (image
478 × 352 mm)
Nicolson 235; this cat. No.57
Huber 1794, Wright no.11; Nagler,
Wright no.11; Chaloner Smith no.199;
Bemrose no.16; Le Blanc, Smith no.209;
Frankau no.123

I
Finished proof with the scratched inscrip-
tion: *Engraved by J. R. Smith from an original
of J^h. Wright in the pofsefsion of J^no. Milnes
Esq^re. Wakefield, Yorkshire Edwin D^r Beatie's
Minstrel Book XVI. Publifhd Decem^r. 30^th. 1778
by J. R Smith N^o 10 Bateman Buildings Soho
Square London* (Derby; Lennox-Boyd
P221 77)
II
With verses engraved on the rock behind
Edwin:–*exulting view'd in Nature's frame
Goodnefs untainted, wifdom unconfined, Grace
grandeur and utility combined* and with the
engraved inscription beneath the print:
*EDWIN And yet poor Edwin was no vulgar
boy; Deep thought oft seem'd to fix his youthful
eye, Dainties he heeded not, nor gaude, nor toy,
Save one short pipe of rudest minstrelsy. Dr.
Beattie's Minstrel Book XVI. Engrav'd by I. R.
Smith from an Original Picture of J^h. Wright's
in the pofsefsion of J^no. Milnes, Esq^r. Wakefield,
Yorkshire. London. Pub^d. Dec^r. 30, 1778 by
J. R. Smith N^h. 10 Batemans Buildings Soho
Square.* (Derby 936–13–24)
III
Republished by Hannah Humphrey with
the publication line altered to: *London Pub^d.
Dec^r. 30, 1778, by H. Humphrey N^o. 18 New
Bond Street.* (BM 1888–7–16–411)

Smith's print was published six months
after Wright's painting was exhibited at
the Royal Academy in 1778, suggesting
that Smith sought permission to engrave
the picture after seeing it at the exhibition.
A note in Wright's account book (p.12)
confirms that he sold impressions of this
print to friends and patrons in the Mid-
lands. It refers to money owed to Wright
for proofs of *Edwin* sold to Mr Senit
[Walter Synnot] and Mr [John] Holland
at 10s. 6d. each, and an ordinary print
bought by Mr Flint (see Nicolson p.218).
While it is possible that Wright was gener-
ously selling prints on Smith's behalf, it is
plausible that the painter had the

right to a certain number of impressions.
Such an arrangement was made with
James Heath in the case of *The Dead Soldier*
where Wright referred to his 'portion' of
the prints.

There is an etching of this subject by
Seymour Haden (Bemrose no.17).

State I exhibited
The Hon. Christopher Lennox-Boyd

P18

Master and Miss Williams

Engraved by Valentine Green
Before 1780
Mezzotint, 19 × 17 in.
Not in Nicolson
Whitman no.98
Not seen

No.148 in Valentine Green's catalogue of
1 January 1780 is 'J Wright of Derby,
Master and Mifs Williams, whole length,
19 × 17 in., 10s. 6d.' (BM Add. Mss. 33,401,
Dodd, VIII, f.107).

Since Green had engraved three prints
after Wright he should not have attributed
this portrait to the wrong painter.
However, neither the painting nor the
engraving have been traced. Whitman
included *Master and Miss Williams* in his
catalogue of Green's prints, citing Green's
catalogue, but failed to trace an
impression after Wright or any other
painter.

It is possible that Green recorded the
dimensions incorrectly and that *Master and
Miss Williams* is, in fact, P4 *The Bradshaw
Children* camouflaged by an unusual
variant identification of the sitters.

P19

The Captive

Engraved by John Raphael Smith
Published by Smith 30 April 1779
Mezzotint, 455 × 552 mm
(image 432 × 552 mm)
Nicolson 217
Bemrose no.25; Frankau no.57

I
Finished proof before all letters (RA, BS
no.128)

II
Finished proof with the scratched inscription: *The Captive Vide Yorricks Journey, Vol 2 Engraved from an Original painting of J. Wright in the Collection of John Milnes Esqr. Wakefield Yorkshire, by J. R. Smith & Publishd as the Act directs April 30th. 1779*
(Derby 936–12–24; Lennox-Boyd
P14044)

Wright's second painting of this subject was exhibited at the Royal Academy in 1778 (no.360) as 'Stern's Captive' and was bought by John Milnes. It is now at Derby Art Gallery.

Smith's fine mezzotint was the first engraving of the subject (see P28). It is apparently rare and escaped the notice of early cataloguers: Frankau relied on Bemrose's description, never having seen an impression herself. According to Bemrose (p.125) the print was 'Engraved for Mr Milnes of Wakefield: who destroyed the plate when twenty impressions had been taken off'. If this is true it is fortunate that at least three impressions have survived. The publication line announces merely that this print was published on 30 April 1779, not that it was published by Smith, a departure from Smith's usual practice that supports Bemrose's view that *The Captive* was a private plate. Similarly, its absence from J. R. Smith's catalogue indicates that he was not the proprietor of the plate (although this is not conclusive since the earliest plates in the catalogue were published about 1781). In May 1778 Wright supplied John Milnes with a near complete collection of his earlier mezzotints and it would seem to have been characteristic of 'Jacky Milnes the democrat' to take a new enthusiasm to extremes.

State II exhibited
Derby Art Gallery

P19

P20

Maria

Engraved by John Raphael Smith
?Private plate, 1781
Mezzotint, size unknown
Nicolson 237; this cat. No.58
Bemrose no. 42; Frankau no. 229
Not seen

Apparently, Bemrose lent a mezzotint of *Maria* by John Raphael Smith to the Wright exhibition held at the Corporation Art Gallery, Derby, in 1883 (no.162). The catalogue indicates that the print reproduced the painting now at Derby (painting No.58), then in Bemrose's collection and on show in the same exhibition. I have failed so far to discover any trace of a mezzotint of *Maria* by Smith after Wright. There are, however, many other engravings of this enormously popular subject from Sterne's *Sentimental Journey*, notably a mezzotint by William Pether of the painting of *Maria* by Wright's pupil, Richard Hurleston (published by Pether, 1777) and a mezzotint by Smith of a painting by George Carter (published by Boydell, 1774). Neither of these are sufficiently like Wright's painting to warrant confusion and given that Bemrose owned the original painting it is difficult to believe that he could have exhibited a print after another painter in the belief that it reproduced Wright's *Maria*. The print was listed but not described by Frankau, who took the details she records from Bemrose, and it was mentioned, but not described, by Morris.

Wright's painting of 'Maria from Sterne, a companion to the Picture of Edwin exhibited three years ago' was shown at the Royal Academy in 1781. It remained in the hands of the artist. Smith might have wished to engrave a print as a companion to *Edwin*, which is itself an uncommon mezzotint.

P21

Miss Kitty Dressing

Engraved by Thomas Watson
Published by Watson & Dickinson
20 February 1781
Mezzotint, 450 × 325 mm
(image 410 × 325 mm)
Nicolson 212; This cat. No.17
Huber 1794, II, p.362 (as Richard
Wright); Nagler, Wright no.21; Chaloner
Smith no.47; Bemrose no.36; Goodwin
no.65
I
Finished proof with the engraved inscrip-
tion: *Painted by R. Wright Engraved by T.
Watſson. London Publiſh'd Febʸ. 20ᵗʰ. 1781 for
Watſon & Dickinſon, Nº. 158, New Bond
Street.* (YCBA, B1977.14.14597)
II
With the addition of a title: *Miſs Kitty
Dreſsing.* (BM 1875–7–10–1036; Derby
936–28–24 and another; Lennox-Boyd
P14812; MMA 553.600.558; PMA;
54–66–46)

Wright's picture was painted before 1771
but not identifiably exhibited. Previously
in the collection of 'a nobleman', it was
sold at auction in January 1771 to Lord
Palmerston in whose family it remained
until the twentieth century. Watson and
Palmerston must therefore have combined
to produce the print: that Wright was not
involved is indicated by the mistake with
his name.

The plate was sold on the second night
of Thomas Watson's sale in January 1792
(lot 57 with 76 impressions, no price or
buyer named). Worn impressions at Derby
and in the British Museum date from 1830
or later.

State I exhibited
*Yale Center for British Art, Paul Mellon
Collection*

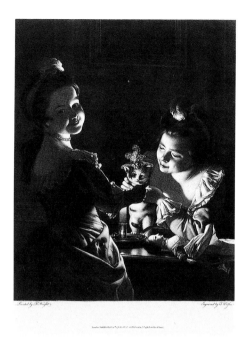

P21

P23

P22

[Moonlight View in Italy]

Engraved by Francis Eginton
Published 1781
Aquatint, 21 × 16½ in.
Bemrose no. 44
Not seen

This print was listed by Bemrose in his
biography of Wright but was not included
in the 'Complete set of engravings after

Wright of Derby' exhibited at Derby in
1883. It seems too small to have been a
polygraph and is certainly not one of those
presently known. Nevertheless, it would
seem to have been a product of the Soho
circle if, indeed, it existed at all.

P23

John Harrison

Engraved by John Raphael Smith
Private plate, *c.*1781
Mezzotint, 375 × 275 mm
(oval image 275 × 175 mm)
Nicolson 74
Chaloner Smith no.74; Bemrose no.15; Le
Blanc, Smith no.74;
Frankau no.165; Russell no.74
I
Progress proof touched with white body-
colour (V&A, E27133)
II
Finished proof with the scratched inscrip-
tion: *Painted by J Wright Engraved by J R
Smith John Harrison Non invenies alterum
Lepidiorem ad omnes res, nec qui amicus amico sit
magis* (BM 1950–5–20–253)
III
With the title in closed letters and the
engraved inscription: *J. Wright Pinxᵗ.
J. R. Smith Sculpᵗ. IOHN HARRISON,
. . . Non invenies alterum Lepidiorem ad omnes
res, nec qui amicus amico sit magis. Plaut:* (Ash-
molean, Hope PC; Derby 936–7–24;
NPG, MacDonnell *DNB*)

The title on the print confirms that the
sitter is a John Harrison but Nicolson (pp.
201–2) argues cogently that this is a Dr
John Harrison, a Derby surgeon, and not
the renowned clock-maker supposed to be
the sitter by Chaloner Smith and others.
The inscription from Plautus (*Miles
Gloriosus*, ll. 659–60) translates 'You will
not find a more ingenious man in every
way nor a better friend to a friend' which
perhaps has the ring of an epitaph. The
print is not in Smith's catalogue which
suggests either that it was published before
1780 or that Smith was not the proprietor
of the plate. Indeed, since it seems never to
have carried a publication line it is likely
that the inscription 'private plate' on the
impression in the National Portrait
Gallery is accurate. In this case most
impressions of the print would have been
commissioned for private circulation
among the friends of John Harrison.

167

P24

The Children of Walter Synnot Esqʳ

Engraved by John Raphael Smith
Published by Smith 25 April 1782
Mezzotint, 500 × 350 mm
(image 450 × 350 mm)
Nicolson 135
Smith no.24; Huber 1794, Wright 12;
Nagler, Wright no.2; Chaloner Smith
no.160; Bemrose no.18; Le Blanc, Smith
no.160; Russell no.160

I

Progress proof (MMA 53.600.4472
inscribed 'This proof is by no means
finish'd & Mr. Smith does not wish any
body but Mr. Wright to see it, as it may
prejudice them against it. Mr. Smith is
working on the plate & wishes for Mr.
Wright's Remarks as soon as convenient.')

II

Finished proof before all letters (recorded
by Chaloner Smith and Russell, not seen)

III

Finished proof with the scratched inscrip-
tion: *Engraved by J R Smith, from an original
picture of J Wright of Derby Children of Walter
Synnot Esqʳ London Publish'd April 25ᵗʰ 1782 by
J R Smith Nº 83 opposite the Pantheon Oxford
Street* (Aschaffenburg II E24,33;
Lennox-Boyd P2805)

IV

With the title in closed letters and the
engraved inscription: *Engrav'd by J. R.
Smith from an Original Picture of J. Wright of
Derby. CHILDREN OF WALTER
SYNNOT ESQᴿ. London Publish'd April
25, 1782 by J. R. Smith Nº. 83, opposite the
Pantheon, Oxford Street* (BM 1886–6–17–55;
Fitzwilliam; Lennox-Boyd P17220; MMA
53.600.4472; Veste Coburg XI 166,7 prin-
ted in colours)

The painting was exhibited at the Royal
Academy in 1781 (no.181) as 'Portraits of
Three Children' and it was presumably
there that Smith, whose publications
betray a taste for sentiment, saw it and
elected to engrave it. His print was ex-
hibited at the Free Society in 1782
(no.120) as 'Children of Walter Synot Esq.
ditto [mezzotinto]' and publication was
timed to coincide with the exhibition. The
note on the Metropolitan Museum's proof
impression proves that on this occasion
and probably, by extension, on others,
Wright was given the opportunity to criti-
cise and correct the engraver's work while
in progress. Smith's original price for 'Chil-
dren of Walter Synnets, square, 20 by

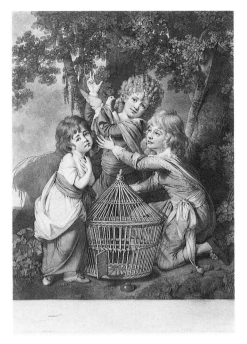

P24

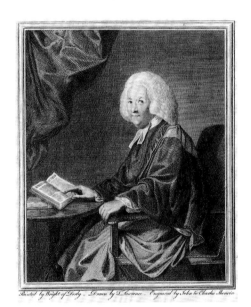

P25

14' was 7s. 6d.

The composition enjoyed renewed
popularity in the early twentieth century:
Messrs. Graves published a stipple by
Leon Salles in 1910 and Greatorex
Galleries issued a mezzotint by Macbeth
Raeburn in 1919.

State I exhibited
*Metropolitan Museum of Art, New York,
Harris Brisbane Dick Fund, 1941*

P25

Thomas Wilson

Engraved by John and Charles Sherwin
after a drawing by Thomas Lawrence
Published by Richard & Clement
Crutwell, Bath, 5 November 1782
Line-engraving, > 292 × 224 mm (image
140 × 116 mm)
Nicolson p.226
Bemrose no.35

I

Finished proof with the inscription:
*Painted by Wright of Derby. Drawn by
T. Lawrence. Engraved by John & Charles
Sherwin* (BM 1838–7–14–189)

II

With the additional inscription beneath:
*THOMAS WILSON, D.D. Son of the
BISHOP of SODOR & MAN, Preben-
dary of Westminster, & Rector of Sᵗ. Stephens,
Walbrook. Aetat 78. Published as the Act directs
Novʳ. 5. 1782, by R. & C. Crutwell, Bookseller,
Bath.* (NPG)

Wright painted a double portrait of
Thomas Wilson with his friend and pro-
tegée Catherine Macauley at Bath in
1776. Thomas Lawrence made a reduction
of that painting for this print from which
Macauley is excluded, probably because
she was not relevant to its purpose, but
possibly because of the estrangement
between her and Wilson that followed her
marriage to the brother of the notorious
charlatan James Graham. Thomas Wilson
was a generous patron to the Crutwells in
Bath and in 1781 gave them a share in the
copyright of his father's popular works,
enabling them to publish an edition in
that year. This print was perhaps issued
separately, a year later, as a token of
gratitude.

P26

William and Margaret

Engraved by John Raphael Smith
Published by Smith 12 April 1785
Mezzotint, 455 × 555 mm
(image 440 × 555 mm)
Nicolson 226
Smith no.91; Nagler, Wright no.20;
Bemrose no.19; Frankau no.377

I

With the title in closed letters and the
engraved inscription: *Painted by J. Wright
Engraved by J. R. Smith Mezzotinto Engraver
to His Royal Highneſs the Prince of Wales
WILLIAM and MARGARET 'Twas at
the silent solemn hour When night and morning
meet In glided Margarets grimly ghost And stood
at William's feet From the celebrated ballad in
Piercies Reliques of Antient English Poetry Vol
3. XVI. London Publish'd April 12ᵗʰ 1785 by I. R
Smith Nᵒ 83 Oxford Street.* (Aschaffenburg II
E24,39; BM 1878–5–11–1013; Derby, two;
Lennox-Boyd; MMA 53.600.4454; Veste
Coburg XI 167,46 printed in colour)

II

With the inscription as above but Smith's
address altered to: *Nᵒ 31. King Street Covent
Garden.* (Lennox-Boyd P20711 in colour
and P3776)

III

The publication line erased and replaced
with: *London publiſhd June 1 1802, by
R.Ackermann at his Repository of Arts Nᵒ. 101,
Strand* (Derby 936–11–24 in colour;
Lennox-Boyd P13054)

The painting was exhibited at Robins's
Rooms in 1785 (no.3) and the publication
of Smith's engraving was timed to coincide
with the exhibition which opened in the
middle of April. Wright must therefore
have given Smith access to the painting
before the exhibition which implies that he
encouraged Smith to engrave it, a
procedure to which Wright resorted
increasingly in later years. One of two ver-
sions of the composition remained on
Wright's hands; the fate of the other ver-
sion is not known. It shows a scene from
one of Percy's fashionably Gothick *Reliques
of Ancient English Poetry* (1765), 'The Ballad
of William and Margaret'. Margaret, for-
saken by William in favour of another, has
died of love for him but, to William's
evident dismay, her ghost appears at his
bedside.
　　Smith's original price for 'Margaret's
Ghost, square, 22 by 10' was 10*s*. 6*d*. It

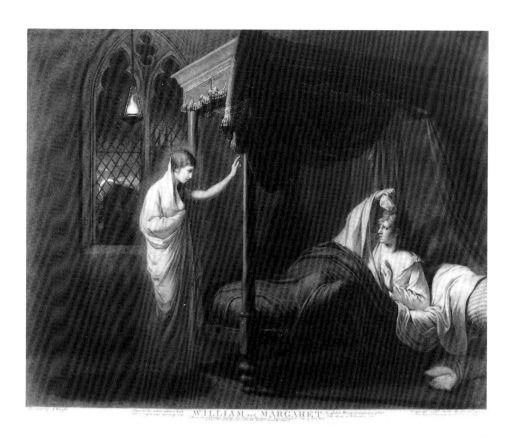

P26

was available in colours from its first
publication.

State II exhibited
The Hon. Christopher Lennox-Boyd

P27

John Whitehurst F R S

Engraved by John Hall
Published by William Bent
2 January 1786
Line-engraving, ?276 × 216 mm
(image 90 × 73 mm)
Nicolson 141; this cat. No.147
Bemrose no. 32

I

With the engraved inscription above:
JOHN WHITEHURST F.R.S. and
below: *Jos. Wright pinx. J Hall sculp.
Publish'd by Willᵐ. Bent, Janʸ. 2ᵈ. 1786.* (BL;
BM,Q2–123;NPG)

Copies:

27a

Line-engraving by Anker Smith,
178 × 111 mm, published by William Bent

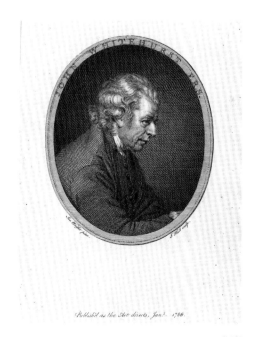

P27

10 October 1788, f.p. 225 of *The Universal Magazine*, LXXXIII, November 1788 to illustrate 'Authentic Memoirs of the Life and Writings of the late John Whitehurst, F.R.S.' (Ashmolean, Hope P C; B L; B M, J4.297; S M 1981–981; N P G)

27b

Etching by M. V. Sears, image 59 × 57 mm, published f.p. 599 of vol. II of Stephen Glover's *History of Derbyshire*, 1829 (B L; Derby 353 – 32; Derby 353 – 32; Derby P L, Mundy, Lyson, III, 110c)

Hall's print was first issued as frontispiece to the second edition of John Whitehurst's *An Inquiry into the Original State and Formation of the Earth* (London, W. Bent, 1786) and reissued as frontispiece to *The Works of John Whitehurst, F.R.S. with Memoirs of his Life and Writings* (London, W. Bent, 1792). It may always also have been sold separately and was still available in 1829 from Moon, Boys & Graves for 6s. John Hall, a close friend of William Woollett, was a reputable line-engraver and succeeded Woollett as Engraver to the King. The relatively high price charged in 1829 for this small print is a reflection of his enduring reputation.

P28

The Captive

Engraved by Thomas Ryder
Published by John and Josiah Boydell
1 October 1786
Stipple, 430 × 500 mm
(image 370 × 475 mm)
Nicolson 216; this cat. No.53
Huber 1787, Ryder; Huber and Martini, Ryder no.1; Nagler, Wright no.6; Bemrose no.24; Le Blanc, Ryder no.20

I
Finished proof before all letters (Derby)

II
Finished proof with the scratched inscription: *Jⁿ: Wright Pinxᵗ. T: Ryder Sculpᵗ. Publish'd as the Act Directs Octʳ: 1: 1786 by John & Josiah Boydell Cheapside London.* (Aschaffenburg 11 E12, 7; Derby 818 – 8 – 21 and 936 – 8 – 24; with Rob Dixon, 1989)

III
With the engraved inscription: *Joseph Wright, Pinxit John & Josiah Boydell excudit 1786. Ryder, Sculpsit T H E C A P T I V E . He was sitting upon the Ground upon a little straw, in the farthest corner of his Dungeon, which was alternately his chair and bed; a little calendar of*

small sticks were laid at the head and notched all over with the dismal days and nights he had passed there. Vide Sterne's Sentimental Journey, Vol. II. Publish'd Octʳ. 1. 1786, by John & Josiah Boydell, Nᵒ 90, Cheapside London (B M 1917–12–8–3425)

IV
With the quotation altered to: *I beheld his body half wasted away with long expectation and confinement, and felt what kind of sickneſs of the heart it was which arises from hope deferr'd. Upon looking nearer I saw him pale and feverish in thirty years the western breeze had not once fann'd his blood. He had seen no sun, no moon in all that time. nor had the voice of friend or kinsman breathed through his lattice: his children. But here my heart began to bleed. Vide Sterne's Sentimental Journey Vol. II* (Derby, two; M M A 53.600.4453)

Wright's painting was completed in Rome in 1774. Having changed hands at auction in 1780 the painting was in the collection of Edward Pickering in 1790 when Josiah Boydell exhibited a drawing of it at the Shakespeare Gallery. The reproduction of the painting was presumably arranged by the Boydells in conjunction with Pickering.

This print was issued printed in black or printed in sepia. It is curious that the quotation from Sterne was altered at some point in the life of the plate. In the Boydell 1803 catalogue (where the print is priced at 10s. 6d.) the inscription in state III is quoted. Since the British Museum's example (state II) is a fresh impression on eighteenth-century paper printed long before 1803, the sequence of states given here is reasonably secure. The plate was sold following the death of Josiah Boydell in 1817 (Boydell 1818, third day, part lot 73) with 94 proofs and 9 prints, together with a pair of *Tom Jones* plates after Downman, buyer and price unknown.

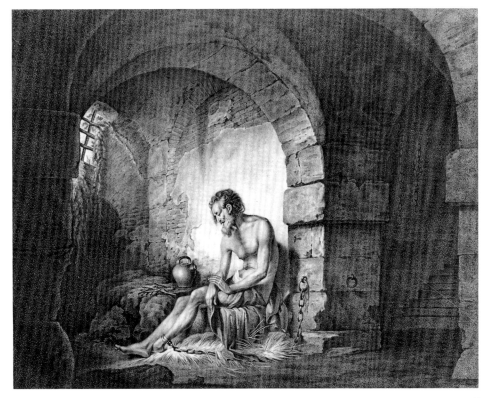

P28

**Distant View of Mount Vesuvius,
from the Shore of Posilipo at Naples**

Engraved by William Byrne
Published by Byrne 1 November 1788
Engraving with etching, 275 × 345 mm
(image 230 × 320 mm)
Nicolson, Appendix B, 10
Bemrose no.26

I

Finished proof (recorded in the Thompson
sale 1810, not seen)

II

With the title in closed letters and the
engraved inscription: *Painted by Jos. Wright
of Derby. Engraved by Wm. Byrne. Distant view
of MOUNT VESUVIUS, from the Shore of
POSILIPO at NAPLES. Published as the Act
directs, 1 Nov. 1788, by Wm. Byrne, No. 79
Titchfield Street, London.* (Alexander;
Aschaffenburg I E 19,55; BM 1917–12–8
–3424; 3 Derby; with Rob Dixon, 1989)

Bemrose (p.53) believed the painting to
have been the one exhibited at Robins's
Rooms in 1785 (no.15) as 'A distant View
of Vesuvius from the shore of Posilipo'.
However, considering the date of Byrne's
engraving, and Nicolson's objections to
Bemrose's view (pp.280–1), Byrne's subject
might more plausibly be identified with
the 'View near Mare Chiare, on the shore
of Paussillipo' that was exhibited at the
Royal Academy in Spring 1788. If so,
Byrne must have worked fast, for six
months was a short period in which to
complete a line-engraving, even of this size.
According to Edward Edwards (p.254) the
painting Byrne engraved belonged to
Mr Bacon.

The plate was sold by J. P. Thompson in
1810, as a pair to a view of Etna after
Smith by Byrne in lot 33 with 7 prints and
21 proofs for £8 5s.

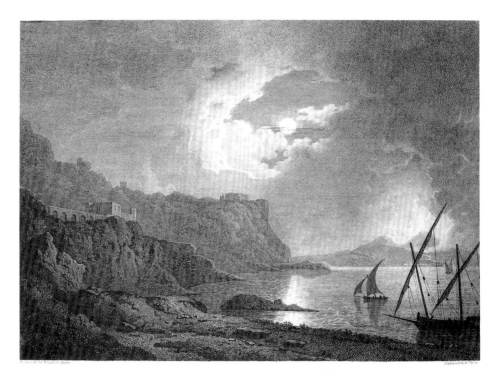

Distant View of *MOUNT VESUVIUS*, from the Shore of POSILIPO at *NAPLES*.

P29

169

P30

The Lady in Milton's Comus

Engraved by John Raphael Smith
Published by Smith 30 February 1789
Mezzotint, 453 × 553 mm
(image 437 × 553 mm)
Nicolson 234; this cat. No.66
Smith no.213; Nagler, Wright no.7;
Bemrose no.21; Frankau no.208

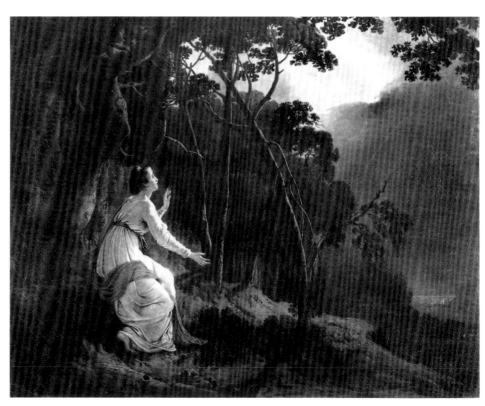

P30

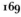

I

Finished proof with the etched inscription:
*Painted by J Wright Engrav'd by J R Smith
Mezzotinto Engraver to his Royal Highn': y'
Prince of Wales & his Serene Highn': the Duke
of Orleans. The Lady in Miltons Comus Verse
221 LONDON Pub: Feb: 30 1789 by I R
Smith N° 31 King Street Covent Garden*
(Derby 936–35–24; Lennox-Boyd P11369;
V & A 29445.5)

II

With the engraved inscription: *Painted by J
Wright. Engrav'd by J. R. Smith, Mezzotinto
Engraver, to his Royal Highn'. y' Prince of
Wales, & his Serene Highn'. the Duke of
Orleans. The Lady in Milton's Comus. Verse
221 Was I deceiv'd or did a sable Cloud Turn
forth her silver lining on y' Night; I did not err,
there does a sable Cloud Turn forth her silver
lining on y' Night, and casts a gleam over this
tufted Grove. LONDON Pub: Feb: 30, 1789 by
I R Smith No 31 King Street Covent Garden*
(BM 1917–12–8–3426; Derby in
colour; Lennox-Boyd in colour; MMA
53.600.4455)

III

The inscription strengthened and the date
altered to: *1802*. The image also reworked
overall by an assistant of Smith's; the right
fork of the drooping branch now passes
over the left hand fork. The extreme right
hand branch no longer forks at the end
(Derby 806–21 and another; Lennox-Boyd
P11435 and another)

IV

Republished by Thomas Palser with the
publication line altered to: *Published March,
2. 1812, by Tho. Palser, Surrey-side of
Westminster Bridge.* Reworked again with
the forks at the end of the extreme right
hand branch restored (Lennox-Boyd)

The painting was exhibited at Robins's
Rooms in 1785 but was already reserved
for Josiah Wedgwood. It was presumably
borrowed from Wedgwood to enable
Smith to make his engraving. Smith's orig-
inal price for 'The Lady in Comus. . .22 by
18' was 10s. 6d.

State II exhibited
Derby Art Gallery

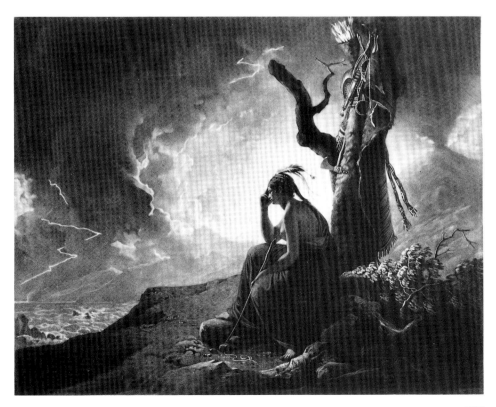

170

The Widow of an Indian Chief Watching the Arms of her deceas'd Husband

Engraved by John Raphael Smith
Published by Smith 29 January 1789
Mezzotint, 450 × 550 mm
(image 440 × 550 mm)
Nicolson 243; this cat. No.67
Smith no. 212; Nagler, Wright no.8;
Bemrose no.20; Frankau no.375

I

Finished proof with the scratched inscrip-
tion: *Painted by J Wright Engravd by J R
Smith Mezzotinto Engraver to his Royal Highn'
the Prince of Wales & his Serene Highn' the
Duke of Orleans London Publishd Ian' 29 1789
by I R Smith N° 31 King Street Covent Garden*
(Derby 818–9–21; Lennox-Boyd P10179)

II

With the engraved inscription: *Painted by J
Wright. Engrav'd by J R Smith, Mezzotinto
Engraver to his Royal Highn'' the Prince of
Wales, & his Serene Highn''. the Duke of
Orleans. The Widow of an Indian Chief, watch-
ing the Arms of her deceas'd Husband. London
Pub'. Ian'. 29, 1789 by I. R. Smith, No. 31 King
Street, Cov'. Garden.* (BM 1850–10–14–894;
2 Lennox-Boyd, one in colour; MMA
53.600.4455; Veste Coburg XI 167,44
printed in colours; YCBA,
B1977.14.14594)

III

Republished by Thomas Palser with the
publication line altered to: *Published
March, 2. 1812, by Tho. Palser, Surry-side of
Westminster Bridge.* (Lennox-Boyd)

The painting was exhibited at Robins's
Rooms in 1785 but remained in Wright's
hands. Another version was sold to Mr
McNiven of Manchester. There is no
obvious reason why Smith should have
published prints of the 'Widow' and its
companion four years after their first pub-
lic showing in London: it seems unlikely
that he could have done so without
Wright's active encouragement.

John Raphael Smith's price for 'An
Indian Widow. . .22 by 18' was 10s. 6d. He
kept a proof (Smith 1814, lot 58).

The impression at the Veste Coburg,
like many others in the fine collection of
English prints to be seen there, is a spec-
tacular example of colour-printing.

State I exhibited
Derby Art Gallery

P32

A Landscape in Italy by Moon-light, from an Original painted on the Spot, by Mr Wright of Derby

Exhibited by the Polygraphic Society in 1790
Transfer-printed aquatint, 'outside measure of picture and frame'
27 × 34 in.
Possibly Nicolson 253
Not seen

This is the first of four 'polygraphs' after paintings by Wright produced by Joseph Booth's Polygraphic Society. The Society charged £4 14s. 6d. for this polygraph and commented of the painting: 'The Effect of the Beames reflected by the Waters, is admirably represented, and forms a most pleasing Contrast with the neighbouring Shades which, in the Words of the Poet, "seem most for Love and Contemplation made"' (Booth 1790, no.9; 1792, no.22; 1793, no.22).

P33

A View of Mount Vesuvius by Moon-Light, from an Original painted on the Spot by Mr Wright of Derby

Exhibited by the Polygraphic Society in 1790
Transfer-printed aquatint, 'outside measure of picture and frame'
27 × 33 in.
Nicolson, Appendix B, 9
Not seen

In 1790 the Polygraphic Society charged 4 guineas for this polygraph but raised their price to £4 14s. 6d. in 1792 and 1793 (Booth 1790, no.10; 1792, no.6). The catalogues note that 'this beautiful and much-admired Picture the Society have been favoured with the Use of, from the Collection of John Arnold, Efq.', a painting that can therefore be identified positively with the entry in Wright's account book listed in Nicolson's Appendix B, no.9.

In 1790 the polygraph was described as a companion to a view of the *Glacieres of Chamouny* after Webber, but in the catalogues for 1792 and 1973 it was treated as a companion to the *Landscape in Italy by Moonlight* (no.31), Webber's picture hav-

ing been withdrawn from the Society's list. In the last two catalogues the entry was annotated to the effect that 'only a few' polygraphs of Wright's subject remained and the Society did not intend to make any more.

P34

A Boy Blowing a Bladder by Candlelight

Exhibited by the Polygraphic Society in 1792
Transfer-printed aquatint, 'outside measure of picture and frame'
41 × 32¾ in.
?Not in Nicolson
Not seen

The Society charged £6 16s. 6d. for this polygraph and wrote of the original painting that: 'Mr. Wright stands unrivalled in subjects of this kind. The lady who favoured the Society with the loan of this picture having removed to a distant part of the kingdom, they are deprived of the satisfaction of shewing by a close comparison, how very near the Polygraphic copies resemble the original'. In 1793 the catalogue entry was annotated to the effect that nearly all the polygraphs of this subject had been disposed of and that the Society did not mean to take any more.

The clues to the identity of the original contained in the Polygraphic catalogues do not immediately lead to any of the paintings of this type described, rather scantily, by Nicolson. It might have been the 'Boy blowing a Bladder' exhibited at the Free Society in 1783 (no.89), a painting that Nicolson could not identify.

P35

Maecenas' Villa at Tivoli

Exhibited by the Polygraphic Society in 1792
Transfer-printed aquatint, 'outside measure of picture and frame'
29 × 37 in.
Possibly Nicolson p.254, no. vi
Not seen

The Society charged 7 guineas for this polygraph and commented that 'the beauties of an Italian landscape are in this picture admirably depicted, and the spectator is at a loss which most to admire – the

warmth and brilliancy of the sky, the transparency of the water, or the elegant and varied tints of the surrounding foliage. The original is worth £40.'

The catalogue implies that Wright's original was for sale, and was perhaps therefore either in the possession of the Society or the painter. It may very well have been the panel priced in Wright's account book at £42 and identified by Nicolson with the picture exhibited at the Royal Academy in 1788 (no.81).

P36

Shakspeare. Winter's Tale, Act III Scene III

Engraved by Samuel Middiman
Published by John and Josiah Boydell
4 June 1794
Engraving with etching, 502 × 636 mm (image 444 × 596 mm)
Nicolson 230
Nagler, Wright no.5; Bemrose no.31
I
Finished proof with the etched inscription: *Painted by Jⁿ. Wright. Engrav'd by S. Middiman. SHAKSPEARE. Winter's Tale, ACT III. SCENE III. Publiſh'd June 4, 1794, by John & Joſiah Boydell, at the Shakſpeare Gallery Pall Mall, & Cheapſide.* (Derby 818–7–21)
II
With the above inscription engraved and the additional quotation: *Clo. I would, you did but see how it chafes, how it rages, how it takes up the shore; but that's not to the point: Oh! the most piteous cry of the poor souls! sometimes to see'em, and not see'em: now the ship boring the moon with her main-mast; and anon swallow'd with yest and froth, as you'd thrust a cork into a hogshead. And then for the land service. – To see how the bear tore out his shoulder-bone; how he cry'd to me for help, and said, his name was Antigonus, a nobleman: – but to make an end of the ship: – to see how the sea flap-dragon'd it: – but, first, how the poor souls roar'd and the sea mock'd them; – and how the poor gentleman roar'd, and the bear mock'd him, both roaring louder than the sea, or weather.* (BM, Dd6 no.39, vol.1; Derby)

A painting of 'The Winter's Tale' by William Hodges was exhibited at the Shakspeare Gallery in 1789 but was badly received. Wright's painting was exhibited at the Royal Academy in 1790 (no. 221) where it was also reviewed unfavourably, a circumstance blamed by Wright on Alderman Boydell and certain dependent

Academicians. Boydell, with whom Wright had been quarrelling for some years, declined both this painting and Wright's other exhibit, 'Romeo and Juliet', for the Shakspeare Gallery. Wright therefore, attempted to persuade James Heath to engrave them in a joint publishing venture with Philips and himself ('Tate says you have so high an opinion of my two pictures that if I will join you Heath shall be applied to, to engrave them. I hardly know how to reply, unless I knew something of the expense & the likelihood of saving ourselves in such an engagement') but Heath, too, declined the undertaking, protesting that the paintings were too dark (presumably too dark to make good line-engravings).

Over the winter Wright worked to brighten both pictures and exhibited them again at the Society of Artists in 1791 (no.219, 'Antigonus or the Storm. From the Winter's Tale'). Wright advised the Secretary of the Society that he wished them to be engraved by a reputable engraver, hoping to entice Heath, or the publisher Thomas Macklin. However, during the exhibition Boydell made the Secretary an anonymous offer to buy 'Antigonus' and proposed Samuel Middiman to engrave it. Although suspicious of a plot to prevent the reproduction of his paintings by Heath, whom he had again approached, Wright asked Philips how good an engraver Middiman was. It soon became clear that both Philips and Heath had lost enthusiasm for 'Antigonus' and Wright reluctantly accepted the anonymous proposal, selling the painting for £126. His fury at the discovery that he had been outwitted by the detested Alderman can be imagined, and it is unlikely that the product of Middiman's exertions with the graver improved his temper. Middiman, like the majority of Boydell's 'half-starved creatures', was an artist of unexceptional talent.

The Shakspeare Gallery prints were engraved at Boydell's Hampstead workshop under the supervision of Josiah-Boydell. Middiman was paid 300 guineas for his work. The print appears in the Shakspeare Gallery section of Boydell's 1803 catalogue. In 1829 Moon, Boys & Graves were still selling prints for 10s. 6d. and proofs and colour-printed impressions for 1 guinea.

P36

P37

Erasmus Darwin, MD, FRS

Engraved by William Bromley
Published for *The European Magazine* by
J. Sewell 2 March 1795
Line-engraving
Nicolson 50; this cat. No. 144
1
With the inscription above: *European Magazine*, and below: *Engraved by W. Bromley, from an Original Drawing. ERASMUS DARWIN, M.D. F.R.S. Published by J. Sewell, 32 Cornhill 2 March 1795*. (Ashmolean)

Copies:
37a
Engraving by H. Wheelwright, 184 × 112 mm, also for the *European Magazine*, published by Sewell from 13, Cornhill, 2 March 1795 (BM 1865–5–20–40; NPG)
37b
Engraving by John Taylor Wedgwood, 200 × 135 mm, after a drawing by John Thurston of the painting then in the possession of Mrs Darwin, published by W. Walker of 8, Grays Inn Square, 1 July 1820 (Bemrose no.23; BM 1933–6–26–7; NPG)

ERASMUS DARWIN, M.D. F.R.S.

P37a

[Joseph Wright]

?Engraved by Joseph Wright
?1796
Drypoint, 90 × 64 mm
See Bemrose, p.106
I
With no inscription (with Sanders of
Oxford, 1989)

Copy:

38a
Line-engraving by William Blake, image
85 × 60 mm, Published in *The Monthly
Magazine*, September 1797 (See Bemrose,
p.106 and p.124ff) with the inscription:
*Blake: s The late M. WRIGHT
of Derby.* (Ashmolean; BM
1867–12–14–743 and Anderdon SA 561)

Bemrose illustrated an impression of this
print found among the effects of Blake's
friend George Cumberland bearing the
inscription: 'Wright of Derby; etched by
himself'. If this inscription can be believed
this rather undistinguished plate would
represent Wright's only known foray into
printmaking. However, there is inad-
equate evidence, stylistic or otherwise, to
confirm or refute the attribution to
Wright.

P38

P39

The Dead Soldier

Engraved by James Heath
Published by Heath 4 April 1797
Line-engraving, 500 × 632 mm
(image 430 × 594 mm)
Nicolson 238
Nagler, Wright no.22; Bemrose no.27; Le
Blanc, Heath no.13
I
Progress proof in etching only, the lower
part of the sky, the distant soldiers, the
foreground figures and the soldier's hat in
outline only, although the lines of the babe
and the hair are etched in (Derby 503–13)
II
Progress proof with the etched inscription:
*Painted by J. Wright. Engraved by
J. Heath, Historical Engraver to the KING and
A. R. A. THE DEAD SOLDIER.
Published June 4. 1795, N.º 42 Newman Street.*
The hat and the woman's blouse still
white. The flesh and dress of the fore-
ground figures unfinished. The distant
soldiers still white. The blanket, trees and
sky almost finished (Derby 818–4–21)
III
Finished proof with the etched inscription
unaltered (PMA, 47–59–149)
IV
Finished proof with the publication line
altered to: *Published April 4: 1797, by James
Heath, N.º42, Newman Street, London.* (Derby;
MMA 49.40.54)
V
With the title in closed letters but the pub-
lication date as in state IV (see letter from
Heath to Philips quoted Bemrose p.73)
VI
With the publication date altered to 4
May 1797 and the engraved inscription:
*Painted by J. Wright. From the original Picture
in the Poſseſsion of John Leigh Philips Esq.
Engraved by J. Heath, Historical Engraver to
the KING and A. R. A. THE DEAD
SOLDIER. To the most Noble the Marquis of
Lansdowne this Plate is most respectfully
Dedicated by his Lordship's much obliged &
most obedient Servant James Heath. Published
May 4. 1797, by James Heath, N.º42, Newman
Street, London* (BM 1893–5–16–108, on
India laid down on wove; Derby; MMA
53.600.4466)

Copies:

39a

Mezzotint by William Dickinson, 480 × 592 mm (image 443 × 592 mm), published June 1804 (Nagler, Wright 23; Bemrose 28) with the title in closed letters and the engraved inscription: *Painted by J Wright. From the Original Picture in the Possession of John Leigh Philips Esq. Engraved by W. Dickinson. THE DEAD SOLDIER. To the Most Noble the Marquis of Lansdowne this Plate is most respectfully Dedicated by his Lordship's most obliged and most obedient Servant, James Heat. Published June 1804 by James Heat, N.º.42 Newman Street London.* (BM 1877–6–9–2013). Possibly a French copy made after Dickinson's departure for that country. The publication line, with Heath's name misspelled appears fraudulent.

39b

Line-engraving by W. Bull, 150 × 214 mm (image 88 × 118 mm) published for the Proprietor by Whittaker & Cº, November 1836 (BM; Derby)

39c

Line-engraving by Bovinet and Nyon, image 99 × 135 mm (Derby)

Both James Heath and John Leigh Philips asked the price of Wright's painting after its exhibition at the Royal Academy in 1789. They probably reached some compromise over it for although Heath engraved it the painting was in Philips's collection when he died in 1814. To complete a line-engraving this size might take about three years even with the aid of the numerous assistants Heath habitually employed (see Raimbach p.18) but in this case progress was even slower, probably because Heath waited hoping for a quick end to the war with France and the consequent disruption of the export market. On 30 March 1795 Wright wrote to Philips: 'I am sorry to find Heath still procrastinates. He was to have begun on *The Dead Soldier* in good earnest last Midsummer. Another is approaching fast and nothing more done to it. I despair of seeing it finished, and many of the subscribers to my portion of the prints are dead.' Philips presumably persuaded Heath that further delay was pointless for on 25 July 1795 Heath issued:

> PROPOSALS for Publishing by Subscription A PRINT To be Engraved by JAMES HEATH, Historical engraver to his Majesty, &c., from the celebrated picture of THE DEAD SOLDIER, Painted by WRIGHT OF DERBY. CONDITIONS: That the plate shall be the Size of the Plate of the DEATH OF

> GENERAL WOLFE. The price of each print will be One Guinea; Proofs, Two Guineas: Half to be paid at the time of subscribing and the remainder on the delivery of the Print. Subscriptions are received by the Proprietor, James Heath, at 42 Newman Street, where a proof of the plate may be seen [presumably state III].

In October 1796 Heath sent Philips 'a proof of *The Dead Soldier* near finished. . .I have sent one to Wright, and have asked him to paint a companion to it.' Wright was impressed with Heath's work and wrote to tell him that 'the effect of the picture is so well preserved and the parts which compose it so true that I have nothing to say but that I am well pleased with it' and Heath promised Philips 'in about six weeks I will send you another proof and the different states of the plate along with it'. On 3 February 1797 Heath visited Lord Lansdowne, showed him the print and asked his permission to dedicate it to him. In March Heath wrote to Wright to ask him if he felt well enough to paint 'The Shipwrecked Sailor' as a companion to 'The Dead Soldier' but got no reply (Wright died in August and ultimately Heath engaged Richard Westall to paint the companion). In April he sent Philips one dozen proofs and four dozen 'first impressions' ('a few of them have the same date of publication as the proofs and consequently are the earliest') to sell to friends and subscribers in the Midlands, noting in his covering letter that he had raised the price of ordinary impressions to £1 6s. and had 'met with more success than I had hoped for in such times as these. It is universally talk'd of and I have orders for between 2 & 300 from the Trade only'. In August he sent Philips one of three India proofs he had taken and seven more ordinary impressions.

From a reference to the subscribers to his 'portion of the prints' it would seem that one of the perquisites of allowing Heath to engrave his painting was that Wright secured a certain number of impressions for himself. The names of some of his subscribers are preserved in his account book (p.45): Revd Thomas Gisborne; Lady Warren; Miss Linwood; Thomas Pares; John Holland; William Tate (four); Richard French; Sir Brooke Boothby; Charles Hurst; Miss Morewood; Adam Slater; Revd Thomas Twigge; Revd Mr Humphrey; Mr Ward. They are almost all familiar as friends and patrons of the painter.

In 1829 the print was available from

Moon, Boys & Graves at £1 11s. 6d. for prints and 2 guineas for impressions on India paper (p.120).

State IV exhibited
Metropolitan Museum of Art, New York, The Elisha Whittelsey Collection, The Elisha Whittelsey Fund, 1949

P40

Erasmus Darwin, MD and FRS

Engraved by John Raphael Smith
Published by Smith 1 May 1797
Mezzotint, 280 × 376 mm
Nicolson 52; this cat. No.145
Smith no.286; Chaloner Smith no.54; Bemrose no.22; Le Blanc, Smith no.54; Frankau no.108; Russell no.54

I

Finished proof with the title in open letters and the etched inscription: *Painted by J Wright Esq. Engraved by I R Smith Mezzotinto Engraver to his Royal Highnefs the Prince of Wales ERASMUS DARWIN, M.D. & F.R.S. London Published May 1 1797 by J R Smith King Street Covent Garden* (BM, K.67.139)

II

The title in closed letters. The date altered to *May 7th.* (recorded by Chaloner Smith, Russell and Frankau, not seen)

III

False proof with the title in open letters but the inscription engraved rather crudely: *Painted by J. Wright Esq. Engraved by I R Smith Mezzotinto Engraver to his Royal Highnefs the Prince of Wales ERASMUS DARWIN, M.D. & F.R.S. London Published May 1. 1797. by J.R. Smith King Street Covent Garden* (Ashmolean; BM, K67.139; NPG)

Copy:

40a

Stipple by McAlpin, > 220 × 135 mm, published by Jones & Co. 1824 (Ashmolean)

A fragment of a letter (of which the full text is unknown) quoted in Charles Darwin's *Life of Erasmus Darwin* (p.68) affords a further insight into Smith's practices as a publisher: '. . . well done, I believe – proofs 10s 6d – the first impression of which the engraver, Mr Smith, believes will soon be sold, and he will then sell a second at 5s . . .'. Desmond King-Hele (*The Letters of Erasmus Darwin*, p.332), believing that the letter discusses a

later print of Darwin by Pym, dates it 1801. However, the name of the engraver and the price of the print indicate that the subject of discussion is Smith's print and the letter should therefore be dated 1797. In Smith's catalogue 'Dr. Darwin, MD. . . .13¾ by 12' was 5s. The fragment reveals that Smith had sold a proof edition for 10s. 6d. and that Darwin approved of his portrait.

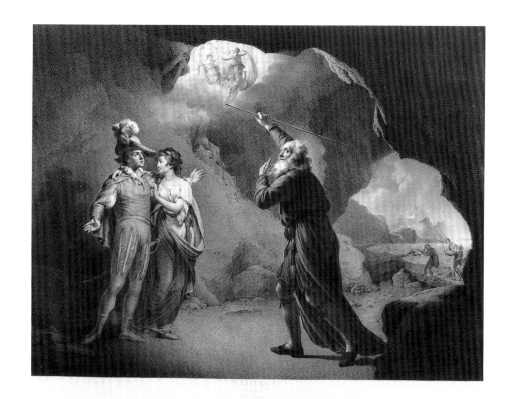

P41

172

P41

Shakspeare. Tempest, Act IV Scene I

Engraved by Robert Thew
Published by John and Josiah Boydell
4 June 1800
Stipple, 507 × 640 mm
(image 446 × 600 mm)
Nicolson 233
Nagler, Wright no.4; Bemrose no.30
I
Finished proof with the etched inscription: *Painted by Joseph Wright Engraved by Robert Thew. SHAKSPEARE. Tempest ACT IV. SCENE I. Prospero's Cell. – Prospero, Ferdinand, Miranda, &c. &c. Pub. June 4, 1800, by J & J. BOYDELL, at the Shakspeare Gallery, Pall Mall; & Nº. 90, Cheapside, London.'* (with Rob Dixon, 1989)
II
With the above inscription engraved and the additional quotation: *Pro. I had forgot that foul conspiracy [Aside Of the beast Caliban, and his confederates Against my Life; the minute of their plot is almost come. – [to the Spirits] Well done; avoid; no more.* (BM, Dd6 No.16, Vol.1; Derby 859–13–39 and another)

The painting was bought from Wright by Boydell for 300 guineas and was shown at the opening exhibition of the Shakspeare Gallery in 1789. Thew was also paid 300 guineas for his engraving, which was not published until after Wright's death.
 In 1829 this print was available from Moon, Boys & Graves at 10s. 6d. for prints and 1 guinea for proofs and colour-printed impressions.

State I exhibited
Rob Dixon

173

P42

Sir Richard Arkwright

Engraved by John Raphael Smith
Published 5 May 1801
Mezzotint, 656 × 455 mm
(image 608 × 455 mm)
Nicolson 1; this cat. No.126
Chaloner Smith no.2; Bemrose no.33;
Le Blanc, Smith no.2; Frankau no.14
I
With the engraved inscription: *Painted by JOSEPH WRIGHT, R.A. 1790. Engraved by I. R. SMITH, Mezzotinto Engraver to H. R. H. the Prince of Wales, May 5, 1801. Sʳ Richard Arkwright.* (2 Derby; Fitzwilliam; Lennox-Boyd; Whitworth 3897)

Copies:
42a
Stipple by Henry Meyer, 225 × 155 mm, published in Stephen Glover's *History of Derbyshire*, 1829 (Derby 86–4–27; NPG)
42b
Stipple by J. Jenkins, 230 × 145 mm (image 115 × 92 mm) published by Fisher, Son & Co., London
I
with the inscription *proof*, 1833 (Ashmolean)

P42

II with the word *proof* removed, 1833
 (BM 1866–10–13–755; Derby
 86–6–27; NPG)
III the date altered to 1835 (NPG)
IV the date altered to 1842 for G. N.
 Wright's *Lancashire* (BM
 1866–10–13–755)
V the date altered to 1847 (Ashmolean)
VI the publication line removed (Derby
 86–5–27)
42c
Stipple by T. Wright, > 170 × 100 mm
(image 90 × 69 mm) (Derby 71/36)
42d
Stipple by J. Posselwhite, 288 × 200 mm
(image 128 × 100), published
I by Charles Knight & Co. (NPG)
II by Charles Knight 'under the superin-
 tendence of the Society for the
 diffusion of useful knowledge' (BM
 1866–11–14–572; Derby)
III 'under . . . knowledge' erased (Derby)

Wright's painting was delivered to
Richard Arkwright junior, who had
commissioned this portrait of his father, in
March 1790. Since it was not engraved
until 1800, three years after Wright's
death, publication must have been
arranged either by Smith or by Arkwright.
Since Smith is not named as the proprietor
on the plate it is possible that Richard
Arkwright junior may have sponsored the
publication in some way.

State I exhibited
Derby Art Gallery

174

P43

Joseph Wright Esquire

Engraved by James Ward
Published by Colnaghi & Co.
1 February 1807
Mezzotint, 380 × 274 mm
(image 344 × 274 mm)
Nicolson 170
Bemrose no. 37
I
Progress proof; the whole image scraped
but clearly unfinished; rocker work exten-
ding unevenly into the inscription space,
the lower part of which is white; deep
shadows under the painter's eyes (BM,
Ward album)

II
Progress proof; the coat lightened a lot: a
shadow over the bottom button which
previously surrounded it now barely
reaches half way across it; the deep
shadow under the right eye lighter (BM,
Ward album)
III
Progress proof; the shadows under the eyes
and the whites of the eyes lighter, with the
white dots of light in the eyes larger and
brighter. Wright's left eye rounded and
softened; the lower area of the coat lighter
and the hair softer (BM, Ward album)
IV
Progress proof; the border between image
and inscription space cleaned to a straight
line. Work begun on lightening the
shadows over the eyes (BM, Ward album,
touched on the brow, nose, mouth and
cravatte)
V
Progress proof; the cravatte blurred with
diagonal scratches of drypoint in the vee
and under the chin to remove its bright
white highlights (BM, Ward album)
VI
Finished proof before all letters; the nose
and the shadows over the eyes lighter; less
obtrusive white highlights scraped on the
cravatte (BM, Ward album, two
impressions, one labelled in pencil:
'Painted by Himself Joseph Wright Esq^{re}',
the other: 'finished, bad impression')
VII
Finished proof with the title in open letters
and the etched inscription: *Engraved by Ja^s.
Ward, Painter & Engraver to H.R.H. the
Prince of Wales. JOSEPH WRIGHT
ESQ R. From a Picture painted by himself in the
poſseſsion of James Cade Esq^r. London,
Published by Meſs^rs. Colnaghi & C^o. Cockspur
Street, Charing Croſs.* (BM; Fitzwilliam
P34.1952)
VIII
With the addition of a date: *Feby. 1. 1807.*
(Derby 859–11–39)
IX
With the title in closed letters and the
above inscription engraved (Ashmolean;
collection of Judy Egerton; Lennox-Boyd;
NPG, MacDonnell coll. and another)

Copy:
43a
Line-engraving by M.V. Sears & Co.,
published in Stephen Glover's *History of
Derbyshire* (Derby PL, Mundy Lyson, III,
110c). Bemrose no.38.
The painting, tentatively dated by
Nicolson 1779–82, was in the collection of

P43

James Cade when James Ward engraved
it in 1807. It was presumably engraved at
the request of the publishers, Colnaghi &
Co., or of the owner. In 1817 Ward pre-
sented to the British Museum a complete
series of all the states of the mezzotints that
he had engraved. The unusually complete
entry for this print exemplifies the pro-
gressive alterations that mezzotints would
typically have undergone but which can
rarely be traced with the confidence that
Ward's gift allows here. The plate con-
tinued to be used until at least the mid-
nineteenth century.

State VII exhibited
Trustees of the British Museum

P44

The Reverend Thomas Seward

Engraved by Robert Hartly Cromek
Published by Archibald Constable & Co.,
Edinburgh, March 1811 as frontispiece to
vol.II of the *Letters of Anna Seward*

Line-engraving, ?170 × 108 mm (image
100 × 82 mm)
Nicolson 128
Bemrose no.40
I
With the inscription *REV?. THO?.*
SEWARD Engraved by Cromek from the orig-
inal picture by Wright of Derby in the pofsefsion
of Thomas White Esq? Lichfield. Edinburgh;
Published by Mefs?. Constable & C?. March
1811. (BL)

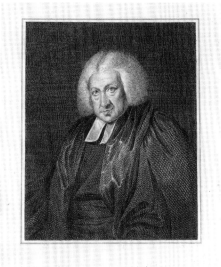

REV? THO? SEWARD

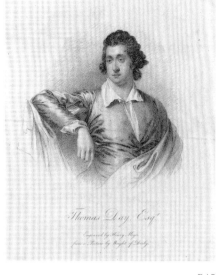

P44

P45

Thomas Day

Engraved by Henry Meyer
Published by Rowland Hunter on p.350 of
vol.I of *Memoirs of Richard Lovell Edgeworth*
Esq. begun by himself and concluded by his
Daughter Maria Edgeworth, 2 vols, London
1820
Line-engraving with stipple,
202 × 105 mm
Nicolson 57; this cat. No.60
I
Finished proof before all letters (NPG)
II
With the inscription: *Thomas Day, Esq?.*
Engraved by Henry Meyer from a Picture by
Wright of Derby. Published March 30ᵗʰ. 1820,
by R. Hunter, N?. 72, S?. Pauls Church Yard,
London. (BL)

Thomas Day, Esq?

P45

Jedediah Strutt Esquire

Engraved by Henry Meyer after a drawing
by Octavius Oakley
Published for Stephen Glover's *History of*
Derbyshire, 1829
Stipple
Nicolson 133; this cat.No.131
Bemrose no.39
I
With the inscription: *Drawn by O. Oakley*
from a Painting by J. Wright, R.A. Engraved
by H. Meyer N?. 3 Red Lion Square
JEDEDIAH STRUTT ESQUIRE.
(late of Derby.) The eminent inventor of that
important machine called the DERBY RIB
STOCKING FRAME. To William
Strutt Esq?. S?. Helen's House Derby; this plate is
most respectfully dedicated by his obliged Humble
Servant Stephen Glover the Publisher. (Derby
PL, Mundy Lyson, III, IIOC; NPG)

Copy:
46a
Steel-engraving by J. Cochran,
252 × 176 mm (Derby 352–32)

P46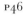

Joseph Wright

[Hannah Turner]
Printed by Graf and Soret, ?1834
Lithograph, image 153 × 130 mm
Possibly derived from Nicolson plate 7
I
With the inscription: *From a Drawing in the*
possession of John Britton Esq?. Printed by Graf
and Soret. JOSEPH WRIGHT. OF
DERBY, PAINTER. (BM, L61.19;
Derby 203–29; Derby PL, Mundy Lyson,
III I IOC; Royal Library)

The British Museum's impression is
inscribed 'June 14 1834 – Presented by
Dawson Turner Esq? Drawn on stone by
Mifs Hannah Turner.'

P48

Fireworks from the Castle of St.
Angelo Rome

William Radclyffe
line-engraving, 8vo.
Bemrose no.41
Not seen

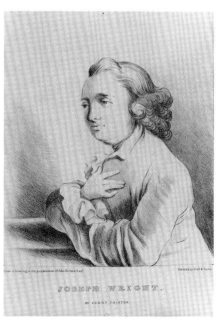

JOSEPH WRIGHT.
OF DERBY PAINTER

P47

CHRONOLOGY

WRIGHT'S LIFE AND WORKS	CONTEMPORARY EVENTS IN BRITAIN, CHIEFLY ARTISTIC AND LITERARY	CONTEMPORARY EVENTS CHIEFLY IN FRANCE AND AMERICA, AND CHIEFLY ARTISTIC AND LITERARY
1734 Joseph Wright born in Derby 3 September, third of five children of John Wright, attorney, and Hannah Brookes	**1734** Seventh year of reign of George II George Romney born 26 December Nicholas Hawksmoor, West Towers, Westminster Abbey William Kent, The Treasury, Whitehall **1740-53** Hogarth paints 'Captain Coram' 1740 Handel's 'Messiah' composed 1741 Edward Young, *The Complaint, or Night Thoughts* . . . 1742-5 Jacobites defeated at Culloden 1746 Gainsborough paints 'Mr. and Mrs. Robert Andrews' *c.*1748-50 Henry Fielding, *The History of Tom Jones* 1749 Handel's 'Music for Royal Fireworks' performed Green Park, London 1749 Lancelot 'Capability' Brown lays out Warwick Castle gardens 1750 David Hume, *Enquiry concerning the Principles of Morals* 1751 Hogarth publishes *The Analysis of Beauty* 1753 Reynolds paints 'Commodore Keppel' *c.*1752	**1732-50** George Washington born 1732 (d.1799) Jean Honoré Fragonard born 1732 (d.1806) Chien Lung becomes Emperor of China 1735 Paul Revere born 1735 (d.1818) Thomas Paine born 1737 (d.1809) Edward Gibbon born 1737 (d.1794) John Singleton Copley born 1738 (d.1820) Benjamin West born 1738 (d.1820) Jean Antoine Houdon born 1740 (d.1828) Jacques Louis David born 1748 (d.1825)
1751 Begins two-year apprenticeship under Thomas Hudson in London		**1750-60** Rousseau publishes *Discours sur les lettres: sur les arts et sciences* 1750 Pompeo Batoni established as leading artist in Rome by 1750 Tiepolo begins his frescoes at Würzburg 1750 Oudry paints 'The White Duck' 1753 Death of Piazzetta 1754 Greuze exhibits 'Grandfather reading the Bible to his Family' at the Salon 1755 Mozart born 1756 (d.1791) Robespierre born 1758 (d.1794) Voltaire publishes *Candide* 1759
1755 Earliest dated portrait, 'Anne Bateman'	**1755-60** Ramsay and Reynolds have replaced Hudson in fashionable portraiture Samuel Johnson, *Dictionary of the English Language* 1755 Edmund Burke, *Origin of our Ideas of the Sublime and Beautiful* 1756 Jedediah Strutt patents a ribbing-machine for the manufacture of hose 1758 British Museum opens to the public 1759 Society of Artists holds its first exhibition 1760 George III succeeds George II 1760	
1756-7 Returns to Hudson for fifteen months' further study, with John Hamilton Mortimer as fellow-pupil, then returns home to establish a portrait-painting practice in and around Derby		
1762-3 Portraits include the Members of the Markeaton Hunt, exhibited in Derby Town Hall	**1762-3** Stubbs paints 'The Grosvenor Hunt' and Reynolds 'Garrick between Comedy and Tragedy' 1762. Benjamin West settles in London 1763	**1762** Rousseau publishes *Du Contrat Social* Library of the Sorbonne founded Catherine the Great becomes Empress of Russia

WRIGHT'S LIFE AND WORKS	CONTEMPORARY EVENTS IN BRITAIN, CHIEFLY ARTISTIC AND LITERARY	CONTEMPORARY EVENTS CHIEFLY IN FRANCE AND AMERICA, AND CHIEFLY ARTISTIC AND LITERARY
1765 First exhibits at the Society of Artists, showing 'The Gladiator' and probably the Shuttleworth group; portraits include 'Mr. & Mrs. Peter Perez Burdett'	**1764-5** Horace Walpole, *The Castle of Otranto* Gainsborough paints 'Countess Howe' (probably 1764) Richard Wright exhibits 'Storm with a Shipwreck' SA 1765	
1766 'The Orrery' exhibited SA		**1766** Rousseau in England March 1766 – May 1767 Fragonard paints 'The Swing' *c.*1766
1768 'The Air Pump' exhibited SA. From end of 1768 to autumn 1771, chiefly based in Liverpool, portraits including 'Mrs. Clayton' and 'Mrs. Ashton'	**1768** Royal Academy founded, with Joshua Reynolds as its first President Laurence Sterne, *A Sentimental Journey* Captain Cook sails on first voyage of exploration	
		1770 Beethoven born (d.1827) François Boucher dies
1771-2 Exhibits at SA include the first 'Blacksmith's Shop' and 'Iron Forge'; also 'The Alchymist', 'Miravan' and probably 'Mr. & Mrs. Coltman'	**1771** Arkwright's first cotton mill built at Cromford, Derbyshire Benjamin West exhibits 'The Death of Wolfe' 1771	
1773 Departs for Italy in October, having married Hannah or Anne Swift in July	**1773** Cast iron bridge at Coalbrookdale constructed Oliver Goldsmith, *She Stoops to Conquer* Romney in Italy 1773-5	
1774 Arrives in Rome in February; first child (Anna Romana) born June. Short visit to Naples from early October until his return to Rome by 11 November. Peter Perez Burdett leaves England for Baden		**1774** Accession of Louis XVI of France First Continental Congress of the thirteen American colonies meets in Philadelphia
1775 Began return journey from Rome, via Florence, Venice, Parma, Lyons etc., arriving Derby 26 September. Spent next twenty months or so in Bath, in the hope (unfulfilled) of establishing himself as a fashionable portraitist	**1775** Thomas Girtin born 18 February J. M. W. Turner born 23 April War of American Independence begins, with British defeat at Lexington James Watt perfects the invention of the steam engine at Matthew Boulton's Birmingham works Sheridan, *The Rivals*	

WRIGHT'S LIFE AND WORKS	CONTEMPORARY EVENTS IN BRITAIN, CHIEFLY ARTISTIC AND LITERARY	CONTEMPORARY EVENTS CHIEFLY IN FRANCE AND AMERICA, AND CHIEFLY ARTISTIC AND LITERARY
1776 First exhibits a 'Vesuvius' and a 'Girandola' at SA	**1776** John Constable born 11 June Adam Smith, *An Enquiry into the Nature and Causes of the Wealth of Nations* Edward Gibbon, *The Decline and Fall of the Roman Empire* (concluded 1788) William Chambers begins building the new Somerset House	**1776** American Declaration of Independence
1777 By June re-established in Derby	**1777** John Howard, *The State of the Prisons of England and Wales* Richard Brinsley Sheridan, *The School for Scandal* Barry decorates the Great Room of the Society of Arts (completed 1783)	**1777** Tischbein paints portrait of Goethe in Italy
1778 First exhibited at Royal Academy, with six pictures including 'Vesuvius with St Januarius's Head', 'Grotto with Banditti' and 'Edwin'		
	1779 Death of John Hamilton Mortimer	**1779** Chardin dies
1781 Exhibits at RA include 'Portrait of a Gentleman [Brooke Boothby]' and 'Maria'	**1781** Fuseli paints 'The Nightmare'	**1781** Rousseau published autobiographical *Confessions*
	1782 Birth of John Sell Cotman Death of Richard Wilson	
1783-4 Quarrelled with RA; in 1784 (and again in 1787) exhibited only at the Society for Promoting the Arts in Liverpool	**1783-4** Thomas Day, *Sandford and Merton*, pt i 1783 Thomas Crabbe, *The Village* 1783 Copley paints 'The Death of Major Peirson' 1783 Reynolds paints 'Mrs. Siddons as the Tragic Muse' 1784	**1784** Guardi belatedly elected to the Venetian Academy
1785 One-man exhibition at Robins's Rooms, Covent Garden; works included 'The Lady in Milton's *Comus*', 'The Indian Widow', 'The Corinthian Maid', 'Penelope Unravelling her Web' and 'John Whitehurst'	**1785** Alexander Cozens, *A New Method of Assisting the Invention in Drawing Original Compositions of Landscape*, 1785-6 Gainsborough paints 'The Morning Walk' *c.*1785 Stubbs paints 'Haymakers' and 'Reapers' of 1785 William Cowper, *The Task*	**1785** David exhibits 'The Oath of the Horatii' Goya appointed painter to the King of Spain
1786 'Rev. and Mrs Thomas Gisborne'		

WRIGHT'S LIFE AND WORKS	CONTEMPORARY EVENTS IN BRITAIN, CHIEFLY ARTISTIC AND LITERARY	CONTEMPORARY EVENTS CHIEFLY IN FRANCE AND AMERICA, AND CHIEFLY ARTISTIC AND LITERARY
	1788 Death of Gainsborough 2 August John Walter founds *The Times*	
	1789 William Blake, *Songs of Innocence* Erasmus Darwin, *The Loves of the Plants*, part ii of *The Botanic Garden* Gilbert White, *Natural History of Selborne*	**1789** Meeting of the Estates-General at Versailles; Oath of the Tennis Court Washington elected first President of the United States of America
c.1790 Landscapes include 'Landscape with Figures and a Tilted Cart' and 'Italian Landscape'; portraits include 'Sir Richard Arkwright' and 'Jedediah Strutt'		**1790** Benjamin Franklin dies
		1791 Paine publishes *Rights of Man*
	1792 Death of Sir Joshua Reynolds 23 February Death of Sir Richard Arkwright 4 August Birth of Percy Bysshe Shelley 4 August	**1792** France declared a Republic Louvre opened as a public museum
		1793 Execution of Louis XVI; Reign of Terror begins David paints 'Death of Marat'
1794-5 Excursion to the Lakes; paints 'Rydal Waterfall' and 'Landscape with Rainbow'		
	1796 J. M. W. Turner first exhibited at RA, showing 'Fishermen at Sea' Edward Jenner vaccinates against small-pox	**1796** Death of Catherine the Great
1797 Wright died 24 August, at home in Derby	**1797** Death of Horace Walpole 2 March Death of Edmund Burke 8 July	**1797** Goya paints 'The Duchess of Alba'

This chronology follows, with grateful acknowledgments, the style of that in ed. Nicholas Penny, *Reynolds*, RA exh. cat. 1986

WRIGHT OF DERBY'S TECHNIQUES OF PAINTING

In the middle of his life, when many another was staying at home, Wright went to Italy and looked at the art of the two preceding centuries. Unlike others before him, Reynolds and Ramsay, the prime examples, he did not come back with a brand-new technique based on his foreign experience. Italy changed his mood, broadened his outlook and his style of brushwork but his basic methods of working, though more flexible and intuitive after Italy, had been established in the decade before he left. He stuck to them because they were developed to depict the two things that interested him most: solid structure of form and, above all, the painting of light. The painting of light is the theme that runs throughout his work and his techniques were deployed to serve it.

To take account of the range of his techniques, however, which were often developed for specific effects within a genre, his work has been considered here in two principal sections: before and after Italy. Within each section his painting is examined in terms of genre: portraits, landscapes and subject pictures.[1] As his materials did not alter much throughout his lifetime, a brief note on them is given first.

WRIGHT'S MATERIALS: SUPPORTS, GROUNDS, BINDING-MEDIA AND PIGMENTS

Wright's principal support for paintings was linen canvas, either woven plainly or with a diagonal twill. He does not seem to have had any particular motive for choosing one or the other; they occur about equally throughout his work, whether it is viewed in terms of size or subject-matter. It is true that the majority of paintings during the seventeen-eighties are on twill, but it was fashionable with many artists around this time. A few landscapes of these years were done on wooden panels.

From about the mid-seventeen-sixties onwards, grounds were nearly all brilliant white. Most of them contain lead white and chalk bound in an oil-based medium. In the last two decades he experimented with other colours. 'Brooke Boothby' (No.59) is on a pale pink ground, a few other portraits on beige. Some 'special effects' landscapes such as the 'Cottage on Fire' series are also on a pink base.

Although all the works discussed here are oil paintings, there are, among the many layers that make up his pictures, some interesting variations in the binding-medium. The red-brown underpainting of the pre-Italian period, for example, is difficult to characterise but is probably very lean oil paint applied with a lot of diluent. This would account for the layer of oil or varnish isolating it from the next layers of paint. The opaque middle layers of the pictures seem to be in straight drying-oil, whereas the glazes certainly contain a resin as well as oil. The addition of a resin would have made the glaze appear more brilliant.[2]

He was on the whole a sound technician in his use of binding-media, especially when compared to some of his contemporaries. In this respect the lessons from Hudson's studio were never rejected. Where his pictures have cracked, it is because of changes in the design or, more frequently, when, in pursuing a special effect, he alternated too many glaze and opaque layers. The Redgrave brothers, writing in 1866, noted that this was a frequent fault in his Vesuvius paintings.[3]

In common with his contemporaries, Wright produced his colours from mixtures of several pigments. The exceptions are in the 'special effects' landscapes, where pigments were sometimes used alone. His opaque mixtures are characterised by the inclusion of vermilion and Naples yellow. Both very bright pigments, they are found in skies as well as in green and brown mixtures, and help create the luminous effect. His opaque greens were formed from mixtures of Prussian blue and Naples yellow, with additons of yellow and red ochres, vermilion, green earth, smalt or bone black. The green glazes were made from Prussian blue, Naples yellow, some lake pigments (transparent vegetable colours) and often very large translucent brown particles. Some of these appear to be lakes, others the naturally occurring substance, Cologne earth. Two samples of red-brown dead-colouring analysed consisted of red and brown ochres, umber and lead white.

His flesh tones are often as described in 'The Contents of ye Pallet', referred to in Section (i), but such is their range that in the subject pictures and certain portraits, where the flesh is coloured strictly in terms of the light source, we could expect to find a variety of pigments not mentioned there. An analysis of some of the tones on Thomas Staniforth's (fig.8) face certainly bears this out. The cool yellow highlight on his forehead, for example, contains the following pigments: white lead, red ochre, orpiment, green earth, azurite, red lake, yellow ochre and chalk. A shadow on his hand contains lead white, red ochre, azurite, yellow ochre and asphaltum.[4]

CROSS-SECTIONS FROM THE PAINTINGS

Cross-sections samples are tiny pieces of the painting, usually taken from an edge or an old damage. They can measure up to 0.5mm³ but are usually smaller. Each one incorporates all the layers of paint at the point at which it was taken and often includes the ground. They rarely include the support. The sample is embedded in transparent resin, which is then ground down to expose the layers of the sample in cross-section.

fig.1 From the green curtain behind Thomas Staniforth.
Photographed at × 900 magnification.
1. Opaque layer of green, containing Prussian blue, Naples yellow, smalt, ochres and black.
2. Red-brown dead-colouring.
3. White ground.

fig.2 From a highlight on Thomas Staniforth's face.
Photographed at × 900 magnification.
1. Varnish.
2. Top layer of cool yellow flesh paint.
3. Orange-tan dead-colouring. The blurred interface between these two layers suggests the underlayer was still wet at the second painting.
4. White ground.

fig.3 From the sky in 'The Blacksmith's Shop', Yale version.
Photographed at × 500 magnification.
1. Sky paint. A mixture of Prussian blue, lead white, Naples yellow and black.
2. Red-brown dead-colouring.
3. White ground. Lead white and chalk.

fig.4 From the sky in 'Earthstopper', at the top edge near the trees.
Photographed at × 340 magnification.
1. Varnish.
2. Pale grey cloud. Smalt and lead white.
3. Sky paint. Prussian blue and lead white.
4. White ground.

fig.5 From the tree on the left of 'Earthstopper' halfway up the left edge.
Photographed at × 340 magnification.
1. Dark, semi-translucent dark glaze.
2. Blob of lead white forming the low-relief layer.
3. Dark basic tone of tree.
4. Granular blue-grey mixture. Function now known.
5. Basic sky mixture. Prussian blue and white.
6. White ground.

fig.6 From the water in 'View in Matlock Dale', bottom edge.
Photographed at × 850 magnification.
1. Reddish-brown glaze layer containing a very large, translucent brown particle.
2. Mixture forming the blue-grey water.
3. Dead-colouring.
4. White ground.

fig.7 Foliage from right edge of 'Rydal Waterfall', where it appears as a beautiful, translucent blue-green.
Photographed at × 900 magnification.
1. Very pale glaze of Prussian blue, translucent brown lake and possibly Naples yellow.
2. Similar layer, slightly denser.
3. Opaque mixture for dead-colouring. Contains Prussian blue, Naples yellow, ochres, bone black.
4. White ground. Lead white and chalk.

THE YEARS BEFORE ITALY

I Portraits

An analysis of the early 'Self Portrait' (No.1) of about *c.*1753–4 reveals how much Wright absorbed from his master, Thomas Hudson. The paint, like Hudson's, is smooth and enamel-like, applied with diagonally hatched brushwork or long strokes following the contours of the face and body. The whole surface is densely covered, no hint being left of the ground layer beneath. This ground, or priming, is visible only with a microscope and, like Hudson's, it is a very pale grey. To the end of his life Wright maintained this practice of covering the ground completely, using it only for its unifying smoothness and general reflective function beneath the paint. Except in a technique used for indicating water in his landscapes, it is very rare indeed for the ground to be visible as part of the composition.

Examined microscopically, the face can be seen to have been built-up in two phases, consistent with this style of painting. In the first painting or dead-colouring,[5] he laid on a solid modelling in muted flesh tones, made up of opaque and durable colours mixed with white lead for the lights and light ochres for the darks. Traditionally the function of this layer, apart from establishing a likeness with the least expensive range of pigments, was to provide a firm base and reflective layer for the second painting. In this second phase, which by tradition was not begun till the dead-colouring had dried, the painter would use brighter mixtures to give colour and animation to the face and enhance the modelling. Shadows could be glazed with translucent paint to increase the sense of depth. By this time, however, partly due to the British climate in which oil paint dries slowly, the second painting was often confined to the lights of the forehead, nose and chin and the pink of the cheeks. Glazing was used less than in the seventeenth century. In general Hudson subscribed to this more economical approach and it is the method that Wright used in this painting. In a similar vein, the diagonal brushwork favoured by both (though Wright's is much more emphatic and developed) was probably a way of doing the second painting wet-in-wet,[6] instead of having to wait till the dead-colouring was dry.

The background of the 'Self Portrait' is composed of ochres and umbers, mixed up and laid on in two or more layers. The first application is isolated from subsequent ones by a layer of oil or varnish. Samples of paint from Hudson's backgrounds of the same time show this to have been studio practice. The function of the isolating layer was to make it easier to apply the next paint layers. In the costume Wright keeps pretty closely to the house style, which at the time of his pupilship would have been set by the drapery painter, Alexander van Aken. The shadows have a full dead-colouring overlaid with translucent glazes. The rest of the modelling is largely wet-in-wet.

For the structure of this portrait, then, Wright used Hudson's method of building up the picture in layers. This particular technique depends on the fundamental principal that any colour, whether transparent or opaque, is affected by the colour of the layer of paint (or ground) beneath it. This gave the artist a potentially enormous range of colours and effects. The fact that in many a portrait-manufactory it was reduced to a pattern should not obscure its power in the hands of a responsive painter. For nearly ten years after leaving Hudson, Wright drew on these methods for his portraits, gaining confidence as he went along. From the beginning, however, he asserted his independence of Hudson in his choice and range of palettes. His fascination with light gave him the boldness to choose colours that depicted not only the sitter's complexion but also the type of light illuminating it. In this he was unlike any of his contemporaries and it is a very far cry from the spirit of the portrait-manufactory. Any selection of his portraits from this period would do to illustrate the point; one has only to compare the range of colours and tones used for the dark shadows on the faces. But it is worth looking in detail at a few from the end of the decade, when, in conjunction with some very unusual palettes, he began altering his technique to achieve the effects he desired.

The portraits of 'Mrs. John Ashton' (No.25), 'A Conversation of Girls' (No.24), 'Thomas Staniforth of Darnall, Co. York' (fig.8) and 'Sarah Carver and her daughter Sarah' (fig.9) were all painted around 1769 and 1770. Two of them, 'Mrs. Ashton' and 'Sarah Carver', are depicted in cool lighting, one indoors, the other out. Mrs. Ashton's greenish-grey half-tones and pinkish-grey translucent shadows are caused by the strong diagonal light entering the room through a window which lies beyond the top left corner. Sarah Carver's colouring, on the other hand, is more diffuse, with pearly blue half-tones and purplish opaque shadows. It is a product of the cold white light that accompanies the storm clouds above her head. These two portraits, then, were painted with different palettes, but in the technique described above.

In the other two, which are of people under warm lighting, both the palette and the technique are different. Thomas Staniforth (lit probably by a domestic oil-lamp) has striking cool yellow highlights contrasted with hot pinky-orange shadows. Standing in bright sunshine, the two girls with their black servant have creamy yellow-green highlights, cool green reflections and half-shadows, bright pink cheeks and warm, diffuse shadows. These unusual colours were applied with a new style of brushwork. While retaining his diagonal and long, descriptive strokes, he added dabs and short, stubby strokes and left the whole thing unsoftened. This style can be seen here and there in portraits of the late seventeen-sixties, in the face of Sarah Carver's daughter for instance, but it is nowhere so developed as in these warmly-lit works. The underpainting is even more

unusual. Beneath Thomas Staniforth's clothes, background and curtain it is done in shades of red-brown, a colour which bears no relation to the final image (fig.1). The face was dead-coloured not with muted flesh tones but with very bright shades of tan and orange (fig.2). Although these first colours are barely visible in normal viewing, their effect is to give the face a warm glow.

This yellow-green-pink style of portraiture was not long lived. Wright seems to have rejected it by 1771, perhaps recognising it as too experimental for commercial success. It is nevertheless a critical phase in his development. Inspired in all probability by his own experience of unusual flesh tones in the candlelight pictures, this combination of expressive brushwork and a new mode of colouring marks his independence from the restrictive side of the Hudson tradition.

The fruits of his new powers can be seen in 'Mr and Mrs Coltman'[7] (No.29) exhibited 1771. Starting off with a plain white ground, which by now had become his standard choice, Wright laid in the composition, including the tones of the sky, with a very thin, monochromatic undermodelling in reddish brown paint, similar to Thomas Staniforth's, though less robust. Having left this underpainting to dry, he then set about colouring the composition in a variety of ways. The figures, horse and dog seem to have been worked up wet-in-wet with dense, smooth paint and a smallish brush. Here and there a dark shadow or highlight was applied in an overlayer. In the background and trees he started off with solid mixtures representing the mid tones of the areas in question. Having laid these in broadly with a brush, he worked up the form, local colour and surface detail with a variety of appropriate tones, applied in marks, dabs and blobs with smaller brushes; areas of the thick paint on the tree trunk appears to have been applied with a palette knife. Some of this textured work was then glazed with translucent tones. Elements of this treatment of landscape can be seen here and there in portrait backgrounds from the later seventeen-sixties, and a couple of years later he developed it further when embarking on landscapes proper.

Before leaving this phase of Wright's portraiture a mention should be made of a page in the back of his account book, entitled 'The Contents of ye Pallet' (fig.10). We do not know when he made the note but it certainly refers to his own practice at some point. Used selectively it could have produced any of his portraits, except the group similar in colouring to 'Thomas Staniforth', where analysis has shown the presence of several pigments not mentioned here. The palette is important for two reasons: firstly in its testimony to Wright's concern for subtle tonal differences, sometimes achieved with complex mixtures of pigments; and secondly, in the source of some of its tints.

The only similar palette in seventeenth and eighteenth century literature occurs in Thomas Bardwell's book, *The Practice of Painting and Perspective Made Easy* of 1756. Only Bardwell uses 'teints' to this extent and several of those on Wright's palette conform exactly to Bardwell's own.[8] The

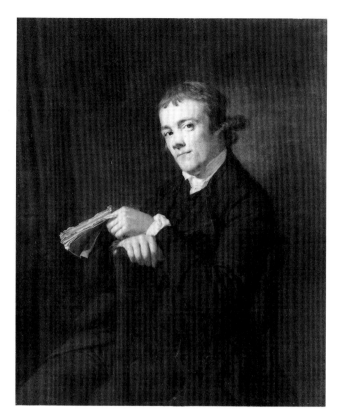

fig.8 Joseph Wright of Derby: 'Thomas Staniforth of Darnall, Co. York' 1769, oil on canvas $36 \times 30\frac{1}{2}$ (93 × 77.5)
Trustees of the Tate Gallery

fig.9 Joseph Wright of Derby: 'Portrait of Sarah Carver and her daughter, Sarah' 1769–70, oil on canvas 50 × 40 (127 × 101.6)
Derby Art Gallery

fig.10 'The Contents of ye Pallet'
First row:
1 Vermilion teint . . . Vermilion and white. 2 vermilion. 3 Carmine teint . . . Lake and vermilion. 4 Carmine X. 5 Lake X. 6 Brown pink X. 7 Dark shade to flesh . . . Brown ochre, burnt lake, terracina and [? burnt umber]. 8 Halfshade . . . Dark shade, Naples yellow and a little white. Quarter shade. 9 Olive teint . . . Halfshade, Naples yellow and blue teint. 10 Blue teint . . . Ultramarine, Prussian and white. 11 Purple . . . Lake and azure. 12 Dark shade . . . Indian red and black. 13 Burnt umber. 14 Black X. The colours marked thus X need not be laid ye first painting.
Second row:
1 Rose teint . . . is ye Carmine teint and white. 2 Lake teint . . . Lake and white. 3 Indian red teint . . . Indian red and white. 4 Light red. 5 Light red teint . . . Light red and white. 6 Ditto lighter. 7 Complexion teint . . . Naples yellow and white. 8 Highlights . . . Ditto very light. 9 Naples yellow. 10 Light ochre.
National Portrait Gallery Archive and Library

practical side of the book has been acknowledged as being almost wholly original,[9] free of the usual plagiarisms from earlier textbooks. Bardwell, moreover, was self-taught as a painter and, having spent most of his life in East Anglia, had few connections with London artists. His instructions, therefore, are unlikely to represent anyone else's practice. Wright's palette is a very strong indication that he had read this book and its importance for him is discussed in the next section.

II Subject Pictures

Very little in Wright's practical experience had prepared him for painting the artificially-lit night scenes which he produced from around 1762 to 1772. No matter how many candle light pictures by other artists he might have seen, he would have had to start from guesswork, hearsay and experiment when it came to producing similar effects himself. An examination of these paintings shows that he did experiment from one to the other but only within a basic structure, which he retained throughout.

He started off with a white ground, on which he sketched in the composition with reddish-brown paint and a brush. Chronologically these are the first occasions in his work for the use of red-brown dead-colouring. In the early subject pieces, 'An Experiment on a Bird in the Air Pump' (No.21) for example, it varied from grey-brown to dark red in the background and from beige to red under the figures. For 'An Academy by Lamplight' (No.23) of 1768–9 and 'A Blacksmith's Shop', Yale version (No.47) of 1771 (fig.3), it became completely monochromatic: a dark chestnut-coloured layer, which was varied in tone by the density of application and by small admixtures of white lead. 'The Alchymist' (No.39) of the same year has a similar chestnut brown used in conjunction with a solid mid-grey in certain areas. In 'Miravan Breaking Open the Tomb of his Ancestors' (No.42) of 1772 and 'A Philosopher by Lamp Light' (No.41) he reverted to dark chestnut brown on its own, though applied more broadly than in 'An Academy by Lamplight'.

In all these pictures this first layer is a fully modelled underpainting rather than an 'imprimatura' (or plain-coloured layer put on to deaden the white ground). In the 'Academy' and the Yale 'Blacksmith's Shop' the under-modelling is detailed and, in the absence of preparatory drawings, this might explain the lack of pentimenti (alterations by the artist) in such complex final paintings. Except in the last two, the dead-colouring is not discernible with the naked-eye, nor is it meant to be. It is visible in 'Miravan' in the horizontal tracery on the architrave of the tomb and in 'A Philosopher' it appears here and there through abrasion of the thin, dark paint layers.

How he came by this method is not known for sure. No-one else of note in England was painting in this way. It is possible that he developed it himself by arguing that predominantly dark pictures would need a stark white ground to reflect light through the paint layers and dark red on top of it to provide an overall warmth. Even so it is no slight to his originality to wonder whether the germ of the idea might not have come from a literary source and carry in it some ideological significance. If Wright's underpainting were just a question of an imprimatura on the white ground, then a possible source could have been a selective translation of Vasari's *Lives*, which was first published in 1685 and then reprinted in 1719. In *Choice Observations Upon the Art of*

Painting, the author-cum-translator, William Aglionby, recommends the following ground for oil painting:

> you paint upon a cloth, which has first been primed with drying Colours, such as Cerus [lead white], Red Oaker and Ombre [umber], mingled together. This manner of painting, makes the Colours show more lively than any other, and seems to give your Picture more vivacity and Softness.[10]

This, it should be stressed, is just a plain coloured ground on which to draw out the intended design, but it is not impossible that Wright might have read it and liked the idea of using in his own way a mixture recommended in a book which went on to discuss the great Italian painters from Giotto to Michelangelo and Titian. In two of the paintings analysed, Wright's underpainting is composed of the exact same pigments mentioned above, though the fact that they are all three very quick driers in oil might mean the choice was coincidental.

A less tenuous connection can be made with Bardwell's book; Wright's palette is very strong evidence that he knew it well. In his instructions for dead-colouring portraits, Bardwell recommends starting with 'Dark-Shade and Umber', 'Shade-Teint' and 'Light-red teint', used separately and worked together. The first was a mixture of ivory black and Indian red; the second was lake, Indian red, black and white 'mixed to a beautiful Murrey [wine-red] Colour'[11] and the third was light red and white. The first and last of these tints occur on Wright's palette, and the instructions, followed fairly closely, would produce a dead-colouring similar to the one in 'An Experiment on a Bird in the Airpump'.

So it looks very much as if Wright's thinking here was influenced by Bardwell, who in his introduction explains that he has made a long study of the old masters to discover the secrets of their colouring, an art last seen to great effect in the work of Rembrandt. Observing that it is the knowledge of technical methods that has been lost since then rather than special pigments, he goes on to say that of all the painters he has studied ' . . . Van Dyck and Rembrandt are the surest Guides to Nature. It is out of these most excellent Masters that I have established my Method: It is from their Pictures I have found the first Lay of Colours; and from them I have learned the Virgin Teints, and finishing Secrets; tho' I have always applied them to Practice from Nature.'[12]

If the idea of incorporating the spirit of Rembrandt into his dead-colouring appealed to Wright, then his independent nature made sure that for the main paint layers he followed nobody's instructions but his own. The pigment mixtures were chosen strictly in accordance with the colour of the light-source and the layer-structures vary according to the overall effect he wanted in each picture. In the 'Academy', for example, the background tones were achieved with one layer of dense paint on top of the underpainting. The figures were worked up wet-in-wet, with some of the shadows glazed over later. In the background of

'Miravan' on the other hand, translucent glazes were used extensively on top of very solid wet-in-wet work to create the mellow glow. The predominantly smooth brushwork in them all is relieved here and there with highlights applied in low impasto, or by palette-knife work to describe a rough surface, as in the broken edge of the stone slab held by the workmen in 'Miravan'. He seems to have applied a thin layer of varnish or oil to the dry underpainting before starting to apply the colours. The procedure in all of them seems to have been from dark to light and from cool tones to warm.

In two of the works examined, 'An Academy by Lamplight' and the Yale 'Blacksmith's Shop', a most unusual technique was used for the principal source of the light, a metal lamp and bar of white-hot iron respectively. In the former, the black paint of the metal parts of the lamp is underlaid with gold and silver leaf, which was applied on top of the red-brown underpainting. The layer-structure of the iron bar is as follows: thick lead white applied on top of the dead-colouring, followed by a layer of gold leaf, which in its turn is completely covered by an opaque layer of Naples yellow paint. In neither case is one meant to be aware of the gold with the naked eye. Its function is to reflect more light through the layer on top and help create the illusion of a glowing substance. He does not seem to have used this technique for sources of light which were not metallic. Its absence in the other paintings examined[13], suggests that he did not think the experiment worth pursuing. In the Derby version of 'The Blacksmith's Shop' (No.48) he described the bar with an opaque layer of yellowish-white on top of the white ground. In theory the use of metal leaf simply pushed the basic principle of his standard layering-technique to an extreme, gold and silver being more reflective than any paint layer, but it is intriguing nevertheless to wonder if he worked the idea out for himself or read about it. No literary source earlier than these paintings has been found but a passage in a book published in 1795, *A Practical Treatise on Painting in Oil Colour*, suggests that there might have been one:

> In order to represent the sun or moon with amazing force, lay on the spot or place where it is intended the greatest light or glow shall be, some varnish, or body of fine white; upon this stick gold or silver leaf (whichever is to be painted, either sun or moon) and glaze over with yellow-lake, brown-pink or Naples yellow, in proportion to the effect of sunshine or moonshine. This, well-managed in the glazings and re-touchings, will produce a wonderful effect.[14]

III Landscapes

In one of his earliest landscapes, 'The Earthstopper on the Banks of the Derwent' (No.51), Wright drew on the experience gained from the subject pictures and portraits by laying in most of the trees, rocks earth and grass with his standard red-brown dead-colouring. The water was indicated with a thin wash of pure Prussian blue. The sky was not underpainted; the traces of red-brown visible in its lower half relate to a change in the composition, this area having been intended probably as a hill at some stage.

At the next painting he laid in the sky with an opaque mixture of Prussian blue and lead white. For the lovely moonlit cloud he made a mixture of the glassy blue pigment, smalt, and lead white, relying on its cool tone to produce silver grey when contrasted with the Prussian blue sky (fig.4). For the rest, as in the Coltman landscape background, he mixed up opaque mid-tones of green, grey and light brown for the respective areas and laid in the forms broadly and smoothly with a brush.

The next stage was one seen in a less developed form in the Coltman portrait. It became for many years one of the hallmarks of his style and it was a direct response to the play of light on broken surfaces. All the detail of light and shade and surface texture was created with a quantity of dabs, dashes and squiggles of opaque paint. They were applied in various thicknesses with a small brush or, as in the rocks and white water, with a palette knife. This low-relief work was then glazed when dry with semi-translucent paint (fig.5).

AFTER ITALY

IV Portraits

The grandeur and serenity of Wright's later portraits were achieved, in a technical sense, by adding to and broadening the methods of applying paint and reverting to a slighter version of the traditional dead-colouring of his early days. After the trip to Italy he never again used the dramatic red-brown dead-colouring for portraits. In 'Brooke Boothby' (No.59) the underlayer is in the muted purplish-brown tones visible in the shadows on his temple. The paint is thinner, though no less dense, and the brushes much bigger. The noticeable difference in the palettes used for the faces in the double portrait of 'The Rev. and Mrs Thomas Gisbourne' (No.146) testifies to his continued interest in the nature of the light, but in general his portrait palette from the seventeen-seventies onwards was warm, becoming ruddy for indoor portraits in the last decade.

The brushwork of this period is much freer and more intuitive than in pre-Italian days. Mrs D'Ewes Coke's (No.142) marvellous green dress, for example, was made by mixing up the colours for the mid-tone and half shadow on the palette and working them together on the canvas. The lights were then applied wet-in-wet in small dabs and dashes, without softening. The dark, semi-opaque linear shadows were applied last. The methods of building up the foliage and tree-trunks in 'Brooke Boothby' are all pre-figured in his earlier work but they were handled here in a much grander manner.

There are in addition some adventurous new techniques, such as the dragging of stiff paint across dry, thinly painted areas so that it stuck only to the ridges of the canvas.[15] It was used extensively on the tree-trunk to the left of Brooke Boothby. He favoured this method particularly for paintings on twill (diagonal weave) canvas. It is sometimes interpreted as over-cleaning but this is not the case. Brooke Boothby's suit was made from three tones of warm beige, mixed up thickly and then worked together on the canvas. When dry the whole area was glazed with a flat, monochrome layer of bluish-black paint.

As Wright approached the end of his life, his paint for portraits became thinner and more uniformly dense. On the faintest of dull-brown dead-colourings, the portraits were worked up wet-in-wet in sanguine tones, with hardly any impasto or palette knife work.

V Landscapes

The post-Italian landscapes display a range of technical methods employed within each picture. Unlike Gainsborough, for example, Wright was slow to develop a uniform style of painting. Largely as a result of his interest in structure as well as effects of light, he tended to treat each part of the landscape differently, choosing techniques that would depict a particular type of topography under specific conditions of lighting.

His general treatment of the landscape tended to fall into three stages. With the dead-colouring he established the space and the basic forms, usually as little more than silhouettes. The structure of the various parts of the scene was built up in the next layer, and the local surface textures and effects of light were put on last of all. It is in these two stages, especially the last, that the different techniques are characterised. Although there was undoubtedly stylistic development in his landscapes over these decades, his practice of using different techniques for the different motifs means that it is not helpful to use a strictly chronological basis for examining his methods of working. For this reason they are classed here under motifs, except for the dead-colouring which is described separately.

The dead-colouring in these decades was done in opaque

tones of pale grey, brown or green, depending on the overall tone of the landscape. As in the portraits, the red-brown underpainting did not survive Italy. Except in the paintings noted below, the dead-colouring is found under all parts of the landscape and it was applied smooth and flat. A few of the cross-sections indicate that he did a very rough outline sketch in black or dark brown before applying the underpainting.

With great uniformity, his skies, which in common with most people's practice were painted first, were done in creamy paint, worked up largely wet-in-wet in a solid layer directly on top of the ground. They are opaque, their great luminosity being a product of two things: the highly reflective white ground immediately underneath, which was deadened with underpainting in the rest of the picture; and, as in 'Earthstopper', a judicious choice of pigment mixtures. Again as in 'Earthstopper', large contrasting clouds were applied on top.

Far distances were painted with smooth, opaque paint, the detail being put in wet-in-wet. In later years this treatment was extended to the middle distance, as in the Lake District scenes where everything but the immediate foreground was described with opaque, creamy paint sometimes applied smoothly, sometimes in varying thicknesses. The exceptions to his rule of dead-colouring the distances are the 'special effects' landscapes, where the source of the light comes from the landscape rather than the sky. In 'Vesuvius in Eruption' (No.102), for example, Wright achieved maximum glow from the cone and its surrounding areas by dispensing with underpainting and applying solid vermilion paint directly on top of the ground. These areas were then glazed and scumbled when dry in a way he normally kept for the nearer parts of the landscape.

For most of his life the middle distances and foregrounds were treated as follows. After the dead-colouring had dried, the structure was laid on in a variety of ways. In 'A Grotto by the Sea-side in the Kingdom of Naples, with Banditti' (No.99), for example, opaque pinky-brown paint was applied expressively with brush and palette knife to describe the planes in the great arch of rocks on the left. In the right hand arch, however, which is seen in silhouette, he chose a variety of the figured relief-work seen in 'Earthstopper'. To maintain the silhouette, he did most of it with translucent brown paint.

In 'View in Matlock Dale' (No.123) on a pale bluey-grey dead-colouring, the wooded part of the landscape was built up in shades of green, mainly opaque and applied in small strokes with a brush. The pink and yellow highlights were put in on top. Some of this colour was applied in dabs with a brush; for most of it, however, the paint was mixed up stiffly and dragged across the surface of the picture, in the manner described for 'Brooke Boothby', though it looks as if a brush was used here.

The final treatment for foregrounds and middle distances was glazing and this too takes a variety of forms. In 'A

Grotto by the Sea-side in the Kingdom of Naples, with Banditti', the whole foreground arch was glazed with thick, translucent brown. Here and there on the left hand side, Wright appears to have wiped it so as to reveal a bit more of the palette-knife work. In 'View in Matlock Dale' the tarry-looking dark blotches in the trees were put on after the highlights. Then, when all was dry, he brushed a very thin reddish-brown glaze over the whole foreground landscape, including the water. This glaze contains unusually large particles of brown and red pigment (fig.6). It is not present on the bare hill in the distance. Although it is not visible as a discrete layer to the naked eye, it is a testimony to the subtlety of Wright's glazing techniques, which were used to great effect in the sunlit scenes of the seventeen-eighties. The top half of the tree on the right was painted entirely in overlapping patches of translucent colours, applied on top of the sky.

In other paintings, particularly some of the Vesuvius scenes, the foreground was built up with an exceptionally heavy amount of glazing and low relief work in his effort to render the light adequately.

Water was usually dead-coloured, then painted in one thin layer of opaque colour (fig.6). The ripple lines were incised into the soft paint with the brush handle to reveal the deadcolouring or the white ground. This technique, known as sgraffitto, dates back at least to his stay in Italy and was used extensively afterwards.

Towards the end of his life, his way of applying paint became smoother and broader. Glazing was pushed down to the immediate foreground, as in the wonderful pair 'Lake Albano' and 'Lake Nemi' (Nos.114 and 115) or the Lake District scenes. To the last he was responsive to the motif, and in his mastery of the layered technique had the means of depicting a wide range of topography and effects of light. His treatment of 'Rydal Waterfall' (No.138), which he described as 'a very intricate subject'[16], testifies to his ability to adapt the technique to the subject, even late in his life when he was dogged by ill health. In this painting he omitted the low-relief work in the foliage and merely glazed subtly in two or three layers over smooth, opaque form (fig.7).

VI Subject Pictures

The late subject pictures display a variety of different structures, which were chosen to convey the lighting and mood of each painting. For 'Maria, from Sterne' (No.58), a cool-toned, daylit picture, the technique was a broadened version of his contemporary portraits. In 'The Indian Widow' (No.67), on the other hand, he referred back to his pre-Italian days and used a red-brown dead-colouring, though more thinly applied and subdued in tone. It may be seen beneath the scumbled paint of the foreground and, interest-

ingly in relation to his landscapes, it is present also under the sky to help create its ominous tone. In 1784, writing to a friend about another picture 'William and Margaret', he said, 'I hope it will prove a chilling picture, [I] have aimed at an unpleasant sort of colouring.' It is an indoor scene lit by cold moonlight and it is painted in livid bluish-green tones on a thin, greyish dead-colouring. In 'Romeo and Juliet' (No.63), a very dark interior lit by a torch outside the field of vision, he again started off with red-brown under-painting, overlaying it with thick, broadly applied opaque paint.

In conclusion, then, his technique may be defined as an orderly system of layers, each composed of interesting and inventive mixtures of opaque and transparent pigments. In essence this layered technique was learned during his pupil-ship with Hudson, though Hudson might have had difficulty recognising the flexible, personal way Wright used it. In each picture the structure depended on the effects he wanted to stress: lighting, mood, topography, space.

Nevertheless this link with Hudson kept Wright in touch with a long tradition of painting. Hudson had inherited his technique from a succession of masters and pupils going back to the time of Sir Peter Lely, in whose work it is seen to very great effect. It is a tribute to Wright's inventiveness that he was able to adapt this technique to such a range of pictures and make it so recognisably his own.

RICA JONES

NOTES

1 Information has been gathered from forty eight paintings, principally with the use of stereo-microscopes, hand lenses and analytical micro-scopes for cross-sections from the paintings.
2 The different binding-media were visible when the layer structures were examined in ultra-violet auto-fluorescence and, in some cases, when the cross-sections were stained with fluorochrome dyes.
3 Redgrave R. and S., *A Century of British Painters*, Oxford 1981, p.106.
4 EDX (Energy Dispersive X-ray) Microanalysis of pigments was kindly done by Dr Ashok Roy of the National Gallery Scientific Department.
5 Dead-colouring is the sketching in of the design and the modelling in naturalistic tones, though more muted and opaque than those in the layers on top. If it were not in muted tones, as with Wrights own red-brown first painting for example, it should more properly be called an underpainting or undermodelling. In practice, however, the terms are interchangeable. Wright called it dead-colouring regardless of its tones.
6 Wet-in-wet means painting into a layer of paint which is already on the canvas but not yet dry.
7 Wyld, M. and Thomas, D., 'Wright of Derby's 'Mr and Mrs Coltman': An Unlined English Paint-ing', *National Gallery Technical Bulletin*, Vol.10, 1986, pp.28–31. For further information on this portrait.
8 The 'teints' for portraits in Bardwell's book are as follows: Light-red tint, Vermilion tint, Carmine tint, Rose tint, Yellow tint, Blue tint, Lead tint, Green tint, Shade tint, Red Shade, Warm Shade, Dark Shade, a tint made from Indian red and white and a tint made from lake, vermilion and white. The following pure colours are rec-ommended also: brown-pink, lake, ivory black, Prussian blue, burnt umber and light ochre.
Of the tints and colours on Wright's palette, the following are made up slightly differently from Bardwell's or do not occur in the book: Carmine tint, Darkshade to flesh, Halfshade to flesh, Olive tint, Blue tint, Purple, Rose tint, Lake tint, Com-plexion [yellow] tint. So of the twenty-four tints and colours on Wright's palette, only nine do not occur in Bardwell's book.
9 Talley, M.K., and Groen, K., 'Thomas Bardwell and his Practice of Painting: A Comparative Inves-tigation Between Described and Actual Painting Technique', *Studies in Conservation*, 20 (1975), pp.44–108 and Talley, M.K., 'Thomas Bardwell of Bungay, Artist and Author 1704–1767', *Walpole Society*, Vol.46, 1976–78, pp.91–163.
10 Aglionby, W., *Choice Observation upon the Art of Painting. Together with Vasari's 'Lives of the most emi-nent painters from Cimabue to the time of Raphael and Michelangelo'. With an explanation of the difficult terms.* London 1719 p.27.
11 Bardwell, T., *The Practice of Painting and Perspective Made Easy*, London 1756, pp.9–10.
12 Ibid., p.3.
13 'The Earthstopper on the Banks of the Derwent' was examined in addition to the paintings men-tioned in this section.
14 Anon, *A Practical Treatise on Painting in Oil Colours.* London 1795, p.210. By coincidence, this book is the first pirated edition of Bardwell's *Practice of Painting*. There is no connection with Bardwell; he had died in 1767. I am grateful to Leslie Carlyle for finding this reference.
15 This is similar to the technique known as scum-bling: drawing opaque paint across a differently coloured underlayer.
16 Letter to John Leigh Philips, December 1795. Derby Public Library 8962, Letter 39.
17 'William and Margaret from Percy's "Reliques of Ancient English Poetry."' B.1973.1.69, Yale Center for British Art, New Haven.
18 Letter to Hayley, April 1784. Private collection.

ACKNOWLEDGEMENTS

The author would like to thank the following people for their help in preparing this essay: Lord Dunluce, Roy Perry, Stephen Hackney, Joyce Townsend, Jo Crook, Leslie Carlyle, Dr Ashok Roy, Martin Wyld, David Bomford, David Fraser and the staff of the Yale Center for British Art at New Haven.

FRAME ANALYSIS BY STYLE AND STATUS

Numbers refer to the catalogue; style dating according to earliest and latest examples

	ORIGINAL	CONTEMPORARY	OUT OF PERIOD
LATE 17TH CENTURY			39, 51, 108, 148
EARLY 18TH CENTURY			1, 33, 98, 117, 146?
ROCOCO c.1760–c.1774	3, 5, 6, 7, 8, 10, 19, 20, 24, 26, 94	9, 29, 31, 136	34
CARLO MARATTA c.1762–c.1794	14, 15, 16, 17?, 25, 35, 36, 37, 48, 58, 104, 124, 138, 143, 144	28, 30, 137	2, 118
NEO-CLASSICAL c.1771–c.1793	23, 32, 47, 52, 57, 59, 61, 63, 66, 99, 100, 103, 110, 111, 114, 115, 116, 120, 121, 126, 127, 128?, 129, 130, 132, 133, 134, 135, 140, 141, 142, 145, 149	27, 38, 53, 64, 68, 113, 123?	65, 105
19TH CENTURY			4, 18, 21, 22, 40, 42, 50, 62, 67, 69, 97, 106, 107, 109, 131, 147
20TH CENTURY			11?, 12?, 41, 122, 150

Frames not inspected (see footnote 4): 13, 49, 60, 77, 101, 102, 112, 119, 139

WRIGHT'S PICTURE FRAMES

INTRODUCTION

Frame-making was a flourishing trade during Wright's life-time. Artists and their patrons, as well as ornamentalists, decorators and architects, were all to some degree involved in the commissioning, design and purchase of picture frames. Sieving the *Dictionary of English Furniture Makers*[1] reveals one hundred and eighty craftsmen in London who supplied frames between 1750 and 1800. In Derby alone, according to the *Universal British Directory* of 1791, there were thirteen craftsmen listed as specialist "frame smiths".[2] Many more in both London and the provinces must be unrecorded. Most of them also produced mirror frames, chimney pieces, orna-mental mouldings and often other interior furnishings. Creators and owners alike must have been well aware of the decorative impact made by gold frames, especially seen by candlelight.

Until recently general awareness of frames has been slight. Modern art history is only just beginning to accommodate the frame. Virtually all illustrations of paintings in art his-torical literature, photographic libraries and exhibition cata-logues exclude the frame.[3] The subject hovers between the fine and decorative arts and few historians of either side have felt keen to tackle it. This is perhaps largely due to the bewildering number of patterns, and to difficulties in dating and attribution, generally so central to connoisseurship. However, even with minimal documentation, much can be learnt from the visual evidence of frames. Particular styles may be analysed, and their duration and overlaps deter-mined. Identification of designers and/or makers is an occasional bonus providing new insights.

Wright's Account Book includes many references to frames. This exhibition devoted to his work presents an opportunity to examine the frame designs prevailing during his career, as well as those with which he was particularly associated.

Prior to their arrival for the exhibition 108 of the 117 picture frames have been assessed.[4] A further 36 frames on works by Wright not included in this exhibition have been studied. The survey thus comprises 144 frames representing well over a third of all his recorded paintings. These may be classified accordingly. First, those considered original to the picture; second those which are stylistically contemporary but probably not original; third, those of a distinctly earlier or later period than the picture. Results are summarised by style and status in the table opposite.

The most significant fact to emerge two centuries later is that just over half of Wright's paintings in this survey still appear to retain the frames originally made for them. It is perhaps Wright's provincialism which accounts for this relatively high ratio.[5] Many of his pictures have descended through the families which commissioned them, the frames unchanged. Relatively few of these have appeared on the art market, where pictures are at their most vulnerable to re-framing, and those mainly in recent decades as Wright's art has been re-assessed.[6]

As well as a general appreciation of the subject this study hopefully will encourage the spectator to contemplate the picture *together* with its frame and assess their relative merits.

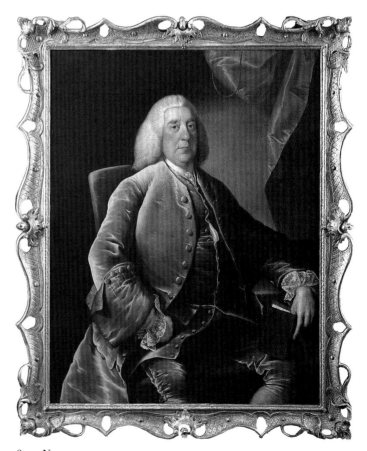

fig. 1, No. 3

ROCOCO FRAMES

During the Rococo period English frame-makers, learning from the sophisticated skills of Huguenot craftsmen, created a wide variety of patterns, many of which were one-offs. Amidst these certain distinct groups of designs may be distinguished. The exhibition has drawn together three Rococo frames which appear to be the earliest identifiable pattern used by Wright. These are the half-length (50 × 40 inches) on 'William Brooke' of 1760 (fig.1, No. 3) and the pair of three-quarter lengths (30 × 25 inches) on 'Samuel' and 'William Rastall' c.1762–64 (figs.2 & 3, Nos.19 & 20). With their swept pierced outer rails, leafy-scrolled corners and rocaille centres, these frames epitomise the lightness and elegance of the Rococo style. They should be contrasted to the preceding generation of more solid Louis XIV based frames, one of which surrounds 'Cornet Sir George Cooke' (No.33). The contours in Wright's compositions are well set off by the frames' sweeping silhouettes. The outside profile is echoed by a meandering band adjacent to the sight edge. Typical of Rococo concern for surface decoration, the panels are incised with trellis-work (or quadrillage) punctuated by bosses. This has been partially obscured by re-gessoing and oil gilding through which traces of the original burnished water-gilding may be seen. The technique of gesso carving was mainly introduced into England by Huguenot craftsmen, many of whom were picture and mirror frame-makers. It is therefore likely that these frames were by a French hand. Primarily for portraits, this pattern does not occur on Wright's subject pictures to which he mainly applied Carlo Maratta frames, as we shall see later.

Comparing the Rastall pair with 'William Brooke' we see an expected design change for the smaller format. Here the outer rail connects corners and centres in a single sweep, whereas in the larger frame this gap is negotiated by merging two sections to a pierced apex. However, the portrait of 'Thomas Bennet' c.1760 (Derby Art Gallery), which is the same size as the Rastall pair, carries the identical design to the half-length 'William Brooke' – showing the frame-maker offered at least three variations on this theme.[7]

Further contemporary evidence of this pattern which supports the originality of these frames to their pictures occurs on the portraits of Mr and Mrs William Pigot 1760 (Private Collection, Nicolson cat.120 & 121, pls 23 & 24.) We can conclude that, being of a consistent design, they were the product of the same workshop between c.1760–c.1764, supplied by a framer with whom Wright worked closely.

From references in Wright's Account Book it is clear that a Huguenot, John Dubourg, was the artist's main framer at this time.[8] Dubourg, who had a separate account with the artist (fig.4), supplied carved and gilt half-length frames at £3.3s., three-quarter lengths at £1.11s.6d. and black and gold print frames from 12s to 16s.[9] Included in these orders is a reference which ties the Pigot frames to Dubourg. It seems one frame was returned to Dubourg and another supplied,

fig.2, No.19

fig.3, No.20

an outstanding sum remaining in 'Pigot's Bill which was due and paid to Dubourg'.

As later evidence shows it seems that Wright was always concerned with the framed appearance of his paintings, and is likely therefore to have proposed these frames to his sitters, most probably having one or two demonstration stock models in his studio – much as artists still do today.

Surviving examples of papier-mâché frames are extremely rare and there can be few finer than those made en suite for Wright's Markeaton Hunt group, probably painted between 1762–63, of which four from the original set of six are exhibited (fig.5, No.5; Nos.6 & 8; No.7, however, is no longer in its original frame).[10] These were commissioned by Francis Noel Clarke Mundy and his five sportsmen friends and relations to be displayed in the Mundy's dining room at Markeaton Hall.

Clearly a commission of this scale and importance demanded an exceptional framing solution. Here the creation of what was probably an individual design avoided the regularity of repeating a standard pattern six times. The design used consists of a narrow bolection moulding surrounded by a medley of Rococo ornament to maximise the decorate effect. Attached to this moulding is a pierced wooden support to which were bonded a complex pattern of interlocking rocaille and leafy C-scrolls and flowers – all in papier-mâché. Although the transition between inner and outer frame is somewhat poorly disguised, the Rococo motifs (decidedly French in form) are skilfully deployed.[11]

If the hand of Huguenot craftsmen has been established in Wright's Rococo frames of the early 1760s, it is most emphatically present in one of the finest Rococo frames exhibited. Most appropriately this is on Wright's 'Self Portrait' of *c.*1772–4 (figs.6 & 7, No.94). Like so much Huguenot work in England, this frame resembles French frames in execution, yet is basically English in design. The quality of carving in the pine and overall re-cutting in the gesso is superbly fluent (fig.2), enhanced by the original burnished water gilding. If this were the only example we might assume that it was a replacement for the original. However, a half-length version of the same pattern exists which originally framed 'Mr and Mrs Coltman' (exhibited 1771), and is now retained on a copy of this picture.[12]

Comparison of the centre cartouches of each frame (figs.7 & 8) shows the same flowing scrollwork set off against a zig-zag textured background, known as hazzle. A notable feature is the treatment of the sight edge rails, enriched with shallow gadrooning raking from centres to corners, carved in the gesso. Clearly these two frames of the early 1770s are of a superior quality of craftsmanship and design to the earlier group. The disparity in date and quality suggests either another maker, or Dubourg working in a more sophisticated style. The question of authorship may be resolved as further frames and/or documents come to light.

That both these exceptional and prestigious pictures had magnificent frames endorses Wright's concern (together

fig.4

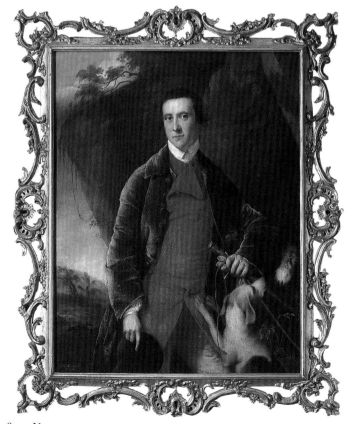

fig.5, No.5

with that of his patrons) over frames which mutually enhanced his pictures and reputation. Similarly the conversation pieces by another highly successful provincial artist, Arthur Devis, were often prominently hung in elaborate frames.

Another important Rococo frame surrounds 'A Conversation of Girls (Two Girls with their Black Servant)' 1770 (fig.10, No.24). The richly carved ornament recalls the 'Self Portrait' frame but the cabled sight edge and straight back are unusual. Certainly its weight and decoration match the composition well and this may be indeed the original, the commission for framing perhaps instigated by Wright.

By contrast to the frames discussed so far, which appear to be more or less supervised by Wright and his regular framer(s), there are at least six examples on view which exemplify mainstream London Rococo patterns. These surround 'James and Mary Shuttleworth with one of their Daughters' (No.10), 'Mrs Wilmot' (fig.11, No.9), 'Mr and Mrs Coltman' (No.29), '"Captain" Robert Shore Milnes' (No.31), 'Richard Cheslyn' (No.136) and 'Mrs Sarah Clayton' (fig.12, No.26). The Shuttleworth frame shows all the signs of being the original. Stylistically it accords with the picture's date of c.1764; the frame is unaltered; the size 56 × 72 inches is irregular, therefore not easily interchangeable with another standard format, and the lower side is darkened by dust and worn by cleaning.

Comparing a centre cartouche (fig.9)[13] with the preceding Dubourg details (figs.7 & 8) illustrates the differences in design and execution between native English frame patterns and contemporary Huguenot productions. Typically English are the flat rather than rounded rails and scrolls, their apex junction, as in the 'William Brooke' frame (fig.1) and, above all, their oil rather than water-gilt finish.

The frame surrounding 'Mrs Wilmot' (fig.11) of half-length format, although closely related to the Shuttleworth design, is probably a replacement. As it was carved for a Derbyshire sitter around 1763 the original frame is more likely to have followed the earlier Brooke pattern (fig.1). The most notable difference is the presence of a back edge to the frame reflecting light behind the trefoil-shaped openings between the corners and centres. The openings in the Brooke frame which has no back are slightly awkward and distracting as are those in the Rastall pair (figs.2 & 3).

The frame for '"Captain" Robert Shore Milnes' (exhibited 1772, No.31) is a standard variation on the preceding, having a husk rather than gadrooned or leaf sight edge, and more exotic centres with rocaille leaves as opposed to a triple lambrequin fan. It is possible that James Milbourne of the Strand, carver, gilder, picture frame and looking glass maker, supplied this frame to Wright.[14] The artist's Account Book refers to his friend Hurleston (a pupil of Wright who accompanied him to Italy) paying Milbourne's bill for "Milnes frames". "Captain" Milnes was the brother of John Milnes of Wakefield, one of Wright's major patrons, and therefore the account may refer to other paintings bought.[15]

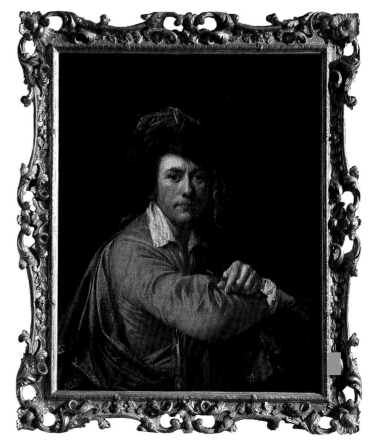

fig.6, No.94

fig.7, No.94

fig.8

fig.9, No.10

fig.10, No.24

fig.11, No.9

'Mrs Sarah Clayton's' frame *c*.1769 (fig.12), wonderfully matched, provides the concluding flourish to the Rococo group. Advanced in design, the gadrooned sight and fanned lambrequins are retained, as in 'Mrs Wilmot', but the panels are fully cut away to a rocaille 'skirt' above which the outer rail is suspended. It is quite possible that this highly decorative late Rococo frame, as fully aerated as the sitter's shawl, was the first intended.

fig.12, No.26

CARLO MARATTA FRAMES

Fashions, particularly in the decorative arts, often show abrupt changes. Picture frames (together with their cousins, mirror frames) are reliable expressions of changing tastes. As the Neo-classical movement advanced in the late 1750s and 1760s, enthusiasm for the Rococo waned. The older curvilinear patterns were overtaken by an entirely different rectilinear form of frame known as Carlo Maratta. With many variations this was the predominant pattern throughout England in the 1760s and 1770s, still being produced in the 1790s.[16] As the name suggests, we do not have to look far for its source. Developed in Italy in the late seventeenth century, the pattern spread from Rome throughout the country in the eighteenth century, being named after Carlo Maratta and sometimes after Salvator Rosa whose works it so often surrounded. As well as seeing countless examples in the great Roman palaces,[17] the English Grand Tour collectors brought home many such frames around their purchases.[18]

Whereas virtually all English frame designs were hitherto derived from French and Netherlandish sources this was the first and historically most appropriate time that an Italian pattern was wholeheartedly adopted. Based on architectural forms, the Carlo Maratta was a precursor of Neo-classical designs. The exhibition displays many fine examples used by Wright, and as in the Rococo frames, the work of Huguenot craftsmen continued to be evident. Depending on effect required and budget, Wright and his patrons would have selected from the range of progressive enrichments shown in figs.13, 14 & 15.

The profile is essentially the same consisting of a deep hollow (or scotia) running up to a top rail (or knull), between which is a step carrying a ribbon or pearl moulding; the inner and outer edges being variously decorated. Fig.13 shows the pattern in its simpler form (and almost certainly one of the original pair) surrounding Wright's portraits of Mr and Mrs Thomas Borrow c.1762–3.[19] Here the sight edge is carved with husks and the back with an egg moulding.[20] The frame on 'Two Girls Dressing a Kitten by Candlelight' (No.17) differs from the usual London patterns with a relatively wide sight cavetto and fuller husk, and is probably provincial. At least four other examples of this open hollow frame are seen here: 'Erasmus Darwin' (No.144) with corner shells;[21] Wright's second Darwin portrait (No.145) and 'Landscape with Rainbow' (No.124) – each with a single run of beading – 'Anne Bateman' (No.2), a later frame with ribbon and beads.[22]

The characteristic decorative feature of the Carlo Maratta is an ogee profile carved with alternating acanthus leaf and shield (sometimes called tongue), as seen on the portraits of Mr and Mrs Francis Hurt (fig.14, No. 129 and pendant No.130). Italian prototypes more often applied the leaf-and-shield to the inner edge rather than in the scotia as in fig.15. The two variations, (figs.14 & 15), are distinguished by frame-makers as semi-Carlo and full-Carlo –

fig.13

fig.14, No.129

fig.15, No.15

or simply Carlo. By comparison to London-made frames, the frames of the Hurt portraits (fig.14) with their broad leaf moulding and pearl back edge, are distinctly regional. The fact that they are unaltered and a pair suggests that they are the originals.

There can be few finer pairs of full Carlo Maratta frames than those so fortunately retained on Wright's fascinating candlelight subjects, 'Girl Reading a Letter, with an Old Man Reading over her Shoulder' c.1767–70 (figs.15 & 16, No.15), 'Two Boys fighting over a Bladder', (fig.17, No.16). The fact that another candlelight work, 'Girl Reading a Letter by Candlelight with a Young Man Peering over her Shoulder' (No.14), bears a full Carlo suggests that this was Wright's personal choice for these themes. It would be reasonable to assume that an artist so preoccupied with lighting effects would have been aware of the enhancement potential of this frame. The contrast of richly carved acanthus moulding with the deep shadows it casts either side compliments and reinforces Wright's chiaroscuro effects. The three different mouldings within a plain burnished knull create a complex interplay of trapped light. By candlelight at night the frame would create a flickering ribbon of gold around the canvas, drawing the spectator towards and into the scene. Thus the Carlo frame with its rich linear decoration provides a consistent play of light which a Rococo frame could not achieve. Indeed it is hard to imagine that any other frame design could be as visually satisfying for these paintings. An unusual feature is the shallow interlacing or guilloche carved into the gesso along the sight rail occurring almost identically in the 'Self Portrait' frame (fig.6) attributed to Dubourg.[23] We must conclude that Wright naturally engaged his most talented framemaker for pictures of a special nature. Interestingly the use of low relief ornament carved in the gesso may be seen in four other Carlo Maratta frames belonging to Wright's Liverpool period c.1768–71: 'Mrs John Ashton' of Liverpool (No.25), 'Fleetwood Hesketh' (No.37) and an unexhibited pair recently acquired by the Walker Art Gallery, Mr and Mrs Thomas Parke of Highfield, Liverpool.

A fine large scale full Carlo appears undisturbed on Wright's 'Maria from Sterne' 1781 (No.58). Fully carved, this was probably made in London where the picture was exhibited at the Royal Academy. Other full Carlo Maratta examples exhibited are on: 'Mrs Lindington' (No.28), probably later; 'Mrs Swindell' (No.30), altered; 'Christopher Heath' 1781 (No.137), a provincial frame; and 'A Philosopher by Lamp Light' (No.41), a modern plaster replica.[24]

In the last three decades of the century the Carlo Maratta shape underwent various modifications. Two further patterns developed, the one (fig.19) being transitional to the other (fig.21). In the frame for 'The Blacksmith's Shop' 1771 (figs.18 & 19, No.48) the scotia is wider and deeper than earlier prototypes. Apart from demonstrating a taste for heavier looking frames, the extra concave surface behind the Carlo moulding would have reflected light *across* the picture.

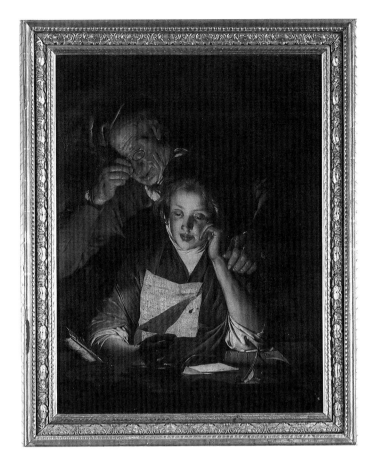

fig.16, No.15

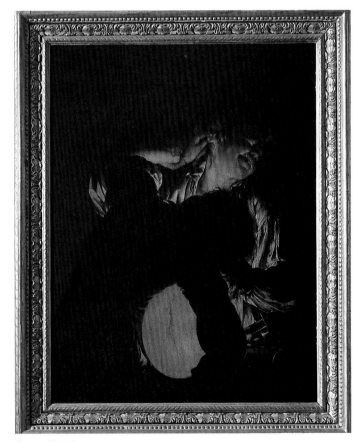

fig.17, No.16

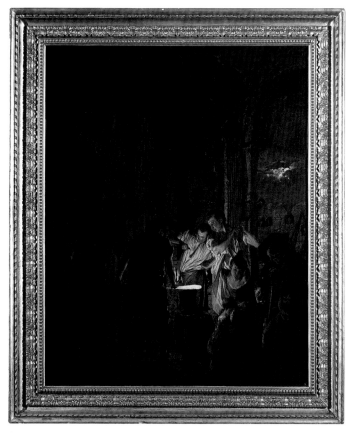

fig.18, No.48

fig.19, No.48

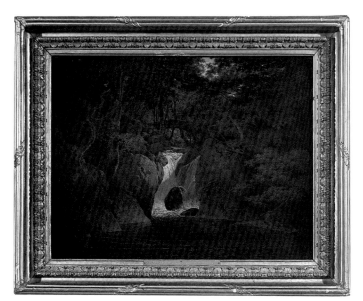

fig.20, No.138

fig.21, No.138

Also changed is the means of production. The ornaments here are all cast in composition from boxwood moulds.[25] Rarely all hand carved, frames were now being manufactured and indeed mass produced. This pattern was still in evidence at the end of the decade, seen on the 'Portrait of a Girl in a Tawny-Coloured Dress', c.1780 (No.143), here with an ornamented back edge.

In the final phase of the Carlo frame on 'Rydal Waterfall' 1795 (figs.20 & 21, No.138) the scotia is extended still further upwards and inwards, with the overhanging top rail being formed into a classic fasces moulding, the antique bundle of rods bound with leaves. The picture appears as if in a showcase. It would seem to confirm that the crucial design reason for this inward facing scotia is to reflect angled light sources across the picture. This enhancing effect can be confirmed by light meter tests.

Interestingly all five examples of this frame surveyed contain landscapes, the largest of which is 'The Annual Girandola at the Castle of St. Angelo, Rome' (No.104).[26] As well as the optical considerations, this deep scotia helps to set up a perspective line, leading the eye through into the picture's illusory distance. Apparently undisturbed, we may assume that these frames were either selected by Wright or approved by him.

NEO-CLASSICAL FRAMES

A fundamental principle underlying Neo-classical interiors was the harmonisation of all the components. The vocabulary of classical decoration was employed in stucco designs on walls and ceilings, as well as fixtures, fittings and furniture. Pictures were sometimes grouped in a fixed display of plaster frames (e.g. Kedleston Hall). Some frames were specifically carved, for example to match mirror frames (e.g. Corsham Court) and regular stock patterns were devised to blend into the novel surroundings. However the acanthus leaf-and-shield motif of the Carlo Maratta frame did not fit comfort-ably within Neo-classical schemes and was gradually phased out.[27] This change may be seen on three pictures here: 'John Milnes' (No.27), A 'Cottage on Fire' (No.111) and the 'Self Portrait' (No.149).[28] The sight edges are now decorated with the ubiquitous waterleaf (sometimes called lamb's tongue) together with respectively triple-bead and rope, stick-and-ribbon and pearls.

Before examining the pattern most frequently and exclusively used by Wright, four other excellent Neo-classical frames deserve attention. The frame of 'Maria from Sterne' 1777 (figs.22 & 23, No.52), with its well worn lower side, appears to have always been on the picture. The scotia profile of the Carlo period is now thickened and decorated with leaves, a ribbed rod and stick-and-ribbon. Carefully terminated with leaves at the mitres these mouldings are finely hand carved being the hallmarks of a costly London-made frame. In the frame made for 'Edwin, from Dr. Beattie's Minstrel', 1777–78 (figs.24 & 25, No.57) we see a different arrangement of motifs. Here a frieze divides stick-and-ribbon from waterleaves, leading through a scotia and pearls to the knull richly carved with feather-like leaves. Again each moulding has specially tailored cornering. It appears that these two subject portraits demanded up-market Neo-classical frames, superior to the patterns normally used.

One of the most striking frames exhibited surrounds 'Matlock Tor by Daylight' (No.113). Distinctly architectural in character the flattish profile resembles a classical entablature and is the basic section of the remaining frames under discussion. Here the frieze is studded with alternating paterae between triple flutes.[29] This form, or usually an all-fluted version, matched door and wall panels in many Adam and related interiors.[30]

The fourth frame which presents 'Thomas and Joseph Pickford as Children' (figs.26 & 27, No.141) is particularly significant since it draws us close to Wright's circle of professional colleagues. At first glance this frame may easily be taken for a later moulded Italian Renaissance style replacement. Closer inspection shows it to be entirely hand carved. No frame like it has yet been recorded. Had it been moulded, many copies would have been produced to justify mould-making costs. Its origin is apparently revealed with the knowledge that Joseph Pickford was a local architect

fig.22, No.52

fig.24, No.57

fig.23, No.52

fig.25, No.57

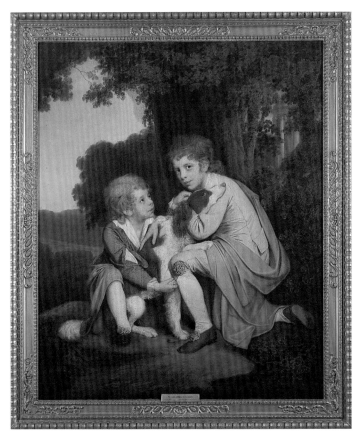

fig.26, No.141

fig.27, No.141

friend of Wright.[31] Thus we are surely looking at the frame he himself designed to surround his children – themselves unique.[32] The looping corner and centre scrollwork and waterleaves wrapped around the upper rail are both unusual and harmonious. For this special task it is likely that Pickford employed a local Derby wood carver and stonemason by the name of George Moneypenny, with whom he had worked at Long Eaton Hall. Moneypenny was also responsible for carving the saloon, north and side doors to Kedleston Hall and for the picture frames in the hall in 1776.[33] Pickford's frame would have been pleasantly conspicuous at the Royal Academy exhibition of 1779.

Wright was later to be unimpressed by the Academy's treatment of his frames. Often leant against the walls, they were inevitably damaged. In a letter to his friend J.L. Philips in 1794 Wright refers to his framer Mr Milbourne: 'The frames of all the pictures which I exhibited [have] been materially damaged at the Academy, Mr Milbourne has orders to put them in good condition'.[34] The first reference to Milbourne occurs seven years earlier in a letter by Wright to his surgeon friend Mr Long.[35] We thus know that Milbourne was supplying Wright's frames in later years.

Evidently it was not always necessary to make a new frame for a picture sent out on exhibition. Wright for practical and economic reasons occasionally used stock studio frames, at least one of which appeared several times. In a letter of 1774 to the secretary of the Incorporated Society of Artists Wright says:

> Sir, I shall be obliged if you will inform Mr. Martin that the picture of *The Earth Stopper* is to be delivered to Lord Hardwicke without the frame. The shabby price his Lordship is to pay for it will leave no room for his Lordship to expect the frame with it; but if he should say anything about it pray inform his Lordship that *The Earth Stopper* was exhibited in an old Italian moulding frame which I have had by me for many years and keep for the use of the exhibition, and on no account let him have it . . .[36]

The repeated use of old frames for exhibition purposes was practised by Reynolds, and presumably other artists.[37]

By now the visitor to this exhibition will be aware that among the wide variety of frames on display there is one predominant streamlined Neo-classical pattern with distinct but clearly related variations. There are some 21 here from a total of 37 surveyed dating from 1778 to 1792. Doubtless many other late canvases by Wright bear the same model.

The particular significance of these frames is that they were evidently devised between Wright and his frame-maker exclusively for him.[38] Had they been a pattern book design we would have encountered them elsewhere. However, to date only one of these frames has been seen on another artist's work by the author in twenty-five years of looking.[39] Romney and Raeburn also used a particular frame very

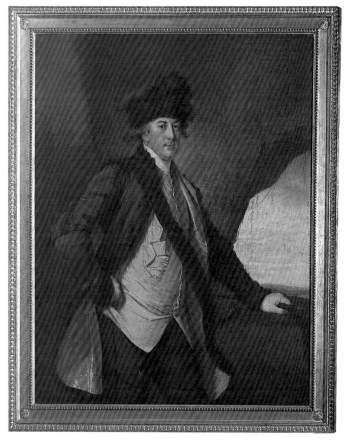

fig.28, No.32

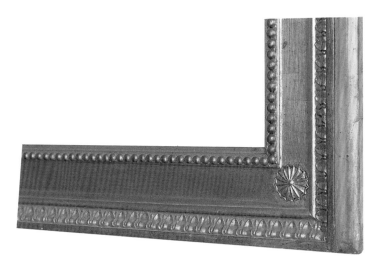

fig.29, No.32

fig.30, No.132

fig.31, No.133

fig.32, No.63

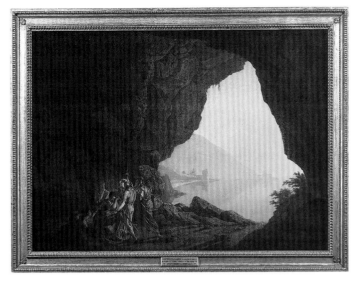

fig.34, No.99

fig.33, No.63

fig.35, No.99

frequently, but these preferred patterns were also applied by other artists.[40]

By using this special frame Wright was advertising the individuality of his pictures. It is not too much to assume that this novel design must have deliberately helped to single out his work among that of other artists on the walls of his patrons' houses as well as in the prestigious Royal Academy and Society of Artists exhibitions. Corner details of the three main variations of Wright's frame are shown in figs.29, 35 & 36, from which we see that they all share the same basic entablature profile decorated with familiar Neo-classical ornaments moulded in composition.[41] The sections' widths range from three to five inches according to canvas size. Examples of the most frequently used pattern are seen on 'John Whetham of Kirklington' (figs.28 & 29, No.32), 'Mr and Mrs Samuel Crompton' (figs.30 & 31, Nos.132 & 133), 'Romeo and Juliet' (figs.32 & 33, No.63), 'Lake Nemi at

Sunset' (No.116), and the portraits of 'Sir Richard Arkwright' (No.126), Charles and Susannah Hurt (Nos.134 & 135), 'The Rev. D'Ewes Coke, his wife Hannah and Daniel Parker Coke M.P.' (No.142),[42] and 'Erasmus Darwin' (No.145).

In this group the inner edge is formed with beading and the outer with waterleaves.[43] Generally the back edge of the larger frames also carried a leaf moulding, and many have moulded circular or oval paterae in the corners. Corners of the largest frames for the Shakespeare subjects 'Romeo and Juliet' (figs.32 & 33) and 'Antigonus in the Storm' received a more substantial moulded acanthus spray.[44]

The second variation with its bold egg-and-dart, water-leaf and ribbed mouldings is the grandest and most evocative of antiquity.[45] It appears on two pictures which draw on classical literature. 'Virgil's Tomb, with the Figure of Silius Italicus' (No.61), and 'A Grotto in the Gulf of Salernum,

with the Figure of Julia' (No.100), as well as 'Brooke Boothby' (No.59) and 'A Grotto by the Sea-side in the Kingdom of Naples', (figs.34 & 35, No.99). The Brooke Boothby frame is distinguished by having a sanded frieze giving a subtle matt texture contrasting with the burnished water-gilt mouldings.

The final variation is characterised by having an inner band of guilloche and the astragal formed into beads. This model was used intermittently by Wright for all categories of his work between *c*.1783–*c*.1786, and can be seen here on 'Arkwright's Cotton Mills by Night' (fig.36, No.127), 'Dovedale by Moonlight' (No.110), 'View of Dovedale' and its pendant, 'Convent of S. Cosimato' (figs.37 & 38, Nos.120 & 121), and with a later aggrandisement on 'The Lady in Milton's "Comus"' (No.66).[46] Its use on a small format is seen to best effect on the Kedleston Hall pair of landscapes (figs.37 & 38).[47] These serene, austere and beautifully proportioned Neo-classical frames with plain gold friezes and rhythmical ornament are in perfect harmony with the landscapes. They ensure our contemplation without distraction. There can be few better examples in this period of the unity between frame and picture.

fig.36, No.127

fig.37, No.120

fig.38, No.121

FRAMES OUT OF PERIOD

Pictures and their frames were generally seen as part of a room's furnishings. Consequently, loss of the original frame breaks a vital link with the picture's past, disrupting the intended harmony.

There are a multitude of reasons for a picture's divorce from its first frame. These are usually changing fashions and interiors, new ownership and re-location. This divorce rate is generally in direct proportion to age. Far more Victorian marriages have survived than Old Master ones. Indeed the re-framing necessary for Old Masters entering Victorian collections (purchased abroad and more easily transported without their frames) often extended to native eighteenth century pictures.

Nineteenth century taste preferred heavier and more ornamental frames. From our standpoint we might say they tell us more about the owners and their interiors, rather than being very well suited to the pictures. The massive frame on 'The Widow of an Indian Chief' (No.67) and the fussy decoration of that on 'Miravan Opening the Tomb of his Ancestors' (No.42) show that frames of novel proportion and ornamental scale can have a somewhat detrimental effect on our perception of the picture. Tinkering with old rules is risky and rarely successful[48]. Wright's pictures re-framed in Victorian times include his two candlelight masterpieces: 'An Experiment on a Bird in the Air Pump' (No.21) and 'A Philosopher giving that Lecture on the Orrery' (No.18)[49]. It is interesting to speculate how these pictures would have looked in the original frames which Wright would surely have chosen for them himself.

PAUL MITCHELL

NOTES

[1] Geoffrey Beard and Christopher Gilbert (Eds), *Dictionary of English Furniture Makers 1660-1840*, Furniture History Society, 1986.

[2] Derby Local Studies Library, ref. BA914. It is the earliest trade directory to survive for Derby.

[3] The first major exhibition catalogue illustrating a quantity of frames was the Tate Gallery's *Manners and Morals, Hogarth and British Painting 1700-1760*, 1987. See also: Paul Mitchell, *Picture Frames in the Cartwright Collection: Mr. Cartwright's Pictures*, Exhibition at Dulwich Picture Gallery, 1987. A comprehensive bibliography of frame studies is published, with several essays in *Revue de L'Art*, no.76, 1987, pp.60–62; this includes three important frame exhibitions in the last ten years, which were the first since Berlin, 1929: Alte Pinakothek, Munich, 1976; Rijksmuseum, Amsterdam, 1984; Art Institute of Chicago, 1986. The most recent exhibition was *Cadres de Peintres*, Isabelle Cahn, Le Musée d'Orsay, Paris, 1989.

[4] Only frames surrounding works in oil are considered here. It was obviously impractical to see all of Wright's scattered frames, and those omitted are listed in the table on p.272. The author plans to include significant omissions in an article after the exhibition.

[5] The author's photographic archive of European picture frames (undertaken in principal museums, country houses, private collections and pictures viewed at auction), indicates that paintings by the most eminent London-based artists are more likely to have been re-framed than their provincial, less celebrated counterparts.

[6] See: 'Portrait of a Lady with her Lacework' (No.34), for the ultimate in lavish re-framing. This extravaganza is typical of the French Rococo style frames commissioned from Paris by Duveen for his English eighteenth century and Dutch seventeenth century pictures. These regal and dazzling creations were more than a match for his collectors' French eighteenth century pictures and furnishings.

[7] Another, slightly more elaborate version appears on Wright's portrait of 'John Day' (early 1760s), Christie's 19.11.82 Lot 88, and another on 'A Young Man' (Private Collection), kindly shown to me by Robert Holden.

[8] From the evidence of a 1749 poll book (*Dictionary of English Furniture Makers*, p.257) we know that Dubourg was in Long Acre, London. Wright would have become familar with the London frame-making trade during his apprenticeship with Thomas Hudson between 1751–53, and 1756–7.

[9] Wright's Account Book, (National Portrait Gallery Archives), refers to the standard frame sizes, "Three quarter length" 30 by 25 inches, "Kit Cat" 36 by 28 inches and "Half length" 50 by 40 inches.

[10] Frame surveys show that pairs and sets of frames have a higher survival rate than individual ones. Due to the expense owners were less likely to embark on re-framing. This point is well demonstrated in the exhibition which includes eight unchanged pairs (Nos.15 & 16, 19 & 20, 35 & 36, 114 & 115, 120 & 121, 129 & 130, 132 & 133, 134 & 135).

[11] Regarding the craftsmen associated with papier-mâché at this date Mortimer's *Universal Director* of 1763 mentions the work of Peter Babel, a designer and modeller, Long Acre, (in the same street as Dubourg) who was one of the "first improvers of Papier-Mâché Ornaments for Ceilings, Chimney-Pieces, Picture-frames etc, an invention of modern date, imported by us from France, and now brought to great perfection". The only other papier-mâché specialist that Mortimer mentions as being one of the 'principals' in the trade is René Duffour, at the Golden Head in Berwick Street.

Heal refers to only two other suppliers: Charles Middleton in Tottenham Court Road and James Shruder in Great Marlborough Street. There are no provincial papier-mâché dealers recorded in local trade directories so we can assume that this highly novel and fashionable material was only available in London.

[12] The replacement frame for 'Mr and Mrs Coltman' (No. 29) is referred to p.276.

[13] The whole frame was reproduced in *Wright of Derby: Catalogue of the Bi-centenary Exhibition of Paintings*, Corporation Art Gallery, Derby, 1934 (Cat.10).

[14] *Dictionary of English Furniture Makers*, p.605.

[15] Benedict Nicolson, *Joseph Wright of Derby Painter of Light*, Paul Mellon Foundation, 1968, vol.1, p.67.

[16] The Carlo Maratta was prominently used by Reynolds and Gainsborough. Dr Nicholas Penny has unravelled many references to Maratta frames from Reynolds's ledgers and pocket books in his excellent study "Reynolds and Picture Frames", *The Burlington Magazine*, November 1986, pp.810–25.

[17] In the first half of the 18th century the pattern became, and remains, virtually a house frame in the Doria-Pamphili, Colonna and Spada palaces; see Paul Mitchell "Italian Picture Frames 1500–1825: A Brief Survey", *Furniture History* 1984, p.24.

[18] An exceptionally fine collection of originals are on Italian pictures at Burghley House bought by the 5th Earl of Exeter.

[19] Derby Art Gallery, Nicolson cat.21, pl.39; cat.22, no pl.

[20] In Italian prototypes the husk is generally pierced beneath.

[21] Also with shells is the frame on 'The Captive from Sterne', (Derby Art Gallery, Nicolson cat.217, pl.162).

22 An example of the hollow pattern without ornament is on 'Landscape with Ruins, by Moonlight', (Nicolson cat.305, pl.236), with Leger Galleries.

23 The pair of frames on the Gwillym portraits (Nos 35 & 36) are virtually the same pattern as these, although blurred by re-gilding, and perhaps also by Dubourg.

24 Other Carlo Maratta frames on works not exhibited include: 'Mrs Beridge' 1777, Minneapolis Institute of Arts (Nicolson cat. 18, pl.192); 'A Study after an Antique Bust in Two Positions', Yale Centre (Nicolson cat.80, pl.124); 'Penelope Margaret Stafford' 1769, Derby Art Gallery; 'Richard Gildart' 1769, Walker Art Gallery, Liverpool.

25 By 1794, if not before, trade directories listed "composition ornament manufacturers" as one of the increasing number of specialist trades. *The General London Guide or Tradesman's Directory*, 1794.

26 Three others are in Derby Art Gallery: 'View of Tivoli' *c.*1783–6 (Nicolson cat.265, pl.260); 'A Cottage on Fire' *c.*1790 (Nicolson cat.336, pl.303) and 'Bridge through a Cavern' 1791 (Nicolson cat.276, pl.326).

27 A superb early exception to this, and surely the original surrounds Wright's portrait of 'The Hon. Richard Fitzwilliam' 1764, (Nicolson cat.60, pl.49), Fitzwilliam Museum, Cambridge. Here the semi-Carlo profile is given a full accommodating Neo-classical treatment with fluting in the scotia, a ribbed knull and corner paterae.

28 Another original is on 'The Convent of S. Cosimato' *c.*1787–90, (Nicolson cat.264, pl.282), Walker Art Gallery, Liverpool.

29 Having only one flute in the lower right corner and two matching adjacent paterae on the lower left, the frame has clearly been altered. The darker right side suggests it was originally for a portrait or, quite probably, a mirror.

30 E.g. Kedleston Hall, Harewood House, Osterley Park. An outstanding ultra Neo-classical fluted frame appeared at Sotheby's 12.7.89, Lot 46 on Wright's Portrait of Sir Robert Burdett Bt of Foremark, Derbyshire, probably designed and carved by Thomas Chippendale whom he employed.

31 Pickford built Alderwasley Hall, for the same Francis Hurt that Wright painted. He was also involved with architectural projects at Alfreton Hall, Ashbourne Mansion, and Robert Holden's home Darley Abbey. See Maxwell Craven and Michael Stanley, *The Derbyshire Country House*, Derby Museum Service, 1982.

32 Architects have always, to some degree, been the designers of frames, particularly in the Neo-classical period for the reasons stated. For the principal exponents and surviving drawings see: Pippa Mason with introduction by Gervase Jackson-Stops, *Designs for English Picture Frames*, London, Arnold Wiggins & Sons Ltd, 1987.

33 Geoffrey Beard, *Craftsmen and Interior Decoration in England 1660–1820*, Edinburgh, 1981, p.272.

34 Derby Local Studies Library, ref.8962.

35 Ibid, Long acted as the artist's London agent.

36 My thanks to Judy Egerton for this reference. W.T.Whitley, *Artists and their Friends in England, 1700–1799*, 2 vols. London 1928, vol.1, p.247. The present frame on 'The Earth Stopper' (No.51) is a cushion moulding pattern in regular use during the seventeenth century. This example (now conspicuously re-gilded and painted, and perhaps partly re-modelled) may conceivably be the 'old Italian moulding frame' referred to by Wright. The frame's design derives from Italian prototypes, via the Netherlands.

37 N. Penny, op.cit.

38 In the absence of references to any other maker these frames can reasonably be attributed to Mr Milbourne.

39 This frames the portrait of 'Captain The Hon. John Tollemache' (unattributed), Ham House, Surrey.

40 Raeburn's deep scotia Neo-classical frame may be seen on most of his pictures in The National Gallery of Scotland and the Scottish National Portrait Gallery in Edinburgh.

41 This same profile was apparently run out as a plain moulding for two of Lord Melbourne's pictures, 'An Academy by Lamp Light' (No.23) and 'The Blacksmith's Shop' (No.47).

42 A bill for this painting included a charge of £6.5s.5d. for the frame, see No.142a.

43 The astragal above the frieze is independent to the frame's carcase, being attached separately, and this partially secures the waterleaf moulding.

44 'Antigonus in the Storm, from The Winter's Tale' (Nicolson cat.230, pl.302).

45 Two narrow versions are recorded: 'Old John' (No.140) and 'John Harrison' (Nicolson cat.74, pl.199), on loan to Derby Art Gallery.

46 Also 'Stephen Jones' (Nicolson cat.100, pl.243); 'William and Margaret', (Nicolson cat.226, pl.241).

47 Another small pair of landscapes 'Lake Albano' and 'Lake Nemi' (Nos 114 & 115) bear fine Neo-classical frames of a pattern not seen elsewhere on Wright's work.

48 Among the earlier frames to have found their way onto Wright's pictures are a late seventeenth century laurel-and-flower pattern related to Louis XIII designs on 'The Alchymist in Search of the Philosopher's Stone' (No.39) and 'Rev. John Pickering' (No.148) carrying a rare example of a later seventeenth/early eighteenth century gadrooned bolection frame finished in silver leaf. An unusual Rococo variation of a standard mid-eighteenth century pattern has been altered to fit 'A Cavern, Evening' (No.98), examples of which have been seen in Ireland. The frame on 'The Sunset on the Coast near Naples' (No.109) with its moulded palmettes is novel and difficult to date.

49 David Fraser has recently discovered a leaflet dated December 1, 1851 issued by Messrs. Woollat & Co. (Cabinet Makers & Upholsterers, 68 St Peter's Street, Derby) advertising the disposal of this picture 'by lot' for which 100 tickets at 2gns each were offered. The announcement describes the picture being in a '. . . . new and handsome gilt frame.'

ACKNOWLEDGEMENTS

I am extremely grateful to Judy Egerton and the exhibition organisers for welcoming the inclusion of this study into their catalogue, and arranging photography of the frames on so many privately owned pictures. This enabled subsequent inspection in situ of as many significant frames as possible for which I thank all their owners.

Particular thanks to: Ruth Rattenbury and Helen Sainsbury at the Tate Galley for their help on many occasions; David Fraser and Sarah Kirby at Derby Art Gallery; Edward Morris, Walker Art Gallery and Timothy Goodhew, Yale Center for British Art.

Thanks are due to staff in the following museums for responding promptly to my request for photographs: Allen Memorial Art Museum, Oberlin; Fitchburg Art Museum, Mass.; The Hermitage; The Louvre; Metropolitan Museum of Art; Minneapolis Institute of Arts; National Gallery, London; National Gallery of Art Washington; National Portrait Gallery, London; Nelson-Atkins Museum, Kansas City; Philadelphia Museum of Art; Saint-Louis Art Museum, Minnesota; Smith College, Mass.; Ulster Museum, Belfast; Vancouver Art Gallery and The Wadsworth Athenaeum, Connecticut.

I am also grateful to the following for their helpful discussions and allowing inspection and photography: Agnews, Christie's, Bill Drummond, Robert Holden, Leger Galleries, Sothebys.

Finally I am immensely indebted to two of my office assistants, Dr Helen Clifford and Mary Ross-Trevor.

LENDERS

PUBLIC COLLECTIONS

Aberystwyth, University College of
 Wales 101
Belfast, Ulster Museum 62
Cambridge, Fitzwilliam Museum 25,
 113
Chicago, Art Institute of Chicago 88
Derby Art Gallery 1, 18, 39, 41, 42, 43,
 44, 45, 46, 48, 51, 54, 58, 63, 67, 70, 73,
 74, 75, 78, 80, 81, 82, 83, 84, 85, 86,
 89, 92, 124, 131, 138, 142, 150, 155,
 156, 158, 159, 165, 169, 170, 173
Edinburgh, National Trust for
 Scotland 95, 96
Fitchburg Art Museum 26
Hartford, Wadsworth Atheneum 38
Kansas City, Nelson Atkins Museum of
 Art 33
Kingston, Agnes Etherington Art
 Centre, Queens University 125
Leicestershire Museums and Art
 Galleries 30
Leeds City Art Galleries 128
Leningrad, Hermitage Museum 50, 106
Liverpool, National Museums and
 Galleries on Merseyside 66, 104
London, British Museum 76, 90, 157,
 163, 174
London, National Gallery 21, 29
London, National Portrait Gallery 60,
 93, 149
London, Tate Gallery 59, 108
London, Victoria and Albert
 Museum 153
Malibu, J Paul Getty Museum 68
Minneapolis Institute of Arts 111
Moscow, Pushkin State Museum of Fine
 Arts 105
New Haven, Yale Center for British Art
 23, 47, 64, 114, 115, 123, 146, 166
New York, Metropolitan Museum of Art
 34, 77, 160, 162, 167, 171
New York, Pierpont Morgan
 Library 91
Northampton, Smith College Museum
 of Art 98
Oberlin, Allen Memorial Art
 Museum 110
Paris, Musée du Louvre 27, 116
Philadelphia Museum of Art 28
Prague, Národní Galerie 40
Saint Louis Art Museum 35, 36
Sheffield City Art Galleries 117
Southampton City Art Gallery 122
Stanford University Museum of Art 8
Vancouver Art Gallery 53
Washington, National Gallery of Art 69, 119

PRIVATE COLLECTIONS

Thos Agnew & Sons Ltd 99
David Alexander 161
Pamela Askew 97
Darwin College, Cambridge 144
Rob Dixon 172
The Viscount Dunluce 102
Judy Egerton 151
Hambros Bank Ltd 57
Robert Holden 32
Michael Hurt 129, 130
D. G. C. Inglefield & C. S.
 Inglefield 109, 148
Trustees of the Kedleston Estate
 Trusts 120, 121
Drs Caroline and Peter Koblenzer 118
The Hon. Christopher Lennox-Boyd
 152, 154, 164, 168
James Mackinnon 139
Lt. Col. R. S. Nelthorpe 14
Vanessa Nicolson 87
Executors of the late R. D. Plant Esq
 and Mrs J. F. A. Plant 3
Trustees of the Henry Reitlinger
 Bequest 71
Professor Philip Rieff 137
Lord Romsey 49
The Lord Shuttleworth 10
Smith of Derby, Tower Clocks, Ltd 147
Mrs Lawrence Copley Thaw, Senior 31
Zankel/West Collection 140

Private Collections 2, 4, 5, 6, 7, 9, 11,
 12, 13, 15, 16, 17, 19, 20, 22, 24, 37, 52,
 55, 56, 61, 65, 72, 79, 94, 100, 103,
 107, 112, 126, 127, 132, 133, 134, 135,
 136, 141, 143, 145

INDEX OF WORKS

Academy by Lamplight, 23; engraving
 159 (P9)
Air Pump, see Experiment . . .
Alchymist, in Search of the Philosopher's
 Stone, Discovers Phosphorus . . . , 39;
 engraving 163 (P15)
Arkwright's Cotton Mills by Night, 127
Arkwright, Sir Richard, 126; engraving
 173 (P42)
Ashton, Master, engraving P6
Ashton, Mrs John, 25

Bateman, Anne, 2
Bedgellert, North Wales, Landscape near,
 118
Belisarius Receiving Alms, 89
Blacksmith's Shop (Yale version) 47;
 engraving 157 (P7)
Blacksmith's Shop, (Derby version) 48
Blot drawing in the manner of Alexander
 Cozens, 74; Landscape study developed
 from a blot, 75
Boothby, Brooke, 59
[Boys Blowing the Bladder], engravings,
 162 (P13, P14); by Candlelight P34
Boys, Two, Fighting over a Bladder, 16
Boy with Plumed Hat and Greyhound, 70
Bradshaw Children, engraving 155 (P4)
Brooke, William, 3
Burdett, Peter Perez and his first wife
 Hannah, 40

Captive, from Sterne, 53; engraving 165
 (P19)
Captive, engraving 165 (P19); P28
Cave, Interior of a, probably near Naples,
 87
Cavern, Evening, 98
Cavern, Morning, 97
Caverns in the Gulf of Salerno, drawings,
 95, 96
Chase, Mr & Mrs William, 13
Cheslyn, Richard, 136
Clayton, Mrs Sarah, 26
Coke, Rev. D'Ewes, his wife Hannah and
 Daniel Parker Coke, 142
Colosseum, Inside the Arcade of the, 79
Colosseum, Part of the, seen in Sunlight,
 78
Coltman, Mr & Mrs, 29
Cosimato, San, Convent of . . . 121
Conversation of Girls (Two Girls with
 their Black Servant), 24
Corinthian Maid, 69
Cooke, Cornet Sir George, 33
Cottage on Fire, 111
Cracroft, Anne or Molly, 4

Crompton, Mrs Samuel, 133
Crompton, Samuel, 132

Dale Abbey, Landscape with, and Church
 Rocks, 117
Darwin, Erasmus, c.1770, 144; 1792–3,
 145; engraving P37, P40
Day, Thomas, 60; engraving P45
Dead Soldier, 171 (P39)
Dovedale by Moonlight, 110; Dovedale,
 study for a painting of, 92
Dovedale, View in, 120

Earthstopper on the Banks of the
 Derwent, 51
Edwin, from Dr Beattie's Minstrel, 57;
 engraving 164 (P17)
Etna, View of Mount, and a Nearby
 Town, 108
Experiment on a Bird in the Air Pump, 21;
 engraving 153 (P2)

Farrier's Shop, engraving 158 (P8)
Fire at a Villa seen by Moonlight . . . 125
Fireworks (? or Fire) in Rome, 82
Fireworks from the Castle of St. Angelo
 Rome, engraving P48

Girandola . . . Rome, 83, 104, 106
Girl in a Tawny-Coloured Dress, 143
Girl in a Turban and Frilled Collar, 72
Girl reading a Letter . . . with an Old
 Man reading over her shoulder, 15
Girl reading a Letter . . . with a Young
 Man peering over her shoulder, 14
Girl with Feathers in her Hair, 71
Girls, Two, Dressing a Kitten by
 Candlelight, 17; engraving 166 (P21)
Gisborne, Rev. Thomas and his Wife
 Mary, 146
Gladiator, Three Persons Viewing the, by
 Candle-light, 22; engraving 154 (P3)
Glass-House, studies of the interior of, 44,
 45
Grotto in the Gulf of Salernum, with the
 figure of Julia, banished from Rome,
 100
Grotto by the Sea-side in the Kingdom of
 Naples, with Banditti; a Sun-set, 99
Gwillym, Mrs Robert, 36
Gwillym, Robert Vernon Atherton, 35

Harrison, John, engraving P23
Heath, Christopher, 137
Heath, Nicholas, 7
Hermit, engraving 156 (P5)
Hesketh, Fleetwood (not exhibited), 37

Hurt, Charles, of Wirksworth, 134
Hurt, Francis, 129
Hurt, Mrs Francis, 130
Hurt, Susannah, with her daughter Mary
 Anne, 135

Iron, Forge, 49; study for, 46; engraving
 161 (P12), (P16)
Iron Forge viewed from without, 50
Italian Landscape, 119

[Kneeling Figure], engraving P10
Kitty, Miss, Dressing, engraving 166 (P21)

Lady in Milton's Comus, 66; engraving
 169 (P30)
Lady with her Lacework, 34
Lake Albano, 114
Lake Nemi, 115
Lake Nemi at Sunset, 116
Landscape in Italy by Moon-light . . .
 engraving, P32
Landscape near Bedgellert, North Wales,
 118
Landscape study developed from a blot,
 75
Landscape with a Rainbow, 124
Landscape with Dale Abbey and Church
 Rocks, 117
Landscape with Figures and a Tilted
 Cart: Matlock High Tor in the
 Distance, 122
Landscape with Trees, 88
Leacroft, Edward Becher, 8
Letter from the artist in Rome, with a
 view of Castel Sant' Angelo . . . , 84
Lindington, Mrs Andrew, 28

Maecenas' Villa at Tivoli, engraving P35
Maria, from Sterne, 1777, 52; 1781, 58;
 engraving P20
Matlock Dale, View in, looking south to
 Black Rock Escarpment, 123
Matlock Tor by Daylight, 113
Melancholy Girl, Study of a, 90
Milnes, John, 27
Milnes, 'Captain' Robert Shore, 31
Miravan Breaking Open the Tomb of his
 Ancestors, 42; engraving 160 (P11)
Moonlight, with a Lake and a Castellated
 Tower, 112; View in Italy, engraving
 P22
Mundy, Francis Noel Clarke, 5

Old John, Head Waiter at the King's
 Head in Derby, 140
Oldknow, Samuel, 128

Old Man and Death, 38
Old Man Grieving over his Ass, study for, 91
Open Hearth with a Fire, 73
Orrery, Philosopher giving that Lecture on the Orrery, in which a lamp is put in place of the Sun, 18; engraving 152

Peckham, Harry, 6
Penelope Unravelling her Web, by Lamp-Light, 68
Philosopher by Lamp Light, 41; engraved as *The Hermit*, 156
Philosopher Shewing an Experiment on the Air Pump, engraving 153 (P2)
Pickering, Rev. John, 148
Pickford, Thomas and Joseph, as Children, 141
Prison Scene, 64

Rastall, Samuel, 19
Rastall, William, 20
Rocks with Waterfall, 107
Roman Ruins, 80
Roman Sketchbook, 76
Rome, View through an Archway, 81
Romeo & Juliet. The Tomb Scene . . . , 63
Rydal Waterfall, 138

Seward, Reverend Thomas, engraving P44
Shakspeare. Winter's Tale, Act III Scene III engraving P36
Shakspeare. Tempest, Act IV Scene I, 172; engraving 172 (P41)
Shuttleworth, James and Mary, with one of their Daughters, 10
Staveley, John, studies of, 55, 56
Sterne, Lawrence, subjects from: Captive, 53; engraving 165; Maria 52, 58; Old Man and his Ass, 91.
Strutt, Jedediah, 131; engraving P46
Sunset on the Coast near Naples, 109
Swindell, Mrs Catherine, 30
Synnot, Children of Walter, 167 (P24)

Ullswater, 139

Vesuvius, Eruption of, seen from Portici, 101; Eruption of, with a View over the Islands . . . 102; in Eruption, 103; Eruption of, with the Procession of St. Janarius's Head, 105; Eruption of, gouache, 85; Terrain near, 86; Distant view of . . . , engraving, P29; View of, by Moon-light . . . , engraving P33
Virgil's Tomb, with the Figure of Silius Italicus, 61
Virgil's Tomb: Sun Breaking through a Cloud, 62

Whetham, John, of Kirklington, Nottinghamshire, 32
Whitehurst John, FRS, 147; engraving P27
Widow of an Indian Chief watching the Arms of her deceased Husband, 67; engraving 170 (P31)
William and Margaret, engraving 168 (P26)
Williams, Master and Miss, engraving P18
Wilmot, Harvey, 12
Wilmot, Lady and her Child, 65
Wilmot, Mrs in Riding Dress, 9
Wilmot, Simon, 11
Wilson, Thomas, engraving P25
Wright, Harriet, the Artist's Daughter, 150
Wright, Joseph, Account Book, 93; Sketchbooks, 76, 77
Wright, Joseph, Memorial Tablet, design by F. Moneypenny, 151
Wright, Joseph, Self-Portraits, at the age of about Twenty, 1; at the age of about Forty, 94; at the age of about Fifty, 149; Self-Portrait drawings P30; *c.*1765, 43; in a Black Feathered Hat, 54; engravings P38, 174 (P43), P47

TATE GALLERY SPONSORS

Academy Group Limited
American Express
Henry Ansbacher
Elizabeth Arden
Art & Design
AT&T
British Gas plc
British Gas North Thames
The British Land Company
The British Petroleum Company p.l.c.
British Rail
British Steel
Britoil
Capital Radio
Christie's Fine Art Auctioneers
C & J Clark
Clifton Nurseries
Cognac Courvoisier
Daimler Benz
The Deutsche Bank
Donaldsons
The Dow Chemical Company
Drexel Burnham Lambert
Drivers Jonas
Electricity Council
Eurotunnel
First Boston Corporation
Ford Motor Company Limited
Gerald Metals
Global Asset Management
Good Housekeeping
Hepworth & Chadwick
I B M U K Limited

Knight Frank and Rutley
Kodak Limited
Linklaters & Paines
London Weekend Television
Marlborough Fine Art Limited
Mars
Mobil
Mobil North Sea
M O M A R T
Olympus
P A Consulting Group
Pearsons
Phillips & Drew
Pirelli
Pitt & Scott
Pro Helvetia Foundation
Radio Times
The Reader's Digest Association Limited
Reeves
Sotheby's
Swissair
Thames and Hudson
Thorn E M I
Alex Tiranti Limited
Ulster Television
United Technologies
Unilever
Volkswagen
Waddington Galleries
Westminster City Council
Winsor & Newton
Arthur Young

THE FRIENDS OF THE TATE GALLERY

The Friends of the Tate Gallery is a society which aims to help buy works of art that will enrich the collections of the Tate Gallery. It also aims to stimulate interest in all aspects of art.

Although the Tate has an annual purchase grant from the Treasury, this is far short of what is required, so subscriptions and donations from Friends of the Tate are urgently needed to enable the Gallery to improve the National Collection of British painting and keep the Twentieth-Century Collection of painting and sculpture up to date. Since 1958 the Society has raised over £1 million towards the purchase of an impressive list of works of art, and has also received a number of important works from individual donors for presentation to the Gallery.

In 1982 the Patrons of New Art were set up within the Friends' organisation. This group, limited to 250 members, assists the acquisition of works by younger artists for the Tate's Twentieth-Century Collection. A similar group — Patrons of British Art — was formed in late 1986 to assist the acquisition of works for the Collection of British painting of the period up to 1914.

The Friends are governed by a council — an independent body — although the Director of the Gallery is automatically a member. The Society is incorporated as a company limited by guarantee and recognised as a charity.

Advantages of Membership include:

Special entry to the Gallery at times the public are not admitted. Free entry to, and invitations to private views of paying exhibitions at the Gallery. Opportunities to attend private views at other galleries and museums, as well as special events and lectures arranged for the Friends. A 10% discount on Tate Gallery Publications and stock apart from books, and a discount on special exhibition catalogues.

MEMBERSHIP RATES

Any Membership can include husband and wife

Benefactor Life Member £5,000 (single donation)
Patron of New Art £475 annually or £350 if a Deed of Convenant is signed
Patron of British Art £475 annually or £350 if a Deed of Covenant is signed
Corporate £250 annually or £200 if a Deed of Covenant is signed
Associate £65 annually or £50 if a Deed of Covenant is signed
Life Member £1,500 (single donation)
Member £18 annually or £15 if a Deed of Covenant is signed
Educational & Museum £15 annually or £12 if a Deed of Covenant is signed
Young Friends £12 annually.

Subscribing Corporate Bodies as at January 1990

*Agnew & Sons Ltd, Thomas
Alex, Reid & Lefevre Ltd
Allied Irish Banks Plc
American Express Europe Ltd
Art Promotions Services Ltd
†Associated Television Ltd
Bain Clarkson Ltd
Balding + Mansell UK Ltd
†Bankers Trust Company
Barclays Bank International Plc
Baring Foundation, The
Blackwall Green Jewellery & Fine Art
Bowring & Co. Ltd, C.T.
Bradstock Penrose Forbes Ltd
British Council, The
British Petroleum Company p.l.c.
Brocklehursts
Bryant Insurance Brokers Ltd, Derek
CCA Stationery Ltd
C.D.C.
Cazenove & Co.
Charles Scott & Ptnrs
*Chartered Consolidated Plc
*Christie, Manson & Woods Ltd
*Christopher Hull Gallery
Colnaghi & Co. Ltd, P & D
Commercial Union Assurance Plc
Coutts & Company
Crowley Ltd, S.J.
Delta Group Plc
Deutsche Bank AG
*Editions Alecto Ltd
Electricity Council, The
Equity & Law Charitable Trust
Esso Petroleum Co. Plc
Farquharson Ltd, Judy
Fischer Fine Art Ltd
Fishburn Boxer & Co.
Fitton Trust, The
*Gimpel Fils Ltd
Greig Fester Ltd
Guinness Peat Group
Hill Samuel Group
Ian McIver Architects
IBM United Kingdom Ltd
*Imperial Chemical Industries Plc
Kleinwort Benson Ltd
Knoedler Kasmin Ltd
*Leger Galleries Ltd
Lewis & Co. Plc, John
London Weekend Television
*Lumley Cazalet Ltd
Madame Tussauds Ltd

for further information apply to:

The Friends of the Tate Gallery,
Tate Gallery, Millbank, London SW1P 4RG
Telephone 01–821 1313 or 01–834 2742